Pinnacle Studio 24
Revealed

Jeff Naylor

Pinnacle Studio 24 Revealed

ISBN number 978-0-9934871-3-2

Published by
Dtvpro Publishing
34 Hillside Gardens
Berkhamsted
Herts, HP4 2LF

Copyright 2020 by Jeff Naylor

First Edition published August 2020

POD file version for this printing: 1.0.0

Software used: Pinnacle Studio 24.0.1

For downloads, updates and support please visit

www.dtvpro.co.uk

Introduction

Pinnacle Studio 24 is a powerful program. It is not based on the classic line of Studio which ended in version 15, but on Avid Studio – a program developed to be a replacement for Avid Liquid, itself a fully-fledged broadcast application. The major enhancements for version 24 include a rewritten Title Editor and improved Masking tools.

I have been producing a book since version 16, with a complete overhaul for version 23, when I used the opportunity to reflect how consumer video production has changed since 2012. I've also tackled the thorny subject of the Standard version of Studio, hence the shortened title.

I want you to use this book as an alternative to wading through the manual. It is often based on examples so that you can practice Learning by Doing wherever possible.

If you are completely new to video editing, then I'd encourage you to start at the very beginning, but you can still use this book as a reference. I've included an index and the chapter subheading will also help you navigate your way around.

I hear of people who work for months on their first editing project. They learn as they go, perhaps doing things the long way round at times, but getting great pleasure from it as they do so. Unfortunately, a few of those find themselves up a cul-de-sac. By making some short projects with me before embarking on your masterpiece, I hope you will avoid the dead ends.

What you need to use this book

Apart from the Whistle-Stop chapter, I've written for users of Plus or Ultimate. There is still plenty of information relevant to the users of Standard in later chapters, but as Pinnacle now make it relatively painless to upgrade from the basic version I would encourage you to do so.

Most of the files I use are quite small and therefore not too difficult to download from *www.dtvpro.co.uk*, but can be sent to you on a disc if you don't have a reliable Internet connection. Details of where to find the files and how to buy a DVD are at the end of the final chapter.

About this Edition

This book was written using Studio version 24.0.1, so some of the issues discussed may well be resolved with later patches. Any significant changes will be covered on the website in the form of a downloadable PDF.

About the Author

Jeff Naylor has worked in broadcast television since leaving school. In the 1980s he also developed an interest in personal computing which led to the publishing of several programs and books.

He began using Pinnacle hardware and software in the late 1990s as a means to making showreels for his directing work.

He has been determined to find constructive solutions to his editing problems since recovering from a Spinal Tap moment in 1999 when the computer very nearly went out of the window.

Author's Acknowledgements

I would like to thank the regular members of the Pinnacle forum for their help and putting up with me, Pinnacle staffers Jon RT for permission to reproduce the Pinnacle Studio screenshots and Nick Glusovich for listening and acting on feedback regarding the program.

Many thanks to Sphericam for their kind permission to use the Train clip in the 360 degree video demo.

In particular I owe a great deal to John and Linda Bagnall for their really useful input. My final thanks go to Fiona for correcting the many typos in the first draft and to my Mother for inspiring me to do something constructive with my spare time.

Thanks Mum - I miss you.

By the same Author

Pinnacle Studio 15 Revealed

Pinnacle Studio 16 to 21 Plus and Ultimate Revealed

Pinnacle Studio 23 Revealed

Videomaking - The Grammar Revealed

Magix Movie Edit Pro 2014-2015 Revealed

Contents

Pinnacle Studio's User Interface 67

Importing and Linking 83

Using the Library 123

The Editing Tab 171

Basic Editing Techniques 193

Audio Editing 255

The Title Editors 283

Transitions 329

Corrections 353

Color Grading 373

The In-Built Editor 389

Photos - and More... 423

Advanced Tools 451

Editing Enhancements 507

Project Formats, 3D and 360 video 525

Multi-Camera Editing 541

Stop Motion 567

Export 577

Disc Creation and Menus 619

Understanding Studio 663

Some Basic Principles

Video editing programs work somewhat differently to other programs that you might use on a computer, and understanding how they operate can save a lot of confusion.

In addition, having a clear concept of how video is stored as a digital file will help you to troubleshoot issues you may have when working with the many different types of files that abound today.

How a Video Editing program differs from other types of data manipulation

When you work with a word processing program, you will often create a document from scratch. OK, you might start with a template of some sort; the layout of the page could be pre-defined, there may even be some text already present – your name and address and the date might be part of a letterhead template. However, the original content of the letter is typed into that document by the user and the file that is used to store the document contains the actual letters of text stored in a digital format. Even if you have copied the text from somewhere else and pasted it into your document, the actual text is added to the document file.

If you open a partially written document file in a word processor, add or delete a few words and then save the document again, you have made a permanent change to the document. If you don't want to change the original document you can perform a "Save As" operation on the edited document file and give it a new name, but if you just allow the program to overwrite the original document, any bits of text that have been removed are lost forever. (In reality, modern sophisticated programs may offer ways to roll back to an earlier edit, but you cannot rely on this.)

Other programs operate on "data" that isn't created by the user within the confines of the program. Consider a photo editing program. You have taken a photo with your camera which has stored the picture as a digitally encoded file. You transfer that picture file to the hard drive of your computer. It's most likely in a format called "Jpeg" but could be in one of dozens of other formats. As long as your system knows how to decode the file it can display the picture for you. When you open the picture file in a photo editing program that also understands the Jpeg format, that program can not only display the picture, but allows you to edit it. You can crop it, alter the exposure or modify the picture in many other ways, depending on the sophistication of the program. However, when you have made the changes, you need to re-save the file.

Although the program will probably warn you of what you are about to do, if you save the modified picture with the same name and in the same format, you will destroy

the original file. You may be able to recover the original picture (it might still be in the camera memory), but then again, you might not.

Photo Editing Process

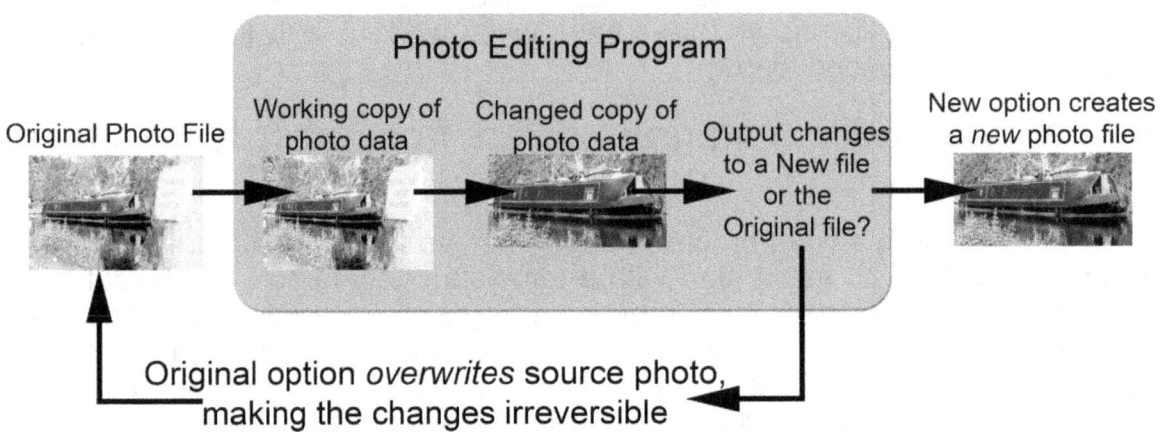

The above process is called Destructive Editing. It's quite easy to avoid destroying the original picture file by careful use of "Save As" and alternative file names, but when you are manipulating a picture file, you are manipulating the data from that original picture.

Let's consider a more sophisticated use of an editing program, where you are using it to create a new object – for the sake of this example let's assume you have taken a picture of a child's birthday party and you want to produce a Thank You card with some text superimposed.

You start a new, untitled picture and set the size to something suitable for printing. Now you import the picture from the file already saved on your computer. You find the picture is the wrong size and shape, so you shrink and crop it to fit the card, and then add some text using a tool in the editing program. You have made a new object, and you save the whole thing to a new file with a name that bears no relation to that of the photo that is part of the card. Even the file format will be different – if you use Photoshop, for example, the default file type will be .PSD, and not a Jpeg.

When you are working on the Thank You card, the editing program contains data relating to the picture, but once you save and reload the card from the publishing file, only the shrunken and cropped picture data is available to the program. If you delete the original, full size, picture file from your computer you can still load the publishing file containing the card and that will hold some, but not all, of the picture data.

This more sophisticated way of working is still potentially "destructive" editing if you overwrite the original Jpeg. More importantly, it is potentially destructive in another way.

Publishing program process

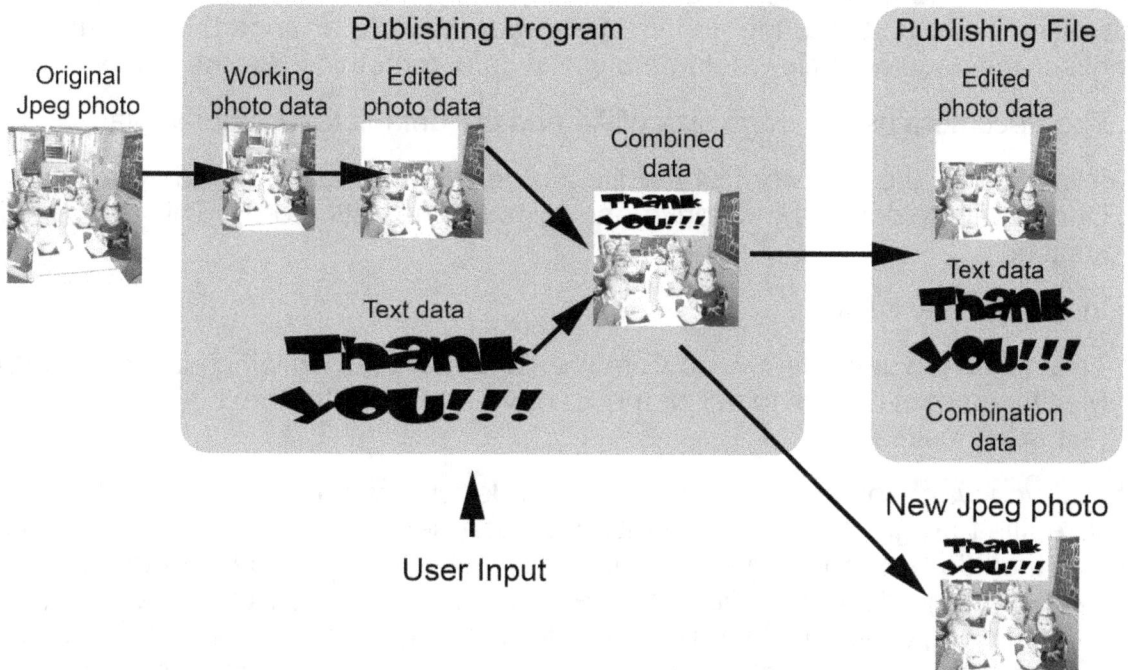

Let's assume someone else wants to print out the card. You can just give them the Publishing file and if they have the same program as you, they can do so - they don't need the original Jpeg. But what if that person wants to change your cropping because you have cut their child out of the frame? With only the Publishing file there is nothing that they can do about your editing because the part of the photo with their child in is not stored in the file you gave them.

This model is one which, in my experience, some people believe applies to non-linear video editing programs. It's an understandable assumption, but not normally how a video editing program works.

Video data takes up far more storage space than text or even pictures, so it makes sense to leave the video data on the hard drive and not try to embed it in the file that defines the edited version of the movie. The Movie project file that you save during, and at the end, of an editing session won't contain any video; neither is it likely to contain any pictures or music. There may be some raw data such as titles, but this will depend on the program.

So what does this Movie project file actually contain? Apart from information about how the movie is set up, it is mostly data that points to other files.

Let's return to the example of writing a letter. If a word processor operated in the manner of a video editing program, the text would be stored as separate files and the document file for a letter would be a set of instructions defining which parts of those files make up the letter, and in what order they are arranged. Translated into "English" the document file would be a set of data something like the following:

- The document uses a page size of A4 and the default text colour is black.

- It starts with the first word of the file *Home Address* which is stored in the My Documents folder of the C: drive and uses the next 21 words. This text is right justified.

- Insert two blank lines

- The next word is the fifth word from the file *Letter to John* which is stored in the My Documents/Letters folder of the C: drive and uses the next 300 words. This text is left justified.

What if you want someone else to read your letter though? If they don't have the same editing program as you, then it's no good sending them the document file. Even if they do have the same program, they will still need access to the text files referenced in the document file. So what you need to do is Export the letter. You might print it out, or you might make a new file that any computer can read - a simple text file or perhaps a PDF file. In the case of the text file, it would only contain the bits of the text specified by the document file - for example, it won't contain the first four words of the Letter to John file because they are only contained in the original text file. The export started at the fifth word.

Now, while this is an unnecessary complication for a word processing program, there are a few advantages. The files *Home Address* and *Letter to John* can be huge, but the document file can be small. The same data files are also in no danger of being overwritten and can be kept in any accessible location as long as they can be read by the program.

Let us take the above model and apply it to a video editing program so you can begin to see the advantages. None of the large assets – video, audio and picture files – that you use in the creation of a movie project need to be embedded in the file defining the movie. What is more, the computer only needs to bring the portions of the assets that it needs to display at any one time into the computer's fast RAM memory, leaving them stored on the hard disc. As long as it can access the assets quickly enough to show the movie in real time they can stay in their original locations.

Non-Linear editing process

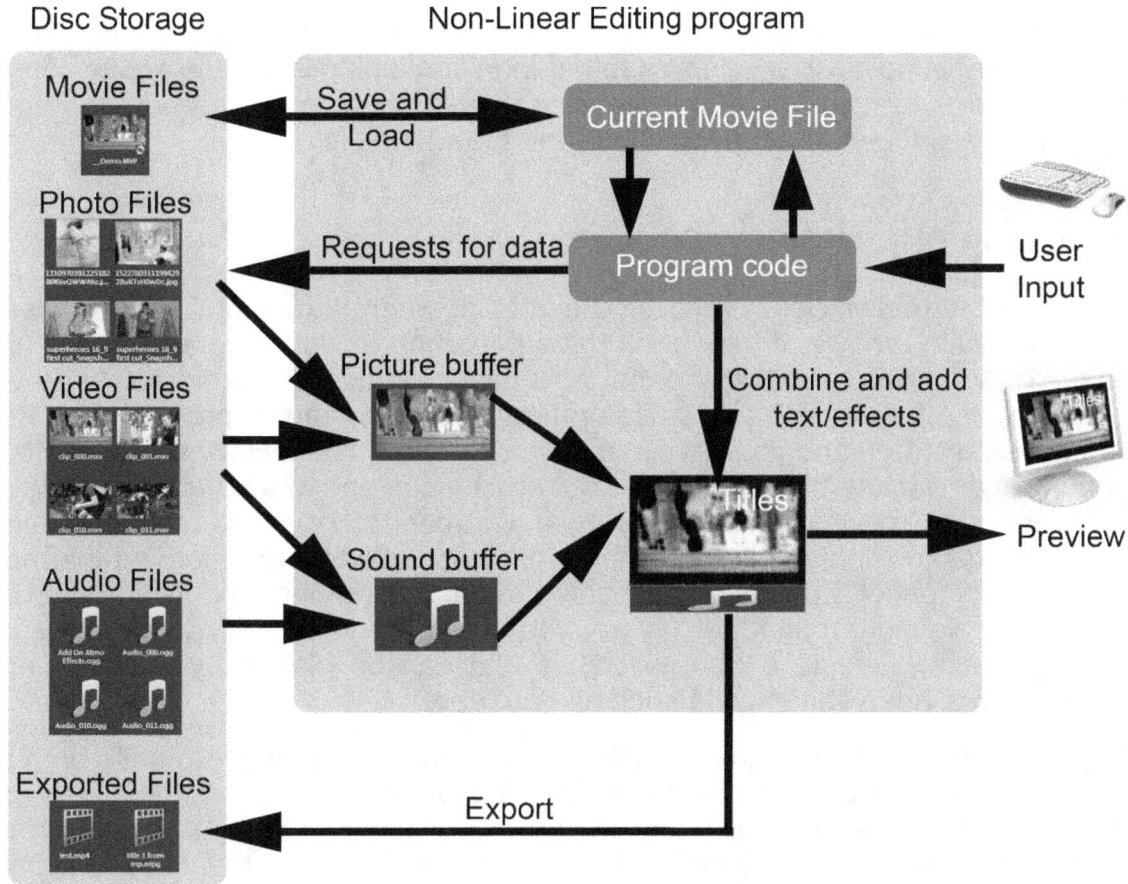

Our Movie project file might translate into something like this:

- This movie has a resolution of 1920 by 1080 pixels and a frame rate of 25 frames a second.

- It begins at 00:00:00:00 (0 hours, 0 minutes, 0 seconds and 0 frames)

- At this point display the text "My Spanish Holiday" in Arial font, yellow 48 point centre justified over a black background.

- At 00:00:05:00 (5 seconds) fade out the text over a duration of 00:00:00:12 (12 frames – nearly half a second)

- At 00:00:6:00 (6 seconds) play the video from the file *28_6_13_01.AVI* stored in the folder *Holiday Videos/Spain 2013* on the D: drive, starting at 00:00:28:05 (28 seconds 5 frames in) for a duration of 00:01:15:00 (1 minute 15 seconds).

- During this shot, apply the video effect "Auto Colour Correction".

If you use a media playing program such as iTunes or Windows Media Player, where a playlist points to music files rather than containing them, the above concept will be familiar to you. An editing program is just more selective and can choose sections of a video or audio files rather than the whole file.

Exporting and Previewing

Just as in the earlier word processing example, when you want someone else to view your edited movie, if they don't have the same editing program as you have used, you will need to export the movie. If they did have the same software, they would still need access to all the files referenced in the movie project, even if the files were very large and you have just used short fragments. However, in much the same way as a letter might be printed out or saved in one of a number of computer readable forms, movies can be exported in a number of ways. In the earlier days of software video editing, exporting was normally achieved by re-recording the movie onto a videotape. Nowadays if you wanted to send someone a copy of your edited video to be played through their TV set you would burn it to a DVD or increasingly likely, you would create a new video file that can be played by a computer or uploaded to a video sharing site such as YouTube.

Playing an edited movie within an editing program or exporting it to a file both use the source files in the same manner. In the case of playback to a screen, it needs to happen at the same pace (or frame rate) as the video was shot at. For export to a file it has to re-encode the video data into a new file and this may take more computer power than simply displaying the pictures. However, it doesn't really matter if it takes 30 seconds or 2 minutes to export a movie with a duration of one minute.

Real time preview may be affected by other factors though. Let's assume we are happy with our "My Spanish Holiday" movie and want to preview it from the beginning. With the cursor at the start of the movie, when we press the play control, the program generates the title specified, then after 5 seconds it fades it out over half a second. Another half a second of a blank screen is sent out before the program begins playing the first video file from the hard disc, starting at the point specified.

One factor that may stop you being able to watch the edited movie in real time is the manner in which the source video is stored on the hard disc. If the data is in a very raw state it will be stored as a large file and even the latest computers will struggle to read that amount of data from the hard disc in the time it needs to achieve real-

time playback. To avoid that problem almost all video files have their data compressed in some way so that they can be read faster than required. However, some types of compression are so complex that the video information cannot be decoded by the computer's processor quickly enough – depending on the power of the computer and the sophistication of the editing software.

Compression and Playback

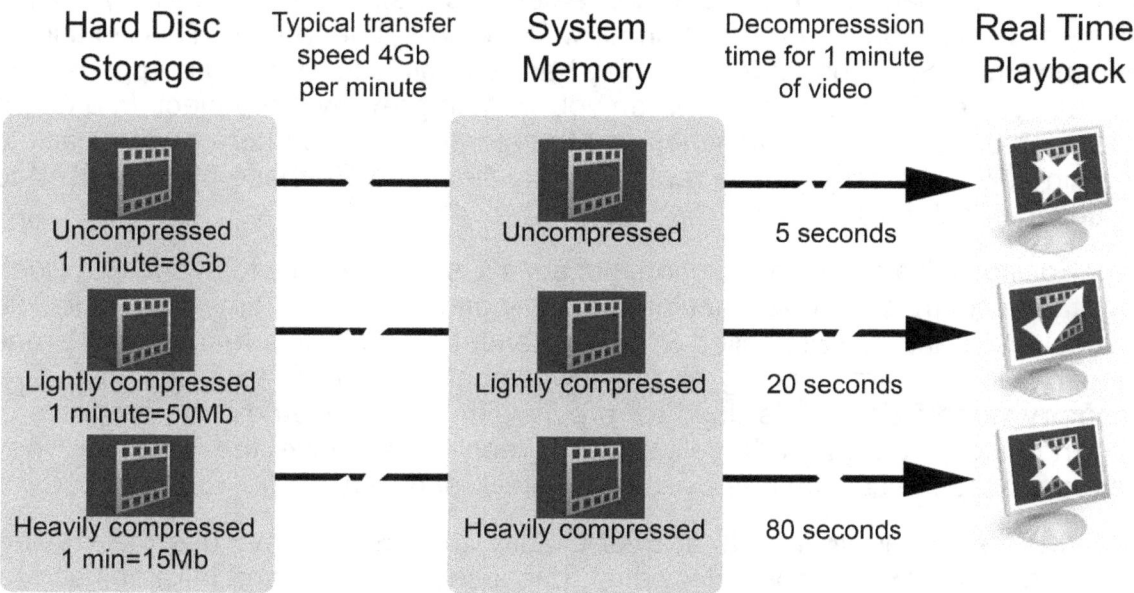

Therefore, if a video file is too lightly **or** too heavily compressed it can overwhelm the capabilities of a computer to play it back smoothly. It is more likely that you will be trying to work with files that are heavily compressed so CPU or GPU power may prevail, but not everyone can afford a very fast machine.

However, in addition to being able to fetch and decode the video data quickly enough, there may be other things that will hinder real-time preview. In the Movie project file I described earlier, you will notice that I specified an effect, "Auto Colour Correction" to be added to the shot starting at 6 seconds. The video editing program needs to calculate and apply this effect to the video data after fetching it from the hard disc but before outputting it to the screen. We will have a problem here if the effect takes a long time to calculate and apply to the video data. If it takes more than one second to add the effect to one second's worth of video we can't play back the video in real time – it is going to slow down and appear jerky.

Proxy and Preview files

What's the solution to the playback problem then? We have to be able to preview our video projects in real time in order to make any creative decisions or if we want to "print" them back to a tape. Two strategies are used to achieve this.

One approach is called Proxy Editing. Pinnacle Studio implements the use of Proxy files in order to make the Multi-Camera feature work smoothly. With Proxy Editing activated, any file you import has a shadow file (a proxy) generated. This file uses a medium compression format that will play back smoothly for preview purposes, and is used in place of the original file when you want to preview the project. In order to avoid degradation to the movie when you transfer the Multi-Camera project back to the main editor, the original files replace proxy files, and it's these that are used to produce the final movie.

Proxy Editing isn't a complete solution, because it is still possible to overload a video clip with effects that can't be calculated quickly enough for real time playback. The more selective approach is called Preview Rendering. With this feature, any areas of the movie that aren't going to preview smoothly can be exported to a new temporary video file which is used for preview. In Pinnacle Studio the progress of this rendering is shown with yellow and green bars above the timeline. They disappear once the section has been completely rendered.

If you are previewing your edits at Best Quality, then Studio may use the preview files when exporting the movie. However, because the format and bitrates used by Studio may not match the original files you can override this feature by deleting the preview files before you export.

The default is to use preview rendering for the whole timeline but you don't need it to work that way - we will see how preview rendering can be used selectively later in the book.

So, if you have added some pretty complex effects and transitions to some parts of your movie, these may need to be preview-rendered. If there are some clips using a highly complex compression scheme that your computer struggles to play back in real time, these can be preview rendered as well. Perhaps whole sections of the movie don't need this treatment, though, saving you the time it takes to re-encode everything.

Why "non-linear"?

You may have noticed me bandying about the term "non-linear" without really explaining it.

Before the advent of Video, movie editing was non-linear. Film is little more than a series of individual photos on a strip of celluloid. Making a movie from a bunch of film clips allows you to build it up in sections and rearrange it with ease. Changing the finished product was easy too – you could cut bits of film out of the movie and repair the gap, or split the reel at a certain point and splice in a new section. So, the process isn't Linear, in a straight direction – you need not start at the beginning and work methodically to the end.

However, video used to be only recorded on tape, with the movie starting at the beginning of the tape and ending at the end. To edit your movie you copied across the bits you needed from a playback machine to a record machine in the order that you wanted them to appear. If you then decided to change your mind and swap two parts of the movie around, you had to go back to the point where your changes began and remake the whole movie from that point on. (OK, if you are familiar with audio tape recorders you might ask why video tape couldn't be spliced in the same way. It could, but it was an extremely delicate operation that risked destroying the recording).

Once it became possible to store video data on a hard disc rather than a tape, non-linear Video editing became a practical proposition. What's more, because a Movie project file is nothing more than a complex playlist, you don't even need to move the video data around in the computer memory or on the hard disc – you just change the playlist. So in many respects it's faster and more flexible than film editing.

Storing and replaying moving pictures

Those digital files on your hard disc are nothing like a strip of celluloid with a series of still pictures on them, but the underlying principles of recording and playing back moving pictures are the same. We won't concern ourselves with how a strip of film is created, but through the wonders of lenses, light-proof housings, opening and closing shutters and chemical reactions, it consists of a series of semi-transparent images, each one taken a very short time after the other. If these images are projected onto a screen by shining a light through them in rapid succession, the human eye and brain isn't aware that they are individual pictures and any movement that occurs in the subject matter appears as natural movement. Each one of the images is called a frame.

The frame is the fundamental unit in film, television and video. The number of frames shown each second varies, unfortunately. Conventional feature films record and display 24 frames a second. The television system created in the USA (NTSC) uses 30 frames a second (actually, slightly less – 29.97 frames a second for technical reasons) and the European (PAL) system uses 25 frames a second.

A series of frames

There are historical reasons for these incompatibilities, (and some other video standards as well). The basic principle, though, is that if you can show still pictures quickly enough, one after the other, the brain is tricked into thinking they are watching continuous action.

Scanning

There is a further complication with video. I really need to mention it now rather than glossing over the issue, but if this section confuses you, come back to it when you need to understand the difference between progressive and interlaced video.

Historically, a video picture was recorded by scanning a thin line across an image projected by the camera lens onto the face of a "Camera Tube". The scanning started top left and "read" the values across to the right of the picture, then moved down the image and scanned another line.

Because of technical limitations, a better picture resulted if the first pass scanned half the image, then a second pass went back and scanned the gaps between the first set of lines. So, in a Top Field First (TFF) scanning system the first pass, called a field, scanned lines 1,3,5 and so on, and the second pass scanned a field consisting of lines 2,4,6 and so on.

The two fields were also played back like this, so instead of there being 30 (or 25) frames per second, there were 60 (or 50) fields per second. Just to make matters more complex, some types of cameras scan lines 2, 4, 6…. and then return to 1, 3, 5… thereby using a Bottom Field First scanning system.

These scanning schemes are called Interlacing and many TV broadcasts are still stuck with them today. They hark back to the days of not just camera tubes but also vacuum tube displays (CRTs – Cathode Ray Tubes). The alternative scanning scheme is

called Progressive because the scanning progresses through the number sequentially – 1, 2, 3, 4, 5, 6… and so on.

Interlacing example with a low resolution format

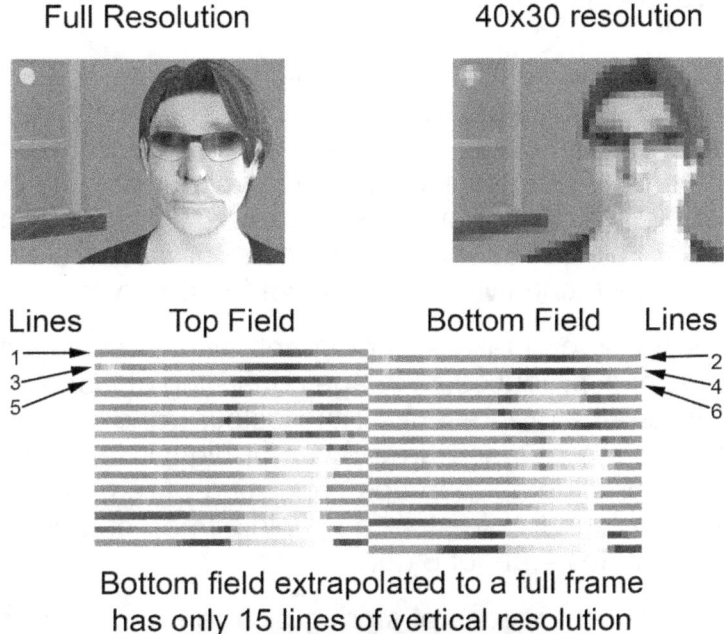

Bottom field extrapolated to a full frame
has only 15 lines of vertical resolution

Almost everyone now watches video on solid state displays – the flat panel display of a Plasma, LCD or LED TV, or a computer, tablet or phone screen. These are natively progressive devices that don't need interlaced signals, but it is often best to let them convert the signals themselves rather than doing it beforehand. Converting interlaced video to progressive doesn't automatically make it "better" and if not done carefully can make it look considerably worse.

Problems start to occur when you try to show two fields at the same time, but a part of the scanned image has moved between scanning the first and second field. In the worst case, you might have to drop a whole field of information, resulting in half the

vertical resolution of the scanned image. The illustration on the previous page shows this with a low resolution picture - 40x30 pixels - to make the example clearer. (It's not far off the resolution of very early mechanical scanning systems, though!

Still pictures as digital files

When you print out a photograph taken with a digital camera, it is nothing more than series of coloured dots that blend into each other. The quality of the picture is a function of how accurate the colour of the dots is, and how many there are to the square centimetre or inch. The same is true when you display the digital photo on a TV or computer screen, except that the screen has a fixed number of dots – or Pixels (picture elements) – to the square centimetre or inch. If we enlarge our view of the photo, we can see the individual pixels that the photo consists of.

A digital stills camera that can take a photograph with a resolution of 1920 pixels wide and 1080 pixels high produces an image consisting of just over 2 million pixels or 2 Megapixels. In order to represent all the colours and degrees of brightness accurately we need to use at least three bytes of digital data for each pixel. This would be an 8-bit colour scheme, perhaps consisting of red, green and blue in the range 0-255 for each colour. So, to store a simple bitmap of that photo the camera needs to use 6 million bytes – about 6Mb.

A bitmap is a very inefficient means of storing picture data, although it is the most accurate. Most photographs are going to have areas that are almost exactly the same colour and brightness so you can start compressing the information by defining areas of the image that have the same value. If you aren't too fussy about the meaning of "same value" or very fine detail you can compress most photos by quite a lot. Far better compression schemes are possible using more advanced mathematics, of course. The highly popular Jpeg scheme, for example, uses Discrete Cosine Transformation, which I'm not going to attempt to explain as I'm not sure I understand it sufficiently myself!

Video as digital files

A very inefficient way to store a video picture is as a series of bitmaps, each one defining one frame. For good quality video you need at least 24 bitmaps for each second of video playback. There is a format that stores video in this manner; it's called Uncompressed AVI (Audio Video Interleave). As the acronym implies, AVI files contain audio as well as video data, and as you might guess, they are pretty big. A program I use to create animations, iClone, produces high definition uncompressed AVI files and 1 second of video needs 178Mbytes of memory to store. These types of files are so large that they cannot be fetched from the hard disc of a computer quickly enough to be displayed in real time.

I've already pointed out that there are perfectly good ways to compress individual pictures, so it seems obvious that compressing each frame using a method such as Jpeg encoding is going to make video files smaller. This is called Intraframe encoding because all the compression is applied within the individual frames. The most common example of an Intraframe video compression scheme is DV-AVI – the first digital video cameras available to consumers. Here each frame is compressed, but a DV-AVI file contains each individual frame as a separate image.

Intraframe video compression

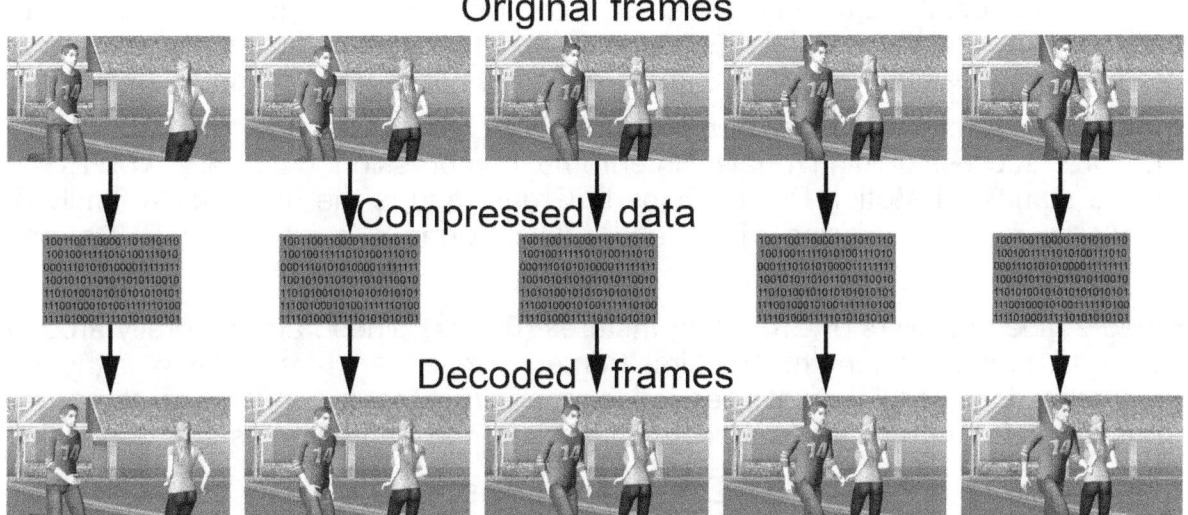

Original frames

Compressed data

Decoded frames

DV-AVI files are only "standard" definition, with the same number of pixels in each frame as pre-HD TV broadcasts, and the compression applied to the individual frames is such that the pictures don't quite meet the high standards required by most broadcasters even for SD. The files are still big, but not so big that they can't be read from a computer hard disk in less than real-time – so they can be played back smoothly.

The compression applied to the individual frames of video is relatively light as well, comfortably within the power of a computer to decode and re-encode without significantly slowing down playback.

There are a number of other video formats that use intraframe compression, but they are normally restricted to the professional world. Apple's ProRes and Avid's DnxHD codecs allow relatively low powered computers to work with HD and even UHD video and achieve smooth playback.

Interframe compression

Intraframe compression methods still produce files that are too big to be sent over the Internet or via transmitters in real time– there is just too much data. The next step in compression techniques for video looks at the similarity between adjacent frames in much the same way as still picture compression looks at the similarities between adjacent areas. Imagine a video of a newsreader sitting at a desk with a picture behind them. The only differences between the subsequent frames are small movements of the newsreader's head. So, by only recording the differences between frames, the amount of data needed is reduced enormously. This is a very extreme example; video with lots of movement, either by the subject or the camera, can't be compressed so much, but there are still savings to be made.

Simplified interframe compression scheme with a GOP of 4 frames
The first successful high quality interframe compression was called MPEG-2. MPEG stands for Motion Picture Experts Group, and is the name for a family of standards for compressing video and audio. Mpeg-2 is used for DVDs and broadcasting.

Mpeg-2 video consists of Groups of Pictures (GOPs). These are generally around 12 to 15 frames in length. The first frame is called an I-frame, and, although compressed, holds all the data needed to reconstruct that frame. I-frame stands for intra-coded frame – all the compression is within the frame just as in DV-AVI. The

Original frames

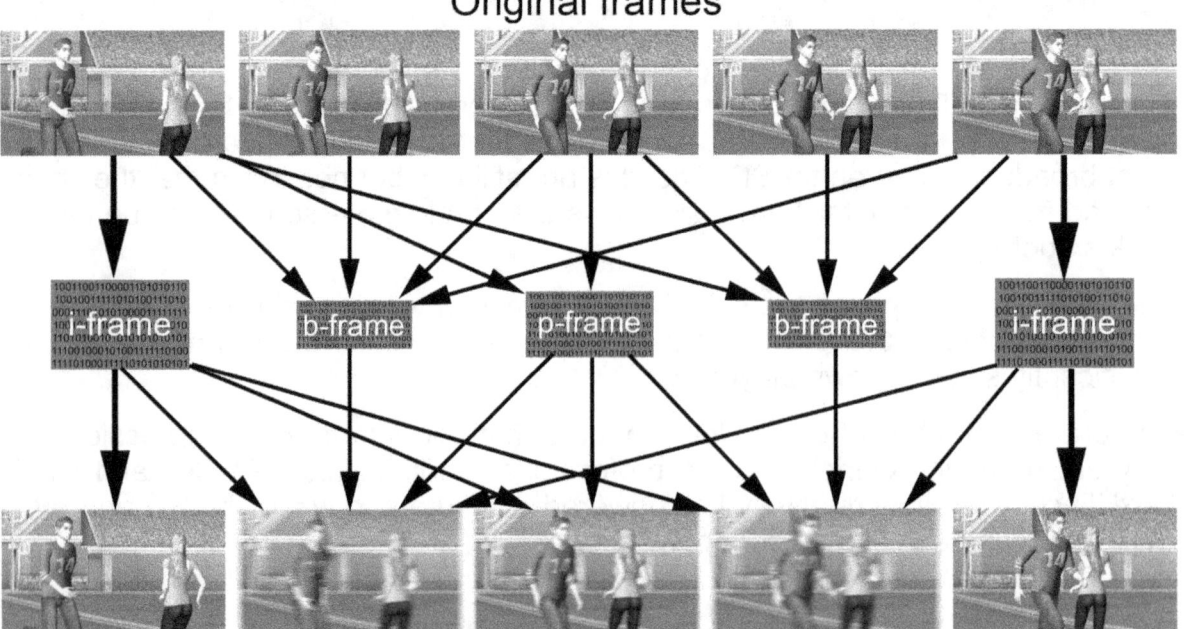

Decoded frames

rest of the GOP is made up of P-frames and B-frames. P-frames (Predictive-coded frames) refer to data from the previous I or P frame when compressing data. There are normally 3 or 4 P-frames in a GOP. B-frames (Bidirectionally-predictive frames) refer to data from frames both before and after it.

If, like me, you struggle with the concept of how that all works, the important point to grasp is that for MPEG-2, there is only one high quality, accurately compressed frame every half second or so. Every eighth of a second, there is reasonable quality data in the shape of a P-frame. The rest is the result of a very sophisticated compression scheme. Or, if you prefer, Smoke and Mirrors.

Bitrates

When compressing a video file, the resolution and frame rate may be fixed but you can vary the amount of compression by altering the Bitrate – the number of digital data bits used to represent a second's worth of video.

MPEG-2 can use variable compression. If the video gets a lot of movement, it can reduce the compression to try to keep up with the large changes. You can also specify the bitrate of the compression to suit your own purposes.

DVD quality MPEG-2 video uses about 6000 Kilobits to represent a second's worth of video, although this may vary depending on the content if the encoding uses variable bitrate – compressing video with less movement more than sections with lots of movement.

Sometimes the words "Data Rate" are used instead of bitrate just to confuse us. That might not be measured in bits, but bytes or something else. So when we look at data rates, let's make sure we are comparing like with like. A Kb is a kilobit. A KB is a Kilobyte - eight times more, so be sure to check if the b is upper or lower case. Some people just love trying to confuse the general public, and whoever came up with those abbreviations wasn't trying to make it easy!

MP4

MPEG-2 video files are too big to use over the internet and get decent quality. Other formats, including MP4 video, use more advanced compression schemes with a correspondingly larger need for computer power to encode and decode the images.

The first attempt at improving on mpeg-2 was mp4 Visual, and you can still use this format in Studio, but as hardware has improved so have the codecs

AVC/H.264

The current favourite for compression is a scheme called H.264, used by AVCHD cameras, Blu-ray discs and much more. Although up to date hardware can handle this format, it can put a strain on older computers, making smooth playback difficult - especially if you use higher resolutions and frame rates It's tough for editing programs to extract single frames from an h.264 file, which media playing software doesn't need to do. If you are puzzled that Windows Media Player can play back your new camera footage smoothly, but your editing software can't, that's why.

HEVC/H.265

Technical advances and the desire for higher resolution video mean that a new standard – h.265 – is becoming more commonplace. This roughly halves the bitrate of video for a given resolution and quality by using even more complex compression techniques

The latest computer graphics chips have dedicated hardware to deal with HEVC and Studio requires a powerful machine to create video files in that format - so you might not have the option to do so with your current computer.

AV1

There is a new kid on the block now. The same sort of advances, with refinements, that made HEVC possible are also used in a system developed by The Alliance for Open Media - **AOMedia Video 1**. This has been shortened to **AV1**, not to be confused with AVI (Audio Video Interleave).

While it's not the sort of leap from h.265 that occurs between h.264 and h.265, it has one winning feature - it is royalty free. Software and hardware companies really like that, so expect it to become very popular.

While the latest version of Pinnacle Studio can decode AV1 quite successfully for use in your projects, encoding to AV1 is behind the curve at the moment, and Studio can be up to 20 times slower - while working at almost full tilt - when exporting a file using AV1 than AVC or HEVC. I'd expect this problem to be addressed quite quickly, even within the life of Studio 24.

Containing file types

I have often read – and answered questions about – video file types that don't behave properly within a video editing package. Media playing software has a great advantage because it only needs to partially decode the files – and often you don't realise that you have to wait quite a while for the playback to get going - buffering.

Another reason, though, is that two files may appear to be of the same type, but contain radically different content. Even an old format such as AVI is just a *Container* – the streams of data within it can use different compression methods. These schemes – known as CODECS (compression/decompression) may not be compatible with the editing software of your choice. Even DV-AVI has two types.

MP4 and M2TS (Sometimes abbreviated to MTS) are two types of container that can use, amongst other schemes, MPEG-2, MP4 Visual, H.264, H.265 and AV1 compression. MOV, the Apple format, is just as indiscriminate, and may contain many combinations of video and audio compression schemes.

You may also come across the use of the phrase *Wrapper* in this context.

The Whistle-Stop Guide

This chapter is intended to get you up and running with Pinnacle Studio. It explains the simplest ways to make a short movie, but also introduces you to a number of concepts that a beginner to editing, and in particular Studio, may not be aware of. We will import a single clip from a drone flight, chop it up and condense it down to make it more interesting, add some titles, a bit of music and an effect, and then export the final product so that you can share it with others. On the way you will learn about achieving smooth preview, keeping your projects in sync, and much more.

Downloading the source material

You can try out the features described here with video footage of your own, but obviously you cannot follow my steps unless we are using the same clip. I've deliberately used a small clip so that it should be accessible by even the slowest internet connection. Use your internet browser to go to the website **www.dtvpro.co.uk** and use the tabs to navigate to the Studio 23-24 download page. From here download the file *Drone clip LQ.zip* - it's near the bottom of the page. Open your Downloads folder, right-click on the zip file and choose *Extract All*. Using the default settings, the uncompressed video file will be placed in your Downloads folder. If you struggle to download the clip a DVD can be ordered from the website.

Starting up Studio

Run Studio from the desktop shortcut (or by using your usual preference). To be sure that we are looking at the same things I'm going to first get you to reset the program. Hold down the Ctrl and Alt keys and press the letter C on your keyboard – the shortcut for opening the Control Panel.

The Control Panel Reset function

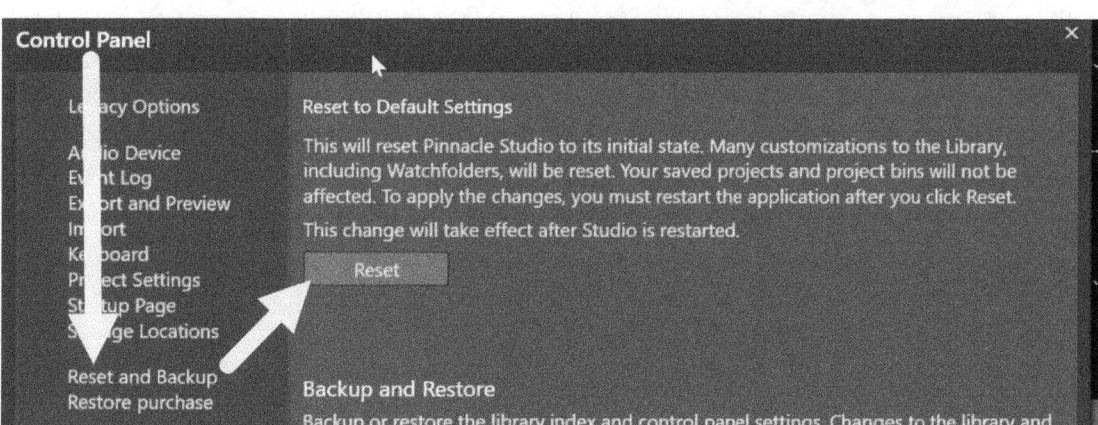

On the left you have a list of the Settings pages available. Choose the penultimate one, **Reset and Backup.** *If you have already changed the settings in the Control Panel and want to retain them for later use, refer to the Understanding Studio chapter for details of how to backup your setting.*

Click on the *Reset* button on the right. Now close Studio and then reopen it in order for the reset to come into effect.

Studio now behaves in the same way as it does when it is very first installed. A dialogue box appears asking you if you want to open the Importer. Decline the offer by closing the box with OK. You will see the sample movie load onto the timeline.

I now want you to make two further changes to the settings before we proceed. Open the Control Panel again using Ctrl-Alt-C or by using the Control Panel option in the upper menus and switch to the fourth option down – **Export and Preview**.

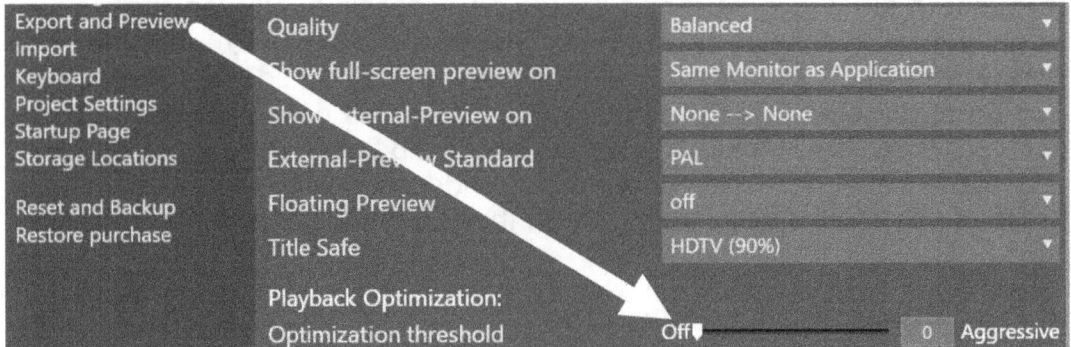

Halfway down the panel is a section labelled Playback Optimization and a slider marked **Optimization Threshold**. By default, it will be slid fully to the right, *Aggressive*. Slide it fully to the left, *Off*, so that the value reads zero. I'll explain the reason for this change shortly.

The other setting to change is the eighth option, Startup Page. Check the box for Edit and from now on whenever you launch Studio it will open at the Edit tab. The default – Welcome – is where Pinnacle offer links to support and acts as a shop front for them. Close the Control Panel with OK, close Studio again and reopen it.

Setting the Default Page

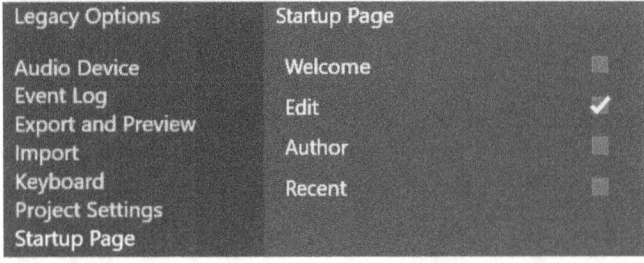

The Mode tabs and Menu options

At the very top of the program there are several drop-down menu options on the left, and a central bank of four tabs. *Welcome* is an icon of a house and the other three are labelled *Import*, *Edit* and *Export*. These tabs are where you switch between the three main movie-making tasks – bringing source material into the Library, editing it into a movie, and then exporting it to your chosen destination. If for some reason you still aren't seeing a similar display to the screenshot, make sure that Edit is selected.

PS24 Standard open at the Edit Tab

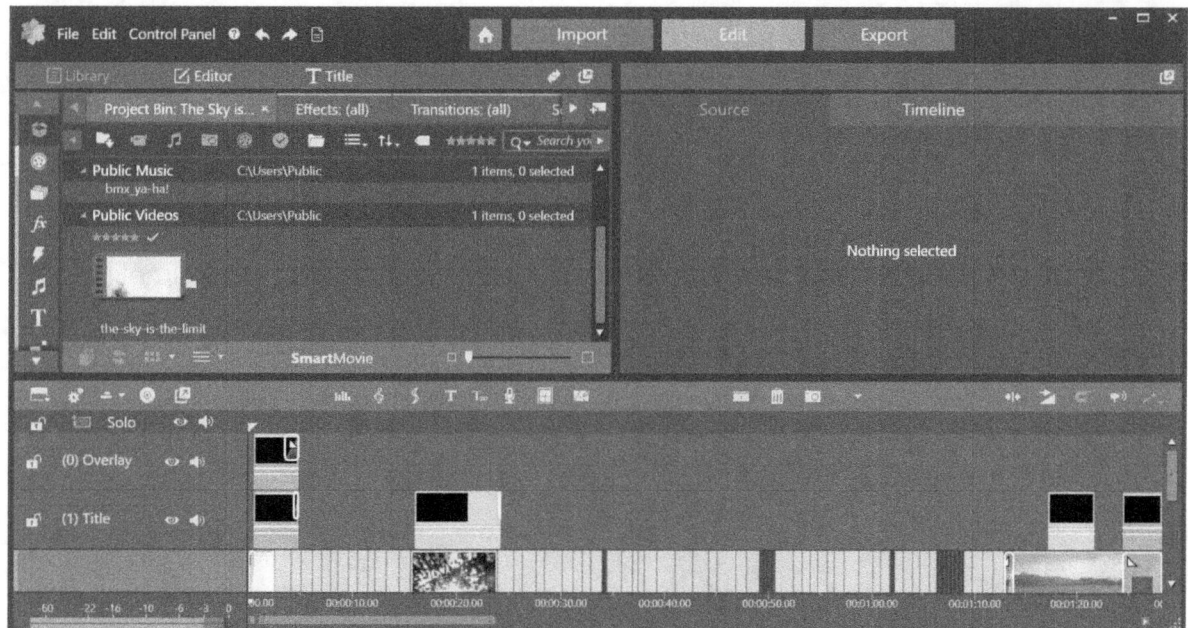

The Edit Page

If your view of the program now matches the screenshot, then you own the Standard version of Studio. This chapter isn't going to stray beyond its features so I will use it for most of the illustrations. If you own Plus or Ultimate you will find the central toolbar has far more icons.

I also want to introduce a tool that is aimed at less experienced editors, although it does have some advanced uses when making slideshows - the Storyboard.

The area immediately below the central bar is where earlier versions of Studio Standard displayed the *Storyboard* by default, but now you need to enable it with

the second toolbar icon from the left that looks like two bars or three dots. Click to drop it down, select the three dots and the storyboard should appear.

Tool for enabling the Storyboard

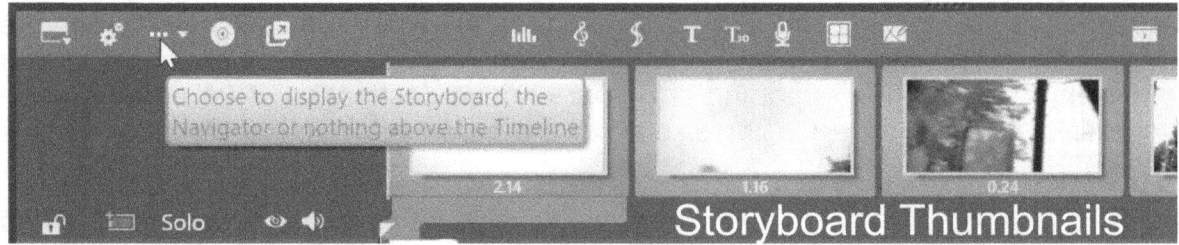

Currently you will have the sample project loaded into both the storyboard and timeline areas below the toolbar. Our first task is to clear the workspace.

Starting a New Movie

Click on the *File* menu option top left of the program and the first option below is *New*. Hover your mouse over it and you will be presented with the option of *Movie* or *Disc*. Select *Movie* and the sample movie disappears from the timeline and storyboard.

Starting a new Movie

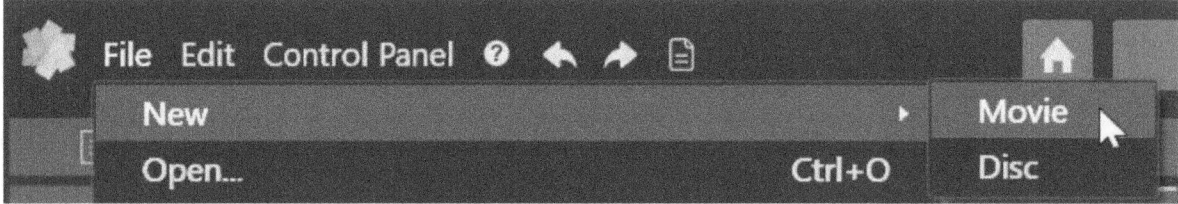

The new movie has no name, so the default chosen is *New Movie*; if you don't change the names of your projects they will end up being called a series of *New Movie (x)* files, which is hardly conducive to remembering what your movie is about. To save confusion, let's Save and Rename the movie at the same time using the fifth option down in the file menu, *Save Movie As…* and use the name **Drone Project**. A Windows style *Save As* dialogue box opens, pointing to the default project location. Enter the name, press the Save box and the new project name will appear above the preview window.

The Default Project Settings

Before we begin to create the new movie, hover over the first icon on the toolbar - it looks like a set of cogs. The current project's timeline settings will be revealed, and because we have an empty project

they will be the default resolution of 1920 by 1080 with a frame rate of either 25P or 30P, depending on your country settings - Countries that use PAL such as Europe will be 25, NTSC countries such as the USA will be 30.

The Studio Interface Layout

The default layout below the Mode tabs consists of a **Library/Effects** editor panel top left, a **Preview** window top right and the **Timeline** (with the optional storyboard) spanning across the bottom of the window. The way the interface can be displayed is highly customisable – windows can be resized, undocked and displayed across multiple monitors. For now, you just need to know one simple way to adjust the layout. If you hover your mouse over the junction of the three windows, a four-way cursor appears. Click, hold and drag and you can adjust the relative sizes of the three panels. This is particularly handy if you are working on a small laptop screen.

Interface areas and the four-way layout cursor

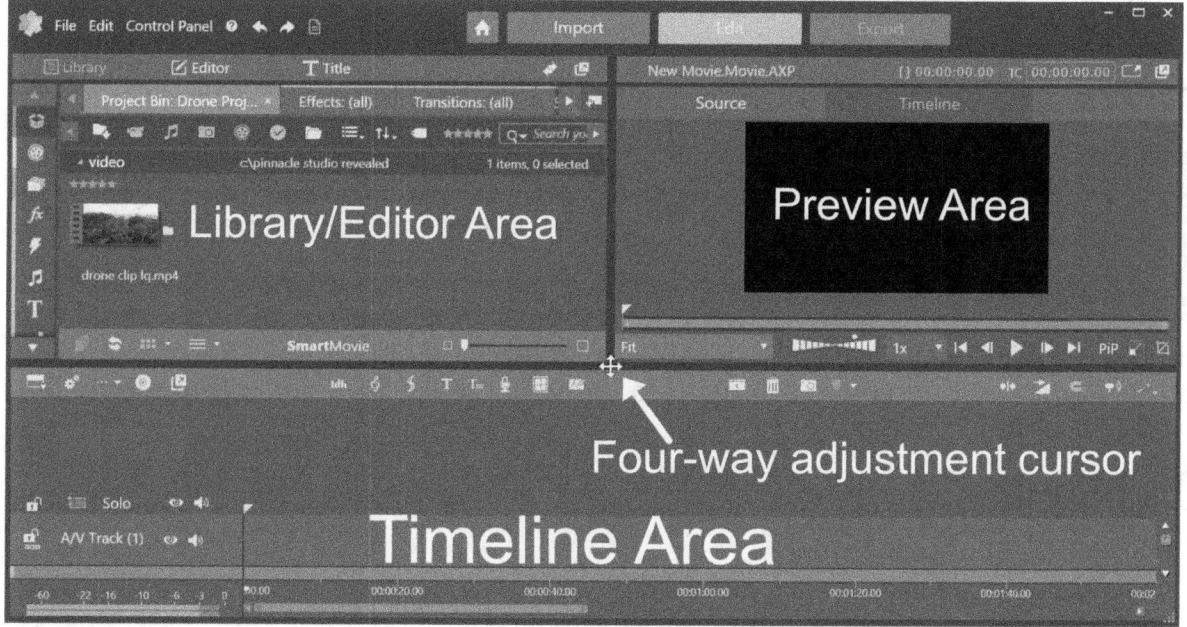

Setting up the Library for your project

Although you can now add items straight to the timeline by dragging them from Windows Explorer, they will automatically be added to the Library when you do so. Any clips used in the movie must exist in the Library, and if you use the default Studio settings, they should also be added to something called a **Project Bin**.

The Library is not a real location on your hard disc, it's a database that points (or links) to where the items are stored. Project Bins are virtual locations within the Library that also point to the items. You could have several bins that all point to the same video file without having to create multiple copies of that file.

It's a really good idea to have a separate Project Bin for each movie you create, and I'm going to harnesses this useful feature in this chapter. Other options and workflow are possible, but I'm going to save those until I discuss the detailed management of the Library.

By default, the Library shares its window with the Editor (which perhaps should be called the Effects Editor), the Title Editor, and also the Mask feature in the Plus and Ultimate versions of Studio 24. If you aren't seeing the same window top left of the interface as the previous screenshot, then click on the *Library* label on the left of the top bar.

The Library Navigation Sidebar

Pinned Library Flyout

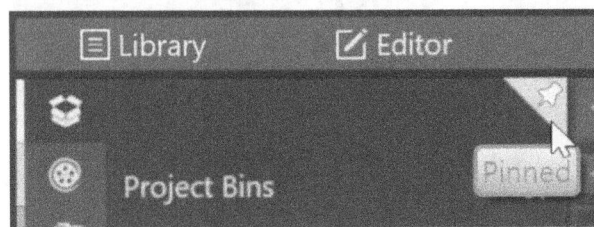

In all versions of Studio the Library Navigation sidebar now "flies out" when you hover over one of the icons on the left - do that now and you will see a list appear to the right of the icon.

How you want to work will depend on the size of the screen, For clarity, I've unpinned it in the screenshots by clicking on the blue and orange Pin tool top right of the flyout, but once you are used to the way the list flies out you may prefer to save the screen space.

Library Tabs

The Library tabs and controls

Scroll Tabs Add New Tab

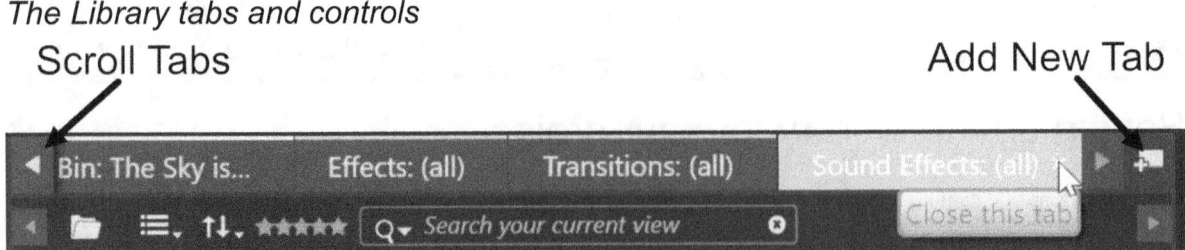

Underneath the top bar you should see up to four tabs. The first one is highlighted and titled *Project Bin: The Sky is...* and contains all the clips used by the sample movie, displayed below. Click on the other three and you will see *Effects, Transitions*

and *Sound Effects* displayed. If you can't see all the tabs you can scroll them with the small arrowheads. There is no limit to the number of tabs you can have open.

For clarity, let's begin by removing the current tabs using the delete cross that appears on the right of each tab when it's selected. You will find that when you have only one tab left, it can't be deleted.

Adding a new Project Bin

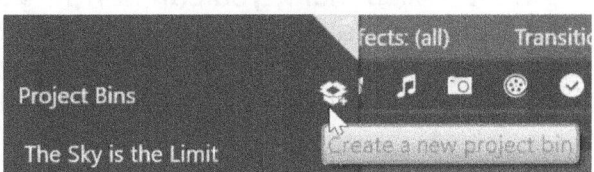

You can change what is displayed in a selected tab by using the column of icons on the left side of the Library. Instead, let's create a new Project Bin to take the place of the current tab.

Hover over the top icon on the left of the Library – it looks like an open box. The flyout panel will appear to the right if you haven't pinned it. It has a header entitled Project Bins and a list of the current project bins below. To add a new project, click on the icon to the right of the Project Bins label. A small dialogue box appears for you to type in the name of the new bin. Type **Drone Project** in the box, press Enter or click on OK, and you have created a new bin.

The Library should now have two tabs. Delete the unwanted tab to leave a Library that is just showing *Project Bin: Drone Project*.

One Library tab will do for now, but when you want to add more you can do so with the small *Add New Tab* icon on the right of the Library tabs.

Importing Video

if we wanted to use a whole bunch of clips, weren't sure where on the hard disc they were or if they were still on a camera memory card, we would be best off using the Import page to add them to the Library.

If the source material we wanted to use had to be acquired from an optical disc or a digital or analogue tape we would definitely need to use the Importer. This feature has a whole chapter devoted to it later in the book.

The Quick Import icon

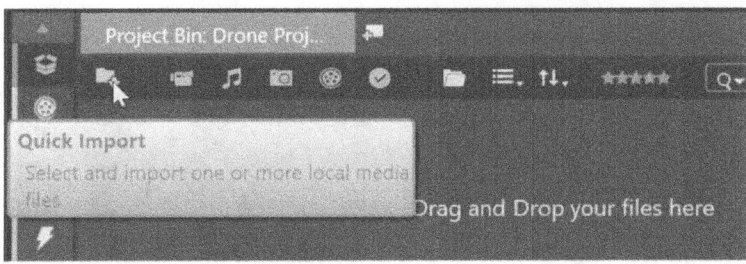

However, adding a few clips that are already on your hard disc to a Project Bin is very simple, assuming you know where they are: just use **Quick Impor**t.

There is a Quick Import icon top left of the Library toolbar, but you can also right-click on an empty part of the Project Bin window and select the function from the context menu. A Windows-style *Import Media Files* window opens up.

Earlier in this chapter we downloaded the zip file containing the required clip into your Downloads folder and extracted the video clip. At this point you can just load it from there - and you can quickly find this in the sidebar under Quick access. If there are a lot of files there, you can narrow your search with the filter drop-down to the right of the file name box – change the selection from *All compatible asset files* to *Video files*. (if you return to this dialogue box looking for other types of assets – audio or pictures – don't forget to switch it back!).

We are looking for **Drone clip LQ.mp4**. Highlight it and click *Open*. The box will close, and the clip will appear in the Project Bin. That's it for importing for now!

Previewing clips

Before we even put anything on the timeline, it's possible to examine clips in the preview window. When a project begins to get complex, you will want to look at what footage you have available before adding it to the movie. You can make corrections to the footage before you add it, and it is possible to pre-edit the clips, so that you can do your preliminary editing without having to add unwanted footage to the movie, only to have to delete it afterwards.

Even though the Standard version of Studio switches automatically between the preview tabs, it is worth understanding the difference between Source and Timeline preview even at this early stage.

Preview tabs

At the top of the preview window are two tabs, labelled *Source* and *Timeline*. With nothing on the timeline, clicking on the Timeline tab does nothing. Highlighting our sole clip in the Project Bin makes it appear in preview, and the Source label highlights to let us know what we are looking at.

Dual View icon

By the way, if you are using Plus or Ultimate, it's possible to have two previews. If that's what you are seeing, click on the Dual View icon to return to a single preview.

Source Preview Window Controls

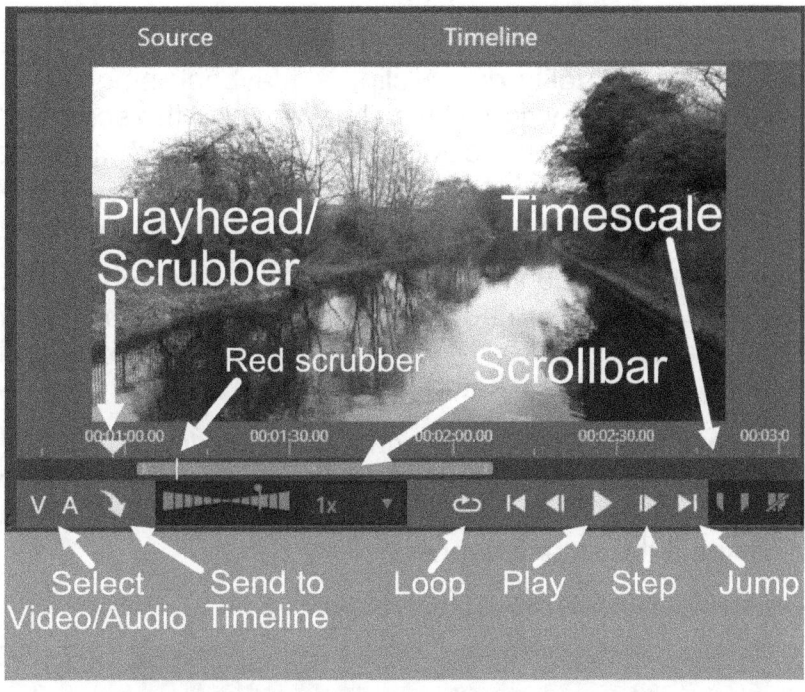

With a clip in the source preview, the easiest way to play it is with the Space bar. Press it to start and press it to stop. As it plays a marker – normally called either a Scrubber or a Playhead – moves from left to right along the bottom of the video, where a series of numbers are displayed on a Timescale relating to the current time within the clip. The start of the clip has a Timecode of 00:00:00.00, and as playback progresses you can see the current scrubber position displayed as numbers top right of the preview window. The clip is nearly five minutes long, so searching through it efficiently can be achieved by using the mouse to grab the scrubber and dragging it left and right.

The timescale can be altered by dragging the ends of the scrollbar, which itself can be dragged, and the scrubber position is also shown as a thin red line on the scrollbar.

Two sets of keyboard shortcuts allow you to position the scrubber more accurately – Z and X or the Left and Right keyboard arrows jog the scrubber back or forward one frame at a time.

Below the timescale a group of transport controls allow you to control playback with the mouse. The important ones are Jump back, Jog back one frame, Play/Pause, Jog forward one frame and Jump forward. Plus and Ultimate have additional controls for playback at different speeds, but the fundamentals can be achieved easily in Standard. I suggest using your left hand to active Z, X and the space bar while using the mouse to drag the scrubber.

The remaining controls that I've greyed out are now available in Standard as well as Plus and Ultimate, but I'll explain their functions later in the book.

Smooth Playback

This is where I explain why I got you to turn off Playback Optimization. When you play the low quality drone clip, is playback smooth? Can you drag the preview scrubber and the video display keep up with the scrubber? If the answer is yes, then you don't need those pesky brown/green bars that appear at the top of the timeline area. You don't need to fill up your hard drive with additional files. You don't need to wait for the "rendering" to complete. At least, you don't for this project, yet.

The clip is pretty undemanding and if your computer can't play it smoothly (some people will call this "choppy") then you are probably going to have to use Preview Optimization to make High Definition movies. However, it might be worth checking a few **Control Panel** settings before you turn it on.

In **Export and Preview** try changing *Quality* to *Fastest Playback* (*Balanced* may have the same effect on most hardware). This ensures that you are playing back at half resolution. Also check the *Hardware Acceleration* settings. Click *Auto Detect* and see if the setting changes.

Hardware Acceleration choices

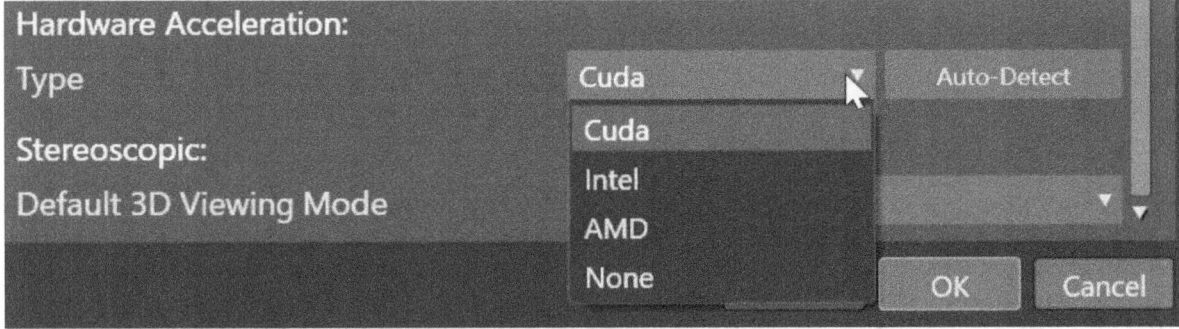

If you have an Intel computer you may have built-in graphics that aren't being used, so experiment with the Intel setting. If you have an nVidia graphics card and Cuda isn't selected, try that. If you have an AMD video card, you should try the AMD setting. If none of this helps and you still get choppy playback, turn the Playback Optimisation setting up to 100 – and refer to how Playback Optimization works In the Understanding Studio chapter.

Playback quality

That small preview window isn't a good place to judge the quality of your video clips. The clip I've provided has a relatively low resolution and a rather modest bitrate, but doesn't look too bad there.

With the clip cued up at the start, hold down the ALT key and press Enter. Full Screen playback! The space bar works, and if you move the mouse a small set of transport controls appear.

Full screen transport controls

Assuming you still get smooth playback and can scrub reasonably well (the small scrub bar is harder to use smoothly), look a little closer at the quality. You are going to see a lot of artefacts – the straight lines of the lock gates will show jagged edges, the detail in the trees will be very mushy, and if you play back a fast moving section you will see the detail become blocky and then every half a second or so "tick" back to a better resolution when playback encounters an I-frame in the encoded video.

Pressing the Esc key returns you to the normal program window. Go back to the *Control Panel/Export and Preview* settings and select *Best Quality*, then test playback again. If you still get smooth playback you should see a marked improvement in quality when using Full Screen.

People will have different playback experiences because there are so many variations in PC hardware. There will be a point where all but the fastest computer is likely to need to use Preview Optimization – 4K/UHD video stresses most machinery beyond it's capabilities once you start to add transitions and effects.

The provided clip is definitely "Low Quality". If you return to the website you can also download medium and high quality versions of the same footage if you have a reasonably good internet connection. The high-quality version is the same as the drone's original footage. My desktop computer isn't "state of the art" but can just about cope with that, but once I add transitions, I have to resort to using Preview Optimization (although not at 100%).

Other Source operations

Because I'm doing a whistle-stop tour, I'm not going to do any pre-trimming of the clip. I'm also skipping over a technique of using scene detection, because it's more suitable for captured or pre-edited video, rather than camera files. See the Library chapter for a discussion about creating and using scenes.

I'm also going to bypass the use of Corrections for now, but will explain them in detail later. If you double click on a source clip in the Library and a new green timeline tab opens, you have entered the Corrections editor, so just click on the new tab and select Close to return to a single timeline tab.

Putting a clip on the Timeline

Selecting track 2

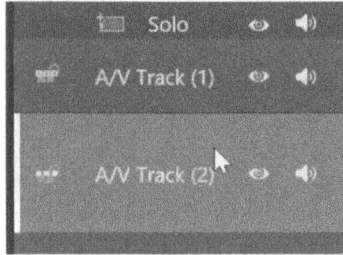

To begin work, we need to put our video on the empty timeline. There are numerous ways to achieve this, but I'm going to use the simplest method.

In the timeline area, click on a blank area of the header for A/V track (2). If it wasn't already, it will become the active track, and this is indicated by an orange stripe on its left edge and the whole track taking on a lighter shade of grey.

Library Clip context menu

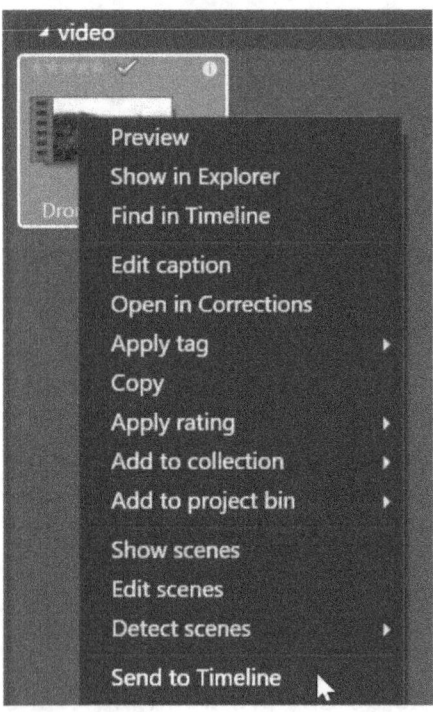

Ensure that the timeline scrubber is at the start of the track by pressing the Home key or dragging it to the left. Now right-click on the clip in the Project Bin and select *Send to Timeline*. The clip appears as a thumbnail on the left of the Storyboard and as a strip on the timeline A/V Track (2).

At this point you might want to adjust the layout with the four-way cursor as described earlier so that you can see both the Storyboard and Track 2 clearly.

Why Track 2?

When you start a movie the people at Pinnacle like you to put your main video on track 2. By default it is set to be the active track. This may seem counter-intuitive, but there is a very good reason. If you want to superimpose something over your main video – a title, perhaps a smaller video clip – then it needs to go on the track **above** whatever it is superimposed on. This matches professional video editing programs. Programs designed more with consumers in mind may work the other way around. Even worse, for some editing programs there isn't even a logic to the order when you start using green screen backgrounds and the like.

Like a stack of paper, in Pinnacle Studio the track on top is the one you see. If there are transparent parts to that track, you see what is underneath, through the "holes". By keeping track 1 clear to begin with, you can superimpose a title on track 1 without having to start rearranging the tracks.

Track and Storyboard selection

If the clip is on Track 2 but does not appear on the storyboard, you may have changed something from the default setting.

The Storyboard can only show the clips from one track, but that track isn't automatically the selected track. The screenshot shows you what to click on to change the storyboard display - the three dot icon in the track header.

Changing the storyboard track selection

Other ways of adding a clip to the timeline

There are alternative methods of adding a clip to the timeline. For example, you can drag the clip, either from the Library or from the Source preview, and drop it on the timeline track of your choice. In more complex situations these methods will have different effects, but in the current situation they all have the same result.

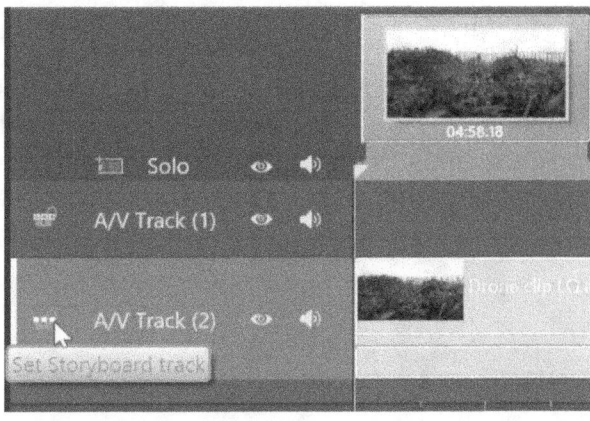

The whole of the drone clip has been placed at the start of the timeline.

Project settings

Now that we have actually added a video clip to the movie, I'd like you to examine the Timeline settings again, using the toolbar icon furthest left. You may be surprised to find that the resolution and framerate has changed from the default to that of the video clip we have just added to the timeline.

The new timeline settings

This should be a good thing, and normally is, unless you have started with a clip that isn't typical for the movie you are making. If you are intending to make a standard definition DVD, but include some HD clips, you should normally start the movie with an SD clip, or

change the Timeline settings. The same applies if you want to make a movie that does justice to the highest quality clip you have used – starting with a lower resolution clip will result in Studio setting timeline settings that match that clip. When you come to export your movie to a file, the high-resolution clips will be downgraded

to the project settings *before* the export, even if you have chosen a higher resolution export setting.

This isn't a big deal, because you can easily change the setting. You can also disable the behaviour in the *Control Panel/Project settings* by unchecking *Detect format from first clip* and changing the default settings under *New Movie Project Format*. The important thing is to know about it! Take particular care when making a slideshow from still photographs.

Smart Mode

In earlier versions, Pinnacle Studio Standard only had one editing mode – Smart. This predicts what you want to happen, but it can limit some of the actions you can take. It's also not as Smart as you are – or at the very least it can't read your mind! However, Smart is as close as you will get to the simplicity of Classic Studio, so for the purposes of this chapter I'm going to work exclusively with Smart mode even when things might be easier by using other editing modes.

Editing Mode selection

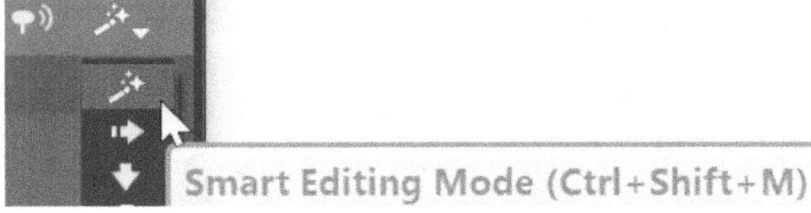

If you want to check you are in Smart mode, compare the icon at the far right of the toolbar with the screenshot. The Smart Mode icon is a magic wand.

Timeline preview

Even though we now have a clip on the timeline, the preview window will still be showing the source clip from the Project Bin. To switch to the Timeline preview, press the H key. Alternatively, you can simply grab the timeline scrubber, currently sitting at the far left of the timeline, and move it, or click on the labelled tabs above the preview window.

Now we have the Timeline Preview open, more controls appear underneath the window. *Go to start* and *Go to end* have been added to the transport controls. The drop down on the far left lets you scale the view, so you can zoom in and out. If you are viewing at 100% then you are seeing the actual resolution of the timeline clips, even if you can't see the whole frame. Normally, I suggest you leave this set to Fit. On the right are a pair of tools to transform the video using crop, resize and re-positioning tools, more of which later in this chapter.

You now have not one, but three scrubbers! The one below the preview is locked to the scrubber that spans the timeline tracks, which has a handle at the top and bottom of the timeline area. Move one and the other one moves. The third scrubber shows up on the storyboard thumbnail, but can't be dragged, it just indicates how far into that clip the preview is.

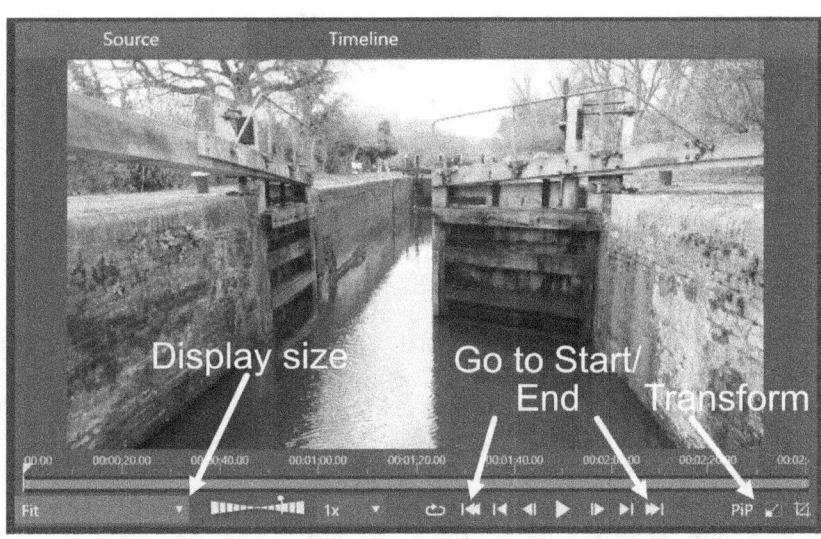

Viewing the whole timeline

Currently there are only three or four tracks occupying the timeline area, along with the storyboard. I'll show you how to adjust the vertical layout later, but for now you should be able to use the four-way cursor described earlier to reveal enough of the timeline tracks for this project.

Timescale context menu

However, in the horizontal direction you won't be able to see the end of the clip on track 2 without scrolling with the scrubber or by dragging the bar below the timescale. Right-click on the timescale at the bottom of the timeline tracks and select *Entire Movie* from the context menu.

You can now see a thumbnail at both ends of the drone clip, the scroll bar underneath the timescale spans the full length of the track, and if you scrub you can see the end of the movie without having to scroll horizontally. To adjust the view further, click and hold on the timescale and drag left or right, drag the ends of the scrollbar or use Ctrl-centre mouse wheel.

Let's start editing

If you have watched the drone clip in full, I think you will agree is that a lot of the time the video is boring. I've made many drone videos in the past couple of years and I've come to realise that what may be interesting to me, the pilot, will not be of interest to my wife or whoever else I want to afflict them on. To a lesser extent the same is true of almost all the video you have shot – at the very least there will be bits at the beginning or end that you want to trim.

When moving pictures were recorded on a strip of film, the editing process consisted of physically cutting up the film, throwing away the bad bits and then joining the good bits back together. That's what we are going to do now.

The group of three icons on the timeline toolbar shown in the screenshot are common to all versions of Studio. The first looks like a razor blade and splits the video clip at the current timeline playhead position. The second looks like a trash can and deletes the currently selected clip. These two tools are fundamental to the editing process. (The third tool takes a snapshot of the video at the current scrubber position, in case you were wondering.)

All three of these tools have keyboard shortcuts – **N** to split a clip, **Delete** to remove a clip and **S** to take a snapshot.

Timeline tools

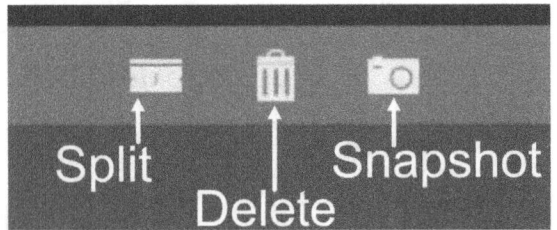

Play the timeline from the beginning. The drone starts up, takes off, wobbles about a bit until it gets its bearings, and then I yaw it to the right until I get a good shot down the canal. None of this is very stable, so let's delete it.

Use the scrubber to find the point where the drone has settled and starts moving smoothly forward. Because you should have decent playback you should also be able to scrub with accuracy. If this was your own movie you would be able to just split the clip somewhere around the 54 second mark, but in order to match my movie, we want a bit more accuracy. Look at the timecode above the preview window and jog with the jog buttons or keyboard shortcuts so that it reads 00:00:54.00 seconds exactly – the counter works in hours, minutes, seconds and frames.

Now click on the Split clip tool (or use the N key). Two things happen. On the Storyboard another clip appears. If you look at the first clip it has a label of 54.00 – that's the duration in seconds and frames. The second clip is labelled 04:04:18 – four minutes, four seconds and 18 frames.

The first edit point

On track two of the timeline there are now two clips. Both have thumbnails displaying their first and last frames. The first clip is much shorter than the second because the length of the timeline clips are proportional to their actual duration.

Notice the blue shading that connects the Storyboard Thumbnail to the timeline clip below, indicating its duration.

Thumbnails and timeline after the first edit

Before we start splitting up the second clip some more, click on the first clip in either the storyboard or on track 2 so that just the first clip highlights – a thin orange border appears round both. Use the Delete tool or the

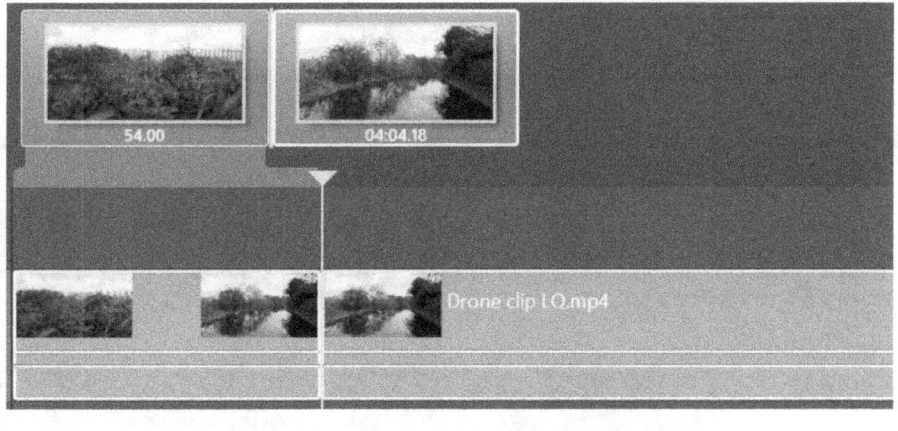

keyboard delete key and the clip disappears as you might expect, but also the second clip moves left so that there is no gap on the timeline where the first clip was. This latter behaviour is part of Smart editing.

Smart mode really doesn't like gaps in the timeline and goes out of its way to close them up where possible. They just consist of black level, unless there are items on other tracks below to show through. Gaps can be created, however, and if you own Plus or Ultimate you can choose a different editing mode.

In this case, Smart has saved us a bit of work. We don't want our movie beginning with 54 seconds of blank video; even if we were going to put a title there it wouldn't be that long!

Let's split the remaining video up some more. At what is now 23 seconds the flying forward stops and the drone starts to fall, so split the clip there. It wobbles about a bit and then swings through 180 degrees to look the other way down the canal. Split the clip at 48 seconds. The drone then flies towards the lock, stopping at 1 minute 8 seconds. Split the clip again. A lot more re-positioning happens, but the drone settles at 2 minutes 7 seconds so add another split before the climbing shot that ends at 2 minutes 21 seconds, where you should add yet another split.

The next part of the video may be of some use as the drone rotates anti-clockwise, but it settles just before the final climbing shot at 3 minutes 1 second. Split again there. The last trip down the canal has a brief pause before the final climb up to a higher shot, but at this point I'm not sure if I want to cut that out.

We now have seven clips – it's easier to count them on the storyboard than the timeline. Two of those clips I've already rejected – the second and fourth. Click on clip 2, hold down Ctrl and click on clip 4. Both those clips are now highlighted, so it's just a matter of using Delete to remove the unwanted video. They disappear and the remaining clips all shuffle up to lose the gaps.

The five remaining clips

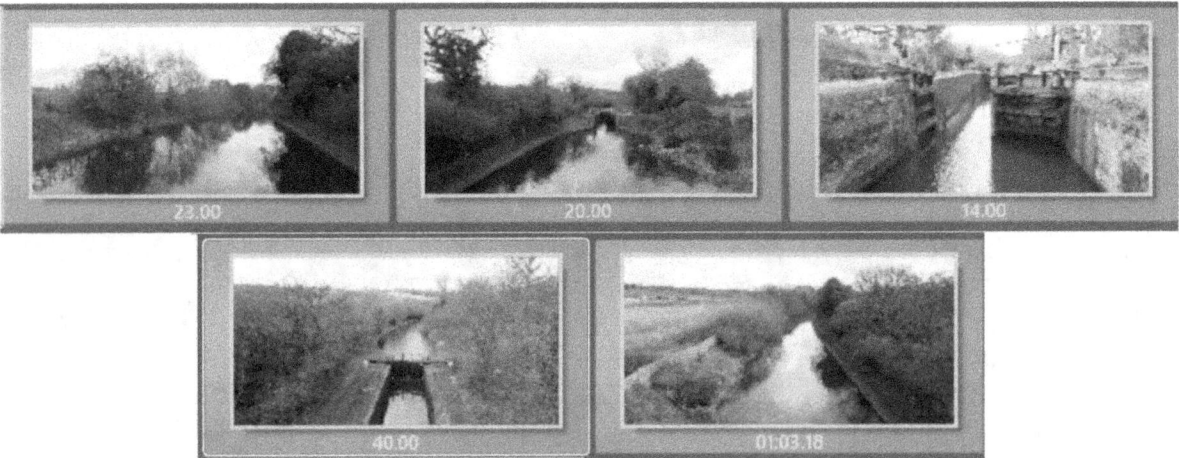

Windows selection and shortcuts

Seeing as I just asked you to use one, I'll add a short digression here – if you are at all familiar with Windows shortcuts, it's worth noting that they mostly work with Pinnacle Studio. If you don't normally use them, it's worth getting to know them.

Ctrl-click – add to the current selection.

Shift-click – select all between the current selection and the item you Shift-click on.

Ctrl-A – select All

Drawing a box with the mouse around a group of items to select them. Sometimes called a marquee.

Ctrl-C – Copy. **Ctrl-X** – Cut. **Ctrl-V** – Paste.

…and the most useful – **Ctrl-Y** – Redo and **Ctrl-Z** – Undo.

Ctrl-Z can be a lifesaver when you have carried out an operation incorrectly. The Edit menu at the top of the interface contains the last five commands, but the keyboard shortcuts are much more convenient.

Rearranging the clips

The movie is now under three minutes – use the *Go to end* transport control or use the **End** key to move the scrubber to the last frame and read the preview counter for the exact duration (it should be 00:02:40.18). The movie could be a bit shorter, but there are only a couple of dodgy flying moments.

There really is no need to present the clips in the order in which they were shot. I would suggest the best clip is the climb up from the lock gates – the 14 second clip currently in third place in the movie.

The storyboard is ideal for rearranging shots on the timeline. Click, hold and drag clip 3 slowly to the left. You will see the other clips move to make space. When you reach the start of the movie, release the mouse button and clip 3 has now become clip 1.

Dragging storyboard clip 3 to the start of the movie

You can see why the storyboard appeals to editors who make slideshows. The thumbnails are large enough to recognise the shots, and the storyboard strip can be

enlarged a little more to help this. Hover over the lower edge of one of the thumbnails and a vertical double arrow appears, click, hold and drag to adjust the height. I'll look at storyboard operations in more detail later.

One advantage of the storyboard becomes more obvious if we try to rearrange the clips on the timeline rather than the storyboard. Before we try this, check that the magnet icon on the timeline toolbar is highlighted.

The Magnetic Snapping tool

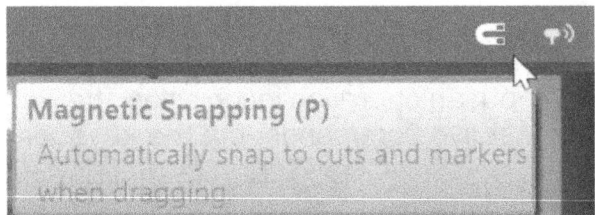

I'm not sure about that 40 second panning shot, but it might link what are currently shots 1 and 2 quite nicely. It's currently the fourth clip, so try dragging that clip on the timeline to the left. You will notice as you do so that the program doesn't treat the clip you are dragging it over as a single clip – it splits the clip underneath, so if you drop it at any point other than where there is already a split, a further split will be created. This behaviour can be quite useful in other circumstances, but not right now. Fortunately, if you carry on dragging left the clip should "snap" into the splits already in place. Keep dragging left so that the 40 second clip drops in just after the first clip.

If you don't want the snapping to happen, then it's just a case of disabling it using the Magnetic Snapping icon.

Floating Preview

If you aren't using the default settings, you may have noticed a new thumbnail appearing as you performed the dragging operation. It's called the Floating Preview and it shows you the Out point of the outgoing clip should you decide to drop the incoming clip that you are dragging at it's current position.

The Floating preview

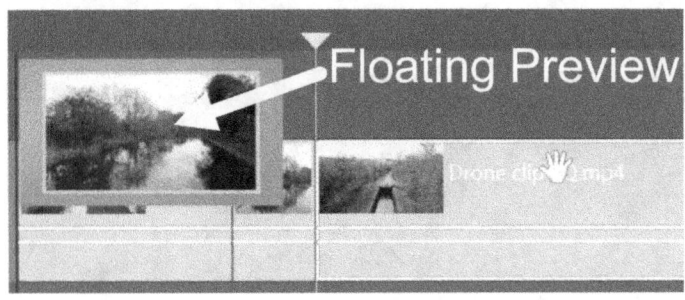

At least it should show you that, but the update takes rather a long time, particularly on a slower computer. For that reason Pinnacle currently have set the default to Off. If it is turned on and you find it confusing then you can turn it back off in the *Control Panel/Export and Preview* by switching *Floating preview* to *Off*.

Saving your work

Programs are much more reliable these days, and even when Studio crashes, it is pretty well behaved – it normally saves your current work each time you perform an operation and when you restart the program you will be back where you were before the crash. However, this isn't always the case, so it is good practice to make manual saves when your reach a point that you might want to return to. The only disadvantage of saving your work is that you lose the undo buffer, so you can't step back to remove a few, possibly unwanted, changes immediately after a save.

You can just press CTRL-S, or use the file menu to save the current project, but performing a Save As from the file menu allows you to keep earlier versions rather than overwrite them. Let's do that now, calling the new version **Drone Project Stage 1**.

Loading my versions of projects

Throughout this book I will ask you to save your projects at particular points. The reason for this is twofold – if you have a serious crash you can resume working on the project from a given point, or if you want to compare your version with mine or simply want to jump in at that point, you will find a version of the project with the same name on the website.

However, loading my version of the project is likely to lead to yellow thumbnails – Missing Media – because I've tried to be a bit more organised with where I store my media. You can just use the Missing Media dialogue to point Studio to the location where you have stored the media. If you intend to follow a number of the projects in this manner, however, it will be worth you storing your downloads in the same location as mine.

Extracting one of the larger zip files – Full or Compact - from the website to your C: drive will create the location and folder structure I have used. If you want to create the structure manually and place individual files within it, create a new folder called Pinnacle Studio Revealed in the root of your C: drive, add the subfolders shown in the screenshot, and then place the individual assets in the subfolder related to their type.

So now, for example, if you put the Drone Clip LQ.mp4 file into C:/Pinnacle Studio Revealed/Video and all my project files in C:/Pinnacle Studio Revealed/Projects, when you load my versions of the projects, there should be no missing media.

Editing terminology

I'm now going to describe some editing terms that you may not be familiar with to help speed up my descriptions.

When we look at the join between two sections of video, the clip that plays before the edit is called the **Outgoing** and the clip that follows is called the **Incoming**. The last frame that we see of the outgoing clip is the **Out** Point. The first frame of the incoming clip is called the **In** Point.

Every clip in your movie will have an In and an Out point and these can both be adjusted. If the clip starts at the very first frame available, then you can only **Tighten** the In point by choosing a **later** frame. If the clip ends at the very last frame available, you can only tighten the Out point by choosing an **earlier** frame.

However, if there are frames available before the current In point you can also **Loosen** it by choosing an **earlier** frame as the In point. The Out point can also be loosened if **later** frames then the current Out point are available.

In all cases, tightening makes a clip shorter, and loosening makes it longer.

An edit between clips can always be adjusted in one of three ways (assuming the clips are longer than one frame!). You can tighten either the Outgoing or Incoming, or both.

If your clips have **Leeway**, (more video frames are available than are currently being shown) then you can also loosen the In or Out points.

So, to make an edit point work, you have lots of things you can change. I'll look at subjects such as Continuity editing, slipping and sliding clips and rolling cutting points later in the book.

Basic Trimming

Some of the trimming operations I'm going to show you may seem a bit cumbersome. There are more elegant solutions available with Advanced trimming, which will be discussed later in the book. However, with basic trimming its hard to go wrong and spoil work you have already done, so let's walk rather than run for now!

Trimming isn't practical on the storyboard. Strictly speaking you can adjust the Out point of a storyboard thumbnail clip by using the right-click context menu option to *Adjust Duration*, but it's a very crude way to go about it. Turn off the storyboard for now.

I want to adjust both the In and Out points of clip 2 – the 40 second panning shot. Let's start with the In point. Hover your mouse cursor just to the right of the start of clip 2 on the timeline.

The trim cursor

Make sure you are over the lower 2/3rds of the clip and a trim cursor should appear, as shown in the screen shot. If you hover a bit too near the top of the clip you may get a different cursor (one that creates transitions), and we don't want this just yet.

Click and hold the new cursor and move your mouse slightly to the right or left, and a green trim bar should appear. If you see a yellow bar then you must have double clicked, and also you aren't running the standard version where the yellow advanced trimming options are only available by using the Trim mode tool. If you do accidentally engage the advanced trimming mode, just press the T key to cancel it.

Keep the mouse button held down for the whole of the following trimming operation. Drag right and you tighten the In point, moving it later and creating a gap in the timeline. Drag left and it will be moved earlier, loosening the In point and overwriting the Out point of clip 1.

Still holding the mouse button down, drag right while watching the preview window. You should see the video frame immediately underneath the In point you are adjusting. Drag until the see the lock pound has almost disappeared as shown in the screenshot. The counter should be showing about 28 seconds. If your try to make accurate alterations, you will find it hard. Get within a second or so, and then release the mouse button.

Near the first trim point

So how can you trim more accurately (without using the advanced Trim mode)? The secret is in the timeline scaling. Use the timescale context menu to select a scaling of 30 seconds and try again. You should be able to hit 28 seconds exactly quite easily. If you have a sensitive mouse or are trying to use a touchpad you might need to set the scaling to 10 seconds.

If you practice adjusting the timescale by dragging the ends of the scroll bar, you should get proficient enough to avoid using the context menu. There is also a very useful pair of keyboard shortcuts. Hold down CTRL and press the closing square bracket key] and the timescale adjusts to 1 second, where you can easily adjust a frame at a time. CTRL-[returns you to viewing the whole movie. You can also hold down the Ctrl key and roll the mouse wheel to adjust the scaling

By the way, when you zoom the timescale view in to below 10 seconds you will start to notice that the timeline scrubber consists of two red lines. The left-hand line sits on the start of the frame, the second, thinner line indicates where the next frame starts.

Try adjusting the Out point of Clip Two now using the above method, but working on the other end of the clip. In this case the trim cursor will be flipped – the arrow points to the right. Trim the clips so that the panning shot ends just at the point that the canal starts to come back into frame at 44 seconds.

Dealing with Timeline Gaps

Our basic trimming action has left two gaps in the timeline. The viewer would have to wait, watching nothing, during the gap.

While it's possible to trim without creating gaps, you need the more advanced version of Studio, and it's not always quite the blessing it might seem. If you are working with multi-track projects it can spoil the position of things on other tracks unless you take care.

You can adjust the length of a gap in exactly the same way as you adjust the length of a clip, but with one significant difference. If you make a gap smaller or larger, all the clips to the right of the gap on the track you are working on will be moved to accommodate the change.

Hover your mouse cursor to the left of the new In point of clip two, and you should be able to generate a right point trim cursor. Click and drag to adjust the Out point of the gap and watch the subsequent clips all adjust their position together. Drag left and when you are approaching the Out point of the first clip Magnetic snapping should take over and accurately close the gap. Even if you have Snapping disabled, you won't be able to trim any further left – the gap you are trimming no longer exists.

Closing the first gap

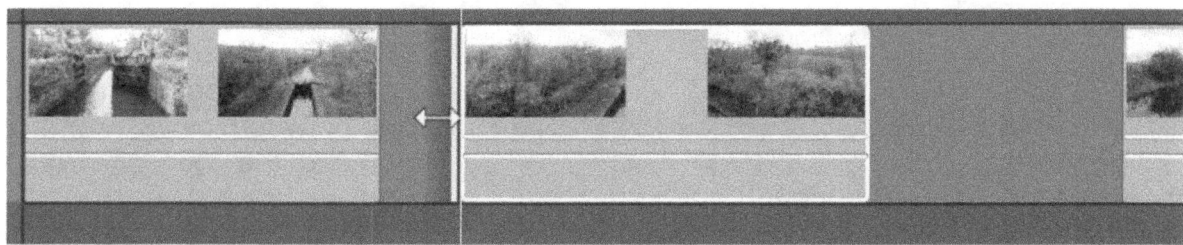

Well, that was quite painless, but Studio has an arguably even quicker method. Right click on the other gap and you will generate a short context menu with just two entries – Paste (which should be greyed out) and Close Gap. Select *Close Gap* and that's exactly what happens.

Closing a gap with the context menu

Incidentally, if you right-click at the end of a timeline track the context menu will offer you the option to *Close All Gaps*.

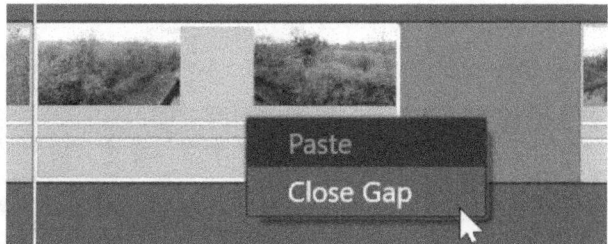

We could have used this to remove both the gaps we had created with one click.

Transitions

A transition is a more elaborate way of getting from one clip to another instead of using a straightforward cut. At its simplest you can mix between one picture to another, although far more elaborate effects are possible – wipes, pushes and complex patterns just begin to describe the possibilities. A whole chapter will be devoted to them later in the book, but for now I'm just going to add a couple of crossfades to indicate time passing and spice up the visual impact of the movie.

There are two basic ways to add a transition to an edit point – you can create one on the timeline or drag one from the Library and place it on a cut point.

Select Clip 2 so that the cursor moves to its In point and adjust the timeline scaling to 10 seconds using the timescale context menu so that it's easy to see what is about to happen.

Generating a transition cursor

I mentioned that if we hover near a cut point and are close to the top of the clip we generate a *transition creation* cursor. Hover over the top left edge of the edit between clips 1 and 2 and the icon shown in the screenshot should appear,

Click, hold and slowly drag left – a white box will grow over the cut, indicating the duration of the transition. In the centre you should see the duration in seconds and frames, along with a tiny icon showing that is supposed to show you what type of transition has been added, and the image of an upward slope to make it clear that you are looking at a transition.

Keep stretching out the transition until it is 2 seconds 24 frames in duration. You may notice that the transition stretches equally on both sides, which is why you can't have an odd number of frames.

The generated transition

We have added a cross-dissolve by default. It is easy to change it to another type of transition and I'll show you how in a moment, but first let's examine the result. Drag the scrubber a few seconds back and press Play.

Smooth playback?

Is the playback still smooth? Because we have added a transition, Studio has to get your computer to do more work. If there are some hiccups in the playback during the transition you may have to give a less powerful computer a bit of help – change the *Control Panel/Export and Preview/Preview Optimisation* setting to 80. A brown line will appear above the transition, gradually turn green and then disappear. Playback will be smooth now. Every time you adjust the transition, you will need to wait for the preview rendering to create new files for smooth playback

Transitions and overlaps

Does the transition look a bit messy and confusing? Although we deliberately edited the panning shot to almost exclude the same lock that shot 1 ends on, adding the transition has revealed more of it at the beginning of shot 2 than is desirable – we mix between two pictures that are confusingly similar.

Explaining what has happened will be easier if I introduce you to another feature – the Editor panel that shares its screen space with the Library.

Click on the transition on the timeline to highlight it and then select the Editor tab of the Library/Editor area so that you see the display as shown in the screenshot.

The Editor panel with a transition selected

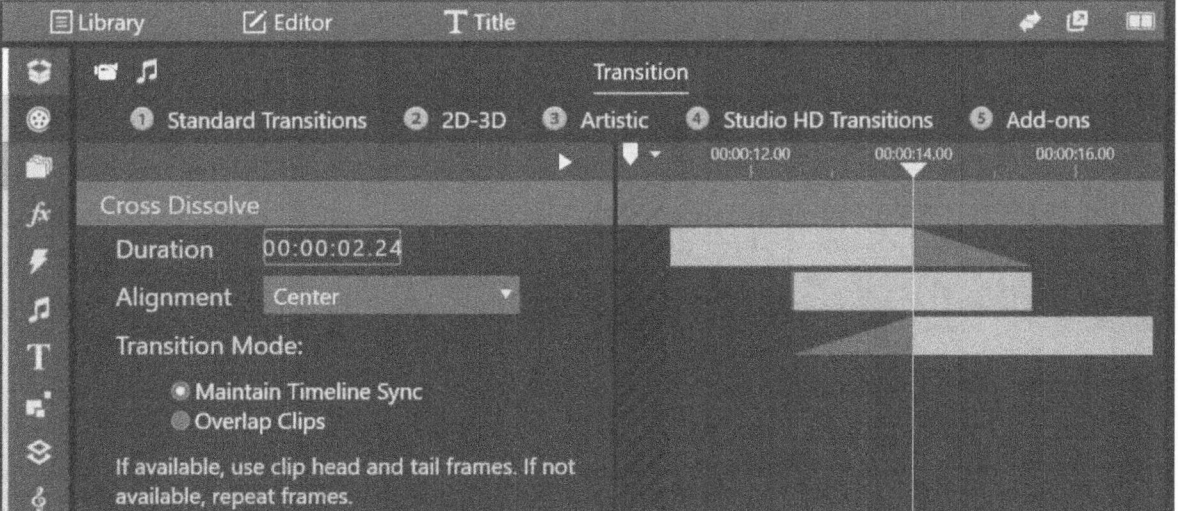

Pay particular attention to the graphic on the right, which shows the current layout of the transition. The top blue line followed by the downward slope is the outgoing

video. Below is a grey bar showing the duration and placement of the transition, and the upward slope and blue area below that is the incoming video.

Where the blue bars begin and end are the original Out and In points that we chose. The dark blue slopes show where video has been added after the outgoing and before the incoming chosen edit points in order to create the required overlap required for the transition to work.

The reason we have a problem is because of the way this overlap has been generated. The program could have overlapped the clips themselves, but this would have shifted the incoming clip on the timeline, as we will see later in this chapter. For now there is a pretty simple solution.

The transition is centred on the edit, but we can change that. The *Alignment* drop down box in the parameter area on the left lets you change the position to *Start* or *End*, we can also move the grey bar in the editor or drag the transition on the timeline.

Let's go with the last method. Click, hold and drag the transition on the timeline and you will see that you don't even need to restrict yourself to three positions, as you can drag it to any intermediate point. As you do so, you change the proportion of which clip contributes most to the overlap required.

Pull the transition as far right as possible and play the transition again. By the time the incoming video is clearly visible, the lock on the right that was causing the confusion is out of shot.

The realigned transition

Changing a transition

At the top of the editor panel you will see a list of transition categories. Open any of the categories and a filmstrip-style list of what is available within that category is displayed. You can scroll the transitions simply by dragging the strip with the mouse.

I'm going to change it to a fairly radical transition. Open up *Standard Transitions*, scroll along and *choose Clock wipe* by clicking on it. The transition selected on the timeline changes from a cross dissolve to one you have chosen.

Selecting a new transition in the editor

Play the new transition on the timeline and I think you will agree that in these circumstances, the Cross Dissolve looked better. You might want to try a few others, but when you have satisfied your curiosity please change it back again to *Cross Dissolve* - which you will also find in *Standard Transitions*.

That's one way of changing a transition, but I now want to show you what I consider to be an easier method. Switch from the Editor back to the Library and select the Transition side bar icon (it looks like a lightning bolt). You now have easy access to all the transitions.

Switching the Library to view Transitions

Dragging any of these and dropping them on top of a timeline transition will also change it to your new choice.

Adding a transition from the Library

As well as using the Library to replace an existing transition, you can also generate them from scratch simply by using drag and drop, which means that if you know what you want from the beginning (and it's not the Cross Dissolve) its a quicker way of working.

The Library can be a bit daunting to begin with, but one simple way to find something is to use the search box. Start typing in *Cross Dis…* and soon it will be the only transition displayed. I'll explore many more tips and tricks relevant to the Library in its own chapter.

Using Search in the Library

Now set the timeline display up so that the end of clip 2 is displayed, and drag Cross Dissolve to the edit point. A one second, centred transition will appear. If you are going to do this a lot you can change the default transition duration in the *Control Panel/Project settings* to something more suitable to your style of project. Sadly you can't change the default positioning, but most of the time using a centred transition is going to be the best choice anyway.

Fade In and Out

A conventional way to start and end a movie is to fade up at the start and then back down to black at the end. We don't need to use a special transition to do this, we can just add a cross dissolve manually. I have a different plan for the start of our movie, but at the end let's add a simple Fade out. Position the scrubber at the end (The keyboard End key is a good way to do this), set the timeline scaling to 10 seconds and then drag out a 5 second slow fade out to give the project a stylish end.

Adding the ending fade out

Before we start adding more content, let's save the movie as **Drone Project Stage 2**.

Titles

Adding text is a good way of informing the viewer about what they are watching, and it's also a good way of letting them know it has finished as well!

Pinnacle Studio has two title generation programs as standard. The Motion Titler is quick and easy to use. In the past it didn't give very sharp results but Pinnacle have fixed that now. The 3D Titler can create some interesting titles, but they can look a bit dated, and programming moves into it is much harder work.

Studio 24 has integrated the Motion Titler it into the main body of the program and added extra animation options using keyframes. This brings it in line with the Effects, Corrections and other Editors.

There are two ways to create a new title on the timeline. For either to work you must not have a timeline title already selected. Then you can either switch the Library to the Title tab and click on the Create Title button, or use the timeline toolbar. We shall start with the latter. Place the Timeline cursor at the start of the movie, and then look on the Timeline toolbar for the T icon and click on it.

Screenshot of the In-Built Title Editor.

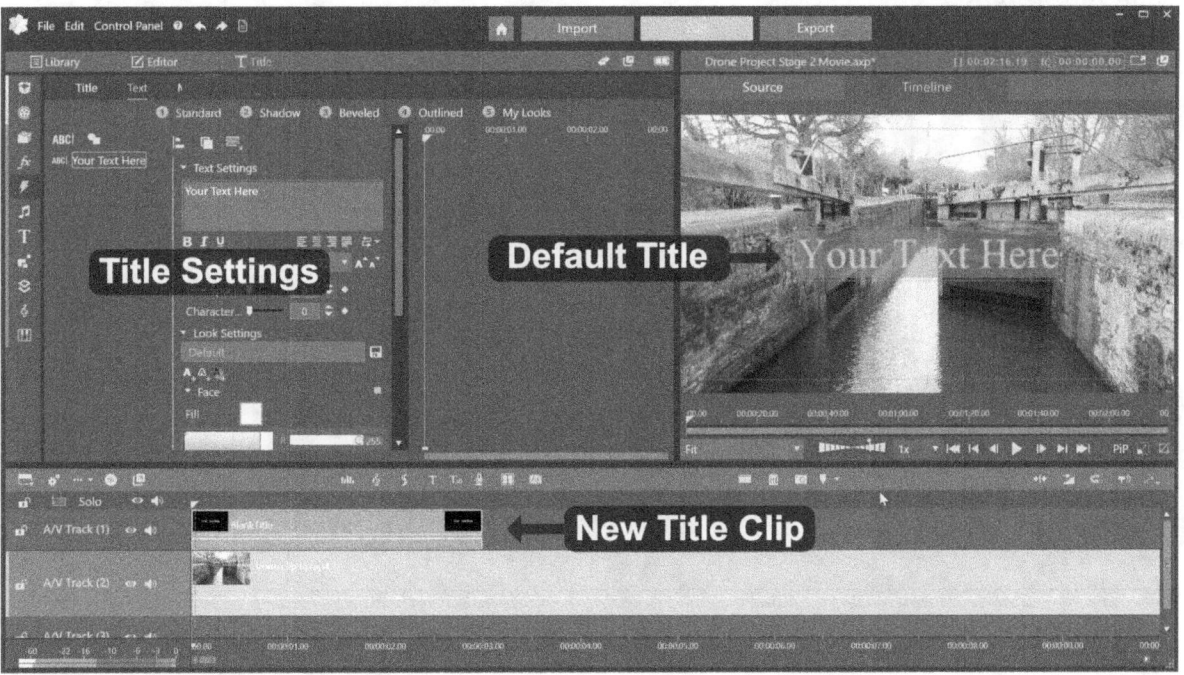

So far we have seen the Library and the Transition Editor in the top left corner of Studio's interface. Now, the Title Editor takes up the position. A blank title of the default duration is placed on the top track following the current scrubber position. It will contain one simple line of text – "*Your Text Here*". The Timeline preview will show this over the video below. The In-Built Editor is populated with the controls for the **Looks** section of the Title Editor

As we are looking at the Standard version of Studio in this chapter, there are no motion effects possible; Plus and Ultimate users will see two more tabs – Motions and Legacy Presets. If you end up seeing something different to the screenshot, make sure that the Looks tab is highlighted.

Firstly, let's change the placeholder text. You can do this in one of two places – the box underneath the Text Settings drop-down, or by using the Timeline preview screen.

Let's use the second method and it gives a clearer picture of what is happening as you edit. Hover your mouse over the text and it will turn into a text cursor. Click and the text becomes active, so use the Arrow keys to navigate and the Delete key to remove the current "Your Text Here" message.

Editing the text

Now type "Grand Union Canal. You can see the text over the video, but it's not that easy to make out over the bright bits. It would be clearer at if it were placed over a plain background, but we don't want to slow the movie down with a plain title.

We could change the colour, or make the font chunkier and bigger, but the most elegant solution is to add some edges.

Everything in the titler is programmable, but for speed I want you to select a preset Look. Leave the text cursor active within the text box but mouse over to the selection bar below the Title Editor's Looks tab.There will be at least 5 choices along the top of the screen, so click on Outlined, and then by hovering over the thumbnails, preview how each Look will affect the title on screen.

Applying a Look

I suggest using *Outlined/Diffused Grey Outline* (number 24). Click on it to apply the Look permanently to the title in the Timeline preview window.

Another important parameter is placement. If you select the text box and hover over an edge you generate a four-way arrow. Clicking and dragging allows you to place the text anywhere on the screen. Place it near the bottom and press the Play button to see how it looks over moving video.

Maybe it might look better against the sky?

Re-positioning a Title

Drag it near the top of the screen and I think you will agree it looks better there as it's not obscuring the more interesting parts of the frame.

Accurate placement can be achieved with one of the tools above the timeline – it's called *Group align* but still has useful options for a single text box.

Titler Tools

Click on the tool to open it, and then use the *Relative position* grid to put the text Top Centre. This grid gives you consistent positioning, particularly important if you are adding lots of consecutive titles.

Relative Positioning

Even in the Basic version of Studio you have a huge range of choices, but once you have the ability to add a motion to the titles, the options are endless. The title programs have their own chapters later in the book.

With the title finished, switching to the Library tab returns us back to the main editing interface. However, whenever a title is being displayed in the timeline preview and the title clip is selected on the timeline, you can still edit it with the mouse without opening the Title Editor window. You will know this is the case because the Title Safe grid – the white frame aiding title placement - will be displayed.

Let's look at editing the title clip on the timeline now.

I think that because of the positioning of the title, it could stay on screen for the duration of the whole of the first clip. Generate an Out point cursor over the end of the title on track 1 and drag the Out point right until it snaps into line with the end of the first video clip.

Dragging out a fade at the end of the title

Play the movie from the start. It's all looking very nice, but the title disappears suddenly, whereas if it faded out it would be more in keeping with the next transition.

You should be able to work out how to add a roughly three second fade out at the end of the title. If you want to see the duration figures in the transition box and can't, try adjusting the height of track 1 by hovering over the boundary between the tracks to generate a vertical double headed arrow and drag the boundary down, making Track 1 taller.

The end title on the timeline

I would like you to add another title at the end of the movie. Use the same font and Look to place **Edited with** (line break) **Pinnacle Studio** centre frame so that it lines up with the fade out at the very end of the project.

The only component missing now is audio, and in the case of a drone movie, that almost certainly means music. I mean, how long can you put up with the sound of the rotors?

Before we move on, save the project as **Drone Movie Stage 3**.

Refining the edit

We have reached that stage in the project where you could say "that's OK, I'm done with the visuals for now, let's add some music". You haven't stepped back and taken a critical look, neither have you shown it to anyone else, but there aren't any glaring errors. You could call it your rough cut.

Let's imagine you show this cut to someone else – the Client, Director or Producer you are working for. They may well notice things that you haven't, but they may also make more broad brush comments – "It's a bit too long, some of the shots are too similar and that second panning shot is dull" If you are solely working for yourself and step away briefly, even just for a hot beverage, and then view the project again, you might make the same comments yourself.

I'm also going to add an artificial restraint. Let's say you want to upload the movie to a website of drone shots and the rules of the website say the movies must not be longer that 1 minute 30 seconds.

Adding Music

The Scorefitter icon

Studio can create music of almost any duration that you like with it's Scorefitter feature, but instead of cutting the movie to length and then adding music I'm going to get you to create the music first. If you were making a music video with "real" music, you would be working to a fixed duration. It's also good to have the music in place so you can pace the cutting to match the music.

The second group of timeline toolbar icons has a treble clef symbol which opens Scorefitter. Click on it and you will see three columns of musical choices. The left-hand column, Category, will help you narrow down the choices, Song and Version expands your choice. In the bottom right corner is a duration box. Enter 00:01:30.00 into the box before you click on the Preview button to hear some of the choices and how the 90 second version will sound.

Scorefitter choices

I'd like to suggest you choose your own music, but then some of the changes I want you to make to the project may not make sense, so please select *Inspirational/Outdoor Breeze/ Evening Sonnet* from the three columns. Ensure that the duration is set to 1 minute 30 seconds and then click the *Save as* button. You should change the suggested name to *Drone Music* and then press the OK button.

We could have used the *Add to Movie* button instead, but now I can show you how to add music from the Library. There is a further discussion about Scorefitter and other music options later in the book.

Close the Scorefitter window and switch to the Library tab if it isn't already selected. There are a number of ways to find the music in the Library. At the bottom of the Library a new icon should have appeared, an arrow pointing at a folder – click on it and the correct location should be revealed.

Finding new Library content

Alternatively, you can open a new tab, click on the Treble clef in the sidebar and start entering Drone into the search box to reveal the new music file. When you find it, right-click on it and select *Add to Project bin/Drone Clips*. Now re-select the *Project Bin/Drone clips* tab and you will see it now also contains the music.

Click, hold and drag the music down to the timeline, placing it at the start of track 3.

The music placed on the timeline

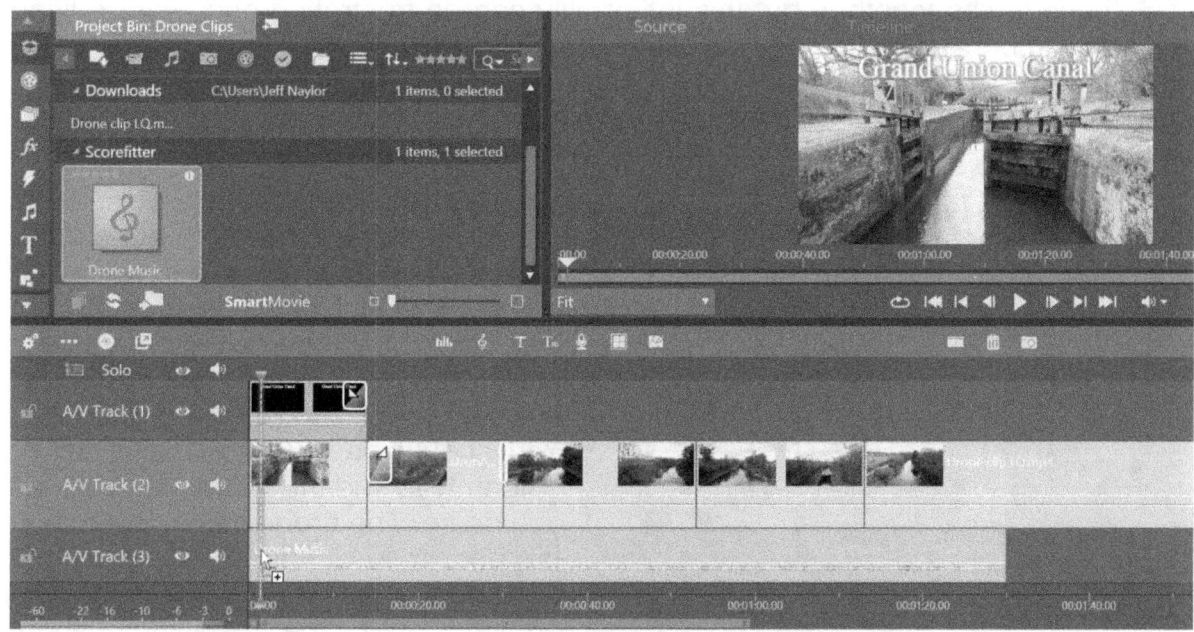

Time to save the project again, I think – **Drone Project Stage 4**.

Keeping movies in sync

What do I mean by "in sync"? The phrase originates from adding sound to moving pictures. If someone is talking and their voice doesn't line up correctly with their image, the illusion is ruined. *Goldfishing* is one term for it, *Out of sync* is another (sync being shorthand for synchronisation)

When audio is embedded in a video file, you should not have an issue unless there is a technical problem with the file. However, as soon as you detach that audio onto another track, it's possible to move clips on one track and not the other. The synchronisation will be broken.

There is a more general problem with multi-track editing. A title may be carefully placed over a video clip and you don't want the two objects to move relative to each other. The same applies to sound effects - the bang of a gun needs to be as accurately placed as dialogue. Superimposed video such as titles or Picture-in-Picture should stay locked to the video it was intended to complement.

So if you suffered from bits of your movie not being in the place you expect, you have an issue "keeping in sync".

Some editing programs force you to use certain tracks for certain items and then lock those tracks together, but this inflexibility can be frustrating once your editing becomes more sophisticated. Pinnacle Studio in it's current incarnation is more sophisticated than that – but that means it is possible to make changes that deliberately or inadvertently break the sync of timeline items.

Losing timeline sync

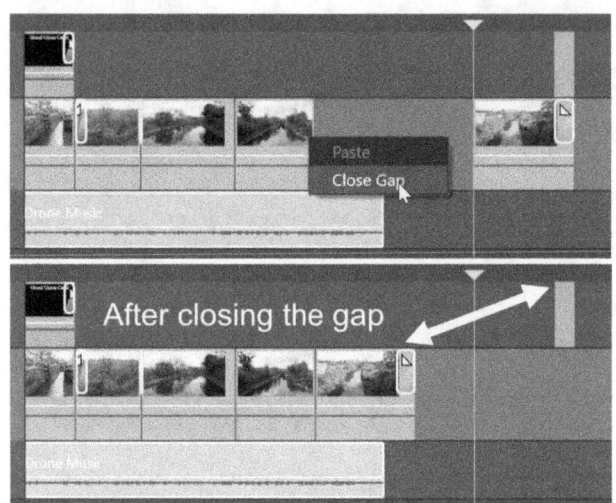

Let me demonstrate the issue by making a simple change to our current movie. In order to bring it down to the correct length I have decided to trim the Incoming of the last clip. Create a green trim point to the right of the last cut on track 2 and drag it to the right. You should be able scrub sufficiently smoothly to see the video play back as you do so. The drone stops, wobbles a bit and then starts to climb – the timecode counter top right of the preview will be reading about 00:01:52:00. Drag left and right until you have located the chosen point and then release the mouse.

There is now a gap in the timeline. Right-click on the gap and choose *Close Gap* and you will see the sync issue in all it's glory – the title at the end of the movie hasn't stayed in sync with the clip below.

So, we can't use Close Gap. Use Undo to restore the gap and try another method – click on the video clip, hold down CTRL and click on the title. They are both selected. Drag the two clips left until the video clicks into place with the end of the previous clip.

By the way, you can form **Groups** from multiple selections of clips, but although these help you select all the clips with one click, it won't stop Studio from splitting up the group if it needs to insert another clip into the group. Grouping is available from the context menu.

There are a lot of additional tools in the Plus and Ultimate versions of Studio that help with the sync issue, but we are working within the confines of the Standard version for now. If you had decided to use Split and Delete to remove the first part of clip 3, the title would have moved with the video when you performed the delete, but both would have only moved to the end of the music. This can be overridden in Plus and Ultimate by locking the music track, but more of that later.

We still haven't got the video down to the correct length, so first of all I'm going to take some time off the front of the movie.

- Select the first video clip and then place the scrubber 4 seconds into the movie.

- Use the razor tool to split the clip.

- Select the first part of the clip and delete it.

- Trim back the In point of the first title on track 1 so that it clicks into place with the In point of the video.

- Draw a box around all of the clips on tracks 1 and 2 to select them.

- Drag the whole group left to click into place at the start of the movie.

Play the movie and I think you will agree it is better to start on a shot that is already moving, rather than starting with a bit of a wobble.

I'm also going to trim the end of clip 3.

- Drag the Outpoint to the left so you have a gap that is larger than the overhanging video at the end of the movie.

- Multi-select the last two video clips and the end title (you can do this by drawing a marquee around them). Drag them left until the end of the video and music line up. You will have to do this visually as end points don't snap.

- Now drag the Out point of clip 3 right until it clicks into place.

Save the movie as **Drone Project Stage 5**.

A refinement to the end title

Play the end of the movie while listening to the music. If you experience any jerky playback, you might need to turn up the Optimisation level and wait for the rendering to complete.

The Audio scrub tool

You will notice that there is a strong note just a bit earlier than the title appears. Wouldn't it be better if that rather final sounding note also heralded the arrival of the title? To help you, achieve this, you can expand the height of the music track. Hover over the bottom edge of the track or the track header and a two way vertical arrow cursor will appear. Click, hold and pull the cursor downwards as much as the

Audio Scrub (Scroll Lock)
Hear your audio when moving at speeds faster or slower than play speed

screen display allows – adjust the relative sizes of the screen areas if it helps. After a moment, a larger waveform will appear on the music track.

Lining up In point of the end title with the music note

Have another listen and you will identify the strong note. You can enable audio scrubbing so that you hear sound as you scrub with the tool to the right of the magnet.

The note is at 00:01:24:05 if you are unsure. Use the trim tool to extend the beginning of the end title to line up with the note.

If you play the end again, I hope you will agree that the improvement is quite satisfying! These are the small improvements that make the almost unconscious differences between a rough cut and a finely honed edit.

Additional Transitions

Looking at the movie now, the straight cuts remaining between clips 3, 4 and 5 somewhat jar on a slow paced video. I think it would be good to replace them with simple crossfades.

In versions of Studio prior to 22, doing so could be perilous because that all important sync might be disturbed. Now however, unless you have changed the default settings you can add transitions at will without any fear of disturbing program sync.

Let's first add a transition between clips 3 and 4. Adjust your timeline view so you can see the edit point but also the end of the movie. Generate a transition cursor to the left of the cut as before and extend it out by roughly 2 seconds. As you do so, look at the end of the movie and note that nothing moves. When you have seen that the timeline remains in sync, you should edit the transition to make it exactly 2 seconds - you can right click on it and select edit to open up the Transitions editor.

Now let's address the edit between clips 4 and 5, but before we do so I want you to change a setting. You could do this in the Control Panel under Project settings, but as the Transitions Editor is open we will adjust it there.

Changing the Transition Mode

Switch from *Maintain Timeline Sync* to *Overlap clips*. Making sure you use the left edge of the cut, create another transition while watching the end of the movie. You will see that the transition is no longer centred, but is created on the left of the cut, and that the incoming video moves left so that it shifts relative to the end title.

Transition Mode:

 ● Maintain Timeline Sync
 ◉ Overlap Clips

If available, use clip head and tail frames. If not available, repeat frames.

Overlapping clips to create a transition

In this case the result isn't disastrous, but it destroys any careful work carried out on the end fade and title. If there were a piece of sync audio there, though, the error would be glaring, and what's more you might not realise that it has occurred.

Use Undo or CTRL-Z to remove the transition – deleting it will not re-position the incoming video clip. Now, instead of using the left edge, generate the transition cursor to the right and drag right. The transition is still not automatically centred, but the incoming video clip does not move. Set the crossfade to exactly 2 seconds before resetting the transitions mode back to *Maintain Timeline Sync*.

The pros and cons of using the Overlap Clips mode will be discussed in the Transitions chapter.

Adding effects

There are hundreds of effects we could add to our movie, and some of them might actually make an improvement! The pictures are a bit flat, so we could adjust the colours. We might attempt to stabilise the video. I'm just going to dip our collective toe into the world of effects so you understand how to apply them. The effect I will add is something that is such a common requirement that it has its own advanced interface.

Click on the first video clip of the movie to highlight, and therefore select it. I'm going to get you to shrink the video down so that it forms a box below the title – a **Picture**

in Picture effect, or **PiP**. Studio has a shortcut for this – click on the icon to the right of the PiP label bottom right of the Timeline preview - it has the tooltip *Scale Mode*.

Engaging PiP

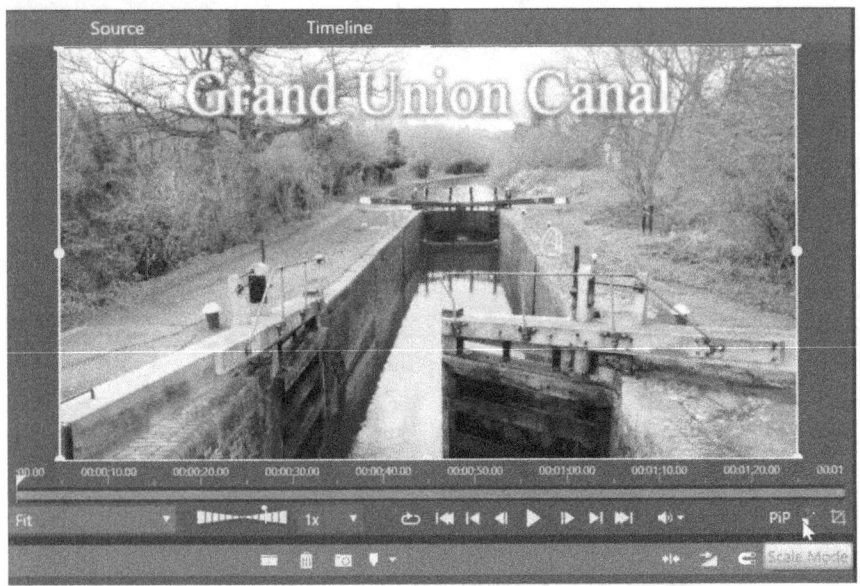

An orange frame with nodes at the sides and corners appears over the preview. Click and drag on any of the nodes and you can manipulate the whole picture. How smoothly you can do this will depend on the power of your computer - preview rendering can't help you here until you switch off the PiP icon, when it will begin to render if your settings are high enough. The node above the top of the picture lets you rotate the clip.

PiP Scale and another effect, Crop, can be applied directly in the preview window – Crop is the other icon to the right of PiP. After you have experimented with the possibilities, reset the PiP and Crop. Unlike most effects, you can do this using the clip context menu, so right clip on the first clip, look for *Reset Properties*, and click on it.

Properties are a set of parameters added to a clip, which behave slightly differently to other effects. However, despite the way they are applied and managed, the Properties Editor is a good example of how other effects can be adjusted.

Open the Effects panel by switching from the Library using the Editor label above the left window and study the new panel.

Top left are two icons for Video (a camera) and Sound (musical notes). We will stick with video for now. Along the top are available categories – Properties, Corrections, Color, Effects and so on. Make sure the selected category is *Properties*.

Below are two sub windows – Parameters to the left and a keyframe area to the right. Generate a cursor over the border and slide it right to minimise the keyframe area (we aren't going to use it, and it is redundant in the standard version).

The Properties Editor

Small arrowheads let you collapse or expand the various sections of parameters. Notice you can adjust much more than position, size and cropping – 3D manipulation in particular.

Return to the PiP manipulation tool in the preview window and use the top central node to shrink the video below the title, then move it up slightly so there is a small space below as well – see the screenshot for what you are aiming for.

Resizing the clip

You can see that accuracy isn't that easy when dragging the nodes, particularly on a slow computer, so it's good that you can return to the Editor and use the sliders on the left or enter numbers on the right. Make sure that the Horizontal = 0, Vertical = -12 and both sizes are set to 70.

Also note that once a value isn't at its default setting, a small circular arrow appears,

which you can click to reset the parameter - or you can click on the parameter name to achieve the same thing.

A very useful, but often overlooked, method of altering the parameters is to click on the slider to highlight it and then use the keyboard. The Left and Right arrow keys alter the value by small amounts, the Page Up and Down keys by larger increments.

Now switch off the PiP tool in order to start or restart the generation of any render files required. Once the brown/green bars have vanished play the movie from the start. If you don't get smooth playback, you might need to increase the preview optimisation level in the *Control Panel/Export and Preview* but remember you don't need smooth preview in order to export your movie.

I want to make one last change now that we have added the PiP effect, as the crossfade at the end of it now looks a little odd at a slow speed. Reduce the duration to 24 frames.

There are a lot more details to discuss about using the Editor, but that will have to wait until later. We are done with our project for now, so save it as **Drone Project Stage 6**. I'm going to use it to demonstrate a number of other Studio features later in the book, so if you make further improvements, use a different project name.

Outputting your movie

If you want anyone else to see your movie you need to export it – unless they too have a copy of Pinnacle Studio 24, and even then you would have to send them a project package, which would be a larger file than an export.

The most likely destination for your movie these days is going to be a video sharing website such as YouTube or Vimeo. Studio lets you export directly to these, but it is often better to prepare a file and then use their own upload routines. That's what we will do now.

Switch to the export tab at the top of the program. A whole new interface appears, with three windows. Below right is an information area which tells you the estimated size of the export using the current settings and the amount of space available for it at the current destination.

Above right is Preview window. You can examine the current project and set In and Out points allowing you to export just a part of the project should you want to. If you are using Plus or Ultimate you have the option of Queuing up Exports - the Export Queue tab shows you a list of exports that you have set up for delayed export, more of which later.

The important window is to the left, Export Settings. For the current task we can leave most of the settings unchanged, and I'll explain them in the Export Chapter.

The Export Tab

The Destination should be suitable – the default is the Video folder on your main hard drive. The file name will be the same as the project name.

The dropdown box showing *Format* should be left alone for now, and the format should show H_264/AVC by default. It's the best all round. Almost everything below that can be ignored as well as long as you check the box that says *Same as Timeline*, because the video resolution and frame rate will be set to the same as the timeline – 1280x720, Progressive at 25 frames a second if you used the LQ clip.

The one thing we might want to consider is the Peak Bitrate. Studio looks at the bitrate of the first clip, but for this particular project it has chosen 20Mbit/s, which is quite a lot higher than the LQ source material which is about 6Mbit/s. I think this is a bug and you might see a different value in a later build of Studio.

There is no point in making a file with a much greater bitrate as it won't look any better, will take up more space and will take longer to upload. Use the slider to set the value to 10 Mbit/sec and you will see the Estimated file size shown in the Information area reduce by 50%

All we need to do now is click on the **Start Export** button (if there is a **Update Selected** button instead, you need to switch the upper right window from Export Queue, a Plus and Ultimate feature, to Preview). If you have already exported a file with the same name you will be warned, but otherwise the export will proceed and you will see a progress bar make its way across the bottom of the preview window.

The export time will be related to the size of the movie, the need to process effects, the chosen format and the speed of your computer. With larger projects, you might have a longer wait than you would expect when the export reaches 100% before it actually completes, so don't immediately assume the program has crashed. (I'll discuss this issue in the export chapter.)

The sign of success!

When complete you will see a small popup window in the centre of the screen which will let you open the export in Windows Media Player, Quicktime (if installed) or open a Windows Explorer folder. Check your export, and then it's ready to upload to your chosen streaming service, or share with your audience.

Upgrading Studio

One thing that may have come across in this chapter is that while the Standard version of Studio is a perfectly competent video editing program (and the PS24 iteration is far more powerful than before, it has a few limitations – for example, you can only have 6 tracks - and we have only just begun examining Studio's features. Fortunately, Pinnacle make upgrading easy and relatively cheap – the cost should be no more than the price difference that you would have paid when you first bought the program (disregarding any special offers).

Upgrading online

A green arrow in the menu bar takes you to the sales page on the Internet. The important thing to remember if you take up this offer is that you will get a new serial number – be sure to enter that when prompted and not

accept the one that came with your first purchase, or to will end up with Standard again and have to re-install!

For the remainder of this book I will try to make it clear where Standard or Plus have limitations, but the screenshots will come from Ultimate.

Pinnacle Studio's User Interface

I'm going to assume that you have successfully installed Pinnacle Studio 24 and possibly used it a little, which means there may be a number of small differences in what you see in comparison to the screenshots in this chapter. If you own the Plus or Standard version, there may be less to see, as the screenshots are from Ultimate. Mostly, though, you will just see more items in the Library window. If you want to start from scratch, you can reset your installation by following the steps in the Whistle-Stop tour chapter.

When you launch Studio, you may see a number of different displays. The first time you open the program after installation or a full reset you will be greeted with the main program interface open at the Edit tab, but may be asked to agree to the User Experience Improvement Program. In earlier versions you were invited to open the Importer, but in the current version of PS24 this no longer happens. The Sample project will load, leaving you in the Editing mode. However, on subsequent launches, the program opens on the Home screen by default. You can change the default in the Control Panel as I showed in the Whistle-Stop tour chapter.

The Menu Bar

What is consistently present in the main interface is the Menu Bar at the top of the screen. It is always displayed, although it is possible to cover it up with other windows.

The Pinnacle Studio Menu Bar

To the left are text labels for three menus – File, Edit and Setup, and a question mark label for the drop-down Help menu. Further right are two tool icons for Undo and Redo, and then an icon to open the Project Notes tool.

The centre portion normally holds 4 tabs that controls which mode the program is – Welcome (the house icon) Import, Edit and Export. These tabs allow you to switch quickly between different pages.

On the far right of the Menu bar are three windows controls that should be familiar. The flat line minimises the program down to an icon on the Windows Task bar – click on the icon to re-open the program. The middle icon lets you switch between a full screen display or one that has been shrunk. The X icon close the program.

When the main interface isn't occupying the full screen, you can drag the edges or corners to make it whatever size and shape that suits your needs. It also responds to the rather handy Windows controls for screen placement – hold down the Windows key and use the keyboard arrow keys – Left and Right shrink the program onto respective sides of the screen, Up maximises it and Down restores it to the shrunken state.

Other Interface Windows

There are circumstances where you will encounter program windows which open over the main program interface. These may be simple messages or information windows – for example asking you if you wish to save your work when you close the whole program. Some features have their own Editor windows which are larger and may obscure the main interface. You will need to close these to return to the Edit mode.

Tooltips

A global feature of Studio is the generous provision of tool tips. Hovering your mouse over most parts of the program window will bring up a message telling you either what a control does, or giving you more information about the item you are pointing at. Try it now with the Mode tabs – you will also see it tells you what the keyboard shortcut is for a particular function if one exists. Tooltips can be disabled in the _Control Panel/Legacy Options_.

The File Menu

The contents of the File menu drop-down always has a basic set of commands. In all modes you can start a New Movie or Disc project, or Open an existing project by browsing for it. You should be able to open a project from Avid Studio or Studio 16 to 24. In this book I'll refer to those programs as _Next Gen Studio_ (it was the working title during development and _NGStudio_ is the process name). The _Recent_ command holds a list of the latest projects you have been working with, so you don't need to search for them.

In Edit mode you can _Save Movie_ (your project), save it with a new name using _Save Movie as…_ or save it as a Package or Template. There is an option to _Create Disc Project from Movie_. You can also _Close Movie_ to leave an empty edit workspace.

All the Tab modes have File menu options to import projects from Studio 10 to 15 using the _Import previous Pinnacle Studio Projects_ option. I'll refer to those programs as **Classic Studio**. Your success at this will depend on the complexity of

the project, the version of Studio and what effects and other features you have used. You will also need to have the project folder present, not just the project file.

The File Menu options in Edit Mode.

It is also possible to switch to the Import and Export modes, as well as access a Disc Burning module and close down the program.

The Edit and Control Panel Menus

The **Edit** menu is very simple – it has entries for *Undo, Redo, Cut, Copy* and *Paste* in case you don't want to use the standard Windows shortcuts. Undo and Redo will only show up in the Edit menu if there is actually something to do!

One thing to remember if you rely on Undo a lot – a saved project doesn't have an undo history, so do a mental check before you actually save or close a movie that you aren't going to want to undo anything at a later date.

The **Control Panel** menu option opens the panel where you change the program settings.

I'm going to deal with most of these options as and when we need them, but right at the outset there are three options that I want to point out as they affect the interface to some extent.

Open the Control Panel, or use the keyboard shortcut **CTRL-ALT-C**.

Legacy Options

As Studio has been developed, Corel has taken the program in a slightly different direction to that initially conceived by the original developers. "Old" parts of the program have been disabled to make way for the new design. However, it is possible to re-enable them should you wish to do so. If you are new to Studio you may not have considered to use the legacy settings. However, if you have already worked with Next Generation Studio – Avid Studio and Studio 16 upwards - you may want to continue to use the older features. I'm going to recommend that even if you

are new to the program you might want to consider using the old features, at least partially.

The Control Panel open at the Legacy Options page

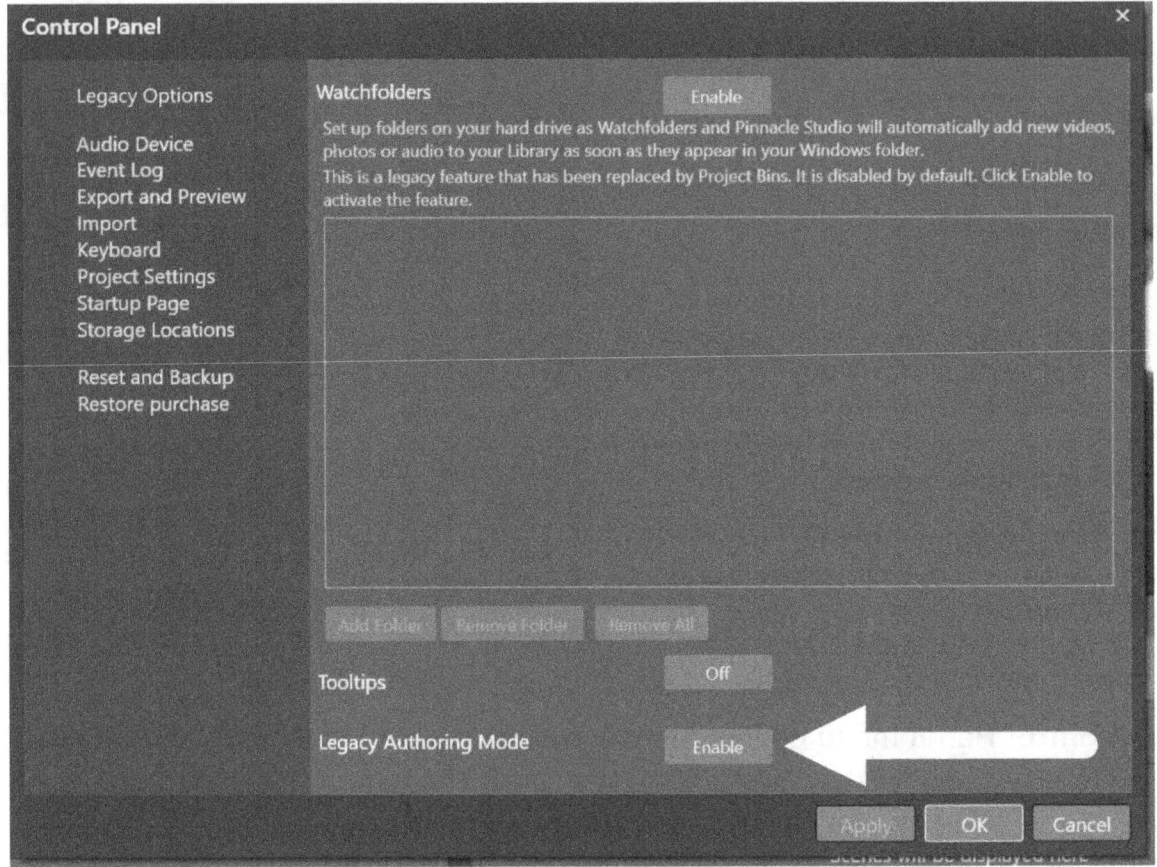

Watchfolders are an import function described in the Import and Library chapters. If you enable them in the Control Panel without actually specifying any folders, a new icon (that looks like a folder) appears in the Library, where you can browse the contents in the locations that they are stored, rather than the Bin in which you placed them. In fact you don't have to use Bins at all.

Tooltips are defined as *On* by default. If you know the program well enough you can reduce clutter by turning them off. I'm not sure why the ability to do this is in Legacy Options, as Studio has always had tooltips..

Legacy Authoring Mode (arrowed in the Screenshot) adds a "new" Tab to the menu bar – *Author*. This is a far more powerful tool for adding menus to optical discs than using the new *Author toolbar* and exporting via MyDVD – a separate Disc Authoring

program bundled in with Studio. Legacy Authoring allows you to use the menus present in Studio, rather than those in MyDVD.

There are other changes that have been made over the years, such as the way transitions are applied. In these cases there may be options in other sections of the Control Panel to change the defaults.

Default Startup Page

We have already seen this Control Panel option in the Whistle-Stop tour chapter. I suggest you switch this from *Home* to *Edit*.

Help Menu

Returning to the Menu Bar, the question mark icon opens up the Help Menu.

There are lots of options here, You can *Search Help*, which opens a searchable online version of the manual, and open the *Sample Movie*. Online Support takes you to the Support site and the User Forums. *Online Offers and News* leads to Sales and Facebook pages. *UEIP* (User Experience Improvement Program) is a function that sends crash logs to Pinnacle. If you don't want to share information about your computer with them, you can disable the feature.

If you want to burn Blu-ray discs you will need to buy a licence, and if you bought one in an earlier version of Studio you can make it work in the new version by using *Restore purchase.* You can check your *Serial Number*, which also displays the Passport associated with your hardware. The passport is something that identifies your installation and Pinnacle Support may need to know it if you have to regenerate additional content or are having other issues.

Check for Updates can be set to look for a patch on a daily, weekly or monthly basis, or, if you have heard about an update through the forums or social media, you can perform a manual check. Given the frequency of patches, I suggest you leave the auto-checking set to daily. There still may be hotfixes that aren't rolled out to everyone, so you might want to check the forums for details of very specific problems.

About will tell you the version and build number of your current installation.

Undo and Redo

These two curved arrow icons are another way of performing the undo and redo tasks can also be reached in the Edit menu or using the Windows shortcuts Ctrl-Z and Ctrl-Y

Project Notes

The small page icon on the main menu bar opens a small but useful text entry page. You can create a list, delete items and check those that you have completed. The notes are then saved as part of the current project.

If you check the *Save as a text file* box, a .txt file is saved alongside the project file. so that you can print out what is left to do.

The Home/Welcome Page

This is accessed by clicking on the Home Icon. The entire content of the Home pages are loaded from the Internet. If, when you load Studio you aren't connected, then you will just see a blank page. Having online access is required to register Studio and enable you to install it, so Pinnacle are safe to assume that you are able to connect. In the past, it was good practice to edit on a computer free from background tasks, but that advice has gone by the wayside as hardware gets more powerful.

A screenshot of the current home page would be pointless as Pinnacle are able to update it on a daily basis. Studio downloads it every time you launch the program. At the time of writing I see a Welcome page with three sidebar tabs – What's New, Tutorials and Get More, with offers to sell you extensions to Studio or other Corel applications.

The Import Page

The Import tab

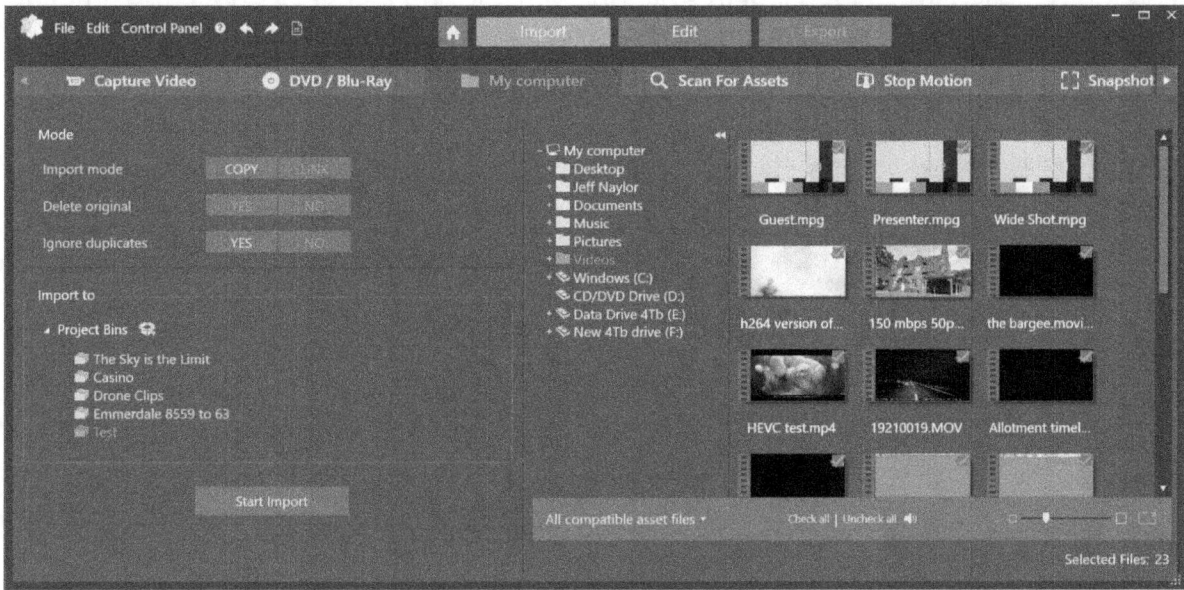

This workspace is opened by clicking on the Import tab. If you just want to add video files to the Library you don't have to use this tab, but if you are populating your library on a large scale, it's a more efficient way of doing so. If you want to get footage from optical discs, an analogue capture device or using the Stop Motion or Snapshot tools, you have to use the Import page. Import is covered in detail in the Import chapter.

The Edit Page

Clicking on Edit brings you to the workspace which you will spend most of your time using. The Edit page is divided into three main sections, with initially the Library placed top left, the Preview Windows top right and the Timeline filling the width of the screen below.

This is only the default, because the interface is a dockable one, allowing you to arrange the sections however you want – particularly useful if you have two monitors. I'm going to finish this chapter with a full description of the Edit workspace and how to manipulate it, but let's wrap up the other tabs first.

The Author Page

You only see this tab if you have enabled *Legacy Authoring* in the Control Panel. The interface is almost identical to Edit, but with a Menu List area above the timeline tracks. Legacy Authoring is discussed in the Optical Discs chapter.

The Export Page

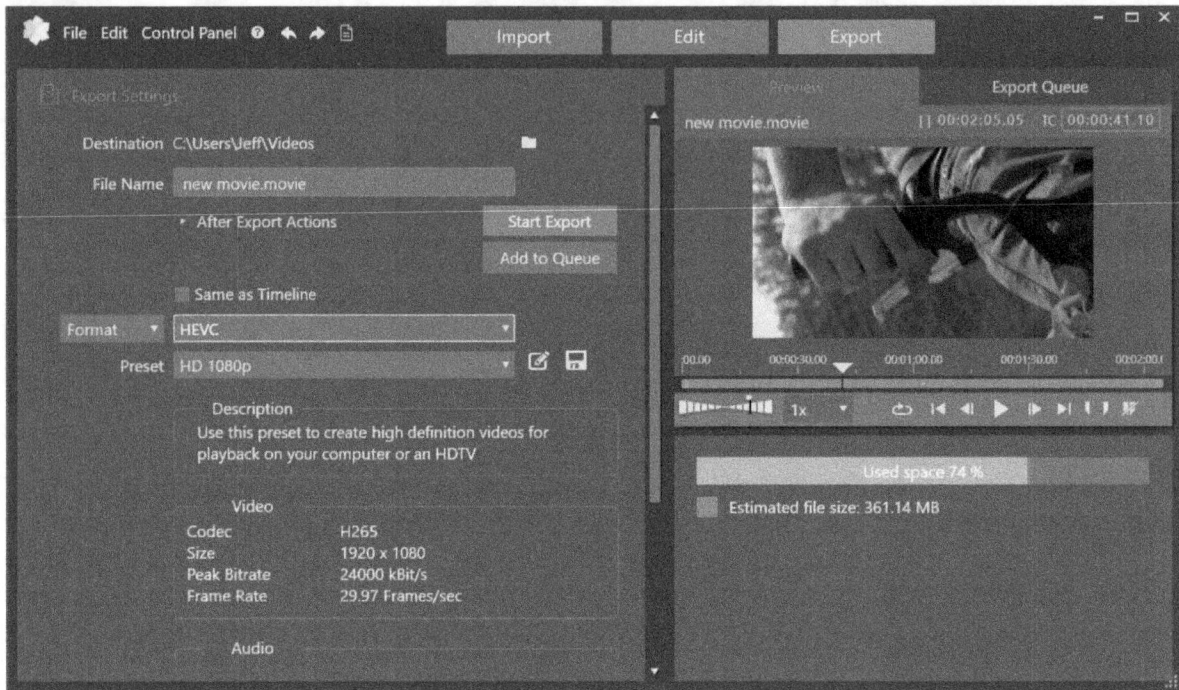

The final tab caters for all your export needs – sending your edited project to file, disc or video sharing sites. You can't open the tab unless you have something loaded on the timeline.

Export is described in it's own chapter.

The Missing Organize/Library Tab

If you have upgraded from an much older version of Studio, you may notice that there is no longer a full-size Library display available in the Mode tabs. However, with the dockable interface you can switch it to full screen with just two clicks, giving you the same options as before.

The Edit Interface in detail

The Edit tab in Studio Ultimate

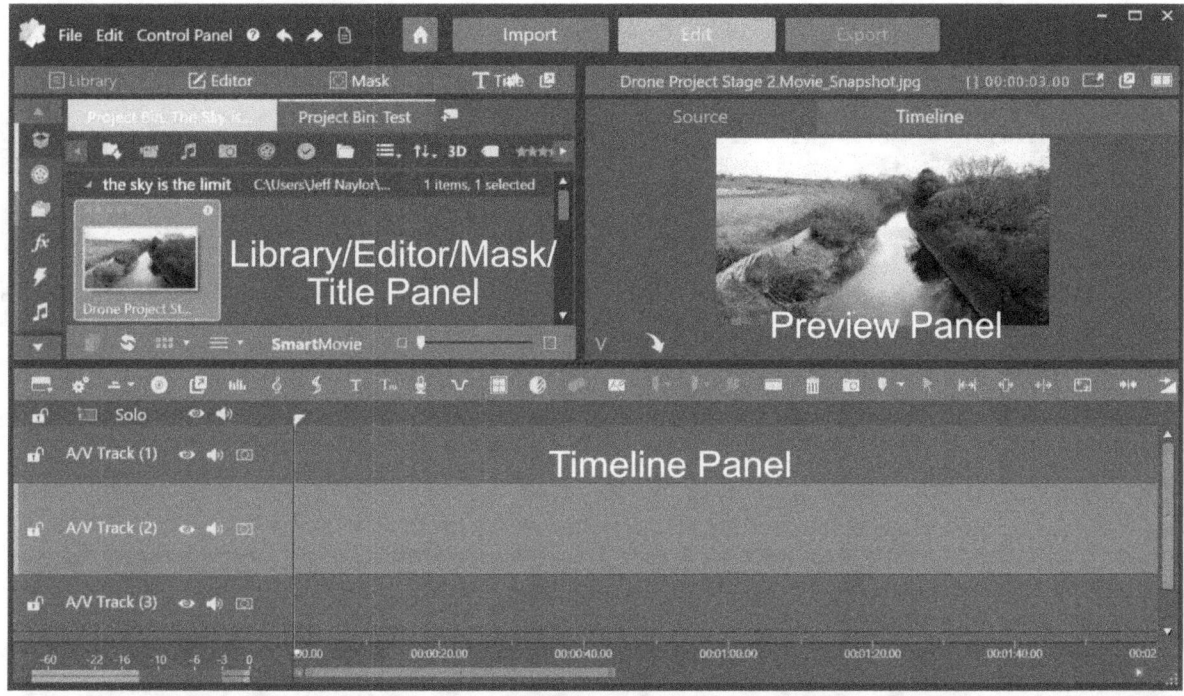

If you compare the screenshot here with that of the Standard version in the Whistle-Stop chapter you will notice that there are many more timeline toolbar icons. The Library/Editor area also has a Mask tab, and the Storyboard is absent.

Timeline options

The number of toolbar icons can be customised in Plus and Ultimate using the first icon on the left. This brings up a selection panel. By default, everything that can shown is enabled. If you want to remove the icons you don't intend using, you just uncheck them.

We have already met the Project settings Icon - it shows the current timeline resolution and frame rate when you hover over it, and if you click on it you can change the settings in a pop-up box.

The upper timeline display can show the Storyboard, but in Plus and Ultimate you have to enable it, and you can also replace the storyboard for the **Navigator,** a thin strip display that helps you find your way around a large project, and can be used to

warn you if you are disrupting the timeline sync. It's worth enabling this feature when working on any long project.

Opening the Navigator above the timeline tracks

Author Mode should no be confused with Legacy Author mode. Clicking on it adds a thin track on which you can place chapter markers, some chapter management toolbar icons and an *Export to MyDVD* button.

The MyDVD author mode

The final icon of the group is *Undock*. All three panels can be undocked, and I'll discuss that in a moment.

Adjusting the Edit Interface layout

You should get into the habit of adjusting the Window layout to suit your current task. If you have a simple movie on the timeline with few different assets, then expand the Preview. If you have a complex multi-track project in the making, expand the height of the timeline. Don't struggle!

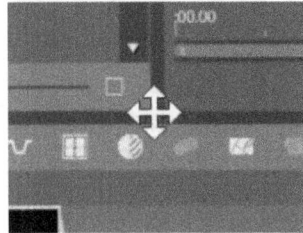

To change the relative sizes of the three main panels you just hover over the junctions between them. There are vertical or horizontal double headed arrows which show up between any two borders, but if you place the cursor over the inverted T junction of all three panels you can adjust them at the same time with a four-way cursor.

Swapping the Preview

There are a number of editing programs that have the preview window on the left of the screen, including Corel VideoStudio. In my opinion, there isn't a right or wrong placement here, it is just down to what you have become used to. It should only take a few days to reorient yourself to a different layout, but if you don't want to do that, Pinnacle have provided a simple tool to swap the preview window to the other side of the display. The Library Window has a twin arrow icon on its upper toolbar and one click does the job.

Swapping the preview to the other side

The Library/Effects/Mask/Title Window

The Library window (which is normally on the left) is where you can find all the assets you might want to use during the making of a movie. This need not just be Video files – Effects, transitions, music, titles and more can be found in the Library.

Studio 21 introduced a new effects editor, and this shares the same screen space as the Library. Additionally, Pinnacle added a Mask function to the Plus and Ultimate version of Studio 23, and moved the Title editor to the same position in Studio 24.

The Library/Editor/Mask panel open at Mask

Swapping between the functions can be done manually using the text icons top left of the Library Window, or it can happen automatically when you perform certain actions. Double clicking on a timeline clip opens up the Effects panel over the Library, clicking on a *Mask* on

the timeline opens the Mask panel, and clicking on any of the Library category icons restores your view of the Library.

The Library and Dual View

It's possible to force both the Library and Effects/Mask/Title editors to divide the space allocated to them using the Dual View icon. If you don't have a particularly large display then this isn't going to be that helpful, but works well with large 4K monitors.

The Dual View Icon

If you aren't seeing the Dual View icon in the left window, it's because you may have shrunk the Studio window too much - it should appear if you go full screen.

The three-way junction created with the Dual view doesn't generate a four-way cursor.

The Preview Window

The Preview window also has a number of controls that affect how it is displayed.

Preview Icons

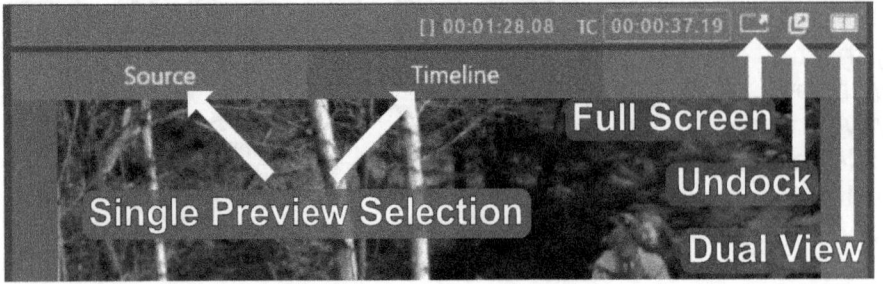

There are two tabs above the video preview that allow you to switch between Source and Timeline Preview, but you can use

the Dual View icon present at the top of the Preview window to split preview into two separate displays. Normally they will show you separate views of the Source clip selected in the Library, and the Timeline.

You can only have either the Library/Effects window **or** the Preview switched to Dual Mode.

Full Screen preview

Another icon switches the Timeline preview to Full Screen. If you only have one monitor it will cover up Studio and any other open window, and although there is a small set of transport controls that you can use to play your movie, you obviously cannot make any changes to the timeline.

Full Screen options

Owning a second monitor really comes into its own with this feature because you can use the Control Panel to direct Full Screen to the monitor of your choice. Select the Export and Preview option and use the Show full-screen preview dropdown. *Other Monitor as Application* is the best choice in my opinion, particularly if your screen resolutions don't match,

Undocking

The Preview Icons screenshot shows the undock tool, but this same icon occurs on all the panels. On the timeline panel it is on the left of the toolbar. Click on the undocking icon and the panel is removed from the main interface and replaced with a resizable window that you can place anywhere on your display. Try that with the Library and The Effects panel has more space.

How useful this is for you will depend on the Size and resolution of the monitors you have attached to your computer. If you have two large monitors there is some value in stretching the Timeline across both screens and rearranging the other windows to suit your workflow.

Sadly, Pinnacle has yet to implement a way of saving and restoring your chosen layout. To some extent, saving a project before closing it and re-opening it seems to restore the layout, but there is an inconsistency here, depending on how many windows were undocked.

Fill Current Screen and Redock

Once undocked you can move the windows by dragging, Dock them back with the redock icon, that appears in place of undock and make them fill the current window with the Fill screen icon.

One really handy way of positioning undocked windows is by holding down the Windows key and using the keyboard arrows. With these you can position the currently selected window in the corners at ¼ size, or vertically at half size.

Take care with undocking, particularly when using Dual view. On occasions I've manged to lose the Source preview window entirely! If you do end up in a muddle, you can always use the Control Panel reset function.

Two UHD monitors with Studio spanned across them

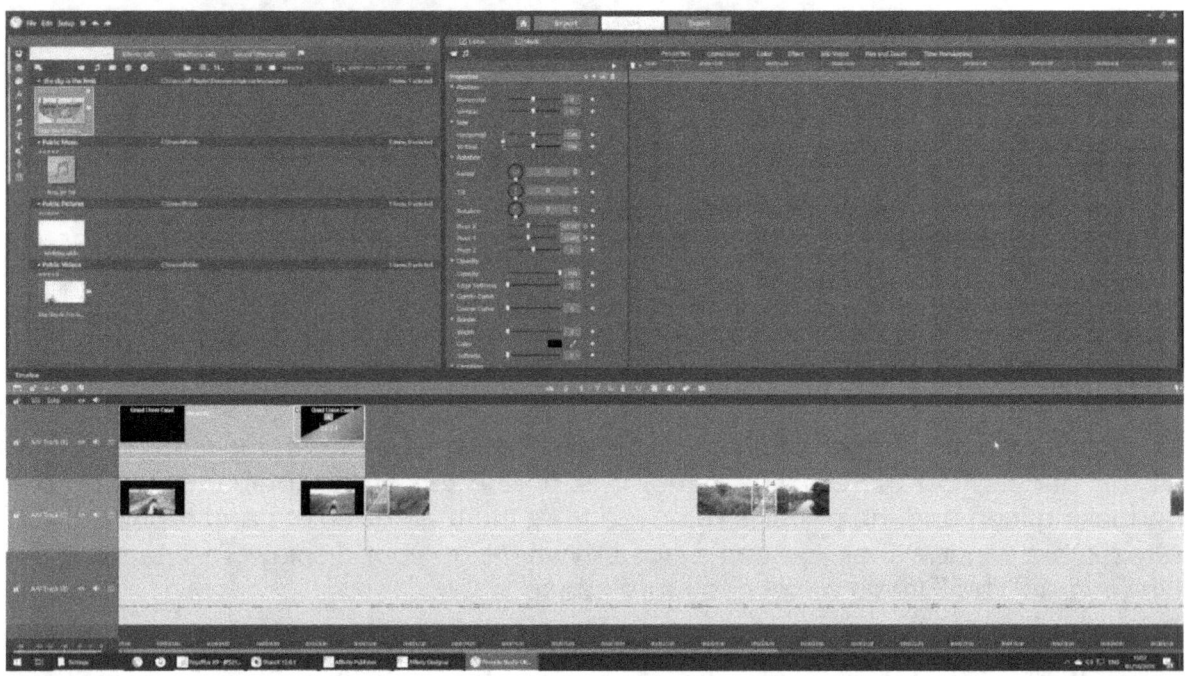

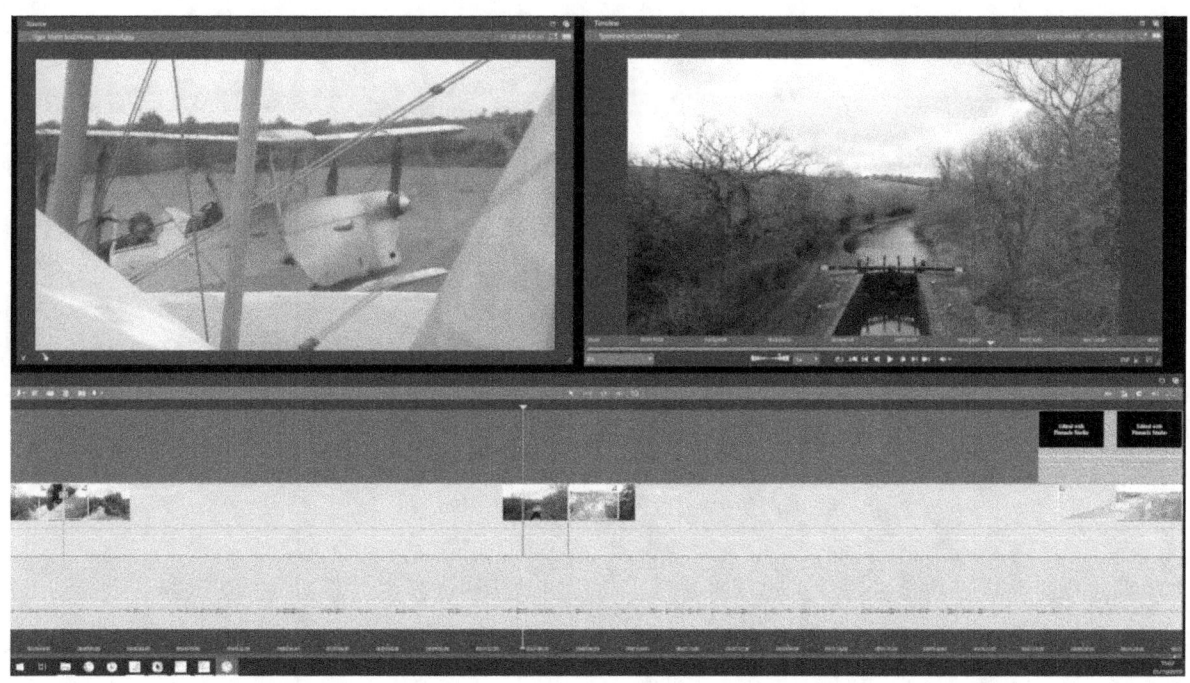

Importing and Linking

Explaining how to import items into Studio requires an understanding of how the Library works, and explaining how the Library works requires an understanding of how Import works, so it's all a bit Chicken and Egg, and tricky to decide in which order to put the chapters about those subjects.

However, if we stick with Pinnacle's current default workflow, and you glance back to the introduction to the Library and Importing in the Whistle-Stop chapter, I think it's best to start with Importing. I will make references to features of the Library explained later in the book - Collections and Library media

Quick Import to a Project Bin

The Quick Import Tool

If you want to add clips to the Library that are already stored in your computer, the fastest way is to use Quick Import. You can use the icon or right click on the Project Bin window and choose *Quick Import*. This opens an Import Media files dialogue box which works in the same way as Windows Explorer.

The files shown are filtered so that you can only see suitable items. If you open the drop down alongside the File name box you can filter your choices further so that you can only see suitable Video, Photo, Audio or Project files.

The Import Media Files dialogue

You can Quick Import more than one file from the same folder using the normal Windows selection methods.

The default is to add your chosen files to the currently selected Project Bin. This adds a link to the file's location on your hard disc to the Library database so that it appears in a Project Bin. The files also get added to the Latest Import collection.

To reiterate, when you use Quick Import the file stays in exactly the same place on your computer. It isn't moved, nor is a copy made, it is linked. Any changes you subsequently make to the item in the Library aren't made to the file. For example, it is possible to rename a Library item – but when you do this the original file is not renamed.

Quick Import to Library Media

In the Library chapter I show you how to view all the media items in your Library database by enabling the **Library Media** icon. With this selected, the Quick Import tool is also available and the process is a little more powerful, because the filter drop-down automatically selects the file type corresponding to the Media category selected - Photos, Video or Audio.

So, if Audio (or a subcategory of Audio) was being displayed in the Library when you clicked on the Quick Import icon, you will only be offered a choice of audio files. To circumvent this, you can override the file type selection in the Import Media Files dialogue box.

Note that when you Quick Import into Library Media, the item is also added to the Latest Import collection, and that is displayed as a new tab if one needs to be created.

Windows Drag and Drop

Pinnacle Studio offers another way of linking media to the Library without opening the Importer. You can drag and drop any file or group of files into the Library from a Windows environment - a Windows Explorer window, the Desktop, or even the standard file dialogue of another program.

The Browse Tool

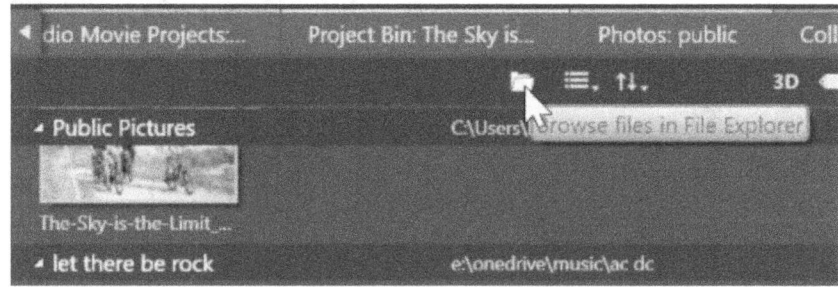

This feature is made easier with the Browse tool, which exists in the middle of the Browser Window toolbar. Clicking on it opens a new, suitably placed, Windows Explorer window for you to drag and drop from. You can use all the power of Explorer to locate the assets you are looking for, including Recent Files in Windows 10.

If you drag it from Windows to a Project Bin, that's where it goes. If you drag it anywhere else it appears in the Latest Import collection and the relevant branch of the Library Media list if that is enabled. If you attempt to import a file that isn't compatible with the Library you will see an error message bottom right of the screen.

Importing from Windows straight to the timeline

In Studio 24 a new way of adding media to a project has been implemented, in answer to the request from people who would really rather ignore the Library altogether. Compatible source media can come from any Windows environment, but now you aren't limited to dragging it to the Library – you can drag it straight to the track of your choice on the timeline.

This opens up additional workflows. However, you must still bear in mind that any item you put on the timeline must be in the Library. This means that when Studio accepts the asset onto the timeline it will automatically add it to your Library whether you want it to or not.

Where does it go in the Library? Well, it gets added to Library Media and the Latest Import collections, but also gets added to the Project Bin that is open in the Library. If you have a Collection open instead, it goes there. If you have a Content tab open, then it doesn't get added to anything else.

So, if you are only ever going to add media from your Windows folder to your timeline, you need not worry to much about what is selected in the Library when you do so. You will be able to use the timeline clip context menu to find the asset in Window using *Show in Explorer*, or in the Library Media using *Find in Library*.

On the other hand, if you are just going to use it occasionally as a quick and dirty way of putting a clip on the timeline, you might want to take care that your current working Project Bin is open before you do so.

When not to use Quick Import or Windows Drag and Drop

People often have more than one hard disc on their computer. If the extra drives are internal, then linking to a file doesn't create an issue – it should always be available unless you start dismantling your computer. However, many people's extra drives are external - plugged into a USB slot - and can be easily removed or even swapped for other drives.

Even in these circumstances you may still find Quick Import sufficient for your needs. If you have added an external USB drive so that you have space to store lots of video files and you aren't going to remove the drive and still expect to be able to access the video files, then that's fine.

Because you can use Quick Import on removable media on your computer, it is very important that you realise it only ever links to files. Linking to a file that is on a USB memory stick that happens to be plugged into your computer isn't a good idea unless you are prepared to leave the stick in place while you perform the editing. Worse still, linking to a video file that was on a DVD in the optical drive on your

computer has two drawbacks, because not only do you have to leave the disc in place, but Studio won't be able to read the video file from the DVD fast enough for you to scrub through the video on the timeline smoothly. The same may be true of some memory cards as well.

The Import Page

The Importer

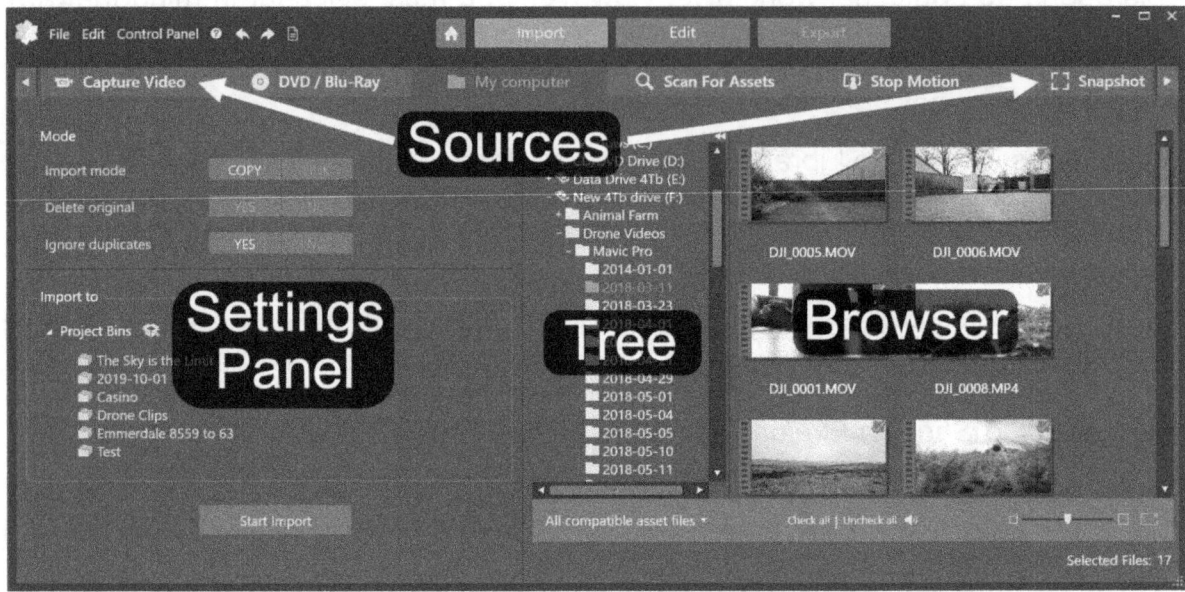

Before we go any further I'd like to clear up a few terms. The Importer can be used for any of the following functions:

Importing – Link mode, where a digital file that is already stored on your computer is linked to the Library.

Importing - Copy mode, where a digital file is acquired from a source – a DVD disc, a camera or removable media – and stored on your hard disc and a link added to the Library. Files can be renamed automatically when they are copied..

Ingesting (digital capture), where the source is digital tape and you end up with a digital file on your hard disc, and a link added to the Library. In the professional world Ingesting can be applied to any digital copy operation, particularly when a networked media server is involved.

Digitising (analogue capture), where the source is an analogue signal such as VHS replay, and you end up with a digital file on your hard drive and a link added to the Library.

The Importer Source Tabs

You can open the Importer window either by using the File menu or clicking the Import tab.

The layout of the Importer varies depending on what source you have selected. Use the Source tabs at the top of the page to select My Computer and your display should look like the screenshot at the start of the previous section. Studio is capable of distinguishing between fixed and removable locations, so any external drives, card readers or USB connected cameras will be given their own tab, as well as appearing in the My Computer tree. If there are a lot of tabs or you have a small screen you may need to use the scroll arrows at each end of the bar.

Beneath the Source selection tabs, **Settings** are on the left, and the right side is used for Input. In the case of My Computer this is a display of the locations on your computer - a tree to navigate with and a Browser to display media thumbnails.

Import Mode

In the Import modes that involve files, the Mode box has three options:

Import Mode - Copy should always be available, even if you are searching your Internal drives. Link will only be available if the source is none-removable. Switch between the two options and you will see that in Copy mode an extra couple of boxes appear below.

With *My computer* as the source and Link as the Mode, we are looking at a grown up version of Quick Import.

Copy Mode options

Delete Original - This option is only available in Copy Mode – because we don't want to delete something we are only linking to!

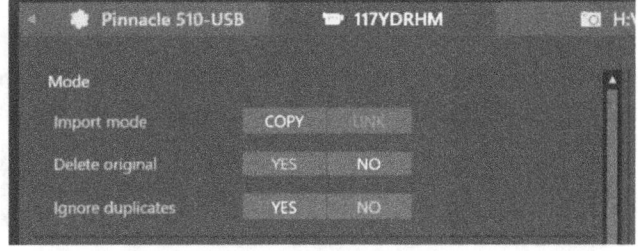

The final selection in the Mode box is **Ignore Duplicates** and it might not do exactly what you would expect. I'll come back to it in a moment.

File Name

If you are linking a file, you won't be able to rename it, but if you are copying, there is a powerful renaming function available.

Customising a file name

You can use the original name, or if you use a custom name you can add a second part that is either a number (incrementing for each file imported), the creation time in hours minutes and seconds (which in the case of a video file is the time you started shooting) or the time of day that the import process happened.

Regardless of your chosen customisation, you can still change the filename from the default Import simply by typing into the text box.

Customising the Save To destination

Save To

You can choose where on your computer copies are placed. Additionally, you don't have to send them to the same location, but different destinations according to the type of file - Video, Audio, Photo, Project and Stopmotion Project can all be given new default destinations, along with custom folders.

The destination can be anywhere on your computer - clicking on the folder icon opens a box that allows you to choose a drive and folder, or create a new folder using the button bottom left. This becomes the default top-level destination for files copied (or created by other processes such as analogue capture)

Subfolder is created at the time of the copy operation. *No Subfolder* will place the file in the top level folder specified in the *Save to* box, *Custom* offers a text box to create a folder for the current operation. *Today* creates a folder with the current date,

Creation date uses the date of the files - one subfolder for each date - and *Current month* uses the current month in the format yyyy-mm.

Import To

Regardless of being in Link or Copy Mode mode, PS24 puts your imports into a Project Bin. It's possible to delete the bin after the Import - the items will still be present in the Library Media category and the Latest Imports Collection.

Import to lists the available bins and also has the *Create Bin* icon. Before opening the Importer, using the Library to select where you want to import to means that location is highlighted. If you choose Library Media, no bin is selected.

Import to in Link mode and the create Bin icon

Importing into an existing bin is pretty straightforward. You select the target bin before opening the Importer, or if you forgot, you can select it from the list. If you want a new bin, then you can create that from within the Importer too.

If no bin is selected, then Studio creates one for you. It will have today's date in the format yyyy-mm-dd as the bin title, but you can always rename it. If you continue to create new bins rather than use the one that has just been created each subsequent bin will have the suffix (2), (3) and so on.

The Browser and Folder Tree view

Import operations that depend on looking for files (rather than creating them from scratch) have a Browser window and an associated Tree View.

If you don't see the Tree view on the right, you need to click on the small double arrowhead at the top of the Tree view bar. This isn't normally an issue for My computer, as it should open automatically, but can cause confusion when opening external memory sources or trying to import DVD and Blu-ray images.

From the Tree view you can navigate to any location on your computer. You click on the + symbols to open up subfolders like the branches of a tree.

The icon to open the Folder tree

On the far right is a browser area, where the media items are displayed, and to its left is the Tree view, (if it is expanded), with scroll bars to help you display some of the longer paths.

We should have at least one item in the Library from the Whistle-Stop chapter – you probably have got a lot more. Let's navigate to The-Sky is the Limit clip which should be in your C: drive, under Users/Public/Public Videos. Open the branches of the tree as required and highlight the Public Videos folder, and a thumbnail of the sample video should appear in the browser window.

Browser View selection

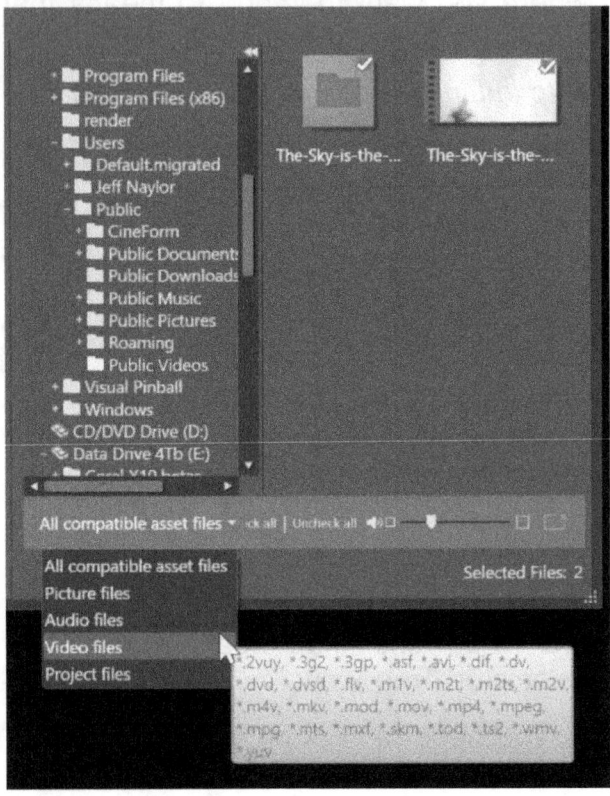

It's possible that you can't see the video. You may have deleted it, but more likely is that you have filtered the view. A Toolbar runs below the tree view and browser and at the left edge is a small drop-down menu.

Here you can select the type of *files displayed, and you will need Video files or All compatible asset files* selected to see the Sky footage. At the other side of the bar is a slider that alters the size of the thumbnails. Use this to make the Thumbnail a decent size.

Once you have the video in the browser window, move back to the Mode box and toggle between the *Yes* and *No* choices under *Ignore duplicates*. If the Sky video is already in your Library (and it should be) a check box top right of the thumbnail will disappear when you choose *Yes*

So, *Ignore duplicates* doesn't exclude any files from being displayed in the browser – **it just controls if a check box is available**. With *Yes* selected, you can't select any files that are already in the Library. The thumbnail check boxes control which files will be imported when you hit *Start Import*. The thumbnails that have the box can be selected or deselected individually by clicking on the checkboxes themselves. You can use the normal multi-select Windows methods to highlight selections of thumbnails in the browser, but the only operation that you can carry out on a group of thumbnails is to select or deselect the check boxes.

Hover your mouse over the Sky thumbnail and you will see a scrubber and play button appear over the thumbnail. These allow you to examine the file.

Look again at the lower bar. *Check all* and *Uncheck all* gives you the chance to select or deselect the whole array of files in the Browser – provided they have a checkbox. The lower bar of the browser also contains a speaker icon to control audio monitoring levels, a thumbnail size slider and the full-screen button furthest right expands playback to full screen. That control will only be available once you start to play the clip – use the Esc key to quit.

Linking an asset to the Library

If the above example isn't working for you, then for some reason the Sky video isn't in the Library. In any case, let's re-import it. Create a new bin using the tool in the *Import to* panel - let's call it Test. Select the *No* option for Ignore duplicates, checking the box on it's thumbnail and unchecking any other assets on view.

The Importer working in the background

Click on *Start Import* at the bottom of the settings panel. A small progress bar will pop up in the bottom right corner of the screen with messages about the import. In this example its appearance will be so brief you may miss it entirely. At other times it may take some time. However, if you have to wait a long time, you can carry on editing while you do so.

Once complete, the new Test bin will show up in Project Bins when you return to the Edit mode and if you open it in the Library Browser, it will contain the *Sky* sample footage.

Something else occurs. If you look in the *Collections* library category a *Latest Import* collection will have been created with a number (1) after it. Open that collection and you will also see the newly imported clip. In addition, the clip will have been added to *Library Media* in the appropriate location if that is currently on display in the Library. In the case of the Sky sample it was already there, but any new clips would appear too.

Copying an asset to the Library

The most obvious reason for using Copy mode is that the file is on removable media. When you switch to Copy mode the *YES* option of *Delete original* becomes available, but for safety I generally clean up my memory cards in the camera after having copied them.

The end of a Copy mode Import

When importing with Copy mode, the same small progress box will indicate how the copy process is performing. Obviously this is going to be slower than linking, and you can carry on working while it happens, but the program performance may be impacted on. When the

copying is complete, a window opens offering the chance to open the storage location in Windows Explorer.

Copying from other devices

If you have a file based camera that you can connect to your computer, there is a good chance that when you do so it will appear as a source tab. Pinnacle Studio might not recognise all cameras, but should pick up the presence as long as it is detected by Windows. If you plug your camera in and open the relevant Import from box, you may go straight to the location in the camera's memory where the files are stored, but on other cameras such as my Panasonic XC-1000 the video files may be in various places depending on the recording format, so you may have to search for them.

One issue might be if you use a stills camera to shoot video, or a video camera to shoot stills. I have a Digital SLR that shoots great video, but Windows thinks it is a stills camera. Pinnacle Studio can't find the Video files automatically unless I use the memory card in a card reader instead of straight from the camera. I also have video cameras that shoot still photos, and in one case this appears as two different sources!

If a camera uses a card, rather than internal memory or a hard disc drive, putting the card in a card reader on your computer may have the same affect as plugging in the camera. I can't test every situation, but I assume this is because Studio recognises the card structure and name.

If all else fails and a device doesn't get it's own tab when you plug it in, then you can use the My computer tab in conjunction with the tree view to find the assets, or use any software that came with your camera to transfer the clips.

It's possible that someone has sent you some files on a memory stick, an external hard drive or as data files on an optical disc. Again, the *My computer* tab should be your chosen route to these files. However, if the optical discs are formatted as DVD or Blu-ray discs suitable for playing on a standalone player, Pinnacle Studio has a better option for importing the video, described later in the chapter.

Displaying old thumbnails when importing camera files

There may be an issue when importing into Pinnacle Studio from a file based camera that doesn't use continuous file numbering. If, when you delete files or format a card the camera starts its file numbering from the beginning again, when you try to import new files with the same filename as you have previously imported, the thumbnails from the old file will be displayed. If you have *Ignore Duplicates* checked, you won't be able to import them either.

Now, this can be extremely confusing if you don't know about the problem. There are two ways of solving the issue:

1 – Just ignore the fact that the thumbnails are wrong, uncheck *Ignore Duplicates* and import the files anyway. They will be suitably renumbered and you can then look at the imports with the correct thumbnails and manage them as normal.

2 – Delete the cache of thumbnails before trying to Import. To do the latter, you need to ensure that you can see hidden files and folders in Windows. In Explorer switch to the View tab and look for a checkbox labelled Show Hidden Items and make sure it is checked.

Show Hidden items in Windows Explorer

To delete the Thumbnails, close Studio and use Windows Explorer to navigate to:

C:Users\Your profile name\ Appdata \Local \Pinnacle_Studio_24 \Studio \Scratch \NGThumbnails
Select all the folders with CTRL-A and delete them. When you open Studio again it will have to regenerate all the thumbnails, which may mean you have to wait briefly as the thumbnails are created when they need to be displayed.

This does mean that when you try to import a camera file that has the same filename as one previously imported the thumbnail won't come from the cache, but from the file location.

Sorting by date issue with video files

Because Studio's Library looks at the date a video file was created, if you have copied across the files, either with Windows or with the Importer, the original shooting date and time will be lost. The time that you stopped shooting is stored in the Modified field, but this isn't accessed by Studio.

Your camera may have a software utility that will move the files for you, or you could risk using the Move command in Windows, but that is a little risky as you will wipe out the original files on the camera. The next section describes a way of working that avoids the loss of the video shooting date and time.

A strategy for camera files

I recognise that we all have different ways of working, but I would like to suggest a workflow for you to use when importing files from your own cameras.

Although I have a separate, internal hard drive to store my media assets, you don't need one to follow this idea - where I refer to "Media drive" you can just as well use the default Windows Library locations.

In my media drive I have a folder called Video and under that a folder for each type of camera I use. When I import from my file based Panasonic XC-1000, for example, I use the customised folder location *\Pana X1000\creation date* and the customised filename *X1000_[creation time]*.

When I import, all my video files can be found both by date and time of shooting. They are arranged in a folder for each day, and the time of shooting is appended to the file name. Even if I imported from a couple of different cards, and do so in the wrong order, alphabetically sorting the filenames will restore them to shooting order.

Scan for Assets

There is a further feature of the Importer that only works in Link mode that is worth considering. If you switch Source tab to Scan for Assets you will notice that the Mode box has lost all its functions, and there are no Save To settings. The collapsible tree view is still there, but the browser window contains a message which explains the function.

Scan for Assets with Video format selection

Checkboxes will have appeared in the tree view. Selecting a particular box doesn't cause the contents to be displayed. You can select whole drives or folders, but if you expand each drive or folder you can see subfolders, each with its own checkbox.

These checkboxes allow you to be very selective about what folders you want to include in the pending scan operation.

A Filter control bar at the top of the Browser contains four further selections – click on *Video* and a tree opens listing all the types of files Studio can import, each with its own checkbox. If you want to only scan for AVI files, for example, uncheck the *ALL* box and then just check the .avi box. If you don't want to scan for photos, audio or Projects, then deselect the ALL check boxes for these categories.

As you change your folder selections you will see a message flashing at the bottom of the browser window as Studio examines the locations, but nothing will appear in the browser. In fact nothing ever will, even when you click on the *Scan and Import* button on the left. The message "Are you sure" will appear, because if you begin the scan you will be starting a background process that will take some time and use computer resources that could otherwise be used for editing.

When you do confirm that you want the process to start, you can return to the Edit page. In the background, the specified folders are scanned for the specified file types, and every one that is found is added to the Library. You are kept informed of the progress by messages at the bottom right of the screen.

So, in this respect, the process is a more powerful form of Watchfolders (which I've yet to describe), but it's a one-shot function – the specified folders aren't monitored for any other items added at a later time. I would recommend using Scan for Assets function when you are first setting up your installation of Pinnacle Studio, or perhaps after plugging in an external drive that contains media you might want to use. It is an all-inclusive process, so if you think you might find yourself going into the Library and removing many of the items after Scan and Import, consider using Import from My computer or even Quick Import instead.

Import from optical media

Just to remind you - if an optical disc has been burned in a data format, you can use the methods previously outlined to import the files. You will want to copy, rather than link to, the files because that disc isn't going to be in the drive forever!

If the disc has been made for playing on a DVD or Blu-ray player, you should use the *DVD/Blu-ray option* in the *Import from* box. This includes DVD discs that have been recorded on camcorders or other DVD recorders as well as created in Pinnacle Studio and other editing programs. Pinnacle Studio doesn't allow you to import DVDs or Blu-ray discs that have been copy protected.

Inserting a suitable disc into your DVD or Blu-ray drive on your computer, switching to the DVD/Blu-ray source tab and selecting the correct drive from the top drop-down box will start the process of reading the disc in the drive. Once the disc is read (which may take a little time) the number of thumbnails displayed will depend on the number of Titles and Chapters on the disc - one thumbnail per Chapter, so you don't have to import the whole disc. On some discs you get proper thumbnails that you can preview and even scrub through. However, on other discs you may get generic video placeholder thumbnails. This bug appears to be somewhat random although it may be related to the type of audio that the disc contains.

The name of the disc pre-populates the Filename box, although you can change that if you wish.

Importing DVD titles can be unreliable, and Pinnacle Studio, along with most other programs I've tried, fails with certain discs, particularly if a standalone DVD recorder has generated them. The problem often doesn't show up with a DVD import until you try to to re-render it into another format. I would urge you to test any imports by making a test file from them before you put mountains of work into a project that uses these files as source material. The most notable issue is a gradual loss of audio sync.

Importing from a DVD Image

Having said that, since version 16 Pinnacle Studio is better at importing problem discs than earlier Pinnacle products.

Importing titles follows the same pattern as copying other files, and you will end up with a Pinnacle Studio compatible MPEG-2 or H.264 video file in the location you choose for Save To and the items added to the Library as well as the selected project Bin.

Importing Disc Images

One thing that may not be immediately obvious is how to import from a disc image, rather than an actual disc. By default the Tree view is closed in the DVD/Blu-ray import mode. Once you open up the tree view with the expand icon top left of the Browser, however, it becomes clear how to navigate to any location on your hard drives where an image might be stored.

If you run Windows 10 you can also easily import DVD images created as ISO files, by using the Mount command to turn them into a virtual drive that will show up in Studio's Importer.

DV and HDV

Two video formats that were popular for many years with consumers and prosumers are the original Standard Definition (DV) and later High Definition (HDV) tape based cameras. Many people will still have tapes containing precious memories that they wish to preserve in a more modern format, or finally get round to editing into movies.

The video that these cameras record is normally stored on Digital Tape, and as I mentioned earlier, importing that kind of data is called ingesting. Video information stored on a tape is of no use to a computer, but a relatively simple digital transfer can be used to ingest the data without degrading it in any way and place it in a file suitable for editing.

One disadvantage of this form of storage is that you can only play back from the tape in real time; another is that mechanical issues can cause poor tracking, leading to data that is incomplete. However, in comparison to analogue formats such as VHS it is far superior.

DV and HDV cameras normally connect via Firewire (otherwise called an IEEE 1394 port) even if your camera also has a USB port. If your computer doesn't have FireWire built in, expansion cards for desktop computers and PC slot adaptors for laptops are available. Buying an expansion device may or may not come with the right drivers so you may need to find and install a Legacy driver in Windows 10 - the file you looking for has the name **1394_OHCI_LegacyDriver**.

Don't buy a cheap "Firewire to USB" device. They are very unlikely to work as they are really nothing more that cable adaptors.

Some of Pinnacle's capture hardware also includes a FireWire port, but you need to get one that works with NGStudio and they are becoming very pricey when bought second-hand. You need a USB 500/510/700/710 or a Moviebox or Moviebox Deluxe. Unfortunately the Dazzle device which is still available is an analogue only device.

Incidentally, there are a few rare models of DV cameras that can pass video via USB, but you will need to use the software supplied with the camera to import from those. I've only seen models made by Panasonic.

With a camera successfully connected, **DV Device** will become available at the top o the screen. Select the tab and will highlight in an orange colour. The DV transport controls will appear below the preview screen.

Failed to get video from device?

I find that to be sure of Studio picking up my DV camera, it is best to connect it up via the FireWire port before starting Studio. Even if your camera is detected you can still get an error message "Failed to get video from device" despite being able to see the camera in the Windows Device Manager. This can be caused by a faulty firewire cable, but more likely it's to do with the order of connection or a prior unsuccessful connection attempt. I've seen this happen often with Studio, Windows 10 and a USB 510 capture device, but re-booting the computer, making sure the camera is connected and **then** launching Studio has always cleared the problem for me. For this book, I tested the system again with PS24 and ran across the same issue, but again a reboot cured the problem.

DV Capture settings

DV Capture in progress.

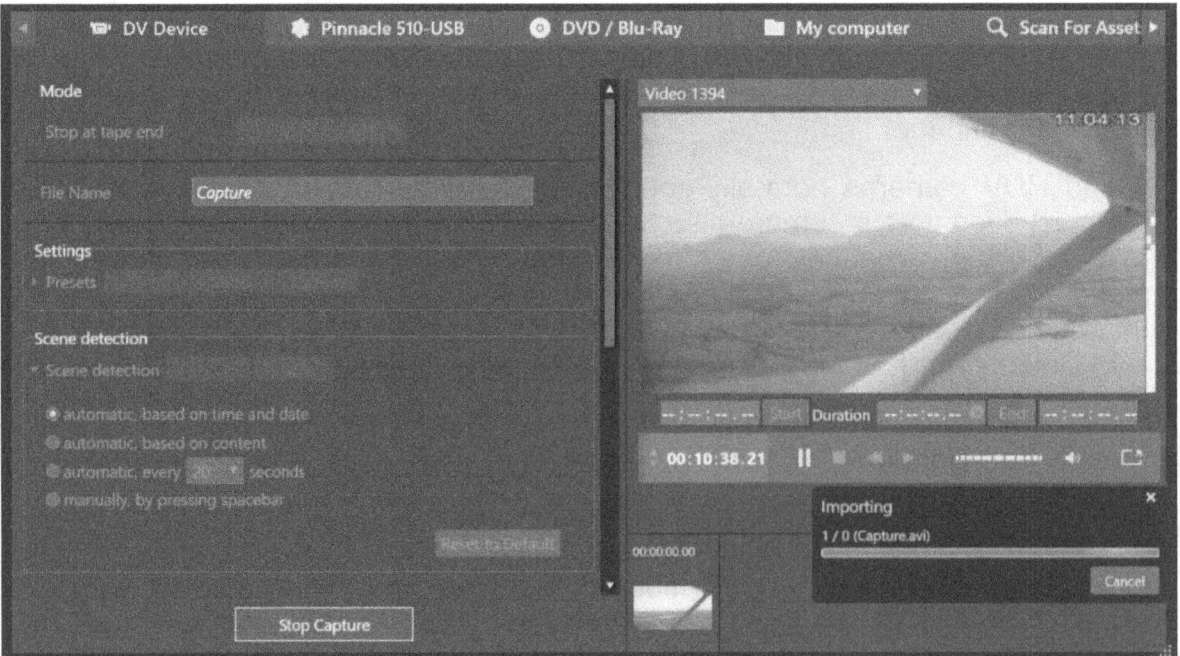

The choice you have in the *Mode box* on the left side of the preview window seems in the wrong box to me. The *Stop at tape end* option should be fairly explanatory – except I don't know why anyone would want to continue capturing after a tape had come to the end! The tape end signal is generated because the tape has physically come to the end, not because the tape is blank.

The settings determine how the file will be stored on your computer. For standard definition DV tape, the obvious choice is to ingest the data from the tape in the same format - DV-AVI. DV is DV; that's it – it's a fixed format with just two types, dictated by the camera.

Choosing MPEG-2 will cause the DV format to be re-encoded during capture to a more compressed format. HDV cameras use MPEG-2 as their basic format anyway, DV-AVI cannot be used to contain high definition video. Custom settings allow you to vary the standard definition MPEG-2 settings if you wish, but unless you have a particular requirement, stick with the default settings that will match the best quality from the camera.

Scene detection

Scene detection during Import is an option that allows you to generate a data file at the time of capture. It also works with analogue capture This file contains information as to how Pinnacle Studio can subdivide the file it is working on into a series of scenes. When capturing from DV or HDV you can choose to detect scenes by *Time and Date* – which effectively means a scene break is added each time the camera was stopped and started again. The second option, *Automatic, based on content*, adds a scene break when there is a noticeable change in the video content. This will often be the same place as you pausing the recording, but can also be triggered by sudden changes such as a camera flash going off. This option is of more use on video that doesn't have the embedded timecode of Digital Video.

Automatic, every xx seconds isn't an option I use much, but if it suits your workflow, it's worth noting that there is very little advantage in doing so at the time of capture. Scene detection by interval is a simple mathematical operation, so it happens very quickly if you decide to detect scenes in this way after the capture.

Manually, by pressing space bar has its uses if you are "minding" a capture and want to mark certain sections. The scene points will only be as accurate as your reflexes, but will help you find parts of a tape you noticed and marked by pressing the spacebar at the time of capture.

The usual *Save to* and *Import to* boxes are present so you can choose your destination and Project Bin

For DV capture/ingest, Studio offers controls on a par with fully professional NLE programs. On the more organised TV or film shoots, shots are logged with a relevant time code and duration. It is then the job of the edit assistant to ingest the takes marked as good into the system once the tape reaches the edit suite. Using the Start, Duration and End boxes this can be done automatically. Below that, are a set of controls for the DV camera, for the less organised amongst us!

Note that the speaker icon only affects preview volume, not that on the final file. You can see the levels of the audio by looking at the meter that sits to the right of the video preview.

HDV Capture

HDV capture differs in that the end result is always a set of MPEG-2 files because that is how the files are stored on tape. Otherwise the process is the same as a DV camera although some HDV cameras need to be switched to HDV mode before you can extract HD video from them.

Dropped Frames

There is one serious error message you might see during the Capture process - under "Recorded" you may see "Dropped Frames". If you do, then you may have a damaged tape, a camera that needs its heads cleaned, or a more fundamental computer issue.

Hard disc data rates – a capture bottleneck?

Let's presume you have a solid, working FireWire connection to your camera, which is playing the DV tape successfully. You are capturing in the DV-AVI format, so no fancy processor work is involved. However, after a few seconds of successful capture, the Dropped frames counter starts to register losses. This is a Very Bad Thing.

The ingest process is pretty straightforward. When I perform DV capture the CPU usage in the Task Manager/Performance tab hardly gets into double figures. The one time-critical task is storing the file onto hard disc. It doesn't go straight there – it is buffered through the computer's random access memory to start with – but the disc needs to be able to keep up in the long term.

Consider the DV-AVI file size. It consists of 3,600KBytes for every second of video, so even on the most well equipped computer it won't take long to fill up the spare RAM. That data needs to be written to the hard disc at the same speed it is being generated from the DV tape – over 3 and a half million bytes a second.

Modern hard discs can achieve this speed with ease. Real life drives can peak at over 20 times that data rate. What can possibly go wrong?

One longstanding recommendation for video work is to use a separate drive for storing files. The main reason for this is that the operating system which occupies the C: drive (in most circumstances) is never really idle, and it is accessing files it has stored, not just as data, but parts of itself that aren't stored in RAM. Windows also uses a paging file that serves as an adjunct to its random access memory, and that too is on the C: drive. If the OS is working on files on one part of the hard disc and Studio is trying to store files somewhere else, much time is wasted as the heads fly up and down the disc platters trying to do two or more things at once. Having a separate drive for video means it isn't being constantly interrupted by other access demands. This affects playback and capture.

What if you only have one drive? Well, capture should still be easily possible if the drive is in good shape. Windows stores files in an increasingly random pattern as the drive fills up. If a large number of small files are deleted, the OS may decide to fill up the empty space with one large file split into smaller parts. The process is called Fragmentation. When it occurs on conventional Hard Disc Drives it lowers the performance of the computer.

Basic defragmentation tools are available in Windows, although Windows 10 keeps your drives in good enough shape automatically. Other tools are available that claim to do a better job, but you don't need to go over the top – if a drive is reported to have less than 20% fragmentation it's highly unlikely that it is causing dropped frames.

General Drive properties

It's not just the Operating System that may be accessing the main drive – other background programs can be using it as well. Some programs could even be scanning or indexing other drives, so it pays to keep a check on what is going on behind your back.

It's possible to automatically compress hard disc drives in some circumstances. Newer operating systems have introduced automatic indexing to speed up searching. Both processes can disrupt smooth data transfer. I'd recommend you turn both off on any drive you wish to capture to. In Windows/My Computer, right-click on the icon for the particular

drive and select properties. I've drawn an arrow pointing to the two boxes that need to remain unchecked on the screenshot.

You might want to check the speed your drive achieves using the Resource Monitor or the Performance tab of the Task Manager.

If you have an external hard disc connected by FireWire, or more likely USB 2.0, another source of problems can be that the external connection is clashing with other devices. Check the data rates and make sure that they aren't sharing a hub connection. The best way to do this is to plug them directly into the back panel sockets of the computer.

One final thing that can affect disc performance is power management software. This is unlikely to be affecting the hard disc of a desktop machine, but a laptop, particularly running on battery power, could be affected by general slow running, including the disc drives.

In the "bad old days" trying to capture to a hard disc using DMA mode 1 access, it was possible to cause a dropped frame just by moving the mouse. Modern discs should be absolutely fine, even if you only have one, but a culmination of factors might still lead to dropped frames.

These aren't the only causes of poor capture, but the others are more likely to cause problems with analogue video, so let's move on to that.

Analogue capture

Ah, those crumbling VHS tapes in the loft, mocking your promise to transfer them to DVDs. One day, one day…

If you have decided to bite the bullet, you are going to need some hardware to convert the analogue signals sent out by the VHS player to a digital file.

If you are familiar with analogue video principles and what digital actually means, you can skip the next few sections, but if you're not really sure how an audio or video picture can be passed down a single wire, take a deep breath. I'm going to go quite a long way back.....

An analogue audio video primer

Let's start with Audio and how an electrical signal can represent it. Before I can explain that, I had better define what sound actually is.

It's a variation of air pressure. A bell passes its mechanical vibration to the surrounding air. The sound of my voice is created by my vocal chords by vibrating the air as it passes through them. When that air vibration reaches your ears, it

moves your eardrum, which translates the signal into nerve pulses that are deciphered by your brain.

The human ear can hear vibrations of varying speeds. A slow vibration – let's say 50 times a second – will be heard as a very low note, and a fast vibration – perhaps 16000 times a second - as a very high note. If that vibration is pure and at one frequency, it will be a clear sound like the tone of a tuning fork. All other sounds are a mixture of frequencies.

In order that we can pass sounds down wires, over the airwaves or record them onto electronic devices, we use a microphone to convert them into an electrical signal that consists of electrons moving around a circuit. They can do that at all the frequencies we can hear, as well as very much higher ones.

So, a graph of a sound wave against time will look the same as the voltage present in an audio circuit. Both will look similar to the waveforms that Studio draws on its audio timelines.

OK, I need to define vision next. The human eye sees light reflected off objects around us. This light – a very high frequency radio wave – enters our eyes through a lens and hits light sensitive cells at the back of the eyeball where it is converted into nerve signals. These signals are sent to the brain and deciphered. The slightly different frequencies of the light waves are what we perceive as colour.

When we look at a TV set, the "trick" that fools us into believing we are seeing a true moving image is the same today as it was hundreds of years ago when people made novelty devices such as Zoetropes or a set of flick cards . A series of still pictures displayed in rapid succession will appear to the human brain as fluid motion. This is often called the persistence of vision, but in fact more recent research shows it is a brain function known as the *Beta Movement Phenomena*. Whatever you want to call it, a flip book of drawings or 16 photographs projected within a second is seen to be smooth movement and this led to the invention of film. Even with further advances, the standard for film projection is still only 24 frames per second.

Television (from the Greek *Tele* (far) and Latin *Viso* (to see)) needed a way of turning this fast succession of pictures into an electrical signal that could be passed down wires, or transmitted over the airwaves. The solution is still with us today, and involves scanning an image to create an analogue Video signal.

A frame is divided up into a series of lines, and these are scanned, starting at the top, from left to right. To produce a monochrome signal, the brightness would be measured along the scanned line and represented as a variable electrical signal. At the end of the line, a new one is scanned from slightly lower, and the process repeated until the whole frame is scanned. Then the next frame is scanned, and so

on. Negative pulses are added to the signal to indicate the start of a new line, and larger ones for the start of a new frame.

Ah, but that's only black and white, I hear you say. A colour TV picture is made by mixing the three (additive) primary colours – Red, Green and Blue. If you can get those colours pure enough, then by mixing them, you can reproduce any other colour. The original cathode ray tubes fired electrons at phosphors. LCD displays use liquid crystals to filter light. Plasma displays contain tiny fluorescent light sources. All of them mix the three primary colours – and a full dose of each will produce white.

Three signals can give us the full colour range, and some Video connections are indeed **component**. A two wire system (**S-Video**) consists of a luminance (black and white) signal, and another which encodes the hue (colour) and saturation (how much) into one signal known as chrominance. Finally, a **composite** video signal needs only one wire, as the chrominance signal is modulated onto the luminance signal in a similar manner to radio signals.

The single composite video signal can also have audio modulated onto it in order to be transmitted through the airwaves on a single transmission frequency. The result is the complex, fragile signal that has been used to transmit and receive analogue television pictures since the introduction of colour TV in the 1950s. It has only just been phased out in some parts of the world, and will be around for many years to come in other parts.

Interlacing, frame rates and digital compression.

Having described the complexities of analogue signals, I can now refer you to the first chapter of the book where you should find the rest of the information you need to understand the process of how video is manipulated and stored in the digital realm. Once we get the fragile analogue signals converted to digital files, the biggest threat to the quality is over-compressing the files.

Capture hardware

If all that theory has left you a little dizzy, let's return to more practical matters.

To import analogue video directly into Studio, you are most likely going to need a Pinnacle capture device. Pinnacle Studio 24 only supports the newer capture devices or a DV Firewire input.

The USB connected Pinnacle branded models Moviebox/USB 500/510 and Moviebox Plus/Ultimate/700/710 (the latter models can output video) are still available on eBay but becoming increasingly expensive. Beware that many of the

earlier models used Moviebox in their name somewhere and won't be compatible with the newer operating systems - check the Pinnacle website carefully!

The remaining USB capture devices are branded as Dazzle products, and marketed as low cost solutions – often without full versions of the Studio software. The models that will work on the latest operating systems are the DVC 101 (DVD Recorder), DVC 103 (Video Creator) and DVC 107 (Video Creator Platinum). They can capture full resolution, standard definition video at good bitrates. At the time of writing Pinnacle still sell a Dazzle model on their website.

The only third party devices that may work with Pinnacle Studio are ones that connect via FireWire. I've talked about adding a FireWire port to a modern computer in the section about capturing DV video. Canopus made a range of analogue to DV converters, but I haven't had the chance to test one. If you own one, you will need to use the DV camera import option.

Of course, if you have another type of capture device, or are thinking of buying one, it doesn't need to work within Studio - as long as it comes with it's own capture software or it works with one of the free capture programs, you can import it's captured file into Studio, assuming it uses a reasonably common format for export.

A neat Analogue Capture alternative

If you own a DV camcorder that you can connect via FireWire, you might be able to use it to capture an analogue signal. This will depend on the model – it's a feature that is more likely to be provided on high-end camcorders.

Check the manual to see if it has Analogue In and is capable of DV pass-through. Some models of camera may have this feature in the North American versions, but have it disabled on the European version to comply with import quota restrictions. You might be able to get a "crippled" European model modified to work.

If you have the correct equipment, you can use the DV capture mode to capture the analogue signal plugged into the camera. One stumbling block could appear to be that when you click capture, the camera starts playing its DV tape. The answer to this is to remove the tape and close the tape housing door.

Sometimes, this method may require a long run up time – the camera needs to obtain a stable signal before it can tell Studio's DV capture routines it is ready – so recording the first few seconds of an analogue tape may be problematic. Once working, though, the quality should be as good as any other capture device and you are capturing straight to DV-AVI.

Connecting up your device

With your capture device plugged into your computer and installed, connect up the cables - the red and white sockets are for audio, the yellow for composite video and the multi-pin socket for S-video. If your analogue source has an output providing S-video use it if you can - you will get slightly better quality.

One important warning – the front panel RCA sockets on VCRs, DVD recorders and TV sets are almost always for input only – you won't get a signal out of them to feed your capture device. Some TV sets may have output RCA sockets at the back.

In Europe, you will be used to the presence of SCART sockets on VCRs, TVs and DVD machines. These connectors are normally bi-directional, but if you have a SCART plug with only one set of leads, there is a 50/50 chance the leads are for input to the SCART. If you need to buy a SCART lead or adaptor, I'd recommend you get one with an input/output switch.

Another word of warning about SCARTs – the sockets of a particular machine may not necessarily output a S-Video signal. If it is capable of doing so, you may have to operate a switch on the back panel, or a menu option on the machine itself. If in doubt, consult the manual. A muddle in this area is a major cause of only getting a black and white picture.

Adjusting the input

Capturing with a USB 510

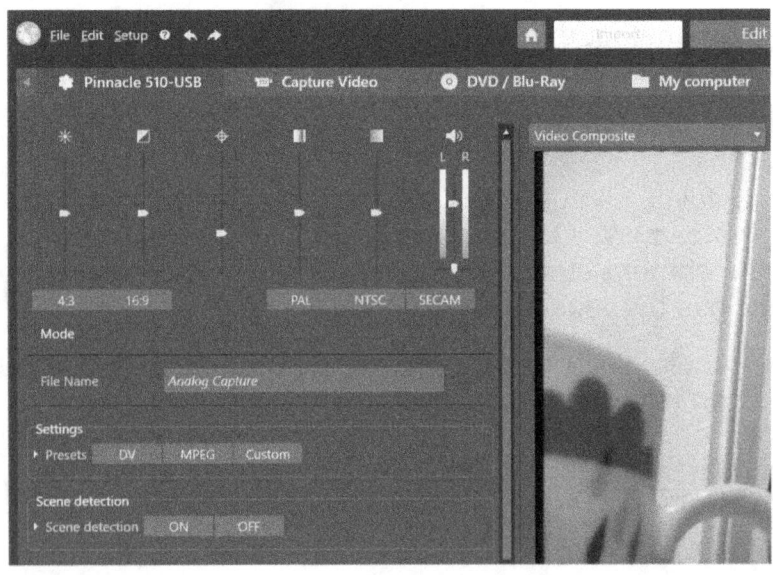

You can choose Composite or S-Video using the dropdown above the preview window. The aspect ratio and video standard can be selected using the buttons under the sliders. Set these to suit your video (PAL for UK/Germany, NTSC for the US, Secam for France, or Google your own country).

The sliders let you adjust Brightness, Contrast, Sharpness, Hue (this has no affect in PAL) and Saturation. The sound level and panning are achieved with the last set of controls,

but the coloured bars are not a level meter - that is on the right side of the preview window to the right. When using a Dazzle device it's not possible to adjust the audio level.

Adjusting the audio level

Other capture Settings

Mode just lets you enter a filename for the capture - no custom settings here. Below, three presets allow you to choose the format that the analogue signal is converted into. Consider using DV for maximum quality but only if you have plenty of hard disc space. Using MPEG capture is discussed in the previous section about capturing from DV, and may be best if you are capturing from standard VHS tapes or want to make DVD discs quickly. Custom also offers MJPEG, but its a very dated codec.

One thing that isn't immediately obvious is that you can get access to the video settings by clicking on the small triangle to the left of the Presets label.

Video and audio custom Settings

Scene detection has the same control to give you access the the choices available, which are the same as for DV, with the exclusion of being able to use the time and date. My recommendation for analogue capture is to set scene detection to automatic based on content, but we will see later that you can do this during the edit process.

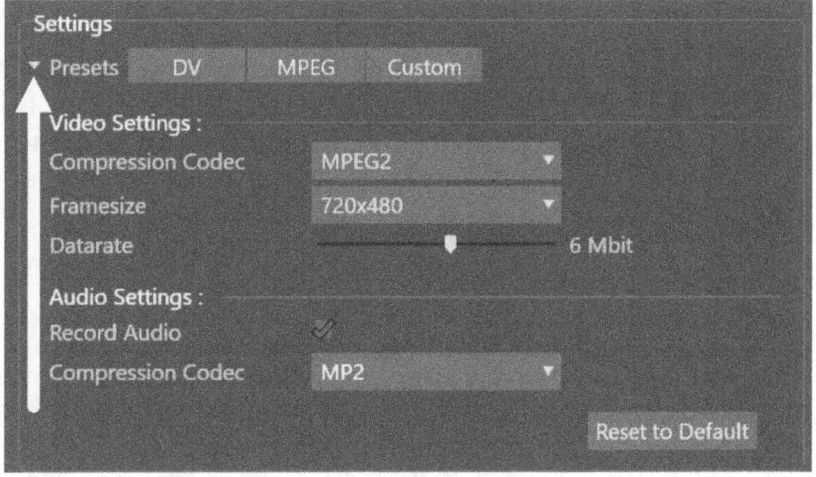

The final two boxes are the familiar *Save to* and *Import to* options that we have seen already.

Performing a capture

With a preview visible in the Browser and audio registering on the meters on the right, you should be ready to record. You need to start the VCR, camera or other analogue source playing manually – Studio can't control it like a DV camera. Set the tape up a little earlier than you want the capture to start and press Play a moment or two before clicking *Start Capture*. Another option is to set up the VCR so it is paused on the first good frame and then press play once capture has started. Which is best will depend on how stable your playback source is, and how close to the beginning of the recording you need to capture video from.

You can set a duration for the capture in the timecode box under the preview, and set a countdown to the start of the recording should you be capturing a live event.

If all is well, you will capture your video and audio, stopping when it's all in the computer, switch to the Edit Mode and get on with the creative bit. If you have dropped some frames, your resultant capture has out of sync audio or Studio refuses to capture, then review the information about DV capture, and then read on.

More Analogue Capture issues.

Where dropped frames are reported

I have to be honest here - the latest Importer module in Studio seems remarkably robust, but if you are getting choppy capture the Hard Disc bottleneck described earlier is worth working through. If the problem occurs using the DV setting, but goes away when you choose MPEG, then it almost certainly is the hard disc access speeds. Even if it doesn't, it is still worth looking at the disc performance as mentioned earlier. If that doesn't solve your problem, let us start looking for the problem at the start of the signal chain.

Most analogue capture is likely to be from domestic video recordings – VHS or Betamax VCRs or analogue camcorders. I'd wager that the tapes you are trying to record from aren't fresh either. To eliminate the cause of the dropped frames being unstable playback from tape, try recording a more stable video signal - the video picture from a camcorder, the off air signal from a TV or the output from a DVD player should all be very stable. If you drop frames with these, then the next section

about tape playback can be skimmed through, but still introduces some good practices.

If you can, use the same VCR or camcorder to play back the tape that recorded it. That may not be possible, particularly if you are doing a favour for someone else! The next best bet is a VCR with a timebase correction feature, although some of the simpler ones can cause "flash" frames (a single frame in an incorrect place) when used in conjunction with the top end capture devices. My VCR has a "Video Stabilizer" feature that has exactly that effect. It is good to have the choice, though.

I have boxes of VHS tapes which I'm still supposed to be digitising, and I have to admit to not storing them in ideal conditions. It is worth spending a little time making sure you are getting the most stable playback you can. If the tape has been stored somewhere like a basement or loft (or particularly a garage!), leave it in the house for a least a few hours to let it acclimatise - preferably longer. Then put it in the playback machine and spool it (fast forward and rewind, as opposed to play) up and down its entire length a couple of times to even up the tension. Finally, run a cleaning tape through the playback machine.

When you test the playback, either let the machine automatically adjust its tracking, or if you have manual control, adjust it for best playback. This is best done on a TV if you can connect to one. If you still see disturbances on playback, it is likely to cause dropped frames, particularly with the simpler capture devices. The newer upmarket capture hardware incorporates more sophisticated electronics.

If you still experience dropped frames, the next suspect to investigate is another computer process interfering with the stream of data. The cheaper devices use software and the computer's CPU for capture. Open up the task manager at the performance tab and have a look at CPU usage when capture is running. If it's peaking over 50%, check for background processes. Disconnect your Internet connection and shut down all the anti-virus, anti-spam security clutter which clobbers the performance of your computer.

Another possible culprit is the USB interface between the capture device and the computer. There are 3 standards, but USB 2,0 is the most common. It can transfer at data rates up to 480Mbits a second – more than enough – but USB 1.1 has a maximum data transfer rate of 12Mbits a second. That's not very good – the standard is obsolete. Most high speed devices will complain if they are connected via this standard, but you also need to be suspicious if don't find the word *Enhanced* in the Hardware Manager/Universal Serial Bus Controllers entry in the Device Manager.

None of the devices that work with Pinnacle Studio can take advantage of USB 3.0 at the time of writing. USB 3.0 HD capture cards are available, but don't work with Studio - you will need to use the software that came with the device.

Connection via a USB hub can cause conflicts, and for capture devices that take their power via USB, be warned that some USB ports are limited in the amount of power they can provide.

So, eliminate all unneeded USB devices, and plug your capture device into a back panel USB socket on your desktop or tower computer. If you are using a laptop, don't use a socket on the front edge, and make sure you are running on mains power.

If you think you have tried everything, see if you can try another computer – there is always the possibility that the device itself is faulty!

What Capture setting should I use?

Given that analogue capture in Studio is restricted to Standard Definition video, and that even DV-AVI files are manageable with a decent sized hard drive, why settle for less and capture at a lower quality than the maximum?

Pinnacle Studio used to use Direct Stream Copy for mpeg-2 files, so there were some advantages in speed and avoiding two lots of encoding by capturing to a DVD compatible format that could be "Smart Rendered"

With faster computers, the DVD render times aren't anywhere so long now, and Pinnacle appear to have dropped all forms of Direct Stream copy for DVD video, so the main advantage of capturing to mpeg-2 has disappeared.

Webcam Capture

One "live" video source that you can capture apart from those plugged into a working analogue capture device is a webcam. A useful function in some circumstances - you might just want to send a short video message, but with the chance to edit or add captions. Most webcams are rather low quality, but if you have one built into the lid of your laptop, it's a shame not to be able to record the output.

The Capture Video tab will appear if you have a suitable device connected. Settings are tailored to webcams - you can record in M-JPEG or MPEG-2 at various resolutions and bitrates, while the Scene Detection and Destination options are the same as analogue capture sources. However, there is a more sophisticated method of capturing from your webcam which I'll talk about in a moment.

Stopmotion and Snapshot

Two additional import functions exist. Both use a video input - A suitable DSLR attached via USB, a Webcam, DV or analogue camera via a capture device - to capture video stills or video frames.

Stopmotion can be quite a bit of fun - it's purpose is to create your own animations.. I've given it it's own section later in the book. The Snapshot feature captures still frames from a video source and saves them as Jpegs. Details of the video source options are covered in the Stop Motion chapter

MultiCam Capture

PS24 comes bundled with a free copy of MultiCam Capture Lite, which you use either as a standalone program or open it within Studio from the Import tab.

MultiCam main panel

The Lite version can capture two video sources and a choice of audio, so making simple computer tutorials with a screenshot, a webcam and a personal microphone for better quality audio is perfectly possible. Upgrading to the full version allows more sources, but the more it tries to record at the same time the more it's going to push your computer's capabilities.

Although the MultiCam recorder can be used as a standalone programme, opening it from the Import tab has the advantage that at the end of your recording session you are returned to Studio's edit interface, with the files you have recorded placed in a Project Bin, and if you requested it, a Project file consisting of the files opened up on the timeline.

If you are the sort of person that does things in one take, then this is definitely the option for you! If you just want to experiment, then you might want to use the capture program as a standalone.

When you open the recorder from Studio, the main Studio interface is minimised down to the task bar. The module actually consists of two windows – The main, smaller, panel has settings for the recording process and controls for starting and stopping recording. The larger one is called the Source view and is split into three panes. The left one shows the available sources, top right is a larger preview of the currently selected source, and bottom right are the settings.

MultiCam Capture Source View

The number of sources shown on the left will depend on how many are available on your computer.

Even without any video sources connected, you can record your computer screen, and this is the default choice for Source 1. Each source thumbnail has a toggle switch top right which shows up green when that source is enabled. The Name of each source appears below the small preview, and you can change it in the settings panel. Below the Name are audio meters for that source.

MultiCam Capture Source View

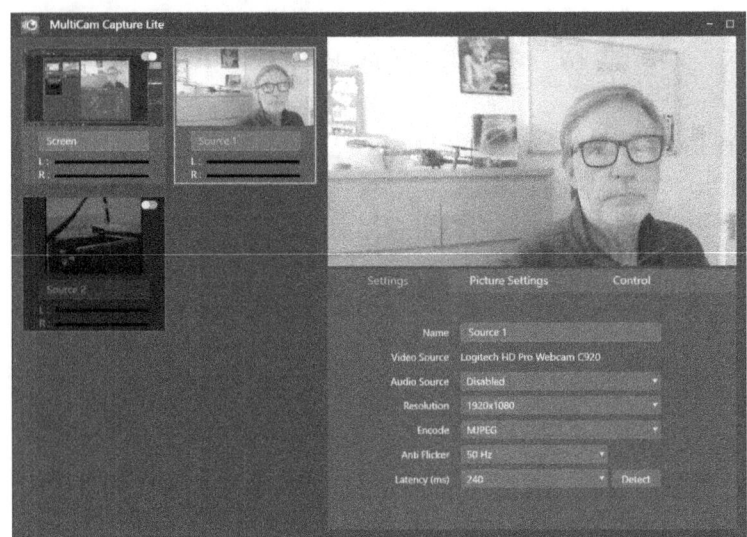

You switch between sources by clicking in the thumbnails on the left. Select the Screen source to examine the options.

Screen Capture Quality

One thing that may worry you when you start to use screen capture is how poor the output looks. Don't Panic! The main reason that you might be seeing a very blurry capture is because you are previewing the captured files in Studio and your preview quality is set to *Balanced* or *Fastest*. It may be hard to believe that half resolution playback of screen captures look so much worse than half resolution playback of "normal" video, but I believe that the number of straight edges and fine detail is at the root of the issue – they degrade far more when re sampled.

The switch to enable a source

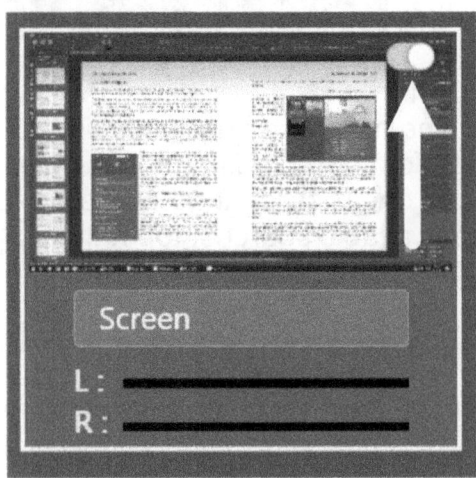

If you can, use the *Best* setting in *Control Panel/ Export and Preview/Quality*. If you need to work with a lower resolution, check your captured files in WMP or another video player.

Settings vary according to the source, and the Screen capture settings are unique. *Monitor settings* allows you to chose between multiple monitors if you have them. If you happen to have matching monitors with the same name, there will be an entry for each in the drop down. Short of editing the drivers, I can't see a way of renaming them!

Settings for Capture Window

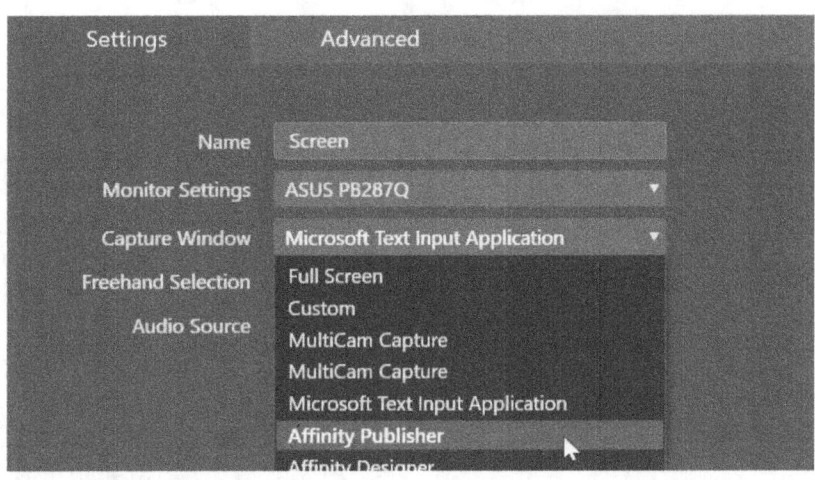

Capture Window gives you a choice of what you capture. The most obvious choice is *Full Screen*. *Custom* allows you to choose an area of the screen. When you select *Custom* an orange box appears on the screen, and you can adjust it with the nodes. Alternatively you can use the freehand selection tool below to draw around the area you want to capture.

The rest of the entries in the drop down will refer to open Windows. For example, in the screenshot I have the choice of capturing from Affinity Publisher, regardless of the window settings. A word of warning – some of the entries in that list give odd results, in that they are minimised or background tasks. In some cases (for example *Backup and Sync*, a Google taskbar icon) you can lose the Screen Source preview entirely and have to restart the Capture program.

You can type resolutions into the *Width* and *Height* boxes should you want to make accurate adjustments to the capture region.

Audio Sources

Selection of audio sources

The Screen and other video sources need not be tied to a particular audio source. A drop-down selection allows you to choose between the *Corel Audio Recorder*, which relays all the active audio that comes from computer, and any other audio source that is plugged in. This is ideal if you have a microphone that gives better sound than that from your webcam. The audio from one webcam can be selected to be shared with any others you may have.

Advanced Screen Capture settings

Advanced Screen capture settings

The second tab of the screen capture settings has a volume level to control whatever audio source you have selected. Beneath that are two neat enhancements to screen capture. *Mouse Click Animation* adds a graphic to the capture whenever you click a mouse button. *Show Keystrokes* overlays letters onto your screen as you type. Their placement can be a bit random if you are using custom capture areas. But they work well on Full screen captures, where they "tickertape" across the bottom of the screen. You do have to type quite slowly, but they are ideal for showing when you have pressed a modifying key such as Shift or Alt.

Performance Checking and recording format

A tool can check what settings your computer will be able to capture reliably, although in my experience it is a little conservative in its findings. The Encode dropdown will give you a choice between AVC (which is h.264) or MJPEG. The former will be more likely to omit detail, the latter will take up more disc space. If you wish to choose a different frame rate you will get smaller files and possible be able to record higher resolutions.

Latency

The time it takes to process a screen recording or a picture from a webcam will vary, and that means that your captures may not be in sync with each other. If they are all delayed by a similar amount that may not be an issue. There is a tool to detect the latency of a webcam capture, but you still may need to make adjustments to other sources.

If in doubt, you can do some simple sync tests by clapping your hands in view of all the cameras, and switching screen windows with a microphone close to your mouse. You can then make adjustments to the latency settings and re-rerun the tests. it's great if you can avoid recording out of sync, but if you can't then you can always sort the sync out afterwards – there is a great tool for this in the Multi-Camera Editor.

Camera settings

The basic settings for webcams and other sources allow your to choose the audio source, change the resolution and encoding (depending on the webcam). *Antiflicker* will be useful if you are shooting at 60hz (30 frames) and are lit by 50hz lighting (the European standard) or vice versa. *Latency* can also be set, and the detection tool prompts you to point the camera at your screen, where a changing number is used to detect the delay. However, if you have a webcam built in to the lid of your laptop this isn't much use – and you can't use a mirror as the numbers end up flipped!

Camera Settings

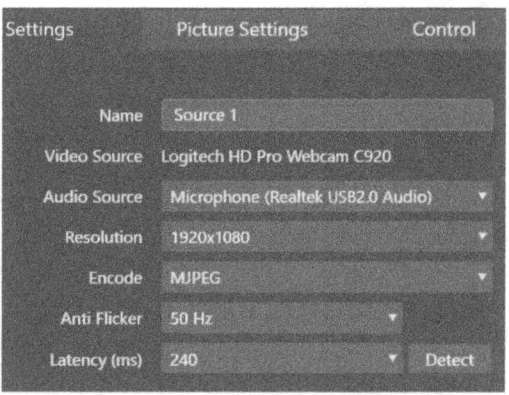

Picture Settings are under another tab. What you can adjust will depend on your webcam, as well as what can be set to auto, but don't forget you can make corrections later. Generally it's best to trust the presets, which you can restore with the reset button at the bottom of the window.

Control may be of more use. There is a volume control, but more interestingly I can Zoom my webcam a little and Pan and Tilt it when it is zoomed in, so minor reframing is possible

Adjusting the camera capture

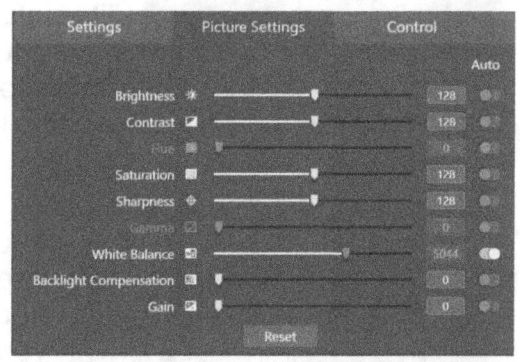

You may be able to set Focus and Exposure to manual as well, and avoid the hunting that can occur when someone moves about the frame.

Other sources

I have found that my USB 510 capture device is picked up by the MultiCam capture as a source, so I can plug another camera into that as an additional source, although it is limited

Camera Control

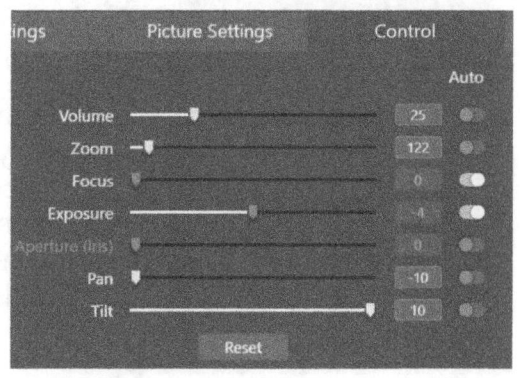

to Standard Definition, and no audio is passed on. I expect the same is true of the Dazzle. If you want to record two camera sources using the Lite version of the program, then switch off the Screen source before enabling the second camera.

Of course, you can record with other cameras not connected as sources at the same time as doing a screen and webcam capture. This means you aren't limited by the capture program and is how I record the tutorials I have made. The master shot is recorded on a 4K video camera to its internal card while the MultiCam Capture records the screen and the webcam. Syncing them up when back in Studio is easy if you remember to put a clapper board or even just perform a handclap before you begin.

The Recording Panel

Hiding the Source View

At it's smallest, the Main panel contains three buttons and a Settings drop-down, with an Upgrade button at the top of the window if you are using the Lite version.

The left button opens and closes the Source window, discussed above. The central button stops and starts the recording, the right button pauses it. If you press Stop, you are returned to Studio, so if you want to perform a second take remember to use Pause instead.

Settings and Shortcut Keys

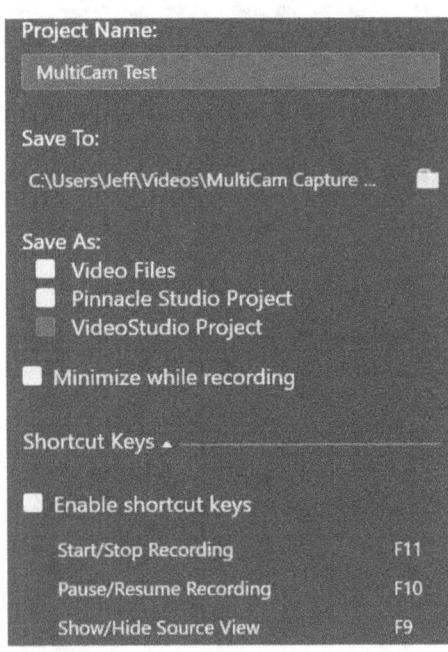

You need to open the setting panel for some important tools. The specified Project Name will become the name of the project Bin created when you return to the main editor. The Save To location can be changed to something more suitable. You then have a choice of also creating a Pinnacle Studio MultiCam project (or one for Corel VideoStudio, a nod to that fact that the capture program is also compatible with with Corel's other editing package).

Minimise while recording is important, particularly if you have a single monitor. When you start recording, both parts of the Capture program are sent to the task bar. You can then reopen them or use the shortcut keys, revealed by the drop-down below.

You may need to disable the shortcut keys if they clash with some other program you are using, as they can't be customised.

Recording

It's a pretty straightforward process to begin your capture, even if you may have to run a few tests before embarking on a long project. You can start and stop recording with the function key *F11* (assuming it doesn't clash with another program) or use the buttons in the Main window, and when complete the files are added to Studio's Library in a new Project bin. If you asked for a *mcam* project to be created, it will be in that bin as well.

I'll continue with the Multi Camera theme when we explore the Multi Camera Editor, a distinctly separate part of Pinnacle Studio discussed later in the book.

Watchfolders

The Watchfolder system has nothing to do with the Import tab. In Studio 24 it is disabled by default. Enabled, they allow you to define a number of hard disc locations that are constantly monitored for valid content – they are "watched" – and if new items are found they are automatically added to the Library. By default, the monitored locations were set to the current user's Media locations. If you used Windows or another program to place a video file in "My Video", it would automatically appear in the Pinnacle Studio Library. Sophisticated users of Watchfolders could customise the list of locations that were watched. Those users never needed to manually link to anything, even though sometimes things were imported that perhaps they wished hadn't been.

Customising Watchfolders

There can be issues with using Watchfolders, however. They add another background process to the running of Studio, and although the impact on performance is normally minimal, it can slow things down in certain circumstances. More fundamentally, if a file that wasn't fully compatible with

Watchfolders Disable

Set up folders on your hard drive as Watchfolders and Pinnacle Studio will automatically add new videos, photos or audio to your Library as soon as they appear in your Windows folder.
This is a legacy feature that has been replaced by Project Bins. It is disabled by default. Click Enable to activate the feature.

C:\Users\Jeff\Videos	Video ▼
C:\Users\Jeff\Music	Audio ▼
C:\Users\Jeff\Pictures	Photos ▼
C:\Users\Jeff\Documents\Pinnacle\Studio Projects	All Media ▼

Add Folder Remove Folder Remove All

Pinnacle Studio was automatically added to the Library it could bring Studio to a grinding halt. Sometimes it might not even be possible to relaunch the program without resetting the Library.

Most newcomers are likely to choose to leave the settings as they are. Having read about the pros and cons, if you decide you do want to use Watchfolders, they can be enabled and customised in the *Control Panel* under *Legacy Options*

If you have installed Studio 24 as an upgrade over an earlier version where Watchfolders were used, you will inherit the settings from before but they won't be enabled to add more media. Everything will be the same except that the Project Bins feature will be added and the Media category in the Library will be renamed as Library Media.

Here you can add new Watchfolders using the button bottom left. Any folder you add will also have any subfolders monitored as well, so in the case of My Photos, all the subfolders named by date are also scanned. Once you have chosen your new folder it is added to the list, where to the right a small drop-down menu lets you choose what type of media to scan for – so for My Photos it would be logical to scan only for photos. Any other items that have found their way into the folder are probably in the wrong place.

Removing unwanted Watchfolders from the list is obviously the function of the Remove Folder button. Neither of these functions do anything until you either click on the apply changes button (giving you the chance to make further changes) or you click on OK. When you do, if you have removed a Watchfolder from the list you are given the choice whether to remove the items in that folder from the Library.

Control Panel Import settings

The Control Panel for import settings

Using the Control Panel function, you can change all of the default settings for Import by selecting the section with that name from the left hand panel.

Not only do all the locations and subfolder options appear here, but you can control settings for Snapshots, (where you create a photo of the content of the timeline or the Corrections Editor), the default scene detection method and the Stopmotion Import mode.

Import problems

There are occasions when importing a file fails. The problem may get reported by the import process, although you are unlikely to get any clues as to why the failure has occurred. There are two types of thumbnails that can indicate a failure. The padlock grey thumbnail indicates that the video file uses a codec that is either unavailable or incompatible with Studio.

A locked Video File

In the past, some codecs would require an extra licence fee to be paid, and this might come about in the future as well for "Pro" codecs. So the first thing to check is if there is an activation required.

Studio comes with it's own set of codecs, and by default only those codecs can be used. If the video file seems to be recognised by Windows then the correct codec might well be in place on the system but not enabled in Studio.

Control panel option to enable third party codecs

If the video file seems to be recognised by Windows then the correct codec might well be in place on the system but not enabled in Studio.

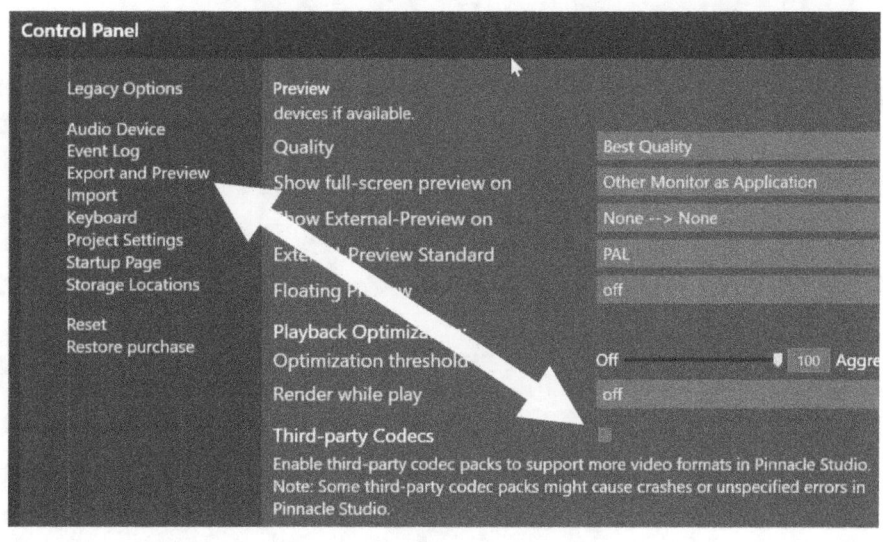

The Export and Preview section of the Control Panel has a checkbox that should allow Studio to use any third-party codecs installed on your computer. This comes with a big warning though - they will not have been tested, so you may experience unusual behaviour or even crashing. To

be frank, I've not seen this feature actually work, but then again, I may not have tried to import the correct problem files - it's certainly worth a try.

A red thumbnail is the more serious. This may indicate that the file is corrupt or that it's contents don't match the information in the header. The best bet with those is to try to re import them or use another program to convert them to a different format.

Cineform

One special case is Cineform, a video codec used by Gopro for their editing software. In the past, Studio could recognise the format if you had installed the Cineform codec. Since Studio 23 the codec has been pressed into use to provide Alpha channel support. PS23 only enabled it in the Ultimate version, but in PS24 you can import Cineform files in all versions, although export is restricted to Ultimate. The practical upshot of this is that if you want to export Cineform files (with alpha channel if it exists in the project), you need to buy the Ultimate version of Studio 24.

Using the Library

Let's start by giving names to the areas of the Library and pointing out some important tools. If your Browser Window is not as shown, but consists of a list of file names, then you are looking at *Details View*. Click the *Thumbnails View* icon on the Library Toolbar and your display should now resemble the screenshot.

The Default Library Layout

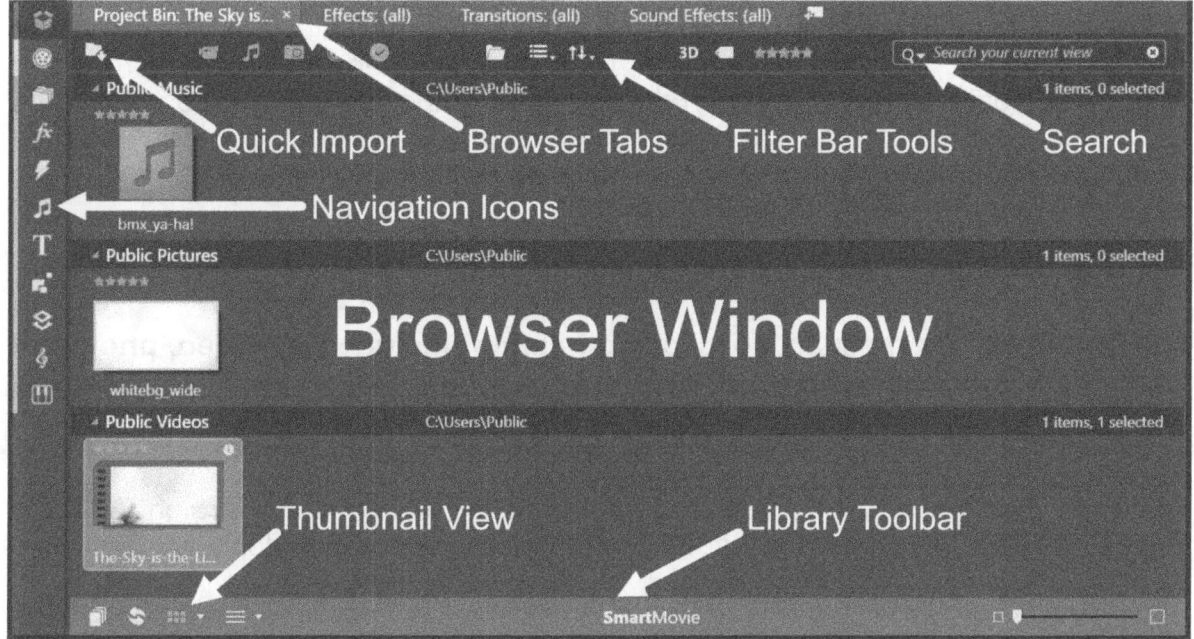

So, what is a Library?

Computers store data within various folders on their hard discs and in the past you had to obey the folder structure. Windows has moved on to introduce Libraries – places where a user can find all their documents, music and so on without having to address the actual folders which contain the data. Libraries are easier to search and organise – your My Music Library only contains music. Tracks are rated, can be sorted by criteria such as Artist and you can generate playlists.

The Library concept used by Pinnacle Studio takes this a step further. It is a database that contains any items that you may want to include in your project. Some of these items are put there by default – Transitions, for example. Other items such as captured video, music tracks and photos will be unique to you . You can choose which of these are included in the Library and organised into Project Bins. The items are still stored in the same place on your hard disk, but their locations are tracked in the Library database.

If you can't see the advantage in using Project Bins and are comfortable with organising your assets within folders the way you have always done, it is possible to just use the Library as a clever search facility, far better than any Windows based "Open..." dialogue box. There are a couple of steps you can take in order to work that way and I'll show you how to do so shortly.

Library Display Size

You will see the Library in a number of places, not just the Edit page. It is present in the Legacy Title, Multi-cam, Template, Montage and Menu Editors, where it can occupy at least half the window. In the Edit and Author pages the Library can be expanded from it's normal size using the usual layout controls, but it can also be undocked and made any size you wish, or even switched to full-screen. Undocking is described In the User Interface chapter.

Media Assets

I'd like reiterate an important concept. **You cannot include any video, photos or audio in any project if it isn't already in the Library**. You, or the Studio program, need to have checked it into the Library before it can be used. This is also the case when you want to include media in titles, menus, templates or montages.

Although Studio now allows you to drag an asset from Windows straight onto the project timeline, it automatically adds it to the Library when you do.

To seasoned computer users this might seem unnecessary it has important advantages – all the media you might want to include can be accessed, searched and categorised in the same way, and any items you don't want to clutter up your view can be excluded.

The way you arrange the media on your computer can be as organised, or as chaotic, as you wish. If your video and audio files are already orderly then you can see that in the Library. If they aren't, then you can bring organisation to the chaos using Library features.

Project Bins, Watchfolders and Library Media

We have looked at the ways of "checking in" media items to the Library in the previous chapter, Importing and Linking. By default, they are added to **Project Bins**. These were introduced in Studio 19, are simple to understand and coincide with Corel's other video editing package, VideoStudio. To some extent they are a duplication of features, because the Library also has a feature called Collections that does a similar thing (and more), but Collections have not been removed. As

Studio continues to develop, I expect that Project Bins will become more powerful and I'd encourage you to embrace them rather than trying to avoid them.

An older feature, Watchfolders, is disabled by default in Pinnacle Studio 24. I discussed these in the Importing and Linking chapter. Before Project Bins were added you could find all your Library contents in the Media category, regardless if they had been added by Watchfolders or any of the other Import methods. The Media category is not defunct, however, although it has been renamed as Library Media, and it isn't displayed by default.

If you are new to Studio you can ignore the old way of working and just use Project Bins. The downside of this approach is that you won't be able to see any items that have been added to your Library without being put in a Bin, or were in a Bin that has since been removed. This is because in the process of adding Project Bins, the programmers have also hidden the full Library listing of media assets. Fortunately, it's possible to see a full listing of your Library media with one of two simple workarounds..

How to see the Library Media Icon in the Navigator

If you want all of the media in your Library displayed as part of the tree view of your Library Navigation structure but don't want the Watchfolder process to be running, the following steps need to be taken:

- Open the *Control Panel* (under the *Setup* menu) and select the *Legacy Options* tab on the left.

- Click on the *Enable* tab

- If there are any folders listed as being watched use the *Remove All* button to delete them from the list.

- Click on *OK*.

From now on, the Library Media icon will be present in the Library Navigator

How to open a Library Media tab

If you just want to open a Browser Tab showing the Library Media:

- Put any clip on the timeline if there isn't already one there.

- Right-click on the clip to select it.

- Select *Find in Library*.

A new Library Media browser tab will open showing the clip you selected. You don't have the advantage of the sidebar to navigate when using this method, and therefore are presented with the whole contents of the Library, grouped by folders (unless you change the grouping method)

Browsing with Tabs

The top row of the Library has a series of Tabs, similar to those you would find in a web browser. Click on any of the tabs and the contents of the Browser Window change to show the contents of your new tab selection. The Navigation Icons are on the left. These control what appears in the Browser Window of each tab.

When you first install Pinnacle Studio there are four tabs, open at the only present Project Bin, *The Sky is the Limit*, but tabs are very easy to add or remove. The currently selected tab is indicated by being fully coloured, the others just have a stripe at the top that indicates what type of tab they are.

Adding a new Browser Tab

To the right of the row of tabs there is a smaller icon that has a + sign beside a folder. This is how you add a new tab. Click on it now – a new default tab entitled *Project Bin: The Sky is the Limit* appears to the right of the other tabs.

To **remove** a tab all you have to do is click the small X on the right side of the tab. Think twice before deleting tabs; if you want to clear the current view and look at something else, it's just as quick to switch tabs, and you may have spent some time setting up the current tab for a specific purpose.

To **modify** the new tab's contents you need to use the Navigation Icons which we will look at in a moment.

Each tab is almost infinitely customisable. You can set each one up exactly how you want to, then browse across to another tab, and when you re-select the original tab it will be just as you displayed it. This includes the addition of a *Search filter*.

You may be wondering how many tabs you can have. When you fill up the available space across the top of the screen small navigation arrows appear at either end so you can scroll to find more tabs. There doesn't appear to be any technical limitations, so if you have a good memory then by all means create as many as you wish!

If you like using the keyboard, then you can navigate across the tabs with the TAB key to move right, and Shift-CTRL-TAB key combination to move back to the start.

Alternatively, Ctrl-Arrow Left or Right change the selected tab.

Using the Navigation Icons and Lists

There are a number of icons stretching down the left side of the Library window. To change the contents of the currently selected Browser tab you can simply click on one of them. Do that now on the fx icon to see a change in the tab to show Effects: (all).

The flyout pin and the Navigation icons

Unless you clicked very quickly, when you put you mouse cursor over the icon a flyout panel will have appeared on the right with a list of Effects categories. When you get adept at using this flyout panel it can be very efficient, but you can also use the pin tool to hold it open, and for now I suggest you do.

The Navigation List changes it's contents for each icon you select, displaying what is available for each category.

There are five classes of content, and each has it's own colour shown in the sidebar: Bins (Red/Orange) Library Media (Blue), Project (Purple) Collections (Green) and Content (Yellow).

If you can't see the Disc Menus icon then you haven't enabled Legacy Authoring.

With the Effects icon selected and the list open, clicking on a category such as 2D-3D changes the current browser tab to Effects: 2D-3D.

The List has a couple of features other than the vertical scroll bar that appears when you run out of room. There is a limited amount of navigation possible with the keyboard arrow keys. Icons at the top right of the list allows you to create new Bins or Collections. Current Bins and Collections have context menus available.

Many of the categories can be expanded. Click on Transitions and switch the current tab to display the contents. If you scroll to the bottom of the list you will see the Standard Transitions category has a small arrowhead before it. Click on the arrowhead and it points down to reveal further subcategories.

Opening up subcategories

While the contents of the subcategories are shown in a browser window, if you click one of the subcategories in the list, the browser window will show just the transitions in the subcategory.

You can collapse the list by clicking on the arrowhead once more.

This may seem trivial when there aren't a lot of subcategories, but it's particularly useful if you enable Library Media as you can browse the folder structure of your hard disc and then display the contents of a single folder.

The Browser

In the Browser Window that occupies most of the screen there are groups of thumbnails separated by darker grey headers.

Collapsed Transitions categories

These grey bars are the Grouping headers - although by default they display which folder or category the items are

in. You can collapse the display to exclude the thumbnails with the orange arrowheads, or use the context menu commands Expand All and Collapse All that becomes available if you right click on a header itself.

The header bars hold useful information. In the centre you will see the hard disc location of "real" assets - files rather than content. At the far right are details of how many items are in the group and how many are selected. Hover over the end of the bar and you get a useful Select All tool.

Selecting all the contents of a group

Before we look at the contents of the Browser window in more detail I'm going to discuss the tools available for arranging the contents.

The Browser Window Toolbar

The first icon top left of the Browser window is the *Quick Import* tool I've talked about already. This tool is only available for Bins, Library Media and Projects.

The next four icons will only be present if you have a Project Bin open, so select one now if you can't see the icons. By un-highlighting them you can excluded the type of media the icon represents from being displayed in the browser.

Media Filters for Project Bins

The fifth icon is also present in Library Media and Collections. Any media items that are used in the project currently on the timeline have a green tick icon on their thumbnails, but this filter removes them entirely from the view. This avoids you inadvertently using the same clip or photograph twice in a project.

The central group of tools

The Browse tool is a simple folder in the centre of the toolbar, which opens a Window Explorer window from where

you can drag and drop media into your Library as discussed in the Import and Linking chapter.

The next icon - *Group by* - controls how the Browser Window groups the display of assets.

Clicking the tool gives the option to group the view by *Date Created*, *Folder*, *Rating*, or *File type*. If you wanted to only look at photo files that were Jpegs, you could select "file type" and then scroll to find the group ".jpg".

Group By choices

Change the grouping and observe the changes in the way items are displayed. The Browser Window still shows the assets arranged into groups that can be opened and closed with the aid of the orange arrows.

The default choice here is to group files by Folder, but you for Media you might want to choose Date created instead, and for Content you might want to choose File type - which has the effect of listing all the content for that category in one browser window without subdivisions that might need opening up, so you can browse through all the options easily.

A really neat feature that took me some time to discover is that if you use Collapse All on a browser window grouped by Date, it leaves one header open - the current or latest date. If this is a bug, it's a useful one!

If you click on your choice of grouping twice, then the sections are displayed in the reverse order. For example, if the the view is already grouped by Folder in A-Z order, clicking on Folder again will change the sort order to Z-A.

The other option for the Browser display defines how the assets are sorted **within** the groups.

There are even more options here to help you arrange the assets. *Date* is particularly useful as it doesn't just use the date, but also the time. *Duration* might also be of use in some situations. There are also a number of choices that only appear when certain locations are open - photo resolution, video frame rate, album, artist and Genre for music and even *Missing Media*.

If you want to sort in the reverse order, click again on the chosen order, and it will be reversed.

You can also reach the Sort options from the Browser Window Context Menu. Right click on an unoccupied space in the window and you also get a shortcut to Quick Import if the particular tab supports it.

Sorting by date - a problem

You may notice an inconsistency when trying to sort video clips by date. If you have copied the file rather than moved it, the Created date changes to the time of the copy operation. There is a solution to this in the Importing chapter.

More Filter tools

To the right of the Toolbar are three filtering options. Regardless of whatever tab you have selected, grouped in any manner you have chosen, in any view, it can be further refined here.

There are four powerful methods of finding the media you want - 3D, Tags, Ratings and a very good textual search.

More Filter bar tools

3D filter

If you are making stereoscopic video projects, then this filter is for you. By selecting it, only assets that have 3D properties will be shown.

Tags

The Tags Window

You may be familiar with the idea of tags from software photo albums or even Facebook, where you can apply tags to pictures – for example, the names of people. A picture with 3 people in it might have tags for Tom, Dick and Harry. A picture of Tom on his own would only have a tag for Tom. Then you can search your collection for all pictures that have Tom and Harry together. Any pictures of a sunset can have a Sunset tag, and then you might be able to search for a picture of Harry standing in front of a sunset.

Before you work with tags, I should warn you that you will need to take special steps to preserve them when you back up your Library or upgrade to the next version of Studio, as they are ignored by PS24's new Library Backup features.

To see if you think they are worth the extra effort, it's a good idea to create some to experiment with. The first step is to click on the Tags Icon on the filter bar - it looks like a luggage label. When you do so, a small new movable window opens up over the screen. Position this somewhere suitable.

Working with tags is best demonstrated with a tutorial. For this we need some source pictures and Pinnacle should have provided some for you when you installed Studio. I'm going to be using these pictures when I discuss Pan and Zoom, so that's a second reason for importing them.

Create a Project Bin called *BMX* and use the Quick Import function to add the eight *The-Sky-is-the-Limit* Jpeg photos that are in the Public Pictures location *C:\Users\Public\Public Pictures*. If you can't find them, they are on the DTVPro website and data DVD. Make sure the bin is sorted by *Name, A to Z*.

The BMX photos in the BMX Bin

Type "bicycle" into the Tags text box as a tag name and click on the + sign. Tag names aren't case sensitive, so "Bicycle" and "bicycle" count as the same tag. You can use the + icon alongside or the enter key to create the tag.

You can apply a tag in a number of ways. By checking the box labelled "Apply the tag..." underneath the name creation box, any items that happen to be selected when you create the tag will have the tag applied. There are three ways to add tags that have already been created to new items. Right-click on the first picture – the 01.jpg – and you should see Apply Tag available in the Context Menu. Hover your mouse over that command and a list of potential tags should appear. We only have one choice, so select "bicycle".

A tag icon will appear alongside the first thumbnail, (If there isn't, it's possible you have switched off the Tag Indicator in the Thumbnails view selection menu). Hovering over the tag icon lists the tags given to the picture (still only one at the moment) and the option to "remove all". Hovering over the tag name itself opens up the option to delete the tags individually.

Pictures 2, 3, 4, 6 and 7 all have bicycles in them. CTRL-Click all of them to select them as a group. Right click on one of the highlighted pictures and from the Context Menu, apply the "bicycle" tag; it gets applied to all the selected photos.

I think that the second way of applying a tag is neat. To demonstrate that, we need some more tags. I've given names to the four people - Fred, Daphne, Velma and Shaggy (you may spot the reference here!). Return to the sidebar and create a tag each for them.

Daphne is the girl with red hair. Drag and drop the Daphne tag from the Tags window to the first picture with her in. Notice the graphic that reminds you of the tag name as you drag it.

To tag the rest, use the third way, which is quicker. Multi-select the remaining four pictures which she is in and click on the tag name in The Tag Window. Notice the number of items has gone from 1 to 5.

Velma is the blond girl. Multi-select all her photos and click on her tag. Both the boys are in pictures 1, 2, 5, 7 and 8. Multi-select those pictures. Now try this – click on Fred's tag, then click on Shaggy's. Both tags should have been added to the selected pictures.

Leave the pictures selected and click on Fred's tag again - whoops, we have deleted the tags! Click again, and they're back.

To complete our tagging, the fourth picture needs a Shaggy tag. When you have done that, select each picture in turn and observe the highlighting in the Tags window – all the tags "owned" by each photo are highlighted as you step through.

You can navigate around the Library thumbnails with the arrow keys. In conjunction with the mouse, you might find this a convenient way of adding multiple tags to items as you work through the latest folder of imported photographs.

At the top of the list of tags are two drop-down selection lists. *Sort by* only dictates how the tags are ordered in the tag sidebar. The ABC choice is obvious, but Relevance not so. It could be called popularity, or even "how many items are tagged with this tag", so when you choose Relevance, Bike and Shaggy top the list because those tags are attached to the most photos.

The Filtering By bar

To see what the *Match* choice does, we need to select some tags. You may have noticed the icon to the right of each tag name in the sidebar that looks like a magnifying glass looking at a tag. Click on Bicycle and a "Filtering by" orange bar appears at the top of the browser and we only see photos tagged as *bicycle*. Add another tag, Daphne and the photos of her will be added as long as *Match* is set to *Partial*. The three settings behave like logic gates And, Or and Nor, if that is a concept familiar to you.

- *Full* - the view will be filtered to show all the photos that have a *bicycle* **and** *Daphne* in (And)

- *Partial* - all the photos that have a *bicycle*, *Daphne* **or** both are displayed (Or)

- *None* – only the photos **without** a *bicycle* or *Daphne* are displayed (Nor).

Closing the Tags sidebar by clicking on the tag icon leaves the tag filters in place. The Library warns you that you have a filter in place by placing the orange bar across the top of the current View Window. The quickest way to clear the filter is to click on the "x" at the right end of the orange bar.

To manage the tags, you hover over them. Two icons appear. You can rename the tag, and all the items that have this tag are adjusted accordingly. Change "Bicycle" to "Bike" to observe the results. You can also delete the tag, removing it from all the items and the list.

Ratings

Ratings are a simple way of sorting your media, projects or creative elements by how important they are to you. **Like Tags, you should bear in mind that in order to preserve your Ratings metadata you may need to take special steps when backing up your Library, or Upgrading to a newer version of Studio**.

Let's use the example of a series of still photos that you take on a day out. When you import them into the computer, some are going to be "must haves" and some are a bit poor. It's very easy to give each picture "stars out of 5" for its content and technical merit. When you start to put together a slide show of your day out, you are going to put in all the five star pictures. However, when you watch it back, you might realise that it looks as if Grandma wasn't with you that day. Perhaps in most of the pictures of her she was being shy, or you got your thumb over the lens. Lower the rating and you'll find those pictures, and include them, perhaps with some Corrections to improve them technically.

Awarding 5 stars the Cross Dissolve

Using ratings is pretty simple. I'm going to use transitions as the basis of a demonstration. Even though Pinnacle have now introduced Favourites categories for Content, I like to rate transitions, because it offers more options then just throwing some in a favourites category. Even if you haven't bought any extra content, you probably are overwhelmed with the choice Pinnacle Studio gives you.

However if your editing preferences are similar to mine, most of the time you will use a simple crossfade. So, let's start by giving that transition a 5 star rating.

Open up a browser tab at Transitions > Standard Transitions > 2D Transitions. You should have a choice of 86 transitions. Scroll down until you find the *Cross Dissolve*. Above each thumbnail should be 5 grey stars.

Now hover over the stars at the top left of the Cross Dissolve transition and they will turn white to show you are in the right area. Clicking on the furthest right star and then moving your mouse away turns all five stars orange. Do that now and you have given Cross Dissolve the highest rating. Clicking on any other star changes the rating to that level. If you really want to "un-rate" something, click on the currently selected star again. Make sure that the Cross Dissolve has 5 stars.

Add a few 4-star and 3-star ratings to some of the other transitions in the 2D Transitions folder so you can see the next effect. Now use the tree to select the Alpha Magic group of transitions and rate a few more with 4 or 3 stars. Using the tree, change the current tab again, so that you are looking at all of the Transitions. Lots of them, aren't there? Make the thumbnails as small as you like and it's still a huge amount. Now that some are rated, we can use the ratings to find our favourites.

Ratings and the Filter bar

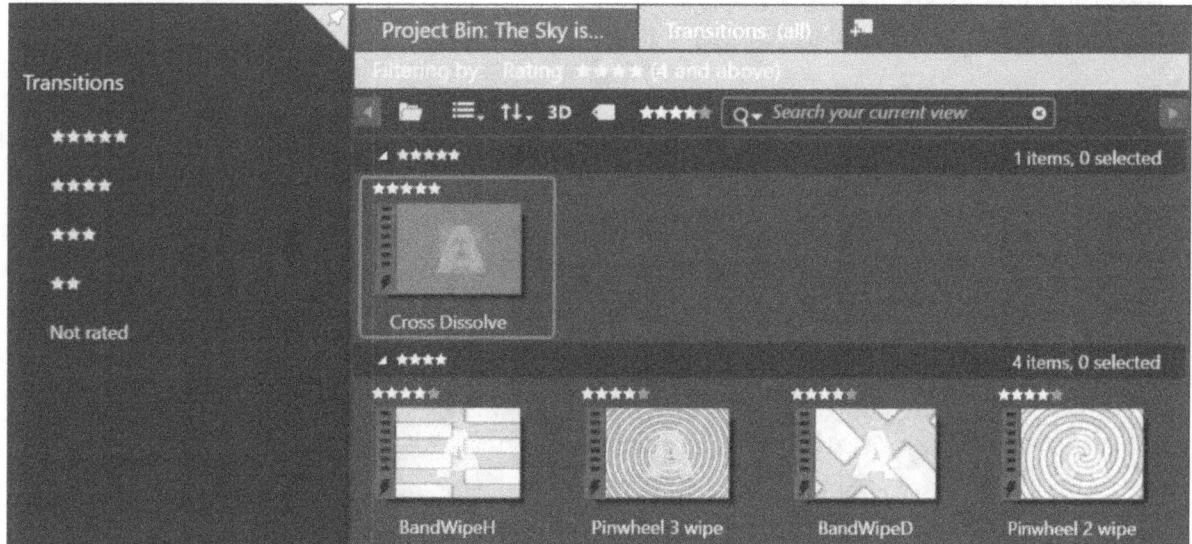

The first way to use Ratings is via the Filter Bar. There are 5 stars after the label "Rating filter", and if you click on the fifth star, you should now only see the Cross Dissolve transition. Change the view by clicking on the fourth star, and you will see all the transitions that you rated with four stars or above. Click on the third star and

you will see all the 3, 4 and 5-star rated transitions. Note that the transitions are still in their groups. If you change the grouping to Rating you get an even better display.

Again, the Library warns you that you have a filter in place by placing an orange bar across the top of the current View Window. In the current case you will see the text *"Filtering by: Rating ***"* on the left of the bar, and a close icon on the far right.

One very useful feature of Pinnacle Studio is that when you import photos that you have given a rating to in your Windows Picture Library, that rating is transferred to the Pinnacle Studio Library as well. The ratings remain separate after that point, so changing the number of stars you have given in one Library doesn't affect the rating in another.

The Search Box

The final item on the filter bar is the Search Box. Here you can enter words that will filter your browser view by the *caption*, *title* or *name*. This basically means the text underneath the thumbnail – different assets have different conventions. You can edit the caption of a media asset so that it is no longer identified by its filename, but you can't do that to a project – you have to rename it. Any Content has an un-editable title. Whatever the convention, it's the text underneath the thumbnail, or in the *Name* field of Details view that is searched.

Searching for "push" in Transitions

As you type the search word, the number of items shown is refined. Enter a second word in the box, and then you have the choice of if you want to match either word, or only see items that have both words. You change the setting with the drop-down arrow to the left of the text box. Select *Content/Transitions* in the Asset Tree, clear any existing filters and type "push" into the box. I'm left with 12 items that all have

the word "push" in their text. (You may have less if you have Studio Plus or Standard.)

Open the drop-down box with the arrow and check "match any word", then type a space and then "left". I now have a view in the browser of 53 items – they either have push or left in the text.

Changing the search logic

Change the search setting to "match all words" and we see the only items in transitions that has both words – the 2D Push Left transition, and if you have New Blue installed, two further versions in Roll and Shredder. You may not have even known you had such a choice!

The search box is in my opinion the most useful of the filters. I know there is a "Old Film" Effect somewhere, and rather than browsing for it, the simple act of typing those words into the search box narrows down the browser view very quickly. OK, there are a couple of effects with the word "gold" in the text, because it contains "old", but that's not too bad, really!

Combining filters

Using more than one filter gives you even more power. You can switch ratings and tags on and off, even when there are words on the search box, so you can apply all the filter techniques at once. When a filter is applied, the orange bar across the top of the browser lists all the filters in place. You can deselect the Rating filter by double clicking on any star, Tags by clicking on the tag icon and text searching by using the close x to the right of the search box.

The Library Toolbar

The bottom of the Library has another toolbar

The lower toolbar

In the middle of the toolbar is a button for **SmartMovie**, the automated movie creator. You work with this function

from the Library, so this is why you enter it from here. We look at SmartMovie in the Photos and More chapter.

The **Thumbnail Size** control on the far right of the Library toolbar only has an affect when you are in **Thumbnail View**. Switch to that view now and select a tab that has a number of thumbnails. If you haven't imported much into the Library yet, try Transitions. Now adjust the slider and you'll see the size of the thumbnails alter in response. I find myself using this control a good deal.

The first icon on the left is the **Scenes View** button. It may well be greyed out at the moment. Scenes are a feature in Pinnacle used as a way of dividing up video files; once they are divided up you can choose to view them with this control. To access this view you need to have a video file highlighted. A "scene" in Pinnacle isn't the equivalent of a "scene" in a film or TV script - it is normally just one single shot, but can be just part of a single shot or a series of single shots depending on how you detect them.

We will look at Scenes later in the chapter. Disable the view for now – if you aren't likely to use Scenes in your projects at least you now know when you have the wrong view selected!

Next is the **Refresh** tool. If you think something is missing from the Library then this is the first thing to try.

Using this feature is non-destructive, but it takes a little time to work. When you first click on the tool, items disappear from your Library - Favourites and Content that has been added to collections, for example. Don't panic, though, because the refresh isn't complete until the tool icon ceases to be greyed out and becomes available again.

The next two icons to the right alter how the browser displays its information. I've already mentioned the first, Thumbnail View. It ensures we are seeing pictures, not text details.

Thumbnail view display options

Click the drop-down arrow on the right of the button and you will see the choices. A tick indicates if that option will be displayed as an icon on the thumbnails.

Rating - Five stars show the item's rating. These are placed top left of the thumbnail

Stereoscopic - if the media has stereoscopic properties, a "3D" symbol appears after the rating stars

Information - The "i" icon top right that opens the Media information window.

Thumbnail Options

Correction – This is more significant. If you have sent a media item to the Corrections Editor and applied a Correction it will be indicated with a gearwheel icon below the Info icon. Whenever you use a media item from the Library in a project, it will have the Correction automatically added. Note that turning off the indicator isn't the same as removing the Correction.

Collections – Shows a folder icon below the Corrections icon if the item is part of at least one collection.

Tag – This is one of the indicators you might want to turn off, because all it shows is if a tag has been applied, not what it is. The indicator is a small "luggage label" icon placed to the right of the thumbnail.

Used Media - If the item represented by the thumbnail is in use in an open project, a check mark appears. The check mark is green if the item is part of the currently displayed project, grey if part of the project in the other tab - for example you have the Edit page open but the item is only part of the project in the Author page. The "tick" appears to the right of the rating stars.

Thumbnail icons on display

Name – Switches on and off the caption below the thumbnail. For items in the All Media category, you can edit this caption by right clicking on the thumbnail and selecting Edit Caption. This doesn't alter the item's filename, so if you are stuck with a load of clips with unhelpful names (Video_01.mpg, Video_02.mpg) and the thumbnails also don't do much to identify them, it's a good idea to label them with something more helpful. The filename can always be found using a number of methods.

Shortcut – Sometimes the thumbnail doesn't lead to a real file, but is a shortcut to another file. The icon appears on the top left of the thumbnail. You are most likely to see this indicator when you work with Scenes or create your own Library Shortcuts.

Expand Thumbnail

The Expand icon

A new feature that was introduced in the first public build of PS24 was another icon that appears in the border of the thumbnails of some Library Content. Currently it can be seen on Effects and Transitions, but I wouldn't be surprised if the feature gets added to other media in the future - perhaps Library Shortcuts might take advantage of them.

The expanded selection of Effects presets, and the shrink icon

If the double arrow icon exists (with the tooltip *Expand*) and you click on it, you are shown all the preset versions of that effect or transition, while the icon changes to a Shrink icon which, as you might expect, closes the optional thumbnails and returns to a single thumbnail view.

Details View Options

Details View

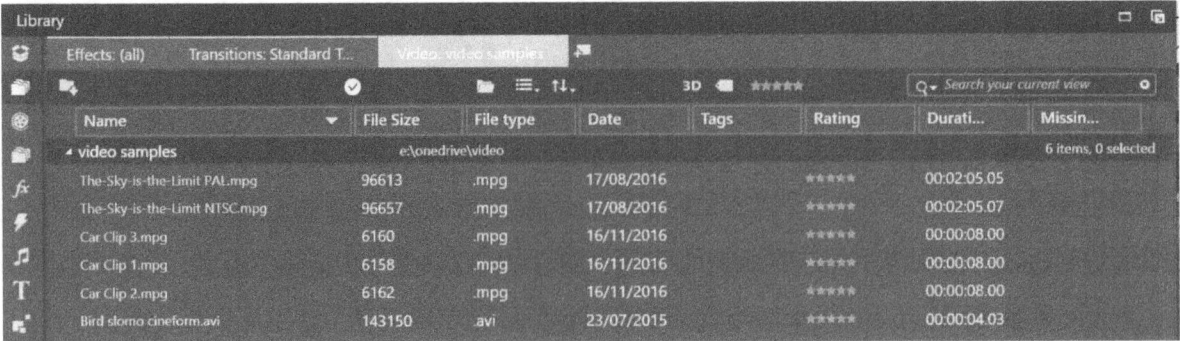

The next icon switches the browser to **Details View**. If you haven't seen this yet, switch to it now to see the thumbnails disappear to be replaced by a text list with a lot more details about what you are viewing.

Details View Options

You can enable and disable which of the fields are displayed with the drop-down arrow alongside the Details View button.

You can sort the display by using the field headers. The small arrowhead shows the current sort field. If it is pointing up the group is sorted low to high, ascending or A to Z. Click the field heading and the arrow head will point the other way and the sort order will reverse. You can click any of the field headers and sort them low to high or high to low.

This sorting only applies within the groups, and is independent of how the categories are grouped. You can achieve this type of sorting in Thumbnail view, but the column layout of Details view makes it much clearer what is going on. If you are looking for a particular tag, date or file size it's also much easier in Details view.

Details View has a similar functionality as Thumbnail View, so we will explore them both together.

Using the Browser Window

If you have too many items to fit on the screen (and you can't or don't want to make the thumbnails smaller) there will be a standard Windows scroll bar at the right of the browser. If you have a mouse scroll wheel, that will also work. Clicking on an item will highlight it to show that you have selected it, and you can then use the keyboard arrow keys to move around the view, highlighting details or thumbnails as you move around the screen.

At times you will want to perform multiple selections. You can use the Windows controls outlined in the Whistle-Stop chapter if you aren't familiar with them. I mentioned earlier that the individual groups displayed in the browser can be opened and closed with the orange arrows on the left of the group headings. If you use Select All, even items in the closed groups get selected, so take care using this feature. You might find yourself handling far more items than you think!

Once an item or items are selected, then you can do something with them. What is possible will depend on the type of item. What you can't do is drag and drop items **within** the Library View.

Browser Functions

Apart from finding stuff to put into projects, there are other functions that we can carry out on assets. It's time to explore these functions. When using thumbnail view there are a couple of controls that become available just by hovering your mouse over a thumbnail.

Thumbnail controls

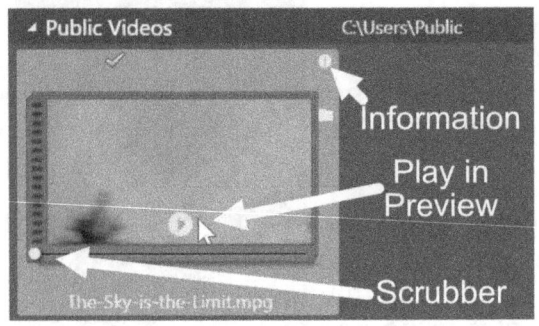

The icon bottom centre, overlapping the picture is normally a Play button and performs a Preview action when clicked, opening the asset in the Source Player Window If the asset is a still photo, the icon looks a little different.

Top Tip - if you just want to play the thumbnail without opening it in a player window, you can do so by holding down ALT and then clicking on the preview button.

Another control is the thumbnail scrubber. This only appears if the asset would have a timescale - it's no use on a still photo, for example. You can use this to choose which frame is displayed, or for a quick reminder of what the clip is about - perhaps the opening frame is black and you want to set it to something more obvious.

You will also find the scrubber available for Transitions, Effects (even those which aren't keyframed), Montages and Audio.

The Info Panel and Player

The Information panel

The **Information** icon on the thumbnail opens up a separate window that has two purposes. It includes all the information you need about the asset - file details, tags and ratings, video/ picture and audio format.

There is also a field for **comments**, so you can make notes about the asset.

This info is also available from the context menu using *Show Information*. However, when you open the panel from the Library, even using the

context menu in Details view - you get a bonus - a video player! You can toggle between info and player with the bottom right "i" icon.

Info panel switched to Player

This might seem a duplication of features - after all the preview window is just to the other side of the screen - but it could be very handy if you are working with an undocked Library in details view - you can even expand the player to Full screen.

This player has another function - you can use it to edit scenes. I'll talk more about that later in this chapter.

By the way, you don't get the Player option when you *Show Information* on a Timeline clip.

Open In...

Another browser function that can be achieved without the Context Menu is **Open In..** which can be achieved by double-clicking. This varies a good deal with the type of asset. Photos, Video and Audio open in the Corrections Editor, projects open in the Movie or Disc Editor, Titles, Montages and Soundstage assets open in their respective Editors. By the way, Scorefitter is a subset of Soundstage - I believe Pinnacle are leaving room for other audio creation editors in the future.

Project Packages, which contain all the media assets of a project, responds to the double-click option by extracting the media and project files which you can then open separately.

Deletion

The **Delete** key works as a shortcut in the Library as well as appearing as a function in the context menu as *Delete Selected*. Media can be removed but Content can't, unless they are items you have created yourself such as *My Titles* and *Menus*. Using Delete bring up a dialogue. Using the Delete key when working with Collections removes the item from that location and nothing else - it's still in the Library – and you certainly don't get a chance to wipe it from your hard disc.

The standard Delete dialogue

Deleting any item in the Project Bins, Library Media or Projects categories results in a dialogue box. In the case of a media item, or a selection of items, then the choice is clear. Do you want to remove the item just from the Library, or also delete it from your hard disc? Removal from the Library only is fairly harmless. If you forgot that you had a project that used that item, the program will automatically search for it when you open the project, and if it finds it where it was before, puts it back in the Library.

If you select the second option then any selected media item will be removed from the Library and the hard disk where they are stored on your computer.

If the list of items includes projects they will be removed from the Library and the project file and any auxiliary render files associated with that project will be deleted from the hard disc. (That's according to Pinnacle - in my experience the auxiliary files aren't actually removed.).

If you click OK, before that happens you will get a second chance and a further description of what you are about to do.

Last chance saloon for Deletion

DANGER - if you are the sort of person that relies on Windows having a recycle bin, then be warned that Pinnacle Studio doesn't put your deleted items in the bin for possible retrieval. It deletes them outright.

If you are deleting a project, then be reassured that although the project itself will disappear, none of the Media items included in the project will be deleted, either from the Library or the computer hard disc.

Double clicking and Delete also work in Details view, but for Preview you will have to use the Context Menu.

Browser items Context menu

When you right-click on an item in the Browser window an extensive Context menu appears. Some functions will be available in all circumstances, others will depend on which Library format you are using and the type of asset.

Let's work through a Project Bin asset Context menu, noting differences with other types as we go.

Preview opens whatever the asset in the appropriate preview window as discussed above. Every type of asset has this option apart from Project Packages.

Show In Explorer opens the asset in a new Windows Explorer window - useful for tracking down where an item actually is on your hard disc. This option doesn't appear for Content.

Find in Timeline is a function that is only possible when working on a project. It will highlight all the occurrences of the chosen media asset

Browser Context Menu

Edit Caption can be applied to all assets except Content. As mentioned before, it allows you to alter the name given to an asset and used by the Library for searching and filtering. It doesn't affect the underlying file name of the asset.

Open In... is the same function as double-clicking, described in detail above.

Unpack Project Package only displays for Project Packages and has the same effect as double clicking. Project Packages are discussed in the Understanding Studio Chapter.

Add to Favourites will be present for all content, unless the item is already a favourite, in which case you will see *Remove from Favorites*.

Apply tag, **Apply rating**, **Add to collection** are common to every Context menu.

Copy adds the selected object to the Paste buffer.

Add to Project Bin exists for all media and offers a list of bins.

Remove from Collection will be available for any item that is already in a collection.

Show scenes, **Edit scenes** and **Detect scenes** all work only with video. If you look closely at a thumbnail that has been split into scenes you will see three thin frame borders to distinguish it. Scenes are a complex subject that require a full section later in this chapter..

Send To Timeline - An alternative to dragging and dropping. The item is placed at the current scrubber position on the currently selected track using the current edit mode.

Export allows you to send an item straight to the export page without having to put it into a project.

Burn Disc Image can apply to Media or Projects, opening the Burn to Disc dialogue. Here you can export files to optical media in the form of a data disc as well as make DVD and Blu-ray discs from projects.

Delete selected duplicates the function of the delete key, just discussed.

Remove from Project Bin is only valid for Project Bin items and does just that.

Display information brings up the same feature as the "I" thumbnail icon.

Project Bins

I introduced you to Project Bins in the Whistle-Stop tour chapter. The idea behind them is that when you start work on a project, you create a bin and place items in there for use on that specific project. You can add further items later on if or when you realise you want to use them.

Because the items remain in their original hard disc location, placing them in a bin is almost instantaneous, and doesn't cause duplication of the same data which would take up additional disc space. It's perfectly OK to add the same clip to a number of different Project Bins.

If you open a Project Bins tab and then return to your current tab, you can drag and drop items from the browser straight into a Bin listed in the navigation tree - you will probably want to work with it pinned for this operation. Beware that this is NOT a copy operation if you are moving items between bins. If you want to copy the media, then hold down the Ctrl key.

A nice feature of bins is that if you hover over a clip in the Library Browser, the titles of all Project Bins that contain that clip light up green in the Navigation List.

If the material needs to be imported from removable media it should be added to the hard disc first and then linked to a bin - the Importer will do this for you. In these and other circumstances you may want to create bins that aren't project specific to give you easy access to the media for other projects, You should also consider the use of Collections or custom named hard disc folders in these circumstances and use Project bins for just that - the intended contents of a project,

Managing Project Bins

We saw in the Whistle-Stop chapter how to add a new Project Bin using the Create tool alongside the category name. Once you have created a new bin, right clicking on its name offers you the chance to rename or remove it. If you do try to remove it you will be warned if it is not empty. You need not worry that any bin content will get removed from your hard disc - it won't. However, if this is the only place that links to a particular clip and you don't have Library Media displayed as a category you might lose track of that clip.

Avoiding Project Bins

If you don't want to work with Project Bins, that's OK, but the worst possible way of working is just to throw everything into the default Bin - The Sky is the Limit - and add it to any project from there. Alternatively you might just create one general purpose "My Project Bin" and use that for everything. I can understand the temptation - perhaps you want to do a very simple edit to quickly create a movie and have no intention of saving the project, but once Project Bins get cluttered up they are worse than not having them at all.

My recommendation in these circumstances is to work from the Library Media category in the Navigation bar.

Library Media and nested folders

If you decide to enable Library Media, the width of the Navigation List is not adjustable or scrollable. Once you start to use folders nested more than 4 levels down it becomes hard to read the names of the folders, and once you get to 6 levels it may not be possible to open the folders from the List. If you use very complex folder structures you may find this a nuisance, and want to consider using Windows Explorer - and probably Project Bins as well!

Favourites

This feature allows you to nominate any content as a favourite, so it then appears in the Favourites section under the relevant content category.

Adding a transition to the Favourites category

This function is only available from the Context Menu, so you can't drag and drop. To remove an item from Favourites, you just open the Context Menu again and select *Remove from Favourites*.

This is a simple way of organising some of the vast array of content into an easy to find location. If you want a more general purpose tool that is far more powerful, you should consider Collections.

Collections

To some extent Collections have been superseded by Project Bins and My Favourites, but Collections is a far better function. You may not want to put in the work required to learn to use them, but if you are a power user, it will be worthwhile.

Unlike Tags and Ratings, Collections are recognised by PS24's new Library Backup options. They are also passed on to a new version when you upgrade, so any work you put into creating Collections is much easier to preserve.

If I wanted to carry out some repairs on a fence at the front of my house and all the tools and materials were at the back of my garage, then although I can't be sure exactly what I'll need, it's a good idea to collect together the items I'm likely to use and carry them round in one go. In reality I may already have a suitable set of tools containing a hammer, screwdriver and small saw in a toolbox, and I'd also put some likely looking nails and screws in another box, stick some wood under my arm and then walk round to the front of the house. I'll almost certainly have to go back for something else, but at least I'm a bit organised.

That's like starting to edit together a movie with a collection of clips you are most likely to want to use in one collection (or a Project Bin), and a set of your favourite transitions in another (or in the Favourites folder).

Like most analogies, this has a flaw. If I've only got one hammer, it can only be in one toolbox. But I can have 10 different Collections with the same video clip in them.

What's more, the video clip hasn't even moved – it's still safely tucked away in its original location on my hard drive.

So –

• You can have as many different Collections as you wish.

• Any type of asset in your Library can be put in any Collection, and they can be in as many different Collections as you wish.

• Anything you put in a Collection isn't moved from its real location on your computer.

Let's create and populate a Collection. Click on the icon alongside the Collections category. This looks like a group of folders and a + sign. A very simple box will pop up that is asking you to name the New Collection. Enter "Testing" into the box and click OK.

Now let's put something in the "Testing" Collection. Unfortunately Pinnacle have removed the Quick Import function from the Collection category. It is possible to use the Windows Browser import method which I've described in the Import chapter.

I'm going to use the photos supplied by Pinnacle. If you created the BMX bin to try out tags then you will already have imported them, otherwise follow the instructions earlier on page 125.

Adding photos to a Collection

Open the *BMX* bin, select all the thumbnails and right click on one of them. From the Context Menu select *Add to Collection/Testing*. Now switch to the Testing collection

Right, I hope you are seeing the same as me. In the browser there should be

thumbnails of all the pictures you chose to import. Now we have created a collection, let's see how to manage it. Right-click on "testing" in the Tree View and four options present themselves.

Rename – Change the name of the collection.

Create Collection – We have just done that, but here is another way to do it.

Create Sub-Collection – Yes, you can create a collection within a collection, but it is more powerful than just that.

Remove Collection – Deletes the currently highlighted collection.

I want to work through the first four options in order to demonstrate a number of important features regarding collections. Let's start by renaming the "testing" collection. Right-click on "Testing" and select Rename, enter "Photos" over the top of "Testing" and press return.

Now, create a new collection and call it "Today's Project". Notice that the list of collections is being maintained in alphabetical order. If you want to test that, create "Another Project" and it will appear at the top of the list.

Subcollections

I'd urge you not to skip over sub-collections, because they aren't as obvious as they may sound. Right-click on "Today's Project" and create a sub-collection called "Useful Transitions".

Browse down the Tree View and open *Transitions, Standard Transitions, 2D Transitions.* All the transitions in that category should now be shown as thumbnails in the View Window, listed in alphabetical order.

Adding Transitions to a collection

If they aren't in that order, use the browser Context Menu to sort them. Scroll down to the "Push" transitions and right click on Push Left. Use the Context menu to add it to the *Today's Project/Useful Transitions* Collection. You will notice that the text (1) has appeared alongside the Useful Transitions name in the list of collections.

Let's add some more. Practice using multiple selections by using CTRL-click to select Push Down, Right and Up. Right click on any of them and the Context Menu will let you add them all to a collection at once.

You can add to collections using **drag and drop**. Open another tab and select Collections to bring them up in the navigation list then return to the Transitions tab. Let's scroll up the 2D transitions group to find the most useful transition of all, Cross

Dissolve. Click on it, hold and drag it across to the Collection name in the list, then release the mouse. The item count goes up to 5.

Click on *Useful Transitions* in the Tree View and you will see the 5 items it is said to contain. Its Parent collection, *Today's Project*, isn't showing that it contains any items. But when you click on Today's Project you might be surprised to see the five transitions are showing in the View window.

This is an important point. If this was a Windows folder structure, all you would see was the sub-folder, not its contents. That's not that case with collections – you see all the individual items regardless if they are contained in sub-collections or not.

The next trick up Collection's sleeve is drag and drop within the tree. Oh, dear, I created the *Photos* collection before *Today's Project* whereas I should have put all those photos in a subfolder of *Today's Project*, really. No need to recreate the photos as a sub-collection though. Click and hold on *Photos* and drag it on top of *Today's Project*. Brilliant! Photos are now a sub-collection, and if we view Today's Project there are 13 items in view.

What if you are looking at a parent collection, and want to know which sub collection a particular item is in? Hover your mouse over any item in the browser. If the item isn't in the parent directory, then the sub collection which contains it lights up Green - the colour of collections. What's more, if that particular item happens to be in another collection, that collection's name will highlight as well.

This feature works when you hover over an item in its home location as well – go to the 2D transitions folder, hover over one of the Push transitions and Useful transitions will highlight.

The Collection indicator tooltip

I mentioned the Collections indicator when we looked at the Thumbnails View selections. If an item is included in one or more collections and you have the indicator enabled, hovering your mouse over it produces a list of collections that includes the item along with options to

remove the item from all the collections. This is more useful than the tree highlight feature if you haven't expanded all the collections in the tree.

Sub-Subcollections, anyone?

Yes, yes, I'm getting the idea, I hear you thinking. It might seem there are so many options that I'm trying to turn you into someone who spends their entire time rearranging their tool shed and not actually doing anything useful. Bear with me…

Create a sub collection under Useful Transitions called Pushes. Add, don't drag and drop, the four push transitions in Useful Transitions to the Pushes sub-collection. So, now the Push transitions are in both "Useful Transitions" and "Pushes"

Open the Pushes collection and there are 4 items. Now open Useful Transitions and it is still showing 5 items. You might expect to see two instances of the Push transitions, but any view of a collection ignores duplicate items that may be included in some of the sub-collections. This actually let's you be less organised, because if you have created a number of collections with overlapping themes and therefore items, you'll only ever see one version of each item.

When you used the right-click on the Push transitions, you might have spotted another option – Remove from collections. Let's remove the duplicate items from the parent directory. We could use the Collections icon method described above, but the Context Menu will work in all circumstances, even Details View.

Multi-select the four Push transitions and use the right-click option to remove them, or just hit the Delete key. The number of items in Useful Transitions has dropped down to 1, but there are still 5 thumbnails on view. Try to delete one of the pushes again and you can't.

I nearly reported this as a bug the first time I encountered it, because I didn't understand how different Collections were to Windows. Silly me…..

Promoting sub-collections to collections is easy when you know how. Click and hold on Useful Transitions and drag it up to just below the Collection category title. A thin highlight bar will appear and then you can release the mouse button. Because the list is maintained in alphabetic order, it might not be immediately obvious what has happened, but look again and you will see that Useful Transitions is no longer a child of Today's project, while Pushes is still a sub-collection, but only of Useful Transition.

By the way, there is a long-standing bug where, if you try to promote a subcollection that is a branch of the highest collection on the list, a small menu informs you that the subcollection already exists. It normally doesn't, but check before you select Merge.

Re-arranging Collections

This is made much easier with two tools – drag and drop and copy and paste.

What if you decide that you have put an item in the wrong collection? Let's try drag and drop to return the four Push transitions to the Useful Transitions folder. Select the Pushes sub-collection, select all four transitions, and drag one of them over the Useful Transitions entry in the tree. Now Pushes is empty and Useful Transitions has 5 items.

To try out copy and paste, multi-select the 4 pushes again in the Useful Transitions collection and use either the edit/copy command from the top menu, or CTRL-C, switch to the Pushes sub-collection and use edit/paste or CTRL-V. You should now have the four push transitions in both collections. This would be most useful when you are making a new collection from an old one, but don't actually want to alter the old one. You can also use cut and paste, but this has the same effect as drag and drop.

I hope you now understand enough about viewing Collections to realise why you don't normally see those grey dividing bars that subdivide the browser into Folders, Rating, Date or File Type when looking at the other categories.

If you want to find items in a Collection there are a number of strategies you can use. Consider switching to the Details View or using the filter options which I'll describe soon. Most importantly, keep in mind that if something is in a Collection, it must also be listed in the Library under one of the other categories.

I hope that this section explains why I think Collections are in a different league to Bins and My Favourites.

Special Collections

You have probably noticed on your own screen and the screenshots a collection called *Latest Import.* You can't delete this collection but you can empty it. Every time you import something, the items will be added to this collection. It's a very useful feature, because if you don't pay much attention when you bring items into the Library it's there to remind you, like a post-it note stuck on the desk.

However, like that scrap of paper, I can't recommend that you rely on it being there after the cleaner has been in overnight. Using Quick Import, the contents will build up each time, but if you use the main Importer, the collection gets reset each time.

You can still find the items you have imported because they will be somewhere in the All Media category as well as the Bin you specified if you used the Importer.

Another useful automatically generated collection is the *Latest Smart collection.* Every time you preview a SmartMovie, the collection is changed to reflect the contents of the previewed Smart creation.

Missing Media

The Library will lose track of assets if they get moved by you or another program. You will see the red exclamation mark on thumbnails, or a red entry in the Details View. If you are happy to lose the file, you can delete the thumbnail from the Library to de-clutter the display. If you want to restore the item then you can manually relink it with the Context Menu option. A Windows style dialogue lets you browse to the new location and find the file. If you don't know where it has gone you can use the search feature in Windows.

Missing Media in the Library

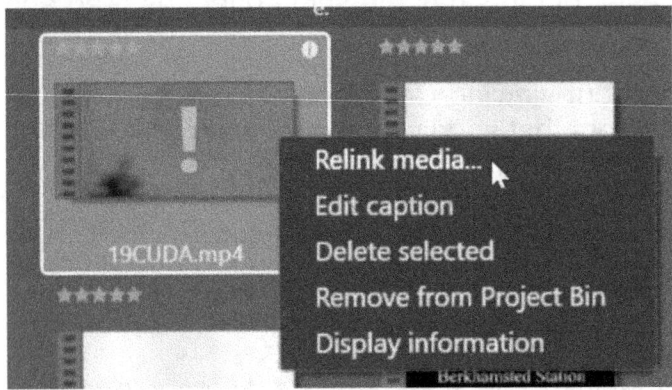

If the file has really been deleted, the first place to look is the recycle bin. Use the right click menu there to restore the file. You can then manually relink the file, but if it has been restored to its original location, Studio will find it again the next time you re-open the program. So, if you had a moment of madness and stuck loads of files in the bin, it's probably quicker to restore the contents of the recycle bin and then just close and re-open Studio.

You can also experience messages about missing media when you open a project if you have moved the files since you last worked on the project. It is also likely to happen if a project has come from another computer and you didn't use Project Packages. Using the project files associated with this book is an obvious example of that because you might not have copied the assets to an identical location to the one that I used when building the project.

So, if you open a project and get yellow clips with exclamation marks, that means it contains missing media. If you don't see a dialogue box offering you the chance to relink the media, try reopening the project and the dialogue should appear. Alternatively, use the *Find in Library* option on the yellow clips and you should be taken to the Missing Media in the Library, where you can relink as described above. For this to work it's best to enable the Library Media display as described earlier. With that showing there is a whole category devoted to Missing Media, so you can see what has gone missing from your Library.

Strategies for using the Library

There are many ways of using the Library, and how you do so may depend on how you tend to organise your computer.

If you are relatively new to video editing, or are installing Pinnacle Studio on a clean computer, then the way the Library is set up on installation may well suit you. You can use Project Bins for each project you make, and possibly use Collections to keep track of any clip you have imported but not included in a bin.

If you enable the Library Media category you can see everything that you have added to the Library, even if it's not in a Bin or Collection.

At this point, if you don't intend to use ratings, tags or collections on a long term basis, you are ready to go. If you want to start adding useful metadata to your Library or carry out some of my suggestions such as setting up a Useful Transitions collection, you should consider backing up the Library regularly – and I'll show you how in a minute.

The next consideration is whether you want to use Watchfolders. This can slow down performance a bit and might lead to problems when adding unusual items to the computer. If you turn them off you can't use Windows as a way of importing without the second step of adding the items to the Studio Library as well.

My suggestion is to use Watchfolders for *My Pictures* and *My Music*, to take advantage of the Windows Library functions (automatically ripping CDs and adding the track information, for example). Video is a different matter for me because adding large video files is a more time consuming task and therefore has a great impact on a computer performance when working in the background.

It is recommended that you keep video on a separate hard drive if you can. Even if you use a separate partition of the same physical drive this can have some advantages – less fragmentation, and easier backups, for example.

Employing a second physical drive – even an external one – has further advantages in that the Operating System doesn't need to interrupt the reading and writing of video to carry out its own background tasks.

If you still prefer to have your video in a Windows Library, you can add locations on another drive to the Windows Library. You can then add a further Watchfolder to that location and set your default Import locations accordingly.

If you have media already scattered all over your computer and want to find and add it to the Studio Library, consider using Scan for Assets as a one-shot solution.

However, I keep my videos on a separate hard drive in folders with meaningful names - it's part of my Import strategy. I don't let Watchfolders look for video. When installing Pinnacle Studio, I used the importer to physically add the whole of the video drive to the Studio Library with the My computer function.

You may want to go further or vary from those recommendations, but once you have set up a decent Library structure you will almost certainly want to take advantage of metadata and collections. The major issue in doing that is the possibility of losing your work, which brings us on to backups.

Protecting your the Library

Pinnacle Studio 24 now has a function that lets you backup the Library – and even save and load different Library setups. There is a separate feature to back up your Settings, but I'll discuss those later on in the Understanding Studio chapter.

At the time of writing, however, there is a flaw in the new feature. It doesn't save some metadata - tags and ratings. I don't know if that is deliberate or accidental, so it may, or may not, be corrected

If you want to use Tags and Ratings you should check carefully that the new method does preserve them. The safe way to back up and pass on your library to the next version is to use what I'll now call the Legacy method.

Library Backup - the Legacy way

In addition to backing up your Library, the technique can be used to back up your settings file, which although less time-consuming to reset after a crash is still a nuisance

Before you embark on this task, please note a few provisos - don't experiment while you have important unfinished projects and if you have any doubts as to what you are doing, back up your computer before trying this for the first time.

Pinnacle Studio stores its settings and Library database, along with a number of other important files, in a location that is hidden from prying eyes on many computers. The first thing we need to do is reveal the location.

Revealing Hidden Files and Folders

You can do this in Windows Explorer. To reveal the hidden files and folders in Windows 7 go to Tools/ Folder options/View and set Hidden Files and folders to Show hidden files, folders and drives.

In Windows 10, click on the **View** menu, and the header should include a checkbox for Hidden Items.

You should now be able to see the files that Windows doesn't normally let you see.

Backup

To backup the current Library and settings using Windows Explorer:

* Go to your boot drive (normally C:)

* Navigate to Users/Your profile name/App data/Local/Pinnacle_Studio_24/Studio

* Copy the whole of the 24.0 folder to save the Library, Effects list and Settings

* Alternatively, if you just wish to save the Library, open the 24.0 folder and copy the NGDatabase folder

* Navigate to a safe backup location of your choice and paste the folder there.

Restore

To restore the saved Library and settings

* Close Pinnacle Studio

* Go to the safe backup location you used to save the data and copy the NGDatabase folder if you just wish to restore the Library or the 24.0 folder if you wish to restore the setting and effects list as well

* Go to your boot drive

* If you have copied the 24.0 folder navigate to Users/Your profile name/App data/Local/Pinnacle_Studio_24/Studio/ and delete the whole of the current 24.0 Folder

* If you have copied the NGDatabase folder navigate to Users/Your profile name/App data/Local/Pinnacle_Studio_24/Studio/24.0 and delete the whole of the current NGDatabase Folder

* Paste the saved folder from the clipboard to the current location.

* That's it. You could extend the technique to keeping different versions of the Library database and settings for different situations.

Manually Resetting the Library

When you install any version of Studio from scratch, or if you delete the old NGDatabase as described above but without replacing it. the new Library that is created consists of just one Project Bin, *The Sky is the Limit*. That bin will hold the clips needed to make that project. You will find the project file in Studio Movie Projects category of Projects.

So it looks like you have a nice, clean Library. However, from version 20 onwards, if you have any older versions installed, Studio starts adding items from the older Libraries, starting with version 19.

The Library Media location - often hidden!

It might take some time to sort through a lot of old content, so at first glance you might not see the additions, but once Studio has settled down you might find a lot of items in the Library Media locations. You can check this either by enabling watchfolders and opening the Library media sidebar tab, or right clicking on a timeline clip and selecting Find in Library, which opens a Library Media Tab in the Library Browser.

I'm currently just talking about Media and Projects, but content such as transitions, effects and bonus effects that came with older versions obey a similar set of rules.

So what gets added from the older versions? Well, anything that was in the Library Media for a start. That could be quite a lot of material, because deleting a Project Bin does not remove the contents of that bin from the Library Media, as it may be contained in other bins. You might think you have cleaned up an older version's Library, but haven't. Even worse, you might have independently tidied up your hard disc using Windows and deleted unwanted files without reference to the probably dormant version of Studio that used them, so the Library you are importing from will be full of Missing Media.

As for metadata, what does get imported varies. For a reliable transfer, I'd suggest you swap the Library databases as detailed above.

Even if you avoid those traps, there is another source of potential clutter. The newer version of Studio will also import all the Project files from the older versions, and importantly it will also add the media that those project files refer to – even if they

have been deleted from the older version's library, in which case it will add Missing Media icons.

Let me just reiterate that if you don't look any further than the Project Bins of your newly installed or manually reset version of Studio, you might think you have a virtually empty Library, but there could be a veritable cesspit of unwanted media and broken links lurking within. This makes the database file cumbersome, and possibly prone to errors.

If you really want a clean Library, check in the Library Media and Project locations, delete any clutter and then save the NGDatabase folder for future use.

Resetting the Library from the Control Panel

In PS 24 you can perform a Reset which not only clears the Settings but also cleans up the Library. This hasn't got quite the same affect as deleting the NGDatabase in the Appdata – it loads a backup file of the state of the Library the last time Studio closed down properly, and then adds in all the content from older Libraries to the content already there. I'll discuss where it stores that backup file shortly.

Importing a Library from older versions of Studio

As I've already mentioned, when you first install Studio 24 it attempts to load the Libraries from any earlier versions installed on your computer. However, if you aren't seeing what you hoped to see, in particular Tags, it is possible to exchange the NGDatabase folder used by earlier versions of Studio with that used by 24. In all the above instructions about Manual Backup and Restore you will find the 17-23 folders by using the version number in the paths instead of 24 - Users/Your profile name/ App data/Local/Pinnacle_Studio_xx/Studio/xx.0. Copy the NGDatabase you want, delete the 24 NGDatabase and then paste the "old" one into it's place.

Studio 16 and Avid Studio Library data lies in a plain Pinnacle or Avid folder.

Please test any Library imported from another version before starting a project. I've tested this as much as possible but that doesn't mean it's going to work with every version.

Backing up and Restoring the Library from the Control Panel

If you are OK with not using Tags and Ratings (or Pinnacle have fixed the issue) this is much easier to do that without all the above messing about. There is still one further issue lurking that may cause confusion when you reload a saved Library, but it not a showstopper.

Making a Backup using the Control Panel

The Control Panel options to Backup and Restore

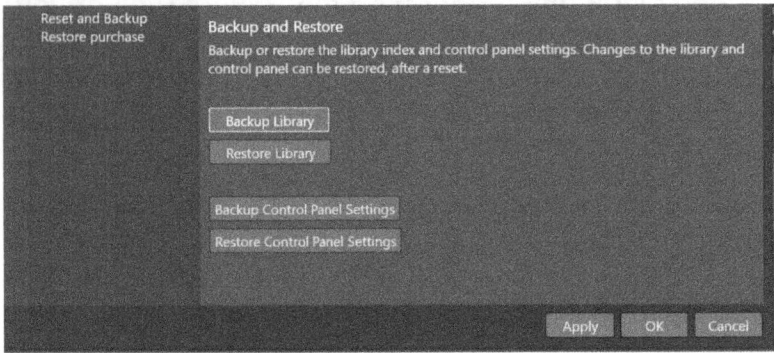

Open the Control Panel and select the penultimate option on the left - **Reset and Backup**. Amongst the options here you will find Backup Library. This makes a copy of the current state of the Library. Select it and a Windows dialogue opens up offering you a default location within your Documents - *Pinnacle/Backup* in which to save the Backup. Choose and enter a suitable filename and press OK. That's it - you have saved the Library.

Library AutoBackups

When you are defining a name for the Backup. you will discover that there are up to three *AutoBackup_DD_MM_YYYY_HH_MM_SS.pslibrary* files lurking in the same location. You can pinpoint the exact date and time of the backup just from the filename.

When Studio closes, if you have made any changes to the library it makes a safety copy. It also keeps two older versions of the backup, so if you make an inadvertent deletion and then close the program, or Studio crashes, you can roll back to an older version to restore the deleted files.

When you use a Control Panel reset in PS24, the latest backup is used, along with data from older Libraries, to create the new library. If you want to stop this happening you can manually delete the AutoBackup files before restarting Studio.

Restoring a saved Library

Clicking on the Restore Library button prompts you to choose a backup from the default location. Once you have done that you will get a message telling you that you must restart Studio for the backup to take effect. If at this point you choose not to do the restart but but carry out some other tasks, when you eventually close Studio and then reopen it, the Restore will be carried out, deleting the current media and replacing it with those defined by the backup.

At the time of writing, however, one section of the Library is not overwritten - Projects. This may be deliberate. The result is that if you are expecting only to see items that were in the saved Library, you should clear out the old Library's projects section before loading the new one.

Scenes

Next Generation Studio has inherited a feature from Classic Studio that lets you divide video files into *Scenes*. We looked at it briefly in the Import chapter but now I want to show you how to create and manage Scenes for use in a real project.

I'm going to work with the undocked Library while preparing the Scenes. There is no point in struggling for space as I'm going to be spending quite some time working there. For this demonstration I want you to create a Bin called *Scenes*, load the file *Flight Over Snowdon Compact.mp4* from the website or data DVD, and import it into the new bin. Note that although the demonstration will be very useful if you are intending to use Scenes, the end result will not be used to make a project, so if you end up with a different set of clips than I do, it won't be a problem.

If you have worked with earlier versions of this book the file may be familiar to you, as it was used as the source material for the main project. Since Studio 23 I'm using different projects to reflect the move to file based cameras, but if you are working with older material this section should be very useful to you.

To save download times I've compressed the file significantly, and this has changed the number of scenes that are detected, so it's important that you use the new file and not the one supplied for Studio 16 to Studio 21.

Scene Detection

Scene Detection Options

With the file open in the bin, undock the Library and adjust it to suit your screen, right-click on *Flight Over Snowdon Compact* and hover over the **Detect Scenes** context menu entry. You should see a choice of three options.

The option **Content** will divide a file when it detects a sudden change in the video. For analogue tape based cameras this will almost certainly detect when when you have stopped and then restarted recording. On edited material it will normally split the video at each cut point.

However, there may be false detection, such as when a photographer's flashgun goes off.

The next option, **Date and Time** is useful for DV and HDV cameras with timecode embedded in the file. The files will be split every time there is a discontinuity in the timecode which will coincide with pausing or stopping and restarting the recording. If you try to use this option on video files that don't have the required timecode, Studio will default to detecting by content.

Detect by Time Interval allows you to specify a duration for each scene. You might want to use this setting when working with material that has no significant shot changes to subdivide files into more usable chunks.

It is also possible to perform scene splitting manually, as we will see in a short while.

I'm going to select *Content*. A *Scene detection* box opens with a list of the files selected – you can apply this operation to multiple files. It also has a checkbox that forces Studio to open Scene view at the end of the operation, but uncheck that as I want to show you something before looking at the scenes.

Clicking *Start* begins a process that takes less than a minute on my computer, with a progress bar running across the box to keep me informed. When complete, take a very close look at the file thumbnail and you will spot it has obtained multiple borders, indicating the file has been split into scenes.

If you use the Context Menu option *Show in Explorer* you will also find that a new file has been created in the same location as the video file with the additional suffixes *.scn.xml*. This is a simple text file that contains the scene detection information. Opening it shows a list of the frame numbers where each scene starts.

The stealth-like scene borders

You can now open the Scenes view in two ways – either by highlighting the clip and using the Scenes icon on the toolbar at the bottom of the Library, or the Context Menu option *Show Scenes*. Either way, you will see an orange filter bar across the top of the Library browser and 19 thumbnails in place of the

original single file, each one showing the start of a scene as detected by the software.

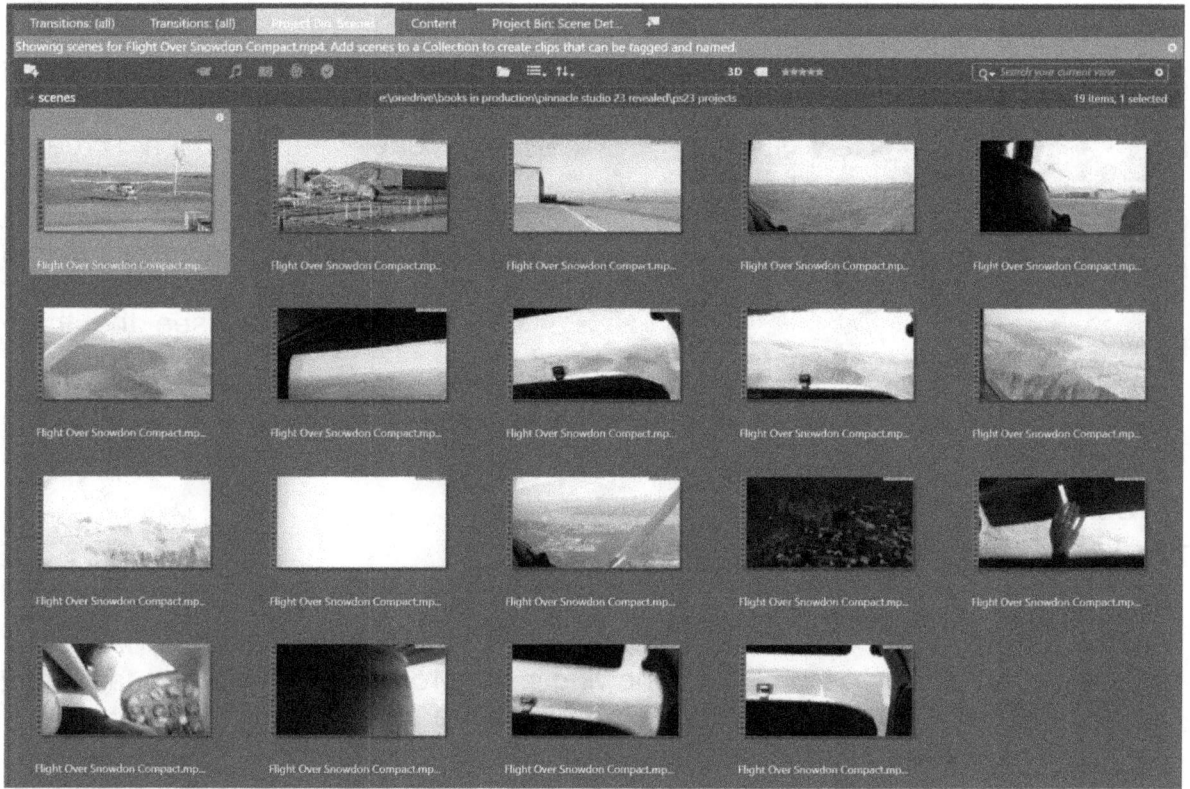

Refining Scene Detection

Having detected scenes automatically, we can now adjust them manually. In my example clip, there have been a number of "false" detections where a big camera bump has caused an unwanted break. There may also be occasions when you want to split scenes based on events that haven't triggered a scene break.

First, let's look at **Combining** scenes You can only re-join two scenes together if they are adjacent in the original file – it isn't possible to add together the first and last scene, for example. If two or more concurrent scenes are highlighted with the orange border, right-clicking on one of them should reveal the *Combine Scenes* command available from the Context Menu. If you don't see that option, then the multiple selection you have made contains a scene that isn't part of a continuous run.

To see that on the current example, Click on the first scene to highlight it then CTRL-click on the last scene. You won't find *Combine scenes* available in the right-click menu.

The Combine Scenes option

Now, let's do a few useful things with this tool. The last three scenes have been created because of the bump caused on landing. By multi-selecting them the Combine scenes option does become available. Select it, and you will see the three scenes changed into one scene.

There are a few more combinations I want you to do. I'll list them starting from the end:

• Combine clips 15 and 16

• Combine clips 8 and 9

• Combine clips 4 and 5

You should now have 14 thumbnails showing in the browser window. Compare them carefully with the screenshot on the next page before proceeding.

The result of combining scenes

Splitting clips requires you to open the Library Player window. There are three ways to go about it.

You can switch off Scene View by closing the filter bar or clicking on the icon bottom left, then right-click on the clip that you want to edit and select *Edit Scenes.* This is how you would begin to create scenes manually from a fresh, undetected clip.

You can right click on the Scene view background and you will find Edit Scenes in the context menu. These two paths open the Player with the first scene loaded.

Use the following steps to open the viewer at the selected scene. Right-click on Scene 12, the dark shot of the castle, and select *Display Information*, then switch off the *Info* icon bottom right to reveal the Player window All three routes take you to the same window.

The preview is a floating window that can be resized, so with an undocked Library and this new preview, I've rearranged my screen for easier working. I can switch between scenes using the Jump forward and back buttons, and although the preview doesn't have single frame jog controls you can use the keyboard shortcuts or scrubbing for accurately examining a clip frame by frame.

You should see the Split button as the third icon from the right on the preview toolbar, as shown in the screenshot. Use the preview controls to investigate the start of the scene and you will see that there are six frames of the castle, then we cut to a wide-shot through the window as the plane is banking onto its final landing approach. Why the scene detection did this, I'm not sure, but I want to fix it.

I'd like to split this scene into two – the unusable castle shot, and then the final approach shot. Position the scrubber on the first frame of the final approach (00:09:01:09 on the burnt-in timecode) and then click on the Split button. Two things should happen. A new scene will appear in the browser window consisting of the 6 frames of the castle, and the current scene's thumbnail will reset so that the first frame is what was frame 7.

Close the preview and examine the two scenes with their roll-over scrubbers and you will find we have achieved our aim. The file is split into 15 scenes. If you now

study what are now scenes 13 and 14, you will see that they are in fact a continuous shot, with a scene break triggered because the pilot pulled down the sunshade. Combine these clips so that we have 14 scenes.

One recommendation is that you don't cut your scenes too tightly. If there are a few frames on the beginning or end which you think are probably unusable, don't be judgemental. There will be plenty of chances to trim the scene further, but if you realise at a later date that extending a shot past the chosen scene break would be useful you will have to go back to the original clip to retrieve the extra frames. One good example is when using dissolves. A camera shot that starts to go soft as it fades out is not too objectionable – and may even look deliberate!

Having split our file into scenes, we can just go ahead and use the scenes in a project. There are some limitations to this approach, though. You can't rename, rate or tag Scenes. The solution is hinted at in Scene view itself, where the program recommends that you convert your scenes to **Library clips** by adding them to a Collection. This message was programmed when it was the only way of creating new clips from Scene data, but there are now other options, as we will see in a moment.

More Scenes Context menu options

The **Context Menu** for Scenes has a number of additional options as well as *Display Information* and *Combine Scenes* (when it it available). **Preview** opens the scene in the Source viewer, just as if you had clicked on it in the Library. The other three options require a little explanation.

Creating Library Clips from Scenes

What is a Library clip? Like Scenes, Library clips only exist in a virtual world. In fact, every piece of media in the Library is a Library Clip - when you import a video file, the Library clip is an entry into the database. Scenes only appear when you open up the Scenes view of the Library clip that the scenes were created from. Scene data is stored in a .scn file which can't hold any other data. Library Clip data is stored in the Pinnacle Studio Library database rather than a .scn file, so you can edit the caption and add metadata. Promoting a scene to a Library clip will allow you to to do this, and also means that the Scenes can be available where you can get at them more easily - the Media Library, a Project Bin or Collection.

When Studio promotes a Scene to a Library clip it creates a **Shortcut**. If you see the shortcut icon on a thumbnail it shows that the Library Clip was created from media already in the Library, not through the Import process. There is another way of creating shortcuts in Studio which we will look at when we study the *Legacy Corrections Editor*.

So, now I can describe the remaining Scenes Context menu options.

Create Library clip produces a clip that shows up in the same location as the source video when viewed in the Pinnacle Library (assuming you have Library media enabled). Note that you won't see this in Windows Explorer, as it's not a real video clip. The feature only works on single scenes.

Add to Collection and **Add to Project bin** have to create a Library clip in order to add the scene, so it will appear in the Library Media location for its parent clip as well.

It's worth noting that you can drag scenes from the Library browser to a bin or collection in the Tree view and Library clips will be created automatically.

One functional difference between these two methods of creating Library clips is that the *Create Library clips* method only allows you to create one clip at a time, whereas *Add to Bin* or *Collection* can be applied to a multiple selection of scenes. Therefore, even if you don't really need to put the clips into a bin or collection, it might be more convenient to do so, and they will be a lot easier to find.

Returning to our project, I'm not going to convert all the scenes we have created into Library clips. Being selective will reduce the clutter. In other circumstances you might well add anything that could be even vaguely useful and maybe use ratings to help you filter out the less important shots.

Make sure you are back in Scene view with 14 clips in the browser. Select them all with CTRL-A and then hold down CTRL and click on scenes 2, 6, 8, 10 and 12.

This will have the effect of deselecting them, leaving 9 clips with an orange border around them. Right click on one of the remaining highlighted clips and select *Add to project bin/Scenes* and click OK. Now switch off scene filtering so you return to the Scenes bin. You should see 10 clips, the original file and nine new Library clips.

The new clips all have a shortcut icon in the top left corner of their thumbnail. If you right click on one of them you will see that they have all the same options as Library clips apart from those pertaining the Scenes - so you can't subdivide them any more. Most usefully, you can use *Edit Caption* to replace those long clip names with something helpful.

Leeway, Scenes and Shortcuts

Although I haven't explained about leeway yet, it will be an important principle when we discuss Transitions. If you put either the second Scene or Shortcut on the timeline and try to extend them in either direction, you will discover that you get frozen frames - dead meat - rather than the video that we know exists in the original file.

Neither Scenes nor Shortcuts have any leeway, unlike pre-trimmed clips that we look at in the Basic Editing chapter. This is why I suggest that you don't trim your scenes too tightly. For more information about leeway, check out the Transitions chapter.

Scenes, Shortcuts and the Corrections Editor

If you reopen the Scenes view of the first clip and double click on one of the scenes, you get a message asking you if you want to open the clip in the Corrections Editor.

Currently this feature appears bugged, as there is currently no way to save your changes, but along with other features of shortcuts and scenes, I'm hopeful the Pinnacle will re-instate and possibly even improve the functionality of shortcuts in future builds of Studio.

The Editing Tab

So far in this book we have looked briefly at the functions in the Edit tab that are required to create the movie in the Whistle-Stop chapter. I've shown you how to arrange the page and covered the functions of the Windows style menus in the User Interface chapter. We have also looked in detail at the Library pane, and noted that this can also be switched to a Clip Editor pane for working with effects and other tools, and a Title pane to create titles.

In this chapter there will be a little repetition as we examine the functions of the Edit page in detail before getting down to the nuts and bolts of editing.

Not every tool you may need is present on the Edit page or opens up where the Library normally sits - some functions open up in standalone windows. A good example of this is the Montage Editor. However, these functions are normally reached from the Toolbar that sits above the Timeline area.

The Player/Preview Windows

Although we used the Preview in the Whistle-Stop chapter, we didn't describe all its functions in detail..

Dual View - both Player windows in Plus and Ultimate

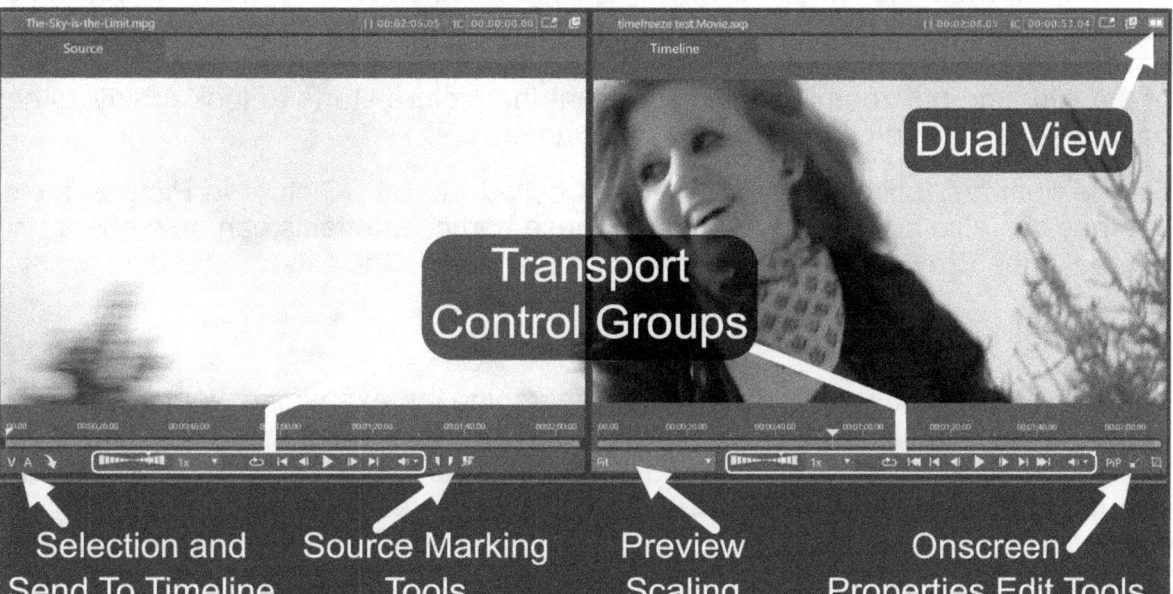

The screenshot shows the Player windows switched to **Dual view**, and expanded to see all the available controls in the Source and Timeline players. If you don't want

to devote that amount of space to them, switching off Dual view means that either one or the other is displayed. They switch to becoming active depending on what area you are working - Library for Source, Timeline for Timeline. In the Plus and Ultimate version of Studio you can also click on the preview tabs or use the keyboard shortcut H.

If your Player Window doesn't seem to have as many features as shown above, then it is possible that you have made the window too small for Studio to be able to display everything. Use the layout control to increase the size until you see them all.

Source Preview tools

The **V** and **A** tools on the left of the Source preview control what you see there. You must have at least one highlighted - V shows the Video, A shows an audio waveform. They also control what gets sent to the timeline by the arrow to their right. The marker tools on the right allow you to set In and Out points that are retained in the Library and dictate what is actually sent to the timeline. These tools are designed to work with pre-trimming workflows.

Timeline Preview Tools

The drop-down to the left of the Timeline preview toolbar allows to set the scaling of the video displayed. **Fit** is the default - you will always see all of the frame. If you have a large monitor you can choose 100% so that you are seeing the actual quality of the clip, and not zooming it so much that the picture starts to look grainy. Other percentages may come in handy when using effects.

On the right are tools that are sometimes called the PiP (Picture in Picture) tools, but they can also be used for cropping. These particular effects can be created and refined in the Preview window. We will discuss them in the Effects chapter.

Controlling Playback

There are numerous ways of playing, searching or examining your clips, both mouse driven and keyboard controlled. Over the next few pages I'm going to list them all, so even if you think you are happy with the way you currently use Studio, you might discover that there are tools that you prefer once you get familiar with them.

Both Players have a set of transport controls as the central group of tools under the preview window. Place any video you have handy on the timeline and we will begin by exploring what they do when using the Timeline Player.

Let's start with the rightwards pointing triangle labelled **Play**. Click it now and the video should play at normal speed.

When the video is playing, the Play icon turns into a **Pause** icon, meaning you can stop the video anywhere without losing your place. Hovering you mouse over the icon will bring up a tool tip showing you a really useful shortcut – something I hope you consider using all the time – pressing the **Space Bar** starts and pauses playback.

Transport controls

This shortcut works in almost any circumstance and even if you normally avoid keyboard shortcuts, you might find yourself using it. You may

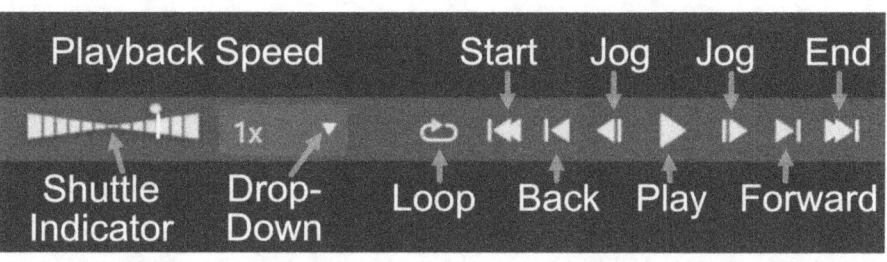

also spot that the tool tip indicates that the **L** key has the same effect, but this is part of a more powerful set of controls I'll show you in just a moment.

Either side of the Play Button are controls to step one frame backwards or forwards. Try them now and note that the movement is a single frame – the smallest amount possible. Once you start working accurately you will appreciate these and the keyboard shortcuts that go with them – the Left and Right Keyboard Arrows. If you are used to a different editor program or are using a keyboard without arrow keys then you can use Z and X. If you happen to be using a keyboard other than a QWERTY keyboard you may have to check these shortcuts - in an AZERTY keyboard, for example, you need to use W instead of Z. The keys are mapped to the physical positions.

The action of moving one frame at a time is often called **Jogging**.

Although these jog buttons won't appear on every player window you come across, you may well find that the keyboard shortcuts do work. For example the arrow keys even work on the Library Browser thumbnails if you have selected the scrubber below the thumbnails!

Jogging can also be achieved with the mouse if yours has a scroll wheel. When you use the wheel while hovering over the source preview window, it always jogs one frame at a time. If you hover your mouse over the timeline, it will jog the timeline scrubber, and therefore the player, either 10 seconds, 1 second, 10 frames or 1 frame at a time depending on how wide your timeline view is arranged. Holding down the Shift key will force it to always work in single frame increments.

The final transport icons viewed in the Source preview player are **Jump Forward** and **Back**. Hit them once and they will take you to the start or end of the currently displayed video clip. If you have any other clips in the Library Browser, hitting them again will move you to the previous or next clip.

These Jump to controls are particularly useful when working on the timeline, and they have keyboard shortcuts which you will find helpful as well. You can use **Page Up/Down**, **D** and **F** or **CTRL** and the **Left/Right** arrow keys. These shortcuts are particularly helpful for lining the cursor up with the beginning or end of the clip that the cursor is over.

There are two further controls available in the Timeline preview – **Go to Start** and **Go to End** which should be self-explanatory - they take you to either the beginning or end of your movie.

J, K and L

Playing the video with the **J**, **K** and **L** keys takes a little practice, but gives very precise control. **L** plays the video forward, as if you had clicked Play or the space bar. **K** stops the playback. Now press L twice in quick succession – and the video plays at 2X speed. Again – 4X. K still stops the playback. J works in the same way, but for reverse playback.

The J and L keys and Space bar play different roles when re-commencing playback. Space will resume the playback at same speed and direction as before you paused it, while J and L revert to normal speed.

Ah, but what about jogging? With the other hand - one frame forward – the **X** key. One frame back – the **Z** key. It's worth playing with this for a few minutes to understand how powerful it can be. Placing your index finger on the J, middle finger on the K and fourth finger on the L, you should soon be able to navigate through the video file very efficiently - use your thumbs for the Spacebar.

There is a further refinement to using the keys to navigate your way around a video clip. The **SHIFT** key, when used in conjunction with L key, plays video in slow motion, beginning at 1/8th speed and subsequent key presses speed up the video even more - you don't have to do a double press in this case. Shift J will cause the playback to slow down again and repeated presses will cause the playback to go into reverse.

Playback Speed Indicators and mouse control

This variable speed capability could cause confusion, but Pinnacle have provided no less than three indications of the current playback speed setting.

In the Preview screen a red message will appear top right for a couple of seconds after playback starts. On the indicator on the left the height of the bars represent speed, those to the left for reverse play, to the right forward play. If you look closely a thin red line is placed at the current setting.

The Dropdown box to the right of the indicator also shows the current setting.

If you want to control variable playback speed with the mouse, you can drag the thin red line. Clicking on the dot above x1 resets the speed to normal. You can also open the drop-down and select your desired speed and direction.

Loop

There are two more icons that are common to most incarnations of the player window. The Loop Playback button to the left of the scrubber causes playback to loop continuously.

When used on the timeline it will play the highlighted clip or clips, or from the first to the last highlighted clip if there are gaps between them. With nothing selected, it will repeatedly play the entire timeline.

Preview Audio

The System Volume and Mute control affects the monitoring levels of the audio and **not the actual audio of the project**. Clicking on the speaker mutes and enables the sound that is going to your speakers from your preview window.

If you are suspicious of the levels, or want to control them, clicking on the down arrow reveals a slider that controls the volume.

Scrubbing

Below the Preview window there is a timescale with a Playhead or Scrubber, which is always placed over the frame of video currently in view in the preview window. Timecode is displayed on the timescale in the same way as centimetres are displayed on a ruler, so you can read where the playhead is relative to the Source or Timeline duration.

Timescale and scrollbar.

Using the mouse to drag the scrubber across the timescale is another way of searching through the currently displayed clip. If your mouse isn't over the scrubber and you click and drag you may see a clock type mouse pointer appear. If it doesn't, check the Control Panel. In Project Settings there is a checkbox for *Ruler Zooming*. When enabled, clicking and dragging left or right expands or contracts the timescale. This feature is useful, but you may prefer to switch it off if you find it interferes with scrubbing.

Immediately below the timescale is another bar which is easy to miss which I call the Timescale Scrollbar, It controls the size and position of the timescale above it. Grab one end of the scrollbar with the mouse and move it toward the centre to see the effect – the timescale effectively "zooms in" to a section of the clip as if you have altered the timescale with the clock pointer. Now you can grab the whole bar and move it left and right. Scrubbing the clip is therefore limited to a smaller area, but gives you greater accuracy. On a two minute long clip it's not as useful as when you have a very long video loaded. A thin red line indicates where the scrubber is relative to the whole clip.

To restore the timeline scrollbar in the Player to full width, double-click on it.

Preview - Asset names and Timecodes

The top of the Player Windows above the preview screen has some text details above the tabs. On the left of the source viewer is the name of the asset you are currently viewing. The Timeline viewer shows the project name. Over to the right are two sets of figures. The first shows the overall duration of what is contained in the preview window. The second shows the timecode for the current scrubber position (and therefore the currently displayed frame). Both are shown in hours, minutes, seconds and frames. Note the use of colons as a separator, except between seconds and frames, when the convention is to use a period.

In both previews, you can type a timecode into the right-hand box and the relevant scrubber will move to that frame and preview it.

The Timeline area

The area which normally occupies the whole width of the lower part of the Edit Window is where you can view the multiple tracks of your project. It's where the editing actually happens.

Navigating and viewing on the Timeline

The Timeline has it's own timescale area underneath the track area. It also has its own Playhead/Scrubber but in this case it has two handles, one embedded in the timescale, the other above the top track, and they are joined by a vertical red line. This is linked to the Timeline Preview scrubber - move either one and the other one moves, so you can scrub through your project without returning to the preview window

Timeline Preview and Area tools

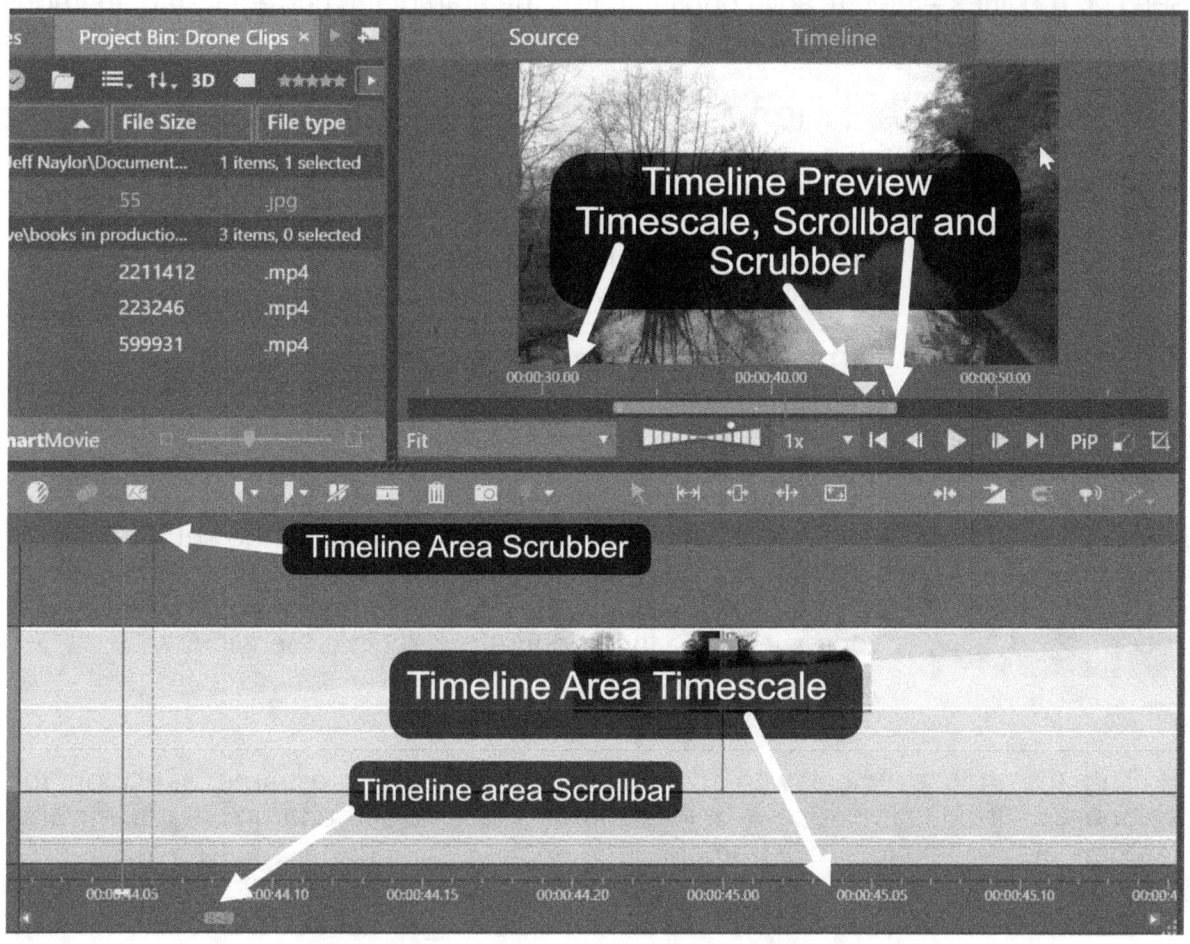

The **Timeline** timescale can also be adjusted by Ruler Zooming just like the timescales in the previews. The scroll bar for the Timeline area works identically, although it doesn't have the thin red line. Indicating the relative scrubber position.

Again, double-click anywhere along its length and the Timeline will rescale its display so that you can see the whole project and a bit more.

Experiment a little to see how the Timeline area's scrollbar and timescale also interact in the same manner as the Preview timescales .- you can adjust the scale by stretching the timescale. If you grab either end of the scrollbar you can also adjust the scale, and by grabbing the middle of the scrollbar you can move it.

These actions are reflected in your view of the Movie project in the timeline area, helping you navigate around a project, or alter the scale of the view.

The scrubber on the Movie timeline has an additional feature over the preview window scrubbers. If the view currently displayed is zoomed a long way in, you will see two red lines - the left, solid one indicates the start of the current frame, the right dotted one the end.

Timescale context menu

Right-clicking on the timescale below the timeline brings up a Context Menu where you can chose specific values for the timescale - handy if you want a consistent display size - but this only appears if you have Ruler Zooming enabled.

Timeline Display Keyboard shortcuts

There are keyboard shortcuts, of course. You can use the **+** and **-** keys on your numerical keypad to zoom in and out. I find these keys particularly useful because they are easy to find. A more sophisticated control is provided by the square bracket keys [and]. Not only do they zoom in and out, but **CTRL-]** zooms the timeline right into the frame level, while **CTRL-[** zooms it out to fit the entire project into the window.

Mouse Control

Rolling the mouse wheel with the timeline active has the same affect on the scrubber as it does in preview - it jogs through the project, and holding down Shift restricts the jogging to single frames.

Regardless of the Ruler Zooming setting, you can also change the viewing level of the timeline with your mouse wheel by holding down CTRL and rolling the wheel. Forward zooms the views in, rolling back zooms out.

The Navigator

An aid to working with more than a few tracks, you might want to load the sample movie to show it to it's best advantage.

The toolbar item used to enable Storyboard view can also be used to bring up the Navigator display. Use the drop-down arrow indicated in the screenshot to select the strip icon, and then click on the icon to display the Navigator.

The Navigator and Context Menu

What you see now is a very upmarket timeline scrubber that takes into account multiple tracks. The Navigator has a fixed height, unlike the Storyboard; the more tracks your project displays, the thinner the representation of those tracks. Each clip is coloured to represent the type of media, just like the timeline itself, so Video is blue, for example. The currently selected clips are shown as bright orange, regardless of the type.

Even for projects with just a couple of tracks there are some good reasons to consider using the Navigator, particularly if it is a lengthy one. Right-click on any part of the Navigator and you can choose how much time occupies the full width of the timeline from the menu. Arrows at either end allow you to scroll, and you can also drag the viewing area left or right with the mouse. A double click on the shaded area will fill the display with the entire movie. Dragging just one edge of the shaded area, or using the + and - buttons on the far right also zoom the active area.

This feature is of particular use when you run out of display real estate. Either your project has grown a lot of tracks or you are working with a small display. The Navigator is there to remind you what content is on the lower tracks. If you don't have a massive screen, leaving the Navigator enabled while you work might be a better idea than it at first might seem.

The Timeline Toolbar

At the top of the Timeline area is a toolbar. If you have the Standard version of Studio it will contain 16 icons - and that's all you can have. Plus and Ultimate have far more, so on the far left the first tool lets you customise the toolbar. If you never use a feature you can remove it to reduce clutter.

The Customize Toolbar panel

By default all the tooltips except two are enabled - these are connected to MyDVD Disc Authoring and will appear when needed. As I describe each tool, if you need a fuller description, please check the index.

If you have enabled the Legacy Authoring mode then note that there is a separate customisation panel, independent of the Edit mode. I'll look at these disc tools when we discuss Legacy Disc menus.

The first group of Tools

Only the first four groups can be customised. The first group starts with **Timeline Settings**, and this can't be removed either. Hovering over this tool generates a tooltip with the current projects settings. Clicking on it will open a new box so that you can chose different settings.

Navigator/Storyboard opens the storyboard, which is open by default in Standard, or the Navigator, which has just been described.

Authoring adds tools to the Edit page for use with the MyDVD disc authoring path.

Undock Timeline allows you to float the timeline window away from the main interface.

Audio Mixer adds tools for working with sound. There is a whole chapter dealing with audio editing later in the book.

Scorefitter is the standard music generation program we used in the Whistle-Stop Chapter.

SmartSounds is a 3rd party music generation program. You need to own Smartsounds and the Studio plug-in, in order to see the tool icon.

SmartSounds has far more options than Scorefitter and a vast library of music types and themes available.

Title and **3D Title** open up the two titler programs included with all versions of Studio.

Voice Over allows you to record commentary during project playback and then add it to your movie.

Audio Ducking can automatically ride the levels to make vocal or other sounds easier to hear relative to background music or effects.

Multi-Camera Editor is a separate editing module for working with more than one camera source. There is a chapter devoted to it later in the book.

Transparency adds features to the timeline to control the transparency of the video tracks.

Motion Tracking opens a separate editor for masking or following moving objects on a video track.

Split Screen opens a separate editor to create Split Screen templates.

Second group of toolbar icons

The second group of tools are mostly to do with Editing operations.

Mark In, Mark Out and **Reset** allow you to place and remove In and Out points for the entire timeline. These are used for selective Import but also for some operations when you are sending clips to timeline.

Split Clip is arguably the most important tool in the whole of Studio. It divides the clip or clips under the scrubber into two parts. If no clip is selected then all the clips are split, otherwise only the clips selected are split. The keyboard shortcut is N - which is a not what users of other editors might expect, but of course this can be modified in the *Control Panel/Keyboard*.

Delete will remove all the selected clips from the timeline. The keyboard Delete key does the same thing under normal circumstances but can't be used in conjunction with the ALT key. What happens to the gaps that deletion would create depends on the *Editing Mode*.

Snapshot creates a still picture of the timeline at the current scrubber position, saving it in the format, and at the location, defined in the *Control Panel/Import* Panel, and also placing it in the current Project Bin. Snapshots can be used to create a freeze frame, amongst other things.

Markers are a useful function that can be placed on the timeline using this tool. They can also be placed on clips using the Clip Editor Panel.

Two tools are available in the MyDVD Author Mode, **Update Chapter Name** and **Set/Remove Chapter Marker**. These will be discussed when we look at using MyDVD disc menus.

The next group of tools are concerned with Three and Four point editing.

The 3-4 point editing tools

The most important of these is **Selection**, because that's the tool you use to get you out of 3-4 point mode should you get into it by error. The other tools are best used with the timeline in the 3-4 point editing mode, and will be described in detail later.

The final group of Timeline toolbar icons are always present. If you are working with Studio Standard you will only have two icons but the other version have five.

Trim Mode is a tool that helps you enter Advanced Trimming - where you can adjust one or more trimming points very accurately, There is a certain amount of overlap between the more complex operation of Trim Mode and 3-4 point editing.

The right hand group of Toolbar icons

Dynamic Length Transitions affects how a transition is generated when you drag it from the Library - when enabled you can adjust the duration at the same time as you add it.

Magnetic Snapping controls if editing operations will click into place at a nearby clip boundary. Normally it's a good idea to have this enabled, but for some precise operations you may need to turn it off. Available in Standard.

Audio Scrub enables the sound when you drag your scrubber across a clip. Depending on the scrubbing speed, you may hear perfectly understandable audio to help you locate a word or phrase. At other times it will just be an annoyance. Also in Standard.

Edit Modes

Studio now boasts five **Edit Modes**. For simple editing **Smart** mode is the best choice - it's the only one in the Standard version. **Insert** and **Overwrite** give you more control. **3-4 point** mode helps you work with the 3-4 point tools, and **Replace** is mostly for use with Templates.

Each of these modes are discussed in later chapters.

Timeline Tracks

The central area of the timeline pane is dominated by the A/V tracks, with the track headers to the left. *Standard* has a maximum of 6 tracks, *Plus* up to 24 and *Ultimate* is theoretically unlimited. Even 6 tracks will be enough for many projects.

This is the area in which you build projects. By default Studio in Edit mode has four track headers on the left – labelled A/V Track (1) to (4). The second track down is taller than the others. This is because Pinnacle have good reasons to want you to use it as the primary track, but there are no special track allocation - you can put any type of asset - audio, still pictures, titles or video with or without embedded audio - on any track.

Studio uses a top down approach. The top track is the top layer, and if it is "full" - occupied by a full screen video clip - then you won't see any of the assets on the tracks below. This is why Pinnacle like to encourage you to leave track 1 free, so you can place titles on it and they will overlay the video below.

You will hear all of the audio on all of the tracks, unless you have muted or faded down any of the tracks.

Every project will start on the left and build to the right – like reading a sentence from left to right. The timescale reads zero at the far left edge of the project, and the numbering shows how far into the duration of the project you are.

There are special cases when tracks are best kept together. Detaching the audio from a video clip will place it on the track below and some editing operations can treat the two tracks as if they were one.

As Pinnacle develops, new types of timeline tracks are being introduced, such as the **Follow Object** and the **Mask** track which obey special rules, but these are not present by default, and we will deal with them in their own chapters.

Adjusting Track Height Dragging

If you want to manually adjust the height of any track, you can generate a vertical double-headed arrow cursor by hovering over the junction between two tracks or track headers, clicking, holding and dragging.

If you end up unable to see all the tracks, a scroll bar should appear at right hand end of the timeline area so that you can adjust your view. With a project that has a lot of tracks you might want to consider opening up the *Navigator* mentioned earlier.

Adjusting the Track order using Drag and Drop

If you have started to build a project and realised that you have been putting assets on the wrong track - perhaps putting titles on a lower track than all the video clips - then rearranging the tracks is easily accomplished. This time you have to use the track headers. Click and hold on any blank part of the header and drag it up or down as required.

When the header is hovering over a junction a highlight appears with a small circle to the left as shown in the screenshot. Drop the track at that point and the order will change.

For an empty project, it's easier to rename the tracks rather than rearrange existing named tracks.

Selecting a Track

There are many occasions when you want to make a track the Active or Selected track. For example, the *Send to Timeline* commands will place the chosen asset to that track. Scorefitter will place its music there, for example.

One track must be selected at all times. It is indicated by an orange stripe on the left edge of the header and a lighter grey colouring. To make any track other than a Mask track active, you simply click on its header. Note that the selected track does not change if you select a clip on another track.

By the way, there are a few tool-tips and messages in Studio that may still refer to the Selected track as the *Main* track. This is misleading, Studio does not have a "main" track as such.

The Track Header Context Menu

Right-clicking on a track header opens a menu with a number of Track management options. Insert New Track has a further fly-out that lets you add the track above or below the currently selected track. There is also the opportunity of adding a Mask track. We will give the subject of masking its own chapter.

Delete Track does just that.

Its not necessary to use the **Edit Track Name** command - you can just click on the name of a track to open an edit field.

Track Sizes can be changed to preset sizes Small, Medium, Large or Very Large, either individually or globally.

Transparency is a feature that can make the entire contents of a track partially see-through. You can also apply variable transparency to individual clips. The Track context menu allows you to delete all the transparency setting for an entire track (including individual clip settings). You can also use the menu to copy and paste the track settings from one track to another.

Unchecking **View Waveforms** removes the audio waveforms and level information from the lower half of the timeline clips. What it **doesn't** do is remove or mute the audio. I'm not sure why you would want to remove the waveforms, other than to de-clutter your display.

Track Header Icons

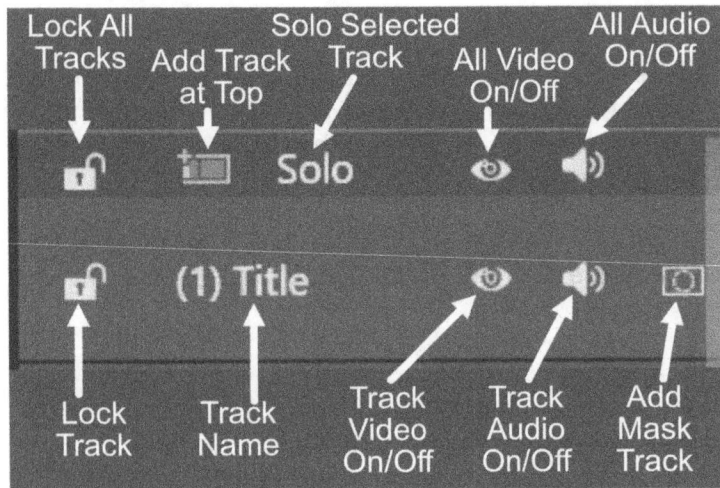

Along the top of the track headers are five tools, three of which are duplicated in each individual track header.

Tracks can be **Locked** globally or individually. You can't carry out any editing operations on the contents of a locked track. Also, locked tracks are excluded from operations carried out on other tracks that might affect them when working in Smart mode.

Tracks can also have their Video and/or Audio monitoring turned off, either globally or individually. Although Pinnacle use the term *monitoring*, that may be slightly misleading. Any Video or Audio that is turned off not only doesn't appear in Preview, it won't be included in any exported project either.

The choices available for Track Solo This is in contrast to **Solo.** This feature allows you to look at and listen to **just** the selected track, or to the selected track and those below it. Which option you use is controlled by a drop-down that appears when Solo is activated. If you try to export a project with Solo switched on, you will still see and hear every active track in the resultant file.

Add Track at Top does just that. I suspect this feature was included for people who weren't aware that titles normally need to go above the video tracks.

Each track header also has a tool to add a **Mask track**, which appears above the selected track, This is in addition to the option of adding one using the context menu.

Two Timeline toolbar tools that we have already looked at can also affect the appearance of the track headers. Both extend the header to the right in order to add extra controls.

Track Header Audio Flyout

Additional Audio controls

Although we look at audio operations in a later chapter, it is worth noting that the Track headers can be extended to add extra audio controls by using the Audio Mixer tool.

This enables audio keyframing and also adds a master volume slider at the bottom of the screen,

Transparency Flyout

Transparency controls

An alternative set of controls can be added to the track headers by clicking on the Transparency tool. You can have either the audio or the transparency flyout, but not both at the same time.

I will discuss Transparency when we look at Effects.

Timeline Clips

Let us now turn our attention to what

Each Timeline A/V track can contain any type of asset in the form of clips. Clips are of a variable length that indicates their duration. The asset type is indicated by the colour of the clip - light blue for Video, a darker blue for still pictures, green for titles, lilac for montages and templates and a khaki colour for audio.

The Video Clip Context Menu

The **Clip Context menu** is very large and varies slightly with each type of clip. It contains commands that lead to features as well as editing, navigation and other functions.

The following list is based on what appears when you right-click on a video clip - exceptions listed later. The more a menu entry is discussed elsewhere, the less description I'll provide here.

Pan and Zoom opens a standalone legacy feature that occupies it's own window. I'm not sure how long this feature will continue to exist in Studio as it is duplicated by the later Pan and Zoom effect in the Clip editor.

Motion Tracking is a complex standalone effect which allows you to identify a point on a video clip and attach objects or a mask that tracks the point as it moves. If you want to blur someone's face or point to a part of your clip, this is the tool you need.

Video Clip Context Menu

Audio Ducking is also available from the timeline tools.

Scaling is a useful took for dealing with photos or video clips that don't share the same aspect ratio as your movie project. **Fit** will make sure you see the whole picture, even though that will generate bars, either top and bottom or at the sides. **Fill** will tighten the picture so that there are no bars, but in the process with lose some of the picture from view.

Alpha relates to if the bars are transparent or solid. Studio's own transparent exports don't respond to the Remove Alpha choice.

Active streams is a very useful control that allows you to choose what part of a A/V clip is used. If both streams are selected, the clip will behave normally. Switching off the Video converts the clip to Audio only, switching off the Audio mutes it. In both cases the clip display reflects the change. You can't turn both streams off!

360 Video is an Ultimate only tool for working with 360 degree video.

Time freeze is a way of inserting a frozen video frame into a moving video clip. The freeze will occur at the current scrubber position.

When you use Time Freeze, you will be asked for a duration, and clicking OK creates a pink insert into the clip indicating the frozen section.

There are a few issues if you use this tool later in the creation of a project. The clip needs to be expanded in order to create the extra duration, and this is done

in Insert mode, regardless of the editing mode selected. This could potentially disrupt your timeline sync. The current implementation can be buggy as well.

Time Freeze duration

Freeze frames can also be created using a Snapshot, which gives you more options.

Time Remapping opens up the current clip in the Editor at the Time Remapping effect.

Reset Properties removes any changes you have made to the current clip using the on-screen transform tools or any of the parameters in the Properties section of the Clip Editor. When a property has been added to a clip, a pink line is drawn along the top of that clip. This is the same colour as other effects, so this can be confusing. Removing all the effects still leaves the pink line, showing that the properties are still present, and they can only be removed using this context menu command.

Adjust Duration opens a box that allows you to change the duration of the current clip. It's a simple and accurate way of doing so. It has the same issue as Time Freeze, in that it works in Insert mode even if you are using Smart.

Rotation is a quick way of rotating a clip through 90 degrees. If you use it repeatedly you can continue to rotate the clip to 180 degrees. However, if you use The **Custom** option you will get a surprise - a whole new window opens containing the legacy Effects Editor. If you are fairly new to NGStudio you may not have seen this before. This is currently the only way I know of reaching it for video use, and I'm not sure that Pinnacle intend it still to be available. There are circumstances where the old editor is superior and we will look at it in the Effects chapter.

Detach Audio only works on A/V clips that contain Video and Audio, and still have both streams activated. It's an important tool if you want to make split edits - where the audio and video are cut at different points. You may know these as J and L cuts.

A new track is created below the current clip, containing just the audio, which has been switched off on the original clip. The new audio track isn't completely divorced from the video track, as we will see when we discuss audio editing.

Find In Library will do just that for a media clip - open the Library, create a tab for Library Media if it doesn't already exist, and then scroll to and highlight the chosen clip. This will tell you where it is located on your hard disc. If you want to know which

project bins the clip is also in, hover over the clip while the Project Bins are open in the sidebar. Each bin containing that clip will be highlighted in green.

This also works for transitions and other assets, showing their Library location within their own content location.

Open In Explorer is a variation of the above - A Windows Explorer window opens up over Studio with the media highlighted in its containing folder.

Group is an editing tool that we will look at in detail later.

Close Gaps, when accessed from a clip context menu, will close any gap that exists to the left of the current clip. The clips to the right are moved left by the duration of the gap. As it only closes one gap I'm not sure why it is plural.

 However, Timeline Gaps also have a context menu consisting of *Paste* and **Close Gap**, which does just that, shuffling the clips as above. Additionally, opening a context menu to the right of the last clip on a track offers you **Close All Gaps,** which will remove all the spaces on that track, regardless of editing mode.

Copy Cut and **Paste.** You can copy or cut any clip or group of clips and then paste them back to the timeline. In older versions of Studio you could only paste the clips back to their source tracks. In Studio 24 the paste command works to any track, placing the clips to the scrubber position of the track that you selected *Paste* from.

There are now two forms of Paste. **Paste All** pasts the copied clip and all it's attributes, including Corrections, Properties, Effects and even Keyframes. **Paste Attributes** pastes just the the attributes to a target clip. If you want to paste individual attributes you need to use the **fx** Context Menu - the one that appears when you right-click on the coloured stripes along the top of the clip.

Transitions have four context menu entries. They have a whole chapter devoted to them later.

Delete is an alternative to the Bin tool and delete key.

Display Information will do just that, opening an information window similar to the Library window, with one difference - there are no player controls, so you can't separately preview the clip.

Other Clip Context Menus

Clips that aren't video will have a few variations in the context menus.

Timeline gaps have the small context menu mentioned earlier - it just contains **Paste** and either **Close Gap** or **Close All Gaps**.

Pictures offer the option of opening the Clip in the Effects Editor, although this actually results in the clip opening in a Legacy standalone version of the *Corrections Editor*. The reason for this is that there are a couple of corrections that are photo specific - **Crop**, **Straighten** and **Red-eye Reduction** - and currently not available in the Clip Editor built in to the main interface.

Titles can be opened in their relevant title editors - Motion or 3D.

Montages offer **Edit Montage,**

A **Split Screen** clip has two *Open In* entries - either editing in the **Split Screen Editor** or opening it as a Sub Movie in a standalone version of the Sub Movie Editor

MultiCam, **Templates** and **Sub Movies** all offer the option to open them in the standalone Sub Movie Editor.

Double-clicking to Open in....

I used to be able to say that double clicking opened the clip in its relevant editor, but it's got a bit more complex than that. Double clicking on **Video**, **Audio** and **Pictures** will open up the most relevant section of the In-Built clip editor that replaces the Library. However, double clicking on a **Sub Movie**, **MultiCam Sub Movie** or normal **Template** opens up a new **Timeline Tab** containing the asset.

Timeline Tabs

Timeline sub movie tabs

If you are seeing a series of tabs above the timeline toolbar then you have stumbled upon Pinnacle's latest version of sub project editing, and that will be discussed in the Editing Enhancements chapter.

This chapter has described the Editing tab. In the forthcoming chapters I'll show you how to actually do some editing in it!

Basic Editing Techniques

This chapter covers operations you can use to place, trim and rearrange clips in Studio on a single track, using the three basic editing modes, **Smart**, **Insert** and **Overwrite**. Note that although I've used A/V clips here, many of the principles apply to all clip types. Other useful editing functions will also be introduced as we go along.

Preparing Clips for Editing

It's always a good idea to check out the material you have available for your projects before you start editing, and while you are doing so you can save yourself some time by pre-editing the clips so that you can work with them easily. Studio has a number of tools for this purpose.

For longer clips, **Scene detection** can automatically split up the clips for you. If you have long takes that have cuts within them because you have stopped and started the camera - typical of an older analogue, DV or HDV camera then you might want to use **Scenes.**

If you are using a file based camera, each clip will start when you pressed record and stop when you press stop. Depending on what you were shooting and how you went about it, the clips may already be divided up into single shots. If you were covering an event, however, you might have kept recording, with unusable reframes between the usable shots. These longer clips can also turned into Scenes, manually should you wish. You can also create a series of Library **Shortcuts**, either by manually creating them from Files or Scenes. These subjects will be covered in the *Scene Detection, Scenes and Library Shortcuts* chapter.

In this chapter I'm going to assume that you are working with files that might need some splitting and trimming, but they are manageable.

To this end, I'm going to use a group of clips prepared especially for the purpose. They are available from the website and data DVD in both PAL and NTSC formats, cycling clips PAL_000.mp4 to PAL_008.mp4 and NTSC_000.mp4 to NTSC_008.mp4. They are only 720p, quick to download and most computers should be able to work with them without having to enable Playback Optimisation. They have timecode burnt into their lower area which will help you find the points I will be using when performing the edits.

If you want to follow my steps, you can import the clips for your countries' video standard into a Project Bin called *Cycling Clips*. If you only own Studio Standard, many of the operations will need to be worked round - or this could be a good time to upgrade.

Pre-trimming clips

Many shots you want to use are likely to have material at the beginning and end that you aren't going to want in your final movie. Even if it's that little wobble you get when you press the record button, it's worth removing before you put the clip on the timeline. Once your editing gets more sophisticated, you should be able to predict where you are likely to want to start and end a clip before you put it into the movie. Setting In and Out points before you use a clip is called **Pre-trimming**.

I want to demonstrate a feature of the **Source Preview** window that we glossed over earlier in the book. It's an important way of selecting a section of a shot before we send it to the timeline scrubber position. It is not available in the Standard version of Studio - you will have to trim your clips on the timeline.

As we saw in the Editing Tab Chapter, the Source Preview window has six additional buttons either side of the transport controls. The **V** and **A** determine if we are previewing Video, Audio, or if they are both highlighted, both. Make sure they are both orange. Next on the right is a downwards curving arrow. We can use this to send the clip in the window to the timeline in a moment. Note that the tool tip, which tells us that the keyboard shortcut is B is best reserved when you are in the special 3-4 point editing mode, otherwise you might see unexpected results if you use it for normal insertion.

The pre-trimming tools in the Source preview

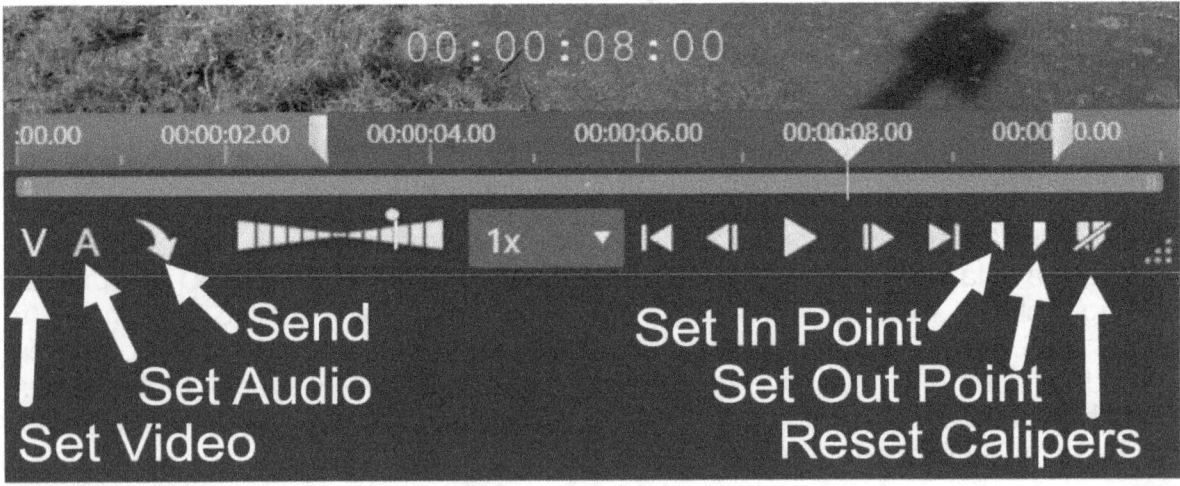

To the right of the transport controls are three buttons that relate to the orange calipers that can appear on the Preview player window timescale. The calipers are used to mark **In** and **Out** points for the clip, with the left-hand one being the In point

and the right-hand one being the Out point. The final button resets both markers to the original positions.

I've loaded up clip 008 by highlighting it in the Library - it is 11 seconds long. If you scrub through it you will see that we could take 3 seconds off the top and a second off the end without losing any useful information. I've also started a New Movie and named it Basic Editing, and ensured that we are in Smart editing mode.

You can use a number of strategies to set the In and Out points. Dragging the calipers themselves is easy enough, as long as the timescale is adjusted correctly. More control can be achieved by using the conventional scrubbing and jogging controls, including the keyboard shortcuts, until you locate the desired point and then click the relevant button, the I key to set an In point or the O key to set an Out point.

Set the Calipers to 00:00:03:00 and 00:00:10:00 seconds exactly using the burnt-in timecode or the TC box above the preview window. You can instantly tell the duration of the pre-edited clip by looking at the duration timecode after the "[]" symbol at the top of the preview window. It should now be 00:00:07:00

Next we want to put what is in the Source Preview player window onto the timeline. In this case we don't have to decide where to put the shot relative to other shots, as the project is empty. How will Studio know which track you want to send the clip to? It assumes that you want to send it to the currently active track, so if Track 2 doesn't have the orange line at the left of it's header, click on an empty part of the header to make it active. Switch back to Source, and you will see the new clip is still there, with its In and Out points intact. Click the **Send to timeline** button.

The In and Out points we have set for the source clip are remembered by the Library, not only if you select another clip then return, but even if you load another project - they will even survive

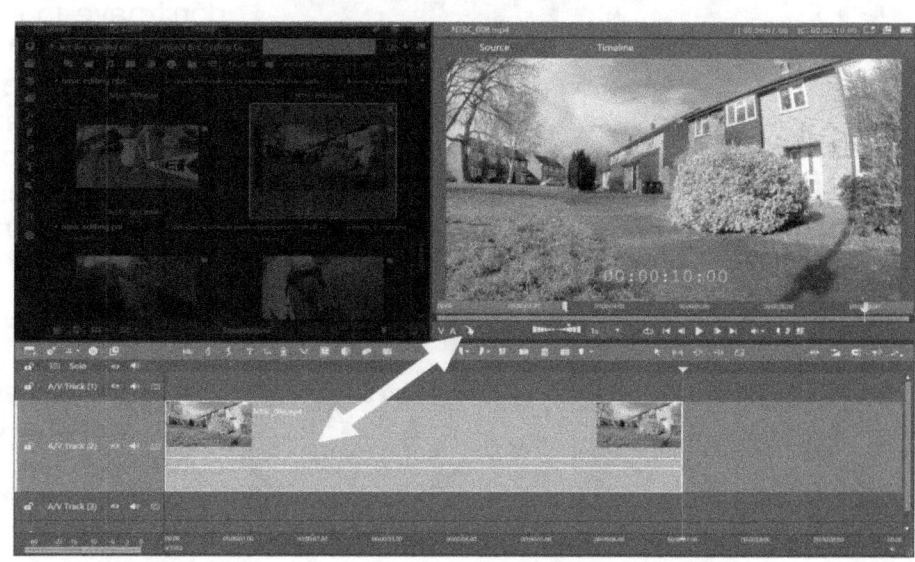

closing down Studio. Whenever we call it up it will have those trims, until we change them.

There are three other ways of sending a Source clip to the timeline.

Dragging from the source viewer

If you don't want to have to bother setting the target track and the scrubber position, you can drag the contents from the Player window and drop it anywhere on the timeline tracks - and I do mean anywhere, because it is possible to drop it into or over the middle of an existing clip.

However, as long as you have Snapping enabled it's easy to make sure that you align to an existing edit point should you want to.

Dragging a pre-trimmed clip from the Library

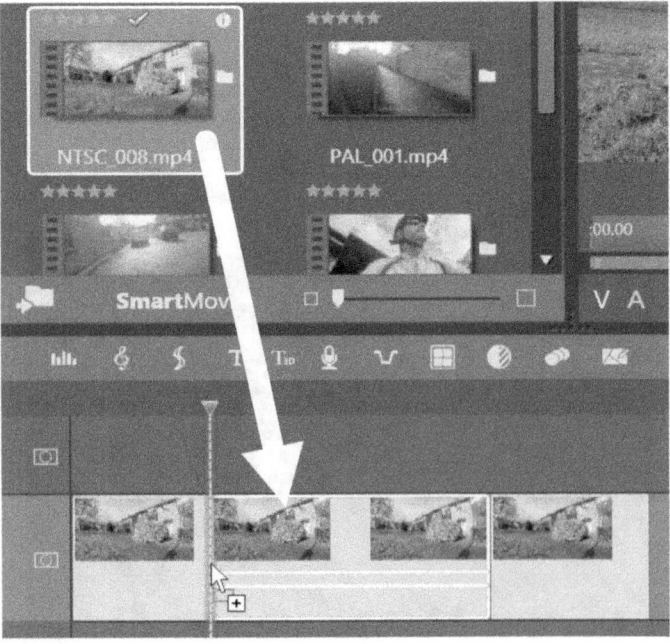

You can carry out the same operation from the Library - and the advantage here is that you don't have to enable dual view or make sure the Source viewer is selected. The operation is exactly the same, because the In and Out points are respected - when you drag a clip that has been pre-trimmed, you only get the trimmed duration.

However, the same is **NOT** true if you use the Library context menu command *Send to Timeline*. In this case, the clip is sent to the current track, at the current scrubber position but will consist

of the full clip duration, regardless of any In and Out points you might have set in the source viewer.

Therefore, it's not always necessary to clear the trims from a clip once you think you might have finished with them because you have access to the whole clip if you want it. If you are sure that you have finished with the trims you can reset the calipers using the Clear button to the right of the Mark In and Out buttons, or use the shortcut Shift-U.

Post trimming clips with Split and Delete

All the above is very useful once your project is underway, but it might seem like a lot of messing about if all you want to do is slightly shorten the first few clips you put into your movie. Also, if you only have Studio Standard you don't have the option.

Split and Delete is the most basic of editing operations and we used it in the Whistle-Stop tour. It can be the safest option when working with multiple tracks as well.

I'm going to put another long clip on the timeline. You can examine clip 001 in the Library by dragging the thumbnail scrubber if you wish, but then just drag it down to track 2 so that it clicks into place to the right of clip 008.

We work in the Timeline viewer for these operations. Scrub along the timeline until reach the point that the bike has left frame during the second timeline clip. We could try to double guess what is coming next to help us decide where we want to come out, but it's a good guess that we don't want too much of an empty frame! I've chosen 00:00:07:00 on the burnt-in timecode. That's going to be the first discarded frame.

The Timeline scrubber set

Having chosen where we want to split the clip, click on the Razor tool icon or press the N key.

The target clip will be divided into two parts at the scrubber position. Now it is just a case of selecting which part we want to remove. In our case it is the second part. Click on it and then click on the Timeline toolbar Bin Tool or press the Delete key.

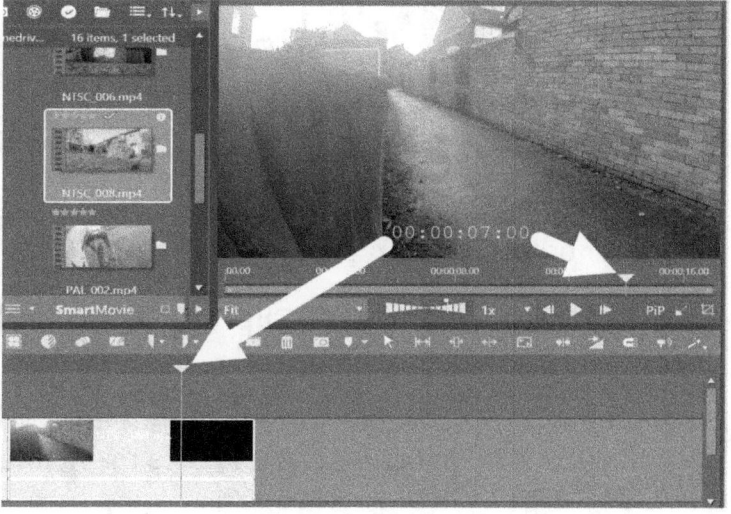

This process is as fundamental as old school film editing. You can get a long way into making a movie before you need any other process!

Clip Selection and Splitting

There is one important point about splitting clips that isn't immediately obvious. If you select and highlight a clip before you split it, after the split both halves of the clip are highlighted. If the clip you split isn't highlighted, then after the split operation only the second half of the clip will be highlighted.

And why is this important? If you are splitting a clip because you want to delete the second part, then doing so to a clip that isn't highlighted means you can just click the trash can or press Delete. This is no advantage if you are trying to cut off the beginning of a clip, but it is worth bearing in mind. Much more importantly, I want you to appreciate that there is a difference between how Split Clip behaves on a clip that is, or is not, highlighted, because when you start to use multi-track editing there are more fundamental differences.

Smart, Insert and Overwrite on a single track

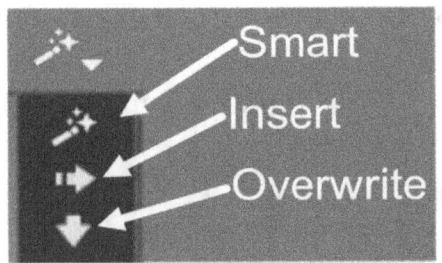

The Studio Plus and Ultimate versions have five editing modes available and you choose them with the Editing Mode tool at the far right of the Timeline toolbar detailed in the previous chapter.

Even looking at single track operations there are a lot of differences between the default Smart mode and the optional Insert and Overwrite modes.

To begin with let me clearly define the difference between Insert and Overwrite operations. Once I have done that I can explain when Smart mode uses one type of behaviour or the other.

Adding and Deleting a clip on the timeline

With two clips on the timeline, the edit between them works fairly well but is a bit dull. There are nearly two whole seconds where there is no bike in frame. However, if we were to cut out those boring bits, the bike might seem to jump - there is a part of the journey that isn't seen by either shot.

We have plenty of clips of the bike going round the corner, so I'm going to choose one to place between them - clip 002. This is a forward facing shot with the bike wheel in foreground. It is 36 seconds long - one good reason not to try post trimming it on the timeline. Place it in the source viewer and set the In and Out points to 00:00:21:00 and 00:00:25:00 seconds respectively.

Now adjust the timeline view so that the two clips take up about half the width of the display. Switch to Insert mode and check Snapping is on, then select the Source viewer again.

The timeline before adding the new clip

Insert mode

Drag the clip in the Source viewer down to the junction between the two clips so that it snaps into place, then drop the clip.

Adding clip in Insert Mode

This action has extended the length of the movie by the duration of the clip we have just inserted. Because we dropped it at the edit point, all of the pre-trimmed clip 008 is still there, followed by the newly added clip 002 and then followed by clip 001.

Play the movie. What we now have is a sequence of three clips in the correct order but with repeated action. After all, we have put in 4 seconds of video to cover less than 2 seconds of action. With further editing it can to made it work well.

The chosen editing mode affects lots of things, not just what happens when you add a new clip. You can see this at it's most fundamental if you now highlight the new clip and delete it. The clip is "uninserted" - it is removed and the last clip on the timeline moves left to ensure there is no gap.

Overwrite Mode

With the timeline restored to its former 2-clip state, switch to the Overwrite mode. Now drag clip 002 from the source viewer again and drop it in the same place. This time the duration of the movie stays the same, and the new clip has taken the place of the first three seconds of the last clip on the timeline.

Play the movie again and you won't see so much double action.

Adding a clip in Overwrite

Now delete the middle clip. This time the operation leaves a gap.

Deleting a clip in Overwrite mode

So, while Insert mode is always polite, making room for itself, or closing up any gaps it would otherwise leave behind, Overwrite Mode just barges straight in; it never alters the positions of any other clips it might interfere with - it just deletes anything that gets in its way instead. When you delete something, in Overwrite, it makes no attempt to clear up after itself.

Smart Mode

Now switch to Smart mode and then reset the timeline by using Undo twice so that it is restored to it's 2-clip state. Repeat the above process, and it will be clear that Smart works exactly as Insert when adding clips from the Library or Source Viewer or deleting clips from the timeline.

Switching Edit Modes on the Fly

Pinnacle Studio Plus and Ultimate can change the mode you are editing in without you having to return to the Editing mode drop-down tool. This is particularly useful if you want to work quickly, or you accidentally find yourself in the wrong mode while actually carrying out an operation.

The way to swap modes is very simple - just press and hold down the **ALT key**.

The demo project should have been reset to two clips with a duration of 14 seconds, so you can experiment. In Smart mode, drag the clip from the Source viewer down to the edit point. Before you release the mouse button, press ALT and move the mouse a little. The last clip on the timeline will jump to the left as the incoming clip is now overwriting it. Try the same thing in Insert mode and you will see the same behaviour. Testing it in Overwrite and holding down ALT changes the behaviour to Insert.

Switching modes with the ALT key works in almost every situation. It's very useful when we trim clips on the timeline. When we discuss Smart mode in more detail, you will see it can be even more helpful.

ALT Delete

Sadly, there is one operation that the ALT key cannot help with - using the Delete Key. Nothing happens when you press delete with ALT held down. Fortunately ALT does switch the behaviour of the Trash can tool, which has the same function as Delete. I'm not sure if this is a bug or a keyboard mapping limitation.

Using Overwrite mode for dropping clips into a movie

It may seem that Overwrite can be a little too destructive, but with a little care it can be both powerful and quick.

Let's return to the demonstration, with just the two original clips on the timeline and the trimmed version of clip 002 in the source viewer. When we dropped the third clip at the junction between the timeline clips the result was that the bike ended up going round the corner twice. However, if we had dropped it towards the end of the first clip so that it overwrote some of the end of that clip, as well as some of the beginning of the last clip, the edit might have worked much better.

This needs to be done in Overwrite (or you can be in Smart or Insert modes and be holding down ALT if you wish). Dragging the clip from the Viewer, it is easy to let it snap into place at the edit point between the existing clips, but continue to drag it

left so that it unsnaps. Now, when the timeline viewer's TC box reads 00:00:06:00, drop the clip.

Play back the movie. This isn't a perfect edit by any means - for one thing the bike goes past the same round green bush on the left twice, either side of the first edit. The choice of the six seconds mark was more by luck than judgement, but there are lots of tools and strategies that can help with the correct placement that we will look at later.

The new clip added earlier

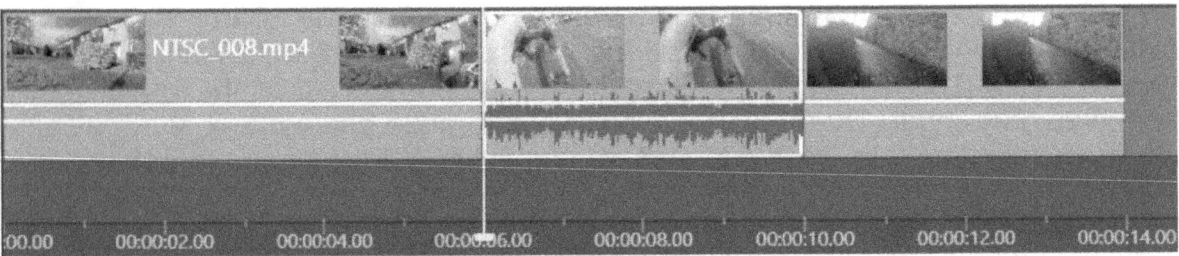

The important thing here is that the two original shots were about right in their relationship to each other. If we were revisiting this part of an edit having already placed sound effects and titles, Overwrite mode would not have disturbed that relationship or the surrounding clips.

This is the first stage of our Basic Editing movie. If you want to save your edit, call it **Basic Editing 1**. My versions can be loaded if you wish to compare them, or so you can just dive into this chapter at that point - they are called **Basic Editing X_YYYY**, where X is the version number and YYYY is either PAL or NTSC. So if you used the NTSC clips to make your version 1, it should match my Basic Editing 1_NTSC project.

Multiple Clip Selection

Now that we have three clips on the timeline, I can demonstrate more of the clip selection rules.

To select a **single timeline clip** you just click on it and the border around the clip turns orange.

If you hold down the **CTRL** key and click on a clip it gets added to the selection.

You can also use the **Shift** key to select a range of clips - click on clip 1, hold down Shift and then click on clip 3 and all three clips will be selected. As we will see later, Shift selection can also span tracks.

CTRL - A selects everything on the timeline.

You can **draw a mouse box** - or *Marque* - around any area to select the clips within that box.

Once a group of clips is selected you can **deselect** individual clips from the group by CTRL-clicking on them.

Selecting everything to the Right

Hold down CTRL and Shift at the same time and click on the first timeline clip. Notice that the clips to the right are selected. Most importantly, if there were clips on other tracks, those that were to the right of the clip you clicked would have been added to the selection as well. This is a very useful tool for making a temporary gap on the timeline, allowing you to work on a section without worrying about the affect you will have later down the timeline, and then close up the gap again.

Trimming

I mentioned earlier that splitting clips and then deleting the sections we don't want isn't the most sophisticated way of editing, although it has speed and simplicity on its side.

A lot of editing operations consist of altering the start or end of a clip, and sometimes you might want to add material, not just take it away. This is called trimming. Pinnacle Studio has two trimming modes, and we will start with the simplest, which I call **Quick Trimming**. Advanced Trimming will be discussed at the beginning of the next chapter.

I'm going to carry out this demonstration on the final state of the three clip cycling movie we have just been working on - your Version 1. I'm also going to ask you to test in Smart Mode unless otherwise instructed, so switch back to that mode using the timeline toolbar drop-down if you aren't already in it.

An Out Point handle

Its time to do a bit of mouse hovering. When you hover near the horizontal centre of a clip, the name of that clip appears, along with a figure that turns out to be the duration of the clip as it appears on the timeline. The first clip should be 6 seconds long, the second and third clips should be 4 seconds long.

Move the mouse very close to end of a clip about half way down. If you are just to the left of the junction an Out Point handle will appear - a right pointing arrow with a bar to its right

– as shown in the screenshot. If you hover to the right of a junction you will get an In Point handle – a left pointing arrow with a bar to its left.

You may also generate other types of handles when hovering your mouse in this area. Go too high and you will get a fold-over effect used for creating a transition - which we aren't trying to do yet. If you have enabled the audio mixer and hover over the green line in the lower half of the track you will generate a small speaker icon. This is for adjusting the audio levels, and again, we don't want to do that. The audio mixer tool is on the timeline tool bar and should be disabled by default.

If you hover, click and release near an In or Out point handle a yellow bar may well appear at the junction of the clips. You have created an Advanced Trim point. We don't want to do that yet. Click somewhere other than a clip junction and the trim point will disappear.

So, for Quick trimming, click, hold and drag straight away. When you are using Quick trimming you will see a green bar on the edge that is being trimmed.

Disabling Advanced Trimming

It's possible that you find yourself creating yellow trim points when you want green ones. You wouldn't be the only one. Pinnacle have provided a mode that disables mouse creation of Advanced trimming points and forces you to use the trim mode toolbar icon. I'm going to stick with what is currently the default - being able to create trim points by clicking near cuts - but if you struggle, you might want to work with this feature turned off. In the Control Panel, go to Project Settings and uncheck the box that controls the feature. When I introduce Advanced Trimming, you might want to consider turning it back on.

At the time of writing, I have heard of a possible move to switch the default state for the trim mode, so that when you first start using Studio you can't create Advanced trim points with the mouse. If that's what you experience, then you know that the change has been made.

The first Quick Trim

For accuracy, use the Timeline timescale context menu to set the scaling to 10 seconds or even less. Double check you are in Smart edit mode.

The aim of this edit is to extend the Out point of the first clip until the bike has left the frame. Hover your mouse just to the left of the junction between the first and second clips to generate an Out point handle. Click, hold and slowly drag the mouse right.

As you start to drag, the scrubber jumps to the point of scrubbing regardless of where it was before, so that the Out point cursor changes to a two way horizontal arrow.

Because the Timeline scrubber is now following your trimming operation, you can use the Timeline preview window to monitor what is going to become the new Out point.

The NTSC trim

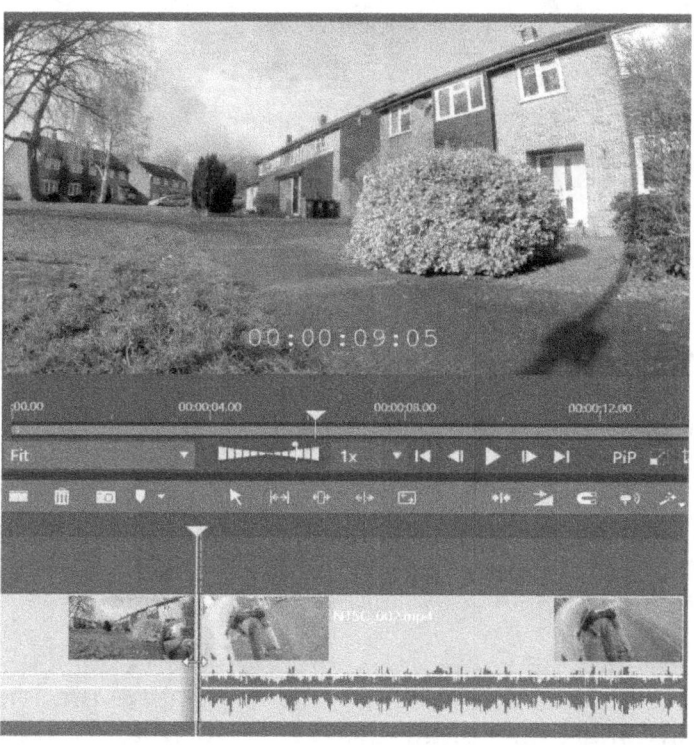

Keep dragging right until the rear of the bike has exited frame. You can overshoot a bit without an issue as long as you don't release the mouse button, because when you drag the clip back it will be reinstated.

I've settled on burnt-in timecode 00:00:09:05 NTSC, 00:00:09:04 PAL for the new Out point of the 008 clip. When you get to that, release the mouse button.

Check the new duration of the first clip by hovering your mouse over it. It should be 06.06 NTSC, 06.05 PAL. If you are puzzled by the 1 frame difference between that and the Timecode, remember that the first frame is numbered as zero and we have to include that frame in the total as well.

If you can't achieve this level of accuracy when dragging the edge of the clip, you probably don't have the timeline zoomed in enough and the effect of the magnet is getting in the way. The keyboard shortcuts can come to your rescue – the number pad + and – keys zoom the timeline view in and out. You can use them even while you are holding down the mouse button. Of course, you could also turn off the magnet by hitting the P key, but don't forget to turn it back on again.

If you are about to embark on a lot of fiddly one or two frame adjustments you might well want to turn off the magnet, but the advanced trimming mode might be better suited to your needs.

So was that Insert or Overwrite behaviour? Well the overall duration of the movie hasn't changed, so the 008 clip outgoing clip must have overwritten the 002 incoming clip.

Revealing the gap

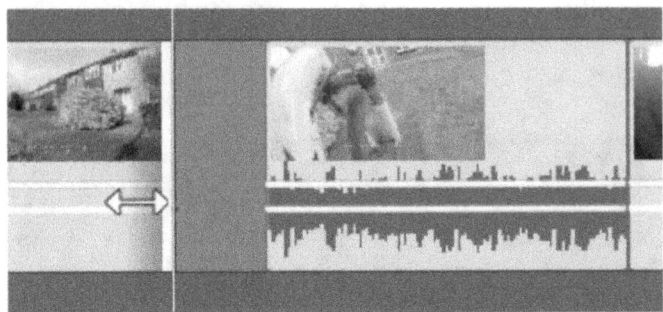

Test the principle by quick trimming the Out point of the first clip back to the left - you will reveal a gap. So it's definitely Overwrite. Use Ctrl-Z to repair the edit.

So, In Smart Mode, Quick Trimming uses the rules for Overwrite when trimming clips.

If you want to double check, switch editing modes to Overwrite and repeat the above operation. Then switch back to Smart.

Check the new edit at normal playing speed. We haven't actually fixed the problem I noted before - that the round green bush appears in both shots. Now, you could say that no one will notice - or think it is a different bush - but if it was a bright red post box people most certainly would. We introduced double action when we chose the original trim points, which is never a good thing.

I'm now going to trim the second clip. This time we want to chose a new In point that is much closer to the corner, so there is no danger of any double action - in fact, we might compress the journey a little.

Generate a Quick Trim cursor on the In point of the 002 clip and start to drag right. Notice that as we tighten the In point we are leaving a gap in the timeline - we are in Smart mode, behaving as Overwrite. Carry on dragging to my chosen frame - 00:00:22:00 for both PAL and NTSC but don't release the mouse cursor. Instead press and hold the ALT key.

Nothing will happen until you move the mouse - the tiniest amount will be enough, so you might not even change the chosen In point - but when you do, your current edit is switched to Insert mode. The gap disappears as the two clips to the right move left. If the In point has drifted, drag it to 00:00:22:00 on the burnt-in timecode, and then release the mouse button.

In Smart mode, Quick Trimming a clip Overwrites, Alt-Quick Trim Inserts.

Using Quick Trim to loosen an edit

It's all very well me showing you how to tighten edits, but you can do that with split and delete. What if you want to open up a cutting point?

In order to demonstrate this, I'm going to make a deliberate mistake first. Using ALT-Quick trim in Smart mode, tighten the In point of the last clip on the timeline to 00:00:05:00 on the burnt-in time code. I've saved this as **Basic Editing 2**.

We now have a definite jump cut because the bike rounds the corner on the onboard shot and then jumps a good couple of meters forward when we cut to the shot in the alleyway.

Fence panels relative to the bike

Have a look at the In point of the third timeline clip - there are two inset fence panels visible on the wall to the right and the bike is just about to pass the first one.

The aim of this next trim is to loosen the Out point of the second clip (002) so that the continuity is at least believable.

We don't want to overwrite the Incoming shot so we need to be in Insert mode - or as we are Quick trimming in Smart mode, holding down the ALT key will do the job.

Hover over the Out point of the second timeline clip to generate an Out point cursor, press ALT, click and drag slowly right. In the Timeline preview you will see the bike moving further down the alley. You can scrub backwards and forwards to get a feel for the position of the bike as as it moves.

When it is about to pass the first panel, have a look at the burnt-in timecode - it should be in the region of 00:00:27:00. We have quite a lot of leeway here because in the next shot the bike is quite small, so I'm going to use that timecode so we have the same values for PAL and NTSC.

Aim to match the screenshot, then release the mouse button.

Loosening the Out point

So, while we were extending the Out Point for the onboard shot, the following shot (and any other shots that happened to be to the right of it) will get pushed down the timeline, In point unchanged. We have loosened an edit.

If we hadn't been in Insert, we would have been "Rolling" the edit - adjusting both the Out and In points. We will look at more advanced ways of rolling edits in the next chapter.

There are other important points I need to make about trimming, but in order to do that, I need to rearrange the timeline, and while I'm about it, I can clarify what happens when we drag whole clips.

Save these changes as **Basic Editing 3**.

Moving Clips on a single Timeline track

With Smart mode enabled, hover the mouse over the last clip on the timeline, click and hold down the mouse key then start to drag the mouse left. The first thing you will notice is that the mouse pointer turns into a hand and the clip moves left with your action.

As you drag the last clip, it splits the clip on it's left. The last part of clip 002 stays on the left, but the split part begins to appear to the right of clip 001.

Dragging in Smart/Insert

We are in **Smart mode**, and the clip is exhibiting **Insert** behaviour.

As you keep dragging, clip 001 snaps into place in the middle of the movie. The second and third clips have swapped places. Release the clip.

What happens in Overwrite mode? Don't reset the timeline. Grab what is now the middle clip (001), hold down ALT to switch Smart to Overwrite, and drag right. This time, as the second clip starts to overlap the last one, there is no sign of a split - the overlapped part doesn't appear on the left and instead a gap opens up.

Dragging in Overwrite

Keep going and the clip you are moving will then start to split the longer clip and part of the 002 clip will begin to appear to the left of the 001 clip - but it hasn't moved on the timeline.

Complete the operation so that the clips are totally swapped over, but there is a gap between the first and second timeline clips. This gap is the same duration of the 001 clip that once occupied the positions. We have now made **Basic Editing 4**.

Floating Preview

A new feature first added in PS23, but not enabled by default, is a floating Preview window that may help when you are dragging clips. You can enable it in the *Control Panel/Export and Preview* page. The thumbnail appears to the left of the In point of the clip you

are dragging and shows the frame that would be the Out point of the clip you would be inserting into. It updates as you drag the clip.

The Floating Preview

The Timeline Preview window shows what will be the Incoming frame, while the floating preview shows the Outgoing, so you can see what the edit is going to look like. However, the window is quite small, and even on a fast computer updating can be a bit slow, so I suspect Pinnacle will try to make some performance improvements before turning it on by default.

Jogging a clip accurately

How can you accurately nudge a clip a frame or two rather than using a rather hit and miss drag and drop approach or having to zoom the timeline right into frame level? Well there are a number of ways that we will examine shortly - you can use Markers or Advanced trimming - but these take a little time to set up.

Studio 21 introduced a "quick and dirty" way of moving a timeline clip a single frame in either direction. All you have to do is select a clip, hold down ALT and then press a Left or Right arrow key. Each key press results in one frame jog in the direction of the arrow you used.

Jogging a clip with ALT-Left arrow

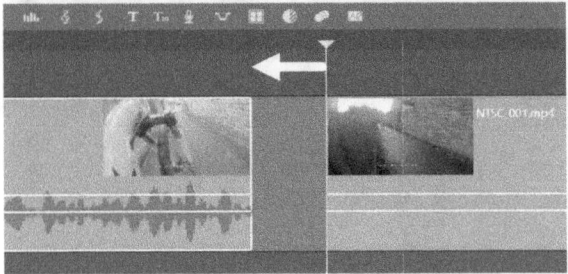

Now, this feature is brilliant for working on a single clip occupying its own track, or a clip surrounded by gaps. In Smart mode it operates in Overwrite mode. It is quick and obviously very accurate and ideal for experimenting when you are trying to line up audio and video clips that are just a little out of sync with each other.

If you want to try this on the current project on the timeline, I suggest you use the middle clip and start by jogging left. Once you impinge on another clip, you will begin to overwrite frames of that clip which won't return when you jog the other way - Undo is the best solution to fix that.

Take care if switching edit modes. For some reason I don't understand, the Insert and Overwrite behaviour is the wrong way round. Also, when working in Overwrite (which actually appears to be Insert) and jogging into another clip, you split that clip for each jogging operation, leaving a bunch of single frame slithers on the other side of the clip. This also happens in Smart mode when you hold down ALT.

Being able to jog a clip (or multiple clips) a single frame is a very useful tool, but unless the clips have suitable gaps either side there is a danger of disrupting your project, and the action doesn't obey the Edit mode rules correctly. Hopefully this will be fixed at a later date.

Trimming Timeline gaps

It's important that I make the distinction between **trimming a clip** and **trimming a gap**. If the body of the cursor is over a clip - either an In or Out point - then you are trimming that clip. If the body of the cursor is over a gap, you are trimming a gap.

You might wonder what difference that makes. In a lot of cases the final outcome will be the same. However, Smart Mode treats them differently, and in all modes you can't make a gap smaller than zero frames - it no longer exists - so that is where any trimming actions stops.

Trimming a gap, then a clip

I've deliberately created the gap in the previous section to demonstrate this point. It is available as **Basic Editing 4** if you need to load it.

I want to be able to loosen the In point of the second clip - so that it fills the gap to its left, but I also want it to overwrite the end of the first clip on the timeline.

Set the Edit mode to Overwrite for the clearest demonstration of this. First trim the Out point of the gap - a trim point to

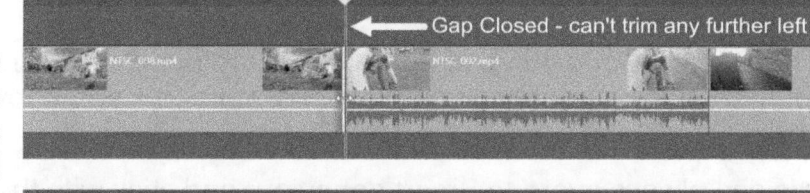
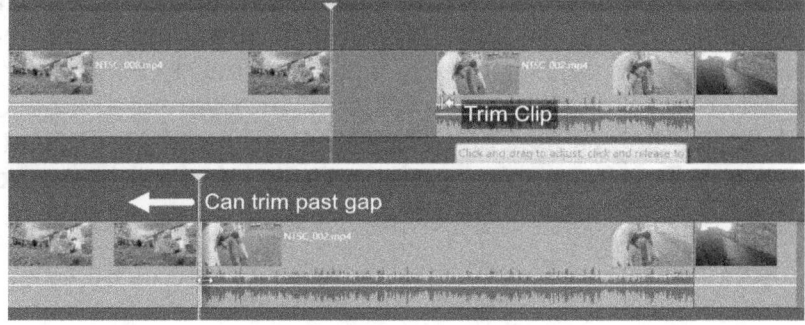

the right of clip 002 - to the left. The In point of the clip is loosened so that it overwrites the gap.

When you reach the end of the gap, the trimming action stops - you can't trim any further.

Reset the timeline with Undo, and then generate a trim cursor for the In point of the clip. Trim left and you can go past the In point of the gap and start overwriting the first clip on the timeline.

So, that's one significant difference between trimming gaps and clips.

You might wonder why I suggested you switch to Overwrite for that demo, rather than Smart mode. Here's why...

Smart Mode and Trimming Gaps

I was being careful when we discussed trimming clips - Smart mode does indeed work in Overwrite. However, when Smart works with gaps, **it works in Insert mode**. Restore the gap in the above demo with Undo, switch to Insert mode and try trimming the gap - notice how the clips to the right shuffle up and down the timeline as you change the size of the gap.

Now switch to Smart mode and try the same thing - and clearly Smart behaves like we are in Insert mode.

So, In Smart Mode, Quick Trimming uses the rules for Insert when trimming Gaps.

Working with Smart Mode in general

The different behaviours of Smart mode are more confusing when you try to analyse them than they are when you just use Smart - it's somehow intuitive, at least it is for me!

We can always override Smart behaviour and stick with the more predicable modes, but Smart tries to do that - Be Smart - and unless you find it very confusing it's well worth working with it until it becomes second nature. Also, Smart mode doesn't always just choose an exact "insert" or "overwrite" function. In more complex multi-track situations it may also adopt a more helpful course of action. In general, holding down ALT defeats this helpful attitude. We will be exploring Multi-track editing in detail later.

Close Gap

If you don't fancy dealing with gaps by trimming, as I've already mentioned, there is a context menu option to *Close Gap*, or if you click at the end of the timeline *Close Gaps*. This is a feature which is useful if you are just working with one track. I don't recommend this feature for multi-track projects, as it won't move items on the other tracks.

Filling a Gap

What if you didn't want to close the gap, but put another clip into it? If you are trying to maintain the length of the gap or not alter the timeline then you could try to pre-trim a clip to fit exactly, or you could make it a little shorter than the gap and trim it once in place.

However, there is a much neater way to perform the operation - and it only works in Smart mode.

Restore the gap you trimmed out of the demo project in the previous section (or load up **Basic Editing 4**). There is a space between the first and second clips that we could fill if we had some footage that didn't give away the continuity. Fortunately, we have exactly the footage for that - clip 004.

Ready to add the clip

With that in the source viewer, I've set in In point at 10 seconds into the clip. **I haven't set an Out point**. So, the pre-trimmed clip is still nearly 30 seconds long and the gap is only 2 seconds long.

Set the edit mode to Smart and place the scrubber on the first black frame of the gap.

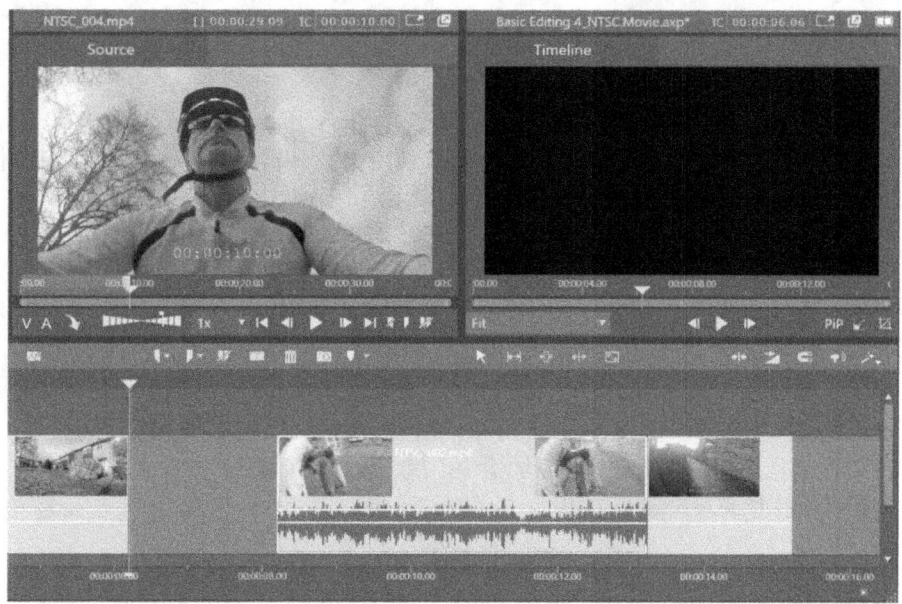

Now switch the preview back to Source and use the *Send To* button.

Gap Filled

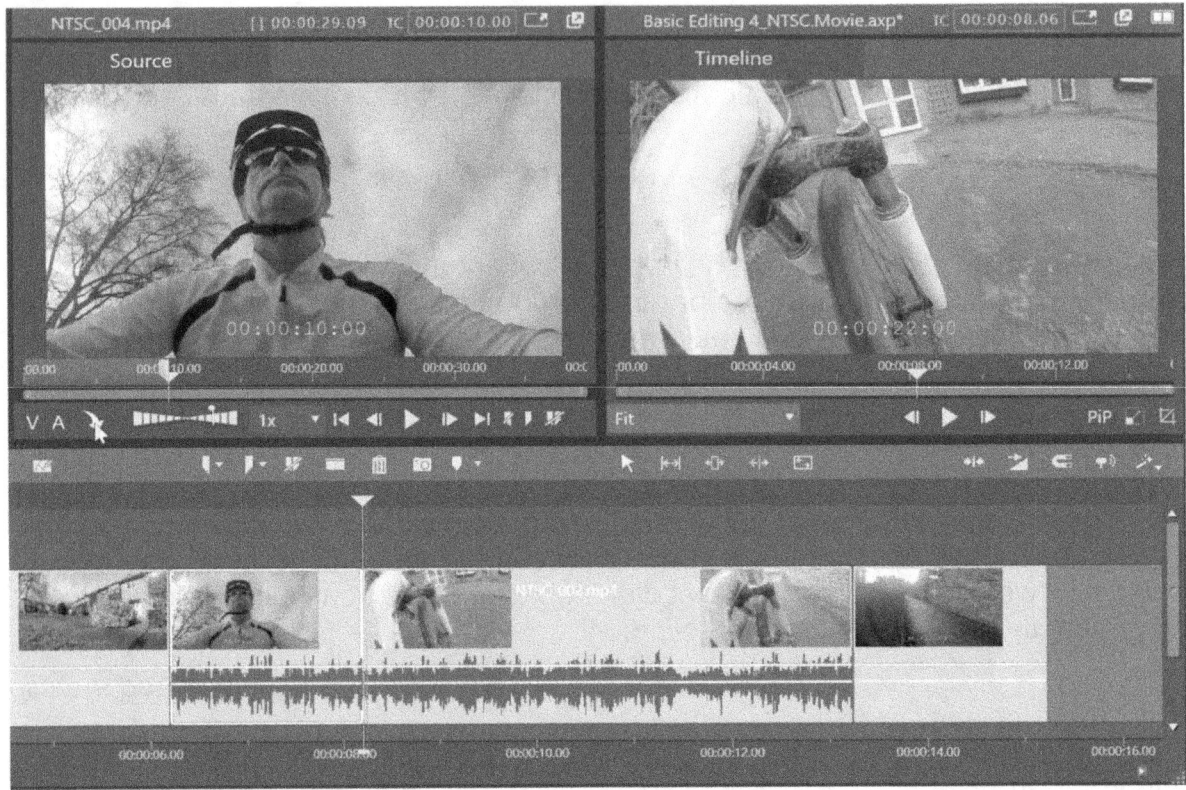

What you are seeing is Pinnacle Studio's Smart Mode being very smart indeed. It has made an assumption that you want to fill a gap with the clip in the source player, and has placed the start of the clip in line with the scrubber but it hasn't overwritten the following clip. Neither has it displaced the following clip to make room for the whole duration of your source clip. It is behaving like Overwrite where there is a gap, but not overwriting any video or audio that is already on the timeline.

That's a very handy feature that saves you time. As we only set a single In point on the new clip, and the In and Out points were defined by the target clip's boundaries, it is called **3-point editing**. Pinnacle have introduced a whole editing mode called 3-4 point editing, but the original NGStudio always had 3-point editing, it just didn't make a big fuss about it!

Save the final result as **Basic Editing 5**.

However, what if you did actually want to insert? You can defeat Smart mode when using the Send to Timeline button by using the ALT key. If we use drag and drop, it's much clearer to demonstrate.

Use Undo to remove the new clip and then try the same operation by dragging from the Source preview window. If you aren't aware of what Studio is trying to do, you might get confused, but once you are aware of the "Gap filling" feature, it makes sense. Drag your clip to a gap in the timeline and it fills it if it can, but never overwrites any other material - here we are seeing Smart Mode do something that you can't do in either of the other conventional modes.

If you don't drag the clip into a gap but instead to somewhere that already has a clip, Smart Mode behaves in the same manner as before and creates space by rippling the remaining shots to the right. If you hold down the Alt key, Smart is disabled and the drag and drop reverts to Overwrite mode regardless of if you are hovering over a gap or a clip.

You aren't restricted to filling the whole of the gap with either Drag and Drop or Send to Timeline. The In point of the new clip is placed at the scrubber position, so that you can fill just part of the gap.

This isn't just a video feature. If you have a gap that you want to fill with audio or a title, Drag and Drop from the Source viewer or Compact Library is a great way of doing it.

You can't use the same trick using clips from the timeline – you would have to trim the clip so it was shorter than the gap, drag it into the gap in Smart or Insert mode and then Quick trim the out point back to the exact duration of the gap. There is a conceptual difference to how a clip behaves depending on where you drag it from, which is an important point to remember.

Replacing a clip

I want to show you another of Studio's clever tricks - it's a variation of 3-point editing. You can drag a clip from the Compact Library or the Source Preview window and get it to replace another clip. The new clip will take on the duration of the old clip. As an example, I'm going to change clip 002 (the forward facing on-board shot with the wheel in foreground) with clip 003 (a point-of-view shot from the handlebars).

We don't want to change the position nor the duration, just the content. If I match the In point of the new material with the In point of the old, the continuity of the shot should be roughly right, assuming the bike is moving at a similar speed.

Put the scrubber at the start of the third timeline shot. If you have the screen space, this is a very good time to use the Dual preview mode.

Preparing to replace the third clip

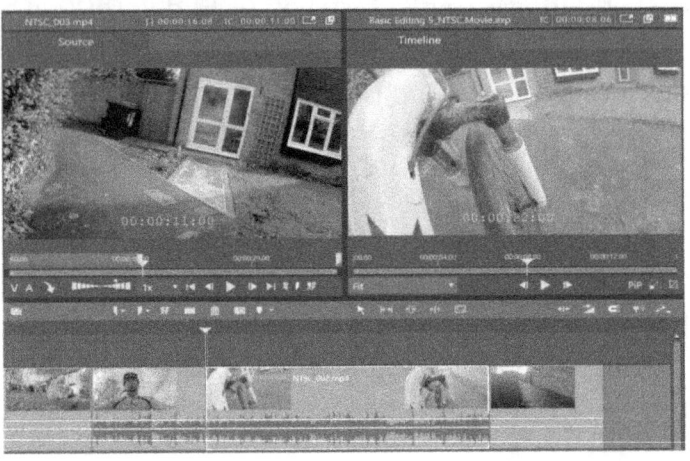

Select clip 003 in the Library and examine it. I'm going to select 00:00:11:00 as a close enough match for the In point of the new replacement clip, so set a In point there by pressing the I key or using the Source Preview caliper tool. Check you are in Smart mode.

The keypress that you that need to remember for a replace operation is **SHIFT**. Hold it down and then drag from the Preview window to the timeline. Wherever you put the cursor the whole of the shot underneath is going to be replaced with the one from the Source Viewer.

Don't panic if the thumbnails of the target clip don't change - this may be a performance issue, so you might see that happen, but if you don't, just trust me. You will see the audio waveforms change whatever. Hover over the current third clip on the timeline - clip 002. You don't need to line up the cursor with the beginning of the timeline clip.

Release the mouse button, and clip 002 will be replaced with clip 003, starting at the marked In point and with the same duration, so nothing else on the timeline moves.

There are a number of points worth making about the replace operation:

• You have to be in Smart mode.

• If there isn't sufficient duration available in the new clip the operation won't work.

• You can select SHIFT **after** you start the dragging operation in the same manner as ALT, so changing your mind is easy.

• You can replace timeline clips with either video or audio from the Source viewer or Library even if either the Video or Audio stream for the target clip is not active.

• You cannot swap a photo for a video or vice versa.

• If an effect has been added to a clip, that effect is inherited by the replacement.

Save this as **Basic Editing 6.**

Copying Clips on the Timeline

The next technique I'm going to demonstrate is also very useful. We can use the Windows style Copy and Paste to create a copy of a clip, including trims, properties and effects but it has limitations. There are also clip context menu options to Copy and Paste All.

However, it's possible to drag a copy of a clip or group of clips, to elsewhere on the timeline as a **single operation**.

The difference is in the CTRL key. Click on a clip, hold down CTRL and then drag the clip to a free spot on the timeline Instead of the original clip moving, a fresh copy goes to the destination.

You should notice that when you are dragging a copy of a clip, the mouse pointer changes from a hand to a double arrow.

The Move and Copy mouse cursors

How the rest of the timeline behaves will depend on your Edit mode and chosen destination. The copied clip behaves no differently than if you had brought it from the Source Viewer or Library.

The copy will include all the additional attributes you have added to it. You can also perform this with multiple clip selections. You are not limited to which track you drag the clip or clips to, as long as all the clips have a track to occupy when you drop them.

Cut, Copy and Paste

Instead of using Drag and Drop to move a clip or group of clips in a project, you might prefer to use *Cut and Paste*. Reasons for doing this include giving yourself a bit more thinking time, seeing the result of the Cut before you apply the Paste, or most likely working on two parts of a long movie that are some way apart. You can also Copy and Paste to make a duplicate of a clip or group of clips, rather than use CTRL-Drag and Drop.

The *Edit* menu at the top of the screen is one place that you can find the Cut, Copy and Paste commands. The standard Windows keyboard shortcuts work - CTRL X, C and V - and operate identically to using the edit menu commands.

Cut, Copy and Paste All are also in the Clip Context menu, and Paste All is in the Gap Context Menu. In the current version of Studio, these commands behave slightly differently, as we will see.

If you *Cut* a clip, it is deleted from the timeline but placed in the Paste buffer (sometimes called the clipboard). When you *Copy* a clip, the original is left in place, but another copy is placed in the Paste buffer. Now, when you use *Paste* or *Paste All*, the contents of the clipboard are inserted into the timeline wherever the scrubber happens to be.

In all versions of Studio up to 23, the clip, or clips, returned to the **same track as they were copied from,** regardless of what timeline track was active or which paste command you used. When pasting to multiple tracks you may be grateful of this behaviour, but it may not be what you expect.

In the current version, the behaviour of Edit menu commands and keyboard shortcuts is still the same. If you want use Copy and Paste, my recommendation is to use the keyboard shortcuts.

However, if you use the Context menu, the track on which you open it to use Paste **becomes the target track**. This seems to work fine for single clips, but once you start to use groups of clips spread over a number of tracks, there can be problems because Studio insists on creating new tracks to accommodate the clips that were on higher tracks, even if there is no need.

Cut, Copy and Paste are very useful in lots of circumstances. If you already have a clear idea of what you are doing they can save time. They can also be used to move items from the Library or even between projects. However, as part of the creative process I prefer drag and drop because it is clearer what you are doing. If your thought process is interrupted after you cut but before you paste, who knows what is on the clipboard?

Over Trimming

This is something that can occur whenever you trim Video or Audio clips.

Restore the project to it's previous state (or re-load version 6). I've decided not to use the last shot - I'm going to use an alternative - but for now I want to see what happens if I extend clip 003 - the on-board handlebar shot. Quick trim the Out point to the right. It overwrites the last timeline clip, but doesn't stop when it gets to the end of the movie. You can keep going, and going - there is no limit to the duration.

However, eventually the source clip will run out of information. There isn't anything else to see (or hear). What Studio does in these circumstances may surprise you. It lets you extend the clip, but marks the over-trimmed material differently - a sort of grubby pink colour. People refer to this as "Dead Meat".

When this is played back, you will see it consists of a frozen picture of the last frame of the clip, and you will hear silence.

Overtrimming

Why would that be useful? In other editors you might be used to the program simply refusing to let you extend the clip. Pinnacle Studio lets you do that to give more flexibility when adjusting multi-track projects. The pink colouring is a warning that the video is frozen.

That frozen video may turn up unexpectedly in transitions,

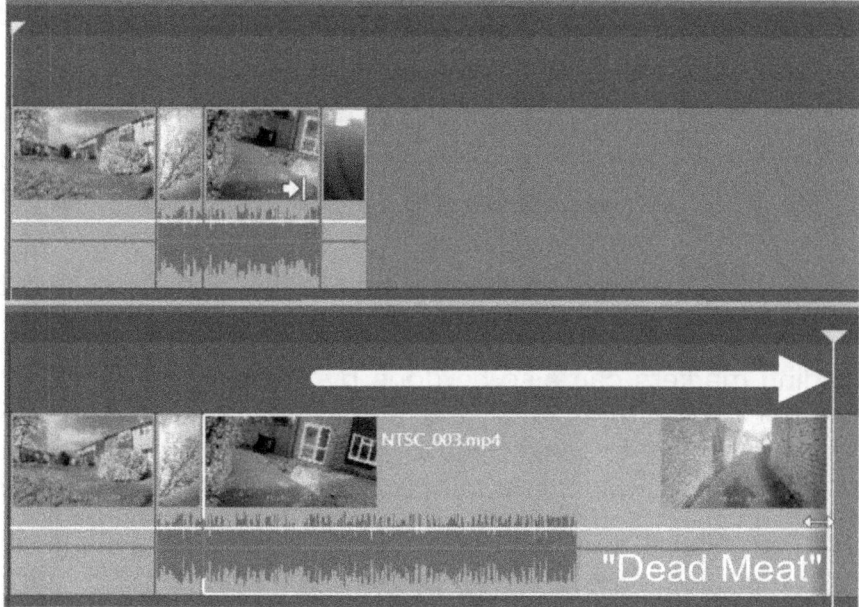

montages and templates as well as on the timeline. It is a lot more welcome than black frames!

Once you have released the mouse button, the junction between the live clip and the dead meat becomes a snapping point. Trim back from the new Out point and the clip will snap to the last available moving frame. Save this as **Basic Editing 7**.

Using Markers

Markers have many uses - you can use them to make a point of reference for later in the edit process, for example - but probably their most important feature is that the scrubber will snap to them, so they are an aid to accuracy.

Using a marker isn't as destructive as splitting a clip either, so I'm going to use one to indicate precisely where I want to insert a new shot.

Let's continue to work on the cycling project (or you can load version 7 if you wish)

Place the scrubber over the last clip at the burnt-in timecode 0:00:18:00. This seems like an arbitrary decision, but in other circumstances you could have a requirement for very precise alignment.

Click on the marker tool on the timeline toolbar and an orange marker will appear on the timescale at the same place as the scrubber,

Adding markers can also be done by pressing the "M" key. Neither method stops playback if it is running, so it is a great way to make a quick note of a point in the movie you want to come back to. I use this feature a lot to mark the beat of a music track I want to edit in time with, as you will see in the *Working with Photos* chapter.

You can alter the position of a marker by dragging it with the mouse. To delete it, when the scrubber is exactly aligned with the marker, the marker tool acquires a line through it. Clicking it now deletes the marker above the scrubber, as does pressing the M shortcut.

More sophistication can be achieved when you open the Marker Panel with the drop-down arrow alongside the Marker icon. The panel can be placed anywhere on the Edit page.

You have a choice of three colours so that you can use different colours to mean different things. As you add markers you build up a list which also displays the timecode for each marker position.

The Marker Panel

Clicking on this list takes the timeline scrubber to the timecode of the marker. Alongside a highlighted marker is a trash can. At the top of the panel is a box where you can edit the marker's name. Scroll buttons either side of the box let you step through the markers, and below is a box where you can type in a timecode to alter the marker's position. When you finally want to tidy up the display, Delete All Markers is available at the bottom of the panel.

So, why did I place the marker? Load clip 006 into the Source preview and set an In point at 00:00:06:00 of its burnt-in timecode. Make sure Snapping is turned on.

Drag the clip from the source viewer and let it snap into place with the marker, then press down the Alt key so that the clip overwrites the on-board shot, preserving its continuity when divided into 2 parts. Release the mouse button.

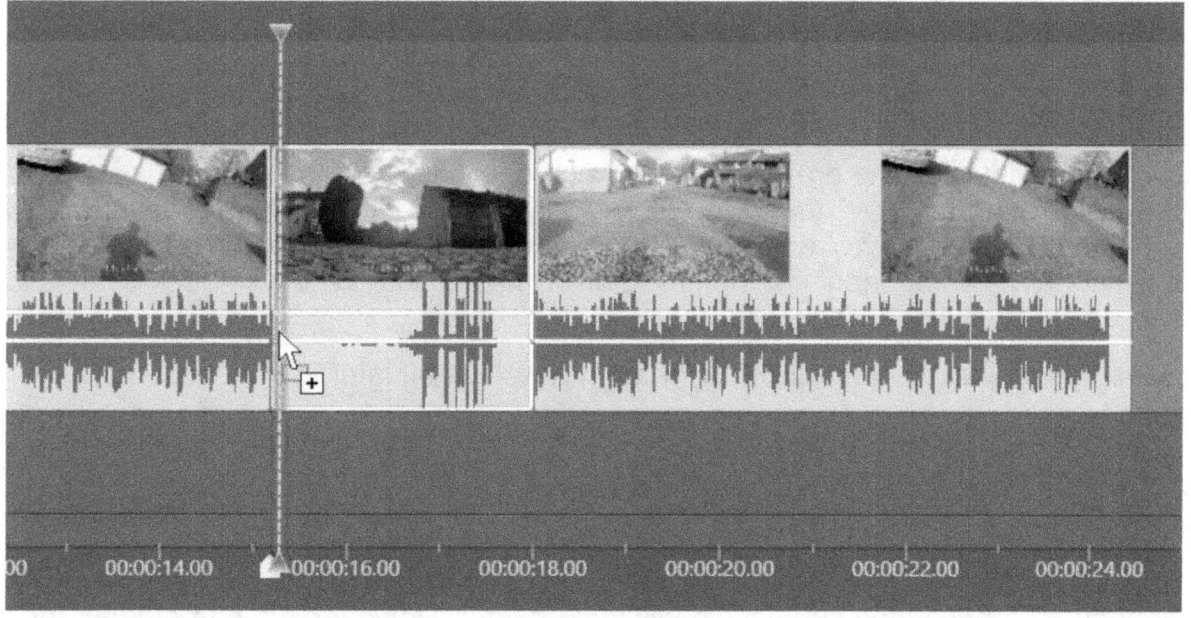

This example might seem a trivial use of a complex feature, but markers are one of the things in Pinnacle Studio that will grow on you. We will see later that you can also add markers to the clips themselves, and there will come a point in a complex project where the only alternative to adding a marker might be actually to write down the timecode of a point you need to line up to, so the sooner you get in the habit of using them the better!

Grouping Clips

This feature turns a selection of clips into a single clip, but only for the purposes of selection. If you have added a title above a particular video clip, or perhaps something more complex such as a Video overlay, then grouping is a way of ensuring that when you select one asset, the other gets selected as well.

Forming a group of clips

Multi-select the last three clips of the project and right-click on any of the highlighted clips. Select *Group* from the Context Menu, then select Group from the sub-menu.

Deselect the clips and now try to select just one of them. You will find that all of them are selected automatically. Now drag the group around the timeline – and you will see how it behaves just as if you have multi-selected the clips.

Put the grouped clips back at the end of the timeline and experiment with something else. Select the second clip on the timeline and drag it into the group of clips. The clips will be disrupted in the same manner as if they weren't grouped. It's important to understand that grouping doesn't convey any special qualities to the selection of clips other than selection. The components of the group aren't locked into sync with each other and can be split just like a single clip.

Save this project as **Basic Editing Final**. We will use it later in the book.

Save Group as Project

You may may have spotted another command in the sub-menu - Save Group as project. That's a new feature that was introduced in PS23, and although it may have uses as a standalone command, its main purpose is to aid working with nested sub-projects - an advanced subject we will look at later. However, we can at least try it

out. Ungroup the current group and then use CTRL-A to select the whole project. Now select Save Group as project from the Group context menu and name the movie **Basic Editing Final Subproject** when prompted.

You will see the whole project turned into a single timeline clip - a subproject to be discussed in the Editing Enhancements chapter.

Before that, there are a whole raft of other advanced techniques waiting for you in the next chapter.

Advanced Editing Techniques

It's now time to take a first look at what I've called Advanced Trimming, otherwise know as Trim mode. If you are only running Studio Standard, I'm afraid this chapter isn't relevant to you, although it does tell you what you will get if you upgrade!.

I'm going to divide up the description of Trim mode into two parts. This section deals with trimming just on one track. Once I have introduced some multi-track fundamentals, I will return to trimming across more than one track.

The Trim Mode and Advanced Trimming

Time to finally generate that yellow trim point. To help with the screenshots I'm going to use some different source material with a large font used for the burnt-in timecode. If you want to use the same clips as me, they are called **Car Clip 1**, **2** and **3**. I've put them in a new project bin named *Cars*.

I've started with all three 8 second clips positioned on the timeline. The timecode you can see in the screenshots is superimposed on the video clips themselves.

The three clips on the timeline

This project is called **Advanced Trimming**. Before we start, you might want to remind yourself of what happens if you trim a clip's In point with Simple trimming and the edit mode set to Smart. A green bar shortens the duration of the clip by removing frames from the front of the clip, and all three clips stay in the same position on the timeline. This is happening in Overwrite mode

Undo any trimming you have done. Now let's set an Advanced Trim point.

As I've already mentioned, there are two ways of setting a yellow Advanced trim point. Hovering in the region of a clip that creates an In or Out point cursor then clicking and releasing the mouse button sets a yellow trim point, as long as *Control Panel/Project Settings* has *Activate Trim Mode by clicking near cuts* checked. I'm going to ask you to set that mode now, even if Pinnacle have turned it off by default, because it is going to save us lot of time.

However, to begin with we will use the Timeline toolbar Trim Tool, or its keyboard shortcut **T**. Place

Trim Mode (T)

the timeline scrubber in the first half of the second clip - about 2 seconds into clip 2. Now click on the Trim Tool or press the **T** key.

So what happened there then? If you haven't seen it before, you should have been pleasantly surprised at the presence of not one but two player windows top right, with the area labelled "Trim Editor"..

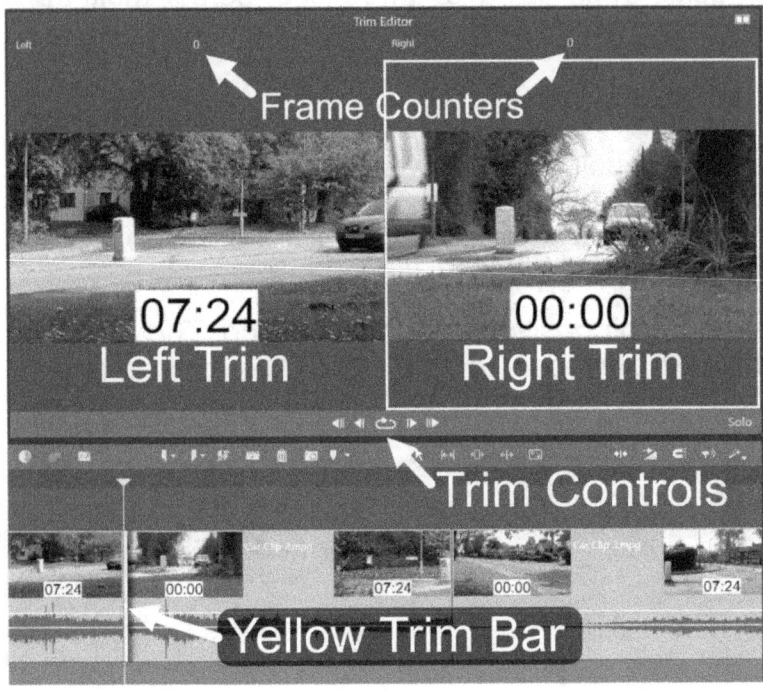

The left preview is showing the Out point of Car Clip 1 and the right preview the In point of Car Clip 2. There is a yellow frame around the right preview, indicating that it is monitoring the active trim point.

Let's start using trim with the mouse. Hover in the lower half of Car Clip 2 near the yellow bar and a familiar In point trim cursor will appear. Click, hold and drag right. The first thing you should notice is that both clips 2 and 3 move to the left – Smart Mode in Advanced Trim works in **Insert Mode,** as opposed to Quick trim, which works in Overwrite. You will see Clip 2's opening frame being updated, in the right-hand preview window. Keep dragging until the burnt in timecode reads 02:00 and release the mouse button. Now the clip thumbnail will also update, but the trim bar won't disappear.

Trimming with the Player Windows

Although it's not immediately obvious, you can also drag on the Player windows to adjust the In point and Out points of the currently selected trim point. This is a neat way of making adjustments that will come into it's own when we have more than one trim point.

Hover over the right trim window and the mouse point becomes an In point cursor. Click, hold and drag to adjust the In point to a timecode of 01:00.

Adjusting Trim points accurately

In my opinion, the biggest advantage of the Advanced trimming is that you can adjust your edits with frame accuracy.

The Trim mode tools

Underneath the Trim Editor are five controls. The middle one is *Loop play,* which allows us to examine the edit at normal speed by playing a short section either side of it, continually looping until clicking it again stops the playback. The arrow buttons either side trim the edit –
left to right they trim 10 frames back, 1 frame back, 1 frame forward and 10 frames forward. You should experiment with these controls to appreciate the accuracy.

There are keyboard alternatives as well – the arrow keys (or Z and X) for single frames, or with Shift added to for 10 frame jumps.

An alternative are the four keys to the left of the right shift key - **M** , . and / on a US/UK QWERTY keyboard. These mimic the four buttons on the Trim Editor.

You should explore all the methods of adjustment before we start working through the next few pages. I hope that you will agree that the tools and keyboard shortcuts bring a degree of accuracy that is superior to just dragging on the timeline clips.

Exiting Trim Mode

To get rid of a single trim bar, you can press the T key again. Clicking on the Trim button has the same effect. The T key and the Trim mode button on the timeline toolbar are interchangeable, so if you prefer working with the mouse, use that control.

Alternatively, you can exit Trim mode by clicking on another clip or blank timeline area if "Clicking near cuts" is enabled.

Advanced Trimming and the Editing Modes

Won't it get very confusing if Smart mode in Simple Trim works in Overwrite on clips, but in Advanced Trim it works in Insert? Hopefully not, once you are aware of the feature. That's why the trim bars are different colours, for one thing. Also you will tend to be using the different trimming tasks for different operations.

When trimming a gap with the yellow bars, you will find Smart Mode operates in Insert (as it does with Quick Trim).

You can use the Overwrite mode, either by switching to the Overwrite edit mode or using the Alt key in conjunction with the Trim Editor controls or the mouse - but not the keyboard shortcuts.

You can even use the difference between Simple and Advanced trimming to switch between modes. Click, hold and drag to get Overwrite. Instead of adding the ALT key to the mix, you can click and release to get a yellow trim bar, then click and hold again to drag in Insert Mode. If you are a "Mouse only" type, you might well prefer this workflow.

Legacy users and Trim mode

In earlier versions of Studio, the *Clicking Near Cuts* option could cause some confusion. I'm happy to say that Pinnacle have now standardised how Trim points are created, particularly when using the Shift modifier. Setting trim points uses the same controls regardless of this setting - it just disables being able to create or delete the first trim point by clicking.

The Trim tool and In/Out Point Placement

If you are using the Trim tool or T key, then the scrubber position dictates where the first trim point is created - it is set to the **nearest** trim point, regardless of track or clip selection.

Changing, Adding or Removing Trim points

Apart from the added accuracy, Advanced Trim offers another advantage - a hugely powerful option to have more than one trim point at the same time.

In fact, **each track** can have two Trim points - one In point and one Out point..

Regardless of the *Clicking near cuts* setting, once in Trim mode you use your mouse to change trim points.

- To change the location of a single Trim point, click and release on the new location.

- To add a second Trim point to a track hold down Ctrl before you click and release.

- To add the first Trim point to another track just click and release as above.

- To change which Trim point is the "active" one - shown in the preview - CTRL-click on the one you want to see and control.

- To remove a Trim point, hover over it, click and release. You can't delete the last Trim point that way if *Clicking near cuts* is set to off, you need to exit Trim mode.

- To exit Trim mode regardless of how many trim points are set, press T or click on the Trim mode icon. If *Clicking near cuts* is on you can also select a clip.

Trimming with the Trim Editor

Pinnacle Studio normally provides two Player windows when Advanced trimming. You can return to using just one by clicking the Dual Mode button or using the Ctrl-D keyboard shortcut. The single Trim mode view will always show you the frame at the trim point you last set.

When you are in Trim mode, you can't use any of the normal jogging controls, but you can scrub through the timeline with the scrubber, even though it returns to the trim point when you release it. **Space** and the **J**, **K**, and **L** keys work, but only in Loop play mode - you cannot play areas of the movie other than those either side of the edit.

Because of the way Pinnacle Studio arranges its edit windows there is very little advantage in disabling Dual View even if you are using a small display. Dual View gives a lot more information and greater control over trimming. The player windows are labelled Left and Right.

If a window has a yellow border, then it is monitoring a trim point. If there is no border, then it should be previewing the next or previous frame on the timeline. If the frame is black then that frame is in a gap. However, in the current build of Studio, "inactive" preview windows don't always update themselves immediately after certain actions, and also if you are at the beginning or end of the timeline you may not see the black level you would expect.

To begin with, let's look at using the Trim Editor with just one Trim point.

If you didn't load the clips I used at the beginning of the chapter, you might want to do so now, or load the *Advanced Trimming* project. If you did, then reset the timeline with Undo so that it contains the three clips without any trims.

Set a trim point for the In point of Car Clip 2. The Trim Editor appears with a yellow border round the Right preview, which is showing the first frame of clip 2 - the active trim point.

Above the window a number is displayed in orange - to begin with it is set to 0, showing that the current trim point is set to an offset of zero into the start of the clip as it was originally placed on the timeline. (This figure is reset if you add new clips to the timeline.)

If I hover my mouse over the Right Trim Player window, I get an In point handle. By clicking and dragging left or right I can trim the clip right there.

A double headed mouse cursor will have appeared during the trim. I have adjusted the In point to 5 seconds, showing a 125 offset.

If you have trouble with accuracy, don't forget the trim buttons under the player, or the keyboard shortcuts for single frame or 10 frame adjustments.

If I play the edit in loop mode I see it is a poor edit. I should have been able to predict that by looking at the outgoing frame to the left, because of the very similar looking car that has just entered the right of frame. My brain can't help thinking that the car we cut to on the incoming shot is the same car and the edit is a jump cut.

To quickly adjust the Out point of clip 1 I don't even have to move my mouse to the timeline - clicking on the left trim window sets an In point at the displayed frame! This happens if no Trim point is already set in that window, but it also can change a Trim point that is already set, so take care once you are using multiple tracks.

I can now drag the Out point of clip 1 left to tighten it by 9 frames, excluding the part of the video where the black car comes into shot. This is **Advanced Trimming 1,** if you want to save your own version.

So, that's a great way to use the Trim Editor, even if you are adjusting single edit points.

Just a reminder - holding down the Alt key during operations in the Trim Mode switches Smart trimming to Overwrite mode, should you wish to do that. You still benefit from the greater accuracy and better monitoring options.

One final feature I need to mention in the Trim Editor is the Solo button bottom right. When it is active (coloured orange), you see the clips at the current trim points in their raw state, without effects added or other tracks overlaid over them - Solo. Otherwise, you see the composite view of the current timeline.

Until you have content on more than one track, or add an effect to a clip, you won't see any difference whether this button is active or greyed out.

Two Trim Points

Working with more than one Trim point is even more powerful. To add one to a track, hold down down the **CTRL** key before you click.

The rule is that any track can have two Trim points; one of them must be an Out point, the other an In point. It doesn't matter where they are in relation to each other as long as there is one of each - The Out point trim bar can be on a clip to the left of the clip with the In point trim bar. If you already have an Out point set and try to set another one, the first will be deleted.

Rolling an Edit

I have added trim points to either side of the edit between clips 1 and 2. This arrangement is called "rolling the edit point". Every frame we take off one clip causes a frame to be added to the other clip.

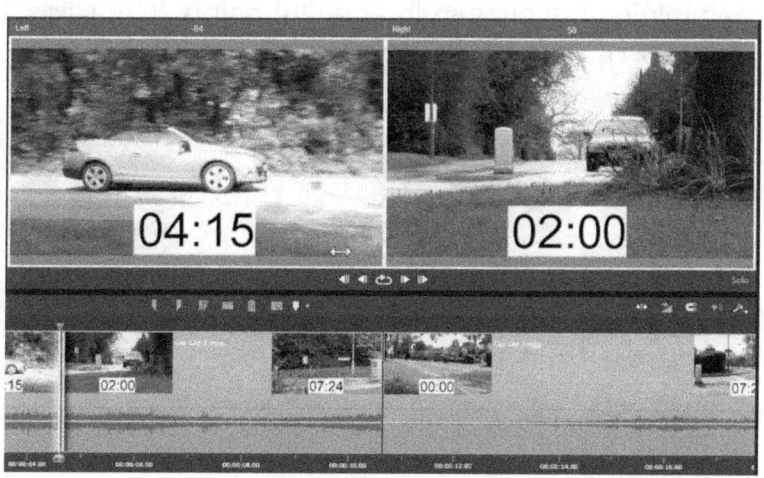

Try dragging the clip in either of the Trim mode windows. Alternatively, try the Trim buttons or keyboard shortcuts.

In my example clips, I can easily find frames for both the Incoming and Outgoing, that are clean of other vehicles or items like the bollards that give the game away that we are looking at the same stretch of road. What's more, I'm not affecting the total duration of the two clips combined, nor am I affecting the In point of the outgoing shot or the Out point of the incoming.

Rolling the edit point is a good way of polishing an edit that feels uncomfortable without having to restructure the movie around the edit. It's handy with audio as well.

This is quite easy to do in Overwrite mode with just one green trim point but you don't get the benefit of two preview windows. Neither can you use single frame jogging.

The 3-4 point Editing tools

Studio Plus and Ultimate now has a set of timeline tools for 3-4 point editing. One of them is to **Roll** an edit, and there are also tools for **Slip** and **Slide**. I will look at them later, and they can be easier to use, but don't dismiss the Trim Editor for carrying out these three tasks - I think it is a more powerful and accurate choice.

Adjusting the Placement - Slide

Let's look at what happens with the trim points further apart. Restore *Advanced Trimming 1*. Add a trim point on the right edge of Car Clip 1, then holding down Ctrl and click on the left edge of Car Clip 3. This will add Trim points to the "outside" of Car Clip 2.

Trimming the clip left or right shows how this combination moves Car Clip 2, maintaining the chosen In and Out points. Car Clips 1 and 3 stay where they were, and their video is either hidden or revealed as Clip 2 is moved. No gaps are created.

Outside trimming reveals Dead Meat on clip 3

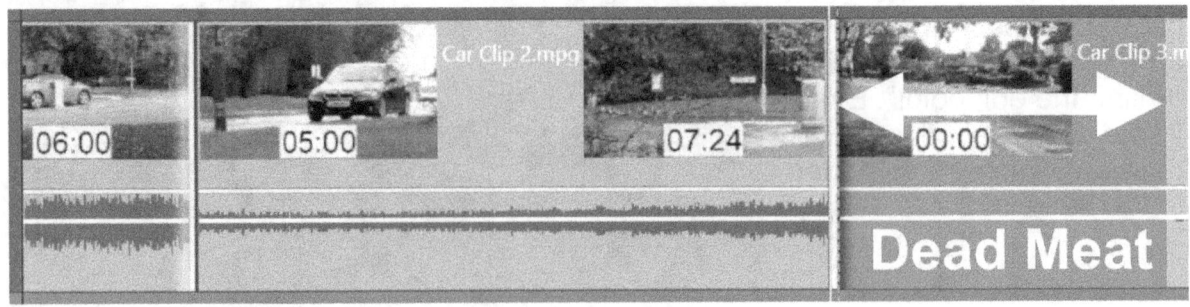

We are adjusting the **Placement** of Car Clip 2 with this trim point selection - **Sliding** it along the timeline

The In and Out points are **outside** the clip we are adjusting. Note that if the two Trim points bracketed a sequence of clips, all these clips would be moved as one - something that the 3-4 point slide tool can't do.

Adjusting the Content - Slip

The next arrangement adjusts the **content** of a clip or clips without altering its position. I've restored version 1 and then placed the In point at the start of Car Clip 2 and the Out point at the end of the same clip.

As I adjust the trim now, the position and duration of the gap into which Car Clip 2 fits doesn't alter, but the video content slides left or right. Moving the content left immediately gives me the problem of there being no more video available on the outgoing of clip 2.

Moving the content right is more rewarding. There were empty frames without a car in them at the end of the shot originally. In this case using the trim function makes it easy to lose those frames while automatically adjusting the In point so that the shot has a fixed duration.

We are adjusting the content with this Trim point selection - the In and Out points are **inside** the clip we are adjusting. This is also know as **Slipping** the clip. Again, note that if the two Trim points bracketed or just one but a sequence of clips, all these clips would be moved as one.

With the Dual mode view of the Trim Editor, it's easy to keep an eye on both the incoming frame as well as the outgoing– both may have a bearing on the final choice of content.

So, even before we look at the use of trimming on more than one track, I hope you've seen some useful possibilities.

Advanced Trimming, Transitions and Split Trim points

The narrative of this book hasn't introduced transitions yet, and when we do I'll write about how to adjust them. However, while we are discussing Advanced trimming, I'd like to explain something.

Prior to the introduction of the new transition behaviour in Studio, transitions could be separately controlled within the Trim mode. In PS24, trim mode leaves transitions untouched when you adjust the Trim points, although it does acknowledge their presence and moves them with the clip they are attached to.

In PS21 and earlier, it was possible to set a transition trim point on the top half of a clip and a clip trim point on the lower half. If you only used one point, then either the transition or the clip were adjusted. To achieve this, you used the **ALT** key when setting Trim points.

A "legacy" split trim point in PS24

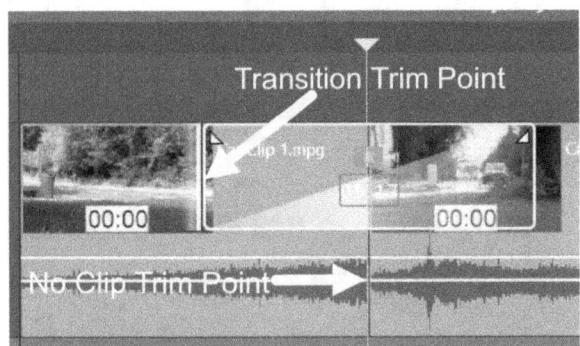

You might wonder why, if this book is about PS24, I'm giving you a history lesson, but the ALT key behaviour is still present in PS24, it's just that if you set a split trim point, it has no bearing on the trimming.

So if you see that a Trim point doesn't cover both halves of a clip, you must have held down ALT at some point. Don't worry though, it will have no affect on your trim operations - at least none that I've been able to detect.

We have reached the limit of what I can demonstrate about Advanced Trimming without adding more tracks to the project. I will return to the subject of trimming when we have explored projects with more than one track.

Multi-track Editing

Apart from the Whistle-Stop tour, we have been working with just one track up until now. Over the next few pages I'm going to show you how to add, rearrange and delete clips on other tracks, and in particular examine how Smart mode behaves during these operations. I'm afraid most of this information isn't relevant to Studio Standard.

Let's begin the demonstration by starting with our three car clips placed in order and in full on timeline track 2 - or you can revert to the **Advanced Trimming** movie that can be downloaded from the website or data DVD.

I'm going to overlay transparent video clips on track 1, with identifying titles and burnt-in timecode as well as audio that matches the clips over which which we will place them. I have created these clips in Pinnacle Studio Ultimate using the new Cineform transparency option.

If you own Studio 24 Standard or Plus, you can now import Cineform with transparency so you can use the same project and source files.

Use the Cars bin we have already created and add three clips from the website or DVD - *Overlay for Car Clip 1, 2* and *3.mov*. Also add a music clip *Multi-track editing Audio.wav* which you will find in the **Music** folder on the zip files or the Data DVD.

Drag each Overlay Clip to track 1 and place it over its corresponding car clip, then add the music to track 3. You should have created a timeline that looks like the screenshot. (This project is available as **Multi-track Editing for PS24***).*

The overall concept here is that whatever operations we carry out on the movie, if we want to retain the sync of the clips already on tracks 1 and 2 then the burnt-in timecodes and audio waveforms must match on each pair of clips.

Multi-track and Insert

Insert Mode is the polite one, so let's see how it handles multiple tracks. Switch the Edit mode to Insert -the horizontal arrow - highlight Overlay Clip 2 on track 1 and then delete it.

Well, that's gone wrong already, hasn't it? Deleting Overlay Clip 2 - *Black Car* - left a gap that was filled by the next clip on track 1 - *Blue Car*.

Insert Mode hates producing gaps, but it has taken no account of the other tracks.

Delete Car Clip 2 from track 2. Now clip 3 and its overlay are back in sync. So that's a solution isn't it? If we had deleted both Car Clip 2 and it's overlay by multi-selecting them and then using delete, Car Clip 3 and it's Overlay would have stayed in sync.

The fact that all our clips are the same size and the In and Out points line up may have lulled us into a false sense of security. Perform two Undo operations to restore the timeline. Now trim the overlays for all three clips so that they start a second later and end a second earlier - if you stay in Insert mode you need to hold down the ALT key to do this with a green trim bar. This is **Multi-track Editing for 24_1**. You can load this from the website or DVD if you wish.

If the overlays were titles, sound effects or music stings we might well not want them to start and end at the same time as the clips below, but we would still want them to stay in sync.

With the timeline set up as shown, highlight both Car Clip 2 and its overlay, then press Delete.

Well, that didn't go well, either. Notice that although Insert mode cleared up the gaps it left behind, they were different sized gaps. The result? The overlay for Clip 3 is now 2 seconds out of sync.

OK, if Insert mode isn't a reliable way of removing clips from multi track projects, what happens when we insert from the Library? Drag another copy of Car Clip 2 down from the Library and drop it between Car Clips 1 and 3 and the answer is obvious - it only ripples down the clips on the track you insert it to.

Drag and Drop on the timeline can be even more disruptive. Reset the project back to version 1 and highlight both Car Clip 3 and its overlay, then

drag them both left so that they drop between Car Clips 1 and 2.

I think that rather indicates that Insert mode and Multi-track operations don't work at all well together. The timeline is starting to look like a Tetris puzzle. Insert has caused Car Clip 2's Overlay to be 2 seconds early relative to the clip.

Multi-track and Overwrite Mode

Overwrite destroys everything in its path - even gaps. However, it doesn't remove a gap left behind when you delete something. So the great advantage of Overwrite mode is that it isn't going to disturb the relationship between other clips.

Restore the movie or reload version 1, and then switch to Overwrite - the downward pointing arrow. I'll remind you here that Insert can be switched to Overwrite by holding down ALT, even on the fly, but let's not use that now. This time, delete Car Clip 1 and its Red Car overlay. You should be able to confirm that overlay doesn't close up the gap. You can then proceed to select all the clips to the right and close the gap manually

CTRL-Shift-Select

The only issue with the phrase "*select all the clips to the right*" is that on a long project with lots of tracks it's possible to miss some clips. Hence one of Studio's most helpful keyboard shortcuts. Hold down **CTRL** and **Shift** at the same time and click on the the first clip after the gap. It doesn't matter how much content your project has to the right, it will all be selected and you can drag it left to close the gap. When you reach the first obstacle - in this case the beginning of the movie - it's not possible to drag any further, but the whole selection maintains it's structure.

Dragging the whole project to close the gap

So, that's a pretty foolproof way of removing clips.

Adding clips from the Library, or dragging and dropping them from anywhere else in the movie is a very destructive process, however, **unless you move then into a gap**. Making a gap is easy - CTRL-Shift-Select the clip just after where you want the gap and drag everything right.

Let's restore version 1 and then attempt to move Clip 3 and it's overlay from the end to the beginning of the project. The only issue with this particular operation is the music on track 3.

Use CTRL-SHIFT-Select on Clip 1 and the music is part of the selection. Hold down CTRL and click on just the music - it is removed from the selection.

Slide the selection to the right, l e a v i n g enough room for Car Clip 3 to be inserted at the front of the movie.

Now use C T R L - S h i f t Select on Car Clip 3. It's Overlay file - Blue Car - is also selected. R e l e a s e C T R L - S h i f t, then click, hold and drag the selection to the left.

As it passes through the other clips, it overwrites them but does not disturb the sync.

If you keep dragging, the group of two clips clicks into place at the start of the movie. However, because we made the gap a bit on the large size for safety's sake, there is still a gap. CTRL-SHIFT-Select what is now the second clip and this will select the four clips to the right of the gap, Slide them to click into the gap.

Job done! Save this as **Multi-track Editing for 24_2**..

Overwrite is the safest mode to use to add clips or rearrange them. I know of a couple of very busy editors that leave Studio in overwrite mode all or most of the time. They have to make gaps, and close them up again, but they don't end up with out of sync projects.

If you prefer to use Cut/Copy and Paste to re-arrange clips on the timeline, Overwrite and employing gaps is also a good choice.

Multi-track and Smart mode

Don't forget, in Plus and Ultimate if you use Smart mode as the default because of how well Quick Trim works but don't trust Smart with other tasks, you can always hold down the ALT key to force it into Overwrite.

In early versions of Studio Smart mode worked well when inserting and deleting clips, but was flawed when using Drag and Drop or Copy and Paste. That has now been put right. If you had issues using Smart mode in the past and reverted to Overwrite, it is worth revisiting it now.

Inserting clips in Smart mode

If you have worked through the Basic Editing chapter you should have some Cycling Clips in a bin of that name. We are going to use the PAL versions of those clips, so if you have already imported them, you can just copy clips 002 and 008 into the *Cars* bin. If not, then locate PAL_002.mp4 and PAL_008.mp4 in the *Basic Editing PAL* location on the website or DVD and import them into the *Cars* bin. Pre-trim clip 008 so it has an In point at 00:00:05:00 and an Out point at 00:00:09:00 on the burnt-in timecode.

Let's remind ourselves what happens in Insert and Overwrite when we drag the clip down to the timeline. Select Insert mode and drag the clip from the source viewer down to the edit point between the first and second clip on the timeline. The other clips on track 2 are pushed right to make room, but now both the Red Car and Black Car overlays are out of sync. Insert takes no account of the other tracks. The same would happen if we deleted clips.

Use Undo and repeat the above with the ALT key held down. Overwrite makes no space for itself, so we destroy the start of the second clip. If we were to delete a clip in overwrite it leaves a gap.

Undo the last operation or restore **Multi-track Editing for 24_2,** then engage Smart mode .This time, when we drag the bike clip from the source viewer a remarkable thing happens, Everything to the right shuffles further to the right to make space for the bike clip.

However, you can now see why I put the music track into the project.

I didn't want the music track to split, but Smart doesn't know that. It has kept the music in sync with the clips above.

Locking Tracks

Fortunately, you have a solution to this. Locking a track not only disables any manual changes that you can make to a track, it also protects it from Smart Mode.

Undo the insertion and lock track 3 using the Lock icon on the left of the track header. Now repeat the operation. The music remains intact, the bike clip is added to

the movie where you want it and the clips to the right have stayed in sync with their overlay clips.

Deleting clips in Smart mode

Unlock the music track and try deleting the clip we have just added. Because the music track is now included in Smart's calculations, deleting the clip leaves a gap - nothing has changed and every clip's relationship with every other one has been preserved. We could choose to close up the gap manually, if we wished.

3-point editing and Smart

Instead, leave the gap and lock the music track. Now bring up the source viewer and drag the Out point we set to the end of the source viewer timescale, making the clip show a duration of six seconds instead of four. Now drag this down to the timeline and first try it in the gap between the first two overlay clips. It fits. Now drag it down to the four second gap between Car Clip 3 and Car Clip 1. It fits there as well. Filling a gap without having to match the clip size to the gap works even with multiple tracks. Remember - this is a Smart Mode feature.

Select the last clip and its overlay and drag it right so that the end of Car Clip 2 lines up with the end of the music. Because snapping doesn't work with the ends of clips you may need to adjust the timeline scaling to achieve this accurately, although it doesn't matter if you are a few frames out.

Now put PAL_002.mp4 into the source viewer and set an In point at 00:00:24:00 using the burnt-in timecode. Drag it down to the gap we have just created between the second and third car clips on the timeline so that it fits the gap.

We have now made our shots match the duration of the music without having to resort to maths. This is **Multi-track Editing for 24_3**.

Drag and Drop in Smart Mode

Now we have established that the music is not to be disturbed, let's leave it locked for the remainder of this chapter. I want you to rearrange the timeline now only using Smart mode - no holding down ALT, and no creation of the temporary gaps we used when using Overwrite. The aim is to swap Clip 2 and its Black car overlay at the end of the movie with Clip 1 and its Blue car Overlay at the start.

Multi-select Car Clip 2 and its Black Car Overlay (you can use CTRL-Shift click here as they at the end of the movie). Drag the two clips left to the start of the movie. So far so good.

Grouping clips

I've mentioned this clip context menu command before, and now is a good time to use it. To select Car Clip 3 and its overlay only you can't use CTRL-SHIFT-click because that will include everything to the right. You can, of course, multi-select them and that will be fine, but it is possible that you might forget.

Given that in this project we don't want to move a Car Clip without moving it's corresponding overlay, it should do no harm to make a group of them (we will see in the next section this isn't strictly true in the current build, but carry on for now). Multi-select the two clips, right-click on one of them and then select *Group/Group*. While we are about it, do the same for the two other car clips and their overlays. Now select Car Clip 3 and start to drag it to the right.

When you get into the Middle of Car Clip 1 you will see that both it and the Overlay split - just a reminder that Grouping does nothing more than affect clip selection - it won't stop clips being split.

It's also worth adding that Grouping clips is a temporary function, in that if you save and reload the project, and grouping information will be lost. Please bear that in mind when reloading any project in which you have set a lot of groups. You may want to use the newer *Save Group as Project* function referred to later in the Editing Enhancements chapter.

You can now continue to the end of the movie and the swap is complete. This is **Multi-track Editing for 24_4**.

CTRL-SHIFT Select bug alert!

There is an operation that doesn't make sense to me. If you CTRL-Shift click on the third clip on track 2 in the movie, everything to the right **except the clip itself** gets selected! This is happening because we grouped the clip with the one above. If you use CTRL-SHIFT and select the Overlay clip above, the clip below **is** added to the selection, even though it starts earlier.

Fortunately, the problem is immediately obvious, so all you have to do is CTRL-click on the first clip of your selection again and you have the selection you desired. If it becomes a nuisance, you can consider avoiding grouping clips.

Cutting, Copying and Pasting clips and Smart Mode

If you use Cut from the Edit menu, context menu or by hitting CTRL-X, Smart mode behaves just as if you had deleted the clip or group of clips.

If you have copied a clip or a group of clips from the timeline by holding down Shift, Drag and Drop works as any other Smart Drag and Drop operation.

Pasting also obeys the Smart rules, apart from the current issue of pasting to a different track when using the context menu, and the subsequent addition of tracks. I suggest you wait for Pinnacle to sort this out before using the context menu Paste command.

Multi-track clip splitting

I alluded to this earlier. If no clips under the scrubber are selected, when you use Split Clip, **everything** under the scrubber gets split other than those on locked tracks. Otherwise only the selected clips are split. This can speed things up once you are aware of it. Try it out now by selecting the first clip on the timeline, dragging

the scrubber to halfway through the next clip, and then pressing the N key or clicking on the Razor tool.

Combining clips

It's quite easy to split a clip by accident. A partial trimming drag and drop operation is often the culprit - you drag a clip into another one, it splits the destination clip, and then you move the active clip again, leaving a split behind. If you spot this straight away you can just undo the operations and redo the drag and drop in one move.

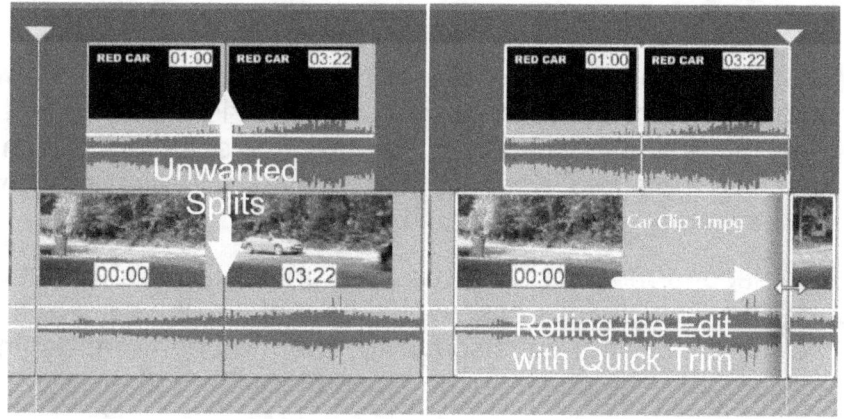

Classic Studio had a context command that let you combine clips. This only worked if the clips were continuous - from the same source file with no gap where the split existed. Unfortunately, this command doesn't exist in NGStudio, but the split is very easy to heal. Just Quick trim one clip into the other - roll the edit so that the two clips become one.

Right - now it's time to return to the subject of Advanced trimming!

Setting Trim Mode with more than one track

Trim mode is particularly useful when editing projects using more than one track. If you set a trim point for every track it will help to keep your projects in sync. There is a way to place a trim point for each track automatically - you hold down the Shift key when you set the trim point. We will discuss where Studio decides to place the additional Trim points in a few pages time. For now, I'm going to explore what happens when you set them manually.

Manual Multi-track Trim Points - Smart Mode

Once a point has been set for a particular track you use the Ctrl key to set the second point. As we have seen, if you already have an In point the second point must be an Out point, and Vice versa.

To add another track to the mix, you just click to set the first point, CTRL-click to set the second.

From then on, each time you CTRL-click a Trim point, that will become the current Out or In Trim point. The current trim point is the one highlighted in the Trim Editor and controlled when you drag that window.

Any track that you don't set a Trim point for will be excluded from the trim operation, as if it had been locked.

So, if you want to make an alteration to a movie and keep all the tracks in sync, you need to put at least one trim point on each track that has content to the right of the point you want to trim. Where you put that trim point will depend on how you want to maintain sync.

There are two relationships between tracks. In the most obvious case one track will be of a video of a person talking, and the other track will be the audio of them talking. If we move one track without the other, the speakers mouth won't open and close in time with the audio. Keeping them in sync will always involve moving the content of both tracks by equal amounts.

The second relationship is the start and end of clips relative to each other and the timeline. The obvious case would be that when we cut to the audio of the person as they begin talking, we also cut to video to see them begin to talk. In this case we would apply trim points to the same place for both tracks.

It is sometimes desirable to begin to hear the person speaking before we cut to them in vision. In this case we would apply trim points to both tracks, but not in the same place.

This is best illustrated with some examples. I'm going to hijack the current demo project (*Multi-track editing for 24_4*) as the video clips make better screenshots! However, I've renamed it as **Multi-track trimming for 24** and added it to the website and DVD.

In the first screenshot I have only set an In point trim bar on the third clip, and not on track 1. Tightening the In point by 30 frames pulls up the other clips on track 2, but the subsequent clips on track 2 are now out of sync. Reset the Timeline with Undo now and also after each of the following tests.

So, we need to add an extra trim point to track 1, but if we want the Red Car overlay to stay in sync there is a choice of four potential places in which we could place it.

Extra trim point on the Out point of the previous overlay

If we place it on the Out point of the previous overlay clip instead, although the overlay clips stay synced up with their Car clips, the Out point of the Black car overlay has been trimmed and the overlay has been shortened so that it ends earlier than it did before. The Red car overlay has the same duration, so now it starts too early, overlapping the end of the cycling clip below.

Extra trim point on the In point of the gap

By moving the trim point on track 1 to the In point of the gap, we solve the issue of the Black car overlap shortening, but not the Red car overlay. Note that this may not be "wrong" - it depends what you are trying to achieve. If the overlay were in fact a voice-over or music sting, you might not want to trim off the beginning. The third option - setting the track

1 trim bar to the Out point of the gap - has exactly the same affect as the previous test.

Extra trim point on the In point of the Red car overlay

The final choice is the safest.

Putting the track 1 trim bar on the In point of the second Overlay means everything stays in sync. The overlays are all in sync, the Red car overlay still has the 1 second offset it had before and it is also 30 frames shorter.

Now, I could run through another set of permutations when trying to loosen an In point, or tighten or loosen an Out point, but they would all be inversions of the above. Matching In points with In points, or Out points with Out points will offer the safest way of trimming, Using In points with Out points will keep the tracks in sync but change the relative positions of the In and Out points. The demo project offers you the chance to experiment with all the possible permutations.

Roll, Slip and Slide on Multiple tracks

In the above demo, we only set a single trim point for each track. However, you can add a second point to as many tracks as you like to that you can roll edits on more than one track with frame accuracy simultaneously. The same applies to Slip and Slide - moving the position or moving the content of a clip on the timeline can be done in conjunction with any clip on another track.

I've only included a screenshot of one of these options - slipping two clips at the same time. By placing In and Out trim points on both car clip 1 and the Red car overlay, we can move the content of the clip but leave it in the same place in the timeline.

Moving the content of two clips simultaneously

If you want to slide the clip, you can place an Out trim point of the bike shot to the left and an In trim point on the bike shot to the right.

Do the same for the gaps either side of the overlay and try dragging the trim editor viewers.

Multiple Trim points and Overwrite

While Smart and Insert modes will behave the same way, Overwrite offers other options, even with multiple trim points - you can control more than one clip at a time, and achieve frame-accurate trimming, However, as Overwrite destroys the material it overwrites, it's not ideal for adjusting large projects unless you use the "add a gap" strategies I've mentioned before.

Automatic Multi-trimming

Pinnacle Studio has a feature which will set a trim point for every unlocked track.

This is how it works - you place the scrubber on or near the place at which you want to trim, hold down Shift, and then press T or click on the Timeline Toolbar Trim tool. If you have Clicking near cuts enabled, you can hold down Shift and click.

This appears at first to allow you to tighten or loosen the whole movie at your chosen trim point and everything on the timeline should stay in sync. That's quite a bold claim, but if your read the manual, Pinnacle doesn't actually claim that.

To understand how Studio should choose the trim points, review the previous section about manual trim points and Smart mode. You will realise that it is actually

impossible for Studio to know your exact intentions - you will want two clips to retain their relative sync - the timecodes on our overlaid clips continues to match the clips below them - but it doesn't know if you also want the positional sync to be preserved - the Overlay clips start one second later and end one second earlier than the clips they overlay, but if we trim the gap between two of the overlays we can't preserve the positional sync of both of them.

The other question that Studio can't know the answer to is "if a clip on one track overlaps two clips on another track, which of the two clips do you want it to stay in sync with?". You could be leading the audio of the second clip, or extending the audio of the first clip.

Studio makes a pretty good guess though. It will set a trim point to the closest end of an overlapping clip, presumably expecting the clip which it overlaps the most to be the one it "belongs" to.

The Shift-Trim Backstory

The algorithm used for automatic trim point selection has changed at least twice in the history of NGStudio. Initially problems could happen when trimming the opening of a movie, but once that was fixed, there remained an issue that caused many people not to trust it - a clip way down the timeline that was the first clip on that track could have its trim point set to its In point, rather than the Out point of the gap before it. This would result in it being being trimmed rather than moved and therefore destroying the positional sync. If this clip was a Title, it looked like it had been moved - and because it could be off the end of the current view, the problem didn't reveal itself until much later in the editing process - or perhaps not even until the movie had been burnt to DVD!

Studio 21.5 fixed this issue, and now Shift trim is much more trustworthy.

Using, or not using, Shift-Trim

I just want to give a few examples of what to expect from Shift-trim, and how you may need to intervene to achieve the result you want. However, if the following starts to seem unnecessarily complicated, it's not essential that you use Shift-Trim. Many editors select everything to the right of the point in the movie they want to address and make a gap. They then work in Overwrite mode in that gap to make changes they want and then pull up the gap - refer back the the CTRL-Shift select selection of this chapter for details.

Tightening a movie with Shift Trim

I'm going to complicate the current project a bit more before I use it as an example. You can modify *Multi-track trimming* by setting the markers shown in the screenshot - they coincide with strong music beats - and detaching the audio for Car Clip 3 - the last clip on track 2. I've not discussed detaching Audio yet - I will in the next chapter - but for now, right click on the last car clip and select *Detach Audio* from the context menu. This adds an extra track with just the audio from the selected clip to it, as well as muting the audio on the clip above.

Alternatively, you can load **Multi-track trimming for 24_1** from the website or DVD.

The idea is to line up the cuts between the clips on track 2 with the marked beats in the music. The bit that is going to push Shift-trim is keeping the 1 second offsets at the start and end of the overlay clips, which need to stay in sync at all times. The detached audio for Car Clip 3 is the Joker in the pack - let us assume its the one clip we can't keep an eye on and therefore most prone to getting out of sync..

The other issue is that we are going to end up with a bit of dead meat, but I'll show you how to sort that out by slipping the clips.

The first job is to trim the Out point of the first Car Clip on the timeline (Clip 2). Hold down Shift and set a trim point on its Out point. If you now drag the Left player window you will see two problems.

The In point of the music is being trimmed to keep it in sync with all the clips to the **right** of the main trim point. This point has been chosen because it is the nearest edge, but we don't want to alter the music at all. Leave trim mode, *Undo* your trims, and lock track 3.

The other issue is that although everything we want to stay in sync is doing so, the Out point of the Black Car overlay isn't moving - the gap is being trimmed instead - so it isn't holding station with the 1 second offset we established. It will end up overlapping the first bike shot.

This is happening in plain sight, so we could just fix it manually, but here is how to set it correctly:

• Set the first Shift-trim point again.

• Click to the left of the Out point of the Black Car overlay - the Trim point on Track 1 changes from the In Point of the gap to the Out point of the Overlay.

• CTRL-Click back on the Out point of the Car Clip to make it the Active Trim point.

• Use the Left trim window to trim left to the marker.

This is **Multi-track trimming for 24_2**. Check out the Detached Audio - it is still lined up correctly!

We now want to extend the first Bike clip right to click into place with the second marker. Set a Shift-trim bar on the Out point of clip 008. Drag the Left trim editor window right so the Out point clips into place with the second marker.

That worked well, apart from having over-trimmed the bike clip, but we can sort this out later.

The next step is to extend the Out point of Car Clip 1. Set a Shift-trim Out point on the clip and you will observe the same issue as we had with Car Clip 2 - the Red Car overlay doesn't hold station. Repeat the same bullet point steps to correct this. Again, we have introduced a little Dead meat, but I'll come back to that.

Extending the Out point of the second Bike Clip 002 works perfectly without having to change any of the chosen Shift-trim points.

The final trim is to the In point of Car Clip 3. Here is another case of having to swap the Trim point on the Overlay clip from the Out point of the gap to the In point of the Blue car overlay to maintain the 1 second offset.

You will need to line up the Out points of the clips and the music by eye as Out points don't respond to Snapping, which you may need to turn off (the P key) to get the accuracy you need.

It's much nicer when the cuts line up with the music, isn't it?

Slipping the first bike clip is a case of setting trim points to both the In and Out points of the clip and jogging the Right trim window so the burnt-in timecode reads 00:00:09:00. To slip the Car Clip 1 and the Red Car overlay we need to add In and Out points to **both** clips, and trim right 18 frame - now the dead meat is at the beginning of the clip, but the resultant freeze frame doesn't look like an error unless you are watching the timecode.

That should have given you a taste of using Shift-trim. At no point were we in danger of losing sync or position for the final detached audio clip. All the trim point changes were concerned with retaining the Out point relationship of Overlay clips.

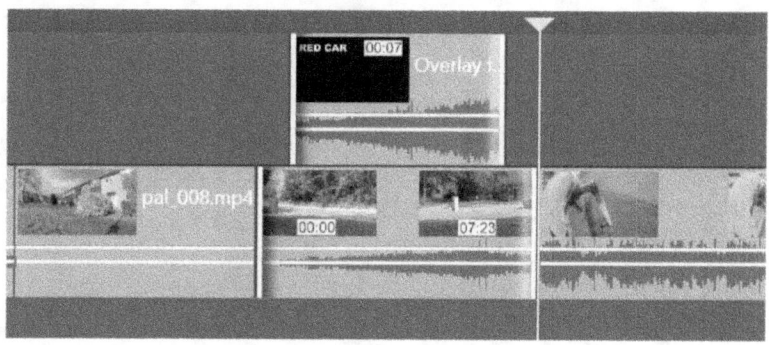

It's now time to deal with Audio editing, and time for a new chapter.

Audio Editing

In the previous chapters, we have been creating movies by assembling, splitting, trimming, and re-ordering clips of video. I've paid scant attention to the sound that comes with the shots. It is very natural for a "film maker" to think about the pictures that tell the story and worry about the sound afterwards – as any professional television or film sound recording engineer is only too aware. Of course, we definitely need to hear clearly any dialogue that is required to tell the story, and if that dialogue takes place "in vision" the movement of the speaker's lips must be in sync with what we hear. However, it's just as important that the background audio or "atmosphere" is believable as well, and that cutting between different background sounds doesn't jar – or if it does, it is because we want it to jar.

Even the simplest of home movies may need to use the natural sound recorded at the same time as the pictures, whether it is your cute child gurgling away, or the roar of an aircraft at a flying display. However, both examples may have sections that are too loud or too quiet, or include distractions such as people talking in the background that make editing difficult.

In the project we have created, we could take the "silent film" approach, remove all the natural audio and plaster some music on. A sophisticated silent film score might even have something to highlight the moment of impact – a crescendo or cymbal crash, for example. In fact, by the end of this chapter, I will have resorted to both those tricks, but as an enhancement rather than a replacement for getting the sound right in the first place.

Listening to the audio

Before you start making any judgements regarding the quality and levels of audio, it's a good idea to "calibrate" how you listen to your sound. I'm hoping you have a reasonable pair of stereo speakers attached to your computer, and that the left channel comes out of the left speaker and the right comes out of the right one! If you don't, or you have to use your computer in a noisy environment (or need to keep the noise down out of respect for others) then consider using a pair of headphones. Play some music with Windows Media Player or get Windows to make some noises and set the volume of your speakers fairly high.

Windows Volume levels

Click on the small speaker icon you should have at the bottom of your Windows task bar and make sure that playback levels are high. Each open application can have its own volume setting that you can reach by right clicking on the speaker and opening the Volume mixer.

In the *Editing Tab* chapter I showed you how you could adjust the level at which you monitored audio in the Player window – the speaker icon and popup volume slider. Just to re-iterate, any adjustment you make using these controls doesn't affect the movie. I suggest you set that volume slider to 100% - we can adjust the levels in other places and it's easy to forget you have changed that one. If you want to play video without listening to the sound, get into the habit of using the mute option. The Source and Timeline players share the same volume control settings, so changing one will reflect in the other.

Having established a baseline, load the **Basic Editing Final** movie project that you made earlier, or load it from the website or data DVD.

Scrub to the fourth clip, the one where the Bike runs over the GoPro camera. Highlight the clip on the timeline by selecting it, then click on the loop play button and listen. If the sound is loud without deafening you, then things are well set up.

Master Volume

At the bottom left of the program window, below the track headers, is a meter that monitors the audio playing. This will show the levels either of the source preview, or the timeline.

The Master Audio meters

The meter is calibrated in decibels (dBs) and as you can see from the numbers, these units aren't linear. The meter responds to peaks of input, and then takes time to "decay" – that is, to fall back - to zero. This helps you read the levels. The coloured bands indicate the safe areas – normal noises should register in the yellow area, loud peaks should get into the orange and only on very rare occasions should you see the red area light up. The penalty for going into or above the red is distortion – the horrible, squared off sound you get from over-driving any audio device (popular with some guitarists!). In the past, sending too high a level could be even more of a problem – in the very early days of radio you could actually blow up a transmitter if the signals were too high!

The Audio Mixer

To get to the mixing controls, we need to click on the tool bar icon that looks a little like a bar graph. Each track header will be expanded to show additional controls and have a track meter added to the header area.

The Mixing Panel tools

The slider that appears alongside the master meter at the bottom of the window controls the combined levels of all the tracks, as sent to the final file or disc when you export a movie. It's best to keep this at the 0dB setting while you make your project, and only if you want to make a change to the final product should you alter the level. The tracks and all their individual level settings relative to

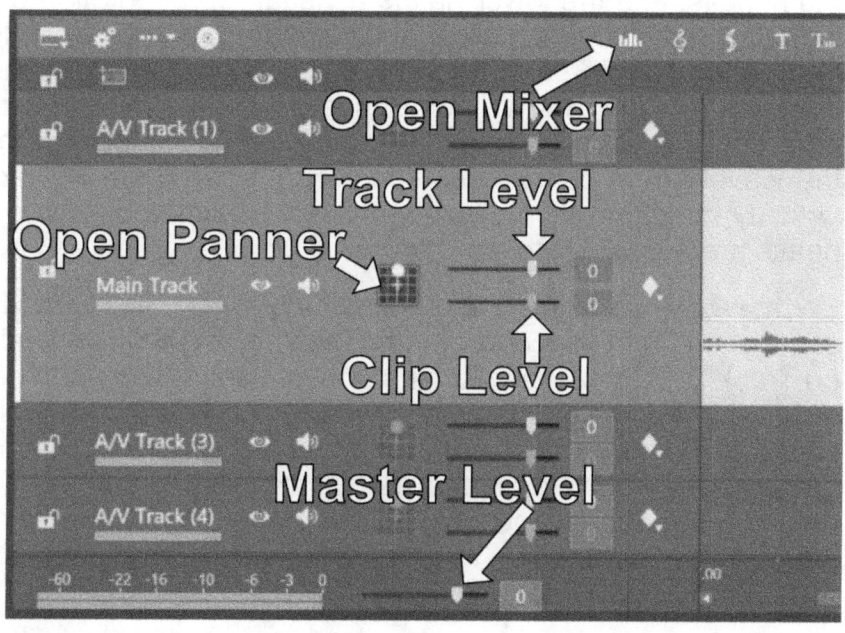

each other are affected globally, so your "mix" will remain the same, but everything will get a boost or a reduction.

Hover your mouse over the slider knob and you generate a horizontal double-headed arrow; click and drag left and right to make alterations - the current value is shown at the left of the scale, in the range *Mute* to +12dB. Use Loop Play to listen to the crash audio and you will see the level is already going into the red - try altering the level; at +12dB the meter stays in the red for much longer. At -12dB it only just gets into the yellow. So it is too loud, but not by much. Single clicking on the value makes the text box active, and you can enter a value.

Reset the master volume to 0dB to observe the effect of the next set of controls. Each track has two sliders. The upper, orange one in each header is the master track volume. This applies to the whole track, and if you adjust it you will see the meter levels rise and fall and hear a change in level, but there is no other visual indication that you have changed anything. It too should be set to 0dB at the beginning of a project, giving you leeway to increase as well as reduce the overall

level of that track. For example, you may have placed some music on a new track and then made some subtle changes at various points. When you review your work, you might think the whole music level needs reducing in relation to the rest of the audio, in which case you could alter the master track level.

Before we start using the next control, take a look at the project on the timeline. Make A/V Track (2) even taller if you can. The top of each clip is occupied by video thumbnails, and the lower half is a visual representation of the audio. A green line indicates the level each clip's audio is set to, and by default that is set to 0dB, with the green line three-quarter of the way up. A blue line indicates the stereo positioning (which we will come to later) and is half way up the area, centred over and slightly obscuring the audio waveform. The first clip of the project is so quiet that the waveform is completely hidden, but even if we moved the blue line, there is virtually no information displayed. The remaining clips have louder audio, and the peaks are averaging to about 80%.

So how do we alter the level setting of a clip? Place the timeline scrubber somewhere in the second clip and then adjust the lower slider with the green button on Track 2. "Adjust the volume at the current position on the clip" is what the tooltip says, and indeed that is what happens. As you increase the setting to +12dB the whole of the green line over the clip moves up until it reaches the maximum height of the audio section. Drag the knob to the left and the green line drops to the bottom of the audio section. You can also set a numerical value by clicking on the value and typing in the number you require.

Volume changes with the slider

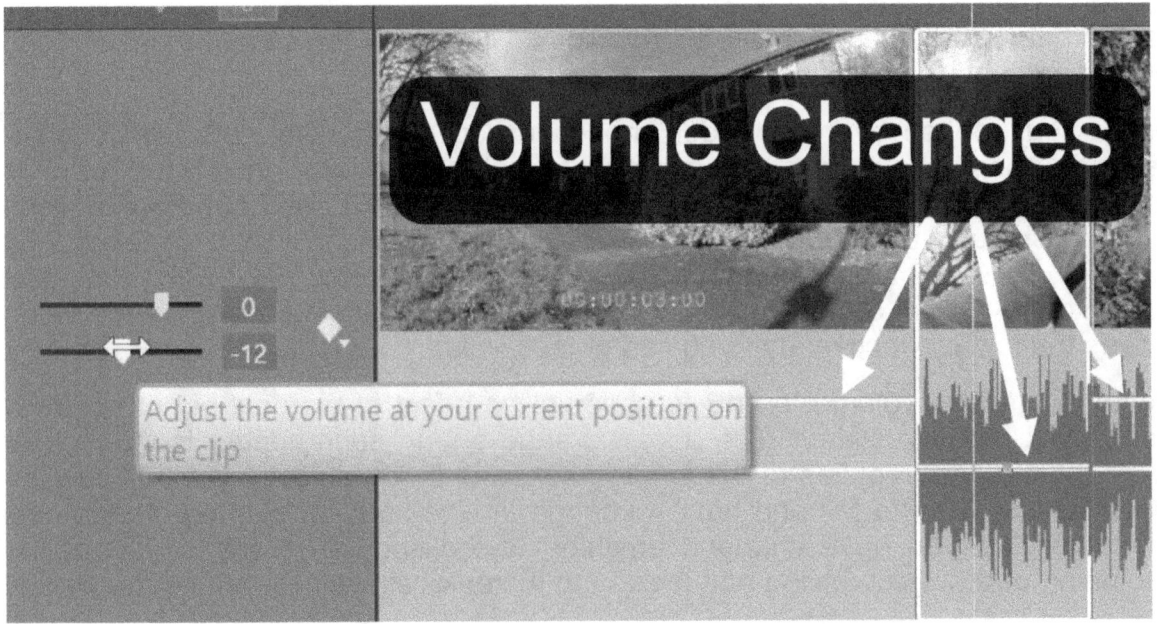

Let's use the control to decrease the level of the second clip. Let's knock it down to -12dB and play it - that sounds a bit more comfortable!

Notice that although the green line moves, the waveform of the audio doesn't change in magnitude.

Manual volume adjustments

The green lines that plot the clip volume settings can only be edited when you open the audio mixer. Once you can see them, you can not only adjust them with the sliders, you can drag the green line with your mouse.

Move the scrubber to clip 3 – the POV shot – and hover your mouse over the green volume level. The line turns white and a small speaker icon appears along with a tooltip. Click and drag the line and try to set the level to -12dB as well – the green line will end up at the same height as the one in clip 2. Not so easy as using the slider - there is no indication of level and if you were moving the line around it would stick at it's original level (and no, turning off snapping doesn't help!).

When you release the mouse button the volume slider moves to reflect the new setting with the cursor placed over the clip.

I would only use this feature if I was setting a clip level very high or low or just lining it up with the previous or next clip. We aren't using the full power of audio adjustment because we haven't used audio keyframes yet. Before we do investigate keyframing, let us look at a couple more audio features.

Surround Sound and Stereo Panner.

You need to click the icon in the track header to open the Panner box. If you are just working in Stereo, dragging the the blue dot left and right alters the position of the track and the result is reflected on the timeline. You can add keyframes here as well.

If you are making a project that is going to use surround sound, further control is possible from back to front, along with surround options. I will use the panner later in this chapter.

If you open the Panner Panel to take a look, you can use the Close icon X top right to close it or it will close when you shut down the mixer.

Audio Scrubbing

One tool that you will find helpful is the Audio scrubber - its at the right-hand end of the timeline toolbar. When turned on, Studio attempts to play back Timeline audio as you scrub. It's often an irritation when working with video, but can be very helpful when examining audio.

Highlight the tool and scrub along the timeline. It's not that impressive with this audio, to be honest, but with music and speech it is far more effective - and when you are editing dialogue it is pretty essential.

Play the first clip and listen very carefully. About half way through there is a distant bell. Switch on the audio scrubber and try it out - you will just about hear the bell, and with a bit of experimentation you should be able to pin down it's location even though it doesn't show up on the audio waveforms. Place a timeline marker for future reference.

Introducing Audio Keyframing

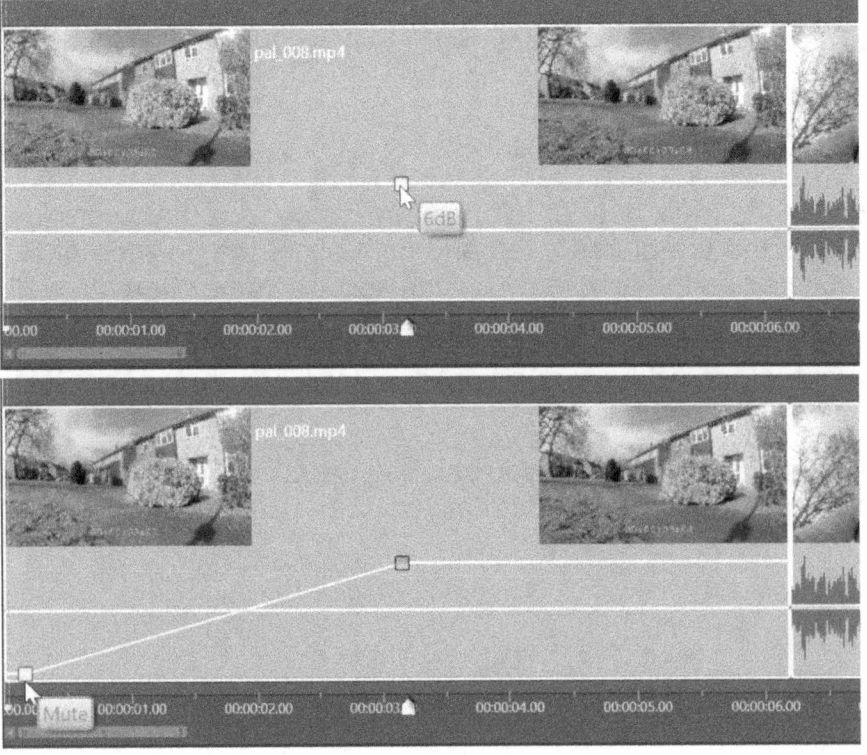

A keyframe is a marker attached to a frame of video or audio that also holds a value for a particular effect or control. In the case of audio, these markers are placed directly on the green line.

Move the scrubber out of the way and hover your mouse over the same point of the clip that we have located by audio scrubbing so that the green line turns white, then click and release. A

square green block appears on the volume indication line – it's a keyframe. Now grab the block again and a small tooltip should appear with a value in dBs. Push it up a little so that the tooltip reads 6dB.

We have set our first keyframe. Create another one to the left, then drag it down and left to the beginning of the timeline. Now we have created a fade up, that stops where the bell rings.

The Keyframe context menu

Adding just two keyframes can be useful, but adding more opens up some powerful options. The easiest way to add them is to click as before, but if you right click on the volume line a small Context Menu appears that allows you to add a keyframe, delete a keyframe if it is under the mouse cursor, or delete all the keyframes in the current clip.

Expanded Audio Keyframe Display

Even with a full height track, keyframing the audio can be tricky simply because of the size of the display and the range of mouse movement.

Expanded Audio Keyframing display enabled

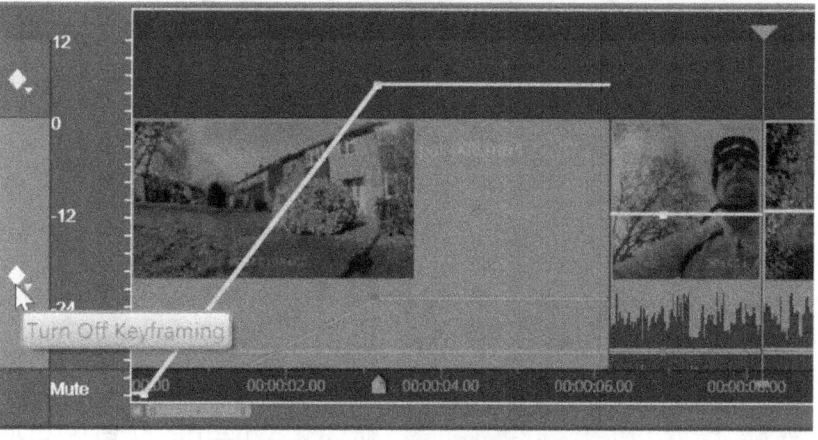

Pinnacle Studio 20 introduced a solution to this - an expanded display. Although keyframing the green line embedded on the track still works, and you could carry out the following operations using that system, it is a lot easier to do them in the expanded display. Another advantage of the new display is that you can leave the track heights at a sensible setting, and don't need to keep altering them.

To enable the large display you need to have the mixer open and then click on the keyframe icon for the desired track on the right of the mixer panel. Before you do so it is a good idea to scale the timeline view to display the area you wish to edit.

One tip here is that the display fills the entire Timeline area, so if you make the timeline area higher relative to the Player and Library you will get an even bigger area to play with.

The Timeline scrubber is disabled with the large display open, so you will need to use the Timeline Preview scrubber instead, but this stops the main scrubber interfering with the keyframe operations.

Having inherited the fade we made with the legacy display, it's easy to adjust simply by clicking, then holding and dragging either of the two keyframes – you can change the position at which the fade starts by dragging the first keyframe right – or even have the audio start at partial volume by dragging it higher. The duration and final level of the fade is adjustable by moving the second keyframe. A fade down is easy to create by starting with a high level and making the second keyframe lower.

Dragging vertical or sloping lines

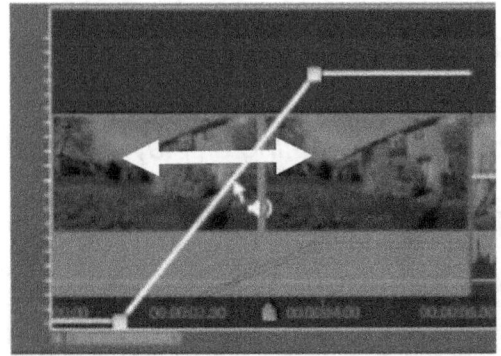

You can also adjust the position of the fade without affecting the levels by dragging on the lines, rather than the keyframes. There are two differing behaviours here.

If the line is sloping or vertical, you can only drag it left or right, effectively moving the position of the level changes.

However, if the line is completely horizontal, you can only move it up or down, changing the amount of the level change. The keyframes at both ends of the line are moved together.

Final fade position

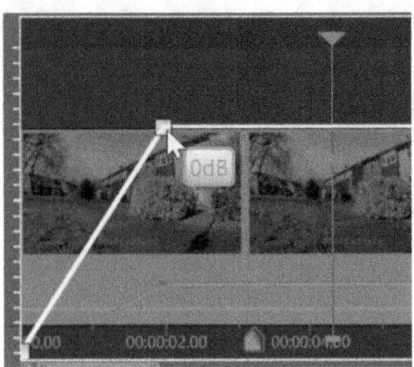

When you drag a sloping line it retains it's angle until one of the keyframes meets an obstruction. Move the slope toward the left and when the keyframe on the left reaches the start of the clip it stops, but the next keyframe keeps going, the distance between the keyframes gets shorter, the slope gets steeper and therefore the fade up takes less time to complete.

Drag right again and when the original fade duration is restored and the slope is back to it's original angle (and therefore duration) the keyframes will move together, retaining the slope.

Establish a two second fade up that starts at the beginning of the clip. Now drag the top line down so that the level after the fade has completed is set to 0dB.

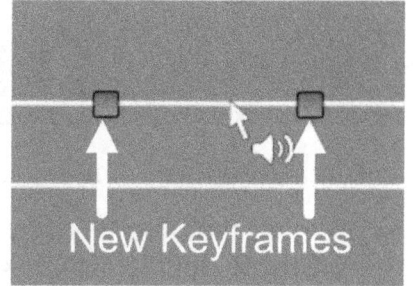

New Keyframes

Now add two new keyframes either side of where where we made a marker for the bell.

Grab the centre of the line between the two new keyframes. You can't drag it sideways. Instead, try to drag the line up. When you do, another pair of keyframes are created immediacy above the two you just added, introducing a sudden level increase with vertical lines.

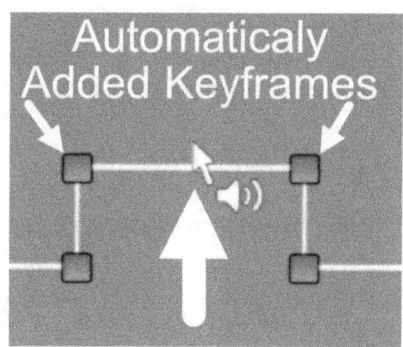

Automaticaly Added Keyframes

Now we can adjust the level just for the bell.

If you want to refine the bell fade up, you can adjust all the keyframes individually to tighten up the area around the bell, and make the lines less vertical. Loop Play is useful here, although you may have to quit the enlarged keyframe display to select to correct clip.

Enhanced volume shape around the bell

The slider and keyframes

If you want you can always bring the volume slider into play as well – it will still adjust the level at the current scrubber position even with keyframes in place, where it has the same effect as dragging vertically, but with the extra function that when placed on a sloping line it adds an additional keyframe.

Keyframe management

Right-clicking on a keyframe in Expanded view brings up the same Context Menu as for the old method, but there is a further menu available if you click on the small dropdown next to the keyframe icon in the mixer header.

Here you will find additional options for navigating the cursor - Previous and Next Keyframe. If the cursor is over a keyframe you will be able to Delete Keyframe.

The first option is somewhat poorly named, in my opinion. Beware! **Reset Keyframe** does not return the current keyframe to it's previous value. It deletes all the keyframes in the current clip.

Something that it is worth getting into the habit of doing is closing down the mixer once you have finished making audio adjustments. It is a little too easy to grab or create an audio keyframe when you are intending to do something else with the clip. The snapping behaviour normally lets you repair any accidental damage to your project easily, but it's better that it doesn't happen in the first place! Before we continue, please close the mixer now!

Detaching Audio

I think we have reached the point where there isn't much we can do with the audio unless we can edit it separately from the video. Pinnacle Studio can do this in a couple of ways but I'll show you the most logical one, specifically designed for audio work.

Detach Audio Command

Our main track contains clips that have both video and audio, and at the moment any editing action affects both equally. However, it is possible to switch to a mode where you can apply operations to one or the other but still have them loosely linked.

Have a look and a listen to the movie. There is actually only one true moment of "sync" - when the bike knocks over the GoPro camera. The variations of the atmosphere audio captured by the on-board shots isn't very significant. The cut to clip 2 and to and from clip 4 do jar a bit.

The first thing I'm going to attempt is to smooth out the first audio edit by fading up the incoming audio from the next clip (004) early.

You may hear of this type of edit called a number of things – a Split A/V (audio/ video), leading the Audio or a J-cut (you will understand this last term a little better in a moment)

However, the audio is embedded in the video clip and at the moment there is no way of cutting to it separately. We could put a separate copy on another track and use that, but Studio has an easier solution.

Right click on the second clip to bring up the Context Menu and select *Detach Audio*. You will see a dramatic change to the appearance to the timeline, although at this point nothing has been altered in our movie.

What had been labelled as A/V track (2) has been divided horizontally into two tracks, with audio from the selected clip moved to the new track immediately below. It still has the volume change we made earlier. The video clip that was selected has lost its audio waveform.

The appearance of a detached audio track

These two tracks are more closely linked than if they were two separate tracks – have a look very closely at the space between them and there is no thin gap. If you try to change the order of tracks by dragging the track header vertically you will see both tracks stick together, and slightly different things happen if you select a clip by clicking on it. Click on

the video and both the video and audio section below are selected.

If you click on the video again, the audio is deselected. So, the first time you click, both clips are treated as one. Clicking on the audio selects just that clip.

Using Quick Trim, loosen the In point for the audio track by dragging left . With Smart Edit on, this will overwrite the gap below the first clip on track 2. Let it snap into place with the marker we set to coincide with the bell.

BUG ALERT: Using PS 24.01,I cannot drag the audio as far as the marker. To work round this click on another clip to select it, and then attempt to trim the first clip further. This doesn't happen in PS 22, but has been happening since PS23, and I've reported it to Pinnacle twice now.

The J cut

You should see now why some people call this a "J" cut – the edited audio clip forms the lower half of a letter J when looked at in conjunction with its video clip. An "L" cut overlaps the outgoing audio over the Incoming video.

If you open up the audio mixer, you will see that both the video track and the new audio track have volume controls associated with them. We have left most of the clips unchanged so we need a way to control the sound levels still locked to the video. Drag your scrubber along the timeline and you will see the green volume controls enable and disable themselves depending on the presence of audio on the two tracks that they control.

Detached Audio and Clip Selection

I said that special selection rules apply to detached audio clips - select the video clip they came from and they will be automatically selected. Before we do any further work on the current movie, I'm going to demonstrate how clever Studio is, so please save the project as **Audio Edit 1**.

Check that when you select the clip 004 video with one click and then drag it, the audio is also selected and moves with the clip.

Now click on the audio and the video should be deselected. Drag the audio left, but not so much that some of it isn't still overlapping the video. Test moving the video clip again, and the audio is still attached. Finally move the audio so it doesn't overlap the video at all - and finally we have broken the loose grouping - the Video is not linked to the audio any more.

Or is it? The really neat bit here is that if you move the audio clip back to where it was - and it has to be on the detached audio track it came from - the link re-establishes itself.

One thing that could cause potential confusion is when you use CTRL-Shift click to select everything to the right. If you use it on the second timeline clip, the detached audio below is also selected, even though it starts before the video. That is only happening because clips on the detached audio track are treated as a special case, and in general it's a good idea. However, there maybe times where it could catch you out.

More Audio Improvements

Fading up the detached audio

Return to **Audio Edit 1** and trim the Out point of the detached audio so that it extends to the end of the movie. Now use audio keyframing to create a fade up that starts at the beginning of the clip and reaches -12db by the time we cut to the second video clip. I think that makes a reasonably convincing start - the on-board audio sounds a bit like the bike approaching as we fade it up.

Now play the movie to the end. When I did this while building up this project, I suddenly was aware of another bicycle bell. I would like to include it, but is it part of track 2 or the detached audio underneath?

Using Track Monitoring

We looked at the track monitoring tools in the Edit Tab chapter, but here is a good use for the Speaker icon - disable the audio for the detached audio track and play the movie - and the bell isn't there! So it exists on the detached audio track. Switch the monitoring back on.

The audio on the two sections of clip 003 doubles up what we have now on the detached audio track, so that's a good reason to lose them, but how? If we detach them, they will overwrite what is already on the detached audio track. It is easy enough to fade them down, but I'm going to use this as a chance to demonstrate an other function.

Active Streams

There is a powerful tool hidden in the Context Menu for clips. It is named Active Streams. Open it now by right-clicking on the third timeline clip and hover over the option. A sub menu shows that both Video and Audio are checked.

Check the video part of the second clip and you will see the *Video* is activated and greyed out (you can't turn it off) but *Audio* isn't checked. Check it now and you will see the audio waveform re-appear underneath the video thumbnail.

We have put the audio back! Now check out the audio clip below – Video is disabled and if you enable it, video thumbnails appear on the second track as well. After experimenting, return the project to it's previous state.

So, with the Active Streams option we can turn the video or audio off on any clip. We cannot switch off both, but I cannot think of a reason why we would want to.

When using Detach Audio we can't "re-attach" audio, we can can re-enable it as an active stream to the video only track, which is in effect the same thing - unless you have changed the audio.

As we have seen, any volume changes to the audio of an A/V clip are transferred to the detached audio track. If you re-enable audio on a video only clip, the original volume changes will be restored, but any changes you made to the detached audio won't be transferred back.

So a few final tweaks to the audio track that you might want to try:

* Disable the audio stream for the third and fifth clips on track 2

* At the start of the 006 clip, keyframe the audio down to -50dB with a sharp slope down.

* Fade up the audio so it back to -12dB just before the bike hits the camera.

This is **Audio Edit 2**.

The final changes to the audio keyframing

Sound Effects

I'd like to add something to the project to allow me to demonstrate a bit of stereo panning, and given that the bike is hurtling towards a blind turning where a pedestrian might be emerging, how about another bicycle bell?

The Sound Effect in position

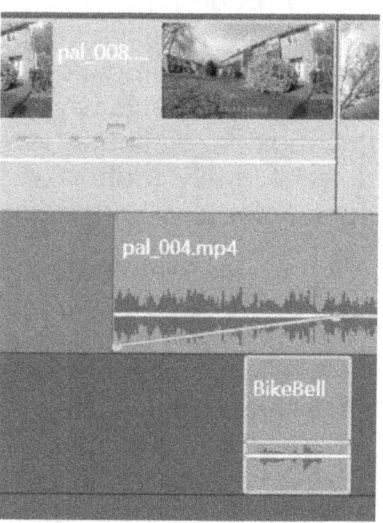

Open a Sound Effects tab in the Library and type "bell" into the search box - ah, there it is, *BikeBell.* Drag it, unedited, down to track 3 and line up the beginning of the effect to 00:00:05:00 on the timeline, or 8 seconds on the first video clip's burnt-in timecode, so that it begins as the bike is left of frame and ends as it leaves right of frame.

Using the Stereo Panner

If you don't have a way of monitoring stereo on you computer, you might want to use a pair of headphones for this. Open the Audio Mixer with the toolbar icon if it isn't already open, select the sound effect clip, and then click on the Surround/Stereo panner tool on the track 3 header.

The Panner is displayed in a small detached window that can be dragged anywhere within the edit tab. I've place it over the timeline for the screenshot..

The small blue dot shows the current audio position, but as we are working in stereo rather than surround sound, the dot needs to be at the top of the panel. Drag the scrubber to the start of the sound effect, and then drag the blue dot to the left.

The Panner and the Sound Effect clip

You should be familiar enough with keyframes now to recognise what is happening here. The blue line on the audio clip has moved to nearer the top of the track display, indicating that the sound is panned to the left. If you look closely you will see a small blue dot - a keyframe - at the start of the track.

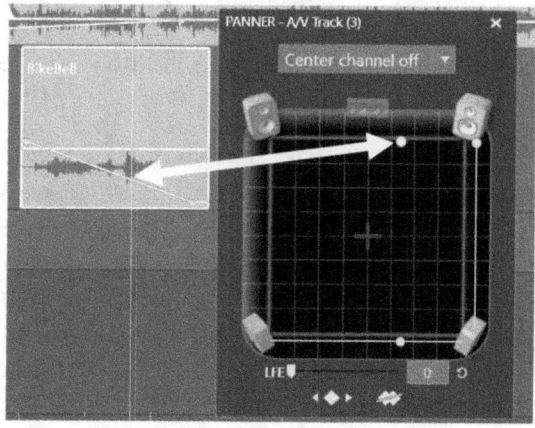

Scrub to the end of the clip and then move the blue dot to the far right.

Play the clip and the bell should travel with the bike.

This is **Audio Edit 3**.

If you decide to use the Surround Sound features of Studio, you can use the panner to control track positioning. The panner has a drop-down menu that controls the Surround options. 5.1 Surround Sound consists of five normal channels and one Low Frequency Effect channel. Four channels give left/right and front/rear positioning. The fifth normal channel is normally behind the cinema screen because that is where the dialogue normally comes from. The LFE channel is used for all those scary effects when the alien spacecraft lands or the shells start landing in the the movies. Because low frequency bass is difficult to locate the position of, it doesn't really matter where the speaker is - and that's why you can put the subwoofer for your theatre audio system anywhere in the room.

We can use the blue dot to position the current track within the left/right/back/front image. The drop-down menus can be used to channel the output of the current track to the centre channel, use it as part of the surround image, or ignore it's presence. The fader at the bottom controls how much of the track audio is sent to the LFE channel.

Music - using Scorefitter

Adjust the timeline view to see all the project and all the tracks. Insert a new track at the bottom of the timeline and select it, put the scrubber at the start of the movie and then Select All (CTRL-A) to highlight the whole project.

Our project could do with a piece of copyright free music 24 seconds long. You could compose it yourself, or find a composer to do it for you. Another option is to use Scorefitter. Ultimate knows 74 basic tunes, the Plus version somewhat less (unless you buy some more) but it can create up to eight or so variations of each tune to virtually any duration you like. Best of all, using it in any type of production with total worldwide clearance is completely free.

You open Scorefitter by clicking on the treble clef icon to the right of the audio mixer button.

The duration box allows you to enter the duration of music you require to be composed for you, and choosing a short duration can limit the variations available. What is very handy is that if you have selected some clips on the timeline the duration will automatically be entered into the box. Close the Scorefitter box, click on the timeline and use CTRL-A to select the entire movie. While you are there put the scrubber at the beginning of the timeline and click on the music track header so that it becomes the selected track. Now re-open the Scorefitter box. You should see the movie duration in the duration box.

There are eleven fairly self-explanatory categories in the left-hand box, and the songs in each Category are listed in the Song box. It's handy to use the mouse tooltips here, as hovering over each song title gives a very full description of each piece.

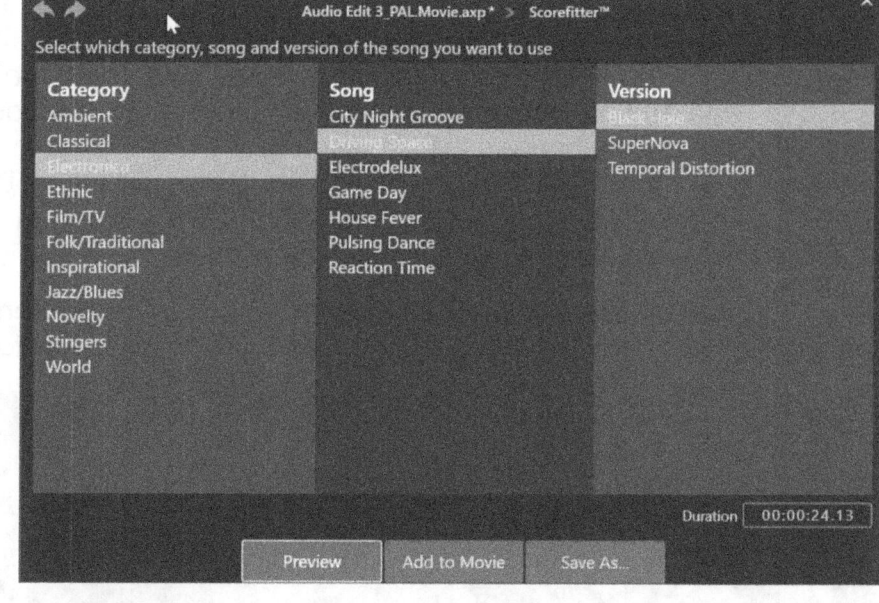

Version on the right contains just that. Shorter durations offer fewer versions, and below 4 seconds some will only produce silence, but short music stings can make interesting punctuation in a movie.

Click on Preview to hear your selection. It's important to note that there may be quite noticeable differences in how songs are arranged for different durations – drumbeats and codas are often added to get the correct duration, rather than varying the tempo.

Have a listen to what is on offer. My choice is *Electronica/Driving Space/Black Hole*.

In the Whistle-Stop chapter I showed you how to save your choice as an audio project to the Library that can then be retrieved as a Scorefitter track.

Clicking on Add to Movie places the composition onto the currently selected track at the scrubber position. You can't add to a locked track. Send the music creation to the Movie and if you got the setup right it should occupy the bottom track, starting at the beginning of the movie. If it isn't in the right place it is the work of a moment to drag it to the correct position.

I'm not sure what colour you would call a Scorefitter track on the timeline. Khaki? Anyway, if you double click on it or use the Context Menu to Edit Music, the Scorefitter box reopens, giving you the chance to change the selection and re-send your new choice back to its original location.

The Mixdown

Now we have all the audio components in place, how about the final levels? I set the music to -9db and the master level to 0dB, On playback, I could not make out the first bell ringing, so I changed the keyframing of the first shot to set the peak to 12dB, although it is still a little lost in the music. I also adjusted to level of the crash, experimenting with loop play, and settled on -3dB - the loudest I could make it to stop the mix going into the red on the master meter.

You might want to tweak things a bit more - the music does tend to cover up a lot of the atmosphere. Now save the movie with a new name, **Audio Edit 4**.

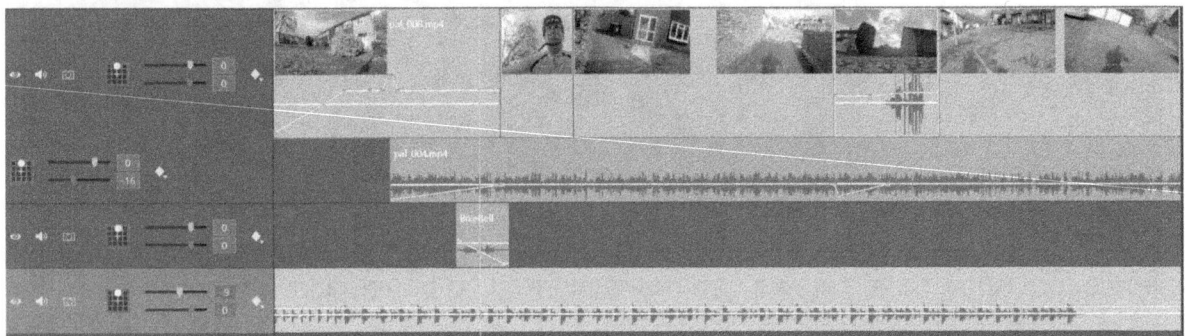

A Note about SmartSound

Many experienced users of Pinnacle Studio use a program called SmartSound for automatic music generation, which was included with the older Classic Studio programs. They prefer the quality of the music and may have invested in additional discs. Studio 17.5 came with a free plug-in which will be inherited if you upgraded to S21, or you can buy the plug-in from Smartsound. This enables the timeline toolbar Smartsound icon.

While the basic Quicktracks interface that comes with the plug-in is similar to Scorefitter, you can also pay extra to enable the Sonicfire pro interface, which offers full scoring features. I've used this successfully in the past to create some great music. One downside is the cost, and I'm disappointed that even when you have paid a lot of money, YouTube often claims that you don't have the rights to use the track you have made. It's up to you to prove that you have bought a licence. Fortunately this doesn't apply to Vimeo.

If music is important in your projects, then it's well worth investigating Sonicfire Pro, but it's a complex program that falls outside the scope of this book.

The Voice Over Tool

The Timeline Toolbar contains an icon that looks like a microphone, and when you hover your mouse over it, the tooltip reveals it to be the *Voice Over* tool. This is how you can record narration to go with video that you have already recorded and edited. You can talk along with the video playback, timing your comments to match the pictures.

I've always found the hardest part of using this feature in all versions of Studio is getting the microphone to work properly. Many PCs have poor quality microphone input circuits that aren't shielded from interference. In addition, recent PC sound hardware is more sophisticated, but that means that if the microphone isn't already up and working before you launch Studio, it might not be detected.

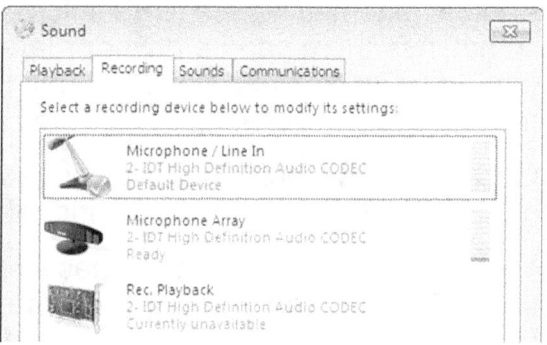

So, get the microphone working in Windows first. The Windows taskbar at the bottom of the screen should contain a small speaker icon. Right clicking on that will allow you to open the *Sound Settings*, where you can open the *Sound Panel* and switch to the *Recording tab*. A correctly connected microphone will be flagged with a green tick, and if you click on the Properties tab you can choose sub-tabs to *Listen* to the microphone and set the *Levels* to test it.

In Windows you will probably have to turn your speakers down, but if you can listen on headphones, so much the better as you will be able to set the levels without worrying about the howl-round you get when the speakers feed back into the microphone.

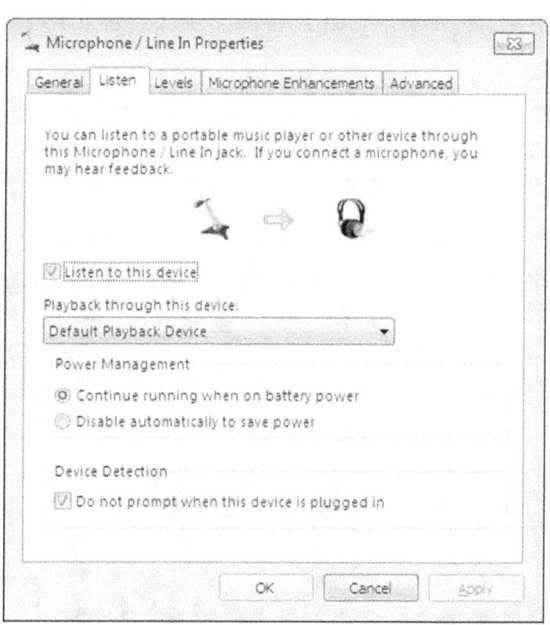

Because the feature is designed to let you watch the screen and also record your commentary, you are going to be near your PC. Make sure the microphone is as close to you as it can be without "popping" (where your breathing causes distortion) and as far from the noise of the PC as possible.

Some microphones will sound low level – even with Studio's fader pushed up to full level. You may be able to address this with Windows settings - look for a Boost setting. If you are going to do a lot of voice-overs I suggest you consider buying a small external audio mixer to feed your microphone into. You can then feed the mixer's output into a line level socket and avoid all the hazards of interference floating around inside your PC case. You can also ride the level of the microphone manually, fading it out if you don't intend speaking for more than a few seconds.

Another alternative is a USB microphone, which avoids audio interference, but sometimes there can be driver or latency issues. I own a fairly recent tie-clip style one and it works quite well, although the positioning is never going to be as good a microphone on a stand.

Once you have achieved a reasonable quality of microphone recording, you can switch off the Listen checkbox and rely on Studio to control the microphone.

You need to check that Studio has selected the correct source. In the Control Panel under Audio Devices is a button that allows you to change the selected device. Clicking it actually brings up the Windows Sound box we used just a moment ago, so you can select the device. It would be here that you would select the Line Input if you have decided to use an audio mixer.

Returning to the editor and clicking on the Voice Over tool brings up a small dialogue box. The meter and level control seems to work quite poorly on my set-up at the time of writing, so I rely on setting up the levels in Windows. You may notice a short delay as well – more of which in a moment.

You would use the Mute all audio checkbox if you didn't have any headphones and you didn't want the audio from the project to bleed back onto the microphone. If you do have headphones and want to hear the project, leave the box unchecked. At the bottom of the Voice Over Tool box you have opened there are also options for you to rename the files and change the location of the file you are about to record.

Voice over countdown

One further change brought about when you open the Voice Over Tool is the addition of a new track at the bottom of the timeline tracks. It will already be labelled Voice Over Track, and it boasts a small microphone icon that shows this track has special qualities – all new voice overs will be placed here. You can always move them to another track or retrieve them from the Library.

With the level set and the scrubber placed at the start of the movie, or a little before you want to start your commentary, click on REC to start a 3-2-1 count in. You will hear a click track if you haven't muted the audio as well. Now, you can watch the pictures and make your comments

When you have finished and pressed Stop, you can decide straight away if you want to make another attempt. If you are happy answer the question "Would you like to keep your recording?" with Yes you will find the result on the Voice Over Track. You can now treat it as any other sound – alter levels, edit and even move it along the timeline.

One problem is that on many systems there is a certain amount of what is a called latency – a short delay. For me, any Voice Over recording is about half a second delayed when it is placed on the timeline, relative to the timing when I recorded it. It takes only moments to slide the voice over into the correct place, however, and the delay is totally constant.

A voice over track added to the timeline

Audio Ducking

Audio Ducking allows you to use the audio of one track to lower the audio on some or all of the others. The most likely use for this feature is to lower background music automatically during a voice over.

The best way to demonstrate this is with a sample project. If you want to follow the steps you can download it as a package from the website, or load it from the data DVD. Because it only contains audio it is quite a small file.

Open **Audio ducking for PS23.movie** and study the timeline. On track 2 is a voice over I have recorded, on track 3 some music. Notice that the voice has been recorded at a lower level than the music – the waveforms are smaller.

There are two routes to get to the Audio Ducking tool. For now use the toolbar icon to the right of the voice over tool which looks like a waveform. A new window opens with a drop down menu and a number of parameters.

Audio Ducking control window

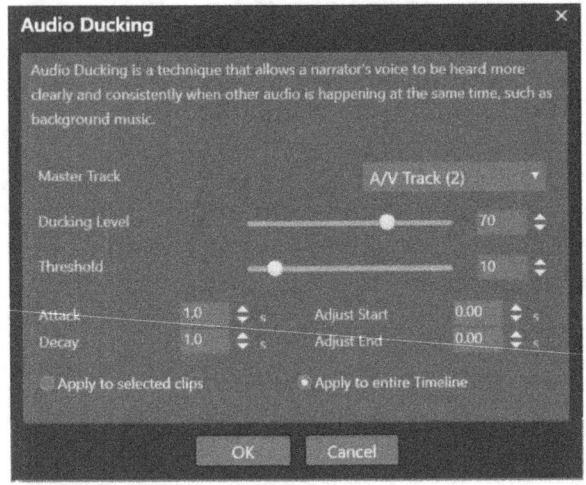

The track that controls the ducking is called the Master Track. In this case the default selection, A/V Track (2) should be selected, and that is the track that contains our voice over. If track 2 isn't selected, there are two possible reasons. Either you have changed the track during the current editing session, or you used the clip Context Menu to reach the Ducking panel. Following this second route will automatically set the master track to same track the clip that you right clicked on was located.

Two check boxes at the bottom of the box allow you to choose which clips or tracks are ducked. When Apply to selected clips is checked, only highlighted clips will be affected. As we entered the ducking tool without highlighting any clips you need to check Apply to entire Timeline to test Ducking. If you want to exclude whole tracks from being affected the easiest way is to lock the track using the track locks, but if you need to achieve something more complex you might need to use the clip selection method.

Ducking Level affects how much the other tracks are lowered by. If you want to completely mute the tracks, set the Ducking Level to 100. The default of 70 is OK for this example, but if the effect leaves the music too loud in comparison to the voice for your project you can lower this setting.

Threshold is more complex, so let's apply the effect and see what it does before experimenting further.

When this feature was first introduced, it had different defaults. Pinnacle changed these defaults to better values, but to make this demo more informative you need to go back to the original defaults. So, please change Attack and Decay to 1 second and Adjust Start and End to zero. I'll explain what they do in a moment.

With the value of *Threshold* set to 10 and *Apply to entire Timeline* checked, click on OK. The Ducking window closes and the program adds a series of keyframed volume adjustments to the music track.

Possible bug warning! **Randomly in PS24 the ducking doesn't seem to work. I've found that using** *Remove Ducking,* **from both clips and even though there doesn't appear to be any applied, makes it start working again.**

Ducking applied to the demo project

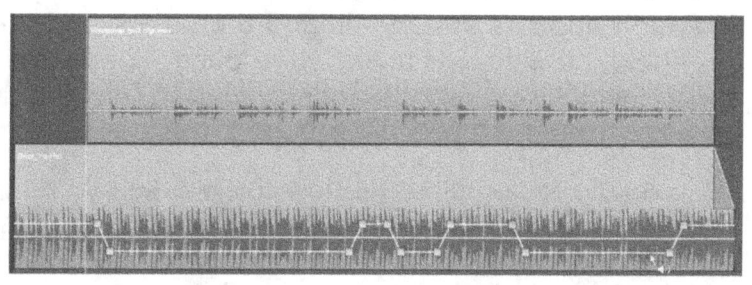

The music ducks down three times. Play the project and I think you will agree that this isn't ideal. The adjustments are being triggered by how loud the voice track is and only the louder sections cause the ducking to occur. My recording level of the voice isn't really high enough and during the second phrase the music comes back up to full level when it really shouldn't.

You might think that all we need to do is increase the level of the voice and re-apply the ducking effect, but that's not how things work – the calculation is made from the waveform, not the level set on the timeline.

Opening Audio Ducking again and adjusting the Threshold to a lower setting – in this case a value of 5 - makes a far better job of things – there is only one ducking event, during a reasonable pause in the voice over. If you set the threshold to zero the ducking would occur for the entire duration of the voice over clip, regardless of levels. If you increased the threshold value then the ducking would only occur for the really loud parts of the voice over.

You can see that the dips in level have slopes, rather than sharp drops and increases. The angle of the slopes, or the gentleness of the changes, are called the Attack and Decay. These values dictate the speed at which the background music fades up and down. If you are making a fast paced video, you will prefer higher levels of attack and decay, but for a leisurely slideshow you might want the music level changes to be more gradual.

The result of adjusting Attack and Decay

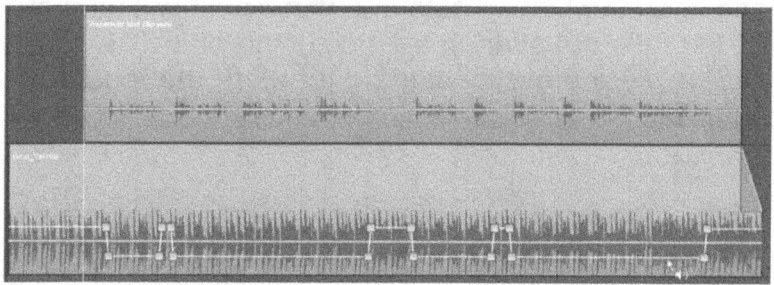

Let's adjust these values. Open the ducking panel again, set the values of both Attack and Decay to 0.2 and then click on OK. What happens may surprise you! Yes, the

slopes are steeper as you might expect, but also there are now four dips in level, rather than the original two.

Ducking parameter interaction

At first, it appears that by altering the attack and decay we have also affected the threshold, but this isn't actually the case. The Audio ducking tool is programmed to avoid a situation where the music is faded back up during a pause in the voice over only to be faded back down before it reaches its normal level.

It's possible to demonstrate how this works by changing the values again. Change Attack and Decay to 0.5 and you will see that the first time the music fades back up the keyframes are virtually touching. Now change just one of the parameters to 0.6 and the fade up doesn't happen at all.

However, if you are getting unwanted adjustments but you really do want to use the Attack and Decay setting you have chosen you may well be able to adjust the Threshold value so that a fade up isn't triggered. Try values of Attack and Decay of 0.2 but a threshold of 2 and you can see that the demo project changes to just three ducking events. However, now that the second fade up and down has a sharp attack and decay it is quite acceptable.

Ducking Start and End offsets

When a fade down is triggered, the fade starts before the threshold point so that the music is fully ducked before the voice over starts. When the threshold value drops low enough to trigger a fade back up, that begins at the trigger point. With fast Attack and Decay values the default values for Start and End are pretty much what you need. However, for slow fades this may not be the case.

Try changing the ducking values to a threshold of 5 and Attack and Decay of 2 seconds. Notice that there is now not enough time even for the fade up during the longest pause in the voice over – we only have one ducking event.

When you play the result you might agree that it is somewhat ponderous. What if we began the fade down later? As long as the voice over is audible when it begins – and often the first syllable of a voice over will be quite loud – then you can afford to let the fade out overlap the beginning of it. The same applied to the fade up at the end of a voice over – starting it before the trigger point may be subjectively more pleasing.

Adjusting the Start and End offsets to slow fades

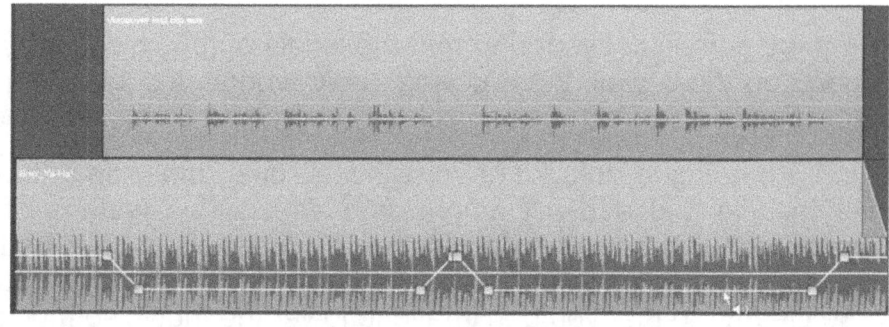

That's what the Adjust Start and End parameters are for. Try adjusting them to a Start value of 0.5 and an End value of -0.5. Now, not only do the fades work a little better, but there is room for the ducking event during the long pause.

It's worth mentioning that you might want to use shorter Attack times and longer Decays. You might also consider using different Start and End offsets. A lot will depend on the nature of the project.

Editing the Ducking

Once the keyframes are added you still might want to move the start and end points or adjust the slopes. If that's the case, you can adjust them manually – see earlier in this chapter for details of working with volume keyframing.

Add your Ducking first

If you have already made keyframe adjustments to the music tracks, these will be destroyed when you add the Ducking effect, so don't waste effort on adjustments. You can use a timeline fade though – as I've done in the example project – and this won't be destroyed.

The voice track doesn't get modified, although as I've just said, any volume changes you may have made won't affect the calculation of the Ducking points.

Remove Ducking – Beware!

This tool is available from the Context Menu, but it's a bit of a blunt instrument. It will reset all the volume keyframes on all the unlocked tracks. That includes the Voice track, unfortunately, so you must lock that to preserve any prior adjustments. If I'm unhappy with the result of applying audio ducking, I find it easier just to reapply it or use the undo tool.

Voiceover quality

In my experiments, I've found that the levels of the voiceover you use makes a big impact on how well the ducking took works. It's also important to eliminate extraneous sounds and in particular the breaths of the voice over artist.

If you are going to do a lot of voice overs, one further tip after recording them is to take the file and add a Compression effect. This flattens off the level changes considerably. One advantage is that it's possible to get better triggering of the threshold values, another is that the compressed voice will punch over the music more clearly, so that you don't have to lower the music so much.

If you want to experiment with using a Compressor, note that you must export the file and re-import it as a new file. As the audio Ducking tool works off the waveforms, these need to be recreated.

The Title Editors

Studio currently has two title editors. The Motion Title editor is the mainstay of the program that has been there since the outset. The 3D editor was added later on – it has been developed from a standalone program and integrated into Studio.

In Studio 24, there has been a lot of work done on the Motion Title editor. It has been brought into the main interface in the same way as the Effects and Masking editors. Additionally, enhanced motion keyframing has been added, although that isn't present in the Standard version of Studio.

Motion (left) and 3D (right) titler toolbar icons

The 3D editor offers a superior interface for a particular type of title – by default they have a solid, three-dimensional look to them, and can be moved and animated in 3D space. With a bit of work It can be used for more conventional looking titles and the end result may look sharper on screen in comparison to the Motion titles.

In this chapter I'm going to address the use of both editors, starting with Motion.

The Motion Title Editor

There is a long-standing complaint about the motion titles being "soft" or "jagged". In my experience this doesn't make them unsuitable for the majority of tasks, but if you like to fill your screen with large, sharp edged text you may see jagged edges, and small text can look a bit blurred. Both issues look worse when you take screenshots and start to magnify them.

I'd like to make two points here. Pinnacle claim to have made significant improvement in the titles over the years, so the reputation may be worse than the reality. Also, the issue seems to be worse when you work in HD. At UHD resolutions the titles appear to be much clearer relative to the overall resolution.

Anyway, in my opinion the titles produced are usable. If you are worried I suggest you do some real world tests before you commit to using the Motion Titler, comparing it's output to titles produced by an external graphics program.

The interface for the Motion Titler

This is the first time in this book where I'll look in detail at the In-Built Editors. When Avid Studio was first written, the space top left in the main Edit tab was used solely by the Library. All the "Editors" – Titles, Effects, Corrections and so on – existed as separate pop-up windows. Throughout the book I'm going to call these the Legacy Editors, as some of them still exist.

In Studio 21, the first In-Built Editor was added. This exists either in place of the Library, or if your screen is big enough you can use a Dual View and have the Library and Editor share the space. It is just called the Editor because it works for Properties, Corrections, Effects, Pan and Zoom and Transitions. It also hosts an improved Speed effect called Time Remapping.

Pinnacle initially left the user easy access to the old pop-up editors so that some functions which weren't possible in the In-Built editors could still be accessed – a good example was the ability to add clip markers. Also, the In-Built editors were not always as reliable as the Legacy ones.

Fast forward to PS24 and some of those Legacy Editors are no longer available or harder to access (and perhaps less reliable). The In-Built Editors have improved. Masking has taken up another tab in the Ultimate version of the In-Built area, and now we also have an In-Built version of the Motion Title Editor.

As I write this the Legacy Title Editor is not available in PS24.

Creating a Title

I'm going to begin by adding a simple title, but describe all the functions as we go. I'll then add other enhancements and motions as well creating roller and crawler captions.

You can build these titles over any video you wish, but I've used the Drone Project Stage 2 (also available as a project package on the website or DVD) as a starting point. I'm going to remake the titles I've put on the later versions of the drone project, so you can either rename your version of **Drone Project 2**, or load it from the website. The next time you save it, we will call it **In_Built_Titles_1** and increment the versions from there.

Prior to opening the editor to create a new title, it's a good idea to decide what track you want to add the title to. As discussed before, Studio uses a top down approach so if a track is above another, its content will be overlaid on top of the tracks below.

Most titles will be overlaid over other video or photo sources, so you should leave Track 1 clear for them. If you haven't done so, you can easily create an empty track at the top of the pile.

By default, a newly created title will be placed on the currently active track at the current scrubber position **if there is space for it.** If there isn't, the title will be placed on the top track, and if there is no space there or no track exists, Studio will create a track for you. Under no circumstances (that I've tested) will adding a title disrupt your project sync.

So the obvious mistake is to have Track 3 selected when you have video on track two. The title will appear on the timeline, but it will be obscured.

With the **Drone Project Stage 2** loaded, click on the first clip so that the scrubber moves to the start, then highlight Track 1 by clicking on the header.

There are two paths to creating a new title. At the top of the window that normally displays the Library, there is a Title Tab, and if you click on that, the window switches to the In-Built Title Editor. Because there is no title selected on the timeline, you get an almost blank display with just the button *Create Title*.

Before you use Create Title, let's explore the other method by using the simple T icon on the timeline toolbar or by using it's keyboard shortcut CTRL+5.

Three things will happen when you create a title in this manner. A green clip of the default title duration will appear on the timeline at the scrubber position and on the track selected (unless the position is occupied, in which case Studio obeys the logic already described). If you find yourself always altering the duration of new titles to suit the type of projects you make, you can change the default duration in the *Control Panel/Project Settings*.

The second thing to happen is that the *Title* tab will be joined by three other tabs, *Text*, *Motion* and *Legacy Presets*. The final change is that a lot more has been added to the Title tab - you may need to expand it or scroll down to see all the options.

The Title tab with a title selected

The three timecode boxes aren't just for information - you can enter new values and the currently selected title will adjust it's duration and position to match the changes. That's probably not the best editing tool, but it does work if you multi-select some titles and change all their durations at the same time.

More importantly, two buttons let you Save the current title or replace it with a different one from the Titles category of the Library.

Assuming you don't want to use any of those features (for now), you can still edit the title in the Timeline preview window, but before we do that, it's worth mentioning what happens if you use the Create Title button rather than the toolbar icon. The green title clip still appears on the timeline, but the In-Built Title Editor automatically switches to the Text tab.

Switch from Title to Text now so we can continue to edit the new title.

The In-Built Title Editor in Text/Looks mode

In the above screenshot you will see a category of Looks named My Looks, but this will only be present once you have saved a customised Look of your own.

Incidentally, as I mentioned in the User Interface chapter, the Library/Editor window can be changed to Dual View, so you can have both the Title Editor and the Library displayed side-by-side. This isn't that practical on smaller displays, but there is one instance where it can be useful, which I'll describe later.

In-Built Title Editor layout.

A horizontal Tab bar sits at the top of the editor. In Plus and Ultimate you have the choice of editing **Title**, **Text**, **Motion** and **Legacy Presets**. As Standard doesn't allow title motion, it doesn't display the last two options. Title divides the workspace in two, but the area to the right is a redundant keyframing area.

The other three options all divide the editor into three panels. On the left is what is best described as the **Layers** Panel. Any title can consist of multiple objects such as text boxes and shapes, and they are managed here.

In the middle are **Settings**, and the panel on the right displays timelines for keyframing or motions.

The In-Built title Editor uses the main Timeline Preview Window as it's workspace, so you can edit the text by typing directly onto the screen and adjust its positioning with the mouse. You can only do this when the Title Editor is active, for which you need to have selected the title clip on the main timeline. You can tell that it is active because you will see faint "title safe" guideline around the edges of the screen.

The default text placeholder is *Your Text Here*. Hover your mouse over it, click and the whole line of text will be selected, indicated by a grey highlight. You can now press the Delete key to remove the text, or edit it using the arrow keys and backspace and typing in your own text. Enter the title **The Grand Union Canal**.

In some circumstances the background video will make the text hard to see – that's certainly the case here. It also makes it harder to edit.

Turning off track monitoring

Before we address that issue by making the text easier to read, hide the background video by turning off the video monitoring of track 2 using the tool in the track header.

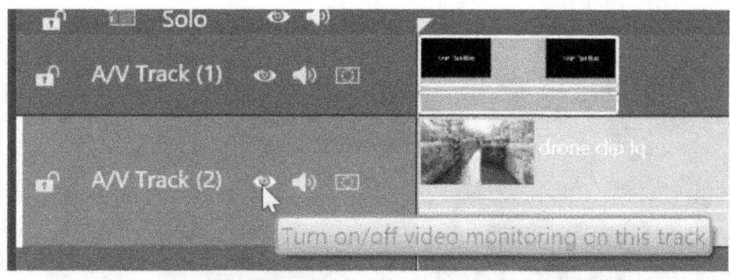

Re-positioning the text manually is easy. Hover over the edges of any selected text box and a four-way arrow cursor appears; click hold and drag.

Moving a text box

You should begin to see the value of the title safe frame now, as it can help you to centralise your text, but it has another purpose, which I'll talk about later.

Drag the text box down so that it lines up with the lower inner frame - it will overlap the vertical guide lines just a little - and release it there.

The nodes around the edges can be used to resize the text box. How the text behaves is controlled by the **Wrap Text** tool, and to find that we need to look at the row of tools at the top of the Settings Panel

The Settings panel Tools

With this control on, the text retains its font size and your control of the text box will be limited – you can change the shape but the area will stay the same, and the text will re-wrap itself to fit in the box. Switch the control off and the text will resize itself to fit the box, even to the extent of altering the height of the text without altering the width or vice versa, therefore changing the aspect ratio.

The corner nodes maintain the aspect ratio of the box, but if you grab the sides the shape will change.

What is more, switching between the two modes allows you to resize the text, then alter the box aspect ratio to change the way the text wraps. It's one of those features that is much clearer with a little experimentation, I suggest you do just that now!

Rotate Node

Above the box in the centre is another node that allows you to rotate the box as well.

Try these features out, but return the text box to its original size, shape and angle using Undo or Ctrl-Z before proceeding. Alternatively, you can simply delete the layer with the Delete key while the frame - not the text - is selected, and remake

the title. To add a new text box once the editor is open, we need to use the **ABC** tool above the Layer panel on the left. Change the text and position the title as we did before.

We will come back to the layers panel and the other tools shortly, but let's continue with refining the current text and how it is going to look over the underlying video.

Click on the Monitoring icon in the track 2 header to activate it and the video on the track below the title will re-appear. If you are using the drone project, you can now see that the title isn't easy to read - the "nd U" letters in the middle of the text are overlaid onto a strong light reflection.

The title superimposed over the video

Would the title benefit from being higher? Drag it around and I think you will agree that although placing in the centre of frame is a little better, it's still not ideal. What's more, if the video clip under the title is a moving shot, a good position for the start of the clip might not work for the end.

You can extend the duration of the title along the timeline to check this. Wherever you position the text, there isn't a place that works for the whole duration. We are going to have to make the title stand out in some other way.

Accurate title positioning

By the way, although dragging a title is a fairly accurate operation, if you want to achieve very precise positioning, it's worth noting that a highlighted text box can be nudged a pixel at a time with the keyboard arrow keys.

Aligning a text box

Sometimes you want to just place your titles consistently, and there is a tool for this on the toolbar. It's actually hidden under a slightly misleading tool tip and icon, but the Group Align button on the left contains a "relative position" grid that works on single layers. Let's use it to at least make the composition of the title and video agreeable.

Highlight the title and open the button, then try the nine boxes at the bottom of the menu. Each one will align the text with the edges of the screen, apart from the middle box which is the best way of ensuring your title is dead centre for the screen.

Use the Bottom Edge setting to place the title below the lock gates, then close the grid.

The other Group Align tools only work with multiple selections of text and shape layers, helping you to line them up accurately.

Title Safe area

What are those frame lines for anyway? A long time ago, broadcasters defined what are known as "safe areas". Because early TV sets were set to overscan, and some overscanned considerably more than others, two areas were defined. The outer frame is the area that any important action should be contained within - the Action Safe area.

The inner frame is where any text that the viewer is expected to be able to read should be placed – the Title Safe area. It was even deemed that some objects you shouldn't see could be included if they were in the very outer area.

I distinctly remember a sit-com director decreeing that we didn't need to do a retake because the boom mike in the top of shot "was well within cut-off". 20 years later when I watched the show on DVD the boom was clearly visible.

Modern TVs and the habit of watching video on computers mean that the "safe areas" are an anachronism. Most people see almost, or even completely, up to the very edge of the frame. However, that's not to say that you should use the whole screen, because some people may still be watching on TVs with overscan of some sort, and there are still aesthetic considerations.

Studio now provides a 90% frame to guide you where to keep your text. If you are making video for portrait devices, the frame can be set to 80% in the Control Panel *Export and Preview* options.

Text Settings

At the top of the Settings panel are the Text Settings. They can be hidden, as can all the settings, with the white triangles for expanding and collapsing them – useful if you are running out of screen space.

The first entry is a text box containing the currently selected text. If it is showing up as empty, click on the text box in the Preview window. Now you know what text you are modifying, sure, but this text entry box has other uses because you can modify or completely change the text with it. This may seem like duplication because you can do that in the preview window, but when a title gets complex, particularly when using the Roller or Crawl motions, this box could come to your rescue. Entering or editing the text here is less resource hungry, so if the Title Editor becomes slow or even unstable consider using this box.

Setting the Font

Searching the Font drop-down

Our title should be using the font Times New Roman as the default. You will see the font name in the next box down. Open the drop-down menu and you should be able not only to see a list of fonts, but the names will be in the style of the font. The text you wish to change needs to be highlighted, so ensure that the whole title is selected before choosing the Arial font. Yes I know, I'm just swapping one boring font for another, but trust me. By the way, if you want to find a font quickly and you already know its name, begin typing it in the Font box and Studio will find it for you.

Notice that when you swap fonts, the text size on the screen can vary significantly. You can resize your text on screen, but it is a good idea to get the correct font size so that no significant recalculation is required. Set the Font size to 60. Alongside the font type, you can also select a specific font size from the drop-down box or use "Larger" or "Smaller" buttons to alter the size a step at a time.

In between the two boxes is a row of text formatting tools. Bold, Italic and Underline should be obvious. Highlight the title text and select Bold to make the text a bit stronger. Note that you don't have to apply these attributes to a whole text box – they just get applied to the section of text that is highlighted. To the right of the attributes are the choices of justification - left, centre, right and justify. When the text neatly fills

the box it is in, as is currently the case, you won't see any difference. Once you start to use multi-line titles by using the Enter key, you will appreciate these controls.

The final control on that line alters the text flow. You can produce some fun effects here as well as it being useful for other forms of writing.

Line and Character Spacing

One text attribute that was introduced in PS24 is the ability to specify Line and Character spacing. This isn't limited to integers - you vary it by small increments to help you achieve a particular style. In the current build, this feature appears to be keyframeable as well, but doesn't appear to be fully implemented.

For now, we have finished working with the Text Settings. If you want more space so you can look at the next group of settings below, use the white triangle to collapse Text Settings.

Looks Settings

Below the text settings, there is group of parameters with the heading **Looks Settings**. These define the colour and appearance of the text, including any edges or shadows.

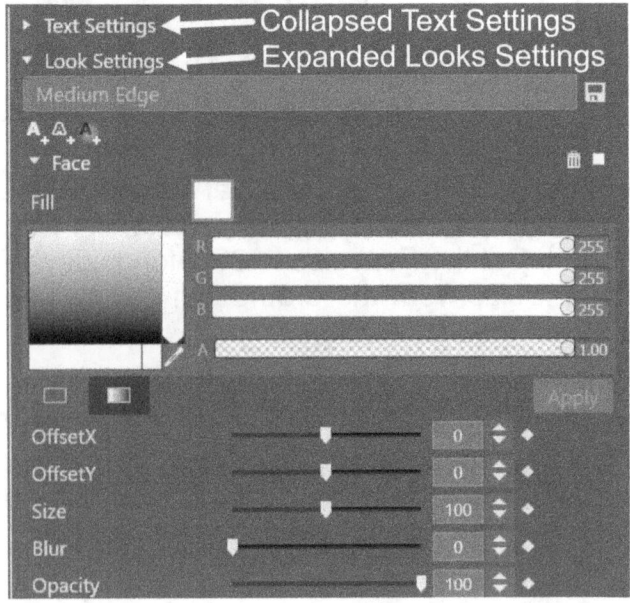

Studio has a very large range of predefined Looks and we access these from the row of Looks tabs at the top of the window, which contains four or five categories. When you click one of the categories, you get a film strip of Looks across the top of the window. Have a browse through what is available – from the subtle to the outright garish. As you hover over the looks, you will be able to preview the effect in the preview window.

We are after something that will just help the title stand out when it is superimposed over bright parts of the picture, and my choice is a Look in

Standard Effects called Medium Edge. When you find it, click to apply. Scrub through the title and you can see how it helps define the text.

Choosing a Look

I'm going to suggest a little modification of the Look as a way of explaining how they are built up. The Medium edge setting consists of two components – one **Face** and one **Edge**. It's also possible to have a **Shadow**. As a general principle:

• A Face is in the **foreground**.

• An Edge is **behind** a Face but is a little bigger so that a bit of it pokes out around the edges. Note that an Edge is actually solid.

• A Shadow is behind them both but **offset** a little so it gives the effect of being a shadow on a "wall" behind. The shadow effect can be enhanced by being slightly transparent and/or blurred.

Adding an extra Face

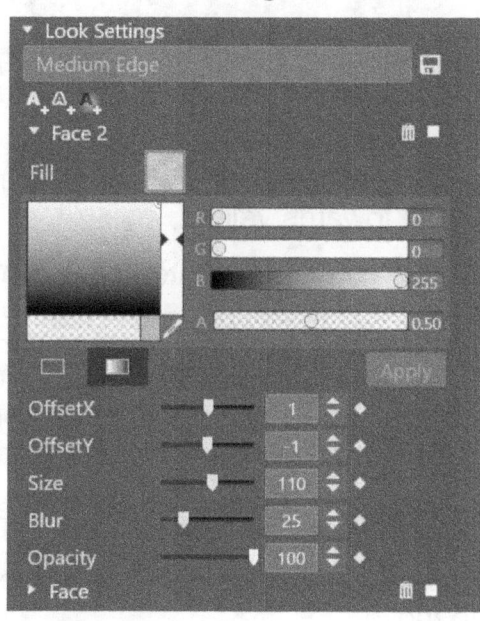

So, in theory a Face doesn't need to have its size or offset changed, but Studio doesn't discriminate and offers the same set of variable parameters to each text layer. In fact, the different types are only there as a starting guide because you can rename them and alter the order of the layers.

Underneath the name of the current look are three icons that let you add additional text layers. Select the top Face before you try this next step, then click on the left hand icon (with the tooltip *Add face detail*). A new layer Face 2 is added to the **top** of the list. Crank the Offset sliders around and you will see it move, allowing the other layers beneath to show through.

Experiment by setting X to 1, Y to -1, Size to 110 and Blur to 25. That's a pretty rubbish looking effect but I'm going to make it look worse before I make it better.

The Colour Selection box

For the next stage to be obvious, I want to change the colour of Face 2. Click on the Fill box of the Face 2 parameter set and the Colour Selection box becomes active. I want to create a single, solid colour, so make sure the Solid Colour icon is active - in this case light grey.

The Colour Selection box

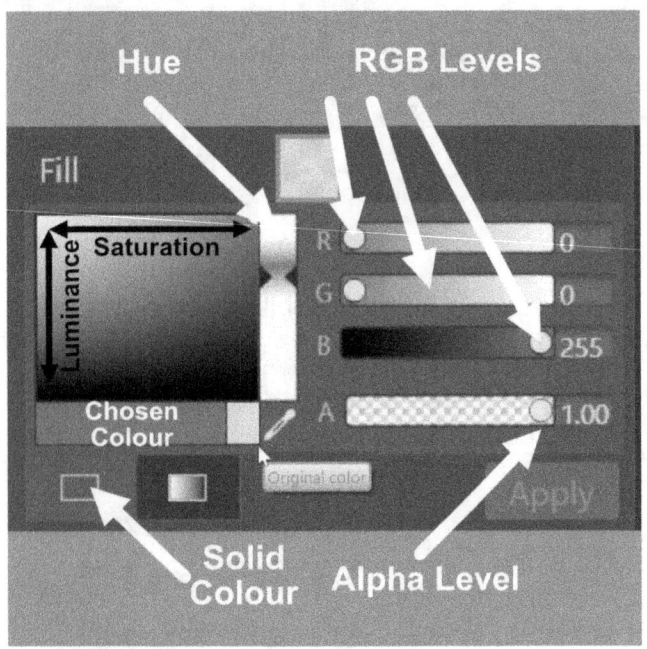

Any colour that can be displayed on a TV or computer can be created by mixing three primary colours of Red, Green and Blue. The range of values is from 0 to 255 for each primary. These values can be controlled with the top three sliders on the right of the box. The resultant colour is displayed in the rectangle under the "Chosen Colour" label in the screenshot. Keep an eye open for a scroll bar. If the menus are getting too big, these tabs are at the bottom of this menu. You can adjust the sliders with the mouse, or type in values. With all three set to zero you get black, and with all three set to 255 you get white. Every other possible shade can be generated by a combination of the three values. If you look at the bottom slider, Studio provides a clue as to what will happen if you lower the value for Blue – the white will start to move towards yellow.

All the controls are interactive. The larger rectangle at the top left of the box has a dot you can drag up and down to affect the Luminance, left and right to affect the Saturation. Alter the Brightness or Saturation and the RGB sliders move as well. Between the large box and the RGB sliders is a Hue control than can be adjusted vertically. This will change the colour of the left-hand window, and alter the sliders as well if the chosen colour isn't monochrome.

Because of the way the colours are displayed within the controls, you don't really need to work out which value you need to change to achieve your desired colour – one of the settings should be displaying a colour which is in the direction you want to move.

There is no real substitute for just moving the controls around to help you understand how they interact. When you have finished, create a solid pure blue colour and click apply.

An area below the Saturation/Luminance box shows the Chosen Colour (as labelled in the Colour selection box screenshot) and a smaller patch to it's right shows the previous colour before you began making changes (with the tooltip *Original color*) so if you have made a mistake you can revert to the original colour just by clicking here. If you were making subtle changes and decided you preferred the previous choice this makes it easier to undo.

There is a further slider below the RGB controls that controls Alpha, which might be better understood if it were called Transparency or Opacity. This determines how much of the underlying layer will show through. 0 is completely transparent, 1 is solid. Set it to 0.5. This value can also be set in the Looks settings when you are dealing with Solid colours, so you need not decide right away how much you might need.

Gradients

While we are studying the Colour Selection Box it is worth looking at Gradients. With this tool you can define how the colour changes over the area to which it is applied. Click on the gradient button on the bottom right and a new bar appears at the bottom of the box.

Two cursors are initially set to the left and right of the bar, and if you click on one and select a new colour you will see the gradient appear. To the right is a direction control, and when you rotate it the angle at which the gradient will appear on the screen changes.

Basic Gradient controls

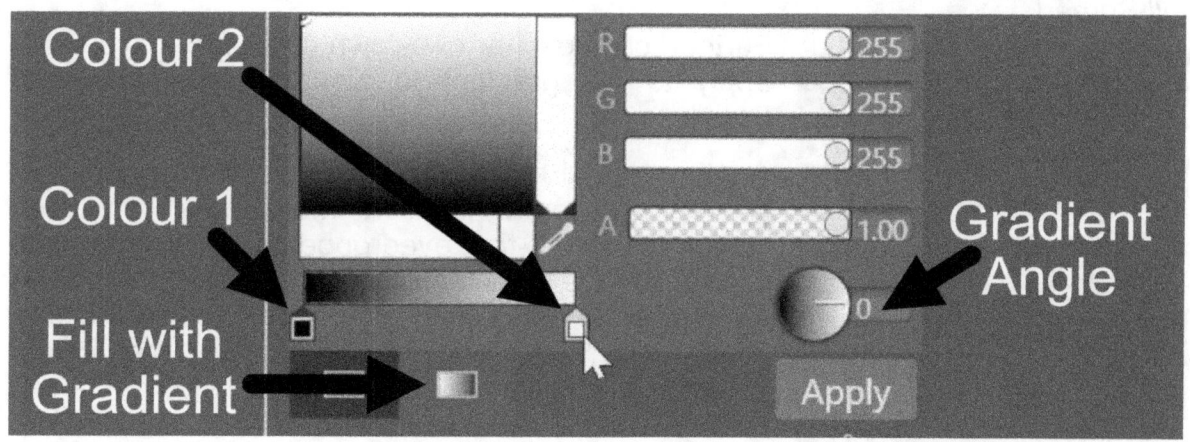

You can adjust the Gradient sliders. In the Screenshots I've set Colour 1 to black and Colour 2 to white. Sliding Colour 2 to the left and Colour 1 to the right results in a non-linear gradient.

Altering the Gradient start points

The power of gradient creation doesn't stop there either. You can add more colour sliders. This is achieved by double clicking on the gradient bar. Each new slider can be given a different colour.

A four point gradient

If you change your mind, the additional sliders can be removed by dragging them vertically.

There is a further parameter associated with Gradients, but it doesn't appear until you click on the Apply button. When you do, it is inserted below the thumbnail showing the current Fill.

When set to Layer (which is the default) the spread will occupy the whole frame.

Fill Spread

Further choices narrow down the spread you can apply to the gradient to Lines, Words, Letter or Details.

Another useful tool is the Colour Picker, which looks like an eyedropper tool. To match any onscreen colour, click on the eyedropper icon. The mouse changes to the same shape as an eyedropper, and as you move the new cursor over your screen the colour under the mouse cursor becomes the colour selection's current colour. Click to set the chosen colour.

When you have finished experimenting, reset the Face 2 colour to a solid R=0, G=0 B= 255 and A=0.50, and **Apply** the colour.

Fill Pattern

What if you wanted to use a fill that wasn't a solid colour or a gradient? This new feature in PS24 expands the power of the title editor greatly. Any Fill parameter can be set to use a picture or even a video file. This opens up endless possibilities.

At a simple level, you can use a graphics file to give your text faces texture. I've provided a file to test this principle, but I'm hoping that Pinnacle will provide some more in the Library in time. The graphic is a called **Dark Carbon Fibre.png** - locate it on the website or DVD and add it to the Pinnacle Studio Library.

Alongside every Fill thumbnail box is a drop-down menu that gives you the choice of Fill Color (including Gradients) or Image Pattern. Select the latter and then click on the Fill thumbnail and there is a dramatic change to the Title Editor – it is replaced by a mini-library.

The Mini-library

Now, this doesn't have the structure of the main Library that you can browse easily, but it does have a search box. There are three categories. Project Bins offers a drop-down from which you can select any Bin you have populated. Video and Photos list ALL the video clips and Photos in your

Library – even ones that are no longer in any Bins.

Selection of the chosen asset is a case of highlighting your chosen file and then using the Apply button.

You don't have to use a specific texture file. Interesting result might be achieved with photographs, The ability to include video opens up all sorts of possibilities as well - the quest for moving video titles is now over, so you can make your own version of the titles to Dallas.

Applying the sample texture to large font text gives it a very specific look. You should be able to find plenty of texture files as free downloads on the Internet if you want another sort of look.

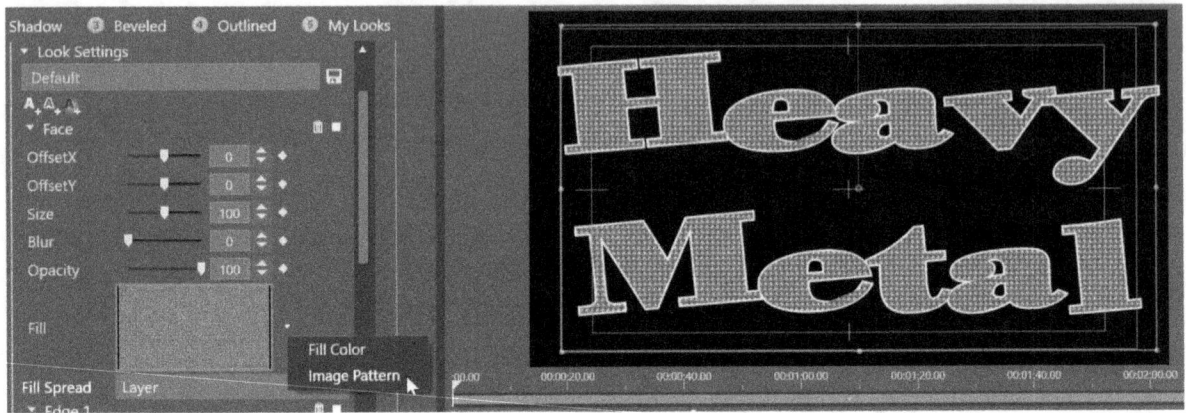

Face, Edge or Shadow?

What I have in effect asked you to do is create a Face 2 but give it the attributes of a Shadow – a bit of offset, transparency and blur. It looks rubbish because it isn't in the right place to be a shadow, though - it is in front of the Face and Edge 1. Let's move it to the background.

In order to do this in the In-Built Title Editor you will probably need to collapse the Face parameters using the white triangles so that the list all fits inside the panel.

Dragging Face 2 down the list order

Once you have done this, click and hold on Face 2 and drag it down the list. In the same way as you can move tracks about on the timeline or effects in an effects list, you will see a thin line appear when you are able to drop the text layer. Drop it at the bottom of the list.

It used to be possible to rename the Faces, but that no longer appears to be the case.

Have a look at the title properly – click away from it to get rid of the selection shading. The white face and black edge are in front of the blue shadow and in my opinion the title doesn't look too bad now. With track monitoring on, scrub through the clip – it seems to stand out better even as the drone climbs.

So what have we learned about the text layers you can add as Face, Edge and Shadow? They are convenient labels and when we add one to a Look they are placed according to their intended effect. Faces get put on top, Shadows at the back and Edges in the middle. However, Studio allows all the parameters possible to be applied to any layer – and the layers can be re-ordered. This might almost be too much flexibility – why would you want to add an offset to a Look that only had one text layer? Indeed, you probably wouldn't. Studio's consistency of design, however, lets you do so if you did have a reason.

You can add lots of text layers to build up a Look, and even if you see a pre-built look that seems too complex to be done that way, dissect it and you will find that is the case. When you spend time making a Look that you like, you can rename it and save it by using the floppy disc icon under the Look settings header. Any Looks you created can be retrieved from the fifth Looks category *My Looks*.

I've saved this as **In_Built_Titles_1** if you want to compare our results. You may want to save your own version before we move on.

By the way, I've seen some issues with the order of Face layers changing when you save and load titles. It's not a bug I've been able to get to the bottom of yet, but if you see the same problems, it's not just you! Once a title has been created, it should work as expected.

Saving Looks

We have seen how Studio offers you the option to load preset Looks from the Looks ribbon, which are part of the program's Content in the Library, although they aren't available from the library itself. There are four categories and a My Looks category becomes available once you have saved your own looks.

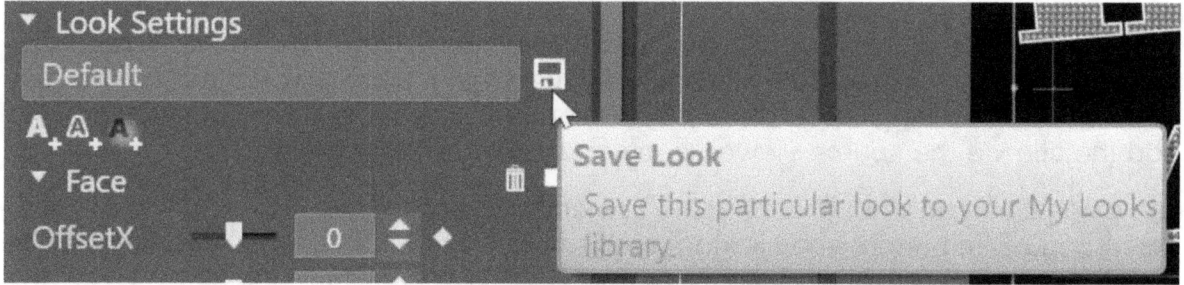

With the Look Settings expanded, there is a text box that contains the name of the last look you loaded, and to it's right is a small floppy disc icon (remember those?). Clicking on it will open a Save as dialogue, which offers to put the look in the same location as the other looks, where it will be picked up and automatically added to the Library content.

Saving Titles in the In-Built Editor

This is done by selecting the Title tab of the title editor while the title you want to save is selected on the timeline. Here you will now find a **Save Title** button which does just that, asking you for a name, while offering you the default location to save the title. When you have chosen a name the title is saved and automatically gets added to the library in the My Titles section of the Content section.

What if you have acquired titles from elsewhere – as a download or salvaged from another version of Studio or from another computer - and want to add them to the current Library? Studio motion titles have the file type title_name.title.axp. Adding them to Studio's Library is just a case of opening the Library tab either at My Titles or a Project Bin and opening an Explorer window over Studio (you can use the Library's Browse tool for this). After locating the title you want in the Explorer window drag and drop it into the Library. If you put it in a Bin, it will also be placed in My Titles for use in other projects.

Loading Titles

The easiest way by far to add a title from the Library to the timeline is to open the Library tab instead of the Title tab and then just treat it as you would a clip. The only feature that is missing is the Library Context menu option *Send to Timeline*. You can add the title via the source viewer, copy and paste or drag and drop.

However, if you do want to stay in the title editor, selecting the Title sub-tab will offer you a Load Title button, and clicking on this will open up a mini-library within the title editor itself. Clicking on the Apply button adds the currently selected title to the timeline using the same rules as Create Title.

The mini-library is discussed in detail when I discuss adding assets to titles, when you are far more likely to use this feature.

Titles on the timeline

Let's take a break from title creation to look at how they can be edited on the timeline.

Check out the current result by playing the video. The first thing that becomes apparent to me is that the title duration is too short - it has taken on the default 3 second duration as defined in *Control Panel/Project settings*. A broadcaster's rule of thumb for a title is that it should be on screen for you to be able to read it out loud twice, so it fails this test!

A title on the timeline behaves in the same way as any other asset. All the editing functions treat a title in an identical manner to video, photos or audio. To extend our title, just use a simple Quick trim to extend the Out point of the title. I've lengthened the clip all the way to the end of the first video clip, giving it a duration of 14 seconds.

Before we return to the wonders that await us in the Title Editor, it is worth noting that many of its powerful features aren't the only way of treating titles. For example, while we can add Motions using the editor, if all you want is a simple fade up or down or to alter the timing of a title it is often easier to do it on the timeline. Let's do that right now. We looked at how to drag out a simple transition in the Whistle-Stop chapter (and will be looking at transitions in more depth in the next). Hover over the top inner left edge of the left, click, hold and drag right to create a 1 second fade up to the beginning of the title. Repeat the process for the right edge of the title.

Adding a fade to the title

Transitions need not be limited to using dissolves. I find that the Push transitions can look very effective, for example. Another tool to consider when you want to manipulate titles is the Effects Editor. If you double-click on a title it opens in the Title Editor, but if you select the title clip and then just open the In-Built Editor you can

add effects - or indeed any of the other items available. Anything you can do with video, you can do to titles – including keyframing. You can also add some really neat third party effects if you have them in your version of Studio.

Even the need to have multi-layered titles with different motions need not always force you into the Title Editor because there is nothing to stop you adding as many timeline tracks above the main video as you require. However, the more complex the title the more likely it will be that the Title Editor is the place to develop it.

Titles and the Library

Studio comes with a vast array of pre-made titles. They are stored in the Library and can be dragged to the timeline just like any other asset. The Title Editor also has the File menu option to Save Title as… so you can save any titles you make yourself in the My Titles Library location – a location which can be defined in *Control Panel/ Storage locations.*

You can treat the pre-made titles as templates, because even if they don't quite fit the bill for your current project, it is often easier to get a professional looking title by modifying a pre-existing one than starting from scratch.

Open in Title Editor

If you want to edit a title from within the Library, there is a context menu option to Open in Title Editor. When you use this on any pre-made titles Studio switches to a second timeline, as it does when you open up a subproject - with just the title on the track. You can now make any changes you wish, before saving the title from the Title sub-tab.

The Legacy Title Editor

At the time of writing, there is no access to the Legacy Title Editor, and I expect it to stay that way. If you do encounter a full screen title editor that is very similar to the Menu Editor, (which we will look at later in the book) then you know that Pinnacle have left a path to it!

Adding a second layer in the In-Built Editor

Of course, no manner of face manipulation is going to make a title completely visible when placed over certain types of video. The easiest solution is to place a second layer behind the text but in front of the background. For this we need to turn our attention to the Layers Panel on the left of the title editor.

There are only two tools at the top of the panel. The ABC icon adds a new Text layer – titles can have multiple text boxes, you aren't restricted to one, and they can all use different looks and be animated separately.

Adding a rectangle

The second tool adds shapes or assets from the Library. For the background to our text I'm going to use a rectangle, but you can see there are plenty of choices – the Pills have rounded corners should you want to be a bit more adventurous,

When you click on the shape of your choice, it is added to the title and an entry is added to the list. In the current title, you need to scrub into the clip so that the fade in has been completed in order to see the result. You can now use the mouse to adjust the size and position using the nodes.

As soon as you start trying to manipulate the shape, you will see we have an issue – the shape has been added as a foreground layer, and begins to obscure the text. Changing the order of the layers is easy, however – there are three ways of doing it.

The rectangle obscuring the text

The **Order** tool is above the Settings area - I labelled it when we looked at the Align tool.

Order gives you a choice of moving the currently selected layer to the back or the front.

When you have more than two layers you can move it one layer at a time with Send Backwards and Bring Forwards.

The Layer Context menu

If you right click on the layer label in the list, a comprehensive context menu also includes the Order commands.

The neatest way of reordering the list, however, is by drag and drop – the same way as we changed the order of the Faces. Click and hold on the Shape Layer and drag it down the list. Now it's easy to resize and move the shape so it just overlaps the text. Don't worry about getting it lined up perfectly yet, though.

The context menu also has an option to edit the layer name. Use that to change it to Background Rectangle.

Select both layers – CTRL-Click does it, either in the Layer list or on the Timeline Preview, just as well as using the context menu. Now click on the **Group Align** tool. Click on Horizontal Center, then Vertical Center, and the rectangle is lined up perfectly. Now use **Group** either from the tools or the context menu, and we have a single GroupLayer that I've renamed and then re-positioned using the same grid as before to put it Bottom Center.

Just a word about another Alignment tool – *Space Evenly Across/Down*. This will save you work when making titles with lots of components. You don't need to line stuff up meticulously, just set the Left/Top and Right/Bottom objects in the correct places, multi-select the rest and use Space Evenly. This will come in particularly handy if you make legacy menus, which uses a very similar editor.

So what about that Shape colour? With just the rectangle selected, not the group, return to the Setting Panel and change the Face Fill Colour to black, but at an opacity of 50%. I think that is highly readable, but for added subtlety, change the Blur setting to 25, giving the rectangle, but not the text, some nice soft edges.

Before we go any further, let's save the project so you can experiment but then return to this point. I've named the save as **In_Built_Titles_2**.

Adding Assets

There are a few features that I'm not going to use but we need to explore. You may have noticed that the last entry on the list of Shapes is **Add assets from Library**. The main reason why you would use this feature is to add a graphic element that you have created in an external program – some shape or logo that is hard or impossible to make in Studio. However, you can also add photos, or even video clips.

Clicking on Add Asset opens up the Mini-library discussed when we looked at adding a Fill Pattern. You can select any one item, and then when you then click on Apply, the video or photo is added to the current title as a new layer, shrunk to quarter size. You can then size and position it with nodes just like any other layer. You can also drag and drop from the mini-library to the timeline viewer. If you want to use graphic files with transparency, you can. I've successfully imported Photoshop (psd), Portable Network Graphics (png) Truevison (tga) and Tagged Image File Format (tif) files into Studio.

So if you want to create your own logo in another software package you can – I'd recommend starting the process with a transparent background of the same dimensions as your project settings in pixels and exporting your creation in the png format.

Arrows and Special Characters

Windows Character Map

If you want a quick way of pointing something out on screen, you have other options than creating shapes in a graphics program. You can build one up using the Triangle and Rectangle shapes. You can also include an arrow as text using the Windows Character Map. This is worth investigating as this is also how you can include characters not available from the keyboard such as a copyright symbol.

You will find the **Windows Character Map** in Windows Accessories. If you intend to use it often I suggest you create a shortcut to it on your desktop. When you find the symbol you want, select it and then use the *Copy* button to put it in the paste buffer. Create a title, clear the text box and use Paste or CTRL-V. You can also paste into a pre-existing text box.

There is a font that contains a whole array of more sophisticated arrows in the place of letters called WingDings 3 which might offer you some interesting alternatives. Near the bottom of the font list are three that obviously start with W but show as a series of symbols. You might find other characters of some use to you in the other two fonts, WingDings 1 and 2.

If you use a particular symbol a lot – perhaps a Euro currency symbol – and it is missing from your keyboard, it might be worth looking up and even learning the ALT keycode. If you hold down ALT and type a number on your numerical keypad then release the ALT key, the symbol will appear. Some common ones are € - 0128, ↑↓→← - 24 to 27 and © - 0169. A quick trip to Google will bring up dozens of websites that list others.

Adding a Background

At the start of this chapter I mentioned in passing that titles can be "cards" – they aren't superimposed over the main video of your movie. In the days of silent cinema they would often be decorated.

If you want to add a full screen background to a title within the editor, it is pretty straightforward. You need to return to Settings pane and scroll down to the penultimate grouping Background settings. If you just want to create a solid colour or a gradient there is a Fill box similar to that we used to set a Face colour. Alternatively, you can add an asset from the mini-library by clicking on the Drop Zone. The process is then the same as adding an asset or a fill pattern, but once you have done so the background will be full screen. If you wish, you can alter the Opacity of the background with the slider on the right.

Dual view with Library

If you are finding the mini-library a bit cluttered, making if hard to find your assets, you can use the main Library. It will require a decent sized screen to use comfortably, though.

Make sure that your Video preview pane isn't in Dual View – if it is showing both Source and Timeline viewers, click on the Dual View icon top right and make sure you have the Timeline view selected. Now, with the Title Editor open on the left, use its Dual view icon and the main library will appear to the left. After you have located the asset you want, drag it either to the Timeline viewer to add it as a layer, or to the Background dropzone to make it a full screen background to your title.

Stereoscopic text effects

One text parameter that you may have spotted and I haven't yet mentioned is Stereoscopic settings. These affect the size and positioning even if you haven't set your project to 3D, although obviously you won't see the full 3D effect even if they move. The only control is the Depth setting, which moves the text closer (negative values) or further away (positive values). Each text layer can have a different value, so with a bit of work you can build up some interesting 3D effects for your Stereoscopic projects.

Motions

The Title Editor has some pretty neat preset animations that you can't achieve on the timeline. It also offers an impressively comprehensive set of title animation tools, unless you are running the Standard version.

Keyframing Faces

Something you may have noticed when the Face parameters were open in settings is that a set of keyframe controls follow each parameter. That might sound like a rather advanced feature, and indeed it is. Unless you use it sparingly, it's likely to give some very fussy, complex results.

The Motions Tab

This feature is new to PS24. It gives you keyframeable control of your text, either at the Layer, Line, Word or Letter level. Yes, each individual Letter.

Simple titles are a mainstay of video production, and if you want to use more complex titles you can use pre-made ones from the Library, or add preset motions to your own creations, as described in the next part of this chapter. However, if you want to make something to really impress, Studio now gives you the tools. It's a thin line between impressive and a random looking mess, however.

Two attributes you will need are creativity and patience. Try to have a clear idea of what you want to see happening on screen before you start programming your moves. Keyframing was described to me by a very experienced editor as "Not a Spectator Sport" and he is spot on – you need to work carefully and methodically, and therefore pretty slowly.

An understanding of two advanced techniques are also required to get the best from Title Motion. Multi-parameter keyframing is described in detail in the In-Built Editor chapter when manipulating Properties and Effects. Animation in three dimensions is used in that chapter as well. Although I'll explain both in the following walk-through,

for more details and further understanding you might also want to explore those sections.

The Title Concept

I am going to build a 10 second title to use at the start of tutorials consisting of the words "Pinnacle Studio Revealed". It will be split into two lines – Pinnacle Studio in a large plain white font, and Revealed in a red script font – like the title on the cover of this book. The first line will animate in as if it is rotating on the inside of a cylinder which the viewer is just inside of. The second line will then appear from the side, a letter at a time. After a long hold, the top line will animate out, and the viewer will fly forwards through the hole in the letter R of Revealed.

If you would like to use some other text, please do, as long as it is similar. While the animation should still work when you change the Line text, there are anomalies when altering the Letter-by letter animation. I also must point out that this walk through was designed with an early version of the Motion feature; I've avoided workflows that might be quicker but appear to be unreliable at this stage of development.

Creating the project

Motion is the third tab in the Title Editor, but before you can animate a title it needs to be created. Start a new project and place the Sample footage (or any other video with light and shade) on track 2 so that we have a background over which to judge the visibility of the text. You should turn off Playback Optimisation unless you have a slow computer – decoding text animations doesn't require a lot of power. I also suggest you set the project setting to UHD – 3840x2160 – to create the sharpest title you can, although if your computer struggles, try 1920x1080 instead.

With the scrubber at the start of the timeline, click the T icon on the timeline toolbar. A default title is placed on track 1 and the In-Built Title editor opens at the text sub-tab. The default *Your Text Here* placeholder is in the middle of the Timeline preview. Change the duration of the title to 10 seconds exactly – there are a number of ways you might want to do this but the clip context menu option *Adjust Duration* is as quick as any.

How you achieve the following is covered earlier in this chapter in detail, should you struggle to make the basic title.

Change the text to "Pinnacle Studio", the Font to Arial, the Size to 96 and make it Bold. It should be centre frame, but use the Group Align tool Relative Positions to ensure it is.

Over the light sky, the white text is hard to read, so I'm going to add an edge. Click on the second icon under the Looks Setting box to add an Edge 1, change the size to 110 and then use the Fill colour selection to choose black, then click on apply. A crisp, thin dark edge makes the text much more readable.

Now to add the second line of text as a separate layer as we want to apply different motions to it. Click on the ABC icon at the top of the Layers panel and change the text to "Revealed". Choose the Font Casmira and change the size to 170 – you will need to type that in as it isn't a preset size. Switch off Bold. In the process of creating the layer, it should have inherited the same Edge 1 as the first layer, but if it hasn't, try disabling and re-enabling Edge 1 or recreate the edge as before. Change the Face colour to pure red and click on Apply. Use the Group align tool to place the Revealed Layer bottom right. The title should now look like the screenshot. You should either save your project or title as **PSR_Title_1**.

Animating a Layer

Firstly, I'm going to animate the Pinnacle Studio Layer. Switch the Title Editor to the Motion tab and click on the Pinnacle Studio layer on the left to ensure we are working on that element of the title.

At the top of the settings panel should be a choice of four types of animation. Each tab has an icon indicating at which level it operates – Layer, Line, Word or Letter. There is also an eye icon which will switch the display to Flat View – in effect removing the effect of that tab so you can see the text in its "home" position.

We could do this first animation either at Layer or Line level because in this case they are the same thing. If the text had line breaks, we could chose to animate the whole text or just one line. Anyway, let's make a decision and select Layer - although the values we enter for Line would be the same.

Before we start keyframing, it's worth experimenting with the Z Pivot Point – the distance the pivot point is between our view of the title and the title itself. Change the Tilt parameter by slowly dragging the white

dot between 0 and 180. With Z set to zero, the title is spinning about its own axis. Change the Z value to 30 and repeat the test – you can see the layer now looks like it is spinning around a point in space closer to our view.

We want to give the impression that the viewer is inside the orbit of the layer. Set the Tilt to 180 and increment the value of Z. At 65, the layer is right in front of us – the pivot point is almost half way between us and the original starting point of the layer. At 70, the text layer is now behind us.

Adjusting the Z pivot point

This is the value I'm looking for. If you scrub round the Tilt value, the text goes just behind the viewer. Try the same with Swivel and the layer orbits the viewer.

Keyframing the orbit

Adjust your screen view so that the keyframe area is a usable size and collapse the parameters we aren't going to change – Position, Scale and Other. We have worked out a value for Z, so set it to 70 and then collapse the Pivot parameters as well – we aren't going to vary Z over time.

Now, with the scrubber at the start of the title, enable keyframes for the Tilt Parameter and then adjust the Tilt setting so that the text just disappears out of the bottom of frame – a value of 50 seems like a good choice. Advance the scrubber to one second and then reset the value of Tilt to zero. A new keyframe appears. Scrub or play the timeline to watch the animation. It's doing what I had hoped, but is perhaps a bit quick. You can click, hold and drag the keyframe to adjust the timing. Try a few values if you like, but then as I have settled on two seconds, set your keyframe to that point.

If you would like to see what happens if you combine a Swivel with a Tilt, you can try a value of -100 for the first position and zero for the 2 second mark. It's interesting, but not what I had in mind for this title. Turn off keyframes for Swivel before we proceed.

We might as well set the exit animation while we are here. Scrub to 8 seconds and add a new Tilt keyframe, then to the end of the title and enter the compliment of the start position, -70 (instead of 70). With four keyframes, test the move. If at some point later on you decide to change the entry and exit speeds, it's just a case of dragging the two central Tilt keyframes.

I'm going to ask you to do two more things before we proceed. Because we are going to try to match animated moves between the two layers, add two timeline markers that line up with the end of the first animation (2 seconds) and the start of the second animation (8 seconds). This will save us a little time later on.

I've saved this as **PSR_Title_2**.

Two things are worth looking at while still in the Motion tab. Click on the eye icon of the Layer tab and the Preview will switch to Flat View – with a small message at the top of the screen letting you know when you can't see the results of your keyframing. Also, there is now a small asterisk in the middle of the tab indicating that settings have been applied in this division – even if they aren't keyframed. Switch off flat view before you proceed.

Where has my move gone?

Switch the editor back to the Text tab and you might get a bit worried – your time consuming keyframe work seems to be missing! However, it just seems that in the Title or text tab, Flat view is the norm. Switch to Motion or Legacy and you can preview your move. When you quit the Title editor by switching away to Library or Editor, the movement is restored.

Letter by Letter

Now let's turn out attention to the next animation. Double click on the title to re-open the Title Editor, select the Revealed layer in the left panel and then switch to the Motion tab. Using the tabs along the top of the setting panel click on the fourth one with the letter A. In the box below each letter of the title text in the layer has acquired a border.

Selection of the letters is done by single clicking with the mouse. Select the letter R and only that will have the orange border. If you want to multi-select letters, the usual windows shortcuts Ctrl-Click adds further letters to the selection, Ctrl-clicking again removes them. Click on the first letter and the Shift-click on any other selects all the letters between the two.

To start, we will animate the letter R. Select it on it's own in the box at the top of settings. It's in it's "home" position as defined by where it is on screen in the Text box, so all of it's co-ordinates and parameters are at zero – this would be the case regardless of where and at what angle it was on screen – the values are all relative so if you decided to change the home position of the text at a later date the animation would still work.

I'm going to change three parameters for each letter – X Position, X Scale and Y Scale. Activate keyframing for each of these with the small diamond to the right of the settings, then for clarity collapse the unused groups Rotation, Pivot and Other.

We now have a keyframe at the start of three tracks. I want to make the letter R smaller and start it off the right of the screen. Start by adjusting the X and Y Scale parameters to 50 to judge the effect of a half size letter – we don't want something too dramatic, so that will be a good staring point.

Testing the scale change on a letter

Drag the X position slider to discover a position where the letter is just off-screen. I've settled on a nice round figure of 60 so that it's easy to remember and type in when we come to adjust the rest of the letters.

We now need to set a holding keyframe to delay the move. It's going to look good if the letters start to animate when the first layer has stopped. Scrub to the position we marked on the timeline for the end of the first animation – 2 seconds – and add a keyframe for each of the active parameters. We have set a holding keyframe for the letter R.

Now to program the first letter's move. I'm not sure at this point how fast I want it to happen, so I'm going to program the move and then judge the speed. Scrub to 3 seconds and then double-click on the three labels of the active parameters This will set them all to the default "home" settings of zero, 100 and 100. Play the animation. Nice, but if we are going to apply the same speed to each letter the whole word won't have arrived on screen by the time the title is over.

To speed up the animation, we need to move the three new keyframe to their left. Scale the keyframe tracks by dragging on the timecode header until you are seeing individual frame divisions. Draw a marquee around the new keyframes to select them all, then drag them to the left – try to place them just two frames away from the holding keyframes. Play the animation and the letter almost jumps into position, you don't get enough movement to give the impression of it travelling.

Briefly hover over the timeline settings icon to check your projects framerate. If it is 25p or 50i you have PAL defaults. If it is 30p or 60i, you have NTSC. I'm going to suggest you try a fifth of a second for the move which is five PAL or six NTSC frames. (If your timeline has defaulted to 50p or 60p then the values are 10 and 12 respectively.) By the way, it doesn't matter if you discover you are creating a title at the wrong frame rate – it will be changed to suit whatever project you add it to.

Adjust the move so that the third set of keyframes are just a fifth of a second to the right of the holding keyframes, then play the animation. That looks like a proper move now. With eight letters to animate it's going to take less than two seconds to get them on-screen so let's go for that – we can always adjust them later.

Incidentally, I found that with an early build of PS24, carrying out a lot of keyframe dragging caused the program to start misbehaving. If you start to see odd behaviour, and in particular your animations stop previewing correctly, you might want to save the project and restart Studio.

The next job is to animate the rest of the letters, and this can be a bit tedious, but there is a feature that will help speed things up a little.

Switch to the second letter of Revealed by clicking on the "e" box to the right of "R". The keyframes are all removed but replaced with "shadow" markers – hollow boxes where the other keyframes were. Scrub to the start of the timeline and set Scale X and y to 50. The letter shrinks. Now set Position X to 60. The "e" will disappear off the screen – it's gone to the right. Now activate keyframes for these three parameters and the familiar white diamonds will appear inside the shadow markers at the start of the timeline.

We want the letter "e" to start moving when the R stops. Place the scrubber on the third set of shadow markers and add new keyframes for each active parameter. Those are the holding keyframes.

Scrub right a further fifth of a second, then reset each of the parameters to the default, restoring the letter to its home position. Test the animation – I think you can start to see something interesting taking shape. The next bit is boring; repeat the above set of instructions for the remaining letters of the word Revealed. Each one needs to start moving when the previous one has stopped and take a fifth of a second to move to it's home position.

The final letter moving into place

If you cut corners and place the keyframes by eye, you might end up with an uneven animation. On the other hand, you could want a more "organic" look to the moves,

in which case you don't particularly want high precision. However, I found that while making this title that even one set of keyframes being misplaced by one frame can be detected as a mistake!

I've saved this stage as **PSR_Title_3**.

Zooming through the R

Having spent a lot of time plugging in numbers to achieve the letter-by letter effect, you might be thinking that you will have to do it all again for the final animation – Zooming through the letter R. Fortunately, that's not the case. We can apply the same movement to all the letters, either by selecting them all while in Letter mode. or switching to the Word or Line mode.

I'm going to use the latter method. With "Revealed" still selected as the layer, switch to the Line tab. For this animation I'm going to use the X, Y and Z Position parameters, so with the scrubber at the start of the title, activate keyframes just for those three.

Notice that wherever you now place the scrubber, the parameters have reset to their "home" defaults – you are in effect adding a new animation on the line as a whole, regardless of what is going on in the Letter tab. Those shadow keyframe markers are still there to help you should you need them, but in this case we don't.

I'm using the Z parameter instead of Scale here to make the title bigger – the viewpoint is flying forwards. In this case the effect would look the same using Scale, but it would not occur relative to the Z pivot point, should you have changed that.

Scrub to eight seconds – there should be a timeline marker to help you. Now add additional holding keyframes for all three parameters.

Move your scrubber to the last active frame of the title. (In the current build of Studio there seems to be a keyframe window error – you can scrub one frame past the end of the title. Make sure you can still see the Revealed text by being one frame from the end.)

I used a bit of trial and error here to set up the X and Y positions and make the viewer feel like they were flying through the letter R. Set the Z parameter to 100 and you can see by how much the end frame is missing my target. It only takes a few clicks of the up and down arrows now to deduce what the end parameters for X and Y need to be to centre the hole up – X=7 and Y=10 looks close enough. Now slide Z to a lower value still at -140 to create a clean frame.

As you make those adjustments, the keyframes at the end of the title are automatically updated, so you can test your animation straight away.

Flying through R

This is my final version, and I've saved it as **PSR_Title_4**.

Changing the text

If at this point you want to change the text content of a layer or a Line, you can do so without destroying the keyframing. You can change the font, colour and look as well. However, if you try to edit a Letter by letter or Word by word text animation, you get odd results. Even if you replace one letter at a time, the keyframing goes out – in the case of the current title, changing Revealed to Tutorial results in all the letters after the first one overshooting their home position and then settling into place. An interesting result, but not what we want. Hopefully in time Pinnacle will address this problem.

Legacy Preset motions

These are the original motions that were possible prior to PS2, They can be programmed using the final sub-tab of the In-Built Title Editor.

Let's take a look at what is possible using the title we created for the Drone Movie, saved as **In-Built Titles_2**. Re-open the project if you closed it to work on the Motion tab, then select the Title editor by double clicking the title on the timeline. Now select the Legacy Preset sub-tab.

The Legacy Presets in the Title Editor

Each title layer can have three separate types of Motion. **Enter** effects bring a title onto the s c r e e n ,

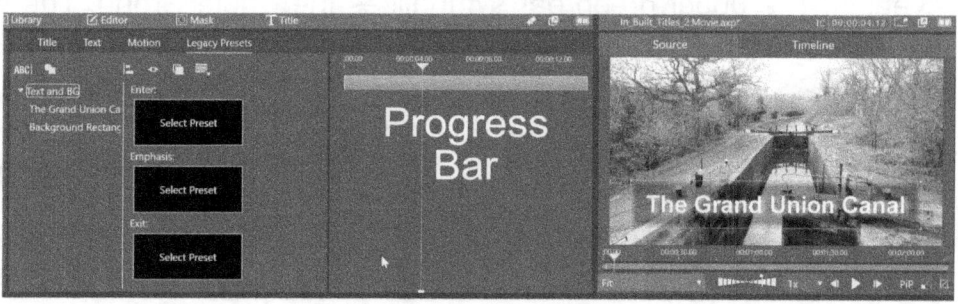

Emphasis acts on the title during the time it is on screen. **Exit** takes it off the screen. Each layer can have all three, and their relative durations are variable for each effect and each layer.

Many of the motions act on a letter by letter, word by word or line by line basis. Even some of the effects that apply to the whole page layer have some very impressive 3D effects that would take quite a bit of setting up using keyframes.

The panel to the right now contains a progress bar rather than keyframes.

Adding an Entry Motion

In the Layers panel on the left highlight the text layer *The Grand Union Canal* so that whatever motion we add will affect just the text.The central pane of the title editor has three choices. Click on the top one – Enter.

A filmstrip style selection will open up at the top of the screen, and for our first example just hover you mouse over *Type*. Although you should be able to preview the effect automatically when hovering, it can be a drain on graphics cards, so click on the effect to apply it and then play it.

You may wonder what is so different with this effect rather than just doing a straight wipe, but the speed at which it is being played isn't doing it justice. I'm going to show you how to extend it.

Adding Type as an Enter motion preset

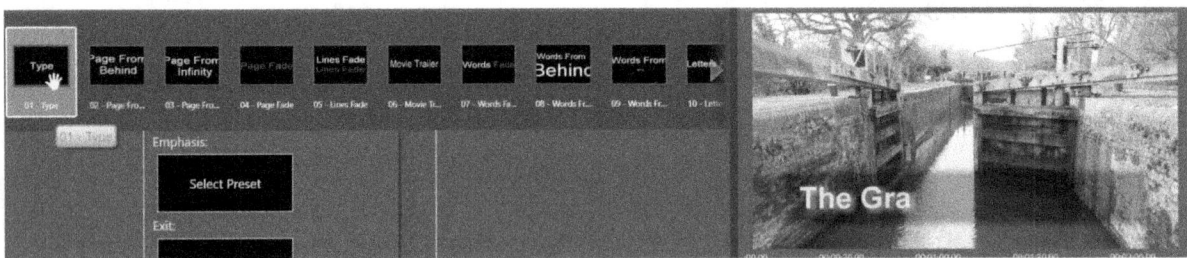

When you apply the motion and the ribbon strip disappears, the progress bars are revealed. The upper green bar symbolises the whole Group. The next bar down is the text layer and the bottom bar is the shape layer.

Each progress bar can have up to three motions - one each of Entry, Emphasis and Exit. We have added an Entry motion which occupies the first 2 seconds on the

progress bar. If we were to add an Exit motion it would occupy the end of the bar. An Emphasis motion will occupy the whole of the bar.

Currently our progress bar has three handles. The one on the left controls where the motions will begin, the one on the far right determines where the motions end. Both can be dragged. If we didn't want the motions to begin at the beginning of the title, we could drag the left hand handle right. If we didn't want the motions to last until the end of the title we would drag the right handle left.

What should have caught your eye is a dotted line starting at zero and it's end handle at 2 seconds, with an "X" in the middle of the dotted line. That's the Entry motion. If you want to delete the motion you just click in the "X".

Editing the Entry Motion

Let's adjust the start of the animation so that it begins when the fade up has finished. Drag the left handle 1 second to the right and the middle handle to the 4 second mark and play the effect. Now you can see that the

individual letters are appearing one at a time. Imagine the clack of a keyboard on the sound track and you can see the potential of this effect!

This same principle applies to Exit motions. Emphasis behaves a little differently when you add it – if there are no entry or exit effects in place it will occupy the entire timeline. It will be added to the title even when Entry or Exit motions are in play. Emphasis also has a few special effects that actually start and end with text off the screen, the Roll and Crawl effects. I'll that a closer look at these later in the chapter.

Close the title editor and play the start of the movie. The background rectangle fades up because of the transition added to the title on the timeline, and then the text is typed out, one letter at a time. Save the movie as **In-Built Titles_3** before we try out a little demonstration.

Quick trim the title so that it is about double in length - and play the movie from the start again. What happened there? The Entry motion has been slowed right down. This is not a bug - if you open the title editor again you will see the relative duration of the motion to the duration of the title is still the same.

This happens in other situations as well - Pan and Zoom, for example. It's a fundamental principle of keyframing. Go back to the timeline and restore the title to it's original length, matching the duration of the first shot.

Adding an Exit Motion

Without me giving a step-by-step set of instructions, use the same principles to add an exit motion to the whole title group, Text and BG. The most effective motion in my opinion is *Page to Behind*, but you might want to choose something else. I've saved this as **In-Built Titles_4**.

Crawlers and Rollers

Some of the Emphasis motions have a more general use than just enhancement. We are all familiar with the roller captions at the end of Movies and TV programmes. They normally roll up the screen from the bottom, listing the cast, crew, writers, the name of the transport captain and who provided the portaloos. Crawls are sometimes used for a similar purpose, but you are more likely to see them used to add information that won't all fit on one title card – maybe the latest football scores or stock market prices. Crawls generally go right to left so they can be read. Studio provides Roll Down and Crawl Left as well.

It's normally best to type your text in before adding the motion effect. The speed of the crawl or roll is dictated by the amount of text and the duration of the title, so if the text is whizzing past too fast to read, then you will have to reduce the amount of text or increase the time that the title is on screen. Another point to bear in mind is that moving text is harder to read, so you should choose a strong look, or place them over a background that helps them to stand out.

The following example places some information over the 3rd and 4th clips of the project that we have been using in this chapter. Place the scrubber at the start of clip 3 and select track 1. Open the Title Editor with the T toolbar icon and then quick trim the out point of the newly added titles so that it lines up with the end of the fourth clip.

Make sure that Text Wrap is turned off, and then use the Arial font, size 60 with the Medium Edge look and type the following text into the small box a text box, without pressing Enter to add any line breaks:

The Grand Union Canal is Britain's longest, joining its two largest cities, London and Birmingham. It began life as at least eight separate canals.

Crawl Left Emphasis motion.

Now go to Legacy Presets and select Emphasis/Crawl Left - its the first one on the list. You will see the text become just one line high again. If you play the title you will realise that at the default

duration of 3 seconds, you haven't got a chance of reading a word! In the main editing tab, extend the title so that is the same duration of clips 3 and 4, then test it again. If playback looks a bit jerky, change Playback Optimization to 75% and the titles should preview render. This is **In-Built Titles_5**.

My final suggestion is that the title is obscuring much of what the viewer wants to look at - it's better placed in the sky, upper third. I've also added a shape behind it - a semi-transparent black rectangle - that uses the Lines Fade motion at the start and end. You should be able to work this out for yourself now, and then compare it with **In-Built Titles 6**.

Creating Credit Rollers

A list of credits should be entered as separate lines in a single text box. You can use two Returns to create extra space between categories. For a lot of credits I suggest you use a word processor to create and check the names and copy and paste them into Studio.

If you work with preview rendering turned up high and want to create long credit rollers you will soon find yourself bogged down waiting for the title to preview render - the program appears to become unresponsive and the render process can be very slow. It's best to turn preview render off, but if you are using a complex Look or backgrounds you won't be able to preview the title smoothly - even more so if the background is moving video. So my suggested workflow for a very long title would be:

- Turn off Preview rendering.

- Create a few lines in plain text of the correct size and font to check the layout. Adjust if required

- Now paste or type remaining credits into the text box. Turn it into a roller by adding the Roll Up motion. From now on use the small text box to edit your text

- Preview the result without preview optimisation. If preview is jerky, turn off the backgrounds using transparency or the monitoring icons. If there is a video on a track below, disable that as well. Check the credits and correct as required, then set the duration by trimming.

- Now add any final look you want and re-enable the backgrounds. Preview will now be jerky but you should still get a good idea of how the credits are going to look.

- Turn on preview rendering and make a cup of tea. When you have drunk the tea the credits should be ready to preview. If they aren't, have another cup of tea.

- If you spot something you want to change, turn off preview optimisation before attempting to re-edit the title.

The 3D Title Editor

Studio 21 saw the introduction of a new titling tool. The 3D Titler is derived from an older Ulead product and had been partially integrated into Studio via a new toolbar icon.

Some of the results from the 3D titler can be very impressive, If you want titles that appear to be 3D objects that can move along 3 axis then this tool is great. However, while the objects it creates are normally easy to see over video, if you try to make something simple it's tricky to add flat edges. Because it hasn't been designed from scratch, the interface is slightly different from anything else in Studio. So overall, the 3D titler isn't a replacement for the Motion Title editor, and now that has been improved, there is no need to use the 3D titler as a substitute to make sharper titles.

Clicking on the **T3D** tool to the right of the Motion Title icon opens a new window with a place holder title object in the preview screen. The layout should be very familiar - presets to the left, settings to the right, menu bar, toolbar and Timescale are all where you would expect them to be.

Track selection and placement of the title behaves in the same way as the Motion titler, but with an anomaly - there is no Solo button on the 3D titler so if you want to edit the title over black it's best to move it the the start or end of the video track before commencing work, then place it back over the track clip to see the effect.

The Interface

Object types

The main type of object you are likely to want to work with are **Title Objects**. Three other types of objects are listed as presets, but they are all shapes grouped under **Extruded**, **Lathe** or **Shapes**. New shape objects can be created and then added from the toolbar - **Geometric**, **Lathe** and **Graphic**.

Adding and Removing Objects

The title card can hold multiple objects, although only one can be selected at a time. You can add an object by double clicking on the preview screen at the point where you want the centre of the new object to be. You select an object by single clicking on it. The currently selected object has thin red, green and blue lines indicating the size rotation and depth of the object. To remove an object, select it and press delete.

Title Objects

While title objects follow the above rules, they have additional tools. You can add and also delete them using the toolbar **+ABC** and **-ABC** icons. Once you have more than one text object the ABC drop-down at the top of the timeline tracks lets you select them.

Presets

Before you change the text, it's worth looking at the Presets on the left. Objects holds a number of Text Objects that are complete styles, but if you select one of them, it adds a new object.

There are three other types of presets. Two are global. **Scene** allows you to change the overall Light conditions – how the 3D objects appears to be illuminated – and **Camera** the point from where all the objects are viewed.

Object Style affects only the currently selected object. You have access to presets for the **Bevel** shapes of the letters, the **Material** that they appear to be made from and the **Colour** and **Texture** of the material.

Editing the text and Fonts

To edit the text of each object you need to use the settings panel on the right. Text setting is where you change the text, because unlike the standard titler you can't edit the text directly in the preview window. Click in the text field to place a text cursor there, then change the text using the keyboard. Icons below the entry box give you control of the text height and width, font and other text attributes.

The rest of the controls on the right change the other object and view attributes. Changing colours uses the same colour picker that you find in the standard titler, as well as sliders. **Surface** sets the basic colour, while **Specular** is the colour of the "shine" that comes off the surface. Texture adds a graphic file to the surfaces.

Bevel holds an important value that isn't strictly to do with the actual bevel but controls **Extrusion**. This controls the thickness of the text object – the distance between its front and back face.

The rest of the setting in this category do affect the bevels - What happen at the edges of the extrusion – None means that the edges meet at a right angle and therefore there is no bevel. A *Flat* bevel adds a 45 degree chamfer, while other shapes such as round can be chosen.

Opacity applies to the whole object – how see-through it is.

The **Lights** control is very impressive – you can specify four simultaneous light sources all varying in colour, positions and even the type of light source as well as an overall Ambience.

Camera position may not seem that important at first, but it allows you to change the view of all the objects at the same time. Camera lens can be manipulated, along with Distance, to change the perspective. Using a wide lens close to an object exaggerates to size of that object. If you want to make two objects look closer together, then narrow the lens angle and move the camera away from them.

Preview controls and editing the object

There is also control of the overall ambience under the preview window. Playback controls are present for reviewing any keyframed moves you create. To re-position, rotate and resize the text you drag and drop it in the preview window using the mouse. You change the mode with the icons on the toolbar.

You are dealing with the 3D object, so the 3rd dimension is controlled by the mouse wheel - the Z axis for Move and Rotate.

Toolbar controls

The Hand icon is for **Move** and to the right are **Rotate** and **Resize** , while the Value entry boxes to the right allow for accurate adjustments. An important tool at the far right of this group is the reset button.

Look out for changing the duration of a 3D title using the toolbar duration control. When you re-enter the main Studio editor the title will be adjusted in Overwrite mode!

Applying colour selectively

It's not immediately obvious that you can apply different colours to different parts of an object. A default 3D text object has a front face, front bevel face, side face, back bevel face and back face. On the right of the toolbar are five icons that let you select these areas.

Face selection

By default, they are all selected. They are rather small, but if you look closely you can see an orange area on each icon. Click on it and the orange area disappears or reappears. Deselect them all apart from the front bevel face (second from the left) and open the Surface colour control. If you change the colour now, it will only affect the front face bevel.

Front face Front bevel face Side face Back bevel face Back face

Keyframes

Keyframing

The keyframe interface in the 3D editor is sufficiently similar to the other keyframe functions in Studio so as not to cause you any difficulty. Not all the parameters can be altered, but each object can be keyframed individually – if they are too close to each other to select with the mouse there is a drop-down box above the track headers. Keyframes can be dragged, copied and pasted, but only individually.

ABC| The Preview Area ▼ 👁

Position
Orientation
Scale
Color
Opacity

Add keyframe

Creating other Objects

Graphic
Lathe
Add Geometric shape

Three toolbar icons allow you to add other objects. Add Geometric shape offers a drop-down list holding an impressive array of solid shapes. Using the other two allows you to create shapes from scratch. I suggest you start with Add Graphic, which opens a small editing window containing shape and line drawing tools.

The Graphics Editor and the resultant shape

Shapes drawn here are transformed into 3D objects with a depth of 100 units. You can make them thicker using the Bevel/ Extrusion setting in the Graphics setting panel on the right.

Lathe is an interesting tool. If you create any 2D shape or drawing about an axis in the centre of the editor, it will be turned into a 3D object that has been generated in a circle around the axis - as if it have been turned on a lathe.

Lathe tool in actions

Saving your work

I've spent hours experimenting with this feature. It's great fun, keyframing moves and changing the lighting effects. The problem is it's hard not to come up with something that is too flashy! You may love the look, but unless you are just using 3D titles for a logo, you will probably want to use them through a movie for consistency. It's a good idea to save your creations for further use and the File menu allows you to do this. They get placed in My Titles as well as the default save location.

If you quit the 3D editor using OK, then the title is placed on the timeline using the same rules as a normal title, (unless you have changed the duration from within the editor). Keyframes adjust themselves when you alter the timeline duration, so if an animation finishes halfway through a title, it will also do that when you alter the length of the title.

Cancelling to quit the editor will make sure you mean it by giving you a second chance to save the title – but this means "Save to the timeline" not "Save in My Titles".

Transitions

A transition is where the change between two clips isn't instantaneous, with both clips being on screen at the same time. The classic transition is the dissolve, where one clip mixes into another, but there are many types of increasing complexity. I'm not a great fan of flashy transitions in most circumstances, but I'm not going to go as far as some people do as to condemn them as giving an amateur look to movies – there are plenty of circumstances where, when used consistently, they can bring creativity or a sense of fun.

Why would you want to use a transition instead of a straight cut? Apart from adding variety, a transition can subjectively imply a passage of time. If I have a shot of someone sitting in a chair reading a book and simply cut to a closer shot, film grammar implies that the reader is still on the same page. If I dissolve to the closer shot, the viewer will surmise that time is passing – our person could have read a whole chapter.

How do I add a Transition?

There are lots of ways, but the simplest and quickest is just to hover over the upper part of a cut between two video clips to generate the icon shown in the screen shot, click, hold and drag away from the cut. When the transition is the size that you want, release the mouse button.

There is a lot more to it than that, though - and I don't just mean how you choose the type of transition. Before I can talk you through the options, we need to establish some basic principles. For most of this chapter I'll be working with Video transitions applied to just one track, but Audio and Multi-track working are discussed later.

Overlapping the video

When you use transitions between two video clips, if you don't want to see any more of the video than is already on the timeline or you don't want the outgoing or incoming video to freeze, you have to overlap the two sources.

Many editing programs aimed at consumers, including Classic Studio and NGStudio up to version 21, create this overlap automatically, even making it their default behaviour.

So, if two 10 second clips are adjacent to each other and you add a 2 second overlapping transition between them, the total duration of the two clips drops to 18 seconds.

The action of creating the overlap can have a serious downside in Studio. Because the space taken up on the timeline by the two clips has been reduced, if there are clips on other tracks after the transition, they will become out of sync.

Hold that idea for a bit while I describe the alternative.

Extending the Video

When you use transitions between two video clips and you don't want their position on the timeline to alter, the program still has to create an overlap, during which time we see video from both sources

To provide this overlap, either the outgoing video, incoming video or both need to be extended. For this to be possible, a clip needs to have leeway.

What is Leeway?

If you want to use a clip from the very first frame recorded in the file, it has no Incoming leeway. If you try to loosen the In point you will get dead meat, resulting in frozen frames (some programs won't even allow that). Outgoing Leeway is the reverse - if you want to use the very last recorded frame it has no leeway. Loosening the Out point is not possible because there is no more video.

If a video file already consists of cut clips, it too can have no practical leeway because if you try to extend it you may encounter a frame from a completely different shot.

A video file may also have no practical leeway if the content before or after the frame you want to use is "un-transmittable" - wobbling about, out of focus or any number of other defects that make it unsuitable.

What you deem as unsuitable depends to some extent on what your standards are and what sort of a movie you are making. The part of a shot from the point of starting to record to it being properly framed (and the clapper board removed), or as it pans to the floor as you look for the Stop button is probably not usable in a movie, unless you are remaking The Blair Witch project. However, if a camera is re-framing rather wildly to get to some sporting action such as a run-out at a baseball game or cricket match, you can justify the footage being in a movie from the very reason that it adds to the excitement.

How can I ensure I have Leeway?

Although you can't always generate leeway, if a shot has none, you should consider if it is even suitable to be partially hidden within a transition.

However, you can help yourself a great deal by pre-trimming your clips. I've covered this technique in the *Basic Editing* chapter - it's where you use the source viewer to set In and Out points to a clip before you add it to the timeline. It saves you time in the course of normal editing.

When pre-trimming your clips, choose In and Out points that are the first or last interesting frame of the clip - when someone actually starts or stops speaking for example. In the Cycling Clips we used we didn't need the empty frames before or after the bike was in shot or even when it was just a dot in the distance.

If you are a bit on the ruthless side when pre-trimming, you will invariably have some usable leeway.

Transition Options in Studio 24

Studio can create transitions that overlap the video sources, or extend the video sources. You can even mix the two techniques should you need to.

However, you need to choose the Mode you wish to start work in. The Control Panel/ Project Settings has two entries related to transitions.

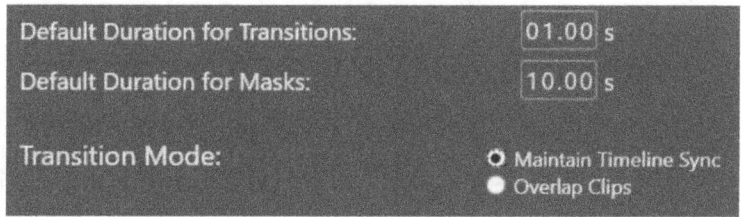

Transition Mode is set to *Maintain Timeline Sync* by default. This mode never moves a clip on the timeline to create the required overlap.

Overlap Clips will move a clip on the timeline to create the overlap, but not in every case. In fact, it only does so in Smart or Insert Edit modes, and even then only if you are adding a transition to the left of an edit point.

Default Duration for Transitions is set to 1 second by default. Note that in this box, the time is entered in seconds and hundredths of a second, and not seconds and frames. If you want a default duration of one and a half seconds you enter 1.50. These parameters are therefore independent of the project frame rate, where one and a half seconds would be 1.15 in 30fps NTSC and 1:13 in 25fps PAL (they round the PAL value up). One second is a good choice for a fast moving project - any less and you will almost miss the transition occurring and find it a bit fiddly to edit.

If you are making a slower moving project you might want to choose a slower default value - I would suggest 3 seconds.

Which Transition Mode should I work in?

Studio's default transition mode is **Maintain Timeline Sync**, which always extends clips when creating transitions. Pinnacle may expect you to work in this mode and gear up their development and tutorials in favour of it.

It's advantages are:

- You will never lose sync with clips on different tracks further down the project.

- You can quickly create a transition in Extend mode that sits equally over the Outgoing and Incoming clips

It's disadvantages are:

- If you are working with clips that don't have enough leeway, you may end up seeing frozen video or even the wrong video entirely.

- Even if the clip has leeway, it may consist of material that you don't want to see in the transition.

In **Overlap Clips** mode the advantages are:

- Clips without sufficient leeway can be overlapped with ease.

- A transition generated using overlapping clips will never display any unsuitable material.

- You can still create transitions in Extend mode by careful placement or the use of the ALT key.

The disadvantages are:

- It is quite easy to make your project go out of sync.

- You can't quickly create a transition in Extend mode that sits equally over the Outgoing and Incoming clips.

My instinct is to work in Overlap Clips mode, but I've been using Studio a long time. I used to shoot on analogue and DV cameras and employ Scene detection. Now I use file based cameras. This has quite an impact on the raw material I work with. The Whistle-Stop tour movie that we started this book with did not involve any pre-trimming, and the only time we switched out of *Maintain Timeline Sync* was so I could demonstrate the perils of *Overlap Clips*.

So, I'm going to assume that you are a new user of Studio and will start working in Maintain Timeline Sync mode.

Changing the Transition Mode

Whichever mode you chose to use when you start work on a project, you are not stuck in that mode until you return to the Control Panel because it is easy to switch modes, although it could be quicker if there were a toolbar icon. Once you have your first transition on the timeline, you can open the **Transition Edito**r alongside or in place of the Library, where there is another instance of the Transition Mode selection radio buttons.

The Transition Editor

A Test Project

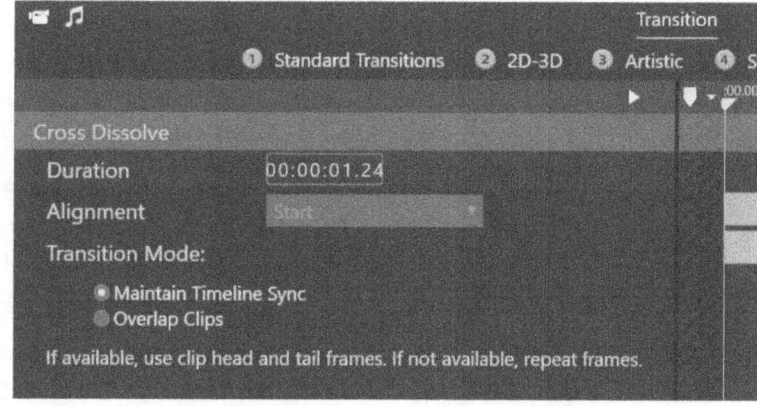

To demonstrate Transitions I'm going to create a project that can display all the various behaviours I've just discussed. You will need to import an extra video clip - Car Clip 4 - into the *Cars* bin, and you may want to download the project file **Transition Demo** instead of following the instructions below.

Put Car Clips 2, 3 and 4 on the timeline in that order. Working with the burnt-in timecodes on the clips, trim clip 2 so that it starts at 01:00 and ends at 05:24, clip 3 so that it starts at 02:00 and ends at 06:24 and split clip 4 at 04:00 and 09:00. Select what is now the last shot on the timeline and detach the audio.

Transition Demo Movie timeline

The first two clips on the timeline have leeway, the next two don't, and the last clip has some detached Audio which we never want to lose sync with the clip above it.

The first edit on the timeline should be totally trouble free as long as we don't add a transition that is too long.

Creating transitions by dragging

Make sure that Studio is in Smart Edit mode. Hover your mouse over the top of the

first clip on the timeline and you can generate a transition handle as shown in the screenshot.

This, or the flipped version, is what you will see when you are about to create a transition.

Click and drag it to the right. The handle turns into a double-headed arrow and a ramp appears to the left indicating a transition is being generated. If you have adjusted the timeline view suitably you will also get the duration box showing up when you drag.

Continue to drag right until the duration box indicates 01.00 seconds and then release the mouse key. You have added a transition to the first clip of our movie.

You can easily argue that it isn't a transition, it is a fade-in. I could equally argue that a fade in is a transition between black (the default when there is no video on the timeline) and the incoming clip.

Hover your mouse over the transition and if the view is sufficiently expanded you should see the duration appear in a dark grey box, along with a small icon indicating the transition type. If your mouse is over the grey slope a few moments later a tooltip with the name of the transition will appear – in this case *Cross Dissolve*.

Editing a transition duration

Although quick and easy, there are a few things that aren't too convenient about this method of adding transitions. Because the style of generating the fade is in effect "freehand", if you want the end of the transition to coincide with a particular frame of video or another event on the timeline (the beginning of a music track, for example) that's very easy, but if you just want your transitions to be a consistent length, it's quite fiddly. You can fix the duration by clicking on the (rather tiny) duration box and typing in numbers, but that's still not ideal. Also, you only get the Cross Dissolve, so if you wanted anything else you would need to replace it. However, before we look at other ways to add transitions, I want to demonstrate the various modes that can be used with the freehand method as it is easier to see how they affect the timeline.

Before you carry on, save your project as **Transition Demo 1**..

Editing Transitions

If we want to change the duration of an existing transition, we can re-generate the transition cursor or the double headed arrow and move the In or Out points.

Double click on any area of the fade up other than the duration box. In the window above left of the timeline - normally the Library - you will see the Editor slide out, in Transition Mode. There is a lot to describe about the Transition Editor, but for now I want to mention two things.

There is a **Duration** entry box, which is a more usable way of accurately changing the duration.

The **Transition Mode** selection buttons are also shown. Check that you are in *Maintain Timeline Sync* mode, as shown in the screenshot.

The Transition Editor

This is how to change modes quickly, without returning to the Control Panel. You can even change mode after the transition has been created but before you re-edit it. The only issue is that the Transition Editor can't be opened if there aren't any transitions on the timeline to edit - which

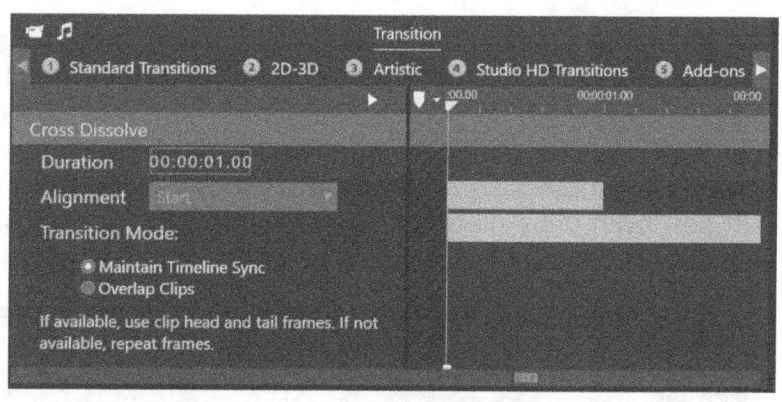

is why I got you to put a fade on first, as they work in the same way whatever mode you are in.

Let's now put a more interesting transition at the edit point between the first two clips on our test movie timeline. Before we do, check that snapping is enabled. Generate the transition cursor on the right side of the cut, click, hold and drag right slowly. The transition will grow on both sides of the cut. When the transition is 4 seconds long, the snapping will kick in, so leave it at that duration.

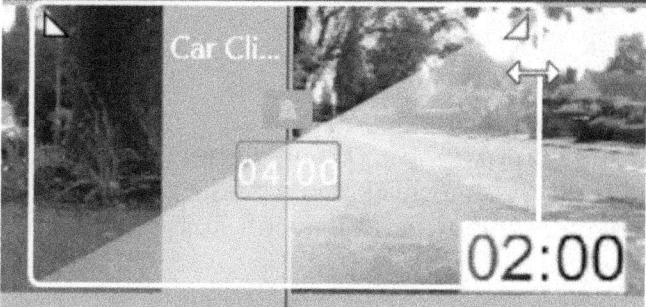

Take a look at the end of the timeline. The last clip is still lined up with it's detached audio. Therefore the video material to create the transition overlay must have come from extending the clips. Because the transition is centred on the junction of the two clips, each must have been extended equally.

Play the transition and it works well. Scrub through slowly and you will see both cars are moving all the time - so no sign of frozen video.

This is the ideal scenario - there is leeway, and not just moving video, but good quality video, so although we are seeing parts of the clips we didn't put on the timeline, the result is fine.

When you create a transition in *Maintain Timeline Sync* mode it **always** starts centred on the cut.

You may be wondering why the transition snapped to a duration of 4 seconds. After all, the default transition duration is set to 1 second. Well, the Snap had nothing to do with duration. In fact, what the Snapping tool was warning us of was that we were just about to start using "dead meat" - frozen video.

Return to the transition and drag one of its edges to extend it even more - eventually the snapping will give up and you can keep going until it extends all the way to the fade up on the left. If you now study the thumbnail of the transition carefully, you will see pink shading at the beginning and end. Play the transition and it may not be immediately obvious that there is a problem - during the middle section where you can see both clips clearly, they are both moving. Scrub through and look carefully though, and the timecodes should give away the issue.

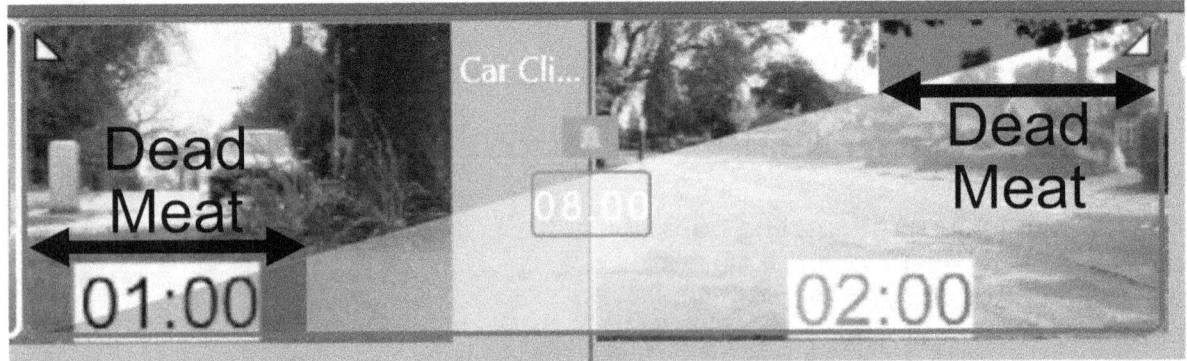

Reduce the duration back to 4 seconds, turn off snapping and hover over the transition to get the "pointy finger" mouse cursor. Make sure it is over the Outgoing clip on the left, click, hold and drag. You should find you can place the transition anywhere you wish - fully left, fully right or anywhere in-between.

If you find that you can't drag on the left side, try the right. Each transition seems to behave differently depending on where it is on the timeline or how it was created.

Keep an eye on the Transition editor as you do so - the bars to the right of the parameters give a good graphic representation of what's going on. The dead meat shows up as a pink area of the slopes.

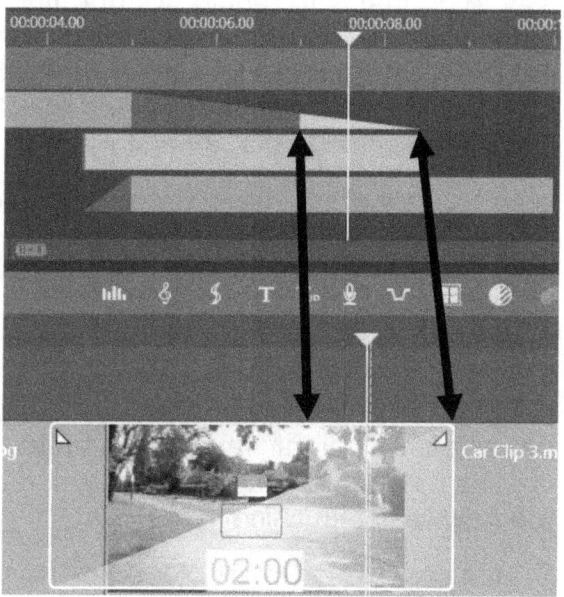

Bug Alert - in the current build, you can only drag on the part of a transition that overlaps either the Incoming or Outgoing clip. This means if you let go of the transition when it is completely over the other clip, you can't get it back using the timeline. The easiest way to get back control is in the Transition Editor, by dragging the grey graphic bar and dragging that.

This ability to customise the transition position allows you to tweak it when you encounter dead meat - it if is only on one clip, you can adjust the position to exclude the freeze. It also allows you to make creative decisions - you might not want a transition to span a cut, but rather begin or end at the edit point, and take it's overlap from the Outgoing or Incoming clip.

You should have also seen the *Alignment* setting change from *Center* to *Custom*, *Start* or *End* as you move the transition. You can select an Alignment from the drop-down if you don't want to drag.

Editing Modes and Maintain Sync

Because the Maintain Sync mode promises to do just that, it should not surprise you that it can't be fooled. Smart, Insert and Overwrite all work the same way - clips are always extended, never moved, when creating a transition. The same applies to the ALT key - it makes no difference if you hold it down when creating or editing a transition.

Deleting transitions

I want you to delete the second transition we added to the movie and one obvious way to do that is to reduce it's duration to zero. You might expect that selecting the transition and then pressing Delete or clicking on the Trash can tool would remove it, but I'm afraid that doesn't work. What you need to do is to open the Transition Context menu by right-clicking and then selecting *Remove*. There are some interesting items in the context menu that I will return to later.

With the transition removed we can move onto the next mode (you can revert to **Transition Demo 1** if your prefer.

Overlapping Clips Mode

There is a potential for confusion with the naming of this transition mode. As I pointed out a few pages back, the mode doesn't always overlap clips to create transitions. It might have been better to call it Legacy transition mode, but that implies it has been superseded, whereas in some editing scenarios it is superior to the new Maintain Sync mode.

Check you are in Smart Mode and snapping is turned on, then double click on the opening fade up to open the Transition editor. Now select the Overlap Clips transition mode.

To the Left...

Create a transition cursor to the left of the first edit point - it's important that you choose the left. Click, hold and drag left. The first thing you should notice is that the transition only grows on the left of the cut. The next thing to notice is that the end of the project is changing - the detached audio no longer lines up with its parent clip.

The third thing to notice is that the transition snaps to a halt at 2 seconds. This is where the dead meat starts, and although in the current operation that will have no bearing on the result, the snapping doesn't know that.

In terms of maintaining Timeline Sync, this operation has committed a serious mistake. If we were in the early stages of making a movie and hadn't populated the other tracks with items that need to stay in sync, that would not be a problem. Something else that would have solved the issue would have been if Smart Mode had been Smart, as it is when we insert, delete of drag and drop clips. However, that currently isn't the case.

Continue with dragging left until you get to the fade. If you look at the thumbnail you will see that no dead meat has been generated, and you can confirm this in the

Transition editor. What is more, you have created a 4 second transition and the Detached audio is now 4 seconds out of sync with it's parent clip. There is a screenshot of how the timeline should look on the opposite page.

To the Right...

Use undo to remove the transition - *Remove* will not reset the timeline. Now create a transition starting on the right of the first edit and drag right, past the point that it snaps into place. It may stall and you might have to release it and grab the edge again, but you should be able to drag it all the way to the next clip boundary. (I think this is the same bug that we have met when trimming - it is easily worked round).

The transition has only grown to the right of the cut - it's not centred. The detached audio is still in sync with its parent clip, and if you look carefully, there is dead meat shown in the thumbnail. Playing or scrubbing through the transition will confirm this - you can clearly see the outgoing timecode freeze at a value of 07:24.

The screenshots compare the differences between creating a transition to the left or right.

Transition created to the left

Transition created to the right

Centring transitions in Legacy/Overlap mode

You should now see why I don't think *Overlap Clips* is an entirely accurate description of the mode we are working in, as by working to the right of a cut, we haven't overlapped clips and we have maintained timeline sync. What we haven't done, however, is created a centred transition.

Now, if we hadn't extended the current transition right to the clip boundary, we could have grabbed it and slid it left to span both clips equally. As it stands, all you need to do is use the Transition editor to select *Centre* as the *Alignment*.

A non-overlapped, centred transition created in Overlap clips mode

The small amounts of dead meat don't really show through, but let's lose them anyway by changing the Duration to 00:00:04:00.

This is **Transition Demo 2**, if you want to save your own version or compare it with mine.

Overlap and Edit modes

There is a final point to make about Overlap mode. The automatic choice to overlap clips when adding them to the right is a function of Smart and Insert mode. If you hold down the ALT key when in either of these two modes, or are working in Overwrite mode, then Studio does not create an overlap, and therefore cannot keep the sync of your movie.

I hope that you can now see the power of both transition modes. Which you choose to begin work in will depend on the type of material you are working with and your preferred workflow. However, don't shy away from switching modes to achieve your desired results for each transition.

Transitions and Leeway

If you are wondering what all the fuss about leeway is about, **Transition Demo 2** has two demonstrations of why it can be so important.

The **second edit** is between an Outgoing clip that has one second of leeway, and an Incoming clip that has none whatsoever. Highlight one of the existing transitions and switch to the Maintain Sync Mode. I'll show you how the issue is created, and how it can be fixed without returning to the Overlap clips mode.

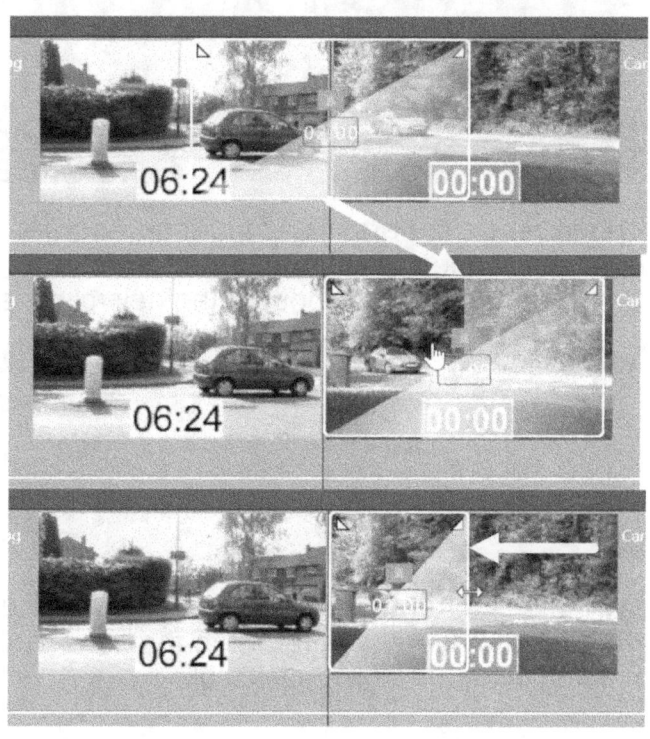

Drag out a transition on the right edge. We can create a two second transition before snapping warns us of dead meat, but that's plenty.

Play the result and before you reach the half way stage you can clearly see the red car is stationary - a freeze frame. When we get half way, it springs into life. That's quite disturbing.

We can fix this quite easily without disturbing the timeline. As there is no leeway on the left, we can slide

the transition right to exclude the dead meat. Now the problem exists on the right - but we can shorten the transition on that side until we exclude the dead meat on that side. We have shortened the transition, and it happens later down the timeline, but it now works. Leave that transition in place while we look at the other example.

The **third edit** is more troublesome. The clips have leeway, but it comes from the same source clip. Put a transition on the third edit while in *Maintain Timeline Sync* mode and it looks like there is no transition at all - they are sub-clips created from the same clip.

So how can we create leeway without disturbing the timeline? Well, the truth is we can't because whatever happens we need to shorten the movie. However, we can shorten the movie *without* disturbing the sync.

There was a way to do all this in one step using Advance Multi-trimming but it currently doesn't work. We will first edit the clips before we add the transition to provide the leeway. You could use Advanced trimming, but Smart delete will be quicker.

Jog to one second from the end of the third clip on the timeline - 03:00 on the red burnt-in timecode - and split the clip. Then jog to 05:00 in the next clip and split there.

Those new clips are a second long (we are working in 25fps PAL). Each of them contains the leeway I'm going to provide for the transition. Make sure you are in Smart mode, highlight both of the new clips, and press delete.

We have shortened the timeline, but as we used a delete function in Smart mode, that didn't make any different to the sync of the project - the detached audio is still holding station with it's parent clip.

Now drag out the maximum sized transition you can - it should be four seconds. Play the timeline and you will see the early and late parts of the Cross Dissolve look a mess - there are jump frames at 12 and 14 seconds on the Movie timeline. We created 2 seconds of leeway, but we are trying to use 4 seconds. You can fix that by dragging the transition below 2 seconds duration, or entering 00:00:02:00 into the Duration box in the Transition Editor.

This is **Transition Demo 3**, if you want to compare our results.

Other Transition creation methods

If you want to work with fixed duration transitions, or you want to choose your transition type at the same time as placing it, then the other two methods of creating transition from scratch will be of interest to you. Both of them can also be used to change an existing transition to another type.

The Transition Library

For a full choice of transitions, switch to the Library, open a new tab and click on the Transitions icon on the left.

Here you can browse endlessly for something that takes your fancy. In PS24, the Library has added an *Expand* icon (a right pointing double arrow) to the right of the thumbnails for transitions that have a choice of presets. If you want explore the options available in a transition such as Seamless, for example, click on the icon will reveal more thumbnails.

For this demo I'm going to add some Wipes. Just type the word "wipe" into the Library Search box and there is still quite a lot, so add "left" to narrow down the choice I still have a choice of seven, but I'm going to use the simplest - in *2D Transitions* just called *Wipe left*. Before we do, rate the transition by clicking on the fifth star top left of the thumbnail - you will see why in a moment.

Click on the transition between the first two clips and check you are in Maintain Sync mode, then right click and select Remove. At the right end of the timeline toolbar is the Dynamic Length Transitions tool - make sure is is off - it should be white. There is a screenshot on the next page.

Now we can drag the transition thumbnail to where we want to drop it. Because we have Maintain Sync selected, and Dynamic Length Transitions turned off, a 1 second wipe appears spanning the two clips. If we had been in Overlay Clips mode, we would have had a choice of putting it to the left and generating an overlap or to the right and extending the outgoing. Holding down ALT or switching to Overwrite edit mode would have made the left choice use the outgoing as well.

A word of warning when using this method of adding transitions. If there isn't sufficient space to add a transition of the default duration, Studio will simply refuse to do so, displaying a red cursor. If you have set the default duration quite long, or your movie has lots of short clips you might think the program has a bug until you you realise this.

Dynamic Length

You have the ability to add Dynamic Length transitions from the Library by toggling

the button on the toolbar. With all the buttons enabled it is the fourth from the right, next to the magnet. When this mode is active – the button coloured orange – drag and dropping transitions from the Library becomes a freehand style operation.

While the Library is open, change your search term to *Wipe Right* and rate that transition with 5 stars as well. Drag and drop the Wipe Right thumbnail on top of the Wipe Left one, and you have changed the transition. This is a good way to achieve that, but there are still other options.

Send to Timeline

The Wipe Right transition should still be highlighted on the timeline, Make sure the track containing the target transition is selected and then using the context menu on the Wipe Left Library thumbnail, choose *Send to Timeline*. The transition changes back.

If a target transition isn't highlighted the transition is sent to a position on the selected track determined by the scrubber. If the scrubber is over empty space, nothing happens otherwise it goes to whichever cut point is nearest. If the scrubber is exactly on a cut point, an In transition is created for the second clip. In Smart mode with Overlap clips selected Insert or Overwrite behaviour is determined in the same way as if you had dragged the transition there.

Transition Context menu

Right click on the next transition on the timeline. Of the two options available, *Find in Library* will be useful if you want to continue to drag and drop the same transition to other parts of the project but have lost track of its location.

Hovering over *Transition* opens a submenu,

Edit opens up the Transition Editor panel if it isn't already selected and selects the current transition. Some transitions have additional parameters, which we will look at later.

Copy puts the currently selected transition into the copy buffer. You can then paste it to a single highlighted clip or storyboard thumbnail, or to a multi-selection of clips. You can even Copy and Paste between projects.

Whenever you **Paste** a transition from the paste buffer to the timeline, it is always added in Maintain Timeline sync mode.

Ripple is the traditional Studio way of adding transitions to a group of clips. You need to have selected a group to activate the command. Copy and paste can be used for the same thing now, but Ripple only requires one click. This form of Ripple *will* allow you to use Overlap clips mode.

Remove is self-explanatory. As you cannot multi-select transitions, you might prefer to use the Clip Context menu for this operation – which I will show you next.

Replace by has a drop-down. Select that and a very helpful box appears. Here you have a choice of the two standard dissolves which are the same effect but achieved by

slightly different means, a selection of recently used transitions, and a further list of all the transitions you have given a 5 star rating. All in all a very handy set of choices, and now you can see why I asked you to rate the wipes!

Clip Context Menu

It is worth now looking at the Clip Context menu, where not only is there a further way to add transitions to a project, but where clips that already have a transition have further options.

Multi-select the last three clips of the current demo, then right click on the first of these and you will see a number of options relevant to Transitions.

In and Out Transition option is available for all clips. Look at the In Transition option and because there already is an In Transition in place you will see you have the same options as you get with the transitions context menu.

If there is no transition, you can **Add** one - you will see the same options as the Transition context menu. The Context Menu options for adding transitions behave in the same manner as other methods. In Smart/Overlap mode, adding an In transition - to the right of a cut - works in Overwrite. Adding an Out transition - to the left of a cut - works in Insert.

Two further options are available when a transition is part of the selected clip.

Ripple Transition works in the same way as described before.

Remove Transition is also only in evidence when there are transitions to actually remove. As I mentioned before, this will work on multi-selections. Both In and Out transitions are removed.

So, the way to ensure that you aren't in danger of over-trimming any video clip when adding multiple transitions is to use the Out Transition/Add clip Context Menu command. Use the normal window selection tools to highlight all the clips you want to add a transition to the end of, and use the right-click option to select a transition. Your chosen transition needs to be a dissolve, recently used or rated with five stars.

Transitions and the Storyboard

The Storyboard thumbnails also have a right-click Context Menu that has the same Transition options as the Context Menu for timeline clips. However, there is no indication of the existence of a transition when you look at the storyboard - you need to glance down to the timeline to see if they exist. Also, it's not possible to alter durations without using the timeline or the Transitions Editor. We use transitions on the Storyboard in the *Photos and more* chapter.

Transition Editor

Apart from the controls we have already used, there are two more options available in the Transition Editor. Double click on the first transition to open it.

You can change the type of transition currently selected by choosing one from the groups at the top. Click on 2D-3D Transitions and a film strip just like the one for titles will appear below the groups. You control this in the same way as well – grab and scroll. There are also arrows at each end for scrolling. Find the *Page Peel* transition, click on it and you will see it replace the current one.

We now have a transition in the editor that has some additional controls, so let's use them to refine it.

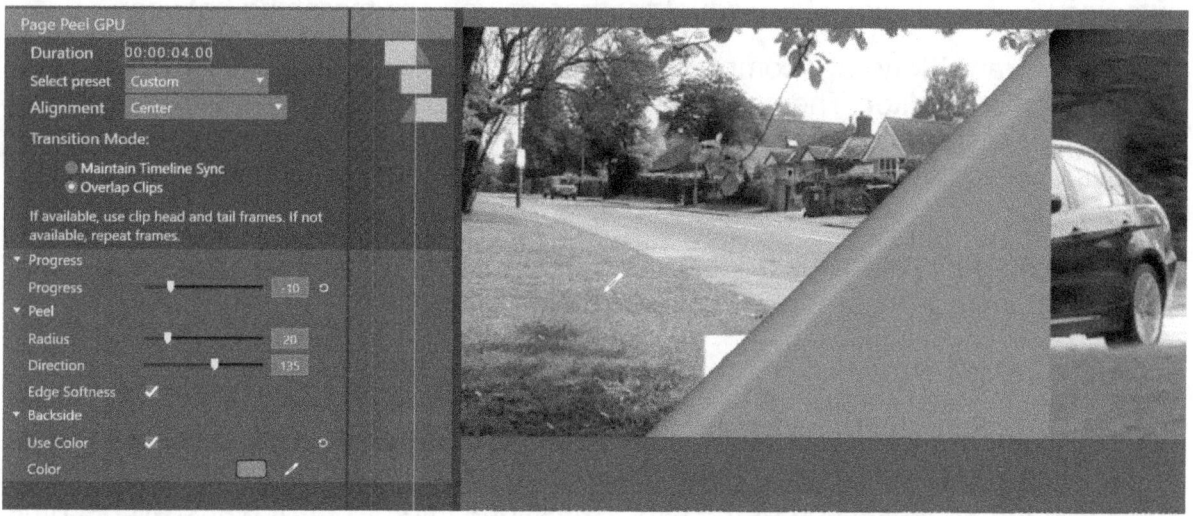

Each transition that is modifiable will have a different range of controls, and I can't itemise every one, but we will use Page Peel as an example. In most cases you should be able to work out what they do from the name, and if in doubt, experiment.

Presets may be available - it's worth opening this drop down to see if what you want to do has already been programmed.

Progress defines how far the transition has occurred when we first see it. Putting a high positive number here will start the transition already in frame. **Peel** has two parameters that let you change the radius of the curling of the page and it's direction. Edge softness doesn't seem to have much influence on this transition, but in others it is quite effective.

We will alter the **Backside** parameters – what is on the other side of the Page Peel. By default it is the outgoing video. If you click on the Use Colour checkbox you get a plain colour, with 3D highlighting that gives the shiny look to the curl. Check the box now and replay the result. Sometimes I hit a program bug at this point and the whole of the transition isn't modified. If that happens to you, switch to another transition and back to Page Peel and it normally corrects itself.

Black isn't that impressive, really, but you can choose another colour by using the Colour Selection tool, that works like the colour picker available in the title editor and you aren't just limited to the preview window

Of the Standard Transitions only *Barn Door*s has any significant options. Some of the others can have their progress and softness altered. 2D-3D and Artistic have some very useful parameters, while Studio HD has none.

Morph is a transition that a has it's own editor which you need to use to see the effect's potential - a series of editable nodes allow you to distort the incoming and outgoing video and take into account the frames you are morphing between.

Seamless transitions are complex transitions that offer a great many parameters in the Transition editor. There is also a graphical drop-down available to help you select what sort of motion you need. They can do things that you might consider achieving using key framed transformation effects for, but behave like transitions on the timeline.

The final category **Add-ons** are for third party transitions and the button *Plug-in* will take you to the editing program provided by the third party.

Audio Transitions

When you apply a transition to an edit between two A/V clips, regardless of the type of transition you will get a cross-fade between the audio sources even though it isn't shown on the audio section of the clip. Transitions into or out of black will become fade downs or fade ups. If you don't want this to happen, you need to detach the audio. On Audio-only clips, you do get a graphic representation of the fade or cross-fade, so it's an easy way to work without having to resort to keyframes

Using Multiple Tracks and Transitions - B Roll

One way of working that is more common in the professional world is to build up a movie using video clips on two or more tracks. Sometimes the upper track is used for "B-Roll" footage. The classical use for this is when you have someone talking to camera on track 2. There may be cuts within the main footage, but when you come to add cutaways of what the person is talking about - or just some pretty scenery - it is placed on the track above, without its audio in most cases. This masks the video (but not the audio) and avoids having to make complex J and L audio edits cuts. It's then very easy to change your mind about the extra shots without disturbing the carefully constructed narrative below. (B-roll is a film term - the supplementary shots have probably been shot at a different time on a second roll of film - the B-roll - which often did not have sound to go with it).

Using transitions in these circumstances is normally a case of adding them to the Incoming or outgoing clips on the B-roll track above. This works for the simpler types of transitions such as dissolves and wipes. More complex effects where the video is being transformed in some way - Pushes for example - will only apply the transformation to the clip on the upper track. This is what happens when you add a title or other object with transparency on an upper track and then add transitions to its In and Out point.

For an example of this, I've placed Cycling Clip pal_002 on track 2 of a new movie and then placed Car Clip 1 on track 1, beginning at 15 seconds on the timeline - **Transition Demo 4**.

Any dissolve or wipe applied to track 1 works just as if you had cut the clip into track 2. Try adding a 1 second Wipe Right (using the transition context menu if you rated it with five stars). Check the movie and all looks good.

Change the wipe for 2D Transitions/Push Right. Play the movie again. The car shot is pushed onto the screen, but the bike shot isn't pushed off.

Now place a timeline marker at the In point of the car clip and use Overwrite mode (or Smart/Insert with the ALT key) to drag the car clip down into the bike clip on track 2.

Play the movie now and you can see the difference - both shots are affected by the *Push* transition. This is **Transition Demo 5**.

Sequences

Once you are used to the mindset of putting your "active" video on more than one track, it's just a small step to you putting different shots or sequences on different tracks. For example, if you were cutting a drama or documentary, each "scene" might be cut as a sequence. You might cut them out of order (perhaps in the order they were shot in if you were working in parallel with the shooting crew) and only when you can work on the finished story might you create an assembly of the sequences. If you were building up a showreel, trailer or commercial, your sequences might be as short as just one shot.

These sequences can then be placed on different tracks, perhaps using just two tracks and alternating between them, perhaps using even more tracks for movies where you might have different stories intertwined.

This makes it really easy to adjust the running order, and keep your separate sequences intact. If the first sequence ends on one track and the next begins on another, without a gap, its just as if you have cut between them. But what happens if you want to transition between them?

Return to the little demo we have built, make sure you are using Overwrite or holding down the Alt key, then click, hold and drag the car clip back up to track 1. It will take its transitions with it. Play the movie and the problem is immediately apparent.

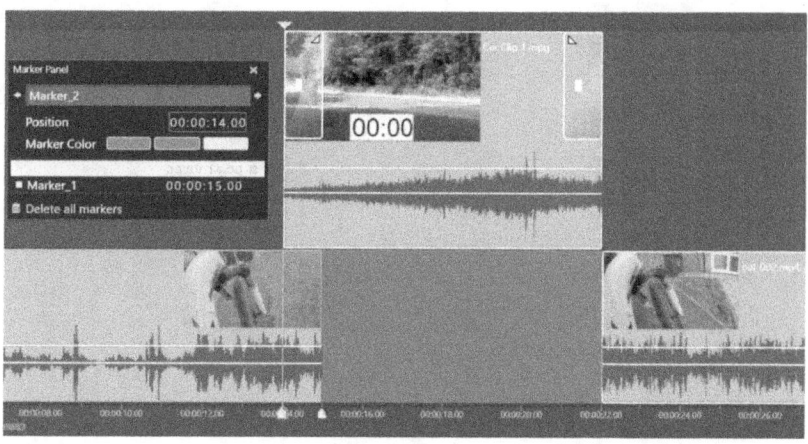

There is no video under the transparent parts of the transitions.

Place a marker at 14 seconds on the timeline, then CTRL-Shift click on the car clip. This will select all the clips or sequences to the right. Now drag the selection left to click into place with the new marker

Play the movie and there is still an issue. The bike shot isn't pushed off screen. In order to fix this, we have to add an identical transition to the Out point of the bike clip as we have on the In point.

You can't drag and drop transitions, and if you try to copy and paste it will know if it is an In or Out transition - so you can either use the Out transition from the car clip, or just add one using the transition context menu.

Now when you play the movie, we have fixed the first transition. If you want to fix the second one, just pull up the second bike shot and add an In transition Push Right.

This is **Transition Demo 6.**

Corrections

Altering Parameters

This section deals with how to alter values in the standard Legacy and In-Built editors in Pinnacle Studio. There are some often overlooked shortcuts available which are worth knowing about.

The appearance of sliders is a feature that you will also see throughout the interfaces. How you control them is generally consistent as well. A slider will normally be at a default value, but if you drag it to the left or right the value alters, and when that value is no longer the default, a white reset icon may appear to the right of the slider. Click on it to reset the value to the default. These circular arrows are important tools which are prevalent throughout Studio, but they don't always appear. In which case, you can reset the parameter in another way - double clicking on a Parameter **Name** sets it to the default.

General Parameter Adjustments

To change the value there are a number of alternatives to dragging the sliders. Click once on any slider so that the control turns orange and, leaving your mouse in place, then roll the wheel to adjust the value. However, this can be a very coarse control on some parameters.

The best way to alter the values by small amounts and with accuracy is to use the keyboard. Highlight a slider and then you can alter the value in large increments with the Page Up and Down keys or - most importantly - in small increments with the left/right keyboard arrow keys.

If you carefully click on the numerical value itself you can type an exact value in from the keyboard.

The Purpose of Corrections

In past versions of Studio there was a very clear line between Effects and Corrections, but often people didn't realise and used one when they should have used the other. Pinnacle have now blurred the rules a little, so if you use corrections

in a manner in which they weren't intended it's not an issue. However, it's still good to observe the conventions, or at least know what they are.

Corrections are designed to be applied to video, photos and audio **before** you use them in a movie. Once you have applied a correction to an asset in the Library, it will be inherited by any scenes or timeline clips you create from that asset.

You can now also apply a correction to a timeline clip without first adding it to the source clip.

Another important note is that you remove a correction by using the **Revert to Original** clip context command. Removing the correction from the source clip doesn't affect the clips that have already been created from it when the correction was in place. Removing it from a clip on the timeline doesn't affect the source asset in the Library.

Types of Corrections

You are most likely to associate correction with the colour balance and exposure of a video clip or picture. However, Studio now treats this type of correction as a special case, as I'll explain shortly.

There are lots of other types of correction, and I'm going to refer to them collectively as **General** Corrections. For Video, you can adjust aspect ratios and video properties. Shaky video can be stabilised and lens distortions removed. Audio can be sweetened, photos straightened and have red-eye removal added. Basically, they are functions that you recognise might be needed before you even begin making a project.

A bit of an anomaly is that you also create still frames from video clips using the Corrections editor - an advanced alternative to taking a snapshot of the Timeline.

Color and Exposure Corrections

Before PS24, if you wanted to make exposure and colour corrections to a whole video file before you used in in movie, you could do so in Corrections, using a version of the Image Correction GPU that was also available as an effect.

In PS22 a more advanced set of *Color* tools were added, offering full grading features, but they could only be applied as an effect to a timeline clip - colour corrections were still achieved with the old tools.

Beginning with PS24, the new colour grading tools have replaced the Image Correction GPU tool in the In-Built Corrections Editor.

If you shot a whole tape or card of video material with manual colour balance but have the setting wrong, your pictures might be all too blue or yellow. You could re-colour balance all the poor source material by applying a Color grade from within the Correction Editor That corrected material would then be pre-corrected as you used parts of it in your project.

If just one part of a shot was wrong, you could apply a colour grade to it on the timeline without entering the Corrections Editor. Additionally, colour grading can be used for artistic purposes - a flashback could be made sepia, or a dream sequence enhanced with exaggerated colours. In this case you would generally apply the Color Grading as an effect to individual clips on the timeline.

Managing Corrections

Because there are two types of corrections - General Clip Corrections and Color - we need to differentiate between them.

The Library Thumbnail Corrections icon

The only thing that indicates that a correction of either type has been applied to an item in the library is the presence of a small cogwheel icon top right of the thumbnail. You have to be in Thumbnail view to see that, there are no clues in the Details view of the Library.

To remove corrections from Library clips you can use a context menu command *Revert to original*. This removes ALL corrections - General and Color grading - from the asset.

Once a clip from the corrected asset has been placed on the timeline, you have a bit more control over the corrections. If the clip only has a Color grade applied to it, then it will have a magenta (light purple) stripe along it's top edge (the same as other effects). If a clip has had a General correction applied, it will have a green stripe.

Green overrides magenta, so a clip with a green stripe may, or may not, have Color grading added. When you hover over these lines the mouse cursor changes to show the label *fx*.

Fortunately, deciphering if Color grading is present on a clip showing just a green strip is easy - right click on the green line and the resulting context menu will tell you.

From this menu you can manage General and Color corrections separately,

The Corrections Context menu

General corrections can be copied for subsequent pasting to another timeline clip, or edited by re-entering the Corrections editor. However, you cannot remove them selectively from the timeline - you can only *Revert to Original*.

Color can also be copied, edit or deleted. So using these two options you can manage the General Clip Corrections and the Color grading separately.

To add to the complexity, if an effect other than Color or Time remapping is subsequently added to a timeline clip that already has corrections, the clip ends up with two stripes - the green one above the magenta. Right clicking on either stripe brings up a context menu with commands for the General corrections, the Effect and if present, the Color grading.

Two Corrections Editors

There are some small but important differences between how you add corrections to a Library asset and a clip on the timeline. I'm going to look at Library clips first, in what I'm calling the Source Corrections editor. Subsequently I will show you what happens when we add or edit corrections to timeline clips, in what I'm going to call the Clip Corrections Editor.

Library Corrections

Select any video clip in the library - the sample footage will do - and either double-click or right-click and select *Open in Corrections*.

Two things happen. The Library is replaced (or joined, if you are using the left hand Dual View) by the Editor open at Clip Corrections. Below, a new timeline tab has been added, coloured bright green, with the name of the file you selected, and what appears to be a new project has been substituted for whatever you had open on the timeline.

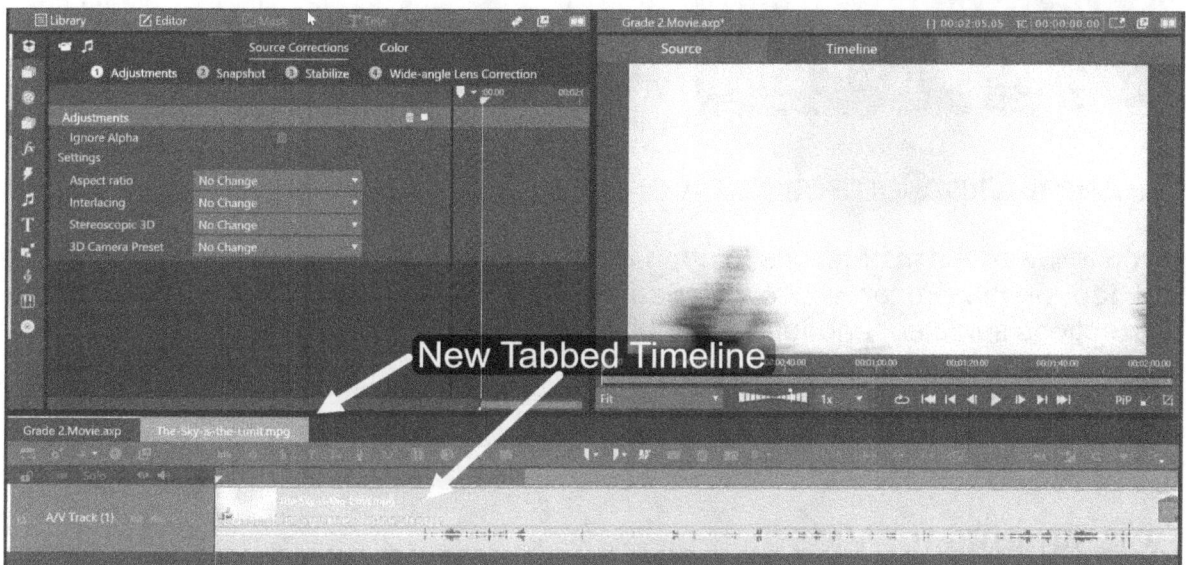

Tabbed Timelines

If this is the first time you have seen a tabbed timeline, I discuss them in it detail in the Editing Enhancements chapter. Normally they are used for working with subprojects, but the interface has also been pressed into service for use with the Library versions of the Titles and Corrections editors.

You don't really need to worry about the new timeline in this case - as you can see, almost all of the timeline toolbar icons are greyed out. It does allow you to scrub the clip more accurately, though.

The only timeline tools that are enabled are the Mark In and Out calipers. If you use these, they change the In and Out points that you see in the Source editor for that video or audio file.

When you have finished editing your corrections and want to return to your main project you close the tab to exit the timeline by clicking on the x icon on the tab, or right-clicking on the tab and choosing *Close*. The corrections you have made are saved to the Library.

Selecting Video or Audio

If you have loaded a Video clip, there are two icons top left of the editor which allow you to choose between the video and embedded audio. If you load an audio clip there will be an audio icon only, and if you have loaded a photo there will be no choice at all. In each case there will be a different set of sub-tabs.

General Clip Corrections for Video

If you followed the instructions to open the cycling clip, you will have two tabs across the top of the Editor window - Source Corrections and Color - with Source Corrections selected, and four sub-tabs below.

Adjustments for Video

Selecting Adjustments opens up a panel on the left of the screen. If you aren't seeing all the parameters, click on the Adjustments banner to open them up.

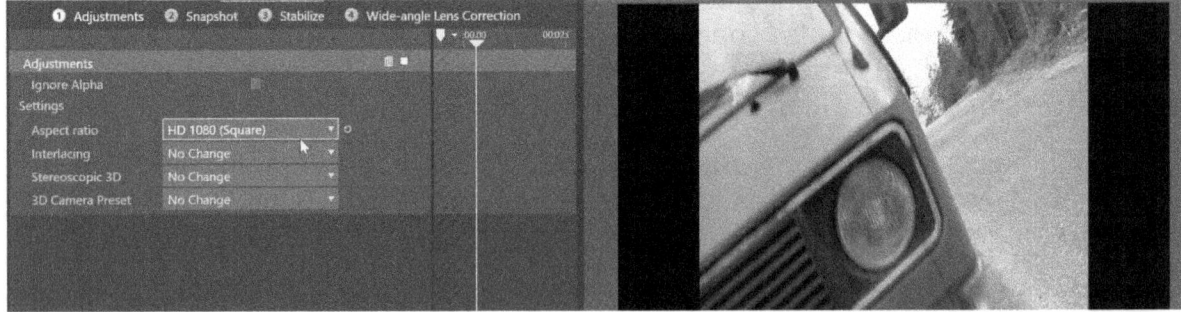

The banner holds a delete bin to remove any changes you make, and a Disable/Enable button to switch the changes on and off without permanently removing them - controls that are common to many parameter sets.

The first checkbox allows you switch off any alpha information in a video clip.

Settings contains four drop-downs. It's sometimes possible that a video is tagged with the wrong information, or that Studio misreads the tags. The most obvious case

for me is that video files imported from some DVDs are tagged as 4:3 aspect ratio when they should be 16:9.

In the *Aspect ratio* box you can easily add a Correction to override the current format.

You may be wondering why it's not just a simple choice of 4:3, 16:9 or Square. With modern video sources this is probably all you will need. However, historically various video formats use different "shapes" of pixels - you might read about "non-square pixels". For example HDV2 video has a horizontal pixel count of 1440, whereas most AVCHD cameras use 1920 pixels, yet both should be displayed as 16:9. If your stretch the HDV2 video horizontally it will display correctly - you are distorting the pixels so that they are "non-square".

NTSC SD video has 480 vertical pixels, PAL 576, regardless of the aspect ratio. Both systems were shot anamorphically with vary degrees of non-square pixels to give them their desired aspect ratios. If Studio isn't picking up the flags in the video header correctly, there should be an option in the adjustments to suit almost every misunderstanding.

Another cause of issues is the misinterpretation of a clip's scanning settings. In the next drop-down menu, *Interlacing*, you can override the detected settings.

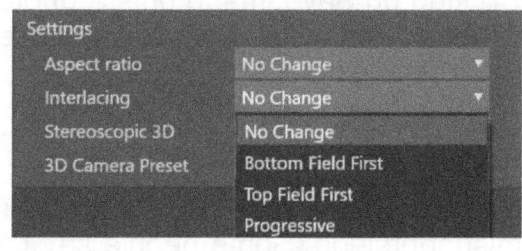

You really shouldn't mess with these unless you have a problem, but if you have got some footage that isn't actually what it says it is, then with a bit of detective work you should be able to correct the problem here. One problem is that my old DSLR shot progressive video, yet Studio thought it is Top Field First. This hasn't caused a problem yet, but if it did, this would be where I change the setting. If you are seeing a "combing" effect on moving video when it is rendered to another file, one possibility is that there has been a field reversal. Changing from Top Field First to Bottom Field First may solve the issue.

The third drop-down is to select what sort of *Stereoscopic 3D* video you might be using. I'll talk about 3D in the Project Formats chapter. If you are seeing something

strange on a 2D project such as colour ghosting, something might have gone wrong here! If you aren't intending to make a 3D video project, make sure this is set to None.

The final drop-down allows you to set the current clip to one of a number of 3D formats, defined by the camera it was shot by.

Snipping

I mentioned that you could take snapshots of Library clips and Snipping is the tool that provides this function. When selected the current frame as selected by the timeline scrubber is shown in the Timeline preview window. A white frame with nodes marks the area that will be saved as a snapshot. You can choose an aspect ratio and then adjust the nodes to select the area you want to create a snapshot of.

Snipping

Clicking on Save image puts a photo file of the snapshot into the default snapshot directory and also adds it to the current project Bin. Clear selection resets the white frame to the default.

Stabilize

I want to demonstrate this correction as it is a feature that can be troublesome if misunderstood. Some people say that it doesn't work, full stop, but it does. Other people recommend using the New Blue stabiliser which comes with the Ultimate version of Studio, but that too can be problematic. Neither will work well on some video clips because they don't respond to the presets that both stabilisers use.

You can stabilize the clip in either the Legacy Corrections Editor or the In-Built Corrections Editor. The behaviour is a little different. The Legacy Editor will stabilise the whole file even if you only apply it to a short scene or Library shortcut from the file. Because the analysis phase is very slow, this may not be worth doing if you are

sure that you don't want to stabilise the whole clip The In-Built editor only stabilises the timeline clip selected, saving time, but if you decide to expand the clip or use another section of the source file you will have a further wait.

Let's set about this straight away, because you will have time to read more while the stabilisation routine is at work.

If you don't have any shaky footage of your own to test with, I've provided a test clip called *Takeoff.mp4* on the website or DVD. Import it into a bin and then double click on it to open the Corrections Editor.

Switch to *Stabilize* and use the Select preset drop-down to choose the Default settings – no borders, Auto Zoom Frames = 50 and Max Auto Zoom = 120. Click on the Action button **Render and Play**. You should see a Rendering... message, a slowly moving progress bar, and a button that will cause the process to *Render in Background*. You might as well not press that for now, as we will have to wait for quite some time even if you do press it.

OK, what is going on that takes so long? Studio is scanning the video clip to build up a whole set of data that it is going to use to apply the stabilize effect. The good news is that it will only have to do this once, because if you alter some of the stabilize parameters it can use the same data. The bad news is that it will process the whole file, so if you only wanted to add the correction to a small section, you may have a very long wait if the source file is a long one. It's a fairly slow process regardless

If you are still waiting for the render to end and want to click on the *Render in Background* button, you can do so. The render operation will continue in the background, and although you can play the clip or carry on with some other editing tasks, you won't see the effect of the stabilisation until the render process is over.

The first stage is an analysis that produces data with the suffix *.stb*. This is stored in the render location in a folder /tmp/meta. If you want to reset the stabilisation data you can clear that location - note that using the control panel to delete the render files has no affect.

If, once you have scanned for data, you want to change any of the settings, you don't have to analyse the clip again - the parameters dictate how much adjustment is made based on the data.

When the render finally finishes, you can see how stabilisation works with the current settings by playing the clip. You may have to turn on Playback Optimization in the Control Panel Export and preview to get smooth playback - 50% should do it. The video is re-framed to reduce the amount of wobbling. We have selected no borders, so that the filter also has to zoom in a little bit for a small amount of wobbling, more so if the video is very jerky. If the zooming is very fast, the effect might actually look worse than the original video. If you zoom in too far, the video starts to look very grainy. If you select no zoom, the borders of the video show up constantly and it can be very disturbing. If you specify some borders, the amount of zoom is less but the black borders may still be distracting. Your choice of settings will really be determined on how wobbly the video is, how much you are prepared to zoom in, and if you can tolerate borders.

It so happens that the default settings work quite well on the shot I have provided. You can see it is working because the burnt-in timecode disappears out of frame quite often, but if you ignore that the effect looks relatively OK. There are a couple of big bumps that still look bad, but on the whole it's an improvement. If you change the parameters you can see the effect - you don't have to wait for that long analyse phase to occur again. Your own footage may not have been stabilised so well, and adjusting the parameters may give a better result.

The New Blue Stablizer

One of the effects provided in some versions of Studio is a stablizer plug-in from New Blue. This is applied as an Effect, not a correction, so refer to the In-Built Editor chapter for details of how to find and apply it. To make it work you need to use the Open Plug-in button in the parameter list and apply the Analyize tool in New Blue's interface. This stabiliser can remove rolling shutter problems and also reduces shots that aren't being held level when a camera is handheld with the application of a Fix Rotation parameter.

Wide-angle Lens Correction

With the increasing popularity of small action cameras such as the GoPro, we are now used to seeing the optical distortions that are produced by very wide-angle lenses. In some circumstances the "fish-eye" look is quite acceptable -it can even add to the dramatic impact of the shot. However, if you are using these types of camera to intercut with more conventional shots, the distortions can look odd. Cameras may also not have their lenses perfectly aligned with the sensor, adding further aberrations

GoPro itself allows you to correct for perspective and alignment problems with its free software, but this adds an extra step to your workflow. Studio 21 introduced a Correction tool that can adjust the video to remove the distortions and also works with other cameras. Unfortunately the presets are all for what are now older models

If you are using one of the cameras in the list of presets – series 3 and 4 GoPro models – then you can just click and go. In different shooting modes the camera uses different parts of the sensor and there are presets that distinguish between these modes. You can adjust the setting even more if you wish, perhaps to "flatten" the image further.

However, if your camera isn't a GoPro, or isn't on the list, you will need to experiment with the parameters to get the best result for your footage. It's best to start by downloading a test chart and putting it on the timeline. I've provided one on the website and data DVD. You can also print it out and record it on your action camera so you can see how much distortion you need to correct.

Wide-angle Lens Correction can be applied to a photo or a video, and in both cases it is is the final tab on the right. Experiment with the settings using un-distorted video clips to become familiar with the principles before attempting to ascertain suitable settings for your camera. When you have worked out a good set of parameters, then make a note of them or save them on a clip in the library – currently you can't save customs settings, but you can copy and paste corrections now.

The first four settings do have a bearing as we will see in a moment, but you first need to enter at least one parameter for Radial or Tangential Distortion.

Barrel Distortion

There are three types of Radial distortion. **Barrel** distortion makes the shot look like it has been projected on the outside of a sphere. Someone close to the centre of a shot then may appear to have a larger nose than they do in reality.

This is a natural distortion that occurs when you use a simple lens that has a very wide angle of view – it is recording the real perspective. However, lenses of poor quality may accentuate the problem.

Pincushion Distortion

Pincushion is the reverse – the shot looks like it has been projected in the inside of a sphere and instead of a large nose, you might have very large ears. Round objects near the edge of frame will look very oval

To make matters more complicated, the distortion may vary from the centre to the sides, varying in strength or even changing from barrel to pincushion.

Moustache Distortion

This can be described as **Moustache** distortion because straight lines may become wavy.

Radial distortion has three parameters. Setting k1 to a negative value introduces pincushion distortion – and therefore corrects a lens with barrel distortion. To correct pincushion, enter a positive value. The parameters k2 and k3 change

the correction further from the centre, enabling you to vary the correction and eliminate moustache distortion.

When you experiment with these controls, you might miss the *Reset* circular arrow to the right of the slider. In this case you can double-click on the parameter name to the left to set it back to it's default value - something that occurs in other areas of Studio when the reset buttons have not been implemented.

Tangential distortion is caused because the lens isn't lined up accurately with the sensor, resulting in a tilted image – bigger on one side of the frame than the other. The setting p1 adjusts the angle vertically and p2 adjusts it horizontally.

Returning to the first four settings, these correct the overall lens characteristics. To see their effect, you need to set one of the coefficients, even if it's to a very low offset. The Focal Length settings will alter the effect of perspective in the X (horizontal) or Y (vertical) plane – these values may differ on lower quality lenses. The Optical centre values change the position of the lens axis relative to the sensor.

With all those parameters interacting with each other, it's no trivial task to create your own corrections but with patience it should be possible to come up with a better image than your camera provides.

Color grading - the big one

There isn't really an ideal place in this book to discuss the Color grading features in Studio - you will want to use it as a correction and as an effect. It's a big subject too, so I'm not going to discuss it now, but in the next chapter.

Audio Corrections

In order to discuss audio, it's a good idea to load something suitable. I suggest you find the *bmx_ya-ha!.wma* music file in the sample project bin. If you have deleted that then any other music you have will be fine.

The Channel Mixer

We need to start with a set of controls that are corrections, but currently can't be applied in the Library editor - hopefully that will be fixed in a patch. So, start a new movie and then put your chosen music file onto the timeline.

Now double-click on the timeline clip and you should see the Editor open with just the audio icon showing top left, because we have selected an audio clip, and displaying the Channel Mixer. Notice that there are three other tabs - Corrections, Effects and Time Remapping. We will look at the last two in the In-Built Editor chapter.

On the left is an audio meter, below which is a slider that alters the gain. It obeys the usual rules about adjustments, but take it slowly – the latency means you won't hear a change for half a second or so when you try to make adjustments as the audio is playing.

The drop-down box labelled **Stereo** can be very useful. The most common use for it would be on a mono recording on just one channel of your camcorder that needs to be spread out to both left and right channels. The other options can be used for correcting some other form of error, such as Swap channels when the right and left channels have been cross-plugged.

This is the go-to tool when working with multi-track audio. Let's imagine you have recorded two-way interview with two cameras. Each camera has one of it's audio channels (let's say the left channel) fed with a tie-clip mic of the person it is favouring, and the other channel (right) is switched to the camera mic, offering a looser audio perspective. From this you can create four separate audio feeds. Both Cameras Audio/Video tracks could be switched to the *Left to Dual Mono* setting, so you would only hear the tie-clip mics. Two other audio tracks could be created on the timeline from the camera files, switched using the *Right to Dual Mono* setting, and used as atmosphere tracks or to cover up any problems with the tie-clip mics.

Test the Stereo drop-down now by switching to Stereo to Left. The music should only come out of the left speaker or headphone earpiece. You will notice that this also results in a green strip being added to the timeline clip - Studio treats it as a correction - but if you return to the Library the corrections icon has not been added to the Library clip.

The **Optimise** button to the right of the Stereo drop-down needs to be treated with caution. It should adjust the audio to a good level, but there is a long standing bug in Studio that means it doesn't do what it is supposed to do - it may not be working at all. Hopefully it will be fixed by the time you read this (but I've been writing that for over six years now).

Whenever the Channel Mixer or the Library Corrections editor are switched to audio the timeline area to the right shows two audio displays. The top one displays the normal waveforms you see on the timeline, but below that is a frequency meter. Play the music and observe how it displays the different frequencies. The lowest, bass sounds are on the left, and as we move across the screen the highest treble sounds are represented by the bar furthest right. We can use this display to good effect, along with our ears, of course, when we turn our attention to the corrections.

Audio Clips Corrections

You can reach the rest of the audio corrections in both the Library Corrections editor or the Corrections tab of the timeline clip editor.

Equalizer allows you to alter the frequency response to an audio track. Select it from the top tabs and play the music. Try the presets available while listening and watching the frequency meter. The two most obvious examples are Telephone, where the *HiCut* setting rolls off all the frequencies above 4000Hz and Heavy, which boosts the low frequencies and slightly reduces the higher ones around 2000Hz. Note that the sliders of other controls have been replaced with rotary controls, but you can use the same keyboard methods to adjust them accurately as you can for sliders.

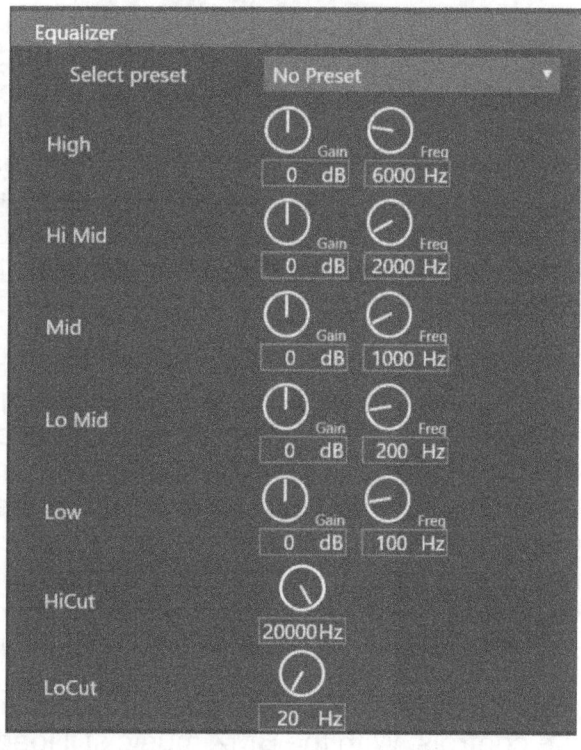

You might use the Equalizer to correct poor audio, or to add an effect. The five top channels can all be tweaked to affect different frequencies. Try adjusting the Gain of the Mid control down to -18, then listen to the effect as you change the Frequency. Turning it down to 125 Hz gives the effect of it bleeding through the earphones of the person sitting next to you on the train. Resetting it to its default of 1000Hz gives the impression that it's coming through the wall from the kids bedroom next door. You can choose how you want to be irritated.

Adjustments only has one setting – enabling or disabling the use of a subwoofer on 5.1 surround sound – the 0.1 part.

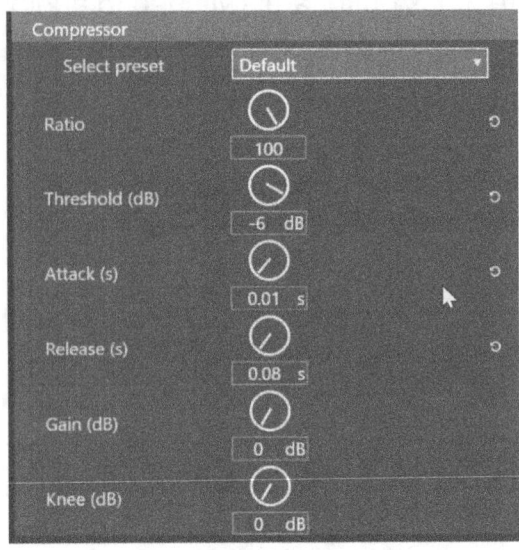

A **Compressor** is a tool that helps you stop audio going over a certain limit. It can also boost quiet sections without boosting the loud ones. If you apply this effect quite brutally the result will sound very bad – it is really a Limiter. When used carefully it will smooth out the dynamic range of audio to help avoid distortion or inaudibility.

I'm going to resort to an analogy to explain the controls. Imagine you have a very quick person operating the volume control of your Hi-Fi. He is so quick he can react instantly to the incoming level from the CD shown on the audio meter before it gets sent to the speakers. The Threshold is the level at which he begins to take action. If the threshold is -6dB, then if the signal from the CD reaches -5db, he pulls the volume to the speakers down. The amount he does that is determined by the Ratio he has been instructed to use. If that is set to 2:1, if the incoming level is +2, he reduces it to +1. If it is +4, he reduces it to +2. If the ratio is 4:1 and the incoming level is +4, he will reduce it to +1.

The Attack is the speed at which he acts – a slow attack time means that the levels can start to creep up more before he adjusts the volume. The Release is the time he takes to turn the volume back up once the incoming volume has dropped below the threshold. The Gain is another volume control further down the chain that can increase the whole signal once it has been compressed, so that if it is no longer going over -6 at any time, he can boost it to 0dB without altering the instructions he is obeying regarding Threshold. Knee modifies the compression ratio – a hard Knee will cut in the the full compression immediately the threshold has been reached, a soft Knee will increase the ratio gradually.

Again, a good idea of how to use a limiter can be gained from experimenting with the controls. With the BMX music still loaded, adjust the settings to ratio 4, threshold -16, attack 0.0001, release 1, gain 9 and knee 0. Switch off the whole effect with the button at the top alongside the title, and listen to the music, watching the meter in the Channel Mixer panel.

The levels hit the red maximum on occasions, while at other times almost fall out of the yellow area. Now switch on the compressor while still playing. It will take a moment for the effect to kick in, but when it does, observe the difference – while the meter is staying higher in the yellow area all the time, it isn't ever hitting the red. Of course, the music doesn't sound so good – we have squashed the dynamic range.

You might want to try some more radical settings to hear how badly over-compressed music can sound.

You can use compression on audio instead of having to manually adjust the levels. For example, a group of people holding a conversation might get very loud at times when they are talking over each other and getting excited, but there might be very quiet patches as well. A little light compression might save you having to go through the whole audio, manually adjusting the levels.

The **Expander** is the reverse of the Compressor, as the name might imply. Why would you want to do that? If you have a poor quality recording with low level hiss or other background noise, it would be useful to fade the audio out completely when it doesn't have any content that you want to hear. To hear this effect on music – which isn't where you are likely to use it but it gives you some idea – select the Expand 2:1 preset and listen the the BMX track. When it goes quiet – it really goes quiet! The settings are much the reverse of a compressor as well. The Threshold is the point below which levels get reduced, Ratio is the amount that they get reduced by, while Attack and Release are the speed at which the operation works, Range compensates for overall level change and Hold is an additional control that delays the application of the attenuation before Release comes into play.

The **De-Esser** is a tool that reduces the sibilance of the human voice generated by pronouncing the end of "S" as well as "T" and "C" and similar sounds. This can be pronounced in some recordings. Because it is at a specific frequency, a De-esser can reduce the effect by compressing just that specific area of the audio spectrum. The precise frequency will vary between people, hence the frequency setting, and too much compression will begin to affect the whole audio, so the Range is adjustable as well.

Noise Reduction is a useful tool, but it isn't always as successfully as you might hope. The problem is differentiating between noise (perhaps the distant drone of traffic) and the audio you want (Maybe the voices in the foreground).

It's not very successful with variable noises, such as wind. Things work better if the unwanted noise is constant – the drone of a computer in the background perhaps.

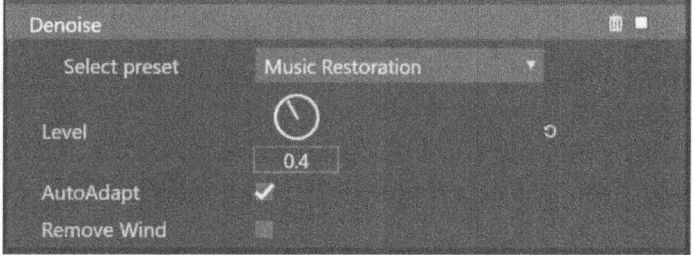

Correcting Photos

Use the Library to find a photo to experiment with. You can use the stills of our biking heroes in the Public Pictures if you can't find anything else. Double click to open the Library Corrections Editor and you can see that again you have two main choices - Clip corrections and Color. We look at the use of Color in the next chapter.

In Clip Corrections some of the choices available as tabs have changed. The first one – **Adjustments** - uses the same parameters as when we are working with video, but for photos the only relevant ones are to do with Stereoscopic 3D.

Using the Straighten tool

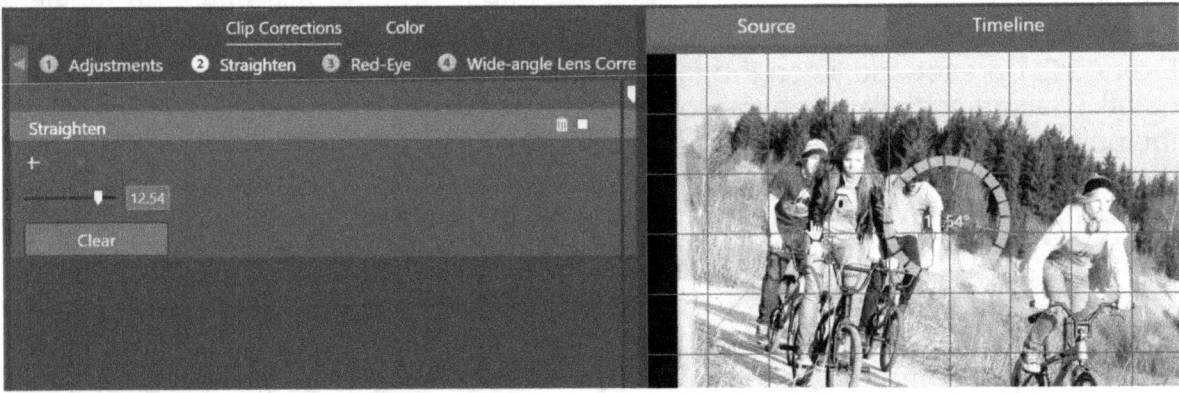

Straightening is a tool that lets you rotate a photo by + or – 20 degrees. The superimposed grid helps to line up horizons or the sides of buildings. You don't need to use the slider on the grey bar – you can grab and drag the picture. Notice that when you adjust the rotation, the picture is automatically zoomed in to ensure you don't shoot off the edges of the photo.

Red-Eye reduction. When using flash photography too close to someone looking straight at camera in a fairly dark room you may create the Red-Eye effect – it's actually a reflection coming off the blood vessels around the retina. The reduction tool requires you to draw a marquee around the eyes of the subject who you want to correct. Depending on the photo, the size and position of the box, and the colours involved, it sometimes works well, and in other circumstances not at all. Different programs have different levels of success, so if Studio can't do it, a third-party program might be able to provide a better fix.

The In-Built Clip Editor and Corrections.

When you double click on a Timeline clip, the In-Built clip editor opens. You can also select a clip and then click on the Editor tab next to the Library tab. I'm going to deal with this editor in detail in the next chapter, but it is worth looking at the Corrections options - the second category.

Corrections in the In-Built Editor

When you use this option, it will only be acting the clip loaded into the editor. Although the keyframe panel is displayed in the corrections tab or the In-Built editor, there are no corrections that can be keyframed.

Save as Shortcut

If you used an earlier version of Studio and were aware of the ability of the Corrections editor to save a clip as a shortcut, otherwise known as a Library Clip, you might go looking for in the new In-Built version. Currently, the option exists when you right-click on the green timeline tab header for the Library Corrections editor, but the command doesn't seem to be fully features yet, as the created shortcut is hard to find in the library. There is no guarantee that Pinnacle intend to re-introduce this feature in future patches to PS24, but I'm hopeful that they will. I was also aware of some anomalies and inconsistencies in PS23 when working with Library clips created in the Corrections editor, so perhaps those will be addressed as well. If they are, please check out the support section of the DTVPro website for any updates to the book.

In the meantime if you want to create Library clips your best option is to create scenes first, as discussed in the Library chapter.

Color Grading

You say Color, I say Colour - however you spell it, this feature takes Studio to a new level comparable with some professional tools. Not all these features exist in Standard and Plus so I'm going assume you are working with this feature in Ultimate.

With the **Color tab** selected in the In-Built Editor or the Library Corrections Editor, the currently highlighted clip becomes the subject of the colour corrections tools. Incidentally, there is also a sub-tab named *Color* in the Effects tab. If you don't recognise any of the screenshots below, you may have selected that by accident.

Basic Colour grading with a Waveform Scope

The Ultimate version of Studio offers you four ways to adjust the exposure and colour renditions of an image. Most importantly, we can also examine the image accurately rather than just subjectively by using the Video Scope, which displays waveforms and vectors rather than the image. This allows us to compare how changes we make with the correction tools affect the waveforms.

Colour grading is a complex subject which I can only scratch the surface of in this book. A highly experienced professional can take many hours to process just a few minutes of footage if it needs a lot of correction, and that's just to make things look "right" – getting the shots to match precisely and look natural. Additionally there is the creative element, varying from just adding a bit of punch to the colours to regrading an entire movie that has been shot very flat to give it the "Gothic Horror", "70's Filmic" or "Victorian Pastoral" look that the producer asked for.

If you want to go a bit further than just correcting your images to look a bit better, you might need to do more research on the subjects I mention in the next few sections. If you would like to get your teeth into using grading to solve a common problem, there is a tutorial at the end of the chapter.

Monitor Calibration

Judging your pictures on a computer monitor in a well-lit room isn't going to be very accurate. If you can at least work with a second monitor that has had the brightness, contrast and saturation levels normalised and isn't in a display mode such as "Game" or "Scenery" it's a start. Working in a low light environment will mean your vision isn't affected by the surrounding décor or light coming in through the window. It is possible for Studio to output to an external preview monitor if you have the right hardware, but the Pinnacle devices are no longer available and only ever worked in Standard definition. Professional quality grading monitors are extremely expensive – if you are thinking that you might want to work with one and have the cash to do so I can honestly say you should consider using professional quality grading software as well.

Video Levels

It's important to get the overall levels right - the brightness and contrast – even if the picture isn't monochrome. A badly exposed clip will be wrong across the board and we need to get the levels right before we look at the colours.

If you look at a combined video signal as a waveform, white shows up as peaks and black as troughs. There are various standards - in the analogue days a video signal was 1 volt peak-to-peak with the sync pulses taking up 30% of the signal. Nowadays the level is expressed in IRE units with zero being black and 100 peak white.

The Video Scope

Start a new project and put the picture **3 shades of grey.jpg** on the timeline. Although this is a picture rather than a video file, it still produces what I'm calling a "video signal" on the video scope, with black, three shades of grey and then white, left to right across the screen.

Select the photo and open the In-Built editor at the Color tab. An additional Preview tab opens up entitled *Color Grading* offering a clean view of the clip but with any corrections you make added to it. In certain circumstances you will be able to sample areas of the preview or alter the colours directly on the screen.

Check the box at the top of the Editor parameter list labelled *Show Video Scope* and select *Waveform* from the drop-down to the right. The keyframe area is replaced by the waveform display.

I think comparing the waveform in the scope with the Timeline preview to its right explains a great deal. As you look from left to right across the waveform you can see the bars of grey in the image, sitting at the levels indicated by the text burnt into them

and aligning with the values added as labels to the vertical axis of the graph. The other dots distributed on the waveforms are from the text and the boundaries between sharp level changes and the edges of the text. I didn't include anything to the picture other than black, white and the three shades of grey when I created it in the Legacy Title Editor, but the artefacts have come about from sampling errors.

Switch through the other Video Scope options. Vector Color has nothing to display – everything is perfectly neutral. We will return to this display shortly. **Historgram** and **RGB Parade** display the black and white picture as three individual colours – RGB Parade is arranged in the same manner as the waveform monitor, Histogram is turned through 90 degrees. Note that as the pictures are monochrome, there are equal levels of Red, Green and Blue.

Basic Controls

With regard to colour balance, there is a very useful group of tools at the top of the Panel under the sub-heading **White Balance**. If the colours just look a bit out to you, this is the easiest place to sort them out.

The Auto White balance is a very good place to start, but bear in mind it can't be keyframed. If your camera wasn't set to auto, or wasn't doing what it ought to have been doing, check the box and see if things improve.

If you want to colour balance a specific frame the Temperature and Tint controls are the things to use. Temperature compensates for the lighting of the scene. Daylight looks bluer than most artificial lighting and has a high colour temperature - in the order of 6500 degrees Kelvin, but that varies with the time of day and the amount of cloud cover. Tungsten and candlelight look yellow, and have a lower temperature, in the region of 3000 K, so for example if the camera has been set to a manual daylight setting but the shot was done in artificial light you can stop it looking so yellow by moving the slider left.

The other setting is Tint, which adjusts the colour balance in the other axis, between green and magenta. If the scene was lit with coloured light, you can neutralise the effect with a combination of both sliders. These setting can be keyframed..

The Selector eyedropper mouse cursor and how it appears in the Preview.

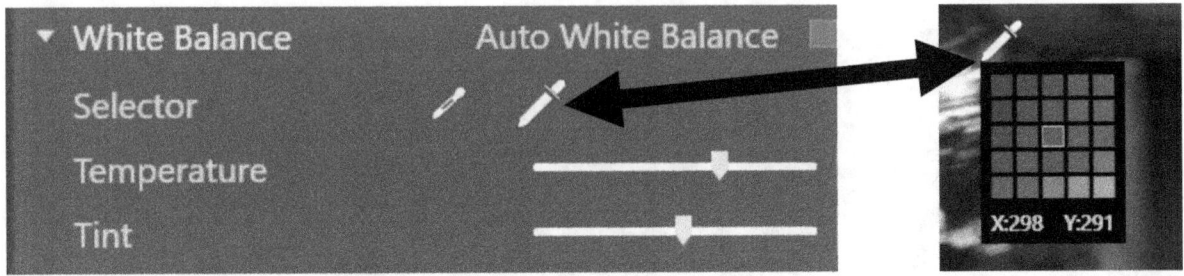

The Selector creates an eyedropper tool when you click on it and if you hover this over the preview you get a small pixel icon showing you the exact colour that the tool is pointing at - it's the square in the centre of the 7x7 grid. When you click, the Temperature and Tint values are changed to make the selected pixel a neutral white, grey or black.

If you know a part of a frame should be a neutral colour, this will colour balance the whole frame to that setting.

Let's look at the tools we can use to adjust the levels independent of colour. Put an uncorrected version of the overexposed *005* cycling clip on the timeline next to the grey scale so we can see what happens with both the 3 Shades of Grey photo and a real, over-exposed, video clip. Switch back to the Waveform display and make sure you are looking at the *Basic* controls. Everything in the **Tone** section affects the levels without altering the colours.

Increasing the **Exposure** tries to push all the levels higher, but unlike Spinal Tap's amplifiers, Video levels don't go up to 11. What happens instead is that as the 75% level gets closer to 100%, the details of the highlights get burnt out. The same happens in reverse if you decrease the exposure on the video clip – the overall level is decreased, correcting the overexposure, but we start to lose details in the darker parts of the picture if we overdo it.

Contrast attempts to widen or reduce the gaps between the steps, increasing or decreasing the differences between the levels, but crushing both the dark and bright areas if we overdo it. By looking at the scope as we adjust these two parameters, we can spread out the levels as equally as possible, and this can be a good way to adjust the levels more accurately than looking at the image itself.

A well exposed image will be spread quite evenly throughout the level range rather than having a waveform that is bunched up in one part of the scope - assuming of course that the original image doesn't have large areas of a similar level.

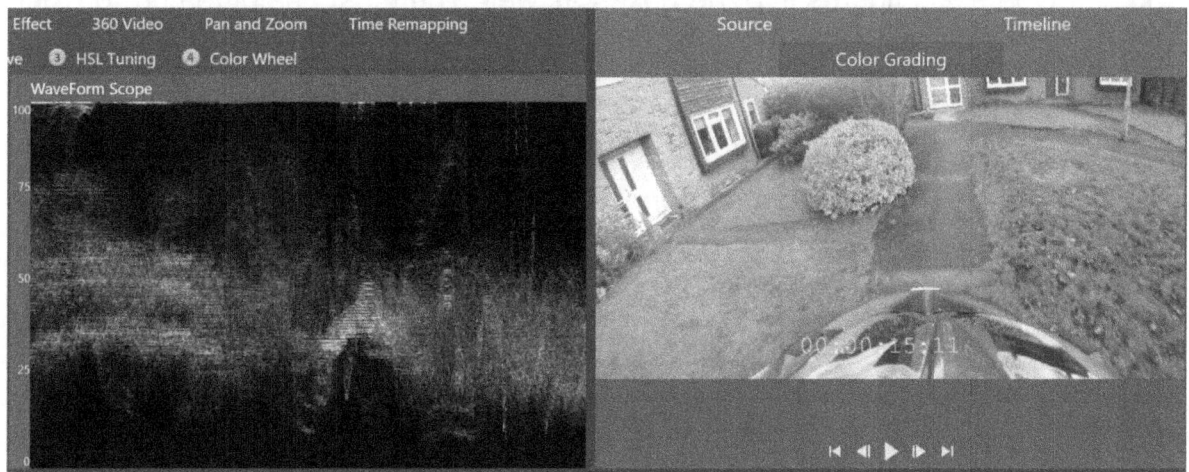

Reducing the exposure and lifting the contrast can, to some extent, restore the picture to how it should look.

Reset the video clip and then return to the grey scale to investigate the setting for *Blacks*. This adjusts the very low values, although you have to push it very hard to get pure black to sit above zero. The inverse applies to adjusting *Whites*. Where the adjustments have the most control is when adjusting the *Shadows*, *Mid-range* and *Highlights*, which target these areas more specifically. However, there is a perhaps more controllable way of adjusting these levels. Reset the Basic settings before we try the next feature.

Tone Curve

Use the Color sub tabs to switch to **Tone Curve**.

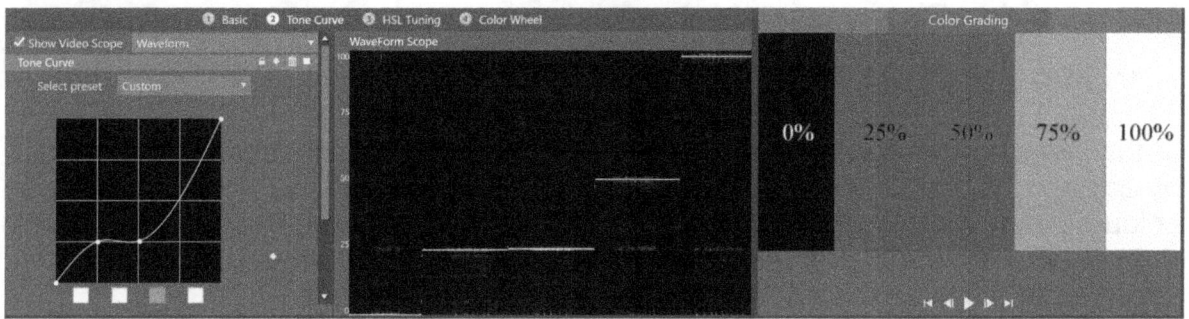

This displays a straight line crossing from left to right, starting at zero and ending at 100. We can add a node anywhere along the line simply by clicking, and then alter the position to adjust the ratio of Input to Output, as displayed in the boxes below. You can type exact figures into the boxes as well. The most useful feature of Tone Curve is that you can add more than one node. Try adding two nodes and fixing both the 25% and 50% levels to 25%. Despite the odd looking curve that results, you can get the two bars to look almost identical.

Tone Curve can be switched to work on just one of the primary colours, more of which in a moment. I'll also use Tone Curve in a practical exercise later in the chapter, there is more detail about it there.

Copy and Paste

In Ultimate you can copy and paste colour effects from one clip to another. Try right clicking on the pink line on the *3 Shades* photo, copying the *Color* and pasting it to the video clip. What looked interesting on the photo looks very odd on the overexposed clip, but with some refinement Tone Curve can still be a better way to correct poorly exposed clips than just adjusting the basic controls.

The other Color tabs could benefit from a colour photo to work with, so please put the photo **Primary Colours** onto the timeline.

Colour Space

The range of colours that can be displayed varies with the *Colour Space*. Consumer video is restricted to what a TV can display, and once you try to display colours outside this "space" you get unpredictable results, particularly if your monitor is working with a different colour space to your camera. For example, a monitor that is connected by an HDMI cable will not display as wide a range of colours an if it is connected via a Display port cable.

Additive colour mixing

In the video world you can make any colour within the colour space that you want by adding together three primary colours, Red, Green and Blue. The purity of these colours define the colour space you are working in. If you have studied painting you may have been taught that the primary colours are different, but when mixing paint you are performing subtractive, rather than additive, colour mixing.

Adding the maximum amount of all three primary colours creates pure white.

With the *Primary Colours* photo selected, switch the Video Scope to *Vector Colour*. This clearly shows that the three colours are pure. You will notice that the completely red, green and blue vectors end in three small boxes marked R, G and B near the edges of the scope – these are the most saturated that they can be without falling outside the colour space used by Studio. If the vector doesn't reach the box it is less saturated.

The three *Secondary* colours in additive mixing are the halfway points between the primary colours – Add Red and Blue to get Magenta, Red and Green to get Yellow and Green and Blue to get Cyan. Each Primary colour therefore has a secondary colour that compliments it. For example, pure Green is the opposite to Magenta, add them together and you will produce a neutral grey. If you look again at the Vector scope three other boxes marked YL (yellow) MG (magenta) and CY (cyan) are directly opposite the primaries.

Now turn to the **HSL Tuning** sub tab. Notice that there are three tabs above the sliders. Select **Hue** and adjust the Red slider – you will see the angle of the colour vector swing around the scope as we alter the actual colour from orange at one end and magenta at the other. Now try the on-screen slider tool at the bottom of the sliders, labelled *Click and drag....* Click on it to activate, hover over the blue area of the photo in the Color Grading preview, click, hold and drag left and right – we can adjust any on screen colours without specifying them with the sliders, notice that there are more colour axis than the six primary and secondary colours – purple and orange fill gaps in the vector angles, giving us more choice. The line which is one round anti-

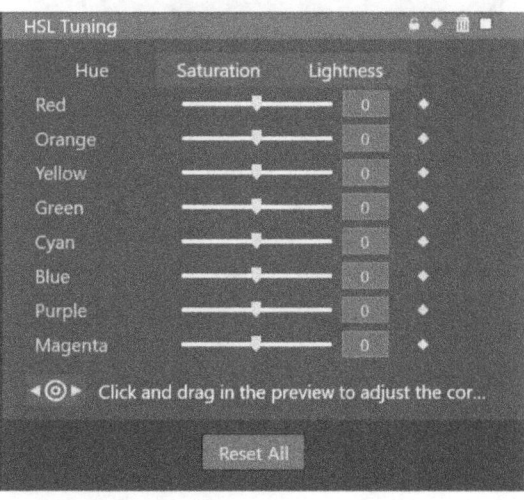

clock from red marks is where skin tones should lie, regardless of ethnicity. I'll use this tool and provide some more screenshots in the practical exercise later in this chapter.

The on-screen selection tool can be a bit flaky in the current build if you use it too many times in a row without switching away, but when it is working properly, it's really handy. Saturation makes the chosen colour darker by removing the colour, and Lightness makes it whiter, adding the complementary colour.

The vector scope display has a selection brush tool that allows you to select just an area of a picture to display. With this you can select flesh tones or some other important part of the picture and then match the angle of the vectors from image to image. If you are unsure how to use the brush, a similar tool will be described in the Masking section.

The final tool is **Color Wheel**. This combines colour balancing of the entire image or

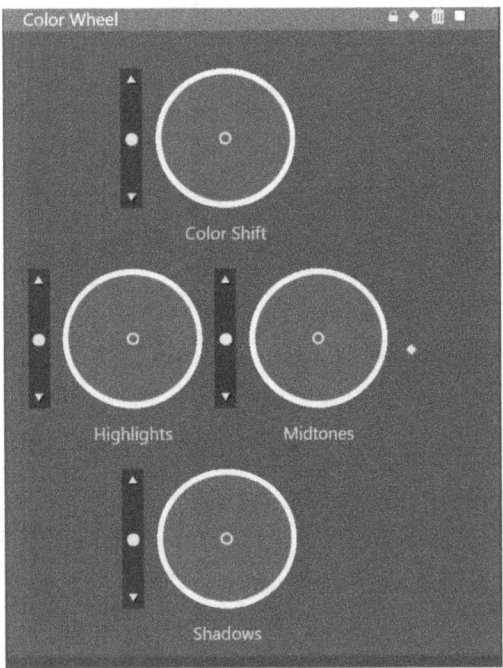

just the highlights, Midtone or Shadows. Each wheel has an associated level control that dictates if the chosen hue is added or taken away.

My suggestion is to try out each control method and see how the various Video Scope modes display the changes in different ways, first on the test pictures I've provided, and then on some images of your own. Tutorials on grading are abundant on the Internet, and you don't need to look for ones that are Pinnacle Studio specific.

Some final points. Adding a **LUT** (Look Up Table) changes an image, but it applies the same change regardless of the image – adding the same LUT to two images that are radically different won't make them match

each other. LUTs should be seen as a additional, creative step, not a solution to poor images.

Bear in mind that all the above controls can be keyframed, so if a video begins incorrectly exposed and then the exposure is corrected as the framing changes, you can change the grading over time. If only one area of your image needs correction, then you can also bring the Masking tool into play.

A Case Study - Underexposed Video

In the professional world, the camera operator may have someone to adjust the focus and quite possibly someone who will "rack" the camera's exposure and colour balance remotely.

If you shoot your own video footage on a consumer or prosumer camera, you will almost certainly have experience of poorly exposed video. We tend to rely on automatic settings for focus, exposure and colour balance and these don't always make the right choices. If you do use manual settings, then you are most likely to be concerned with focus as it is almost impossible to fix should you get it wrong.

There are only so many things one person can cope with, particularly if the shot is a developing one. If the lighting levels are relatively even you can use manual exposure, and if you know that the camera isn't coping with the current lighting you can use backlight compensation to add an offset to the automatic exposure level. Colour balance is the last thing to worry about, and the easiest thing to sort out later, assuming it isn't miles out.

I'm going to use a piece of footage that has been shot on automatic settings. The shot you need to load is called **HD shot for grading**. It is available on the website and DVD, and there are also UHD and 720P versions available should you have a more, or less, powerful computer.

The person is standing in sunshine with a broken up background behind them – the shot is focused on the person and correctly exposed. They then move to a new position where they are in shade but in front of a brightly lit background. The camera pans with them, and at the end, their face is seriously underexposed – the camera has tried to prevent the sky from burning out by stopping down.

Without manually adjusting the camera exposure during the shot, it would be hard to find a way of shooting this successfully. You could change the move so that the end position wasn't backed by sky, or put some light on the person's face in their end position if you have a powerful enough light – in fact in the professional world they would probably do both! If you are shooting your Cousin's wedding, however, you don't have the chance to make those sorts of changes.

Evaluating the footage

Put the shot on an empty timeline, click to highlight it, open the In-Built Editor and switch to the Color tab.

With the scrubber at the start of the clip, click on the *Show Video Scope* checkbox and make sure *Waveform* is selected. There is a lot that we can learn from the Scope.The person's face is what the viewer is going to be looking at, and unless we are trying to achieve some sort of artistic effect, it should be reasonably exposed for most of the time. See where the face sits on the waveform scale – it's mostly between 30% and 70%. Some parts of the sky are at 100% and the darkest parts of the frame are just over the 0% level.

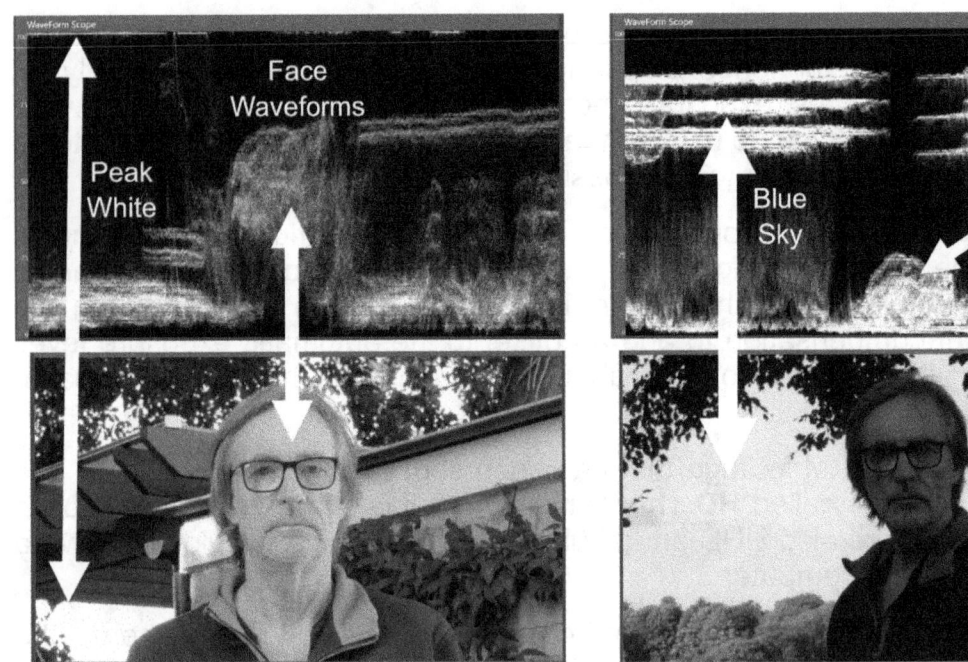

Now scrub to the end of the clip. None of the face is registering at over 25%, while the majority of the frame consisting of sky has been pulled down – the blue component is at about 80%. The picture is nicely exposed – for the trees and sky behind our subject.

Backlight compensation

If you had tried to compensate for the end frame, you might have used a camera setting for backlight compensation, and we can emulate that here to some extent by increasing the exposure.

Make sure you are switched to the *Basic* tab and, with the scrubber still at the end of the clip, increase the *Exposure* setting to 40. The waveform area that corresponds to the face is now roughly in the right place and the sky is getting close to being burnt out, but all the dark areas have become "milky". You can see the reason for that – the darkest areas are sitting at around 10%. If we had altered the exposure on the camera, details in the dark areas would have been revealed, but there is nothing in the recorded video signal to recover.

Lower the exposure setting to 25 and you get a better result – something more like the camera might have produced with a moderate amount of backlight compensation selected, but now scrub to the start of the clip and you can see that the opening of the shot is overexposed. Obviously we can correct that with keyframing, which I'll discuss shortly.

Return to the end of the clips and firstly increase the *Contrast* setting. This will restore the black levels to make them less milky, but because the face is in the lower half of the range that gets lowered too.

Instead, you could try selectively adjusting the *Blacks* and *Shadows* settings, increasing the *Midrange* a lot and the *Highlights* and *Whites* a little, but notice how everything interacts. At least with the waveform scope open, you can accurately see how each setting affects the overall levels. As you start to approach a decent result take a look at the positions of the sliders. They are starting to resemble a curve. This takes us neatly to the next type of correction.

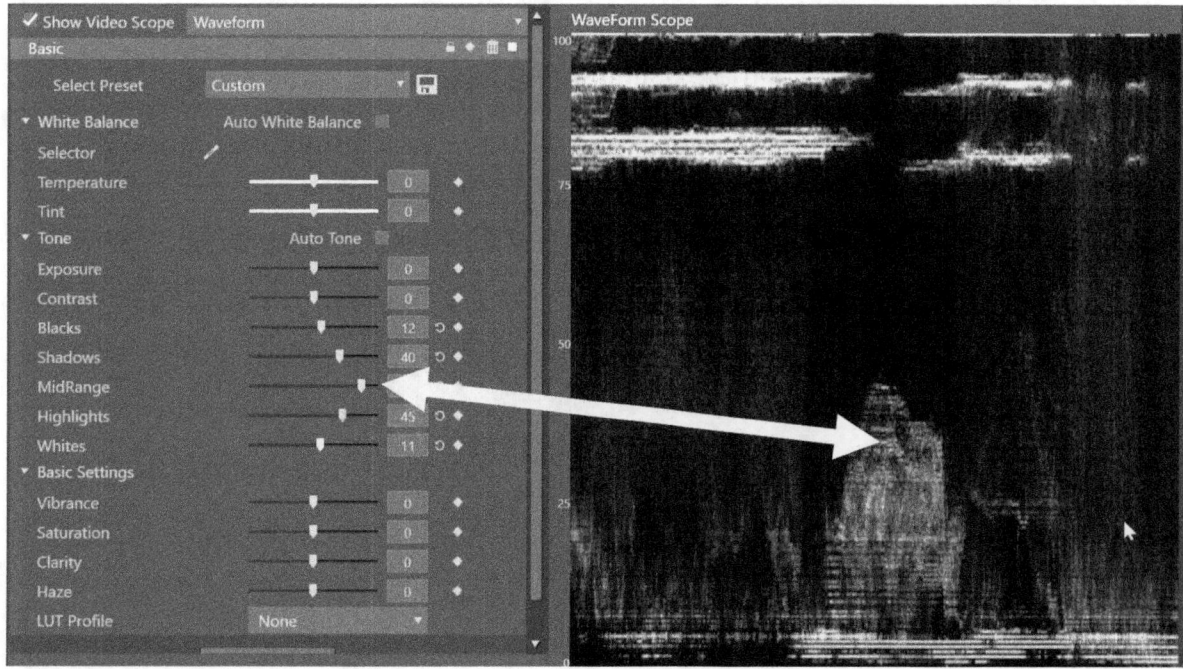

Using Tone Curve

Reset all the values before switching to *Tone Curve* and take a look at the graph on the left. I'm only going to adjust the RGB value, so make sure that the line is white – if you select a single colour the line will become that colour.

The horizontal scale of the graph is the input level, the vertical scale is the output. It's the face we want to boost, which sits at around 20%. Click on the line to create

a node at about 20% and then drag the node upwards. To start with, just make the face look OK, not too dark, and then turn your attention to the values in the *Input* and *Output* boxes. With an Input of 25 and an output of 50, we are boosting the face levels into the area where they should be. The dark areas have been stretched, rather than lifted, but the sky is now

rather bright.

Let's add another node above the existing one – the idea being that round about the 75% level we want to flatten the curve, which will bring some colour and texture

back into the trees and sky.

Incidentally, once a node is set and selected you can adjust its position by entering values into the Input and Output boxes.

With multiple nodes you can create complex curves, but for realist results the curve shouldn't change direction and start

heading down again. After some experimentation I settled on three nodes that gave a shape that boosted the face but became a straight line in the highlights and whites area. The Input/Output values are 25/50, 45/70 and 75/87.

Keyframing the Curve.

Having found a good value for the end of the shot, we can use keyframing to adjust the clip over time. Close the scope to restore the keyframe area and then click on the single diamond the the right of the graph to enable keyframes. Two diamonds should appear and the start and the scrubber position. Make sure the Timeline preview is selected and scrub back to the point that the person is about to turn back to camera at 4 seconds, and set another keyframe there. Now scrub to the very start and use the *Reset All* button to remove the curve at that point.

If you scrub through now you will see that the curve begins to be added over the four seconds until the next keyframe, but we should delay the adjustment at least until the person has turned their back, if not a bit later – let's say 3 seconds in. Add another keyframe there and reset the curve again.

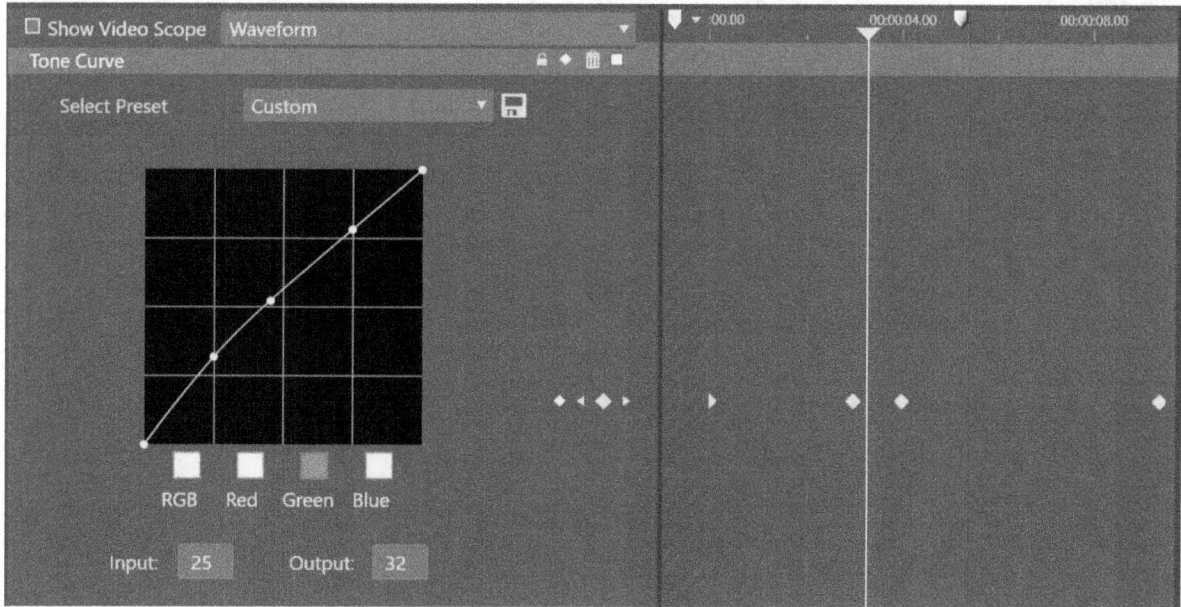

Play the graded clip. By now you might be finding that playback has become a bit unreliable on early builds of the software, so you might need to render the clip or even restart Studio to see the result play smoothly. Not bad, I hope you will agree. There is room for improvement – you might want to space out the two central frames a bit more.

I've saved my version as **Graded clip_1**.

White Balance

There isn't anything hugely wrong with the colour balance of the shot because although it is set to auto, when the person walks into the shade there isn't a big difference in the overall colour of the picture. But take another look, just watching the face and you will probably agree that it ends up more red than it starts. Because that's what people (should) be looking at, I'll show you how to tweak it a little with the the HSL tool.

Using HSL

Hue, Saturation and Lightness gives you control of the those values over eight colour axis. The neat thing, however is the tool that lets you sample and adjust a particular colour range from the *Color Grading* preview window.

I'm going to start by sampling the end of the clip to see what corrections we can make. Scrub to near the end of the clip and open the *Color* tab at *HSL Tuning* and select *Show Video Scope*. We are just going to adjust the *Hue*, so make sure that tab is selected. Using the drop-down at the top of the Video Scope select the *Vector - Colour* display. Now make your preview window as large as is practical and then switch it to the *Color Grading* tab.

Click on the sampler tool icon and then hover the mouse tool over the person's camera right cheek - it's the clearest area of skin tone. Click, hold and drag left to observe the adjustment it makes. As the face gets redder the area of the Vector Scope representing those colours between red and yellow moves clockwise towards the red axis. Drag the sample tool back to the right and the face turns yellow and the vectors move anti-clockwise towards the

yellow axis. You can only make relatively small adjustments, which in this case is a good thing.

Note that the other sectors show no movement, assuming you have selected the area of interest accurately. As you experiment, the sliders don't move, but with the face colour as yellow as you can make it - which still isn't a unreasonable adjustment - release the mouse button.

Ah, now the sliders change, In fact, if you selected the correct part of the face, only one slider will change - Red will jump up to 100 or so, all the others should remain the same.

Now we have some data, we can decide what values to keyframe. Disable the Vector Scope and the keyframe area will reappear. Enable keyframes for the *Red Hue* setting only, and two keyframes will appear on the keyframe timeline, one at the start and one where the scrubber is.

We will match the positions of the keyframes we set in Tone Curve. Scrub to 4 seconds and drop another keyframe for the HSL setting, move to 3 seconds and reset the value to zero, then jump to the opening keyframe and reset that to zero as well.

This small colour adjustment will now happen at the same time as the Tone Curve adjustment, so the viewer will hardly notice it happening.

I've saved the final stage as **Graded clip_2**.

I hope you agree that we have turned a shot that wasn't really usable into one that is. You could spend a lot more time just on this example, but the law of diminishing returns will start to come into play.

The In-Built Editor

The Library area can also host the Title Editor, In-Built Editor and the Mask Editor (only available in Ultimate). I discussed how to switch between them and about using Dual View in the User Interface chapter.

I'm going to use the project **Basic Editing Final** which we made in the Basic Editing chapter and further modify it with Properties and Effects using the In-Built Editor. If you didn't make the project, get it and the clips it uses from the website or data DVD.

Load up the project. Make sure that nothing is selected on the timeline by clicking on a blank space. Now switch tabs above the Library area from Library to Editor.

The Project loaded, nothing selected on the timeline but the Editor open

When nothing is selected on the timeline, the Editor shows the obvious message *Nothing selected*. Highlight the third timeline clip and now take a look at the Editor.

By default the display has two areas. On the left are the parameters for the current effect, and on the right is a keyframing area. You can hide and restore the keyframing area with the white triangle top right of the parameter area, or drag the border between the areas to adjust the relative sizes.

You won't need the keyframing area for a lot of the effects, so it's worth keeping it small – which is what I'll do for screenshots that don't involve keyframing.

There is a vast choice of possible effects. Firstly, you can choose between Video or Audio with the two icons top left. If all the options don't fit in the space available, there are scroll buttons at either end of the list.

Starting with the Video options, the first is **Properties**. This is a very useful effect, that works a little differently than the others – you can alter the size, angle and cropping of a video clip or picture using dragging within the preview window itself. The Properties feature is often called PiP or PiP/Crop - PiP standing for Picture in Picture. You can use keyframing to alter the parameters over time. We will use this shortly to transform a video clip and give an overview of the controls and keyframing options that work with many of the other clips.

Corrections are discussed in detail two chapters back, where we looked at applying them using the Library Corrections Editor as well as what was possible in the In-Built Editor.

Color holds *Basic*, and *Tone Curve*. Plus and Ultimate also have *HSL Tuning*, while *Color Wheel* only exists in Ultimate. We looked at them in the previous chapter.

Effect contains a huge choice, with up to seven subcategories (eight if you have created any FX Compositions) and is discussed later in this chapter

360 Video is discussed in *Project Settings* chapter.

Pan and Zoom is an In-Built version of the Pan and Zoom tool available from the Timeline Clip Context menu. It can work on Video, but is more often used on photos and slideshows. I'll discuss it in the *Photos and more* chapter.

Time Remapping is a comprehensive interface for altering the playback speed of video clips, either by a set amount or variably over the duration over the clip. We look at it later in this chapter.

If we switch to the Audio setting there are four options. The first two tabs, **Channel Mixer** and **Corrections**, have already been discussed in the Corrections editor. **Effect** holds a number of functions that are different from those in Corrections. You can also apply **Time Remapping** to audio only clips.

Controlling Parameters in the In-Built Editor

Studio uses a fairly consistent interface throughout its editors, so the controls described at the start of the *Corrections* chapter apply to the In-Built Editor as well as the Legacy Editors. There are a few differences and additions, which will become apparent as we work through the tabs. The sometimes overlooked keyboard features work, so very accurate parameter adjustments are easy to achieve. Keyframing is also consistent, so I'll cover that in the Properties section and you can refer back when you need to use them in other features.

Properties - Transforming a Video Clip

Properties are a relatively recent addition to Studio. They can be used to transform the size, position, cropping, and 2D rotation of a clip directly in the Timeline preview window. To make very accurate adjustments, you can also access and adjust Properties in the In-Built Editor. With this open, there are also many further parameters available - borders, 3D transformations and more. Properties can also be keyframed so that we can adjust them over time.

In the past you would probably have used the 2D Advanced Editor or one of the 3D Editors for the type of transformation we are about to perform, but the graphics interface used by Properties is a very nice way of working. That doesn't make the other effects redundant, however, because of a few quirks in Properties.

PiP, Scale and Crop modes

We are going to modify the third clip on the timeline so that it shrinks into the top right corner. Before we do, please go to the *Control Panel/Export and preview* panel and turn *Playback Optimisation* right down to zero, so that not too many things need to be explained at the same time.

With the third timeline clip highlighted and the scrubber at its first frame, look at the small icons bottom right of the preview window to the right of the PiP label. The first actually has the tool tip **Scale Mode**, and it changes the size and position of the clip without altering it's aspect ratio. You can make it larger than the frame as well as smaller. The next tool to the right, **Crop**, can be used to cut away at the edges so that you only see a part of the clip.

Both tools can be used to create a Picture-in Picture effect when the clip that we transform is placed over another picture on the track below. It's very easy to use the term PiP exclusively for the Scale mode tool, but I'll try my best to always call them PiP/Scale and PiP/Crop.

Cropping

Making sure that clip 3 is still highlighted, click on the PiP/**Crop** tool first. An orange border appears around the clip in the preview window, with flat control nodes in the corners and half way along the sides.

You can drag the corners to crop the clip and maintain it's aspect ratio, or the sides to crop in just one dimension. Try a couple of alterations, and then use Undo to reset the clip to it's original, full size.

Now switch from the PiP/Crop to the **PiP/ Scale** tool

Scale down

Eight round control nodes will appear on an orange frame around the video.

Unlike cropping, all the edge nodes work in the same way - they resize the clip without distorting it's aspect ratio. The image anchors itself to the node opposite the one you are moving. Grab the top centre one and drag it down to shrink the clip to about half size.

Rotate

Above the top edge of the clip is a node that is slightly detached from the frame. It can get hidden at times, but is always present,

Hover over the node and a circular arrow appears - it is used for rotation. Grab the node and try rotating the image as shown in the screenshot

We can move the clip by the simple act of dragging. Hover over it while either PiP

control is active and a pointy finger is generated. Click, hold and drag the clip around and you will see the Position parameters changing.

We have applied nearly all the transformations it is possible to do in the preview window, but to see the final control, you need to turn off the PiP controls below the Timeline preview window, so that neither of them are orange, but ensure that the properties window is still open and the third clip on the timeline is selected.

For clarity, reset the H and V positions to zero and then try dragging the three rotation wheels in the Properties panel. **Swivel** spins the image around its vertical axis (X) and **Tilt** around its horizontal axis (Y). **Rotate** twists the image around its centre point (Z). Once you are happy with that concept, reset all three values to zero.

The Rotation Pivot point

At this point the **Pivot Point** still won't be displayed - you need to make sure that *Show Pivot Point* is checked and at least one of the Pivot values is non-zero, so set Pivot X to a value of 30 and then a round marker will appear the preview window.

You can now drag the Pivot point to alter the position X and Y positions around which the three Rotation controls work. When you adjust the Z slider the pivot will change its size to give you an impression of it being closer or further away.

From this state, you should be able to adjust the various values to get an idea of what they all do. The Pivot point is a place in 3 dimensional space around which all three controls operate. What's more, you can also move the pivot point and rotations in time by adding keyframes. It's all gone a bit Doctor Who, don't you think?

The Editor window should still be open at the properties tab and the third timeline clip should still be open. If that's not the case, double-click on clip 3 and select Properties.

If you click on another timeline clip, the Clip Properties editor will switch to showing the parameters for the newly selected clip.

Switch back to clip 3 and reset all the parameters.

Properties Parameters

Unlike some other effects, there is no *On/Off* button for Properties or the individual parameters - just a trash bin for the whole effect, or individual reset buttons.

You can hide all the parameters by clicking on the text label *Properties* should you wish, but as you can't add other effects into the properties window there isn't much point.

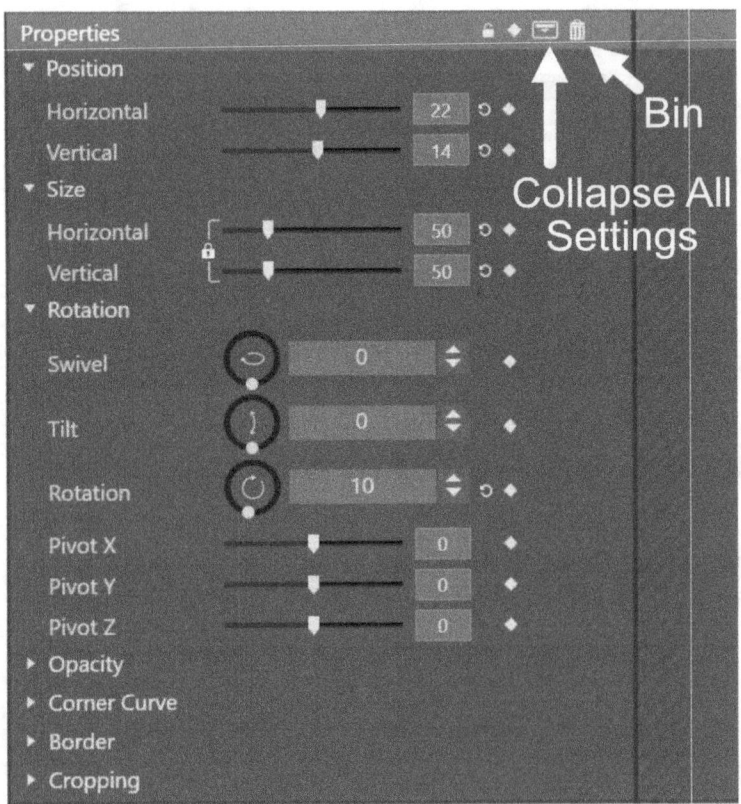

If you have too many parameters open, a scroll bar will open to the right. You can hide the individual parameters by clicking on their text labels, but it's better to use the small triangles to avoid accidentally resetting the sub parameters. I have done so on the screenshot to the left, to hide what we aren't going to use.

The values can be altered by dragging in the preview window, but you can't achieve complete accuracy. This is the small downside of freehand transformation, but as already mentioned it's really easy to set them accurately, either by highlighting the setting slider and using the Page Up/Down and left/right arrow keys to change values, or entering new values in the boxes. Of course, if you know you want to set a particular value - say the size of the clip to 50% - you can come straight here and enter the value without using the freehand controls.

Lets set some fixed values so our projects agree, Make sure that the third clip (PAL_003 or NTSC 003) is still selected on the timeline

Change *Position Horizontal* to 22, *Position Vertical* to 14, *Size* to 50, and *Rotation* to 10. Notice the lock for ganging the Size settings together - if you want to distort the aspect ratio you can unlock them.

I'm going to change one more parameter - something that can't be done freehand. The **Rotation** category has (3D) **Swivel** and **Tilt** as well as (2D) **Rotation**. Let's just change one of them - type **40** into the parameter box for *Swivel* and the frame adopts a jaunty angle that gives a sense of perspective.

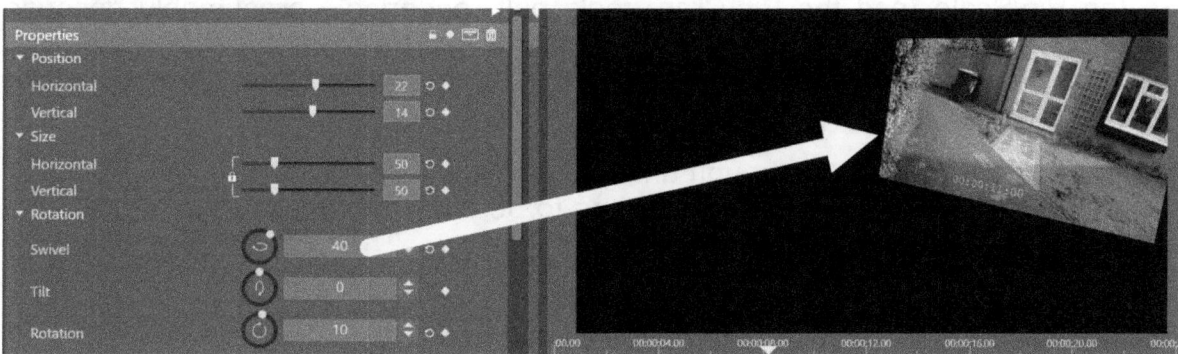

I've saved the current project as **Properties and Effects**. You should do this as well.

We have already looked at the effect of adjusting the Pivot Point, but you can also add a **Border, Corner Curve** and **Edge Softness**. I'll discuss the whole issue of **Opacity** later in the chapter as it linked to the Track Transparency feature.

I'm not going to add any more Properties as I think the effect I'm working towards is busy enough, but please try out the options for reference. When you have satisfied your curiosity, make sure you reload the project **Properties and Effects** or your own saved version.

Playback Optimisation and Properties

Try playing back the timeline clip in the Timeline Preview window. It may stutter a bit if you don't have a powerful computer, or you have used a more complex clip than me. This is what Playback Optimisation is all about. I hope you did turn it off before we started adjusting the PiP settings, but if you didn't, do so now and then delete your render files.

Click on the PiP/Scale tool to turn that on, then enter the *Control Panel/Export and Preview* and turn up the *Playback Optimisation* setting to *100 - Aggressive*.

What you would normally expect to happen is that above the timeline a brown bar appears, saying that the timeline needs rendering. If you wait a little while, it starts

to render, turning green in parts, and when it's all green the bars disappear and you can play back smoothly.

However, in the current situation, I'll expect the brown bars to have frozen. No rendering. You can play the timeline, but if it wasn't smooth before, it still won't be.

Turn off the Pip/Scale tool. After about 5 seconds, the rendering begins. Wait for it to finish and any jerky playback will be eliminated.

So the Pip/Scale (and the Pip/Crop) tools halt rendering - presumably because when you are making free-hand adjustments it would be restarting to render every time you made the smallest change. Because Studio keeps the render files, a long session of PiP could fill up a small hard disc quickly.

I don't think this is a bug, although until you know what's happening it may appear to be. There are occasions when it seems to be possible to trick the program into starting the render, but it's best not to try!

Now I've explained that, you might want to reduce the level of Playback optimisation, either to 50% or turn it off until you need it.

Keyframes

We have already looked at keyframes in the title editor and Color tab, but now it's time use them in the main body of Studio.

Take a look at the keyframing area to the right of the settings - make it a bit larger if you wish. Along the top the Timescale should be familiar. It responds to Ruler Zooming. At the bottom is a horizontal Timescale scroll bar that obeys the same rules as the one under the Timeline.

A full length scrubber hovers over the keyframe area. It has handles at each end, but can also be dragged by grabbing the red line. The thin, faint horizontal tracks will display keyframe markers belonging to a particular parameter in the horizontal plane, holding a value for the relevant timecode in the vertical plane,

Load **Properties and Effects** from the website or DVD if you haven't made it. The plan is to program a move so that the third clip on the timeline will start full frame and then, after a pause, shrink down to its current size, shape and position.

Before we do that, let's run through some more of the controls on the Properties setting panel.

You can **Hide** all the settings by clicking on Properties (or whatever the settings are for). It saves some space, but you need to be aware of it's function because if you click on it accidentally you may wonder where all your work has gone!

Lock All Keyframes stops you from dragging keyframes to alter their position. It doesn't stop you from altering their values, deleting them or using cut and paste..

All Keyframes On adds a keyframe at the start of the clip and also at the the current scrubber position, if it isn't at the beginning, for *every* setting. When you turn it **Off**

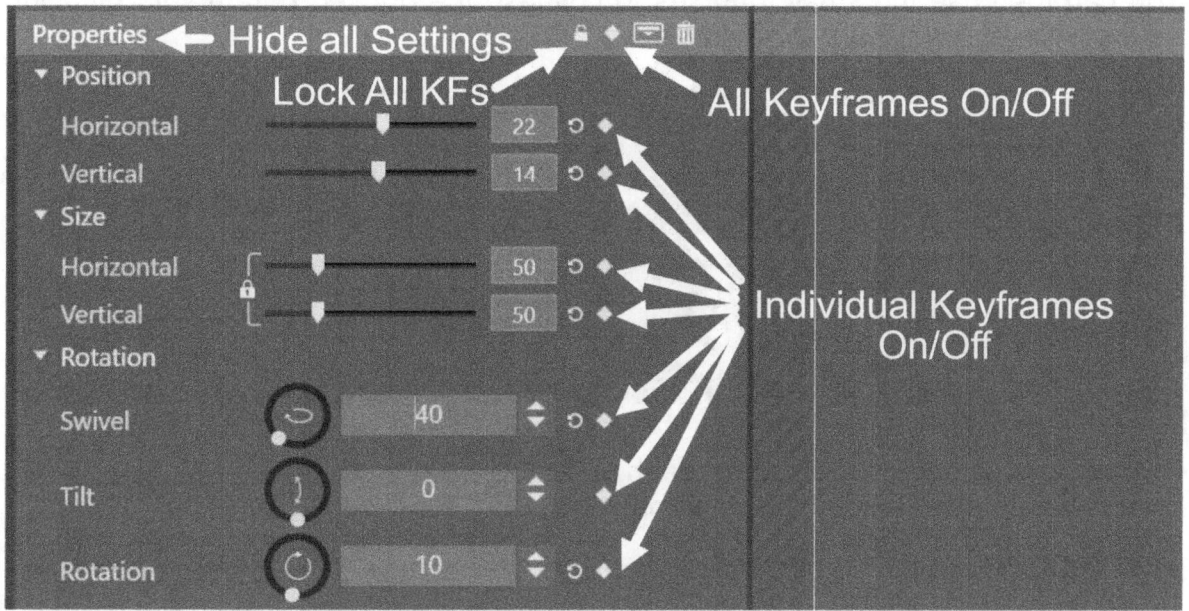

it deletes **all** the keyframes. You should use this with great care as it doesn't really do what the tooltip implies - turning it back on won't restore any additional keyframes you had added before turning them off.

Individual Keyframes On enables keyframes, adds one at the start of the clip and also at the the current scrubber position if it isn't at the beginning, **for the selected parameter**. If the parameter is locked to another (as the Size parameters are) then both are affected. Turning it **Off** deletes every keyframe on the timeline for that parameter. Again I suggest you use this with care, but you will need to use it at least to start the ball rolling.

Let's enable keyframes on the current clip. For clarity I'm just going to turn on the keyframes we need. There may still be some anomalies in the current build, so it's important for the later steps that you carry these out in the order I do.

We want our first keyframe to be a little way into the movie. Please ignore all the timecode that is burnt into the clips for the rest of this chapter, unless I specify that is what to look at - they will vary between PAL and NTSC version of the projects.

Move the scrubber to 00:00:09:00 on the timescale above keyframe area - you can see the exact timecode in the box above the Timeline Preview window. Click on the individual **Keyframes On** buttons for all the active parameters - *Position*, *Size*, *Swivel* and *Rotation*.

You can then use the small triangles to collapse the unused parameters *Opacity, Corner Curve, Border and Cropping.*

Now we have some active keyframes, there is a bit more to see.

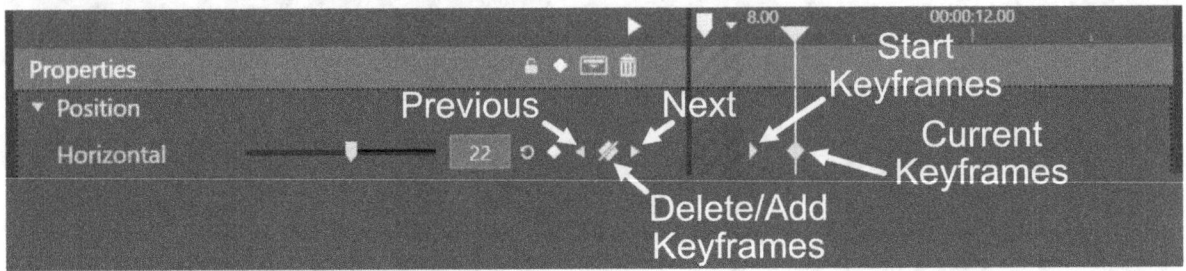

Two keyframes have appeared for each parameter - one right at the start so you can only see half a diamond shape, and one under the scrubber.

The **Previous** and **Next** buttons moves the timeline scrubber to the Previous or Next keyframe for that parameter.

If the **Delete/Add Keyframe** button has a line through it (as in the screenshot) the scrubber is directly over a keyframe for that parameter. If the symbol is also greyed out, then you can't remove that keyframe - probably because it is a Start keyframe. When active, clicking on a button with the line removes just that keyframe. If there is no line, there is room on the timeline for a keyframe, so clicking the button adds one.

There is no apparent movement yet, because the start and current keyframes have the same value. Use one of the *Previous* buttons to return the scrubber to the start of the clip. You can't delete these start points, but you can reset them with the circular arrow, so do that for all the start keyframes, then play the clip. We have Movement!

What we haven't done is program in a pause before the move starts, though. What we need is a set of keyframes between the start set and the current set that also hold the start value until it meets the new keyframes. There are a number of ways to do that, and I'll use the process of adding them to explore the different methods as well as the Keyframe context menu. Before we do that, you might want to zoom in your view of the keyframe timelines by adjusting the ruler edges at the bottom of the panel.

Creating a keyframe between the others

If you click on an empty spot and right click, you can see the option for Create Keyframe. Do that on the Position Horizontal track between the start and last keyframe. A new keyframe appears, and the scrubber moves to be over it. If you look at the parameter, it has adopted a value **between** that of the keyframes either side of it. Useful, perhaps, but not in these particular circumstances.

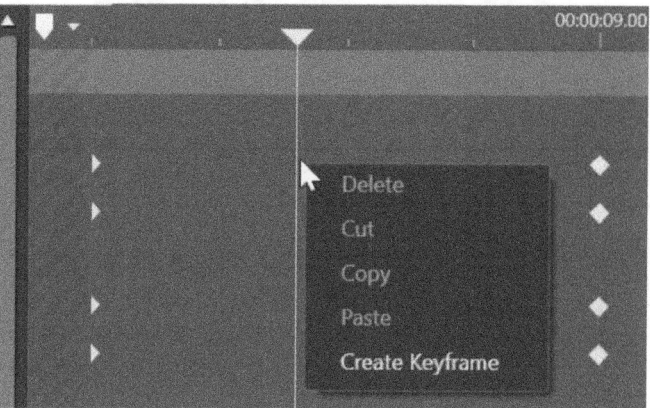

An intermediate keyframe value

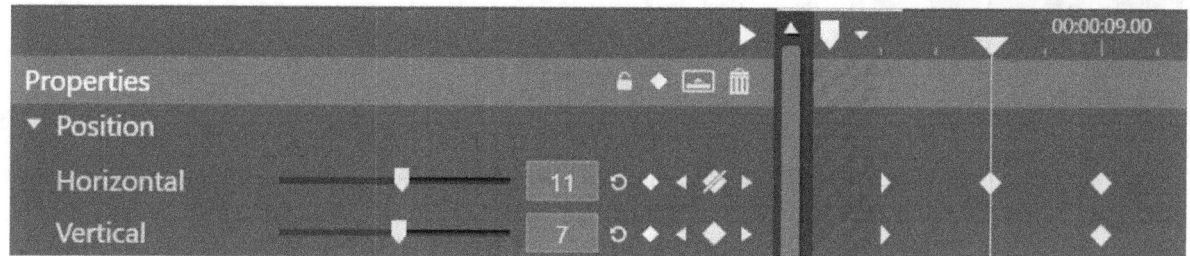

However, it's easy to change - as long as the scrubber is exactly over it (the diagonal line should be on the Delete/Add tool). Click on the reset circular arrow.

With the scrubber still at the timecode of the newly inserted keyframe position, let's use a different method to set the second intermediate keyframe. Click on the *Positions Vertical* reset button. A new keyframe is created with a zero value. **Every time you change a parameter value, if there is no keyframe, one is created.**

Try dragging the *Size Horizontal* slider. You can actually see the size of the PiP changing in the Timeline preview as you do so. Get the value as close to 100 as you can and release the slider - this time *two* more keyframes pop into place, because the Horizontal and Vertical values are locked together.

You probably couldn't get the value spot on, so type 100 into one of the size boxes. While the scrubber is still in the correct place, also type zero into the *Swivel* and *Rotation* boxes. We now have three full sets of keyframes, and an animation that pauses before it moves. If you'd like see how that looks, try playing the timeline.

That's quite a fiddly business. I suggest you save your work as **Properties and Effects 1.**

Deleting, Cut, Copy and Pasting Keyframes

As you saw in the keyframe context menu, they can be deleted directly, as well as being individually cut, copied and pasted. However, working with multiple keyframes is often required in order to make a holding set - a series of keyframes identical to those preceding them so that no movement occurs in the time between.

Selecting a group of keyframes

In order to select a group of keyframes, use your mouse - click and hold to one side of the top keyframe and "draw" a box around all those that you want to select. When you release your mouse button the group of keyframes should **all** turn orange.

Now a right-click on one of them will copy the whole group and you can the right-click elsewhere on the keyframe timeline and paste the whole set.

Moving Keyframes

To move a keyframe you just drag it. Sadly there is no snapping, so doing so with individual keyframes can be tricky if you want to keep them lined up. However, the technique of drawing a box around keyframes to select them all and then dragging one of them moves them all.

Changing the timing of an animation.

We made a pretty arbitrary choice when we set the middle set of keyframes. If in retrospect we decide that we wanted the move to start at 9 seconds and end at ten, it would be rather annoying to have to reprogram the animation.

You probably need to expand the scaling of the keyframe area again to do the following accurately. Multi-select all of the second and third sets of keyframes as described above and carefully drag them right so that the left hand set lines up to the 9 second point on the timeline. Now multi-select the last set only, and drag them to 10 seconds. When you test the animation, it should be timed as I suggested.

Properties on the timeline

If you take a look at the clip we have just modified, you can see a pink line along it's top edge. This means that the clip has had a Property, Effect or Color Grading added to it. They share the same colour, but they aren't quite the same thing. Right-click on the current line and you will only see one command - Effect -with one sub-command - Copy All. There isn't even an option to remove the added properties.

So, we can copy Properties, and if you test the principle and apply them the the previous timeline clip it too will animate. As with title movements, keyframed properties (and effects) are applied proportionally to a clip with a different duration, so on the shorter previous clip the move will be sped it up significantly.

Removing Properties requires you to use the clip context menu. The entry is **Reset Properties**, and if you modified the second timeline clip you can see that when you reset it, the Properties disappear from the clip, along with the pink line.

Clip markers

It has always been possible to add markers to clips, but the In-Built Editor makes it really easy. A marker tool is present at the top left corner of the keyframe timeline area, and all you have to do is click to set a marker at the current scrubber position. The drop-down beside the tool opens up a marker panel for the clip so you can navigate, re-name and delete the markers. Currently the M key does not work, but there are requests to enable it.

An on-clip marker

Set the scrubber to the middle set of keyframes and create a marker. If you look down to the clip displayed on the timeline, a small white pyramid has appeared below the audio waveform. There are lots of uses for clip markers, including lining up keyframe points, marking the beat in a piece of music and syncing up audio and video. Unlike Timeline markers, which stay locked to the timeline, these small white triangles stay locked to the clip, whatever you do with it.

Intertrack Keyframe Markers

I am going to demonstrate a feature which can be a puzzle when you stumble across it for the first time. To do so we need to add another clip to track 3 of the project. I'm going to create another PiP to go top left of the screen, complementing

the one top right, and use the backward looking on-bike clip PAL_007 or NTSC_007, depending which standard you have chosen to make the project.

Put the clip in the source viewer by selecting it in the Library and set an In point at 00:00:09:00. Drag the clip down from the source viewer to track 3 on the timeline and snap it's In point to the start of the third clip on on track 2. Trim the Out point so that it snaps into place with the end of the third clip. Play the timeline and you should see the new clip being revealed as the upper clip animates to its reduced size.

Now double click on the clip on track 3 to open it in the Properties Editor.

The screenshot shows the two clips aligned and the properties Timeline area above. There are no keyframes set yet - but there are 18 green markers.

What are they? Well, given that we have set up quite an obvious pattern, it is clear that they are showing us where the keyframes are on the clip above - if you select it so it is displayed in the In-Built editor you will see they coincide exactly.

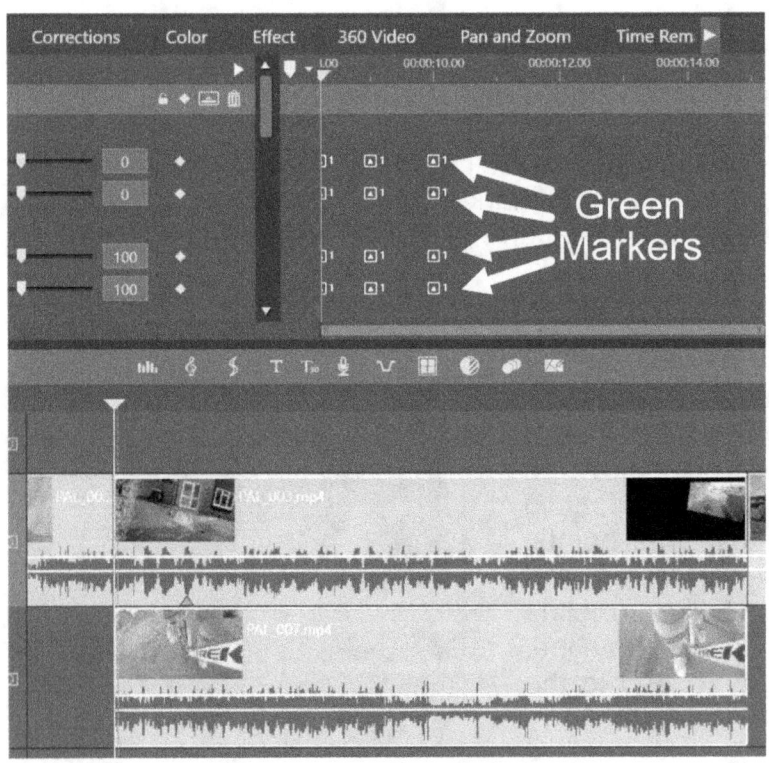

Green is used to indicate that they are on a clip **above** the currently selected one. If they were **red**, it would indicate they are on a clip **below**.

What about the numbers? Well, when we add some more keyframes, we will see that they indicate **how many** are located at that timecode, for that parameter - particularly useful once you have two or more clips stacked up.

What is their purpose? They let you line up new keyframes on one clip with existing keyframes on another. It is possible to use clip markers and the scrubber to do this, but the green/red keyframe intertrack markers are a far more powerful tool (and the sort of unheralded small but helpful features that get added to Studio without Pinnacle making a fuss about!)

With the lower clip highlighted and the Properties editor open, line up the scrubber with the second set of green markers at 9 seconds and then turn on the keyframes for the Position, Size, Swivel and Rotation. That has created the pause. Now scrub along to the final set of green markers, enable PiP in the Timeline Viewer and transform the new clip so that it is a rough mirror image of the original transformation on the top left, placing it on the right. You will have to enter the Swivel value by hand to -40, the opposite direction to the original.

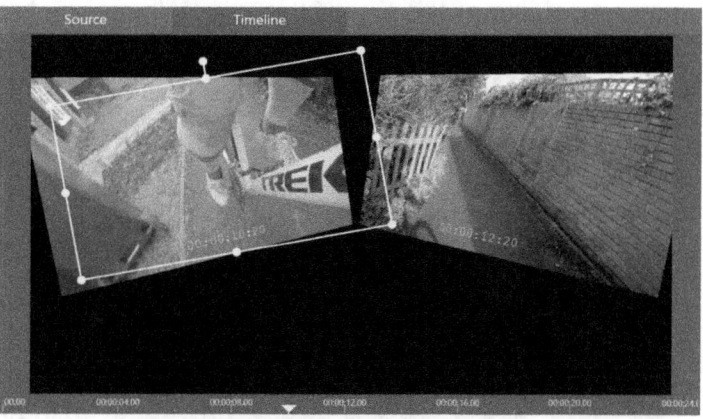

Making these adjustments on the preview screen will get you in the ball park, and help you work out the exact values you need to enter if you want a symmetrical effect - for example, the *Horizontal Position* setting looks like it needs to be a negative value of -22 and the *Rotation* -10. Enter 14 for the *Vertical Position* and 50 for the *Size* and we have an exact match, not just for the size, shape and position, but because of the green markers, also the timing of the move. Check it out in the player - It looks quite impressive given that is completely custom made and you won't see anyone else using it on YouTube, which is what happens with stock transitions and montages.You could add all sorts of enhancements - borders, soft edges perhaps. You could make the animations happen a different times by dragging the keyframes in groups. You have all the tools and techniques required.

We haven't finished with this animation yet, but save it as **Properties and Effects 2**.

Track Transparency

Earlier in the book I showed you the Track Transparency tool on the timeline toolbar, and how it opened up extended track headers with transparency sliders. Transparency is one of the Properties, although in the parameter list it is actually called *Opacity* and set at a value of 100.

You don't need to open the Properties Editor to work with Transparency - you can adjust the slider or type in a value to affect the whole track. The overall track transparency is not stored in Properties because it is a project wide setting, but if you want to use transparency/opacity keyframing on a clip then your work is stored in the Properties settings for the clip.

Keyframing on the timeline for transparency works exactly in the same way as the small scale audio keyframing with the green line which we used in the Audio Editing chapter, but the line that appears when you open the Track Transparency tool is yellow, and sits at the top of the clip. When you hover over the line the transparency icon (which looks just like its Toolbar Tool) appears. Clicking to create keyframes, dragging to manipulate the line and the context menu all work in the same way.

I want to add a fade on the end of both of the PiP clips, and although this would be easier to do with a transition, by using keyframes I will be able to show you how it works, should you want to do something more complex in your own projects. We can also see how Track Transparency and Properties Opacity interact.

Having turned Track Transparency on, create a keyframe on the yellow line about 1 second from the end of the clip. You can pull down the level of the whole clip with just one keyframe, then create another to the right and drag it down to the bottom right of the end of the clip Now adjust the first keyframe to 100% and try to get it to line up with 14 seconds on the timeline.

Take a look at the Properties Editor, scrolling down to the Opacity setting if required. There are the two keyframes we just created. Drag the one on the left and the yellow line over the clip responds. You can also change the value in the parameter box. So you have dual control, either of which can be made easier for you to use by expanding the timescales. Overall, the Properties keyframes are probable easier to adjust accurately, but the choice is yours. Set the beginning of the fade to 14 seconds on the timeline, with it reaching zero - completely transparent - at the end of the clip.

Using either method, I'd like you to try placing a Transparency fade on the other PiP clip that matches the first one, then close the Track Transparency tool. This is our last Property, so save it as **Properties and Effects 3**.

Rotation

We have used Rotation already - the Rotation properties parameter - but there is also a Timeline Clip context menu option that stores its values in Properties. Right click on the first timeline clip and select Rotation. You can rotate clockwise or anticlockwise, and each time you click, 90 degrees gets added in the chosen

direction, so 180 degrees is just two clicks away. Keep clicking to set it back to zero. This option only changes the value at the start of the clip, so if you have set keyframes, it will be modified as soon as you start to play through the clip. The other option is **Custom**. Clicking on this currently opens up the Legacy Effects Editor, or as I like to call it, Pandora's Box.

The Legacy Effects Editor.

Currently, the only way I know of opening the Legacy Effects Editor is via the route I've just mentioned - Rotation/Custom. It pops open at the properties tab but there is a whole row of tabs at the top where you can switch to one of the categories of effects that we are about to look at. In the Studio 21 version of this book I was of the opinion that the In-Built editor wasn't quite ready to completely replace the Legacy Editor, but in the last two years Pinnacle have done a lot of work, and that is no longer the case. Therefore in this book we won't be using the Legacy version for working with Properties or Effects, although if you would rather continue with it, please bear in mind that I think Pinnacle will eventually remove it all together.

Nothing to see here, move along please...

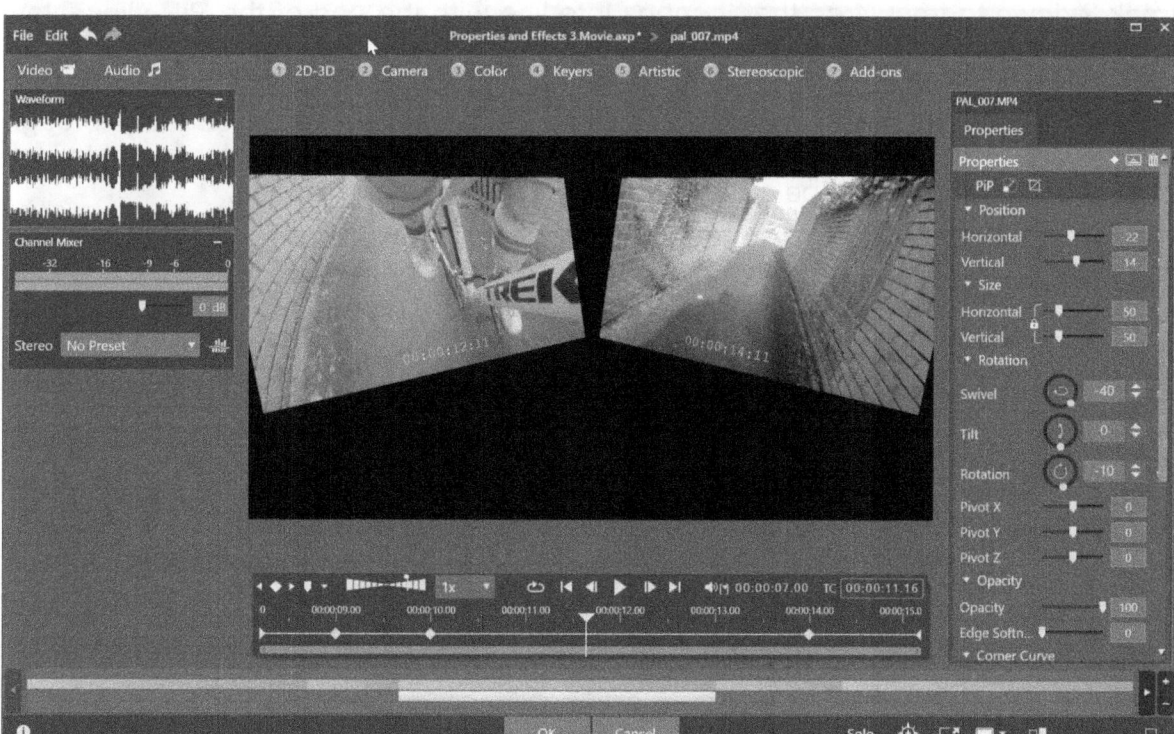

The Legacy Effects Editor works rather well in simpler situations. Keyframing where it has now been superseded by the In-Built editor, because instead of a keyframe

track for each parameter, there is only one multi-purpose track placed below the transport controls. This does make it easier to move a set of keyframes at the same time to the same place, but the In-Built editor can achieve that by multi-selection. It does make it much harder to see what you have placed on the keyframing tracks - and of course you don't benefit from the intertrack markers.

Also, the Legacy Editor has to use a complex set of Solo commands bottom right of the interface, whereas the In-Built editor can just let you use the Track Monitoring controls to enable and disable tracks so that you can see what you are working on. If you do want to keep working with the Legacy Editor, despite the difficultly of reaching it, the principles of adding Effects is the same as with the In-Built Editor.

Using the In-Built Effects Editor

To continue using the demo project we are going to modify the current one. If you haven't made your own version 3, you can load **Properties and Effects 4** from the website or DVD and skip the following steps.

Working in Smart or Insert mode, hold down the ALT key and drag the fourth clip on track 2 down to track 4 so that it snaps into line with the end of the PiP clips. Now trim the In point left so that it clicks into place with the clip marker we put on at the upper PiP clip at 00:00:09:00 seconds (you did add the marker, didn't you?). You will notice a bit of dead meat on the track 4 clip, but the clip isn't revealed early enough for the viewer to detect the resulting freeze frame. For safety, you might want to lock track 2, as the gap might be a bit vulnerable to accidental changes.

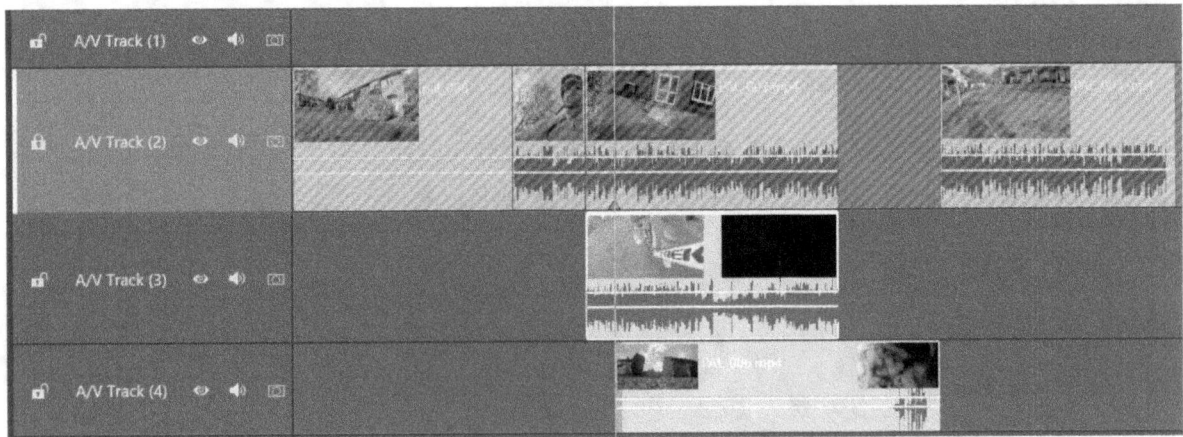

The In-Built Effects Editor can be opened by double clicking on a Video or Audio clip on the timeline and then selecting the **Effect** Tab. Do this with the clip on track 4.

This looks very similar to the Corrections Editor, but with a different strip of sub-tabs at the top. These divide the available effects into useful subcategories. Place the timeline scrubber at 16 seconds so that we have a clear view of the clip on track 4, then open the first one, **2D-3D** and a scrolling banner of thumbnails appear which works in the same way as those in the Transitions Editor.

In general this category alters the position, shape and size of the video. There are many variations and you can preview the effects by hovering your mouse over the effect thumbnail and see it applied to the timeline clip in the timeline preview window.

Historically, one of the most useful effects for manipulating video is here, the *2D Advanced Editor*. This has been surpassed by Properties now, but let us use it to run through some principles as it's easy to see the results (and Properties can't actually be applied by the Effects Editor).

Clicking on the thumbnail adds the effect to the video and the parameter box appears to the left of the preview window. The default preset for 2D Advanced Editor effect has been added to the clip, squeezing the video into a smaller, tilted box with soft edges positioned to right of the screen.

Now reopen the 2D-3D category and move your mouse over to the Flip GPU effect. Notice that the Flip is added to the current effect rather than replacing it. Click on that effect as well and then take a look at the parameter list on the left.

Two effects are shown, because it is possible to stack Effects.

The order in which these effects are applied can be important. To change the order, grab the main strip of the Flip effect and drag it down the list so a line appears below the 2D effect.

When you release the strip, the effect order is reversed and the video is flipped **before** it is resized and moved, giving a different result. At the top we now have 2D Advanced, and down at the bottom Flip. Open the 2D Advanced parameters by clicking and the Flip box closes but the parameters are still being added.

Flipped then shrank, rather than shrank then flipped

The enable/disable button is on the right of the effects strip, allowing you to turn off an effect without removing it from the list. To the left of this is a trash can, which you can use to get rid of the effect entirely from the list.

Click on the label of the 2D effect and it will expand to show all of it's parameters, click again to hide them and make space for more effects.

Clearly it's possible to have a rather long list of effects applied.

Saving FX compositions

Having spent a little time setting up a whole stack of effects with custom parameters it is possible to save them as a new effect.

The floppy disc icon at the top of the effects list opens up

a box where you can select which of the currently used effects to include and what name you want to call the new effect.

Give it a name and then click on Save.

Casting your eye to the sub-tabs above, you will now see a new category, *My FX Compositions*. Have a look and you will see it contains the effect you just saved! Now close the Effect Editor to return to the timeline.

Adding a 3D effect

We need to take care when using the term 3D. Studio is capable of *Stereoscopic* video and that's dealt with in the Project Settings Chapter. The term is also used to mean manipulating a video frame in 3 dimensions. The Swivel and Tilt properties we used earlier are a good example of that. Now that Properties is capable of working in the X, Y and Z planes you may not need to use the 3D effects, but if you do I recommend using 3D Editor GPU as the best effect for transformation. (3D Editor CPU has some further interesting parameters but is more likely to need Playback Optimisation).

Delete any experimental effects you may have applied, and add 3D Editor GPU to the clip on track 4. I want to distort this clip to make it more dramatic, then add some keyframes to emphasise the motion.

Working with parameters and keyframes in the In-Built editors is almost identical whether you are working on Properties or Effects - (Effects currently lack the intertrack keyframe markers). As I have included a very detailed description of using the former just a few pages back, I hope you can achieve the following without me spelling out the steps.

I've added these settings:

* Position Vertical - 10

* Position Z Position - 200

* Rotation Tilt - 30

All the others have been left at their default. I'm using the Z parameter instead of size to help clarify what moving something on the Z axis does - a larger value brings it closer to the viewer, a smaller or negative value moves it further away..

At 00:00:06:00 on the clips burnt-in timecode, I've created keyframes for the three parameters. In the process Start keyframes were also created with the same values.

Moving to 00:00:08:00 on the burnt-in timecode, I have reset all the keyframed parameters to their defaults. When you have copied that (or loaded **Properties and Effects 5**) and played it back, I hope you will agree that we have achieved an effect that looks a little like a real camera tracking movement by the addition of the tilt, vertical re-frame and pull back on the Z axis.

If it were a real move, it probably would have a non-linear start - an *Ease* as it got going. This is something that is possible with the Pan and Zoom effect, so I won't try to fix it here, but if you want to have a go, try adding an intermediate set of keyframes at 6 and a half seconds, then drag the first set left to 5 and a half. This gives the move a more organic feel, and could be improved with further sets of keyframes.

Effects on the timeline

The clip we have just edited now sports a pink bar along its top edge. This shows it has an effect added - or it might indicate it has a Property. I'm hoping that Pinnacle will eventually offer different colours for these two indicators, but in the meantime you can easily find out if the pink line is for effects by right clicking on it.

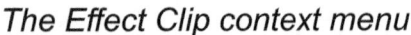

Studio provides additional Context Menu options for effects. If you hover over the pink line – and you need to be quite accurate – an fx cursor appears. Right click and bring up the Context Menu. However, you can also reach the Effects menu using the Clip Context Menu.

The Effect Clip context menu

We can *Cut*, *Copy* or *Delete All* the effects on a clip. Cut or Copy obviously leads to the conclusion that we can *Paste*, and if you put an effect into the paste buffer with either Cut or Copy, opening up a clip Context menu and using Paste will add the effect to the new clip.

Of course, multi-selection of clips will allow you to paste the same effect to a series of clips in the same way as pasting Properties, Corrections or Transitions. This is a

useful point to remember for the times you might be adding an effect to a number of clips.

You can also save the clip's current effects as a Composition from there. The final three options let you *Edit*, *Delete* or *Find In Library* any of the effects that the clips have had added to them on an individual basis. Note that you can't find saved compositions using this last command.

Paste Attributes

A new feature in the Timeline Clip context Menu, this feature allows you to copy and paste ALL the Effects, Corrections, Color and Properties from a clip, along with ALL the keyframe information, and then paste them to a clip or group of clips of your choice with just one click. You won't need to open the individual attributes using the fx context menu and copy them one at a time. Obviously, if you don't want them all, you can still use the fx context menu, or you could use Paste All and then delete the attributes you don't want!

Adding Effects from the Library

If that Filmstrip banner seems a bit difficult to search easily, don't worry - just like transitions, we can use the Library.

Open a new tab in the Library and select the fx icon from the left. From here you can drag and drop any effect to a clip on the timeline, even one of your saved compositions. It's also a much more convenient place to browse for effects because of the Library's organisation tools. Most of the thumbnails give a good idea of what an effect does, and if that effect is animated in some way you can play the effect in the preview window. If the effect has some presets already programmed, you will see the Expand icon on the thumbnail, which opens up thew thumbnails representing the preset effects.

Artistic effects are mostly obvious, but there are a few effects that don't otherwise have a home that you will find here. The oddest in my opinion is *De-interlace*, which is an effect to change video from interlace to progressive. Some of the effects could also be put in **Camera** which also contains some effects that could be in **Artistic** or even **2D/3D**. I suppose what I'm suggesting is that you might want to browse for effects rather than expecting them to be in what you consider to be the most logical place. **Color** is a category that should not get confused with the upper level *Color Editor*. Color effects contain technical and artistic effects that alter colour, and includes the powerful *Image Correction tool* that we have already met in Corrections. There are other neat tools such as *Selective Color*. **Keying** contains *Chromakey* and *Lumakey* for when you want to overlay foreground video over

another background – most notably used for green screen effects. There is also a Transparency effect in this category.

Categories for **Stereoscopic** and **360 Video** are specific to making 3D video and using 360 degree cameras.

Add-ons

This category of effects holds any additional content you may have acquired. If you have owned additional effects in previous versions of Studio and PS24 found them at the time of installation, they should be added automatically. They may have been bundled with the Ultimate version of PS24 or added when you purchased them from Pinnacle.

Audio Effects

Obviously when you try to use these in the Effects Editor, you need to select Audio from the top left tabs. There are a few differences between audio corrections and effects – *Equalizer* and *De-esser* are common to both, but you don't have compression and expansion tools as effects. The remaining tools add effects of a more artistic nature. *Stereo Spread* and *Grungelizer* have their own Plug-In buttons to open a separate interface.

Time Remapping

Studio uses a technique for changing the playback speed which can catch out the unwary. However, a little understanding will reveal that it is in fact a very powerful feature, particularly suited to Multi-track projects.

Time Remapping allows you to change the speed of playback within a clip - for example, slowing down for the interesting parts of a clip, then speeding up again, with the changes taking place gradually. It's a nice effect, but not one you will use all the time. Often you will want to use fixed speed changes, so we will start with them.

Slow and fast motion is frame based, so to make something play at twice the speed, Studio removes every other frame. Slow motion involves duplication of frames. Interlaced video is stretched out to separate fields. The "smooth motion" effect attempts to blend frames and fields, but in my opinion it rarely makes little difference to the smoothness and tends to degrade the pictures.

When you see really smooth slow motion, this is achieved in one of two ways. A high speed camera can be used that shoots at a frame rate higher than that which will be used for the final product. When this footage is altered to play back at the slower

frame rate there is a whole, proper original frame for each playback frame. If you make movies using a frame rate of 50i or 60i and have a camera that shoots at 50p or 60p you will see this happening to some extent. The other method uses specialist software to interpolate frames. This only works with certain footage, takes ages to render and the software that does it is normally expensive (and not part of Studio!)

Changing speed with Stretch

Start a new project and load the C**ar Clip 1** we used in the Advanced Editing chapter onto the timeline. Double click on the clip and the In-Built Editor will open, then select **Time Remapping**. For fixed speed changes we won't be using the keyframing area, so you can reduce it's size. At the top of the parameter box are two radio buttons labelled *Anchor Frame* and *Stretch*.

We are going to use the **Stretch** option first. One thing that won't ever happen when you add a Speed effect is that the current duration of the clip on the timeline will be altered, so often Stretch is the best option to use.

Click on Stretch and you will see a number of the parameters become disabled, and

the keyframe area becomes blank. Make sure all the other boxes are unchecked, then take a look at the timeline. The only difference you will notice is a yellow hatched line along the top of the clip that was selected, indicating that a speed effect is in operation. The clip is still at normal speed

Trim the end of the clip right to double it's length to 16 seconds. No dead meat is generated and if you look at the In and Out points you will notice that they are still the same frames as before!

Play the clip, and it should play at half speed. Single step through the clip with the jog buttons on the player, the arrow keys or Z and X keys. Notice the timecode on the player changing every frame, but the burnt-in time code only increments every second frame. However, because we are using interlaced video the frame content

changes more often than that as each individual field is extracted. If you try this with progressive video you will see repeat frames.

Let's study this in a bit more detail. Right click on the clip, select *Adjust duration* and use the boxes to enter a duration of 32 seconds. Now when you study the video clip a frame at a time it should be clear that the video moves every two frames and the burnt-in counter increments every fourth frame.

Time Remapping should still be open in the Effects panel. You can study what the three check boxes do by checking them one at a time.

Reverse does just that – plays the video backwards. An important point here is that you don't need to change the speed from the original for this to work. The answer to the question *"Where is the Reverse Video effect"* is *"In the Speed control box"*. Not immediately obvious to a newcomer to the software, but now you know about it!

Smooth motion I mentioned earlier. On our current clip it shows little improvement to the smoothness, but you might find on other footage that it has a more useful effect.

Speed has some interesting uses for audio. Obviously we can add the comic "chipmunk" effect to a voice, or slow audio down to make it more dramatic. One obvious use for speed is making music fit a desired duration, but the natural consequence of this is that the pitch shifts. Slow down the music and it drops into a lower register. Small changes are OK, large ones tend to sound very wrong.

The **Hold Pitch** checkbox tries to counteract this effect, but has limited usefulness. Odd phasing and digital artefacts creep in, and not always when you specify a large change – sometimes a 1% change can sound worse than a 10% one on certain musical instruments.

If you apply *Hold Pitch* to the clip and listen back, you will clearly hear why it is sometimes a failure – the digital processing makes an attempt to hold the pitch, but the digital artefacts sound very bad.

When you have finished experimenting with the options, switch off all the checkboxes, then click on the Reset button below them.

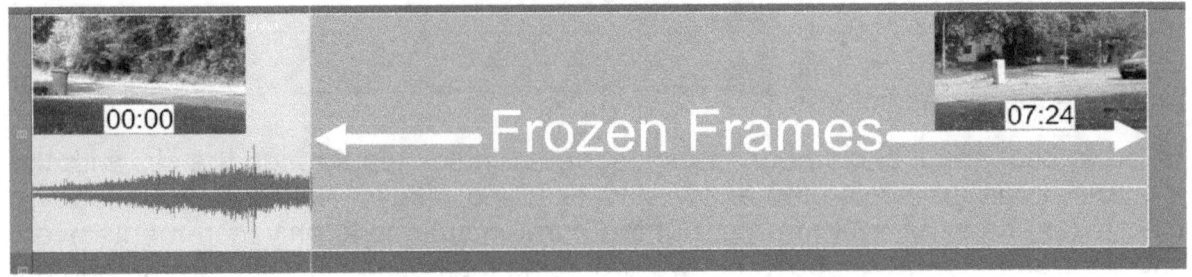

Whoa, what happened there? I said that Speed will never automatically alter the duration of a clip. However, we altered the duration when we dragged the clip and entered a value in to the duration box. Speed didn't do that, we did. You now have the same clip duration of 13 seconds, but with the Speed effect removed, the source material has run out and the pink area indicates "dead meat" – Studio has frozen the last available frame. This is of no use to us! Use a quick trim to shorten the out point of the clip and with the magnet on it will click into place when we reach live video.

You've seen how useful the Stretch mode is. We don't need to do any maths if we want to make a video clip run to a particular duration. In most cases you will use simple trimming to make the shot duration suit your purposes, and Studio will work out the speed reduction or increase required.

This behaviour is particularly useful for filling a fixed size timeline gap with a clip that you don't want to trim (or can't). It's used by the 3-4 point editing tools, but you can also use it manually.

Anchor Frames

Let's try the other Time Remapping option, **Anchor Frames.** Put the scrubber at the start of the restored clip and click on it's radio button.

Nothing happens. Perhaps we need to alter the **Speed** setting For the sake of consistency, choose 25% - adjust the slider or type the value into the box. The hatched yellow line appears on the clip.

Again, you will see that the duration of the clip on the timeline hasn't altered. If you bear this in mind as a hard and fast rule – ***The Speed effect never alters the duration of a clip of its own accord*** – you won't go far wrong.

Play the clip and it plays back at quarter speed, but stops after 2 seconds of the original clip has played..

Calling this function Anchor Frames masks the fact that it changes the playback speed of a clip to the percentage you select in the settings box.

Change the slider value to 200%. Now the clip plays at times two, but freezes after half the timeline duration - we have run out of video and met our friend Dead Meat.

This means that if we want to change the playback speed of a clip by a preset amount *and* want to see all the original contents - and not any frozen frames - we have to adjust the clip on the timeline after we have added the speed change.

You might wonder why you can't just change the playback speed and the timeline automatically compensate. The answer is timeline sync might be destroyed.

Perhaps Smart Mode could be programmed to compensate automatically, but it hasn't been.

So why is this mode called Anchor Frames? I got you to set the scrubber to the start of the clip, but that was in case the default had been changed. Drag it to the centre of the clip - 4 seconds- and you should see a red marker on the In-Built Editor's timescale still lurking at the beginning - the **First Frame**. This is the current Anchor Point.

Click on the **Last Frame** button. The red marker jumps to the end of the clip and now we have dead meat at the beginning of our timeline clip.

Click on **Current Frame.** The marker jumps to the Scrubber position and we have dead meat at both ends of the clip. You can drag the red marker independently of the scrubber to set it.

So, the Anchor Point defines which part of the modified clip is displayed in the unchanged space on the timeline. You can get a better impression of this in action if you reset the clip to 25% and then drag the red marker to various points and letting it go, then watch the timeline clip update it's thumbnails.

This system can be very helpful as long as you don't chase your own tail. Make changes to the Speed and Anchor points, *then* accommodate your changes on the timeline. For example, you have a five second clip of someone kicking a ball and you want to slow it down. Set the Anchor point to the important action moment - the actual kick. Now change the speed to what you think is best. Then, if you want to see more of the action, trim the clip as if it were a normal one, taking into account the usual precautions for remaining in sync.

Freeze Frames

I'm mentioning this here because it's the logical place to look for the information, but Time Remapping only goes down to 10%. There is a timeline clip context menu entry for Freeze Frame which we discussed in the Editing Tab chapter. Currently it's a bit buggy. The alternative is to take a timeline snapshot with the timeline toolbar Snapshot tool and manually insert it into your movie.

Variable Speed

The Time Remapping feature allows you to add keyframes so that you can alter the speed within a single clip, and what's more, do it gradually. Other editing programs may call this feature *Dynamic Timewarp* or *Variable Motion*.

If you aren't familiar with keyframing then we looked at it detail when discussing Properties earlier in this chapter. There are additional features in Time Remapping

so you can also use green keyframe nodes on the yellow speed line just like we did when we edited audio changes in the Audio Editing chapter.

I'm going to use **car clip 1** again to demonstrate it. Start a new project and drag the clip to the start of the timeline. Double clicking opens up the Editor. Select the Time Remapping tab and Anchor Frame radio button should be highlighted, so select the First Frame button to enable the effect.

Scrub to 3 seconds exactly into the clip. The car is now well into frame and the camera has started to pan with it. It's at this point I want to begin slowing down the clip – up until now it should play at 100%. Click on the diamond to the right of the Speed value entry box to turn on keyframing.

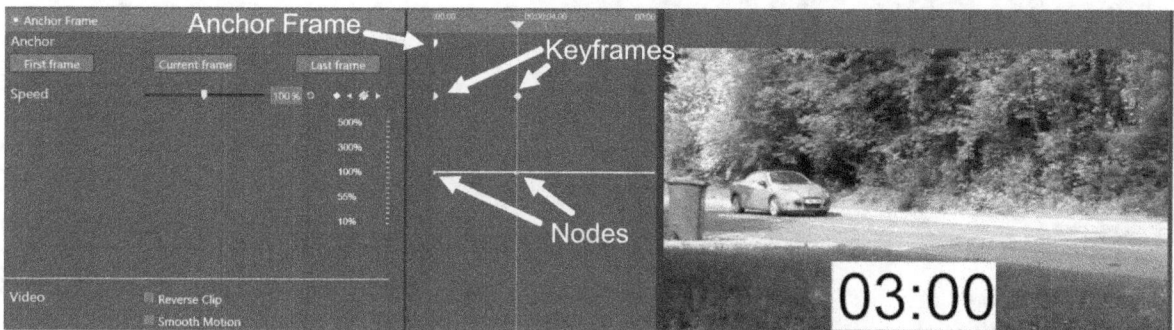

In the keyframing area, two keyframes appear above the yellow line. Two green nodes appear on the yellow line - these are quite hard to see, but if you hover over the line it enhances their visibility. Now scrub to 4 seconds 12 frames. This is the point I want the slow-motion effect to reach its slowest. Click on the icon to set a new keyframe. So far we haven't altered the playback speed and the clip shows as 8 seconds on the timeline.

Without moving the scrubber, change the speed value to 25%. The third keyframe drops to a lower value and the yellow line slopes down from the second keyframe to meet it. Although the preview

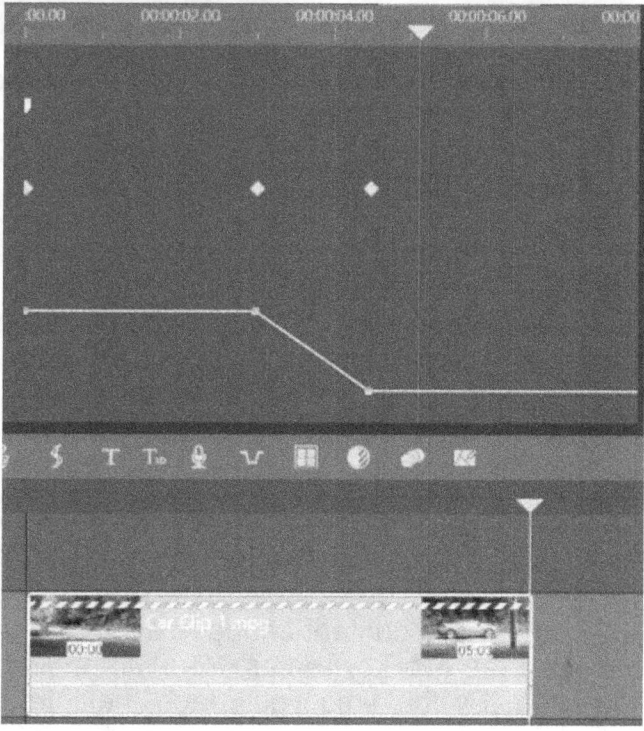

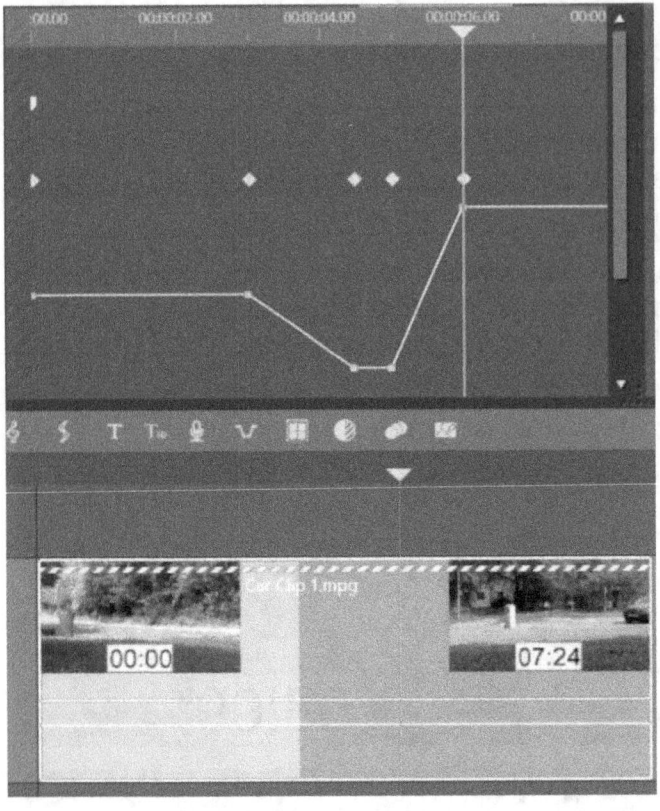

meet it. Although the preview changes to show a new frame, it hasn't fully refreshed yet.

Review the clip. It plays at normal speed for 3 second, then over the next 37 frames of burnt-in timecode, but 59 frames of real time, the car gradually slows down to quarter speed. The clip on the timeline is still only 8 seconds long, and if you use the timeline scrubber to move to the end, the burnt-in timecode shows 5 seconds 3 frames. Look at the keyframe area though – the scrubber there hasn't reached the end of the clip.

So where has nearly three seconds of material gone? It's been trimmed out – because Studio doesn't alter the duration of timeline clips. The keyframe area is still representing the whole clip though. Trim the end of the timeline clip to the right until you see the pink colour, then set the Out point to the last "moving" frame.

Speeding the clip up again

Set keyframes at 5 seconds and 6 seconds on the burnt-in timecode and then set the value of the last keyframe to 500%. The clip on the timeline now only shows about eight seconds of blue, with the rest being a frozen frame. Re-trim the timeline clip again - if you look closely, the boundary between blue and pink background doesn't quite coincide with the scrubber, but the frame with just a bit of blue should show the burnt-in timecode of 07:23 and you need to include the last frozen frame to see the whole clip. Obviously the calculations don't always result in an exact frame number, so check your re-trimming carefully.

Let's take a look at what has happened to the clip on the timeline. Locate the scrubber at the start of the clip and jog with the left and right keyboard arrows. You will see that the content changes every frame. Now scrub through the next section between the two keyframes. You will begin to notice that some of the frames are repeated. By the time you reach the third keyframe each frame appears to be

repeated twice. You might have expected each frame to be repeated four times – quarter speed after all. If this demonstration used Progressive rather than Interlaced video that would have been the case.

When you reach the point that the car starts to speed up, you will begin to see fewer duplicate frames, and then once the value passes 100% the playback will start to drop frames, so by the time it reaches 500% the timecode jumps in five frame increments.

If that all seemed a bit fiddly to program, I'll just say that in the professional world it's not much easier. I recently worked on some scenes that we shot at 100fps and used timewarp to speed up and slow down the action. We were also trying to fit the shots to some music. My editor earned his money that week, because just one small change would cause everything further down the timeline to have to be remade.

"Real" slow motion

If you want to slow down movement properly, interpolation is not always going to give you good results. There are special software tools that will analyse video on a frame by frame basis and only work on the areas that should be moving. For these methods to work, you need to choose the source footage very carefully so that the software can differentiate between what should, and should not, be treated. For example, a skateboarder flying through the air in a locked off shot might be a good source, but panning with him while he is on the ground is unlikely to work well.

The real solution to getting smooth slow motion is to use a camera that captures at a higher frame rate than the standard you are using for your movie. The higher the frame rate, the more discrete frames you get and the more you can slow the video down without getting jerky motion. While professional cameras that do this are expensive, the latest models of GoPro cameras can record video at as high a frame rate as 240 frames per second in HD. One downside of using high frame rates is that by necessity you have to use a high shutter speed, so the footage can look quite jerky when played back normally.

If you would like to experiment with some high speed footage, I've shot some GoPro video at a rate of 100 progressive frames a second with a resolution of 1280 by 720. We will be able to slow this down significantly without the judder becoming noticeable. The original file is very large. I have rendered a version for you to use. The MP4 file **Bird slomo compact.mp4** is small (9MB) and of reasonable quality (although significantly lower than the original). If you put the file on the timeline and then set the project setting to 25p, you can go down to 25% without having to duplicate any frames, and at 10% the resulting slowmo is only adding 2 or sometimes 3 duplicate frames per real frame, so even that speed reduction looks OK.

Dragging Keyframes and Nodes

The Bird footage is a good clip to get to grips with the keyframe controls. You can click on the yellow line to set a keyframe, and then drag the upper white node left and right or the green node in any direction you want. To reset a a keyframe to 100%, double click on the value entry box.

As you drag the nodes, the preview will update, but it's a good idea to over-trim the clip before you start so that you don't run out of room on the main timeline as the live video expands and shrinks.

As you can see from the screen shot, its easy if time-consuming to build up smooth curves so that speed changes accelerate and decelerate. I've saved a version on the website called **Bird Slow Motion.movie.axp**, but you will learn more and have fun creating your own version. Have Fun!

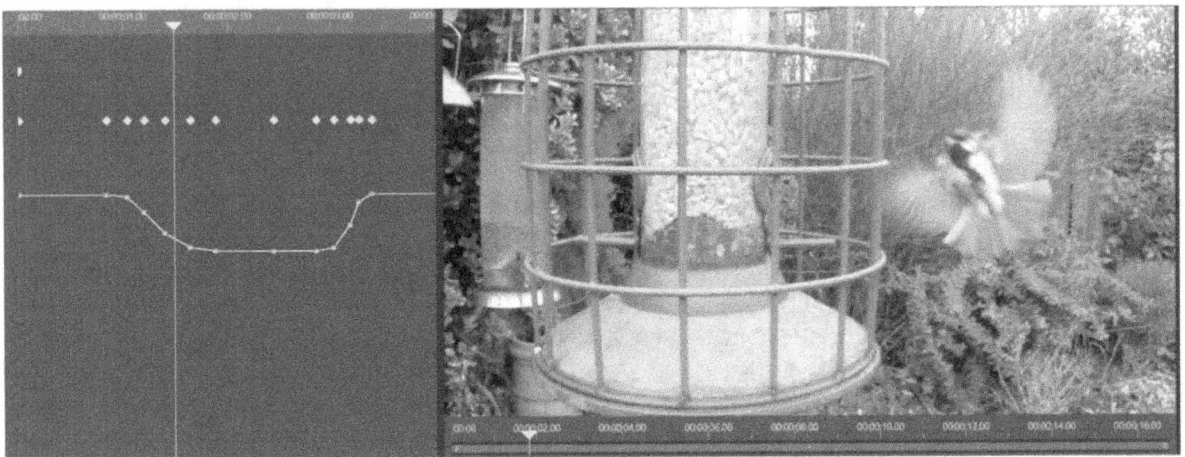

Photos - and More...

This chapter covers a number of tools and workflows that are mainly concerned with making slideshows. However, the tools work with video as well, hence the slightly vague chapter title.

Working with Photos

One reason for including still pictures within a movie might be as supplementary material. You could have made a video recording of a holiday, perhaps, but some days you just took your stills camera with you. The photos can be included in the holiday video.

Many people like to make projects that consist entirely of photos, producing a slideshow of a series of photographs, sometimes with quite elaborate motions added to the stills. These can be particularly moving when you chart someone's life using a collection of photographs taken over the years. I'm planning to embarrass my daughter enormously if she ever gets married!

There is a whole documentary genre that uses old photographs as source material, and to make these more interesting a style of animation has developed over the years, initially using rostrum camerawork. While you may have heard of it described as the "Ken Burns" effect after the celebrated American documentary maker, the technique came to the fore with the release of the Canadian film City of Gold in 1957, directed by Colin Low and Wolf Koenig. The film makes use of some 200 glass-plate negatives of life during the Klondike gold rush, and the resolution of the source material was so high that a rostrum camera could zoom into a one inch wide section of the 10 by 8 plates and still achieve good enough pictures to fill a cinema screen.

This is an important point. If you want to use a photo as part of a video project, the resolution of the photograph needs to match the resolution of the video project, more or less; otherwise the photo will look blurred. Now this isn't normally a problem. Even if you scan a 5 by 4 inch photo using a 300 dots per inch scanner, the resolution will be more than Standard definition unless the photo is particularly grainy. More likely your photos will have been taken with a digital camera, and only the cheapest cameras will have a resolution less than High Definition Video.

We do have to be very careful about resolution, though. Most photos aren't the same aspect ratio as video, so when we crop them to fit the screen, we immediately lose some of the resolution. The photo may have been taken in portrait mode, which limits the resolution even more if we don't want to shoot off the sides.

The main reason for wanting high resolution photos, though, is so that we can re-frame and animate them – send the software "rostrum camera" around the photo,

selecting the view, adding movement, pace and style to a movie. The more resolution you have, the closer you can go.

Now, if we had those 10 by 8 inch glass plates, we would be very happy indeed, but most digital cameras have a horizontal resolution of 3200 to 4500 pixels. For a SD project, you can zoom into about a quarter to a sixth of the picture. HD isn't so good – even with a top of the range DSLR, the resolution is 5600 – so you can only zoom into a third of the picture before the onset of blurriness. If you are thinking of working in 4K, then you will need a very good stills camera to even think of zooming in much at all.

When you take photos that you think you might put into a video project, regardless of the quality of your camera, you can do a few things to help. If the camera has a choice of aspect ratios, select one that matches your video camera – most likely to be 16:9 in this day and age. This will force you to frame the photograph to suit the video project. Never use your camera in portrait mode by tipping it on its side. Finally, if your subjects are people and objects, rather than landscapes, make sure you fill the frame. Either use an optical zoom lens if you have one, or get closer if you can.

In a previous chapter we looked in detail about the Corrections you can apply to photos even when they are in the Library, but we can add these Corrections to any photo in a project by opening the Effects Editor and switching to the Corrections tab. Therefore we can adjust the exposure and colour balance, and crop, straighten or reduce the red-eye effect. You should use these tools whenever possible and not, for example, decide to use the Rotate Effect that is intended for Video. There are good reasons for this.

Only the tools specific to photos will maximise the resolution available. If you re frame a photo with a video tool, the photo will be down-sized to the project resolution before the effect is added. This is a bad thing, because although you might get away with a 10% zoom in, anything more will start to introduce fuzziness. If the effect you want to use is going to reduce the size of photo – you want to shrink it and put on screen using a picture-in-picture effect perhaps - that's OK, but otherwise steer clear of the video re-framing tools.

Adding a photo to a project that you want to remain static is as simple as it is to add a video clip. You drag or send it from the Compact Library to any suitable timeline track. The default durations that are defined in the Control panel, and for photos this is normally set to 3 seconds. The timeline Context Menu options Scaling/Fit and Fill can then be used if you want to simply remove or retain the black bars that are created when a photo isn't the same aspect ratio as your video project. If you want to re-frame it more creatively, then you use the Pan and Zoom tool that I'm about to describe in detail.

One important point to remember when you work with photos is that, unlike video or audio, you cannot run out of material – the "dead meat" issue. A photo (and a title) can be any length you want it to be, because unlike video it is a static picture. Studio will extend a photo to any duration you like without complaint. This means adding transitions requires a little less thought.

A Photo Project

For the next short project I'm going to make use of photos and demonstrate some of the techniques you can use to enliven them. I will use the sample music and photos that are provided with Pinnacle Studio, so you don't need to download anything or use the data DVD.

You may have already created a BMX bin if you tried out the Tags tutorial, but if not create a bin called BMX and add the eight *The-Sky-is-the-Limit* JPEG photos that are in the *Public Pictures* location. Also add the audio file *BMX_YA-HA! wma* from the *Public Music* location - you should also find it in *The Sky is the Limit* bin.

If you can't find them, they are on the website and data DVD. There are also saved versions of the project at various stages should you get a little lost.

Start a new project and set the timeline to 720p and either 25p for PAL or 30p for NTSC. For the sake of clarity delete timeline tracks 1 and 4 and rename track 2 as Photos and track 3 as Music.

Open your BMX Bin in the Library and drag the first picture from the Library down to the Photos track, then save the project as **Slideshow**.

The Storyboard Feature

If you have used a storyboard before, particularly if you have graduated from Classic Pinnacle Studio, then you won't find the Pinnacle Studio 24 Storyboard quite the same as you might be expecting. If you are unfamiliar with the concept, then you deserve a brief explanation.

Normally, a series of still pictures arranged left to right, top to bottom on a page represents each distinct shot used to tell a story. You read the story in the same manner as a comic book. Sometimes a shot that develops may be represented by a series of still frames - perhaps indication the opening and closing frame of a shot. The duration that each shot lasts on screen isn't indicated. When a director plans a complex sequence - one he will almost certainly have to shoot out of sequence - he may draw the shots in the order that he intends them to appear in the final cut of the movie.

In Video editing programs the storyboarding process is extended to using shots that have already been shot, and perhaps trimmed to contain only the useful parts. These are dragged and dropped onto a storyboard area and can be played in sequence to check if the story is working in the most effective way. If the director or editor is unhappy with the result then shots can be rearranged by dragging and dropping.

Timeline editing is far more sophisticated, but can mask the underlying structure that is made more obvious with bold thumbnails telling the story.

Next Generation Studio has a form of storyboard that is limited to a single strip along the top of the timeline, but offers a clearer view of the story and makes drag and drop much easier to use.

Enabling the storyboard

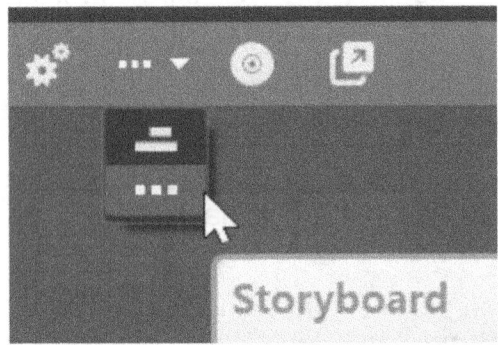

Let's turn on the storyboard. The third icon from the left on the toolbar may show as two strips or as three "frames". To change the control, use the drop-down arrow and select the lower storyboard "frames" icon. Now, when you click on the Choose Display icon, you alternatively switch the storyboard display on and off. (The strip icon switches to the Navigator display)

To adjust the height of the storyboard generate a double headed arrow by hovering your mouse over the bottom edge of the storyboard area. Click and drag to make the storyboard a decent size.

If there are no thumbnails displayed when you first open up the storyboard then you need to select which track is being displayed.

Setting the track for storyboarding

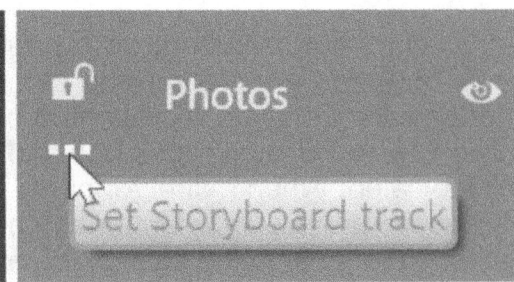

You may notice a small icon has appeared on the track headers. Click on this to make it the active storyboard track.

We need to put some more pictures into the project. Multi-select the remaining seven pictures, drag them down to the storyboard area and drop them there.

The storyboard uses a very nice "Touch Screen" style interface. If you are working with a display larger than HD you

probably can see all 8 storyboard thumbnails, so you might need to shrink down Studio's window to experiment with the controls.

If, for one of a variety reasons (too many clips, too small a screen display), you can't see all the clips, you can scroll the strip left and right by clicking and then immediately dragging. Alternatively, you can scroll the thumbnails using the scroll arrows that materialise at either end when you hover over the storyboard when it isn't showing all the clips. Notice that the durations of each shot are displayed on the thumbnails.

If you click and hold on a storyboard thumbnail and then pause for a moment, the hand pointer turns into a normal mouse pointer, the thumbnail below becomes highlighted, and you can drag the shot itself, rather than the whole storyboard, left or right to re-position it relative to the other shots.

The rough story that we want to tell is that the girls are cycling, see the boys, they stop to talk and the boys show off a bit. They then all cycle to the beach, where they leave their bikes and stare into the sunset.

I decided that we had one photo too many for the project so I chose to delete jpg 2 - the loose 2-shot of the boys Try ordering the remaining photos using drag and drop and see if you come up with the same order as I did.

I've got the pictures in this order - 6, 3, 4, 5, 1, 7 and 8.

Adding some Music

Most slideshows will benefit from some music as they can help define the pace. If a movie is for your own private use you may want to add your favourite commercial tracks, but if you are going to share your creations on streaming sites you probably need to use library music, Scorefitter or Smartsound. I've created a Scorefitter track

of 30 seconds duration using the category *Inspirational*, the song *Spring Time* and the version Green, Green, Green. I showed you how to use Scorefitter in the Audio Editing Chapter. Do the same, put the music on what is now the second track (relabelled as Music) and lock the track.

Using Markers with Music

In common with most popular music, the main time signature of our music is 4/4 – that is four crochet beats to each bar, with the music generally composed into blocks of 4, 8 or 16 bars. However, there is a short 2-bar intro before the main body of 8 bars, then a long note and fade out at the end. Although I asked for 30 seconds, its a bit shorter than that.

I'm going to attempt to start each new photo at the beginning of a bar. It can be quite fiddly to find the start of each bar just using the waveforms. In fact, some music has waveforms that are too complex to really see the beat and bar structure anyway. We haven't got enough photos to cut on every beat, so some pictures will have two bars allocated to them.

PAL Markers

If you have a reasonable sense of timing, one handy trick is to use the Marker feature to mark the start of each bar as the music plays.

•Identify the intro - it ends at about 5 seconds with the strong bass note that then starts each bar.

•Try counting the beats – "1 2 3 4, 2 2 3 4, 3 2 3 4, 4 2 3 4" a couple of times along with the music track before you start.

•Hover your finger over the M key, play the music and proceed to hit the M key at the beginning of each bar.

NTSC Markers

You may struggle to do this, or you may find it very easy. Even the most talented musician may not hit the beats exactly, and because of the delay in the program, the markers will almost certainly be a few frames out, but they should at least indicate which peak in the waveform you should be aiming for when you edit.

You might want to drag your markers a little closer to waveform peaks. The screenshot gives a list of

the PAL markers I will be using for the rest of this project - as you can see, I'm a few frames out as well

Adjusting Durations.

We now have some really easy beats to hit with the photo durations, all we have to do is work out how to make the photos we have fit the music.

The storyboard isn't much use at the moment, so turn your attention to the timeline. I'm going to lengthen the first photo so that it ends at the first marker, and the easiest way is to trim the Out point right in Insert mode. If you stay in Smart mode, hold down ALT and use the green Quick trim cursor to drag the Outpoint right, all the following photos will shift right. Carry on trimming until the Out point snaps into place with the first marker.

Shorten the next three photos to snap their Out point to the markers to the left, using Insert so that the following clips all move up.

We now have three photos left and five bars and a fade out to fill, so let's go for a double length clip. Extend the 4-shot of them all cycling to the marker at just after 18 seconds, so that it bridges bars 4 and 5. Trim the end of photo 6 to marker 7 and then extend the last photo to snap to the end of the music.

I've saved this at **Slideshow 1**. Play the movie and I think you will agree it's a bit more agreeable than just sticking 7 pictures on a timeline.

Adding Transitions

If all that talk in the Transitions chapter of leeway, overlaps and extending clips left you feeling that you might not bother with transitions after all, the good news is that with photos they hardly matters. If you work in Overwrite mode or Maintain Timeline Sync, you won' get any dead meat or flash frames because if you extend a photo it doesn't freeze or display something else.

Adding transitions before we do some work on the photos will help us with our timings. It will also allow me to demonstrate how to use transitions with the Storyboard. We could use the timeline, but that has been extensively covered in the Transitions chapter.

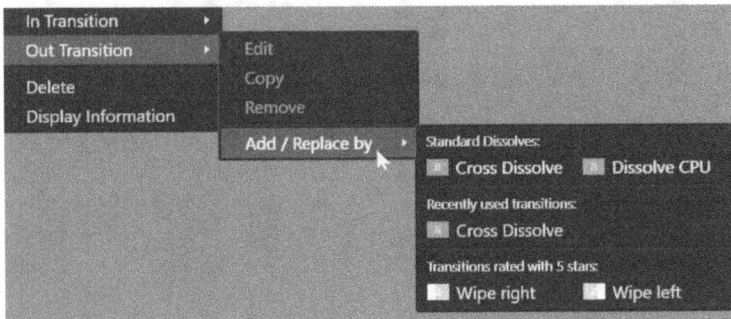

Right-click on the first storyboard thumbnail and take a look at the lower section where you will find In and Out Transition entries. Choosing *Out Transition/Add /Replace By,* there should be a choice of transitions, or at least *Cross Dissolve.* Click on it and a transition is placed on the timeline - you wont see it on the Storyboard. Technically, we put it on the Out point of the first photo, but it is bridging equally the two photos because it has been added in the default mode (if you get a different result, check out the Transitions chapter). It will also be 1 second long - unless you have changed the default duration dictated by the Control Panel Project Settings page.

Ripple Transitions

OK, so add one of those on the out point of each photo - we can always change them later. What do you mean, there are 120 photos?

The **Ripple** command is specifically for adding transitions to groups of clips, and the principle is the same for the timeline or the storyboard. Perhaps the command should say "Copy the current transition to the highlighted group of clips", because you can multi-select clips and they don't need to be adjacent to the current transition nor do they need to be in a continuous run. However, we are going to add them to all the photos, so select the first Storyboard thumbnail, hold down shift and select the last one. Right click on the first clip and select Ripple Transitions. You will see

each Out point has a cross dissolve to the next clip, except the last one which has nothing to dissolve to, so just fades to black.

I think that's quite pleasant. Feel free to check out the transitions chapter to find out how you can do more work on them, but stay in the default transition mode if you want to keep the timing.

Even with the transitions in place, check out how easy it is to to change your mind and re-arrange the story by dragging the storyboard thumbnails.

Re-framing Photos

The first thing that people are going to complain about are those black bars at the sides. This is the aspect ratio dilemma - people don't like black bars but they don't compose their pictures for the TV aspect ratio - and if you are shooting to put something on a TV screen why would you shoot it in Portrait mode? Don't even get me started about TV companies putting clips on Facebook using a square aspect ratio....

You are going to have to deal with pictures that were taken years ago, shot on film formats, so you can't blame the people who took those shots. We have to deal with the situation as best we can.

The quick solution lies in the Timeline or Storyboard Clip context menu. Multi-select all the storyboard thumbnails and right click on one of them. The command **Scaling** has a choice of Fit or Fill. Select **Fill** and the black bars will all go.

This is Slideshow 2.

However, when you look at the results I think you will agree that some of the photos have been rather badly framed. We need to use a more powerful solution.

Introducing Pan and Zoom

Pan and Zoom has been a part of Pinnacle Studio since the outset but there have been a number of changes over the years.

There are up to four versions of Pan and Zoom, with one in the the *Camera* Effect category, and another from New Blue called *Auto Pan*. I would leave those alone, unless you need them for legacy reasons. You can also perform Pan and Zoom with a number of other effects, as well as Properties

The two that concern us here are available in the In-Built Editor and as a full screen Legacy Editor, and they are essentially the same tool in different clothing.

Pan and Zoom For Video

If you followed the discussion about resolution and photos, it should be obvious that with a standard definition project and a standard definition video clip, zooming in is going to degrade the picture. However, if you are making DVDs and not HD movies, you should be able to use HD video and zoom in on it quite a bit before you will see the degradation. Perhaps more relevant nowadays is the availability of UHD - (4K) video. More people are now shooting in this format but if you are only making HD movies from the video, you can tighten into your clips quite a bit.

One issue with the previous versions of P&Z was that it could only be used on Photos. If you wanted to re-frame video you could use an effect but it would always degraded your picture.

Now, the same tool that you use for photos is also available for video. It's very important to realise that if you are making, say, a 1080p movie with 1080p video you cannot electronically zoom in the picture without degrading it - maybe 10-15% at the most before people will start to notice, depending on the quality of the camera. However, when the resolution of the video exceeds the timeline setting, re-framing looks OK and is easy to achieve.

Regardless of what sort of source material you are using, Pan and Zoom works in the same way. It's easier to demonstrate using photos, but the functions for video are identical.

Using Pan and Zoom - In-Built or Legacy?

The In-Built Editor allows you to use Dual Preview but otherwise should be very similar in function to the Legacy version. I say "should be" because there are still minor issues with the In-Built version - although Pinnacle are making rapid progress and I suspect it will become the only tool when it is more reliable than the Legacy

version. Currently, however, the Legacy version is still present and working. I'll describe it briefly later in this chapter should you need to use it.

In-Built Pan and Zoom

Double click on the first clip so that the In-Built Editor opens up over the Library, and select the *Pan and Zoom* tab.

Even if you don't normally have Dual View open, the player windows split into two. On the left you now have the choice between *Source* **or** *Pan and Zoom Source*. On the right, *Timeline* **or** *Pan and Zoom View*. You switch with the tabs above the previews.

The *Pan and Zoom Source* preview contains a very powerful tool - frames similar to that we have seen in Properties, with adjustment nodes. A white frame indicates the current framing, and this is reflected in the *Pan and Zoom View* preview on the right, where the source is shown in its cropped and re-framed state.

The Pan and Zoom previews in Static mode

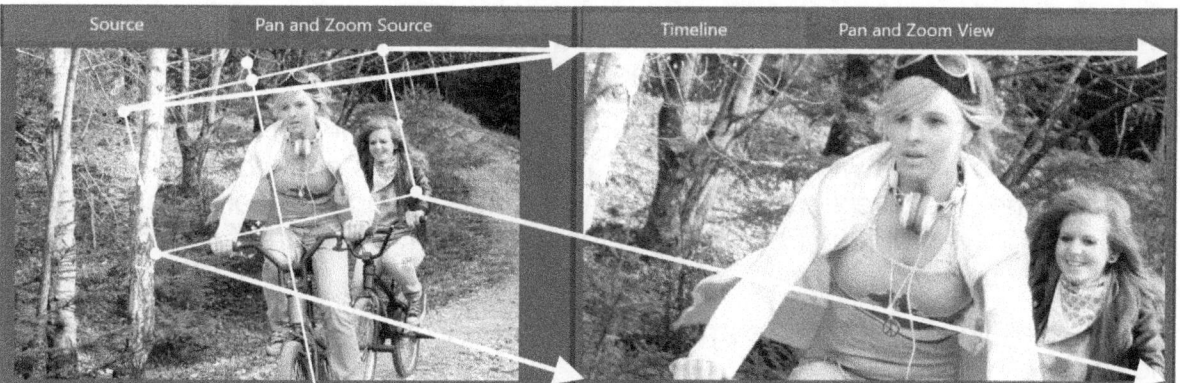

You can switch between the previews by clicking on the headers. However, if you are in the middle of a Pan and Zoom task and then decide to look at another part of the timeline, you will lose the Pan and Zoom previews as the program switches back to Timeline and Source automatically.

In the workflow below, always make sure you are looking at the Pan and Zoom view after switching clips - because we have already added some transitions you will know that you are in the wrong view, but in other situations it's possible to forget.

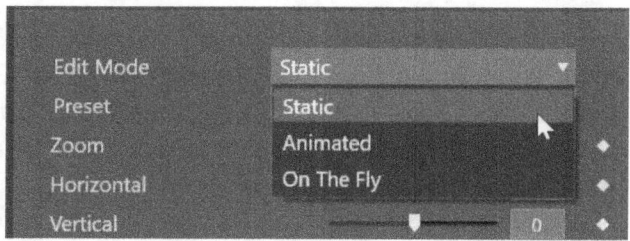

Pan and Zoom Settings

The *Edit Mode* box has three entries, *Static*, where no keyframing is used, *Animated* for keyframed moves, preset or programmed by the user, and *On the Fly*. The latter lets you play the timeline and create your own animation as it plays. Rather than interrupt the slideshow narrative, I will return to a demonstration of this final mode once we have finished animating our current project.

There is a second drop-down box for *Presets*. Select the **second** photo and try out *Static Small Zoom*. This is a suitable substitute for the Fill setting, which will be automatically removed, so leave it in place.

Move back to first clip, the wider shot of the girls cycling, and select the Pan and Zoom view again.

There are four parameters - *Zoom, Horizontal, Vertical* and *Rotation* - everything you need to manipulate a photo in 2 dimensions. The parameters can be adjusted in the same way as all the other editor functions we have looked at, and keyframe diamonds are available for all four parameters.

While the frames and nodes are a great way of re-framing the pictures, for very accurate positioning you can use the settings, including the keyboard shortcuts.

Assuming that Pan and Zoom **Edit Mode** is set to *Static*, the left viewer has a white frame with the nodes we have seen in PiP properties. It's easy to reframe, so that the white lines indicate what we will see in the final version. The control panel has a check box *Stay within the frame* which stops us moving any part of the photo out of shot. I'll discuss the remaining settings shortly.

On the right, you can see the current composition as dictated by the frame in the left viewer.

For this first photo, all I'm going to ask you to do is to tighten the shot in the same manner as the Static Small Zoom preset, but by a slightly larger value (25), and to re-frame the picture to give the girls the maximum amount of headroom. When you have made your adjustment, scrub through the timeline to see the result. The mix through to the next picture shows that the girl on the left lines up on both the Outgoing and Incoming sides of the transition.

I've saved this version as **Slideshow_3 for 24.** (In the Studio 23 book, I switched to the Legacy Pan and Zoom editor at this point, so from now on the projects differ slightly. Please make sure you download the correct project files if you are using them.)

Pan and Zoom indication on the timeline

Now we have added P&Z to some clips, take a closer look at the timeline. When a Pan and Zoom effect is added to a clip, it is indicated by the same pink/magenta bar over the timeline clips that are used to show you that other Effects have been added. The storyboard thumbnail also has the indicator and you could right click on that should you wish - but we have finished with the storyboard and it can cause some issues when scrubbing in the effects editor, so close it now.

Unlike Effects, the Context Menu available for Pan and Zoom is somewhat meagre. If an effect is also applied to the clip the Context Menu will have two main entries - the Effect menu with all the bells and whistles, and the Pan and Zoom menu with just two options - *Copy* and *Delete.*

Copy and Pasting Pan and Zoom on the timeline

Being able to copy a Pan and Zoom setting is a new feature introduced in PS24. It has limited use if you are using it for static re-framing, as each picture will probably require different settings. However, some animated moves may be reusable, so being able to add them to other clips could save you some time. The same methods used for other effects works here - use the *fx* context menu to copy the P&Z, select the target clip and then use CTRL-V, Paste from the Edit menu or right-click on the clip and select Paste,

If there is a difference between the source and target clip duration, animations will be adjusted proportionally - so if the target has double the duration, the movement will slow down by 50%. This is in keeping with the way copy and paste works with other effects.

Animated Moves and Settings in the In-Built Editor

It's time to actually program a move!

Click on the **second** photo in the movie to select it but also scrub into the photo a bit to clear the transitions. Make sure the In-Built Editor is open at the Pan and Zoom tab, change the *Edit Mode* from *Static* to *Animated*, and then switch the previews back to *Pan and Zoom* if they aren't already selected. Studio will have automatically added the preset animated move *Small Zoom Out*, and then switched the preset to *Custom.*

Some important changes occur to the interface. The keyframes for **all** the parameters are enabled, and another tool has appeared underneath both of the Pan and Zoom Previews. It's a single line keyframe timeline, complete with scrubber. Two keyframes have been automatically placed at the start and end of the clip, and show up on all three keyframe displays - the two under the previews and the keyframe area to the right of the settings. Also, the Pan and Zoom source now has two frames, one green to indicate the opening framing, the other red to show the end framing.

Try dragging any one of the scrubbers, and all four will move. You can preview what happens in the right preview, and view the frames moving on the left. Unless the scrubber is at the start or end of the clip, a third white frame with nodes is displayed showing the current frame's settings.

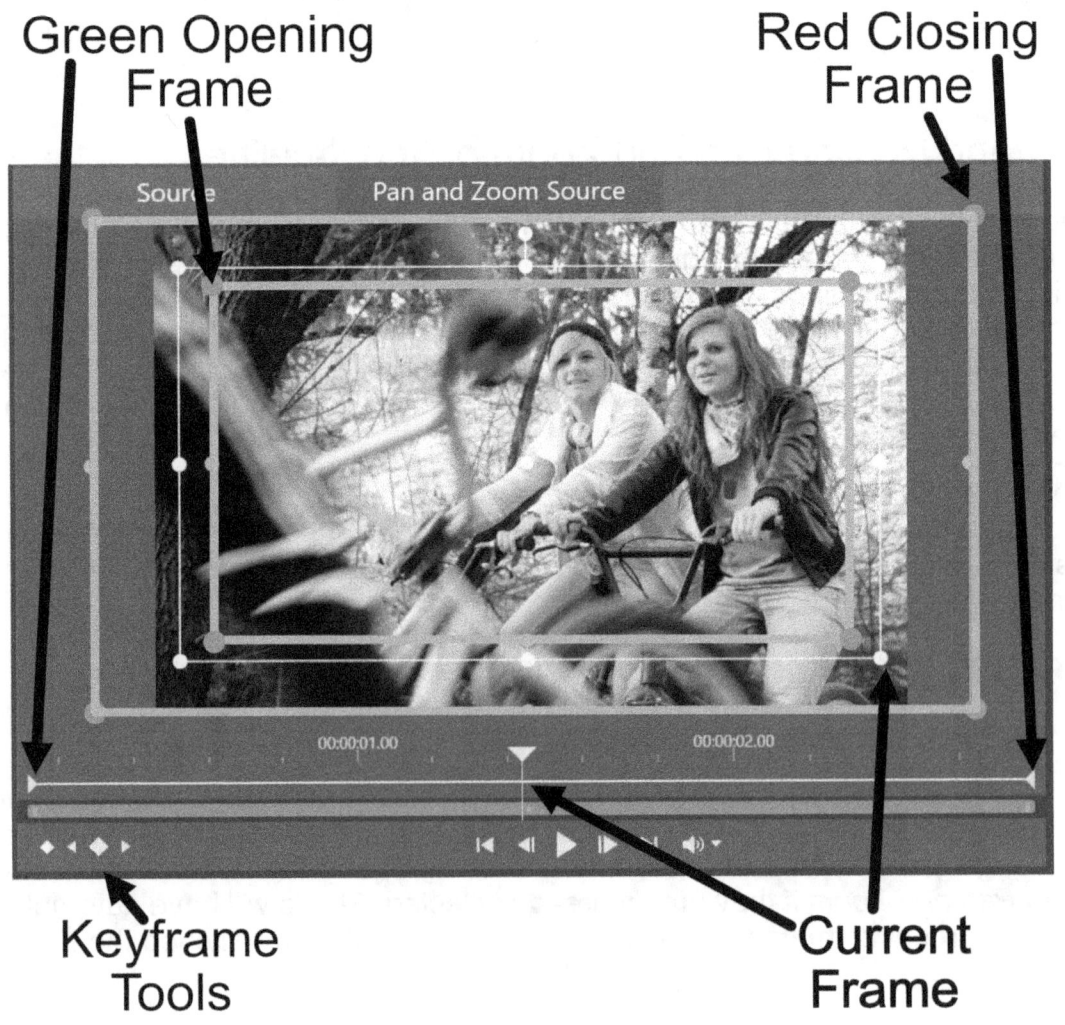

Green Opening Frame

Red Closing Frame

Keyframe Tools

Current Frame

In the bottom left corner of each preview window are familiar icons for enabling and navigating between keyframes as well as creating and deleting them.

Pan and Zoom and Playback Optimisation

Once you start adding moves to P&Z, you may start to experience choppy playback if you don't have Playback Optimisation turned on. A lot will depend on your computer power, project settings and if you are working with pictures or video. However, even with rendering enabled, the process won't start while you stay in the Pan and Zoom tab. You need to switch away – just going to Properties should do the trick and kick-start the rendering. When the area you are working on finishes, you should be able to preview the moves smoothly.

For our first animation I'd like you to try and reverse the preset move we have just added, starting fairly loose on the girls and tightening into their faces The only tricky bit is selecting the frames – sometimes one frame can get hidden by another and you can't grab the central dot of the frame to make it active.

Start by selecting the green frame and then typing *20* in as the zoom value – that's the size that worked well when we transitioned from the first photo. Make the Horizontal and Vertical values zero by double clicking on the parameter names. Making the red end frame active is now best achieved by scrubbing to the end of the clip so that the white and red frames are identical, and adjusting the white frame instead. See the screenshot for my suggested framing.

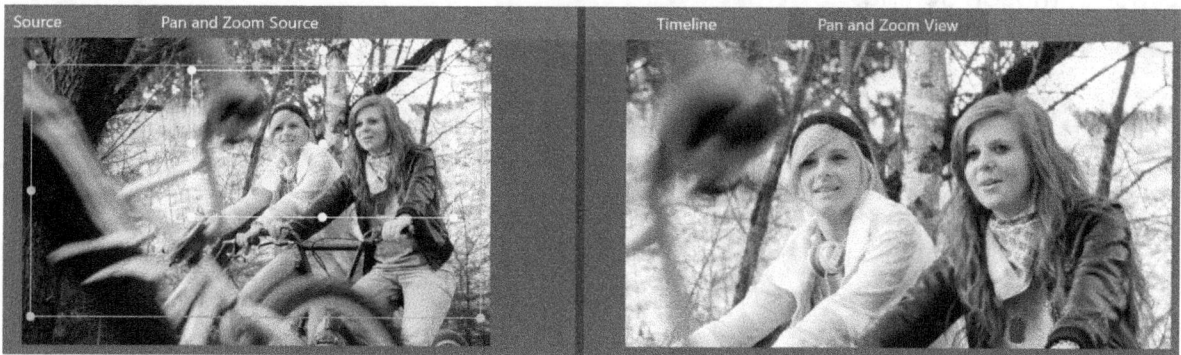

Other *Animated* settings

The *Low Pass* checkbox is designed to reduce patterning during a move – it effectively filters out the sharp edges that might cause Moire patterning.

Motion might not be that clearly named. Other software calls it Acceleration, as it affects the timing of the moves.

If you open the drop-down there are four choices, with the default being **Linear**, which sets the motion to a constant speed - it starts and stops abruptly.

Ease In forces the animation to start slowly and then speed up.

Ease Out is the reverse - the movement starts at full speed, and then tails off as it reaches the end.

Smooth combines Ease In and Ease Out so the move starts slowly, speeds up and then slows back down as it gets to the end.

Animated Motion settings

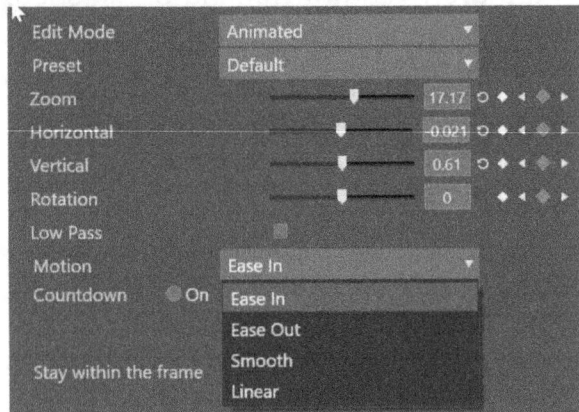

If you apply these motion attributes one at a time to the current shot it's quite easy to see the differing effects. You can experiment with playback or dragging the scrubber to see the difference. When you have finished, switch it to Linear.

Now for the portrait photo of the red bike. You should have no issues selecting the frames in this instance if you first set the green box to the fill the bottom of frame and then red box to fill the top. This animation looks a lot better if you use the Smooth motion setting.

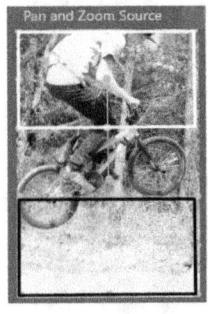
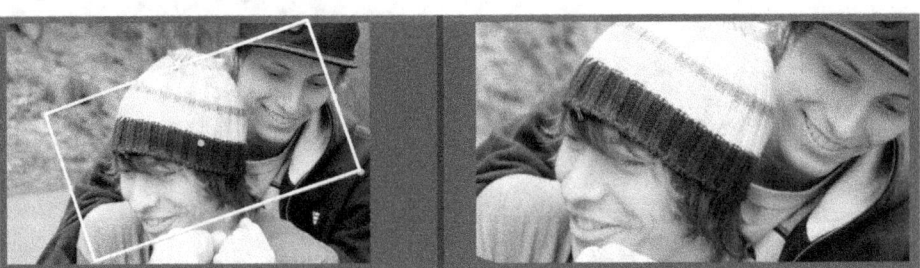

For the fourth photo, the tight shot of the boys, I've started wide and used a little rotation as well as a tighten.

This is **Slideshow_4 for 24**.

Multiple Moves

We haven't got a lot of time during the next shot to do anything too complex, but I think there is time to show off a multi-stage development.

Right click on the 4-shot of all the youngsters cycling, and switch the Scaling setting to **Fit**, re-enter the Pan and Zoom Editor, and then switch to Animated. Set the green frame so that it isolates the blond girl at the front of the group in a single.

Adding a holding keyframe set

I don't want this move to start until the transition has finished mixing through. In order to do this we put a second set of keyframes with exactly the same set of values a little further down the keyframe timeline. The duration between the two sets of keyframes dictates how long the "hold" lasts. If I had chosen easy values for the framing, we could just create a holding keyframe manually, but this isn't always going to be the case – the parameters can have values in with three decimal places!

So therefore, the easiest way to do this is to copy and paste the keyframes. There are two ways of doing this. The simplest method is to use the keyframe timeline under either the *Pan and Zoom Source* or *Pan and Zoom View* preview windows.

Copying the first keyframe and pasting it to the right

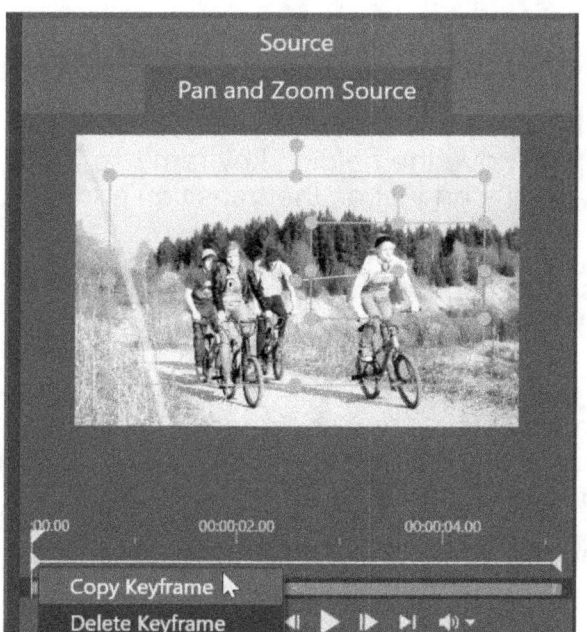 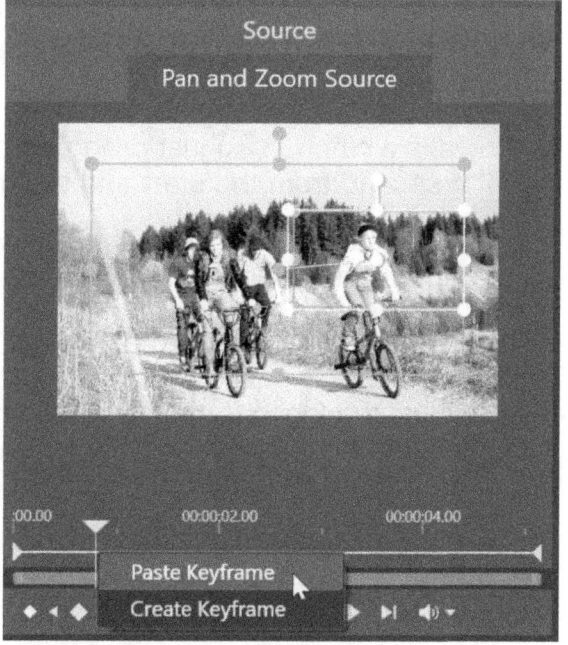

Right-click on the white keyframe that we have created at the start of the photo, and select **Copy Keyframe**. Now right-click on the timeline a little further the the right and select **Paste Keyframe**. At this stage don't worry to much about the placement - we can easily adjust it later on.

The alternative method involves using the keyframes in the panel to the right of the parameters. Here, you can draw a box around any group of keyframes using the mouse, then use the context menu to copy them and then paste the whole set elsewhere.

Copy and pasting multiple keyframes

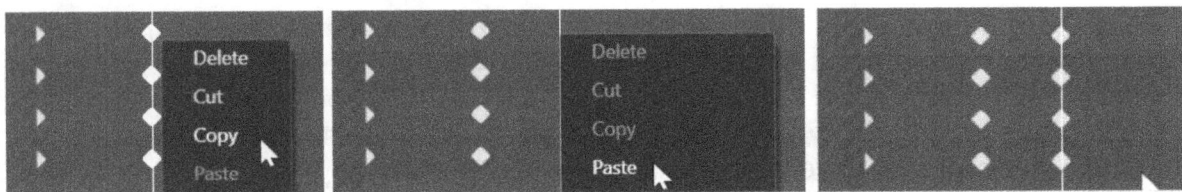

This gives you more flexibility if you either don't want to copy and paste all the keyframes at a given timecode, or want to include those that are nearby as well. Of course, you can also copy and paste individual keyframes should you wish. If you want to try that now, make a further copy of the holding keyframe we just created further to the right and then delete the original holding keyframe.

Moving a group of keyframes

Having placed our holding keyframe set in the ball park, moving it under the preview windows is a cinch - you just drag and drop it. Move the holding keyframe so that it is half a second from the start and the move will start just as the transition ends.

f you multi-select the set of keyframes in the keyframe window by drawing a box around them with your mouse, you can also drag them as a group.

Adding an intermediate position

If you adjust the white frame at any point in it's path, a new keyframe is dropped on the timeline. I'm going to use this technique to get the framing to move over to the group of three cyclists before we zoom out to a full frame.

Scrub to halfway through the clip and drag the white frame to a three shot of the group of cyclists on the left, then use the corner nodes to tighten the shot so it is about the same size as the opening frame.

Test the result and I think you will agree it is a bit fidgety. It might look better if we set some more holding keyframes so the development settled completely on the three-shot before setting off again, and this is definitely a technique you might need to use on complex animations – exploring a map, for example. However, there is a quick fix that will often suffice. Set the *Motion* to *Smooth*. As the move approaches the

three-shot it slows almost to a halt before then gradually accelerating back up to speed, and in this case the development looks pretty good.

The Final Frame

There is a slight issue with the last set of keyframes on any given animation. They have been preset to the last frame's values and you can't delete them (as you can with other keyframe interfaces), nor can you paste different values over them. I want to change the end composition by tilting down to get the bike wheels in shot, but I also want a holding keyframe before the transition into the next picture begins.

The best solution here is to set the red frame first, then create a holding set using the same values to the left of the last frame, as described above. I'll let you try that before saving the project. I've saved my version as **Slideshow_5 for 24**.

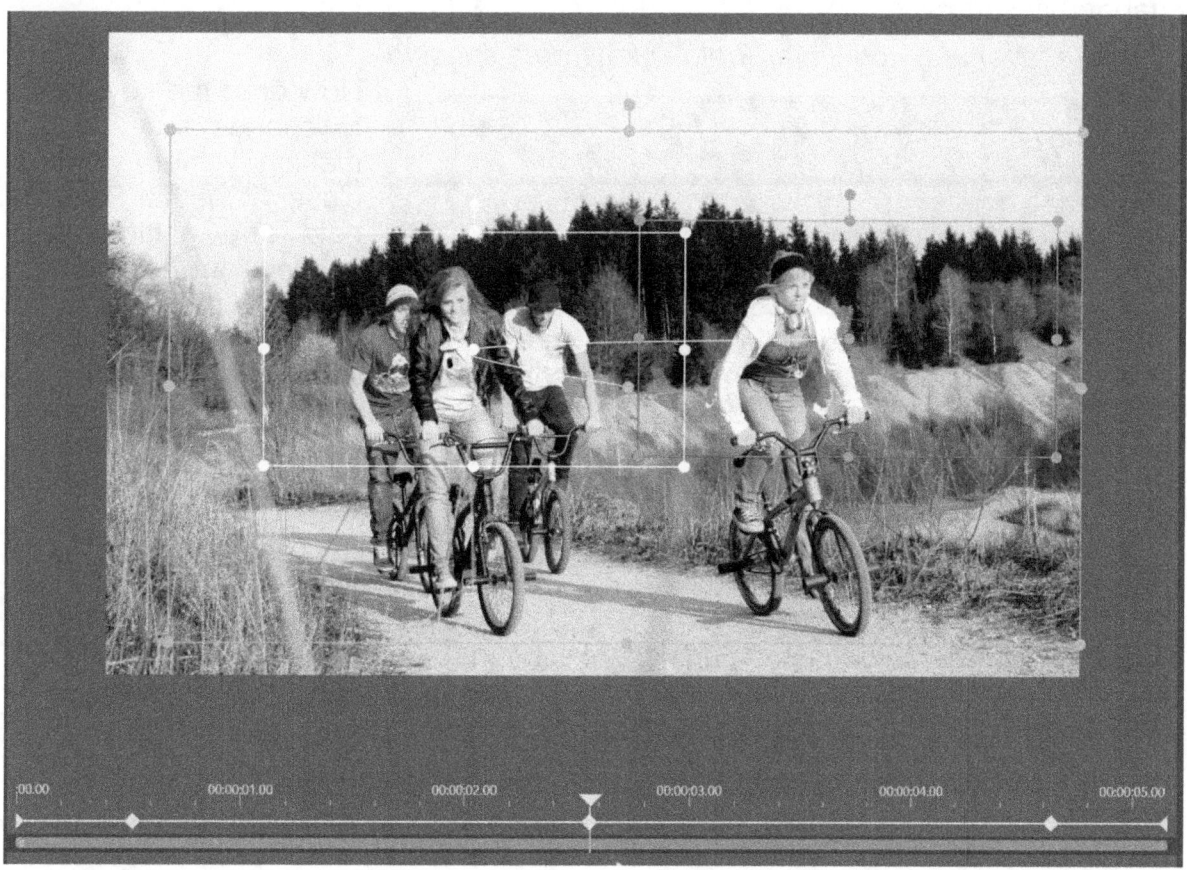

Non-linear movement

The Motion settings are really useful for giving movement a more "organic" look – as if the rostrum camera was being operated by a human rather than a computer. If you want to adjust the speed of a development in an even more non-linear manner, however, there is a trick you can use.

Switch to the penultimate photograph and program a move that starts tight on the bike in the foreground and then pulls back to a wide-shot. Make it Linear, and don't add any holding frames.

At about 0.2 second intervals on the Preview timeline, use the context menu command *Create Keyframe* to add a series of 6 roughly equally spaced keyframes. Play the animation and you should see no difference, as long as you haven't changed any framing.

Linear (above) and non-linear (below) keyframe spacing

Now drag the keyframes to change the spacing, making them much closer together on the right and getting more spaced out to the left. Playing the animation makes it look pretty seamless, with the move starting slowly but constantly accelerating. You might need to render the effect to appreciate it properly. I've made it accelerate very rapidly towards the end of the move to demonstrate the principles, but if you want to refine it further, add more intermediary keyframes and adjust the spacing – the more keyframes the better.

Wobbly holding frames

There has been a long standing issue with the Pan and Zoom feature not generating stable holding keyframes over the years – the developments looked as if they were being performed by an intoxicated cameraman!

I thought we had seen the back of the issue around about PS21, but in early tests of PS24 I have seen the problem reoccur intermittently. Attempts to reproduce it reliably have failed, but if you are seeing it happen, the old solution will work - when the development approaches a holding keyframe and fails to stop cleanly, place a second holding keyframe with the same values **one frame later** on the keyframe timeline.

I haven't done anything with the last photograph. Please feel free to use it to experiment and explore the feature. However, I've got a plan which involves the Masking feature, available in the Ultimate version of Studio, so we will return to this project in the next chapter. In the meantime I've saved the current state of the movie as **Slideshow_6 for 24**.

If you want to experiment further, you can try creating a move that starts on the left-hand couple, zooms out to see all four, and then zooms in to the right-hand couple.

On the Fly Pan and Zoom

On the Fly means you make your Pan and Zoom choices in real time. As the video plays, you adjust the framing. It can be a great time-saver if you want to make some quick and dirty adjustments to a long video clip that is miss-framed – either shot in the wrong aspect ratio or just been poorly operated. You can also use it to process a shot from a fixed camera to single out an object of interest, such as the person burgling your house!

Currently it works OK when not trying to compensate for mixed aspect ratios.

It also works reasonably well when scanning a 4:3 frame to put it in a 16:9 aspect ratio project, and vice versa, but the Square and Portrait modes still need work. By the time you read this all the modes should be working, but for my example I'm going to illustrate a 4:3 to 16:9 conversion.

I have provided a very brief clip to use for this exercise. Begin by loading **4_by_3_Clip.mp4** into a Bin, and then putting it on the timeline of a new movie. Now let's assume that we are working on a 16:9 project, so change the timeline settings using the Cog tool icon to Widescreen (16:9). There is project **4_by_3_On_The_Fly** if you would rather load that.

Now we can see those black bars, so right-click on the clip and select Scaling/Fill. That's got rid of the bars, but what about the framing? In the first shot the subjects are too low in frame, and in the second, too high. In this simple example it would be easy enough to use animated Pan and Zoom to correct this, but if the sequence was longer, it might be better to do the correction using On the Fly.

Before we start, switch the clip back to Scaling/Fit. Now, open the Editor at Pan and Zoom and select On The Fly from the Edit Mode drop down. The preview windows will show the Pan and Zoom tabs and if you click on the Pan and Zoom Source tab for the left preview the Framing tool will appear. Using the scrubber under the preview window, drag along the clip. The Start frame is green as usual, but if you look closely there is a red frame underneath. Scrub through the body of the clip and the frame is white, and when you reach the end keyframe the frame turns red – but with green underneath.

This is indicative of a function of On The Fly – When you adjust the opening Green frame the closing Red frame is set the same values.

Do that now - adjust the Opening green frame so that the video fills it and we are looking at the lower part of the frame as in the screenshot. When you release the Mouse button, the red frame will jump to join it.

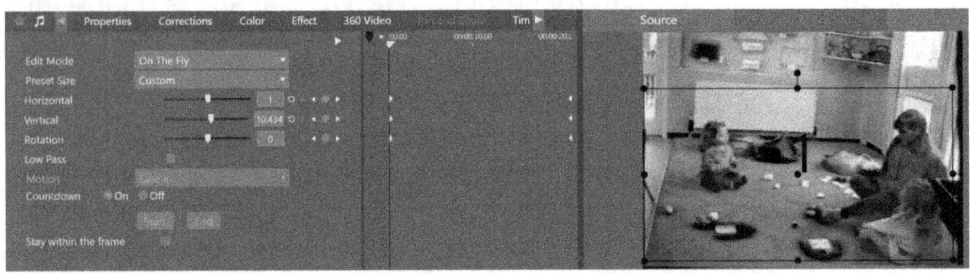

Looking across to the right preview, the Pan and Zoom View may look wrong, and I think this is a bug in the build I'm using, so ignore it. Select Timeline to see the result of your re-framing.

Now adjust the red frame by switching the left preview back to Pan and Zoom Source and scrubbing to the end of the clip. On this occasion, the green frame shouldn't move. This means that if we momentarily release the mouse button, the framing should move to something suitable.

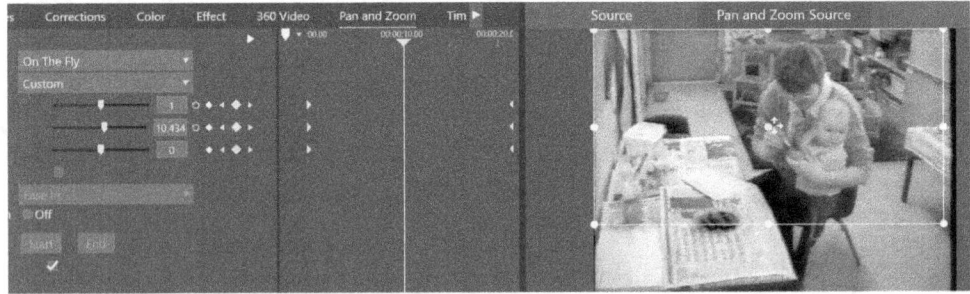

Read what I'm going to ask you to do next before attempting to carry it out. Check that t h e Countdown Radio Button is On, set the playhead to the start of the clip and then click on the Play button under the left preview window. While the countdown is running, hover over the green dot in the middle of the frame so you are ready.

Once the playback starts, the cursor should become a four-way pointer. Click and hold the mouse button - from this point on, you are in control of the framing. Wait for the cut to the second shot and then smoothly move the frame upwards for a better composition. Once you are happy with the framing you can release the mouse button.

It might take a few moments for the keyframes to appear in the keyframe area, (and I found that sometimes the scrubber there froze), but when they do, switch to the Timeline preview and check out your work.

If you think you can do better on a second attempt, I recommend that you delete the whole Pan and Zoom effect from the timeline clip - when I've tried other methods they don't seem to get fully deleted.

You can see my results by loading the **4_3_On_The_Fly with Move** movie.

You can probably guess from the above detailed description and provisos, the feature isn't very stable

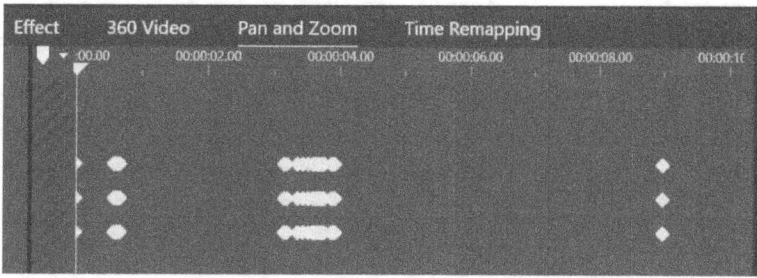

or predictable at the moment of writing, but I'm sure Pinnacle will fine tune if over the next few patches.

The Legacy Pan and Zoom Editor

If you right click on a timeline photo or video clip, *Pan and Zoom* appears as an available option. Currently this opens the Legacy Pan and Zoom editor.

One interesting point here is that PS24 Standard does not include In-built Pan and Zoom, and yet the Legacy P&Z editor is not only available, but includes animation functions. (at least in Build 24.0.1.183).

I'm not going into detail with this editor for two reasons - it may not exist for much longer, and the principles are almost identical to the In-Built editor

This should be a familiar interface if you have used any of the legacy editors and although you don't have access to individual keyframes, using it is similar to the more up-to-date interface, including the positioning of green, red and white frames and the generation of holding keyframes.

The bar running across the bottom of the screen is a Navigator. You can use it to select another target clip without returning to the timeline interface.

SmartMovie

Pinnacle Studio has the ability to "automatically" create movies, slideshows or a combination of both. The feature is best suited to processing lots of photos, so that's why SmartMovie is described in this chapter.

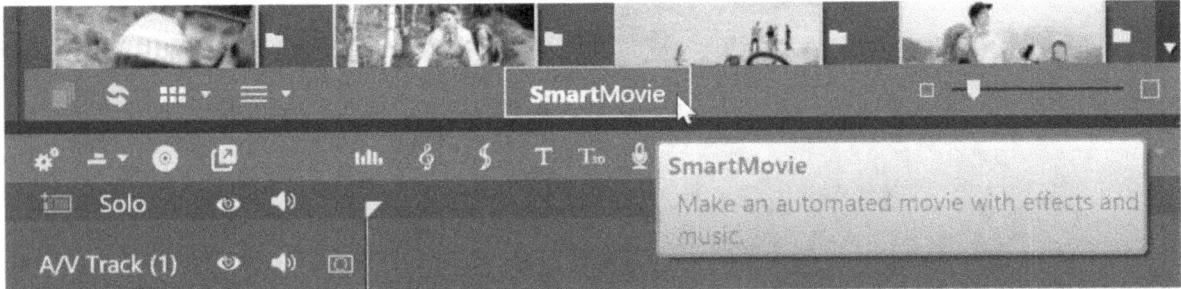

I've put the quotation marks around the word automatic because you do have a little work to perform, and you also have a bit of creative control over the end product. The important thing to remember about the Smart Creation functions is that they are only a starting point.

You open the feature by clicking on the *SmartMovie* command in the centre of the **Library Toolbar**. This opens an editor over the timelines.

Once you have supplied the assets and SmartMovie has done its thing, you can click on the Edit button and the project gets transferred to the Movie Editor. Here you can correct, refine and embellish the Studio version and put your own spin on things.

At its very simplest Studio creates a movie consisting of the photo, video and audio assets in the drop zones, adding transitions at each edit point. The assets default to different durations depending on the settings in the Clip length drop-down menu.

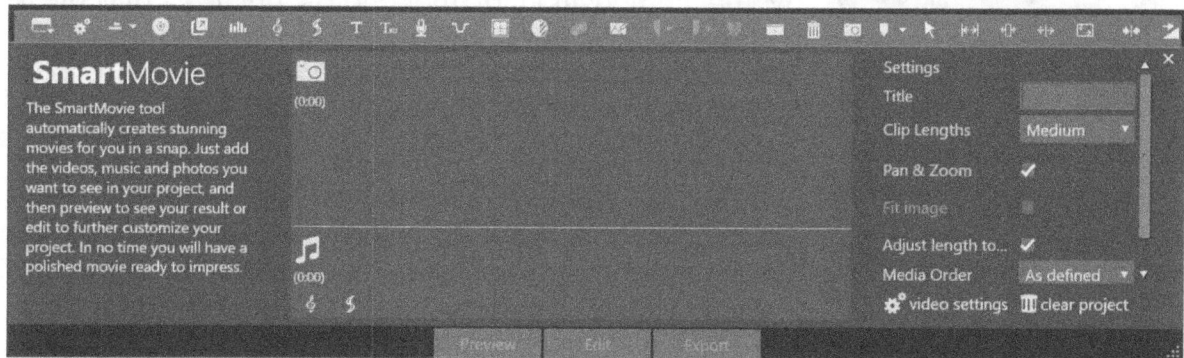

You drag Photos or Video from the Library to the upper Drop Zone. Because we are in the Library, selecting suitable sources is easier because the browser window is larger. The Drop Zone allows you to re-arrange the photos or video clip in any order just by dragging and dropping. Multi-selection works too, so you can CTRL-click a selection and then delete them, or drag them to another position. Double clicking on a photo opens the Photo Corrections Editor, on a video in the Video Corrections editor, where you have access to the full array of tools, in particular the crop tool for reframing the photos. Any Corrections added within the SmartMovie don't get echoed back to the Library.

The Audio Drop Zone is below. You can drag music tracks from the Library or add Scorefitter music by clicking on the treble clef icon to open the Scorefitter Editor. You aren't limited to one piece of music and just like the Photo and Video zone, re-arranging the order is possible by drag and drop. Notice that the running total of all the music in the zone is displayed on the left of the list.

The settings list to the right is where you have some control. **Title** allows you to enter a name that is displayed at the start. Studio always puts an Emphasis motion on this title that you may not find is to your taste, so you might decide to put a title on later by omitting any text from the entry box. No text – no title.

The major choice you need to make is in the drop-down box labelled **Clip Length**. Even when using the **Maximum** setting, video clips over a certain length – 1 minute – are never used in their entirety – so a 1 minute 5 second clip will be split and used twice. Photos are set to around 27 seconds.

Short, **Medium** and **Long** results in clips of about 3, 6 and 12 seconds, with photos of a similar duration.

Pan and Zoom adds a little gentle movement to the show. Photos are analysed for content for each P&Z, and there is variation in the direction of the zoom. The direction may be determined by the composition of the photos but it is difficult to guess what the actual algorithm is. Pan and Zoom will also eliminate any black borders caused by the photos and project not having matching aspect ratios.

If you don't want to use Pan and Zoom and also don't want to use the Corrections Editor to crop photos the function Fit Image will do the cropping for you, but the results may not be very sympathetic to the content of the photos. The comments I made about shooting stills in the Photos chapter apply just as much here – if your camera can shoot in the same aspect ratio as your projects, use that setting, don't shoot in portrait orientation and fill the frame as much as possible.

Adjust length to music is where the feature starts to get very helpful. The duration of the photo and video clips and transitions are adjusted to fit whatever music you have placed in the Audio Drop zone. This is subject to a sensible limit. If the music is short and there are lots of clips, the clip duration isn't lowered below a second, including the associated transition. This means that some clips may be left off the end of the movie. Therefore, the duration of the music in seconds needs to be greater than the number of pictures or video clips. If you want to make a faster paced photo slideshow you will need to adjust the durations manually in the Movie Editor.

To make the slideshow fit perfectly, the first and last photos will be adjusted to take up any odd number of frames that are left over after Studio does the maths.

Media Order is another useful feature. The Smartmovie will normally follow the pattern you have set in the dropzone – *As defined* - but you can reset this to the time and date of the assets (if available) with the **Chronological** setting. **Random** is just that. When you apply these changes they aren't reflected in the drop zone, so the assets are still displayed in the As defined order. You will only see the changes when you preview the movie or switch to the Edit mode.

Video Track Volume controls how much of the original audio is present in the final movie.

Random transitions are added at each edit point, although they are restricted to the relatively simpler types.

Adding music to the Audio Drop Zone shows off the power of Smart Movie more, because the music will define the duration of the final movie.

At the bottom of the settings is an option to define the **Video Settings**. One trick here that will speed up the preview of changes is to build your project in Standard Definition even if your final product is going to be HD. The rendering for the P&Z will be quicker. When you are happy with the final result, change the Timeline setting in the Movie Editor before re-checking the project. The final Settings option - **Clear Project** - empties the drop zones.

At the bottom of the SmartMovie box are three buttons. If you select **Preview** you will invariably get a message bottom left as the movie is generated, then a preview window with the result will open. Notice that preview optimisation will still be working on any animations, unless you have it disabled (which might well lead to jerky playback). Once the Smart Preview window is open, you can make changes to the project, but you will be warned that you need to press play to refresh the preview window.

Edit transfers the project to the Movie Editor for further enhancements. Any changes you make there are non-destructive – they don't get reflected back to the SmartMovie project in the Library, so you can make a variety of movies from the same set of photos even if you decided to delete some of them from the Movie Editor.

Another interesting thing happens when you select Preview or Edit. The current contents of the dropzones are added into a special Collection entitled Latest Smart Creation. This is a one-off. The next time you try to preview or edit a different Smart Creation it will be replaced, so there is only ever one of these Collections. So, when you continue working on the Smart Creation that has been transferred to the Movie Editor, you can open the Collection in the Compact Library. If you remove an item from the timeline, it's green checkmark disappears, so you know it is missing.

If you use the Export button, the project is transferred straight to an Export window where you can carry out all the usual operations just as if the project had come from the Movie or Disc Editor.

I find that for Smart Movie to be helpful the video clips need to be chosen with care, possibly even pre-edited as Library shortcuts or scenes. For a wacky "pop video" the tool may have its uses, but to be honest it's not as well developed as the version in Classic Pinnacle Studio.

Advanced Tools

This chapter covers enhancements that Pinnacle have added over the years which are separate from the main editing functions. Although Montages have been in NextGen Studio since the beginning, I've covered them here as they help to explain Templates. Multi-camera Editing is also a separate development, but is complex enough to warrant it's own chapter.

Masking

First introduced in PS23, and only available in Ultimate, a mask enables you to select a section of a picture or video clip. You can then treat the part that has been selected differently to the part that has not.

A mask contains a single piece of data for each pixel of the image it is applied to – either the pixel is to be masked, or it isn't. At its simplest the mask could be a geometric shape.

Many tasks require a more complex mask that is closely related to the image over which it is placed. The sky in a picture may be dull and you would like to replace it. If you separate the picture into two parts, you could add a filter to just the sky to enhance its colour, or you could replace it entirely with transparency and put a different sky on a track below. You would need a mask that closely followed the skyline to do that.

PS23 Ultimate only had a track-based masking feature. This means the masks you create are independent of the clips that you create them for, existing on an independent timeline track. In PS24, Clip Masks were added, which work just on the selected clip and with no need for any Mask tracks.

PS24 also added Motion Tracking to masking, almost making the older standalone feature redundant, although for some tasks it is simpler to use. There are other enhancements to masking too, including face detection

Getting Started

I'm going to use the current Slideshow project to demonstrate the principles of masking. If you didn't make it, load **Slideshow_6 for 24** from the website or DVD. You are also going to need another photo, so download **Sky Background**.

Let's adjust the framing of the last picture as *Fill* hasn't done a very good job. Use the clip context menu *Scaling* option to change it to *Fit*, and then change the Properties to *Position Vertical-10* and *Size Vertical* and *Horizontal* to *120*. For clarity remove the transitions at the start and end of the photo - we can always put them back later.

Mask Track or Mask Clip?

With the photo selected, click on the Mask tab. In PS24 the feature has been enhanced. Three options are offered in the left-hand window pane. You can now choose if you want to work at the Track or Clip level. You can also Save and Load

masks. The default method is to use a special mask track that is independent of any timeline clips. This allows you to use a mask and it's features on a whole group of clips on the track below. Because it is the default, you use the button *Create Mask* to begin masking, although you will be creating a Track Mask.

The other option is *Create Clip Mask*. This applies a mask to the selected clip only. No additional timeline track is needed or indeed created. The mask you make will only be associated with the clip, but it is locked to that clip, so should you move the clip, the mask goes with it. A timeline clip that has had a Clip Mask added to it will show a yellow strip along its top edge.

Loading and Saving Masks

Although there is a distinction between Track and Clip masks during the creation process and how they work in a project, the mask data is actually interchangeable. So if you save a mask, it uses the suffix *.psmask* (in the default directory defined in the Control Panel/Storage Locations). When you load a mask it can be applied to a track **or** a clip, So if you aren't sure if you do want to work with Track or Clip Masks, you can change you mind at a later date. A saved mask that uses keyframes will adjust the duration of the destination you load it to, spacing out the keyframes proportionally in the same way as keyframed effects.

Working with Track Masks

Using this method, we create a mask track and create the mask on that. To start work, click on **Create Mask**.

The preview window gets a new tab called *Mask* and is switched to displaying it. You can toggle to Timeline at any point to check what the result of the masking looks like.

A **Mask Track** is added to the timeline above the picture, and it has a yellow bar showing you the duration and positioning of the mask on that track - it has taken its duration from the selected clip. There are other ways to create new mask tracks and add masks to existing mask tracks. Masks can be moved, have their duration

changed, cut, copied and pasted and of course deleted. You can *Save* and *Load* them using the buttons in the left-hand panel. Mask tracks can be dragged to a different layer of the timeline so they sit above another track.

For now we have one picture, one mask track and one mask. Note that the mask is above the picture.

An important point – **A mask track can only hold one mask**. So, if you want to add individual masks to a number of different clips on the same track, you will end

up with a whole stack of mask tracks. In these circumstances you would be better to use Clip Masks if you can.

Another important point – **A mask only affects the first A/V track below it**.

So, if you are using a mask to punch a transparent hole in a picture, that hole is only generated on the picture immediately below it, revealing whatever is on tracks further down.

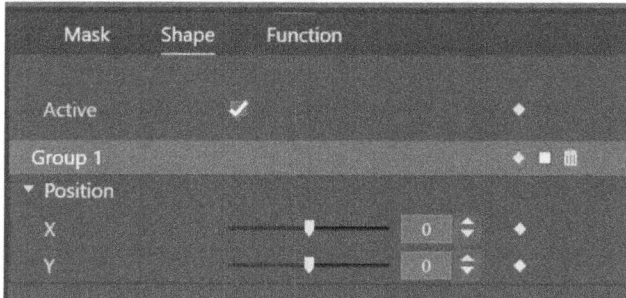

Once a mask is present and selected but has not been set up, the Mask Editor offers you a choice of creating a Shape or a Panel. We will discuss panels later so choose **Create Shape**.

Creating a shape

The Shape section of the Mask Editor has settings on the left and what I hope by now is the very familiar keyframe panel on the right. The very first setting is **Active** – a checkbox that allows you to switch the mask shape on or off. Note that it is keyframeable – so if a mask track spanned a number of clips you can choose to have it active for only some of them, or for just part of a single clip. If a mask is inactive if changes colour to a light brown.

Next comes **Group 1**, with keyframeable controls, an on/off button and a trash can. The parameters available for a group are currently just *Position*. Once we have added a shape to the first group we will be able to add further groups with a button that will appear at the bottom of the panel.

Mask Tools

Down the left edge of the Mask preview are eleven icons – labelled in the screenshot. For simple masks you may be able to use just one or two of them, but once things get tricky, you may need to use a combination, and an understanding of them all is essential to choosing the correct tool and working efficiently.

Creating an accurate mask can be very time consuming. One tool in particular – the Magic Wand - promises much but needs to be used carefully. It's very tempting to think that with one or two clicks we can select the whole of the sky behind the people in the picture, but it's hardly ever that simple – and not knowing how the masking tool works as a whole can add extra frustration.

Let's create a few simple shapes and see how they interact before trying something too challenging. The Pointer icon is the usual **Selection** tool and can be used to switch away from whichever tool you are using, amongst other things.

Rectangle

Select the rectangle tool and using click, hold and drag to draw a box in the sky to the right of the people. Once you have set the first corner you can make it any size or aspect ratio you want, as long as **Custom** is selected in the Aspect drop-down that has appeared above the tools. As we are working in a video environment, the choices that you can constrain the rectangle to while drawing it are the obvious ones; Wide Screen and Standard in landscape and portrait mode, plus Square.

When you have finalised the shape and position of the rectangle, release the mouse button and a pink shaded area appears, filling the shape that you just drew. It's a mask!

Of course, we might not have got the positioning quite right. Click on the Selection tool and the pointer tool and nodes appear around the rectangle. We can drag the shape, use the corner nodes to resize it or the offset node to rotate it.

With a rectangle in place, Group 1 has acquired a single **Shape**. We can rename Shape 1 to *Rectangle* by clicking on the caption in the header and hide or reveal the parameters by clicking on the header bar. The same three tools that are on the right of the Group header also exist for Shapes - and as one of those enables keyframing, you can deduce that your rectangle shape's aspect ratio can be altered over time, as well as as it's position, size and rotation.

In the middle of the Rectangle shape header are controls for **Motion Tracking** - rectangles are one of the shapes that can be used for motion tracking, which we will look at later. Obviously motion tracking is only going to be effective when masking video, not still photos.

The final parameter is Transform. (I'm not sure that's the right name, personally). It is currently greyed out and in order to see what it does we need another shape.

Circle

The next tool down draws an ellipse, or if you hold down the shift key or set the aspect ratio to 1:1, a circle. Draw one now below the rectangle. Switch from the Circle tool to the Select tool and use it to confirm that you can make all the same

adjustments as you can on the rectangle. Circle too can be keyframed, and it also has a special editing tool available when using the Selection pointer.

Editing Circle shapes with Nodes

Make sure you are using the Selection pointer and hover carefully over the edge of the Circle shape. With it right over the border, the mouse cursor changes to a **smaller** four-way arrow with pointer. This tool creates *and* adjusts nodes. Click and hold to create one now, then drag it in towards the centre of the circle, the release the mouse button.

Using the Node tool on a Circle shape

Notice that nodes in the Circle tool don't show up as dots - they are just the points that you have "broken" the circle. If you now explore the edge of the shape with the Selection tool, you will detect three nodes - the middle one you have created and two more either side. They can be dragged, using the same mouse cursor.

No more nodes can be created between these three points but you are free to add more anywhere else around the edge of the shape.

These changes to the shape can be recorded as keyframes as well, once you enable keyframing on the Shape parameter. The reason for this special editing mode will become clear when we look at the Face Recognition tool.

Selecting and Deleting Shapes

Something that you need to get used to is that even with the selection pointer as your mask tool, once you have more than one shape in a group you can't just click on a shape in the Preview window and start manipulating it. You must select it in the list of shapes in the Mask editor. Even if a shape is selected, **never press the Delete key to remove it**. It will delete the mask track. Use the trash cans alongside the groups and shapes. This makes it worthwhile renaming the shapes as you create them.

Fortunately, Undo and Redo work on masking operations, so if you spot a mistake straight away you can deal with it.

Blending Masks – the Transform option

With two shapes, we can now see what the drop-down option at the bottom of the shape parameter list does. Select Shape 2 from the list of shapes if it isn't currently selected and drag it so that it overlaps the Rectangle shape.

Combine is the default. Both the ellipse and the rectangle are contributing to the combined mask. Change it to **Subtract**, and the second shape is then removed from the mask, and takes away any parts of masks that it overlaps with. The final option is **Intersect** – only the areas that are part of both shapes form the mask.

These options are very important when creating masks because they can save you so much time – particularly when

you use them with the Magic Wand.

They also bring into play the order in which you create shapes. The first shape has no blend/transform options because there is nothing "behind" it to interact with. The second shape interacts with the one above, and if we added a third shape it will interact with the combined mask created with the two shapes above it in the list. Having got used to the timeline tracks stacking up bottom to top, I'm afraid you now need to come to terms with the shapes list working the other way. It's also important to get them in the correct order from the start – the list of shapes can't be re-ordered, and you can only add new shapes at the bottom of the list.

The Pen tool

The job of the pen tool is to create an enclosed shape using nodes. Select the tool and click on the trees on the left of the picture. A single node appears, and as you move the mouse away, it is joined to the node by a line. Create a second node, move and create another. You now have the minimum you need to create an enclosed shape – in this case a triangle.

However, to close the shape you need one more operation. If you hover exactly over the

Completing a Pen shape

first node you created, a small circle is added to the Pen tool icon. It is a good idea to avoid putting the first node over a light part of the picture to help you see the circle. Clicking on the starting node completes the shape which then fills with the pink mask indication. However, if you struggle to find the start node, pressing the Esc key or right-clicking will complete the shape for you.

Adding a Pen node

Using the Selection pointer you can now move the shape and adjust the overall size and aspect ratio by dragging the corner nodes. To edit the shape, the Pen tool appears when you hover over a line between two nodes, this time accompanied by a + sign and when you click a new node gets added to the shape.

To move an exiting node, hover directly over it and the small four-way arrow pointer will appear, and then click and drag.

I'd like you to try editing the pen tool shape by adding nodes and dragging them out to modify the shape to cover the whole hill covered in trees in the background.

Moving a Pen node

You will find getting a reasonable match isn't too hard – say about 14 nodes, but you might struggle with accuracy after a while. What would help is a close view of the area you are working on.

When you have a reasonable mask rename the shape *Left Forest*. As we have started some actual work now, delete the Rectangle and Ellipse shapes.

Preview scaling

When performing a delicate operation in the preview window, you might find using a small display screen limiting. One trick that may help on laptops is changing the scaling in *Windows Settings – System – Display* to a lower setting. On a 14" laptop screen I use 100% rather than the default 150% so that I can enlarge the preview more. However, there is another solution.

One feature of the Studio preview windows that I've mentioned elsewhere but not used up until now is the drop-down box on the left of the preview controls that normally says **Fit**. Set it to 100% and you scale the view to match the pixel count - you can judge if the mask is going to be accurate enough with this setting. Choose 200% and you get decent accuracy and at 400% you get even more detail. The down side is that you may experience a certain amount of lag when editing masks, although there has been a great improvement here between PS23 and 24, at least on my desktop computer..

I suggest you do a bit more work on the forest using Preview scaling so that you think it's a useful mask, and then return the preview to the Fit setting.

The Lasso

The next tool down is a freehand drawing option. Let's try it out over the right-hand patch of forest. Hover over a starting point, click and hold down the mouse button, then start to draw round the forest. Like the Pen tool, the operation aims to produce an enclosed shape, but unlike the Pen, you don't need to press escape or complete the shape, because when you release the mouse button, the program completes the shape for you.

This tool isn't as good for creating a mask of the forest as the Pen tool - it requires a bit more dexterity. If you want to create a freehand shape, however, it is ideal. There is a parameter called Smoothing which helps you create either an accurate shape that follows your every move (including small mistakes) or one with nice rounded edges.

Smoothness uses a type of control we haven't met yet in Studio. Yes, you can type in a value (between 0 and 40), or you can use the small up and down arrowheads to make incremental changes, but if you click and hold on the drop-down arrow on the right a slider opens, and all you have to do is move your mouse left or right to adjust it.

You will get a good idea of the effect Smoothness has if you try to draw a shape with a shaky hand. With a setting of zero, you get almost exactly what you draw. With Smoothness set to 40, you tend to get what you intended to draw!

The Lasso certainly has it's uses, but it's not ideal for tracing the outline of the forest so delete your experiments and move on to the next tool.

The Brush tool

This tool emulates you painting over the picture with a paintbrush. You can vary the size of the strokes with the *Radius* slider that works in the same manner as the Smoothness parameter setting for the Lasso.

Smart Edge is an enhancement that lets you paint "up to a boundary" automatically. Whether it works or not will depend on how pronounced the boundary is and the tolerance setting you choose. Turn it off for now if is already checked.

Invert is an interesting option. If you click it before you start using the brush, a full screen mask fills the screen, and the brush works as an eraser. You can also use the button at any stage before you click Done to toggle the mask state. If you want to paint out a large area, it may well be quicker to paint over what you want to remain and then use Invert.

I'd like you to try painting out the area of trees on the right of frame. Start with a fairly large brush to get the rough shape and, without clicking on Done, change the brush to a smaller one and improve the edges. You need not worry about the right edge going out of frame.

If a tool has a Done button, you can use it even if you aren't sure that you have completely finished. Click it now, and then look in the panel to the left - the new shape that has been added to the list has a **Modify** button available, which you can use to re-enter the editing mode and add detail, or use the Eraser to correct errors.

That should be a fairly easy task, but it still requires a bit of skill and patience.

How about the Smart Edge option? Delete the mask you have just created, enable Smart Edge, set the *Radius* and *Tolerance* to 10 and, starting in the centre of the right-hand forest area, start using the brush, working your way out to the edges,

With these settings the tool works remarkably well, not just on the strong edge where the boy's arm overlaps, but also the much more subtle edge with the mountain behind. Smart Edge is a quick yet accurate feature.

When you have made a reasonable job of the mask, rename it as *Right Forest*. I've saved this stage as **Masking Slideshow_1 for 24.**.

Right Click beware!

I get caught out occasionally by accidentally clicking on the right, particularly when trying to do something fiddly with the mouse. This has the effect of closing the brush shape, which is annoying if you hadn't finished working with it.

The Magic Wand

This tool may not always be magic, but it's still very useful. It samples the pixel you click on, selects it and every other pixel in the image with the same or similar value and makes a mask from the chosen pixels.

This sampling can be performed in a variety of **Modes**, selected from a drop-down list. The default mode of *RGB Value* is almost certainly the best in most situations, although for a troublesome clip you might want to try some of the others. For example, a photo that has similar colours throughout but strong contrast may work well with the Brightness mode.

The setting for "similar" is **Tolerance,** which will reduce the number of sample points you need when lowered.

Make sure that *Contiguous* is unchecked for now, and set Tolerance to the default value of 10. Click on the tall lad's blue t-shirt. You will see some, but not all, of

the blue selected. Try another spot and the first selection will probably disappear to be replaced by another batch. Obviously with a low tolerance the wand isn't going to be able to select the whole shirt, but before we turn up the value, try holding down the CTRL key. A + symbol appears beside the wand and clicking somewhere that isn't selected adds a second group of pixels. With a few more clicks you should be able to select all of the t-shirt, but in the process other pink spots of masking may have appeared on the other people's clothes.

Change the Tolerance setting to 25 and then try the t-shirt again. As long as you clicked near the centre, you should have got a similar result to using multiple selections of lower tolerance. What tends to work best of all is to use a setting that selects most of what you want, then reduce the tolerance to add more areas by holding down the Ctrl key.

However, we have a serious issue with the girl on the lefts top. It's quite close in colour to the one we are trying to select - just a bit nearer to cyan - and the higher the tolerance the more of it gets added to the selection.s There are ways to refine the selection still to be described, but if we are going to have to get out the Eraser, then the Magic Wand isn't being that Magic,

PS24 added the **Contiguous** check box, and that makes a huge difference, however. The word means "sharing a common border; touching" and when set, only pixels that are within the same boundary are added to a selection.

Check the box and click on the same place as before. All the selected pixels are on the boy's t-shirt. Change the tolerance to 80 and try again. One click will select the whole t-Shirt apart from a few sections on the left - one of which is separated by a strand of hair! Turn the Tolerance down and a few more Ctrl-clicks should produce a perfect mask.

The Eraser

The seventh tool down is probably one of the most useful. Rather than spend ages trying to eliminate unwanted selections by the magic wand or mistakes when using the brush, you can just erase them. This tool only works on the Brush and Magic Wand tools. It has a variable *Radius* and a *Done* button.

You probably have lots of pink spots left over the other people's clothes, so select the last shape, switch to the Erase tool and rub them out – it shouldn't take too long.

Other Erasing Options

If there is a large area of false masking that needs erasing, don't forget the *Subtract* option in the Transform/Blend drop down. You can quickly draw a lasso or other mask over the area you want to remove and then select Subtract.

Text

The Text tool lets you create a mask of any text you care to type into in the Text Settings box, and all the usual text properties are available in the Text settings panel that appears on the left with the other Shape properties.

Import

Import will be of use when we use Panels, although the masking tool can be used independently should you wish to add a video clip or still picture, either as an object or as a Mask Shape.

Object

This tool offers you some pre-made shapes that would otherwise take some time to create with the other tools. The additional *Style* parameter allows you to choose variations of the basic shapes from a drop-down box, and you can change the Fill colour and add borders if you wish.

Face

This is a new feature added in PS24. It recognises human faces and tags them for you. You can create masks and use use motion tracking, but it only works on video. I will return to this subject once we have looked at the rest of the mask features using our slideshow clip.

Moving and changing shapes

When you move or adjust a shape on screen, the changed values are reflected in the settings panel. Each shape has parameters for all the adjustments you can make, including Rotation. What's more, keyframing is available, so if we were working with a moving picture you could adjust each shape as the picture moved. We will look at that feature shortly.

Add a new group

Once you have created more than one shape, you can also alter the position of all the shapes in the group with keyframeable control. It's also possible to add additional groups so that one set of shapes can be moved independently to another set in a different group. However, we will see in a moment that you can only apply a function to a whole mask and not individual groups.

Now we have masked an area of the photograph, I would like to treat it with an effect – the forest areas are shrouded in mist and I'd like to increase the saturation to make them look a little more cheerful. I'm also intending to replace the sky, but I'll do that with a second mask. For now, remove any shapes you have been experimenting with so that just the two forest masks remaining, or load **Masking Slideshow_1 for 24.**

Mask Functions and Filters

The third sub-tab choice, **Function**, is where we actually perform the operation that we created the mask for. Select it and you will see a choice of **Mask Properties** and **Matte Properties**, each with two drop-down boxes.

The first drop-down for each of the properties is set to **Function**. If you open up the drop down you can see that the other choice is **Filter**. The second drop-down is currently set to **None**.

Mask or Matte?

Open up the second drop-down for Mask Properties and you will see a very long list. Select **Opacity**. The forests turn black, but in fact they have just become completely transparent. Switch the Mask back to None and then set Matte Properties to Opacity - and now everything *except* the forests are transparent. Matte is the inverse of Mask. You can apply one function or filter to the area you have masked, and another to the area left behind. For now, switch Matte back to None

Functions

Now start switching through the available functions to see the parameters available.

Opacity is the most obvious function. It allows us to see the tracks behind, but you can also create a ghostly effect by using *Opacity* values higher than zero.

There is also a **Feather** parameter - which softens the edge between the Mask and the Matte. This is an invaluable tool when used in very small amounts for making a slightly inaccurate mask work better. Larger values give an interesting but artificial look. **Detect Edge** can be used to remove the feather effect if the mask happens to coincide with the edge of frame.

Feather and Detect Edge are available in many of the other functions.

Now select the Mask Properties Function **Color Correction.** This allows enhancement or more radical changes to the colours of the image. We have met and used this tool in Corrections.

I want to make the forests look more inviting, so I've changed the settings here to Tint -40, Blacks -30 and Saturation 50. You can choose other settings, but beware of introducing noise into the image.

To help disguise any mask imperfections scroll down to the bottom and set Feather to a value of 5 and check Detect Edge.

Don't worry about making these changes and then losing them when you experiment with the other functions, as Studio will remember them.

Invert Color is a simple effect, but **Replace Color** is a more complex, allowing you to change the values of Hue, Lightness and Saturation for a chosen range of a specific colour, thereby giving it a new colour. We could change the t-shirt colour with ease. **Black and White** just removes all the colour from an image.

Zoom and **Loupe** is an interesting feature. Want to create a magnifying glass effect and move it over a map? This is the tool for you. Zoom increases the magnification of the area of the mask, Loupe adds barrel distortion - it's the French word for magnifying glass.

Fill adds a solid colour of your choice in place of the mask or matte.

Two additional functions have been added since Masking was first introduced - **Blur** and **Mosaic.** Both of these replace the mask (or matte) area with out of focus or pixelated versions of the source video or photo, obscuring it.

The list currently continues with a number of functions taken from the Effects List. Some of them may be useful, others less so.

Filters

Switch Mask Properties to Filter and open the second drop-down.

High and Low pass have nothing to do with frequency - they work on the video levels. If you set the High pass Light Threshold to 25%, all the pixels with a value of over that are untouched. Those below that are altered by the amount set by the Intensity value - the higher the value the darker they become - so setting that to

100% results in an image that has all the dark areas up to 25% crushed down to pure black. Low pass works in an inverted manner to High pass.

Dichroic has the effect of putting a single colour filter over the image, removing any colour in the image that isn't the same as the filter. **Color** is a more flexible version of Dichroic that can select a contiguous range of colours that are allowed through, and you can also invert the effect to exclude the chosen range.

That's quite a lot of functions and filters to choose from - you should find something to suit your creativity!

If you made the Forest mask shapes and changed the colour correction values to those I specified above, switch Mask Properties to Function and select Color Correction, then set the Matte properties Function to Opacity. You should have some nice bright forests on a transparent background.

If you didn't do that, load **Masking Slideshow_2 for 24** before you move to the next step.

Replacing the Sky

I'm going to use another mask to cut out the outline of the four people and the beach, but I'm using another layer, otherwise we can't have our colour enhancement added just to the forests.

Add a new AV track at the top of the timeline and use CTRL-Drag and drop to add a copy of the last photo above the original. The existing Mask track is in-between the tracks, so it will have no affect on the new copy of the photo, but any parts that we make transparent will show the enhanced forests on the track below.

Clip Masks

Instead of adding a Mask track, this time I'm going to use a Clip Mask. Highlight the new photo and then switch to the Mask sub-tab on the left and click on **Create Clip Mask**. This time, no new Mask track is added. All that happens initially is that a yellow stripe appears at the top of the target clip and Clip Mask (1) appears in the left hand panel.

The yellow stripe has the same features and the green and magenta ones we have seen for effects and corrections. Right click on it and you will see a context menu.

You can Edit, Delete, Cut and Copy Clip masks, and from the layout it's possible to deduce that a clip can have more than one mask.

Turn your attention back to the left panel of the Mask Editor and create another Clip Mask. There are now two buttons below the other controls, one for each new mask, with three icons to the right. The Disc and Bin tools are for Save and Delete

The layer icon furthest right allows you to grab the Clip Masks and drag and drop them into a new order - as shown in the screenshot.

Having explored the potential of these tools, delete Clip Mask (2) and double click on the Clip Mask (1) to start creating a shape. I want to make a mask that includes all the people and the beach but not the sky.

In Pinnacle Studio 23 I found the quickest way to create the new mask was to use the Pen tool, but now Studio has the Contiguous and Smart Brush features you can find a much quicker way to do this. For the project I used Smart Brush to create the mask in not much more than one minute. It's not perfect when you see it in front of a moving background, but with a little more time could be.

When you have made your own mask, set the Matte Properties to Opacity, with a value of zero and you should see something similar to the screenshot.

The final step is to add a background. We need a new track below the Photo track. I've added the *Sky Background.jpg* file set to *Fill*, and then animated it using Properties and keyframing so that it drifts a little - you can see the result if you load **Masking Slideshow_3 for 24.**

Transitions, particularly fades, can be an issue with masked images, as you need to add them to all the active tracks, and in the example I've built, while the inaccuracies of the masking area are not a big problem with the sky background, as the fade out occurs they are revealed. If you want to add transitions easily I suggest you form a subproject from the composite masks and apply fades to that.

Exchanging Clip and Track Masks

If you decide that you would rather use a Clip Mask instead of a Track Mask or vice versa, use the Save and Load masks functions.

Transparency and Export

If you have created a masterpiece and then find you want to animate it, there may be problems matching the moves you apply to the masks and the images - you can't copy and paste properties to Mask tracks and they don't work on Clip masks either. The easiest way to work round this is to create a still image or video clip of your masked section and then add that back into the project. For a still image set the Snapshot format to *.tga* in the *Control Panel/ Import settings*. For video, use the *Cineform* export codec available in Ultimate.

Moving Masks

The keyframing capabilities of the mask function are very useful, and easy to use. Every shape you create can be moved or transformed easily using drag and drop and nodes, and when you do so a keyframe is instantly created.

I'm going to perform a simple operation on the video file *car clip 2*. I've tried to blur out the number plate on this car in the past using motion tracking, and I've also tried to use the Motion Tracking feature now available for Rectangle in masking and it's never very successful. You might think doing this manually would be very labour-intensive, but in comparison to struggling with the motion tracking when the car goes behind the foreground lamppost, adding a moving mask is pretty quick.

Load the clip onto a new timeline and create a Shape in the Mask track mode, then scrub to the start of the clip and use the rectangle tool to draw a shape that obscures the number plate – make it a bit bigger than it needs to be.

In the Shape 1 properties settings, enable keyframing for *Position* and *Size*, then scrub forward about a second. Switch to the selection tool, drag the rectangle to cover the number plate again, adjusting the size a little if you need to.

Repeat this process every second of the clip, including dragging it off screen when the car leaves frame, and then slowly drag the scrubber along the clip. There are

times when the number plate is revealed, so add further keyframes just by adjusting the rectangle. You will find that the last second or so requires more adjustments, but I managed to create a perfectly usable mask with 15 sets of keyframes.

Switch to Function and use the Mask Properties Mosaic function to obscure the masked area, then switch to Timeline preview and check your results – pretty good considering the work we put in, I'd say.

You can check out my version by loading the **Moving Mask** project..

Panels

The Panels feature in Mask appears to be designed for one purpose, but at it's heart there is a principle that means you may find other uses for it.

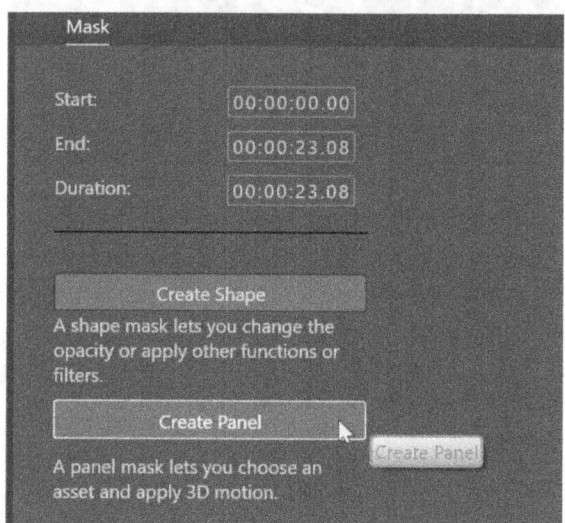

I'm going to walk through the intended use, which is to place a video or other asset on screen, contained in a mask. The mask can move, and the asset – or Panel – will automatically make the same moves as the mask. If you have a shot where you want to add a dummy TV Screen, or add a panel that looked like an information screen, all the tools are present, including the ability to manipulate the panel in three dimensions.

Start a new movie and pre-trim the first four seconds from the front of *cycling clip 003* so the In point is a 00:00:04:00 and the Out Point to 00:00:26:00 and then send it to the timeline. Select the clip and then open up the Mask feature in the In-

Built Editor, use Create Mask to add a mask track and then **Create Panel** to reach the Panel sub-tab.

The first step is to create a shape mask into which we are going to fit our Panel. We can use any shape tool we want for this, or even a group of shapes, but if we are trying to make the Panel look like a screen the most obvious choice is Rectangle, and while we are creating it we may as well restrict it to the aspect ratio of the proposed Panel - in this case 16:9. Use the Rectangle shape tool switched to a 16:9 aspect ratio to draw a mask in the top right corner of the screen.

Now we can add the image we are going to use - switch to the next sub tab Asset. Across the top of the parameter mask editor window are three location tabs - Project Bin, Video or Photo. The later two list Library Media locations so you can find any video or photo that has been added to the Library, but you should have the Cycling Clips in a Bin, so click to open **Project Bins**, locate *cycling clip 007*, highlight it and then use the **Apply** button at the bottom of the window to make the clip the chosen asset for the Panel mask.

When we return to the normal Asset tab display, the preview windows will switch to a Dual Preview, with Source/Asset on the left and Timeline/Mask on the right. In the Asset Settings the chosen asset will be shown at the top of the screen, with a trash can icon alongside in case we decide to remove it.

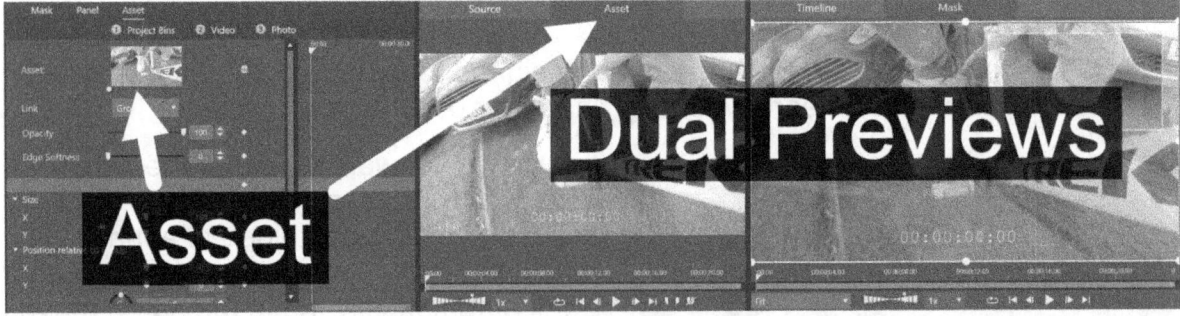

Further below the drop-down box labelled Link allows you to choose which Group or Shape the Asset should be attached to - choose Shape 1 so that the asset and the rectangle are locked together. Notice that there are also controls here to adjust the Opacity and Edge Softness of the asset.

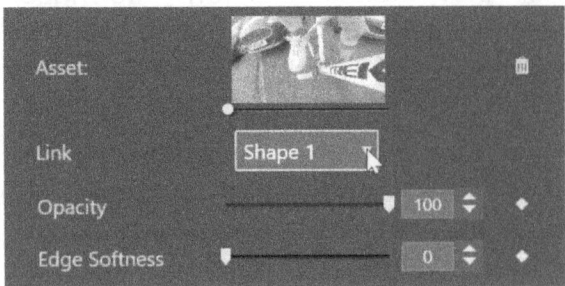

Under the thumbnail, a small scrubber allows you to explore video clips. In PS23 this also set the start position of the clip,

but PS24 introduced the Asset preview, so you can use the In and Out point calipers to set the start point and duration of the clip.

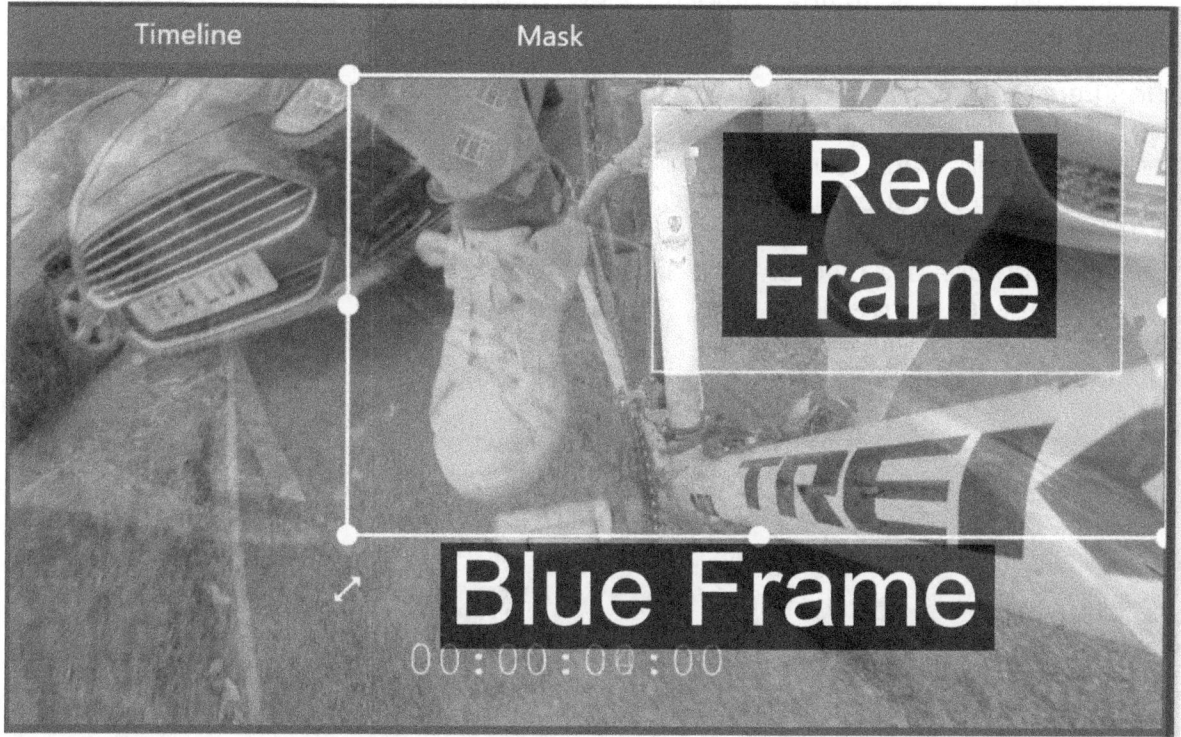

With the right-hand preview switched to Mask, the asset will have been added in a semi-transparent preview form over the Mask preview window, but look for the blue frame with nodes around the outside.

It will be full screen, but if we want the asset to fit into the mask we can use the nodes to shrink and move it to fit the rectangle, currently showing as a red shape in the top right of the screen. Do that now - there is no need for great accuracy, although it should be fairly easy to achieve.

Switch the preview window to Timeline. Only now will Playback Optimisation kick in - if you don't have it enabled you might need to switch it on for smooth playback.

So far we have done nothing that could not be done using the PiP tools - the panel appears in the position dictated by the mask. However, if we had used a mask that wasn't the same shape as the Asset, or not lined them up precisely, the mask would crop the asset to fill it, which is something that can't be done with irregular shapes in PiP.

Now for the good bit. Return to the Panel sub tab of the Mask Editor, put the scrubber at the start of the clip and enable the keyframes for *Position*. Drag the scrubber to the end of the clip and then re-position the mask to the top left of the screen. Switch back to the Timeline view, wait for any rendering to finish and preview the move.

The interesting possibilities that this feature opens up include the ability not only to use all the available masking shapes, including one created using the pen, brush and even magic wand tools, but being able to use keyframed moves on the asset via the shape or group it is linked to. Imagine a masking exercise like the one we carried out on the car number plate earlier in this chapter. We could replace the plate with a photograph of a different one, if only there were a way to manipulate the Mask and linked asset in 3D - oh, wait.....

3D manipulation

I suggest you make a temporary save before you experiment with these settings - I've called mine **Panel Test** if you want to load it.

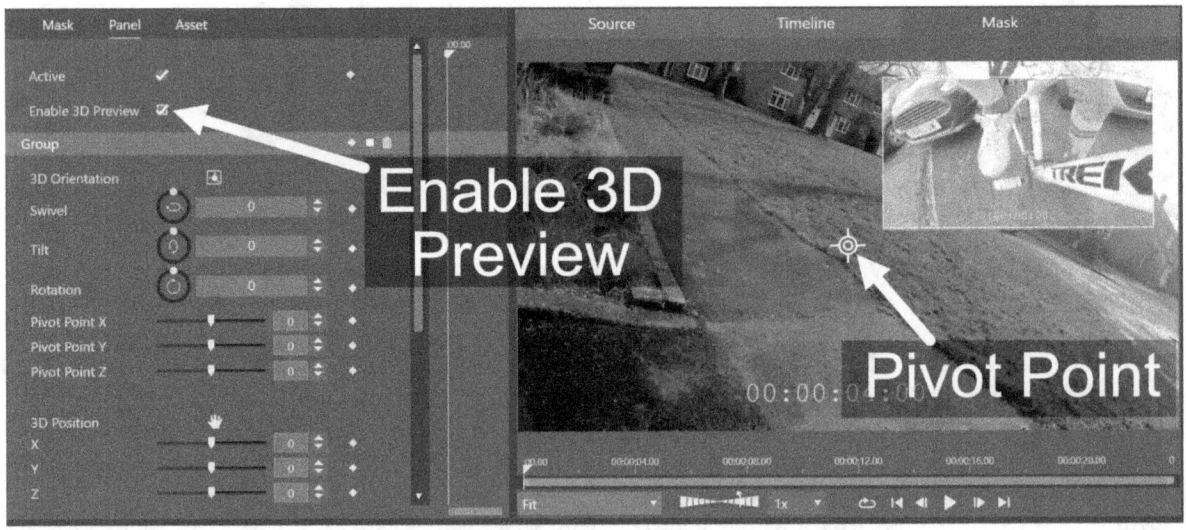

The Panel settings contains a checkbox labelled *Enable 3D Preview*. Switch it on and you can see three sets of parameters have been added to the Group. The Mask Preview has also acquired the Pivot Point icon we saw when using the PiP tools and Properties and the Title Editor.

The additional feature of these 3D controls is that the 3D positions can be manipulated on the preview screen. **3D Orientation** has a small axis tool, and if you click to highlight it the mouse cursor turns to a circle made up of three arrows. Clicking and dragging on the mask changes it's Swivel and Tilt values. If you

experiment with these you can see that the operations happen around the Pivot Point. Switch off the Orientation tool and you can drag the Pivot Point in the X and Y planes. The Z value moves the pivot point closer or further away from the viewer.

3D Position has a hand icon. When activated it allows you to move the mask in the X and Y planes. If you need adjust the Z position with the mouse, you can do so by holding down the Shift and Ctrl keys at the same time. The Z setting appears to change the panel's size, but it is actually moving it to and from the viewer.

All these controls have an affect on the 3D distortion of the panel. I'm going to create a simple example.

Reset any changes you may have made to the 3D parameters. With the scrubber at the start of the clip, change the Swivel setting to 30 and the Tilt setting to 20. Scrub through the effect this has created and you will see the the plane on which the original mask move happens has changed. Enable keyframing for the Swivel setting, and with the scrubber at the end of the clip change the value to -30. Switch to the Timeline preview and check the new move. I've saved this as **Panel Test 3D**.

Changing just one parameter at a time, you can experiment with this move to help fix in your mind how all these parameters interact. Begin by moving the Pivot point Z axis nearer or further away from the viewer. You might also want to remove the keyframing for the original mask move to clarify things further once you start using the 3D Position tool.

Motion Tracking

So you want to blur out your car number plate before you post your video on YouTube? Maybe you are trying to show off your offspring's great positional play in the football game? If the object you are trying to obscure or point at is moving in any way at all, using conventional effects can be tricky, but possible - and now keyframing as been added to the Basic version you can even manually track movement in the cheapest version. The masking options in the Ultimate version of Studio has made the task a lot easier, with far more choices, as we saw with the Moving Mask project a few pages back.

However, if the movement is anything other than a straight move at a constant speed it can also be very time-consuming. We need to harness the computer's power to follow a moving object automatically, and then attach an object or masking effect to the movement, thus saving a lot of time.

Studio 24 has two Motion tracking interfaces. The first one, available from the timeline toolbar, is available in Plus and Ultimate, and I'm going to start with this feature as it is simpler to use and to explain. After that, we will return to the Motion

tracking and Face recognition tools that have been added to the Masking tool, only available in Ultimate.

The Principle

Motion Tracking starts by creating an extra layer above the video clip with the object you wish to mask or follow. On this layer you will place the object or the mask.

For clarity, I'm going to define some terms:

The video clip that contains the object we want to track or mask is the **Target Video**.

The part of the video we want to follow or mask I'm calling the **Target Object**.

The layer or track on which the Target Video is placed is the **Target Layer**.

If we are trying to follow the Target Object with an asset then I'll call that the **Moving Title**, **Moving Graphic**, **Moving Photo** or **Moving Video**.

If we are trying to mask (obscure) the Target Object with a degraded version of the Target Object then I'm calling the asset which does the masking the **Moving Mask**.

All of the five different types of moving items may be referred to as the **Moving Asse**t.

The layer or track on which the Moving Asset is placed I'm calling the **Movement Laye**r.

The Manual Method

To follow a Target Object you need a Movement Layer above the Target Layer on which you place the Moving Asset. You then add a 2D Advanced Effect or use Properties to resize the asset and place it precisely at the starting position. Next, you then have to step through the timeline, adding keyframes to re-position the Moving Asset whenever required. You don't have to add a keyframe for every single frame if the object is moving smoothly, but the more complex the movement the more keyframes you will need.

To mask a Target Object, you need to create a copy of the Target Video on the Movement Layer. That copy is then cropped to just cover the area and shape of the Target Object to create the Moving Mask. The mask is degraded with a Blur and/or Mosaic effect. It then not only needs to be keyframed to follow the object, but may also need adjustments to its shape and size as the object moves.

Masking an irregular shaped object in Pinnacle Studio has got a lot easier with the introduction of the Mask tool, but in order to track movement accurately we could do with some help.

The Motion Tracking tools

Introduced in Studio 20, Motion tracking has been refined over the last few years. It is not available in the Standard version. Plus can only perform Follow Object - you need to own Ultimate to mask an object.

In addition to the above principles of manual tracking, an analysis of the Target Object (not dissimilar to that used for stabilising video) is used to create data which is used to alter the keyframes for every frame of video.

Now, this analysis is far from foolproof. How successful it actually is will depend on how well the software can recognise the Target Object, how fast and far it moves, and the quality of the video. If you are trying to track an object that doesn't stand out from the surrounding area particularly well, or gets lost behind another object even for a single frame, then the process will fail.

However, the Motion tracking routines take into account that this may happen, so you can make manual adjustments when the analysis starts to go wrong and then re-analyse the Target Object from that point.

Does it actually work?

Yes, it works. The examples I give below have been tested on a number of computers, so if you can't get them to do so, there is either a hardware compatibility issue or the exact steps aren't being adhered to.

That's not to say that Motion tracking is always easy. The way areas are selected for tracking could do with some refinement, Mask Object is particularly choosy about what areas it will and will not track. Some video clips will be almost impossible to add the effect to (but the same clips would create issues in other editors).

So how do you tell if it is the quality of the Target Object or a bug that is the problem? If you try to apply motion tracking and the analysis only takes a short time, but the Moving Asset disappears before the section you want to follow or mask ends, it's probably that the target is too poor. There are things you can do about that.

If you can, work with preview rendering set to zero, then you won't be caught out with preview rendering not being updated when you make changes. If your computer can't handle the video you are trying to process smoothly, check the tracking in the Effects Editor rather than on the timeline, and regularly refresh the preview render files by using the Delete option in Control panel/Storage locations.

Another issue that I have discovered is that Motion tracking will get very confused if you mix aspect ratios on the timeline - a 4:3 clip in a 16:9 project and vice versa. The position of the Tracker or Mask doesn't appear to take into account the rescaling and may try to track a completely different part of the target!

Follow Object - A working example

Let's go through the steps required to create a Follow Object effect that should work straight away.

* Create a new bin called *Motion Tracking Tests*.

* Copy and paste **The-Sky-is-the-Limit.mpg** from the sample project into the new bin.

* Start a new project and make sure the new bin is open in the Library.

* Select *The-Sky...* clip so that it appears in the source viewer window.

* Create the following In and Out points:

* In at the first frame of the four cyclists heading along the road at PAL 00:00:50:18, NTSC 00:00:50:20.

* Out at the frame after this shot ends, PAL 00:00:52:13, NTSC 00:00:52:14.

* Drag the trimmed clip to the start of track 2 on the timeline..

* Click on the T toolbar icon to open the Title Editor.

* Using the default settings, change the default text to "Fred", leaving it in the centre of frame. Switch to the Title sub-tab of the Title Editor and save the title as *Fred*.

* Now return to the Text sub-tab and change the text to "Daphne", save the title again as *Daphne*.

* In the Library, locate the titles you have just created by opening the Title category and selecting *My Titles*, select both new titles and from the context menu select *Add to Project Bin/Motion Tracking tests*.

* Delete the title on track 1.

So, the **Target Layer** (Track 2) contains a **Target Video** of less than 2 seconds duration. The **Moving Titles** are in the Library. The **Movement Layer** is going to be created by the **Motion Tracking** editor and we can do this from the **Clip Context** menu or if the clip is highlighted, the Timeline Toolbar.

- Right click on the video clip on track 2

- Select Motion Tracking

An important point to note is that if more than one clip is selected on the timeline, both the context menu or timeline toolbar motion tracking entries will be greyed out. This can catch you out quite easily because when you exit the motion tracking interface it sometimes quits with two timeline objects highlighted, so unless you look very closely it appears that motion tracking has become unavailable..

In the new editor that opens, there are two tabs top right - and by default Mask Object will be selected. For this demo we need to select **Follow Object**.

Opening Motion Tracking at Follow Object and the tracker tool

Before we can do anything else we need to set a tracker.

- Click on the small crosshair icon to the right of the label Tracker. A parameter box labelled *Follow Object (1)* will open on the right.

- Below the timeline a Follow Object (1) thumbnail box will appear

- This is where we will Drag and Drop the Moving Object - in this case a Moving Title.

- If you now hover your mouse over the preview window it becomes a cross. Hover over the blue sky and click.

- This action will create an orange circle with cross-hairs. This is the **Tracker**.

- Click and drag it so it is right across the face of Fred – the cyclist with the purple T-shirt and beanie hat

- Use the Library panel on the left to locate the *Fred* title and drag it into the *Add Clips* box.

- The title is superimposed on the preview window right over the Tracker. It's been shrunk down and has the familiar orange border and nodes used for PiP/Crop properties editing.

- Drag the title up so it is above Fred's head

If we closed the effect now it would result in the Moving Title not moving, and just disappearing after the first frame. You can see what the result would look like by playing or scrubbing the timeline of the Motion tracking editor.

Between the preview transport controls and the dropbox area below a yellow bar shows how much of the clip has been tracked - in our case, this is just one frame.

At this point we need to carry out another step before the effect will work.

Immediately below the Follow Object box header are the **Analyze** controls, consisting of five buttons. The most important button is the middle one, and we will discuss the others when we add another tracker.

Click on **Track All** - the centre one of the five tools. It consists of three overlapping circles. A progress bar will pop up, and should be in place for

around five seconds, depending on the power of your computer. When it's finished the yellow bar should be the full width of the timescale (**BUG ALERT** - in early releases of PS24 this isn't the case, but the tracking should still have worked).

Scrub through the timeline. In this case the Moving Title should follow Fred's face pretty accurately. There may be a small amount of drift from the position you originally chose depending exactly which pixel you chose to centre the Tracker over. If it does drift significantly you can try again by moving the first tracking point slightly, then re-analysing the clip.

Tracking Parameters

PS24 has added some additional tracking parameters to the Motion Tracking tool which may help you achieve a better result. However, in all these examples I've used the defaults. **Select Channels** is normally set to RGBA - all the video information that a clip might have - even transparency. If the object you are trying to track is a strong colour, however, you might want to try tracking only the Red, Green or Blue channels.

The Default for **Motion Type** is *Perspective*. I can't perceive any significant difference in the performance of the other types, and the PS24 manual doesn't (currently) give any clues as to the differences. The names of the choices aren't exactly intuitive either, so all I can really say is that if one type of Motion type doesn't give you the result you were hoping for, you might want to try another. If I find out more about these parameters I'll publish the information on the website.

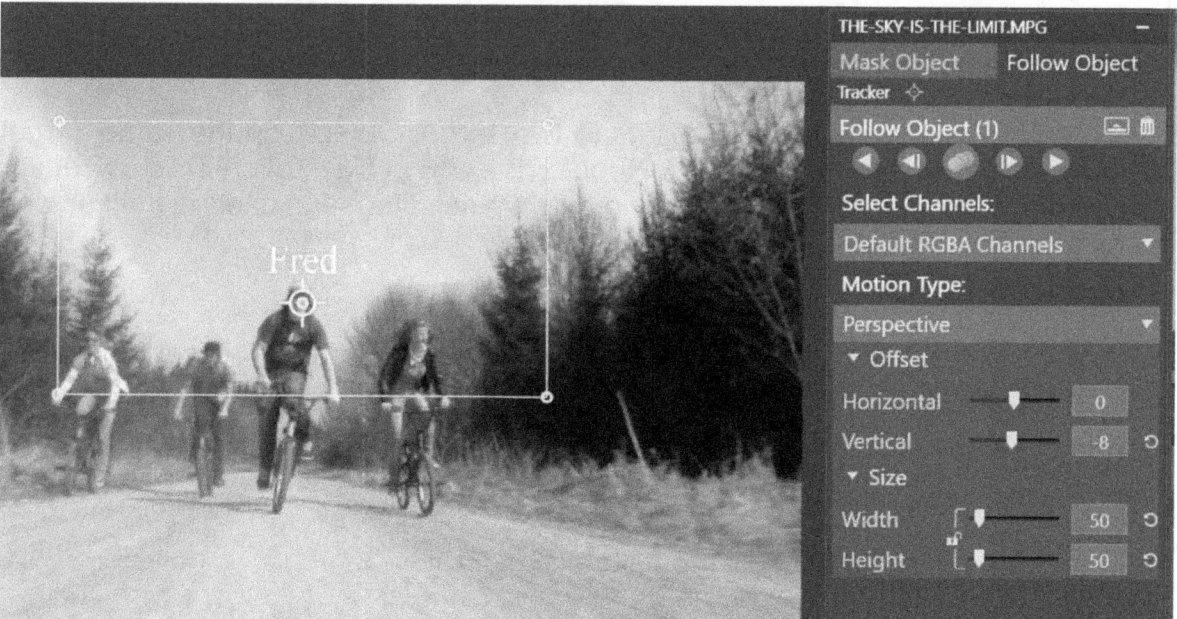

The other parameters for Follow Object allow use to adjust the positioning of the moving asset - in this case the title.

- Lock the size parameters in the Follow Object (1) box together if they aren't already locked.

Tracking Fred complete

- Set Offset/Vertical to -8 and both sizes to 50.

- Close the Effects Editor by clicking on the OK box at the bottom of the Motion Tracking editor.

Follow Object layer added to the timeline

Now you can see that the Moving title has been added to the project on it's own track - inserted between tracks 1 and 2, It even has been named **Follow Object (1)**!

Play the timeline. Pretty impressive eh? Save your project as **Follow Object Test 1**.

More than one Tracker

If you want to apply two Moving Assets to two Target Objects on the same Target Layer you need to use two trackers. Reopen the clip in the Motion Tracking editor (remember what I said about only having one clip selected) and use the tracker icon to create a new tracker, Follow Object (2)

- Set the scrubber to the start of the video.

- Daphne is the red-haired girl on the right of frame. Carefully place the tracker over her face.

- Add the *Daphne* title from the Library to the new drop zone that has appeared

- Click on the Play All central tool in the Analyze section.

- Scrub along the clip to study the effect.

Tracker Troubles

If you chose exactly the same spot as me, the tracker will only stay with Daphne for about 5 frames. It looks like the Motion tracking has failed - as indeed it has. The title may stay locked on Daphne for a bit, then the title will disappear.

If you have managed to find a point to track that lasts the whole clip, well done (or perhaps Pinnacle have done some work on the effect), but for the purposes of this demo, please go back and try again!

Now, the sensible thing to do here would be to try another tracking point. You should be able to set the tracker to her hand and get a perfect scan. You can then just change the offset values a little to place her name where you want it.

However, in other situations it might not be possible to find an alternative tracking point, so you should try the following workflow.

Something about the details of the target area have changed sufficiently to cause the tracer analysis to fail. I think it is because Daphne is turning her head.

* Scrub along the clip until you reach the first frame where the Tracker disappears.

* You mouse cursor should now be a crosshair

* Centre it on Daphne's face and click

* This time, we don't want to destroy the tracking data that is already in place, so click on the forward play icon (Track Forward) in the Analyze box.

After the operation finishes, scrub the timeline. The tracking may just go one frame forward, it may go a few, or it may go to the end. If it doesn't complete, repeat the above four operations.

* When you are successful, change the vertical offset to -8 and Size parameters 45 to give a sense of perspective relative to Fred's tracker.

* I've saved the project as **Follow Object Test 2**.

The Analysis Tools

You will notice that there are alternative analysis tools below the preview window and you can use these if you wish as they are closer to the transport controls, but both sets have the same affect.

So what are the other Analyze controls for? If the Track Forward control scans from the current position to the end, clearly the left pointing play button will do the same to the start of the clip. The beginning of a clip isn't always the best place to start the

analysis. There may be times where you want to set up a tracker some way into a clip to find a good Target Object, then track forward, return to the first tracked frame and then work backwards. At other times you might only want to scan in one direction.

The left and right jog style icons either side of the main tracking controls step through a single frame in either direction. If you haven't analysed that frame yet, the software will attempt to do so and place a marker where it would have tracked to from the preceding keyframe. If you see no tracker, then you can place one manually. You can also use these jogging controls to make individual adjustments to tracker positions on a frame by frame basis so as to do a little manual keyframing where the automatic method won't work

Editing Follow Object

Opening the tracking parameters

You can go back and tweak the tracking itself, or just change the parameters. If you decide you don't like the offset or size of the Movement object right click on the pink strip and select *Effect/Edit/Follow Object*.

and a set of parameters will

open in the Clip Editor.

Follow Object parameters

Here you can change the offset and size of the Moving Asset.

If the asset is a title, you can edit that in the Title Editor as well.

If you have added a graphic or video clip and you change your mind, it's also possible to copy the tracking data on the Movement object via the pink line context menu, and then paste it to a replacement asset on another track.

If you decide to go back to the tracking data, then your need to open the target clip in the Motion Tracking editor again. Don't be put off if there is no pink line on the clip - Pinnacle may have disabled that,

or it may be bugged. Also don't panic that your tracking data appears to be missing when the Motion Tracking editor first opens - click on the Follow Object (x) box at the bottom of the screen and the yellow tracking bar will appear for that object.

Further experiments

The clip we are using has nothing more to teach us now – you should find that tracking both Shaggy and Velma is quite straightforward, should you want to do so.

If you want to try out something a bit trickier – but still possible with a LOT of patience – I suggest you experiment using **car clip** 2 that I used earlier to mask manually.from the Trimming chapter.

Mask Object

This feature is only available in Ultimate. There is no denying that this process is trickier than a simple Follow Object effect and if you are happy to simply obscure something with a graphic you might find it easier than trying to blur it out. What's more, everything you can do in Motion tracking is available in the Mask tool, and the interface is more flexible, so I'll just write a few pointers before turning your attention back to the masking tool.

Mask Object has to define an area of the picture to mask and therefore requires at least three tracking points to work.

The process is slightly different to Follow Object. You apply Mask Object to the Target Layer, and the first step is to define the mask that forms the Target Area. There is a choice of two drawing tools to start the process, a simple rectangle with a node at each corner, or an ellipse with 16 nodes around its edges. Having used the drawing tool of your choice you can then drag the mask to move it and edit the shape of the mask by moving or adding nodes.

When you trigger the analysis, each node becomes a tracking point and the video is analysed in the same way as Follow Object. If all goes well the Target Area is cut out of the Target Video and replaced with transparency, while the Target Area that has been removed is placed on a newly created track above, and therefore in front of, the Target Video, becoming the Moving Mask. The new track is automatically labelled Mask Object.

You then have a choice of how to obscure the mask. Within the Mask Object effect itself there is a choice of Blur and/or Mosaic. Alternatively, you can add your own choice of effect to the Mask Layer or remove it altogether. This reveals the transparent hole in the Target area, through which you will see what is on the tracks below, or just black if there is nothing there.

The Mask Tool and Motion Tracking

I'm not going to lie to you – I've gone out of my way to find footage that works well, and chosen tasks that are relatively simple, in order to demonstrate the Motion Tracking tools in PS24. The reasons for this are twofold. It's not a very mature set of tools and you are likely to encounter crashes, but even if this was not the case there are some situations where you will spend more time trying to track an object automatically than it would take to do the same job manually, with a better end result. - As we did with the *Moving Mask* project earlier.

If you have jumped straight here, you should at least skim through the previous sections on Masking and the standalone Motion Tracking tool, as it will give you a basic idea of what is going on.

I'm going to perform my motion tracking exercise on a single clip. It was shot in UHD but I've downsized it to lower the computer power required to work with it. Please create a Bin or use the Motion Tracking Test bin from earlier and place **Mask Object test clip 1** into it, place it on timeline track 2 and then take a quick look at the shot.

At the very beginning of the footage we are looking towards The Cornish Pasty Company's food stall. Let us assume that you don't want to see their logo in the middle of the sign.

Select the timeline clip, place the place the scrubber at the start of the clip, open the Mask took in the Library window, then click on Create Mask. A mask track will appear above the clip, and we are ready to create a Shape, so use the button in the left panel to do so. The Mask preview appears on the right and we are going to draw a circle around the logo, so use the Ellipse tool in conjunction with the shift key to create the circle, then switch back to the selection tool in order to position it more accurately should you need to. For best results, try to match my screenshot as closely as you can.

Let us take a chance here and go straight for a full detection. In the *Shape 1* header are the five motion tracking tools I labelled in the motion tracking section earlier.

Click on the furthest right in order to scan forwards through the clip. An *Analyzing Video* message box appears informing you that it is *"Tracking Object"* and a progress bar tells you that there

are 333 frames. It counts through the frames, but when it gets to around frame 90, it will probably stop. The keyframe area will have acquired what at first look like five white lines, until you zoom in and see that they are in fact a series of keyframes.

You can examine what has happened to the mask by scrubbing slowly through the clip. The red mask won't appear until you stop scrubbing, but you should see that not only does the mask stay over the logo, but although we started with a circle, it adapts its size and shape as the camera pans.

I cannot be sure that your tracking result will be the same as mine because of the variability of the shape we have created. On one occasion when I tested this, the mask lost track of the central logo and then actually locked on to the logo to the camera right for a few frames before giving up. This shows how clever the tracking algorithm is!

Whatever result you have achieved, the tracking should be OK until the logo starts to leave frame. Things will start to go wrong after that, but before we fix that issue, let's complete the masking operation. Switch to Function and then In Mask Properties select the function Blur, but don't change any of the other defaults. Switch back to the Library tab to start Playback Optimization, and if it doesn't start, check the level you have it set to in the Control Panel/Export and Preview – it shouldn't need to be above 50% to start the render process. Play back the result and you should be pretty happy with the result until you get to 3 seconds 14 frames

– after which we are left with an unwanted blob top left of the picture. In this case that's pretty easy to fix.

Modifying the Mask

Select the clip again, open up the Mask tab and choose to Edit Mask Track (1). In my case, the first point at which the mask starts to wander is at 3 seconds 15 frames, and I've just dragged the shape a little to the left, jogged to the next frame and repeated the action until the last frame where there is a sliver of the logo left at 3 seconds 20 frames.

In other circumstances you have the power to be more creative. If you want to edit the shape you can edit on a node-by-node basis by generating the small 4-way cursor I showed you in the Circle tool. If the mask has stopped tracking the shape for some reason other than it leaving frame, once you have repaired the frames that are problematic you can try to continue automatically tracking with the *Track forward* tool. You can even track it a frame at a time, making small adjustments as you go. Each further change you make will result in extra keyframe information being added.

Using Active

If, like me, you have been left with an annoying sliver of blur on the edge of frame, or in other circumstances a mask shape somewhere in frame that has become redundant, the easiest way to disable it is to use the *Active* keyframe. Enable keyframing by clicking on the diamond shape, scrub to the point where it becomes unwanted, and click on the *Active* checkbox to turn off the check mark from that point on. Although the shape mask will still show up in Mask preview, the yellow Mask bar will be truncated, and the Blur effect won't be applied after the keyframe you have set. This is a lot more reliable than trying to trim the mask track, and you can even bring the shape back into play again by adding further *Active* keyframes.

I've saved my version of this exercise as **Mask Motion Tracking_1**. If you want to practice more, try adding two more shapes to mask the other logos on the food stall. If you would rather replace the logo rather than blur it out, refer back to how we programmed a Panel – I've tested this and it works well, but you need to remember to link the asset to the motion tracked shape, and not a group.

Other Shapes

Obviously, only those shapes that have motion tracking tools present in their header can be tracked, and although the Rectangle is as effective as the Ellipse/Circle shape I've really struggled to get the Pen tool to work at all. Perhaps this is a bug, or perhaps the motion tracking tools should not be in the header.

Face Detection

This technique is very common now in cameras. The human face has a very specific set of features that makes it pretty easy for software to say "that's a face" - a couple of eyes (or a pair of glasses), a nose and a mouth. In Studio, the masking module has a specific mask tool that will scan the current frame and tell you where it thinks a face is. Start a new movie with the Mask Object test clip on track two, scrub to 3 seconds, create a mask, then a shape and then click on the Face detection tool - it's the last tool in the masking side bar so you may have to scroll down to find it - and you will be offered three faces – they are marked with orange boxes and an outline of the features – eyebrows, eyes, nose, mouth and chin. Try the same thing at 7 seconds and three different faces are detected.

We have to track each face individually, although you can keep adding new faces by adding new masks.

I suggest you try tracking a number of the faces in the clip. When you hover over one of the detected faces, the outline turns green, and you click to select it. The mask shape can be a bit peculiar but try clicking on the Modify button to extend the mask to include more of the face. My conclusion is that you need to do quite a bit of adjustment to get a good result on small faces. The best function to use for testing is Fill, where using a solid colour indicates what has and has not been successfully masked.

I still think there is work to be done on this feature. It seems to be set up to detect skin tones on the face, so it would be best used to beautify the subject rather than blur their face out. Although the tracking itself works pretty well, the mask shapes are too detailed and the detection is somewhat insensitive, so I'd welcome some adjustable parameters. What is good is that if the tracking loses the face it was following, it can pick it up again pretty quickly, so you get non-continuous areas of detection.

Tracking Tips

Here is a summary of some things you might want try to if you are struggling to get Studio to Motion Track your clips.

- Split your clips to isolate only the sections that need to be tracked before you start working on the tracking.

- Experiment with starting the operation with the scrubber in the middle of the clip rather than the first frame.

- Try to choose tracking points that are surrounded by contrasting pixels.

- Make sure that the timeline settings match the aspect ratio of the clips.

- Make use of the forward and back tracking tools so that you don't overwrite analysis that you have modified.

- Have the patience to use the frame by frame tools for tricky sections.

- Outside of the Motion tracking editor or Mask tool don't perform any operations on clips that have already been tracked that might alter their duration.

- Don't trust timeline clips that have been preview rendered prior to the latest tracking operation - check them in the Editor and if that doesn't match the timeline, refresh the preview render files.

Montage

While the unlimited tracks of Pinnacle Studio Ultimate allow almost any type of composite effect to be created (and the 24 tracks available in the Plus version should be enough in almost any circumstances!), given enough computer resources, skill and patience, the Montage feature is a shortcut to some very complex, elaborate and visually impressive effects that require far less time on the part of the editor. The downside is that you can only customise Montages within certain limits.

Montages are stored in the Library under the category Montages and Templates, in the Themes section.

Most montage Themes consist of an *Opening* for you to start your project with, then a set of *Segues* for you to link together sections, and finally an *Ending*.

Perhaps the most obvious example can be seen in the basic Album Montage. This is an introduction, bridging and closing for a slideshow, and it demonstrates many of the controls.

To examine the Montage Editor, start a new project and drag *Album 1 - Opening* to the timeline. Switch the project settings to 16:9 and 2D. Double clicking opens the Montage Editor and we are presented with a tool that looks like the other Legacy Editors that you might still meet. To the left is the Library where we can gather assets to use in the Montage. At the bottom, above the Navigator is a blue, single track timeline that acts as a progress bar. Above the timescale and transport controls are four drop zones for adding media, and to the right are the parameter boxes, which vary considerably depending on the Montage.

The Montage Editing interface

Load up the Montage with the first three photos of the kids on their bikes in the Public Photos location - I asked you to put them in the BMX bin in the Library Chapter. Drag *The Sky is the Limit* video clip from the *Sky* bin into dropzone 4. We could put photos or videos in any of the dropzones, but in some dropzones the video

will be frozen. Some of the drop zones can also play the audio – they are invariably at the beginning and end of a Montage and have a small speaker icon in the top right corner. Clicking on the icon turns it red and mutes the audio. Click again to re-enable. The slider beneath the video sets the point at which the video begins. To remove an item from a dropzone you can either overwrite it by dropping another item over it, or right click and use the Remove Media command.

Montage Scaling

Studio has control over what happens when you add a photo or video to a drop zone that doesn't have the same aspect ratio as the drop zone itself. The default setting is **Crop**. If we put the photo of the red bike that has been shot in portrait mode into a drop zone it is cropped to lose the black edges. If you open the Control Panel at the Project Settings page you will find a drop down box with a choice of *None, Fill* or *Crop.*

Fit will distort the photo (or Video) so that it fills the frame. **None** will place the asset in the frame - if it is a photo it will have transparent edges, if it is a video it will just place it to the left or top.

In many circumstances it will be better to pre-crop the photo to the framing you want using Corrections, rather than be stuck with the cropping that the Montage tool selects automatically, or a distorted photo.

Montage Settings

Font Properties

The parameters in the case of *Album 1-Opening* include two text entry boxes to allow you to change the titles. Alongside each is a very small "I" icon that leads to a simplified version of the text controls from the Title Editor, complete with Colour Selection box and Colour Picker. The final control turns the background off, or rather, makes it transparent.

Montages can have their durations altered on the Movie or Disc Editor timeline using the normal trim controls, but the internal timing is determined by the blue timeline progress bar within the Montage Editor. The white bars and dotted lines are adjustable by dragging left or right on the handles in the same way as you adjust the motions in the Title Editor.

In the case of the *Album 1 – Opening Montage*, the solid area is the duration of the entire animation, and the dotted portion is how long we hold the full frame of the Video (or photo) in dropzone 4 at the end of the montage. When there is a slider at the beginning of a Montage it affects how long the opening asset is held before the animation begins.

If you alter the duration of a Montage on the Movie Editor timeline, the additional time is added to the end of the effect, invariably extending the duration of the dotted section at the end of the Montage timeline. To slow down the animation, I need to edit the Montage itself by adjusting the Montage timeline slider back to the right. It's also possible to adjust the incoming asset's static duration, so you can re-arrange the three sections to get the desired relationship between the static incoming and outgoing full frames and the linking animation.

The tricky thing when using montages for video is getting in and out of them. If there is a cut in the video somewhere near where you want to begin or end the use of the Montage then it's much easier to line things up. Let's work on a simple example.

In the case of the Montage we have built up, the whole effect lasts 25 seconds. The last shot – the view of the van wheel – only lasts 7 (PAL) frames. If we put another copy of the Sky video on the timeline we can match the cut by counting frames and trim using the In point of the video to the eighth frame.

But, let's say we think the animation is a bit too ponderous. We need to modify the Montage on the Movie Editor timeline first. Using the Context Menu, use Adjust Duration to change the length to 15 seconds, then open it in the Montage Editor. Whoops – we have lost the trim handle. Also we can't type in durations with the Montage Editor so that won't work either.

Exit back to the Movie Editor and use Undo to restore the Montage to 25 seconds. Return to the Montage Editor and adjust the trim handle between the solid and dotted lines to around the 12 second point.

Returning to the movie, you will see we have speeded up the animation nicely, and the outgoing video just plays for longer.

At this point, assuming that the video source you were using was long enough, you could just count the frames and edit the rest of the Sky video to make the edit seamless. However, it's going to be easier to trim the end of the Montage. Quick trim

it to around the point that it cuts to the wheel shot, and then for accuracy, use the Trim mode to generate a yellow handle on the Out point of the Montage. Use the keyboard or Trim mode controls to trim the Out point to the last frame of the trees before the video cuts to the wheels.

Now, when you put a second copy of the Sky video on the timeline, it's easy to trim the In point – it's the first frame of the wheel shot.

Montages behave slightly differently to subprojects when you edit them on the timeline, as we have just seen. The animations don't alter in the same way as keyframed effects within subprojects do. In common with subprojects, though, you cannot add a Speed effect to a Montage.

Using the project timeline Context Menu for Montages allows you to open them in the Effects Editor. You can even use keyframes effects, so it's possible to spice up the Montages even more – for example, adding an animated 3D Editor effect to one of the Multilayer Mix Animations can make for some spectacularly head-spinning results – I've used the technique to build up an opening title sequence to a discussion programme that would have taken absolutely hours to achieve in other editing programs. Perhaps it was a bit over-elaborate....

The Context Menu also has the option for you to paste whatever you last cut or pasted from the timeline (but not the Library) into a choice of dropzones, which may be a time-saving feature, particularly if you want to use clips to which you have already added effects - even the speed effect!

The Montage Context menu - Paste to Drop Zone

The Paste to Dropzone function has another use as well. In the Montage Editor you aren't allowed to add Projects or other Montages to dropzones – the program just won't let you. However you can do so by putting the project or second Montage on the timeline, and then using copy and Paste to Dropzone. Obviously if you want to use a Montage within a Montage, you need to populate the dropzones of the nested Montage first.

Stereoscopic Montages

While Montages offer a shortcut to some very neat effects for 2D movie making, if you are making 3D movies they can bring much more. The themes which have stereoscopic qualities are flagged up in the Library – there are over 90 of them. Using 3D Montages for 3D projects will really let you punch home the 3D at the beginning and end of a movie. Also, don't overlook the Video Transitions section of Montages to use in addition to the other transitions available with 3D properties.

Templates

Pinnacle Studio comes with a huge array of Montages, but even so, there are bound to be times when they don't suit your needs. Also, many of the pre-made montages are very recognisable, given the popularity of Pinnacle Studio. So, if you are trying to make an impressive movie – perhaps to advertise your own business or promote your creativity – then it's a good idea to use something original.

The tools required to create the montage templates aren't available to users (and those who do experiment with hacking into the montages to edit them find the process complex and quite prone to causing crashes).

However, Pinnacle has now introduced a new class of montages that it calls **Templates**, and these draw on the power of Studio's editing tools themselves. There are two starting points for creating your own templates. They can be created from any timeline project. Pinnacle also provide a Split Screen Template Creator which is available from the Timeline Toolbar. There are also some pre-made Split Screen templates available from the Library.

Converting Movies to Templates

It's always been possible to create some very complex movies within Studio, but if you want to use them as a model for other movies using different footage it's been hard work to accurately replace the clips. Now you can save a movie as a Template, replacing any clips that you wish with placeholders, similar to the dropzone system in Montages. Placing a saved Template on a new movie timeline, you can open it as a sub movie for editing. The clever thing about editing templates is that the Replace editing mode makes filling the placeholders nearly as easy as using dropzones.

The next demonstration goes through all the stages of producing a template, then loading it with different clips. The example I make is fairly simple, but there isn't anything special about making this sort of template, you just use the power of Studio's tools to make a short movie – as complex as you like.

For this example, I'm creating the opening titles for a YouTube channel. The imaginary channel is called Cycling News, and the opening is only 10 seconds long. I want to clearly identify the channel, but may, over time, use different video clips.

I'm going to use the Cycling Clips from the DVD or Website, and in this demo make a PAL movie, but if you wish you can use the NTSC clips or your own clips instead. If you don't want to make the project, you can load it.

If you haven't done so already, locate the cycling clips on the website and download PAL_001.mp4 to PAL_008.mp4 or NTSC_001.mp4 to NTSC_008.mp4. Now add them to a new project bin. I've called mine Cycling Clips.

Start a new movie. Select Clip 002 in the library and use the source viewer to set the In point to the burnt-in timecode of 20 seconds. Drag the source to the start of track 2. Check your project settings by clicking on the cogs icon on the timeline toolbar. They should be Widescreen 2D 1280*720 HD, with a framerate of 25p if you used the PAL footage or 30p if you used the NTSC clips. If they aren't set to that than do so manually - you probably don't have the default selection in the control panel (see page 93).

You now need to set the In point of Clip 007 to 7 seconds and put that on track 3, and the In point of Clip 004 to 23 seconds and place that on track 4. On the timeline, trim one of the clips to a duration of 15 seconds (out at 14.24 PAL, 14.29 NTSC) and snap the other clips into place.

Three keyframed effects need to be added, one for each track. Tracks 2 and 3 have a PiP added to place the clips initially top left and right at just under half size. You can do that using the PiP nodes, or enter the values – Track 2 Pos H -25 Pos V 25 Size 45, Track 3 Pos h 25 Pos V 25 Size 45. Add a second set of keyframes with those values at 9 seconds. At 11 seconds change the Track 2 Pos H value to -75 and the track 3 Pos H value to 75. Test the moves – at 9 seconds the two clips should move apart like a pair of curtains.

The opening clip positions

For track 4 I've used the 3D GPU effect to perform a flip. The clip starts in the lower part of the frame at a tilted angle, then rolls about its X axis to fill the frame. Starting keyframe values that are different from the default are Pos V -30 Size V 50 (unlock the parameters) Tilt -30. Add another identical set at 9 seconds then at 11 seconds set Pos V to 0, Size V to 100 and Tilt to 360. Mute the audio on tracks 2-4.

I'm going add a music sting and a title, so we need another track. Add one to the bottom of the timeline as track 5, select the clip on the track above, then make track 5 active. Open Scorefitter and select Inspirational/Quarterly Report/Sharks in the Water then Click OK to add the music to the project.

Final timelines

The title should say Cycling News, using the font *Elegance* set to bold, Centre justified size 120 attributes are Fill 1 Red, Fill 2 Yellow with a size of 200 and a Blur of 40. Start it on the first loud note of the music (00:00:04:10 PAL 00:00:04:12 NTSC) and stretch it to the end. Add fade ups on all three video tracks to end when the title starts, and add a 2 second fade down on the end of track 3.

Save the project as **Cycling News**.

Shift-Smart v. Replace Modes

We could just use our Cycling News project and edit it when we want to change the clips, then re-save it with a different name so as not to destroy the original. Let's look at that the easiest way to change a clip right now - it will be the same principle when we work with a template.

Make sure you are in Smart editing mode. Locate clip 005 in the library and drag it down to hover over the clip on track 2. Oh, that's no good – its punched a hole in the entire project. Press and hold Shift – ah, that's what we want! If you look closely the clip thumbnail has changed. Release the mouse button and the new clip replaces the old one. Better still, the properties that were applied to the original clip have

been transferred to the new one. The duration of the incoming clip has also been truncated to fit the space available.

You can easily choose the In point of the new clip before you add it to the project. Click on clip 005 in the Library to put it in the source viewer, then scrub the preview along to 15 seconds and set an In point (just press the I key). Now drag from the Source viewer to the clip, hold down shift and release – Job done!

OK, Now try replacing the video on track two with Clip 001. It won't work – because Shift-Smart won't let you replace a clip with one that is shorter.

Replace Editing Mode

So we have two issues with Shift Smart. You need to look quite closely at the thumbnails to see if it is working, and you can't replace a clip with one that isn't as long.

Select Replace Mode using the drop-down tool at the far right of the timeline toolbar. Now use Undo to return the project to the version we saved, and reset the In point of clip 005. Drag it from either the Library or the Source preview to hover over the video on track 2. You will see a very different display – the incoming clip is coloured pink and does not disrupt the timelines at all. Release the mouse button and the clip takes the place of the original as well as inheriting its properties.

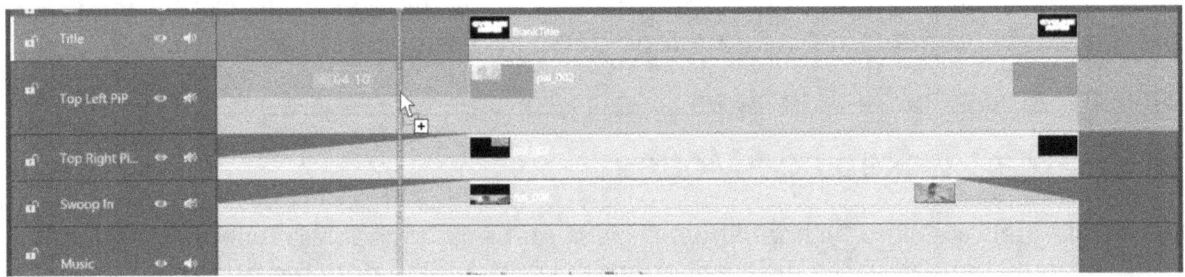

Now try the same operation with clip 001 as the source. It works – sort of. The track now holds two clips, filling the space that clip 001 could not use with the previous clip. If you play the project, though you will see that the movement of the properties has been duplicated for both clips.

To fix this, you can overtrim the first clip so that it overwrites the second. This results in a frozen frame (indicated by the pink colouring, but the keyframes now happen in the correct places.

So, that's why Replace mode exists – it's easier to see what is happening, and it works with short clips. What's more, Studio selects replace mode automatically when you are working with templates.

Creating a Template from a movie project

This is very easy. Restore the project to its original state and then open the file menu and select Save Movie as template. A new Editor opens – the Template creator. Where the Library would normally be is a list of all the replaceable assets (Scorefitter isn't a "private" asset). Each asset has a checkbox, so select all of the clips and click on Replace with Placeholder.

Template placeholder options

Now scrubbing the Movie shows that all the cycling clips have been replaced with numbered placeholders. Further limited editing can be carried out on the template if you wish, before using *Save Template* to create a new template called **Cycling News** in the *My Templates* location in the Library.

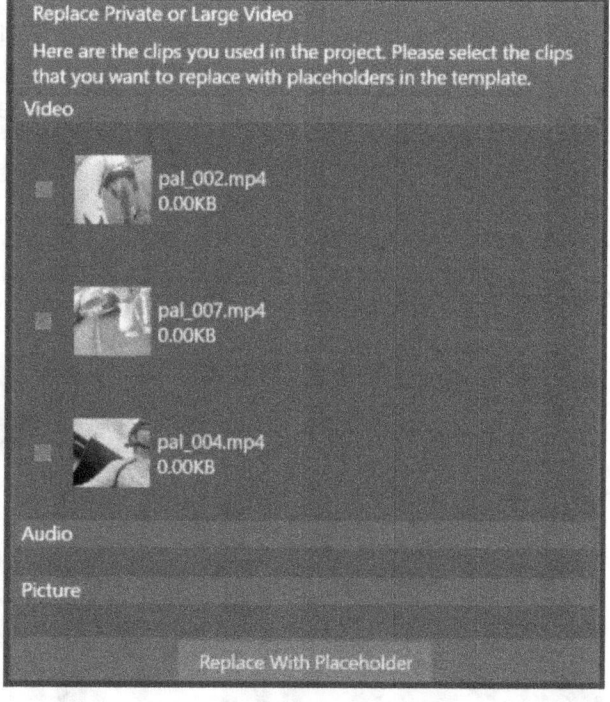

Using Templates

You can use templates in a project in three ways. If you drag a template to the timeline it behaves just like a subproject, apart from one thing – when you open it in the Sub Editor you automatically get Replace selected as the editing mode. This is how I would suggest you normally work.

You can also open a template, begin editing and then save it as a new movie, or copy the contents of a template and paste them into a normal movie.

I've just showed you how to replace clips in a movie. Placeholders can be replaced in exactly the same way using the Replace mode (or Shift-Smart if you wish).

Split Screen Templates

The description *Split Screen* disguises how powerful this feature is - you can also add shapes and animate them, as well as use motion tracking.

As we work our way though the features, we will need some media to drop into the zones. I'm using the BMX pictures we used in the Library and Photos chapter - if you haven't already put them in a bin do so now - I've called mine Split Screen.

Open the Split Screen Template Creator using the Timeline toolbar icon.

It's a Full Screen editor that has a Library panel on the left, a Settings Panel on the right, a keyframeable timeline at the bottom that works just like Legacy Pan and Zoom, a thumbnail drop zone just above the timeline and the main preview just above. Both the preview and the drop zone have the number 1 displayed. - there is only one drop zone and it occupies the whole screen.

Let's start at the beginning - by putting a picture into Drop Zone 1. Remember that we are building a template here, so although we will also get a final product, the media we use in the drop zones are place holders and when we edit the the template we can use the Replace Edit mode to swap the media for something different.

Drag a picture down to Drop zone - I've used picture 01. We could use video if we wished, but let's not put too much strain on the system yet. Nothing has changed, except the picture is in both the drop zone and the preview window. If it were the

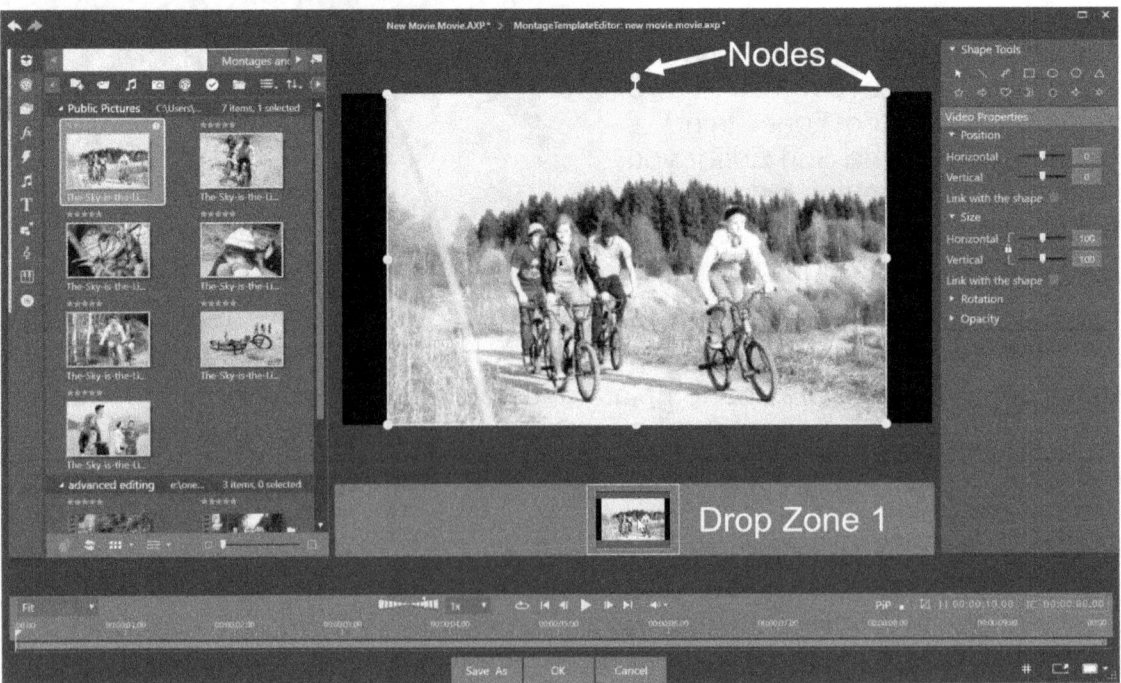

correct aspect ratio it would fill the screen, but it has been fitted to the area as best it can be. We don't have any controls although *Shape Tools* occupies the top of the settings area on the right. Click on the drop zone, however and an orange frame with nodes appears around our picture and a group of parameters appear on the right labelled *Video Properties*. Perhaps it should say Media Properties, because they work on pictures as well.

The frame indicates that we can re-position and resize the picture manually as we have done using the PiP/Scale tool.

We can use the sliders to adjust *Position* and *Size*, and if we open them up, *Rotation* and *Opacity*. The usual controls work, including the accurate keyboard ones I explained in the Corrections chapter. Make sure that the *Size Horizontal* and *Vertical* settings are locked, then enter 125 into one of their parameter boxes. There, that's fitted the picture to the screen nicely.

Notice all the *Link with the shape* check boxes. They don't do anything yet, but soon will.

Drawing a line

The simplest way to create our first split screen is to draw a Line with one of the two shape tools designed for the purpose. I'm going to show off the Curved Line, as the Straight Line has exactly the same functionality, but with one node less to play with.

Before we can use the preview screen we need to deselect the media showing in drop zone 1 - and the easiest way to do this is to click on a blank area anywhere other than the preview. The orange nodes disappear. Click on the Curved Line tool to select it and hover over the centre of the preview, click and drag downwards.Once you are near the edge, release the mouse button.

The line you have generated has automatically extended itself to reach the edges of the screen. We would not have created a split screen if it hadn't! A new drop zone has been generated, and the left side of the screen is blank, apart from the label showing us it is drop zone 2.

The line has two nodes, but if you hover over any other part of it, a four-way cursor appears and we can drag the line to change the amount of space allocated to each

drop zone. The node that is a little displaced is the Rotate node. Use it to spin the line through 180 degrees and now Zone 1 is on the left.

The node to generate a curve sits in the middle of the line. Try dragging it a bit to the right to add a curve. You can move it up and down as well to modify the curves positioning, but I'm not going for anything too radical.

Look to the right and you can see a new group of parameters is being displayed. Set the position to zero values and the rotation to 90. You can see that Size isn't adjustable, but we can play around with the border. Set the width to 10 and the Opacity to 50. By checking the *Apply to All* checkbox, all our borders should match.

Drop picture 07 into drop zone 2 and set the size to 125.

You can now switch between the two media sources by clicking on the drop zones. You see semi-transparent versions, so you can see the relative positions of them both. Click on some blank space to return to editing the Shape tools, and click on the line to bring up the Shape settings if you

need to. In this case it is a Line and doesn't do everything a Shape can, but more of that later.

OK, we still have a great deal to play with in the template creator, but I think it's best to explain the workflow of using and editing templates before we get too bogged down. There are three choices at the bottom of the screen, with **Cancel** being the best way of getting yourself out of a muddle and not destroying existing work. During the

writing of this section I found that some of the more complex actions cause Studio to be using the most memory I'd ever seen without it crashing - and then it crashed. So save often, and if the template editor starts behaving oddly, *Cancel* rather than use Save or OK..

Save As will save the current state of the template with your specified name in your specified location (check the location carefully - at the time of writing it seems to take the same default as Restored Projects.) After the template is saved it has, it should also be added automatically to your Library in *Montages and Templates/ Templates/ My Templates* location.

Do this now, saving the template as **Split Screen 1**. One slightly confusing thing is that Split Screen templates are actually saved with the extension *.psmontage.* This means that they can't be opened using the file menu. To load a Spilt Screen template into the editor, the Library context menu has an option to open Split Screen templates, or you can double-click on their thumbnail.

OK takes you to the next step. If you opened the template from the Library to edit it, then you get returned to the Library with any changes you made incorporated in the template. If you opened the template on the timeline, however, you get handed over to a Sub Editor that is in *Replace Edit* mode, just as with other templates

Now you can make further changes -including changing the Media placeholders, changing the duration, adding effects - or just close the Editor and return to the timeline from where you came.

Split Screen Templates on the timeline will re-open in the Template Editor if you double click on them. Open the context menu and you can choose to open the Sub Editor instead.

Adding more lines

Obviously the more lines you add, the more zones that you create. Open up our template from the timeline in the template editor. Add a short new line within zone 2 and it will extend automatically until it either reaches the edge of frame or another line - creating three zones. Undo that operation and redraw the new line so that it crosses the first line while drawing. In this case the new one will divide the screen into four zones - two on either side of the original.

Shapes

The remaining 11 Tools are for Shapes of various forms - from a simple rectangle to a complex 6-pointed star. You draw them using the same method as lines - click and drag - but they won't extend to the sides of the frame automatically in the same way,

rather they form an enclosed space. Once placed, they can be dragged to change their placement and you can manipulate them with the corner and rotation nodes. They don't need to stay entirely within the frame, and because they have different properties to Lines, you can use this feature to create a zone that looks the same as one created by a line, but with the behaviour of a shape.

Shapes don't break up other zones when you add them - they always sit in the foreground. New shapes overlap rather than bisect old ones.

When you create zones with lines, they are background zones, and this is apparent if you add a further line after you have added a shape - it will split up the background zones, but passes behind the shape. The zones are renumbered accordingly.

"Real" Shapes have additional properties to lines. You can set their aspect ratio to suit the aspect ratio of the media you are using. 3D Effect is also available so that you can Tilt and Swivel as well as rotate the shape.

Reload Split Screen 1 if you have been experimenting with adding more zones. We are likely to be pushing the limits of many computers here, so I suggest you turn Playback Optimisation up to 100.

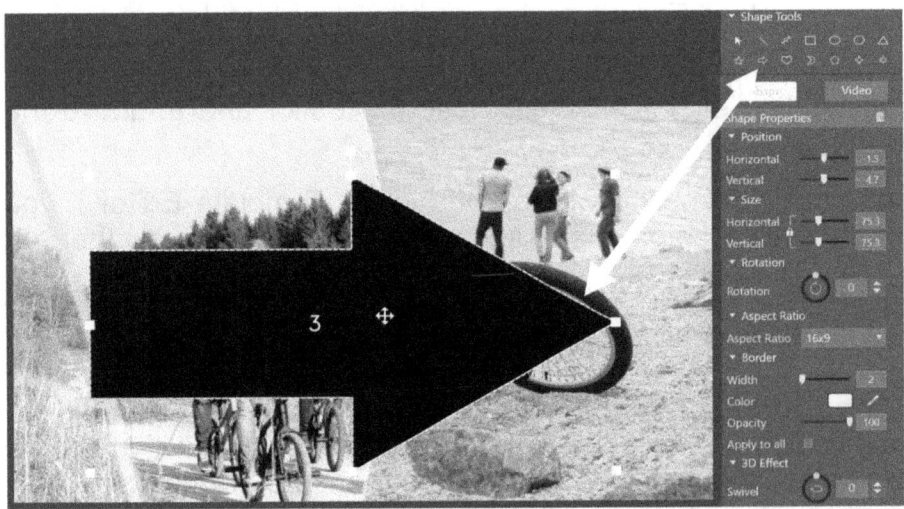

The aim is to create a drop zone in the shape of an arrow. It starts on the left of frame and is static for a second, and then flies across the screen and disappears at the seven seconds mark.

Click on the shape tool second from the left on the bottom row and draw a large arrow in the centre of frame and then drop Car Clip 3 into Drop Zone 3.

Animation

Any Line or Shape can be animated with keyframes. The principles we used in Legacy Pan and Zoom all work here too - once turned on, keyframes are generated on the timeline whenever you adjust the size or position of the currently selected shape. You can add further keyframes with the tools top left of the timeline or the

context menu, and drag, copy and paste them. For a further explanation, see the Legacy Pan and Zoom section in the Photos chapter.

Any Media - Video or Picture - can be animated in exactly the same way, independently of the drop zone it is associated with.

Keep with shape

If you want to animate a drop zone and the associated media at the same time you need to use the *Link with the shape* checkboxes. These only work with media associated with real shapes - even though they appear in the parameter lists for all media. The choice is sophisticated - you can chose to link Position, Size Rotation and Opacity independently should you wish - for example the drop zone and the associated media could be moving across the screen and changing size, but only the shape of the drop zone might be rotating.

These boxes are applied in one direction only. If you change the shape, the media changes. If you change the media, the shape is unaffected.

Let's make the arrow drop zone move across the screen now, and take its video asset with it. Make sure that *Link with the shape* is selected for all the properties of Car Clip 1, and then switch to the arrow shape. It's important that through the next steps you are dragging the Shape and not the Video asset. Place the timeline scrubber at the beginning of the montage and then drag the shape to the left.

Take it far enough so that the back of it is off the screen - the tip should just be poking into frame as in the screenshot.

I'm going to make it pause for a second before it moves. Turn you attention down to the timeline and keyframes should be enabled - if they aren't, click on the white triangle icon on the far left. Scrub to 1 second and use the set tool to create a holding keyframe.

Now scrub to 7 seconds and then drag the Arrow shape to the right until it is right off the screen - if you need to have two bites at the cherry to achieve this, it's fine - as long

as you don't move the scrubber. A third keyframe now appears - so that there is one at zero seconds, one at 1 second (both with the same values), and the third at seven seconds with new values for the off-screen position.

Click on OK. The template will be shown in the Sub Editor, so wait for the Playback rendering to complete before closing the editor and returning to the timeline and waiting for more rendering. Finally play the template and you should see the drop zone containing Car Clip 3, fly across the screen. This is **Split Screen 2**.

Motion Track in Split Screen

I'm not going to lie - it took me ages to get this feature to work. The main problem is that the motion tracking option appears in the parameter box for any video asset, but video needs to be in a drop zone created with a Shape, not a Line, in order for it to work.

The secondary problem was my own expectation of what it should do. I assumed that it would link a further drop zone to the motion tracking data from the current one.

Having got over my own stupidity, I still couldn't get it to work because I hadn't unchecked the *Link with the shape* boxes. It seemed more logical to me that they needed to be linked, not un-linked. Once you know, however.....

I've had quite a lot of issues creating a stable demonstration for this feature - I was hoping to add tracking to Split Screen 2, but things got a bit flaky, so instead here is a simple introduction to the feature. Start a new template and draw a half-size box in the centre of frame. This will create Drop Zone 2. Switch to Video properties and make sure that *Link with the shape* is disabled for position and size, and then drop Car Clip 3 onto drop zone 2.

Make sure that you have the video selected and drag it out to more or less fill the screen - the Shape should stay at half size.

Scrub to 5 seconds so the the car is nice and central and open the Motion Track parameter. Use the tracker we saw in the Motion Tracking chapter on the car's number plate, select *Track object within the split area only* from the drop-down

and click on the track All button. There will be a bit of a wait while the tracking data is collected.

You can save and exit to preview this smoothly. You will see that the car has been tracked where possible - the Shape stays still, the video is re-framed - you can see the timecode bobbing in and out of frame. This is **Motion Template 1**.

Return to the Template editor and delete the tracking with the small trash can and change the setting to *Follow Object beyond Split boundary*. Move the scrubber to 5 seconds and re-track the car. This time, the shape moves as the video stays still! You can check this as **Motion Template 2**.

These are just the bare bones of what can be done in Split Screen templates. It's a very powerful tool, but still needs some work. I look forward to returning to it in later versions and writing a more comprehensive tutorial.

Editing Enhancements

This chapter will feature some of the newer developments in Pinnacle Studio that are related to editing workflow.

Subprojects

Being able to edit Movies within Movies has always been an option, but in PS23 the implementation took a major step forward. I believe Sub projects often get overlooked, and also misunderstood. They introduce some really useful options when both editing movies and creating optical discs. If you are familiar with other upmarket editing programs such as Avid Media Composer, you should think of sub projects as an implementation of Sequences.

Benefits include:

Simplifying part of a project vertically. A particular section of a movie may require the use of many tracks, while the rest of the project does not. You might have built up an elaborate opening sequence that means the number of tracks used makes it difficult to display all of the the timeline clearly. Creating a subproject will allow you to reduce the track count.

Protecting a section of a movie. When a group of clips are contained within a subproject, it isn't possible to disrupt the relationship between the clips. So, if you want to make sure that a title is always locked to a particular position above a video clip, just make those two items a subproject. In the past, the subproject solution to sync issues was a lot of work, but now it's far easier and quicker to use.

Applying a global effect. Because a subproject is treated as a single clip, you can add an effect to the whole subproject. This is particularly useful for keyframed effects that apply changes over time.

Simplifying a disc project. When you build a disc project, you are unlikely to want to make changes to the details of the movie or movies themselves. Using subprojects rather than rendered copies of the projects both simplifies the timeline and protects the movies from inadvertent changes.

In the past, the alternative to using subprojects would be to render the movie to a new file. This will always bring with it the possibility of reducing the picture quality, even with a very careful choice of settings for the new file. The other disadvantage with rendering out to a new file is that making even a small change within the file requires you to go back to the original movie and carry out the whole render again.

One thing subprojects aren't a substitute for is the troubleshooting process of rendering sections of a project to a new file to overcome problems at the Export stage.

Creating a Subproject

A subproject can start life as a fully fledged project that has already been created. You then load into your current Movie or Disc project. The Library holds all the projects you have made with the current installation of Pinnacle Studio. Any projects that are on your computer that currently don't show up in the Library can be imported just as if they were any other asset. Therefore if you can only find a project using Windows, use the Importer or Quick Import to link it to the Library.

In Studio 23, a new method was introduced to greatly simplify the creation of subprojects. While you are already working on a project. If you select a group of clips and right-click on one of them, the context menu command **Group** has the option to **Save Group as Project**. Not only does this save a copy of the group of clips as a new project into the Library, it also removes the clips that were grouped together to form the Project and places the project on the timeline in their place.

Subprojects on the Timeline

Create a new bin called *Projects* and place the **Basic Editing Final** project into it. I'm going to refer to this as a donor project. Start a new movie, and drag the donor project to the start of track 2, where it will appear as a subproject.

Subprojects on the timeline are grey. They take up a single track, regardless of how many tracks the donor project contains. They have the same duration as the donor project unless you pre-trim them in the source viewer before adding them to the timeline.

They behave like any single clip - almost. You can Drag and Drop, Copy, Trim and Split them. Unlike splitting a title with motions, if you split a subproject you get two clips with different content.

Scrub to 18 seconds into the clip - the cut at the end of the shot where the bike hits the GoPro - and press N. Thumbnails are generated that show the In and Out points of the clips differ. Subprojects are no different from clips when you drag another clip into them - they split just like normal clips. Set a marker under the first part of the subproject at the internal cut to the shot looking back at the cyclist (just after 6

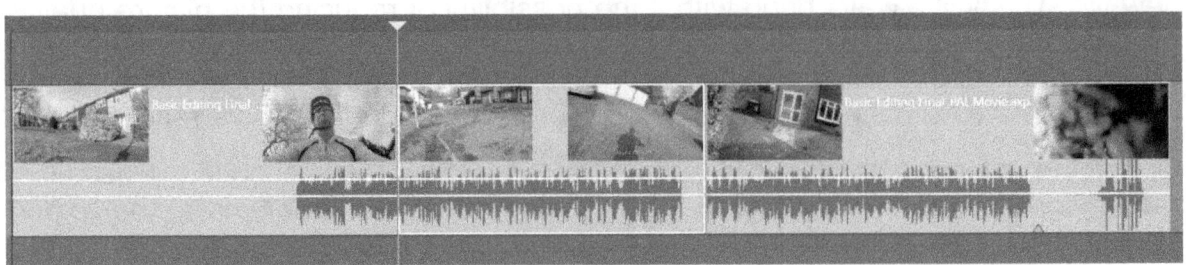

seconds). Drag the second subproject left and it inserts itself in the first subproject (or it would overwrite it, if you were in Overwrite mode). When it clicks into place, drop the second part of the subproject. (You could use the Floating preview for this, if it is enabled.).

One feature that you might appreciate is that any timeline markers in the donor project show up as clip markers on the subproject clip.

Things you can't do include Motion Tracking, adding Corrections, Detach Audio, Detect Scenes, Show in Explorer or Rotate (so you can't open subprojects in the Legacy Editor).

One behaviour that subprojects don't exhibit is displaying dead meat. If you over-trim a subproject it does not offer up a frozen frame and pink colouration. You get nothing to indicate that you have run out of material on the clip, and the clip displays black level - although as we have come to expect, this is actually transparent.

Editing Subprojects

One very important thing to understand about creating and using a subproject is that it is a non-destructive process. This means that any changes you make to a sub project aren't made to the **saved** project from which the subproject was generated, only to the copy of the subproject used in the current project on the timeline. If this doesn't quite seem logical, think of the subproject as if it were a video clip – if you trim a clip on the timeline it doesn't change the clip stored on your hard disc, so there is no reason to expect subprojects to behave any differently.

If you want to make a permanent change to a donor project that has been loaded as a subproject, you need to specifically save the subproject, not the host project.

There are two ways to open a subproject, with different results.

Opening Subprojects in the Sub Editor

This is the longstanding approach to editing a subproject. Right click on the first part of the subproject on the timeline and select *Open in Sub Editor*.

A completely separate Movie Edit window opens up **over** the current one. The only difference is that it doesn't have Windows drop-down menus, which means you can't use the Sub Editor to save any changes you make to a subproject back to the donor project. If you want to do that you most use the new workflow.

You can only open up one iteration of the Sub Editor from the host Edit window, because you have to close it in order to return, in the same manner as leaving any other Legacy editor. However, you can nest subprojects within subprojects. This

allows for the opening of multiple sub editors, which can start to use up system memory.

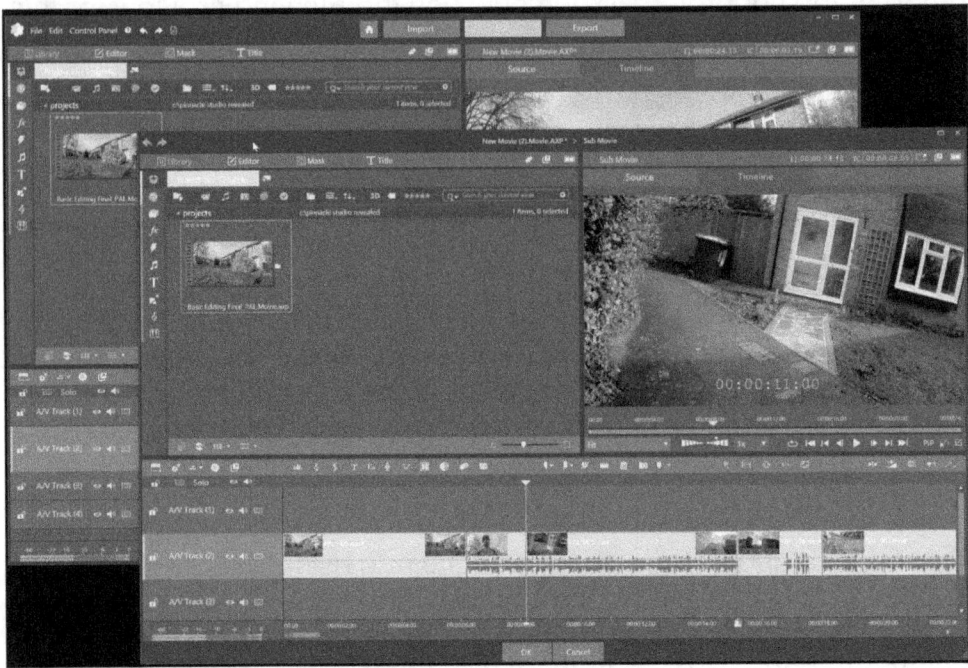

Take a look at the sub-Editor timeline. Despite the fact that we have chopped the donor project up and rearranged it, the Sub Editor shows the original order of the clips. This is what we would also expect to happen if we had done the same with a video clip on the timeline and then looked at the source clip in the Library.

However, that analogy does not work when we carry out the next step, because you can't edit a clip in the Library. Select the third timeline clip and then use Overwrite mode to delete it - either switch to Overwrite or hold down ALT and click on the Trash icon on the timeline toolbar. We have created a gap in the the timeline. Click OK to close the Sub Editor.

What you see on the main timeline may surprise you. We actually removed the video that is shown in the third slice of the subproject on the timeline, but it is still there!

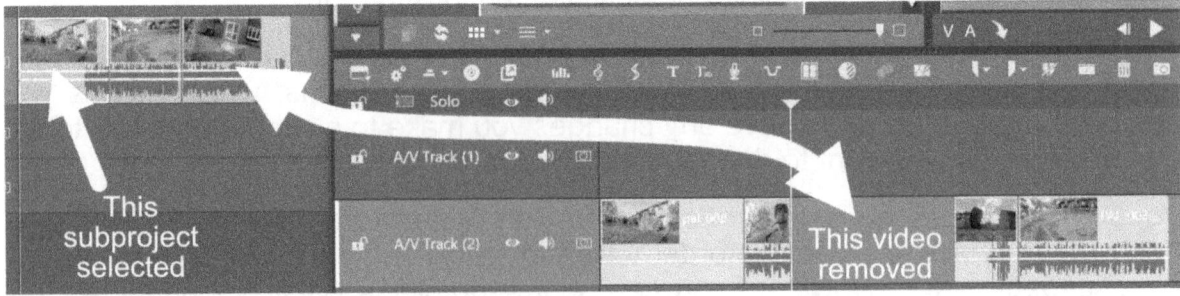

The reason that the third slice on the timeline was not affected was because each slice of the subproject on the main timeline holds it's own copy of the subproject data. We altered the data for the first slice, not the third one.

If you want to cement that principle in your mind, try editing the third slice in the same way as we just did with the first. In this case the video **will** disappear.

These principles are important if you are going to start slicing up and rearranging subproject and then re-editing them in the Sub Editor (or using the new methodology I'm about to show you), but I don't think that is likely to be a mainstream use of subprojects. The main advantages are outlined at the start of the chapter, where these complications won't have an affect. Dive into a subproject to correct the spelling of a title or change a transition and you won't have a problem.

Opening a Subproject on the Timeline

This feature was added in Studio 23 and, in combination with the grouping feature, makes subprojects much more usable. I'm not sure I'll ever be using the Sub Editor again, and would not be surprised if Pinnacle eventually dropped it.

Let's add another project to the bin - locate **Drone Project Stage 6** and Quick Import it, then double click to open it as a proper timeline movie (closing the current one in the process). Now drag the **Basic Editing Final** project to the end of the timeline and drop it on Track 2, then double-click on it.

There is no new window created. Instead, the timeline area is replaced with one that shows the subproject's, track layout and contents. The important thing is that a tab bar has been added about the timeline toolbar, with two tabs. The one with the label *Basic Editing Final* is highlighted blue, indicating it is active.

You can have more than two tabs. Each time you open a subproject a new tab is added. When you reach the physical limits of your display, small arrows appear to let you scroll between the tabs.

Click on the left-hand tab, *Drone Project Stage 6*. It becomes active, but is orange, indicating it's importance - it's the main (or host) project. If you use the standard Windows style **File menu** commands they apply to the main project even if the contents of a subproject is being displayed on the timeline and its blue tab is open.

Switching between the tabs is very quick - far quicker than opening and closing Sub Editors. As I mentioned earlier, this is reminiscent to Sequences in other editors.

The tabs have Context menus. The **Close** command (or using the small close x on the tab) simply removes the tab, not the project. When there is only one tab, the tab bar disappears.

Save stores an updated version of the project or subproject using its original name, in its original location. When you use this option on a subproject you **do** change the donor project to reflect the changes you have made while it was loaded as a subproject.

Save as offers you the choice of renaming the project or subproject and saving it to a new location.

Applying Properties and Effects

With the main project open, drag the subproject from the end of the timeline to track 1 and place it over the third clip on track 2. With the scrubber over the start of the subproject, turn on PiP/Scale and shrink the clip into the top right-hand corner. If you scrub through, you can see the PiP has been applied to the whole subproject, not just the first clip inside the subproject.

If the In-Built Editor isn't open at the Properties tab, then open it now and ensure that the subproject is still highlighted (don't double click on the subproject to do this as it behaves differently to other assets).

Scrub to the beginning of the subproject and enable the keyframes for Position and Size, scrub to halfway into the subproject and then drag the PiP across to the left of frame. This will add a second set of keyframes. Turn off PiP and then lay the timeline and you can see that the animation works on the subproject as a whole, regardless of it's internal structure. It really is as if we have exported the donor project to a file and added the export to the timeline as a new clip.

This principle applies not just to Properties, but all Effects, including colour corrections.

I'm going to use the above project in the next section, and I've saved it as **Movie with animated subproject**.

Creating a Subproject on the Timeline

Although I described how to do this at the start of the chapter, I'm going to demonstrate exactly how it works and how it can help protect your projects from losing sync.

Look at the timeline in the screenshot above and imagine that you decide that you want to pull up the last clip on track 2 by tightening the Outgoing of the penultimate clip. There are many ways to do this, but the simplest method, even in Smart mode, is a danger to the sync of the movie, because we want that last title on track 1 to maintain its position relative to the end of the last clip on track 2.

Hopefully this book has shown you the many ways you can perform the tighten safely (using Shift-Trim, Overwrite mode and gaps or even Split and Delete). However, it is easy to forget. If I use Alt Quick trim (or Advanced trim with just one trim point) on the outgoing of the penultimate clip, the final clip moves but the title stays where it is.

It can be very irritating if you are working at start of a movie, make an adjustment and don't spot what the knock-on affect has been at the other, out of sight, end until much later - perhaps even after you have exported the movie. Because of this, people are often requesting a way of locking clips together. **Now there is a quick way of doing so!**

Restore the project to its sync state and remove the transition at the start of the final clip to save confusion. Multi-select the last clip and the title, right-click on either and select *Group/*

Save Group as Project. A small dialogue box appears asking you to name the project. You can either ignore this or give it a useful name. When you click on OK two things happen. All the clips you had multi-selected disappear and are replaced

with a single grey subproject, and a project with the title you gave to the subproject appears in the Library in the current Bin.

New subprojects are placed on the highest available

track. To complete the substitution, drag the *Closing Title* subproject down to track 2.

Open the subproject by double-clicking and you can see it contains all the elements that were selected, including the end transition. It would also contain any effects, if there had been any.

This is merely scratching the surface of what you can create as a subproject. Whatever is multi-selected is included - and if you select two clips that aren't adjacent, the resulting subproject will even include a gap where other clips existed but weren't selected.

Copy and Pasting between Projects

Yes, you can! If you want to use clips or whole sections of a project in another project all you need to do now is open them up as subprojects and then copy and paste between them. This is safer than storing items on the clipboard while one project closes and another opens. The tab context menu Save or Save as commands then allow you to store your changes. I mention in the Disc menu chapter that you can use the author tab for this, but the new subproject workflow almost makes that method redundant.

Subprojects and Playback Optimisation

It is easy to push the limits of smooth previewing when you start working with subprojects. If up until this point you have not needed to have the optimisation set to over 50%, you might need to increase that for smooth playback

In addition, I've seen Studio override the setting for more complex subprojects, so don't be surprised if you see preview rendering occur on some sections even with the level set to zero.

If you do struggle to get a smooth playback, set the level to 100%, open up each subproject, wait for the rendering to occur, close the project then reduce the level back to that at which you normally work..

Latency and subprojects

Unless you have a powerful computer, you may find editing complex, nested subprojects on the timeline a bit hit or miss. The trimming operation may be jerky and you may have issues with clips lining up as if the magnet isn't working properly.

What we are seeing here is the program beginning to be overwhelmed by the complexity of the timeline, and the edit controls becoming less responsive. If you have left your preview rending at the default high setting you will be seeing render

sections appearing all the time, and if you have turned them off your preview will become laggy. (If you haven't investigated these settings yet, they are covered in the Understanding Studio chapter.) This latency will determine how far you can go with using subprojects.

Slip, Slide, Roll and Stretch

When introduced, these functions were included in the generic heading of 3-4 point editing enhancements, but they are separate, not least of which because they use just two points or less.

If you have read the Advanced Editing chapter, you will know that Studio has the ability to achieve Slip, Slide and Roll using multi-point trimming. Stretch is a fundamental tool in Time Remapping, discussed in the In-Built Chapter. However, Pinnacle have now introduced additional timeline tools to perform these tasks. They are easy to find and also easy to use, although I still find them buggy at times. You can decided to use them, or the older methods, but as each method has advantages and disadvantages, its worth understanding both.

There are actually five extra tools available on the timeline toolbar in Studio Plus and Ultimate. The **Select** tool is there so you can extract yourself from the other modes and return to the default behaviour. If for whatever reason your editing experiencing becomes odd, check that Select is orange and you haven't dropped into another mode.

Adjusting the Content - Slip

To demonstrate the four tools, I'm going to use a small project we created in the Advanced Editing chapter. It's called **Advanced trimming 1**, and if you didn't create it, you can download it from the website or load it from the data DVD.

Slip adjusts the content of a clip without altering its position on the timeline. In order to be able to do this, the clip needs leeway; unlike using multiple trim points it will never reveal a frozen frame. Take a look at the second clip on the timeline. It was originally 8 seconds long but I have already trimmed 5 seconds off the In point, so there is leeway at the beginning, but not at the end, of the clip.

Highlight the clip and then click on the **Slip** tool. The cursor changes from the selection pointer to a new cursor that indicates it is in Slip mode.

The preview window changes dramatically. It switches to a dual view mode with four frames on display - the Outgoing and Incoming for both ends of our chosen clip. If you switch off Dual View you can't see this display.

You control the amount of slip in one of two ways. Under the preview window are five icons. The central one is Loop Play and will play the whole of the trimmed clip in the In point preview. The arrow buttons either side trim the edit – left to right they trim 10 frames back, 1 frame back, 1 frame forward and 10 frames forward. You should experiment with these controls to appreciate the accuracy.

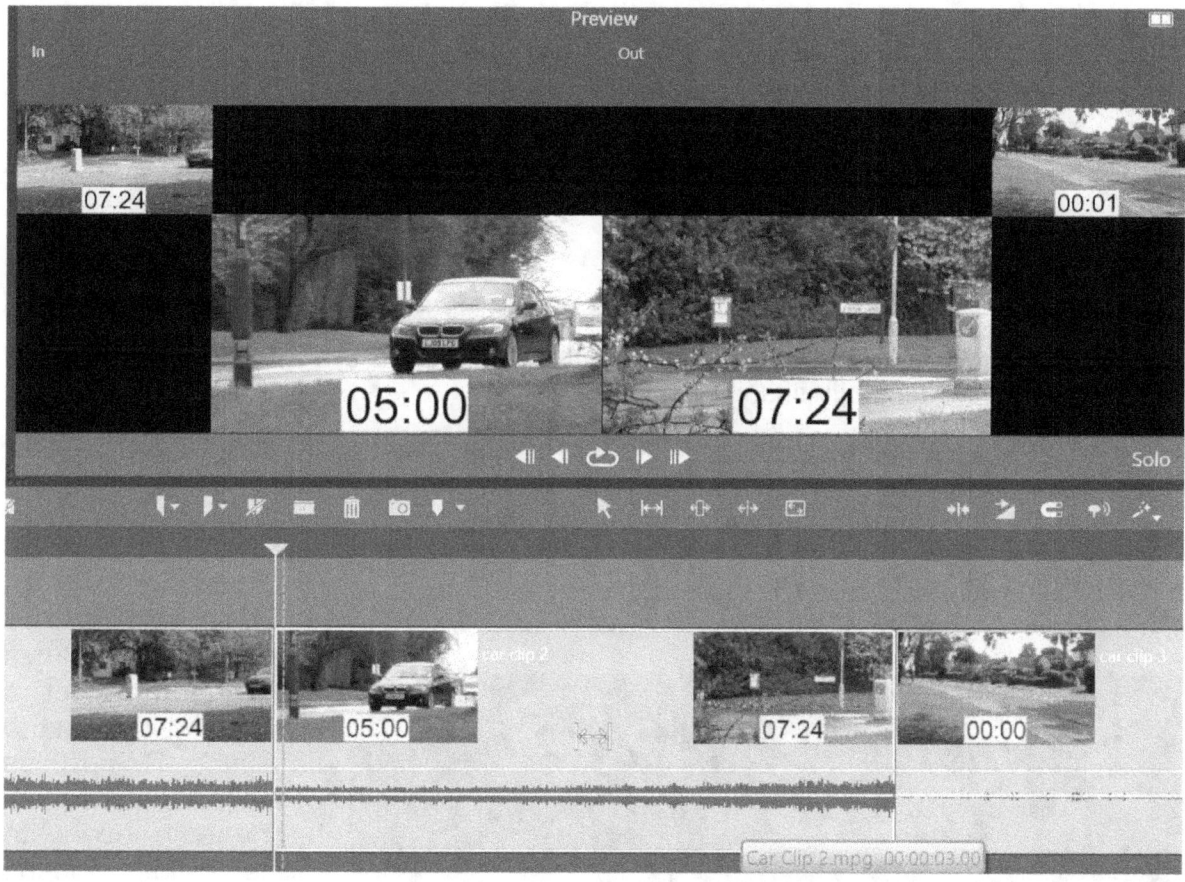

There are keyboard alternatives as well – the arrow keys (or Z and X) for single frames, or with Shift added to the arrow keys for 10 frame jumps.

An alternative are the four keys to the left of the right shift key - **M** , . and / on a US/UK QWERTY keyboard. These mimic the four buttons in the Slip Editor.

Adjust the clip now. Initially you can't go left because there is no leeway, so jog right. The position and duration of the gap into which Car Clip 2 fits doesn't alter, but the video content slides left or right.

Although this method of control is accurate and quick, if there wasn't any burnt-in timecode you would have no clue as to how much adjustment is available.

Turn to the timeline now, adjusting it to show the whole movie if that isn't already the case, and using the new cursor over the central clip, click, hold and drag a little to the left.

A semi-transparent white representation of the whole of the clip will appear superimposed over the track.

This give a very clear indication of how big the clip you are dragging is relative to the space in which it currently sits.

Currently the process can be a bit laggy, but I suspect that will improve in later releases. Incidentally, at the time of writing the thumbnail for the Incoming of clip 3 seems to be one frame out in the preview window. I have reported this to Pinnacle.

Adjusting the Position - Slide

This feature adjusts the **Placement** of a clip, sliding it along the timeline. Regardless of the editing mode, it happens in overwrite mode. Slide doesn't need leeway, but if there isn't any on the clip that is being revealed it will leave a gap.

This mode has exactly the same controls as

Slip. The preview swaps over the thumbnails so that the small ones show the unchanged In and Out point of the clip you are dragging and the large one the frames where the clip will land.

Dragging on the timeline produces a green outline of the clip you are moving and where it is going to be dropped. I find dragging is laggy, and the previews don't update often enough for it to be really useful at the moment, but the other controls work well.

An important difference between just dragging a clip in Overwrite mode and Slide mode is that while you stay in Slide, the parts of the clips which you obscure aren't deleted when you release the Slide cursor - you can adjust the clip back in the direction it came from and reveal the footage that was obscured. Once you leave Slide mode the overwrite operation is finalised.

Roll

"Rolling the edit point" is a way of saying that every frame we take off one clip causes a frame to be added to the other clip. It happens when we use Overwrite to trim, but you don't get a preview of both the new Incoming or Outgoing. You can Roll in Multi-trim mode by placing two trim points, one either side of the edit you are adjusting. This allows you to preview both points at the same time.

The Roll tool brings a new approach. Click on the toolbar icon and every edit point in the movie acquires a yellow marker. Click, hold and drag in the desired Roll direction and the cursor turns green and the split preview displays the proposed new Out and In points. You can also use the trim tools under the preview for further accuracy.

Timeline Roll won't work unless there is leeway, I'm finding the preview update to be laggy and the whole tool crash prone at the moment.

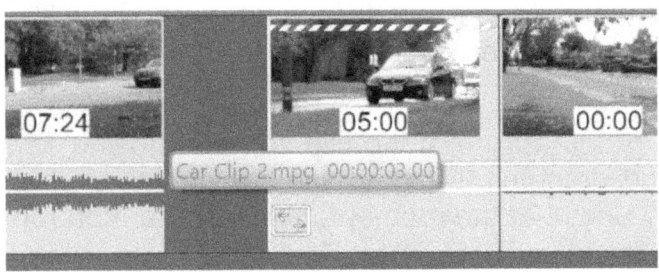

Stretch

The final tool is pretty straightforward. When active the trim cursor changes to a white box with two arrows when you hover over an In or Out point. Click, hold and drag and a yellow dashed line appears on the clip - indicating a time remapping effect has been added. The clip changes duration (in overwrite mode) but retains it's original In and Out frames, the speed of the clip changing instead. If we make it shorter, we actually shrink it, but the speed increases. Make it longer and we stretch it but make it slower.See the Time remapping section of the In-Built section for further details of how Time Remapping works.

3-4 Point Editing

To engage 3-4 Point Editing, use the drop-down Edit Mode tool at the end of the timeline toolbar and select the tool shown in the screenshot.

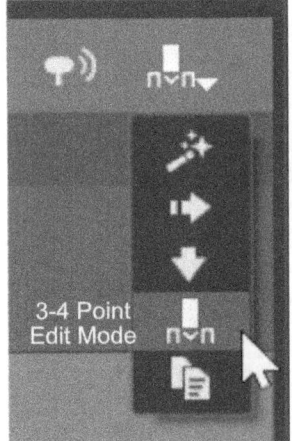

The preview switches into to Dual mode if it isn't already, and the Source Viewer acquires two new tool icons in the place of the Send to Timeline arrow. On the left is the Keep Speed control, on the right Fit to Duration. The In and Out calipers on both the Source Viewers and the Timeline have been restyled, and now the timeline ones have a more important function.

In the Basic Editing chapter I described how we can automatically fill a gap using Smart mode and also replace a clip with one of a different length using Shift when dragging a clip. While these are both basic forms of three point editing (and the most common requirement) the new tools allow you to do much more. You aren't confined to clip boundaries because of the provision of active timeline In and Out points. When you aren't in 3-4 point mode the timeline In/Out calipers are purely for selective export. The Source viewer is also capable of setting In and Out calipers.

4 Points

If we define In and Out points for both the Timeline and Source viewer, when we try to insert the source clip onto the timeline, unless the marked ares on both the source and the destination are the same duration, we have a problem. Let's see what Studio does about that.

I'm going to use the project Basic Editing 3_PAL for this demo. If you didn't make it you can load it. You will also need the PAL_003 clip - the GoPro shot from the handlebars. It may be in your Cycling Clips bin, otherwise import it.

There are only three clips and I want to add another clip, so that we cut away from the first short earlier and then cut to the third shot

Enter 3-4 point editing mode and look for an In point on the timeline. I've chosen 00:00:08:00 burnt-in timecode, 00:00:05:00 timeline timecode, and set a timeline In point.

Put the GoPro shot 003 into the source viewer. The biggest clue to continuity is the large round green bush. In the wide shot the bike is just about to pass it so I've set the source In point to 00:00:09:13 (the timecodes match)

Back to the timeline, we want to cut straight from the new shot to the second timeline shot - we don't want a slither of the first shot - so I've set the Timeline Out point to the start of the second clip, 00:00:06:05 timeline timecode.

Looking at the Out point of the source clip, and comparing with the Incoming clip in the Timeline preview, I've made a rough guess at what might cut together and set the Source Out point to 00:00:11:13.

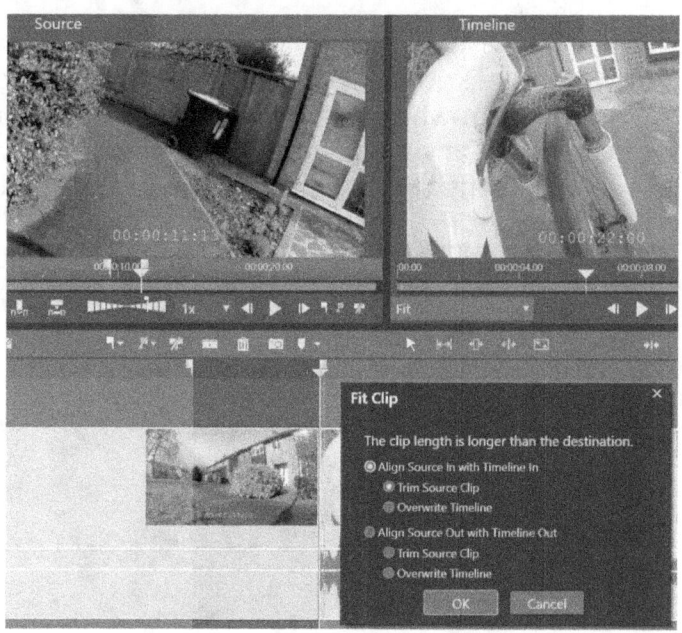

The marked duration of the source and target don't match deliberately so we can investigate what happens when they don't.

With that all set up, click on the left hand *Send to Timeline* tool **Keep Speed**.

Studio wants to know what to do because it can't obey all four markers. It only needs to ignore one of them, though.

The first choice you need to make is which is the the most important of the two edit points - do you want to match the two In points or the two out points? Given that I put a bit more thought into the In points, let's chose *Align Source In with Timeline In*.

Now we need to decided which of the two Out points to ignore. Let's cut off the source clip early by selecting *Trim Source Clip* - which in this case really means "*trim the source clip even more than you have specified*". Press OK.

Now, when I play that edit I can't help feeling there is a bit of double action with the bike passing the bin at the Out points. You might want to undo the edit and try *Overwrite Timeline*, which ignores the Timeline Outpoint. That seems a little better.

Aligning the Out points is worse. We definitely go past the blue bin twice!

I'm sure that with a bit more tweaking and perhaps slipping the content we could make aligning the In points work well. Rolling the cut would help too.

However, let's imagine that there were pressing reasons why we wanted to try and make all four of the chosen points work. That's where the **Fit to Duration** button comes into play. Undo the current edit to restore the chosen In and Out points and try clicking on the button.

We weren't asked any difficult questions. The clip in the the source viewer is now sitting between where the timeline In and Out points were marked. There is clue to what happened to achieve this this - the yellow hatched line on the inserted clip. Play the timeline and it is clearly playing back at a fast speed - almost comically so.

However, in other circumstances, a subtler version of this fix might be exactly what you need.

If the Source clip were shorter than the timeline target, you would have less choice and the source clip would not be able to overwrite the timeline.

In this example, we used one clip boundary, but neither the In or Out

points on the timeline need to coincide with the start or end of a clip. 3-4 point editing can therefore be used as an accurate way of inserting into the timeline without setting normal timeline markers.

3 Points

Setting only three points may still leave a need for questions.

If you set an In and Out point on the source and an Out point on the Timeline, Studio sets an In point at the start of the timeline, so it still needs to know if you want it to ignore the Source In. The same principle applies to setting just a timeline In point, when Studio creates an Out point at the end of the timeline.

However, if you mark two timeline points and there is only one Source point, there isn't a choice to make. If the source clip isn't long enough then when using Keep Duration, Studio will just add as much as it can.

Mark position

Alongside the timeline In and Out point markers are small drop down arrows that open a box that allows you to refine the marker's position. Rather than just set it to the playhead/scrubber, you can add an offset, set it relative to the other marker or adjust it's current position. For example, if you want to create a target area of a certain duration, setting the second marker to a value relative to the first will do the trick.

These settings currently do not remember the values you enter - you have to set them every time.

Project Formats, 3D and 360 video

Pinnacle Studio is set up by default to try to guess the correct settings for the project from the first clip you put on the timeline. That is normally what you want to happen, so why worry? Well, you could be starting a project that is going to contain both older, Standard Definition, and newer, High Definition video. If you start with the Standard Definition video, and therefore with a project that has Standard Definition settings, then any High Definition video is going to be downgraded to match the older video when you make your movie. One major advance over the earlier Classic Pinnacle Studio is that you can change project settings even after you have done some work, so if you don't start with the correct settings it is not a huge problem.

If you don't want Studio to take a guess, then you can force it to start every project with the setting you specify in the drop-down in Control Panel/Project Settings by un-checking the box *Detect Format from first clip*.

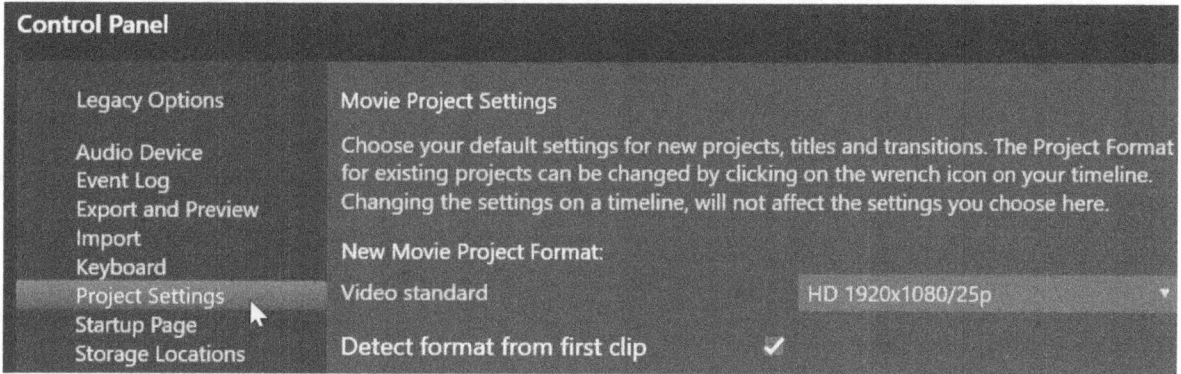

We can discover what settings the current project has adopted by using the settings icon top left of the Timeline Window – it looks like a pair of gearwheels. Hover you mouse over it and read the tool tip.

How do we change the settings if they are wrong? Click on the gearwheel icon, and you will see a box entitled Timeline Settings appear. The settings are interactive, so you can't choose an invalid combination such as PAL at 30 frames a second.

The first drop-down is for **Aspect** ratio with five choices. As well as the established standard and widescreen ratios, the 360 degree video setting allows for a 2:1 aspect. Square Video (1:1) is an aspect ratio that is becoming increasingly common for Facebook and Instagram.

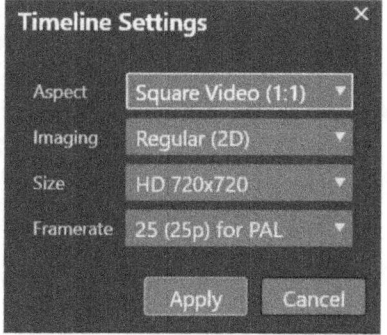

PS24 finally introduced a portrait aspect ratio of 9:16 - the equivalent of holding your mobile phone upright - so you can edit and export videos that were shot vertically.

Imaging has a choice of 2D or 3D for 4:3 16:9 and 9:16 projects. When you set a project to 3D you get a choice of preview formats, and if you haven't changed the default - Anaglyph - the colours will look strange, as you are supposed to be using Red/Cyan glasses.

Size is the resolution of your project, starting at PAL or NTSC Standard Definition (they have different vertical resolutions as well as frame rates) with 1280*720 and 1920*1080 versions of HD, and then PS Ultimate offering 3840*2160 UHD. People are used to calling that 4K, but true Cinematic 4K has a slightly higher horizontal resolution. If you want to work in that format you will need to use the Control Panel to set it. There are also equivalent resolutions for Square and Portrait aspect ratios

Frame rates vary, up to a possible 50 (PAL) or 60 (NTSC) progressive frames a second. Studio can't be tricked into faking slow motion - it will play a clip back at the correct speed even if the timeline and source frame rates are different. A 240fps clip on a 60p timeline will still play at normal speed, but you can slow it down with Time remapping to quarter speed and it will still look like smooth slow motion.

3D editing and monitoring

3D was added to Studio a number of years ago, and since then it's popularity has declined. Studio 24 does not include a licence for Multistream export or import any more, so it's worth bearing that in mind should you be a 3D enthusiast. Pinnacle may make it an Add-on at a later date, but there is no guarantee of that.

The principle of 3D video is relatively simple. Humans get a sense of depth perception because they have two eyes, spaced apart. If we can record, edit and play back a separate picture for each eye then all we need to do is feed the viewer's left and right eyes with the separate videos and they will experience the depth perception.

Recording at a basic level is also relatively simple. Two cameras placed side by side about the distance of the human eyes will give us the two channels we need. The details of the correct spacing, alignment, synchronisation and recording methods can get very complicated, but that hasn't stopped consumer video camcorder manufacturers, and you can buy 3D cameras relatively cheaply these days, although they are a lot less common than they were a few years back when 3D was added to Pinnacle Studio.

The principle of editing isn't that complex, either. The two video streams must be treated as one stream. That's about it really. The complex bit is how you feed the two eyes individually.

You can use head mounted displays to do that, but it's a pretty expensive and antisocial way of watching a movie. Cross-eyed is a format of two pictures side by side that may allow you to view 3D without any special equipment, if you can do the "cross-eyed" trick. I've never been able to achieve this form of 3D viewing, which requires you to go cross-eyed and stop focusing on the image. All I get is a blinding headache after a few minutes of trying. So this one isn't for everyone!

The first real commercial solution was the use of coloured filters in front of the eyes of each viewer. This is called anaglyph filtering. Normally 3D for this method use Red (left eye) and Cyan (right eye) – directly opposite each other in the colour triangle. When you view an image that has been coded as an anaglyph without the glasses you will see odd coloured fringing. Put the glasses on and a 3D image appears. It's not brilliant 3D, even in a darkened room.

There are three other practical methods of displaying 3D on a screen, but they all need complex hardware.

Light can be polarised – so that it vibrates in one plane only – by passing it through a filter. With a screen that transmits two images polarised at 90 degrees and two polarising filters at 90 degrees placed over each eye of the viewer, the eyes can receive two separate images.

Glasses with a shutter system can be used to switch between the left and right eye in synchronisation with a screen that is showing alternative left and right images.

Screens that use masks or lenses to display two images to a viewer whose head is in a certain position are called *Auto-stereoscopic.*

Although these three methods all require special hardware, that equipment simply needs to be fed the left and right video streams to work. In the past both streams were combined in a side-by-side view so that only one signal chain was required to connect up the viewing hardware. Formats have now been developed that combine the video signals in a way that is compatible with older equipment.

Apart from the requirement to be able to recognise the various 3D video formats and decode and recode them, editing 3D video is no different than 2D.

Studio has a wide choice of methods to monitor 3D video, but unless you own a special 3D monitor or are willing to wear Red/Cyan glasses you won't actually see the 3D effect while editing.

3D features in Studio start in the Library. There is a 3D filter available in the Filter bar, and the 3D icon is used to flag any media that Studio recognises as having stereoscopic properties.

The Corrections Editor has a drop-down menu that allows you to define the format – so if it has been incorrectly detected it can be set to the format it should be.

As you can see from the screenshot, there is a long list of choices - and therefore lots of opportunities to make a mistake!

The Effects Editor has three effects within the sub tab Stereoscopic. You can use the S3D effect to enhance or even create 3D information – and obviously to use this effectively you will need to be able to view the picture in 3D.

For example, if you add a picture-in-picture effect to a photo, you can bring it to the foreground so that appears to "float" in front of the background.

Setting up a 3D PiP effect

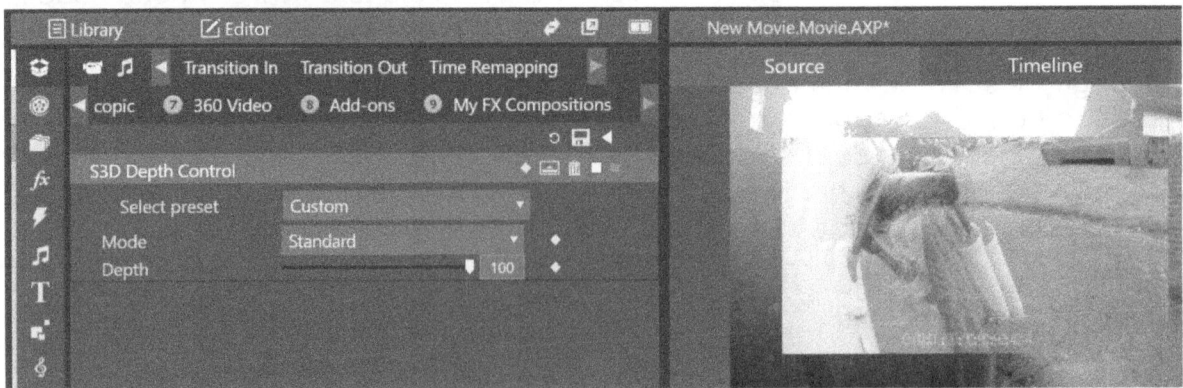

The Eye Selector can be thought of as a similar tool to the audio channel mapping – you can send the left eye information to the right eye and vice versa.

Monitoring images has a default setting in the Control Panel/Export and Preview box. There are 7 options: Left and Right Eye displays just the channel for the selected eye.

Side by Side shows both channels alongside each other without distortion. Therefore a 16:9 view becomes a 32:9 view!

Differential shows the amount of 3D information by displaying grey where the left and right channels have little or no stereoscopic information,and Red/ Cyan when the images diverge considerably

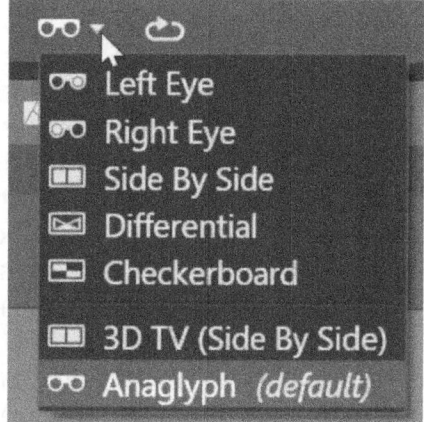

Checkerboard divides the screen area up into rectangles of alternative Left and Right channels.

3D TV (Side by Side) is a signal that can be sent to a suitable 3D capable monitor used for preview. If it is correctly set up, it will display a 3D image. On a non-3D display you see the left and right channels squashed together horizontally to fit into the correct aspect viewing window. This is the format you should use to feed full screen preview on a second monitor.

Anaglyph is the video encoded for viewing with Red/Cyan glasses.

These choices are not only available in the Control Panel. Any preview window that contains media that has stereoscopic qualities has a new control icon, showing the current display mode. A drop-down menu lets you change the mode for that window. The modes each have their own unique icon, as shown in the screenshot.

To export 3D movies you need a number of options, due to the various ways you might want to view your images. When you send a 3D project to the exporter and select File or Disc, a further drop-down menu is added to Settings for S3D. If you have a pair of anaglyph glasses and want to view your 3D movie or disc on a 2D screen, then anaglyph is the setting for you. The other settings will be required for more advanced playback methods.

Multistream is an option that is offered with the AVCHD 2 standard, and the file is backwardly compatible with older files, so if you watch a Multistream encoded file on 2D playback equipment, you will just see a 2D picture – no side-by-side images or coloured fringes. You can also make multistream Blu-ray compatible files. Unfortunately Studio doesn't currently offer this option.

360 Degree Video

I suspect that the first time most people saw 360 degree photography was when they looked at Google Street View. Not only could you visit a street that was thousands of miles away, but the picture was panoramic, and you could drag the view around to look in any direction.

Next there came 360 degree video, and at the time of Studio 21 it became the "Next Big Thing". For a true 360 degree view that looks in all directions, you need more than one lens and sensor, and you have to stitch the video files together to give the impression that they are one shot. This can be achieved by mounting individual cameras in a rig or having multiple sensors and lenses in the same housing. The more cameras or sensors, the less you rely on using wide angles of view and therefore there is less distortion. Six cameras or sensors looks great. Two sensors fitted with 180 degree lenses provide an all-round, spherical view but with distortions. At the bottom of the scale a very wide angle lens on a single sensor can achieve a view of 220 to 260 degrees. This allows you to shoot just over half of a sphere, although the edges are very distorted. I'm going to call that format half-spherical and although it's not true 360, some tools supplied for 360 degree video will work on these. What's more, you can buy a half-spherical video action camera for less the £60. The picture quality isn't great and the lens distortion is to be marvelled at, but it works.

To view 360 video properly you need a suitable viewer, so that you can look around you. When watching on a smartphone you can alter the view just by moving your phone about, and that's pretty impressive the first time you see it. On a computer monitor, enabled viewing software allows you to drag the view around.

Apart from the process of creation, there is nothing special about a 360 degree video file. It's a flat plane where, on proper 360 degree video, the left edge continues over at the right edge – so if someone walks out of shot on one side they will immediately appear on the other side.

So how does a viewing program or a video sharing site know a file is 360 video? Some special players, such as GoPro VR Player, just assume that the file is spherical. For YouTube and Facebook the file needs to have some metadata injected to it – a simple bit of information in the header that flags up that you want the file to be treated as such. Some 360 cameras add this to their output as a matter of course. There are free programs that will inject the metadata required to any other file, even one that isn't spherical. Search the Internet for Spatial Media Metadata Injector to find the one that YouTube recommends.

It's the same principle as making sure that 3D video is treated as such. If fact, with enough cameras in the rig you can produce 3D, 360 degree video for an even more immersive experience!

The more upmarket cameras will have software for viewing and editing their own footage. Specialist software can also be used for DIY projects where you may have built your own rig to hold individual cameras, and then want to stitch the files together.

Pinnacle Studio and 360 video

So, if you want to experiment with 360 video, what can you use Studio for? Well, you can't use it to create 360 degree video from individual cameras. You can't export a file using the 360 degree export presets and expect YouTube software to treat it as 360 degree video – you still need to use a small routine to inject the metadata.

You can edit pre-made 360 degree video, and then export to a suitable format. Full 360 degree video, where the aspect ratio is 2:1, is catered for with new project settings and export presets. You have to use quite a few workarounds to use half-spherical cameras.

The major benefit of using Studio is that you can make use of 360 degree video in normal projects, and then select how the 360 degree video is shown. You can include it all, or select which view you want to take. The selection can be done by simply dragging on the preview player, just as if you were using a 360 degree player.

Even better, your chosen view can be altered over time using keyframes – and therefore you can shoot in 360, then create developing shots for normal viewing.

360 project settings

Most of the fully spherical cameras work on a 2:1 ratio. It probably makes the maths a little easier as well, although YouTube seems to work to a 16:9 display. Studio doesn't seem to *Detect format from from first clip* if you add 2:1 video to a new timeline, so you will have to set it manually. When you do set the project to 2:1 the preview automatically switches to Dual view, and the source window on the left acquires a second tab labelled 360 preview. If you want to work in 16:9 using spherical or half-spherical video you can still bring up the 360 tools using the 360 entry in the Context Menu.

The additional 360 preview can be dragged to explore the clip, and a slider below the preview allows you to zoom in and out. If you just want to edit 360 footage, then you can now do so, using the preview to give you a better view of the footage. Export is possible via a couple of dedicated presets in the HEVC and the H.264/AVC

formats – you can choose SD (1280x640) or HD (1920x960). Your export, when used in the correct viewer, can then be explored by the viewer.

However, using 360 video in a standard project would normally require you to add an effect.

360 effects from the Clip Context Menu

There are a number of options in the Clip context menu for 360 conversions.

Equirectangular to Standard is for use on a file that has already been treated to look "flat".

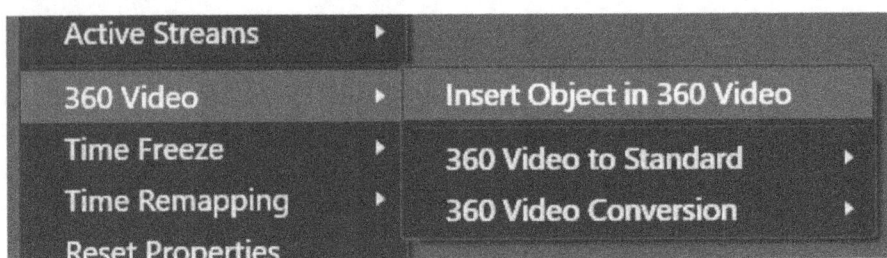

Converting it to "Standard" also adds tools for you to choose which part of the video gets shown in your movie.

In the Legacy Effects Editor this effect is referred to as **360 to Standard**.

Single or **Double Fisheye to Standard** lets you work with other types of clips – effectively the raw output from a 360 degree camera that is half (single fisheye) or fully (double fisheye) spherical. Again, you get pan and zoom controls.

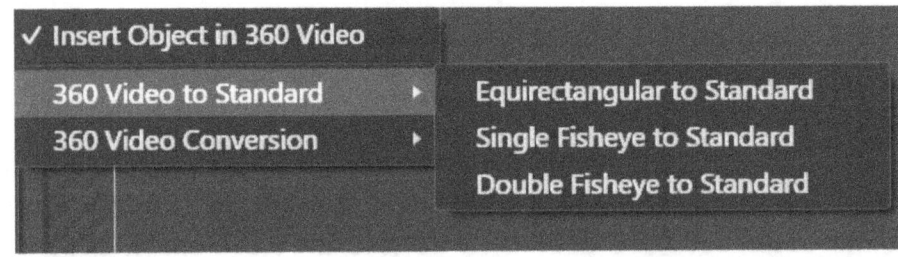

Single or **Double Fisheye to Equirectangular** are conversion tools to make raw camera video look "flat", or at least fairly flat. You fine tune the setting you need to open up the Legacy Effects Editor.

I'm of the opinion that the In-Built 360 interface is far easier to understand and use, but you might need to revert to the Legacy effects editor for precision work.

Using Equirectangular Video

You may want to load up the **Train.mp4** sample file to look at this - many thanks to Sphericam for permission to use the clip. Place it on the timeline, and set the project to 16:9, because we want to produce a "Standard" video. Right clip on the clip and select *360 Video/Equirectangular to Standard*. This is the effect you use to change

the viewpoint. It "zooms in" to a natural angle of view, by default into the centre of the video.

In the right preview window you get 360 preview, and this is where you can most easily reframe the picture. Just click and drag on the view. The parameters you set by doing this are transferred to the effect, so that's all you have to do!

In the left hand preview you get a 360 source tab that has a white graticule. Click and drag on that and it turns orange. You can use this tool to reframe the view in the right hand preview.

Reframing 360 video using the left preview

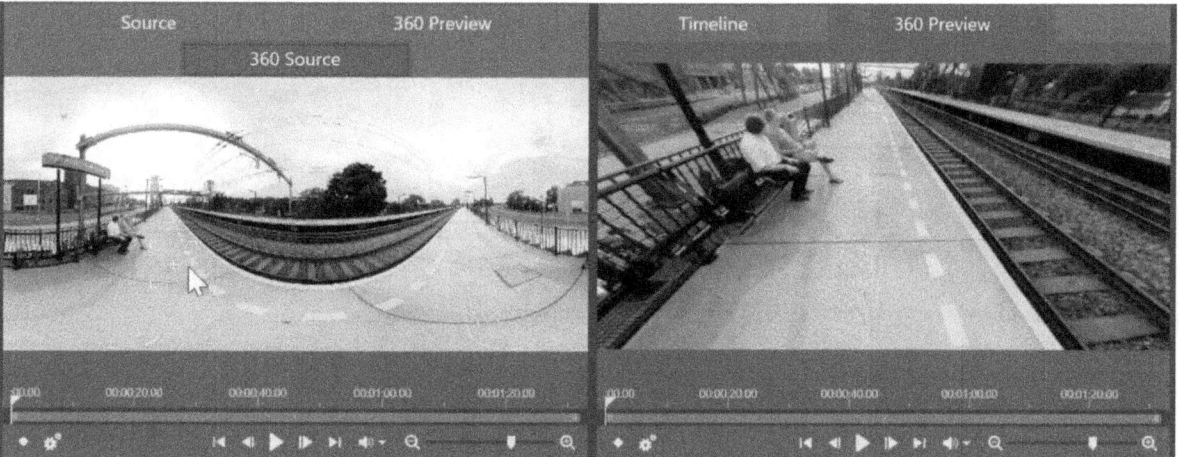

The angle of view has it's own control - a slider below the preview windows.

Keyframes

If you want to change the viewpoint during the shot, you can open up keyframe timelines under the preview windows. The principle is the same as any other form of keyframing. Currently you cannot drag and drop the keyframes using the In-Built Editor.

Keyframe Settings

If you open up the small gears icon an additional settings box appears. This allows you to either use normal keyframes - the Linear from previous keyframe radio button - or select a duration. This setting applies two keyframes at once. The first fixes the old view, the second sets the new view, with the distance between them controlled by the value specified.

When you switch to Timeline playback to test your masterpiece, the extra tabs disappear. To bring them back, click on the pink line above the clip you are editing.

Fisheye Video to Standard

This tool should be more effective on half-spherical videos such as those shot by my clone of the Kodak PixPro. You can also download my sample clip **Rising Sun.mp4** from the website. All the same controls are available. However, because of the way I mounted the camera, it's also worth trying the Equirectangular setting.

360 in the Effects Editor

Single Fisheye to Standard in the Effects Editor

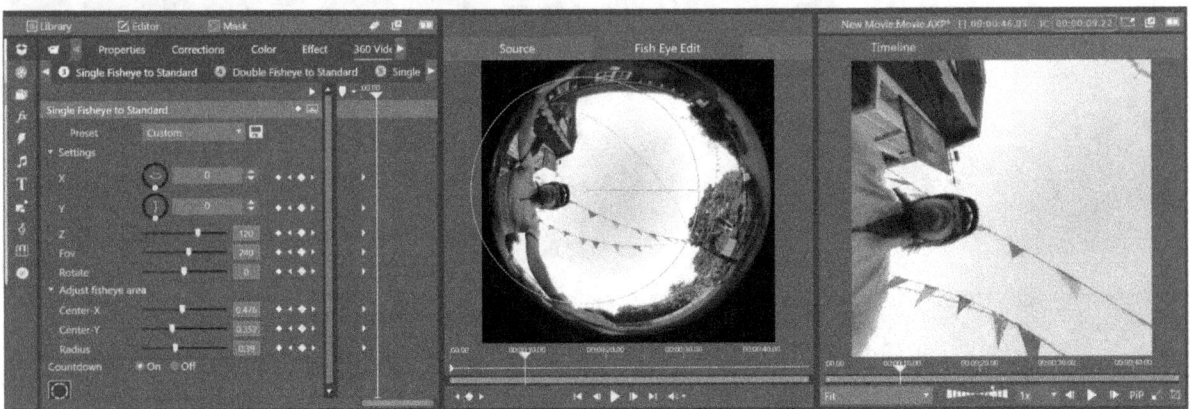

If you open an effect in the in the Effects Editor there are rotary controls to move the viewpoint as well as Field Of View, but it's with Spherical video that the Effects Editor comes into it's own. You can control the Fisheye area to suit your particular cameras.

Insert as 360

This effect is much more straight forward - it shrinks down the video so that you can see off the edges. If you use the Effects Editor, you can adjust the size and placement.

Issues with 360 video

I've been finding 360 video somewhat crash prone in Studio. The preview render files – which are really required for smooth playback for high resolution 360 – tend to get stuck once you make multiple keyframed changes. Switching to the timeline tab normally regenerates them. Failing that, try deleting the render files using the

Control panel/Storage Locations panel. Sometimes the program seems to hang completely – you might need to restart Studio.

Programming a keyframed move across the edge of a Spherical video seems flawed to me. The program always goes the "long way round" even though you can easily drag the preview in that direction.

Half-spherical videos aren't properly catered for. It's possible to use the reframing tools and keyframing, but there isn't a project setting for 1:1, nor can you export in that setting, even though YouTube handles the format reasonably.

Hopefully by the time you read this those things will be ironed out!

Square and Portrait Video

Studio gives you all the tools you need to make Videos with aspect ratios of 1:1 - the width and height of the frame are the same - and 9:16 - to suit people who shot and watch videos while holding their phone or table upright.

The attraction of Square Video is that if it is viewed on a Phone or Tablet, it's not so important in which orientation you hold the device. To some extent placing a square video display into a portrait or landscape display is slightly flawed which ever way you view, but neither are as bad as showing portrait on a landscape display or vice versa, where the black masking bars take up most of the available screen space.

Square Video is popular on Facebook, particularly with advertisers. The problem with making square video is that there aren't any cameras that I know of that shoot in that aspect ratio.

You either have to take it into account when shooting, or more likely, "sort it out in Post". This is particularly true of the trailers I see for TV shows where virtually no effort has been made to keep action within the frame, or decide which member of a 2-shot the viewer should be seeing, rather than just leaving half of each of them in frame.

The issue of Portrait video is a bit simpler. Shooting video on a phone while holding it in portrait mode is a very natural thing to do. Using that video in a landscape video project will give you a lot of work if you want to avoid showing it as a thin vertical strip. However, if the destination of your movie is a mobile phone or tablet held vertically, then you can just set the project aspect to vertical and use the provided export setting to make the final product.

Settings for Square and Portrait video

The Timeline settings are where you put Studio into Square or Portrait Video mode. Square Video (1:1) has a choice of 3 resolutions, 720*720, 1080*1080 and

2160*2160. If you are creating a video for viewing on a phone, your project is unlikely to need to be shot in the square equivalent of UHD - 2160*2160 - but it is good to have the options.

With a 1:1 aspect chosen, switching to Export reveals that there aren't any presets available for square video, but using Same as Timeline works, with the export resolution.

The Portrait mode is currently called Mobile in PS24. There are 4 possible resolutions - 540*960, 720*1280, 1080*1920 and 2160*3840, with export presets to match.

Tools for Square Video

In the likely event that your source footage is 16:9 , portrait or landscape, rather than square, you are likely to want to do some extra work rather than just choose square project and export settings. By default there are going to be black masking bars.

Fit or Fill is the choice in Scaling we used for a quick fix on photos which didn't match the project aspect ratio. **Fit** at first glance is pointless - you are just making the issue even worse by adding a second set of black bars. **Fill**, on the other hand, is going to make the sides or the top of the source footage disappear and likely lead to a lot of work.

Borders

A simple but effective way to at least reduce the impact of the those black bars when you stick to Fit is to use the fact that they aren't black on your timeline, they are transparent. That makes it the work of a moment to stick a background on the track below to take the curse off the shots. You can use a graphic of any complexity you like, or create a title with a solid background - even a colour gradient.

A further technique that you may have seen is to add a blurred version of what is happening in the foreground to the background. In the screenshot I've dragged a copy of the clip on track 2 down to track 3, used the 2D Advanced Editor to change only the vertical size of the copy to 150 and then added the Blur effect from Camera at values of 25 horizontal and 100 vertical. The result is arguably distracting, but it at least looks like you have made an effort.

Creating a moving blurred border

By the way, by using the 2D Advanced Editor instead of Properties I am able to save the new effect as an F X Composition for later use.

Other solutions

Fill is going to work far more often than you might think.

Shots that are not too tightly framed or of individual people, who are basically portrait shaped anyway, will often be fine, unless you are worried about losing information off the side of frame. However, tightly framed shots, and in particular group shots, are more of an issue. I'm sure Grandma was on the trip, but she isn't in the video....

Studio's In-Built **Pan and Zoom** tool are great for this now that they can operate on video. What's more, if you have shot in 1920*1080 and use 720 project settings, there is going to be less degradation if you zoom in a bit to improve the framing.

Animated Pan and Zoom opens up more possibilities, but also the prospect of a lot more work. If you haven't read the Photos chapter you should refer to it before starting work, and in particular the section about the *On The Fly* mode.. I'm going to give you a little project to play around with shortly, but there is another issue we have to discuss.

Just a little warning: in the first build of PS24, the preview windows and framing guides in the In-Built Pan and Zoom editor when working in Square or Portrait mode are buggy. You may have to revert to using the Legacy Editor.

Workflow for Square Video

If you are tasked with converting an existing movie from Portrait or landscape to Square you can only do a conversion. However, if it is your own movie, I'd urge you to start the project in Square. Let me show you why.

Open the **Basic Editing _2** movie - you may have made it, but it is available on the website.

Scrub to the first cut and then jog back a frame at a time. You can see the bike appear straight away. We cut away from the outgoing shot on the first empty frame - after all, there is nothing interesting about an empty frame.

Now change the project aspect ratio to Square, select all the clips and change the scaling to *Fill*.

Examine the cut again, There are now three empty PAL frames, 4 empty NTSC frames before we cut to the incoming clip.

So, what's that - a tenth of a second? Not really worth bothering about, you might say. Don't say it to a professional editor though.

Now look at the start of the first clip. Would you really have chosen to use so much of the incoming with the bike so close to the edge of frame? The eye needs to hunt around much more before it lands on what you want it to concentrate on.I would take at least a second off the In point if I was shooting

This is a very picky example of how framing makes a difference to the way you might edit a sequence, even if it is just subconsciously. So, by working in the correct aspect ratio you are making the correct choices from the start.

Pan and Scan

If you are a bit younger than me you may never have heard of or had the unhappy experience of watching Pan and Scan. It was employed when TV was 4:3 while Cinema is 16:9 or even wider. When a film was shown on TV, Instead of inflicting black bars on viewers already staring at a small screen, the film was subjected to a re-framing process beforehand that was recorded as data. That was used to reproduce the re-framing when the film was transmitted from the telecine machine for transmission.

This re-framing wasn't carried out by the Director or the Cinematographer, just somebody that knew how to operate the machine. Sometimes the results weren't seamless and to say the Director wasn't happy would be an understatement.

So, if you want to try a bit of Pan and Scan on the first shot of the Basic Editing 2 movie, open it in the Pan and Zoom editor and see how you get on. If you haven't read about Pan and Zoom yet, it is described in full in the Photos chapter, and take note of my previous warning about the framing lines when using the In-Built version.

Multi-Camera Editing

Pinnacle Studio includes a module that is designed to edit material that has been shot simultaneously with multiple cameras. Of course, it's possible to do that without a Multi-Camera Editing function. You can put your various sources on individual tracks and sync them up manually, decide on each edit point and then drag or copy the source you wish to use at any point in the movie up to a higher track. This can be very tiresome after a few edits, though, and it's easy to knock the project out of sync.

Multi-Camera helps in a number of ways. If there is sufficient information it can automatically sync up your sources, or speed up the process if you need to sync them up manually. Once the clips are lined up they can be easily locked into place. You can view all the sources at the same time in a special display. Cutting between the sources is performed with a single mouse click.

Most usefully, you can even do this as the sources are playing in real time, performing the role of a Vision Mixer on a "live" event, but with the bonus that you can go back and improve the cutting points or correct any mistakes you have made.

Once you have completed your Multi-Camera edit, it can then be used in a mainstream project, with the added bonus that you can open it just like a Subproject to carry out further changes using the multi-camera tools.

The most obvious example of a project that would benefit would be when you have used a number of cameras to cover an event such as a play, musical performance, sporting event or ceremony of some kind, with most of the cameras running for most of the time. A simpler project might also benefit from the feature – for example a tutorial using a screen capture and a shot of the person giving the tutorial.

Even if you own just one camera there are times when MultiCam may be useful. Getting your whole family to lip-sync to a song and turning the individual shots into a cut pop video is just one idea that comes to mind!

The three versions of Studio offer different number of tracks. Standard allows 2 video tracks, Plus 4 and Ultimate 6. They all have 2 audio tracks.

I'm going to start by describing the workflow and functions of Multi-Camera editing, then demonstrate how to use it with a sample project which will use three video sources. I'm afraid you will have to simplify it if you only own the Standard version, but you can still test out the principles.

Multi-Camera Workflow

There are three stages to producing a movie with the Multi-Camera feature - selecting the sources, editing in the Multi-cam module and then using the main editor for polishing the edit and exporting the final result.

The Multi-Camera tool icon

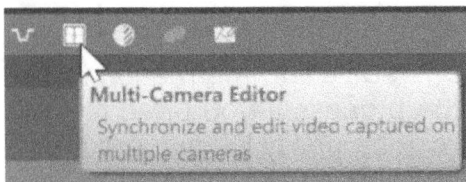

You enter Multi-Camera mode from the main Edit or Author interface using the toolbar Multi Camera icon. It looks like a screen divided into four squares. If you cannot see it, then check your toolbar customisation in case it has been hidden.

Clicking on this tool opens a new window over the main program.

Source Selection

The Source Selection Window

The purpose of this first stage is to select the clips you want to edit. On the left is the Library and on the right are the tracks. While I've called them tracks, they are in fact storyboard style strips. You drag and drop the sources that you want from the left pane to the camera and sound tracks on the right. You can have multiple clips on each strip and drag and drop them between the tracks to change the order of the clips.

Note that while it is irrelevant what you have on the timeline when you enter the Source Selector, it is possible to pre-select items in the Library that will be sent to the first stage of the Multi-Camera interface. If a single video source is highlighted, it will be sent to the Camera 1 track, and if you have multi-selected Library items the subsequent video sources will be sent to the subsequent tracks. The same occurs for audio sources. However, while this approach is quite efficient, it does mean that the sources are placed on tracks in the order that they appear in the Compact Library. You could adjust the sort order, but you can also simply drag and drop the clips between the tracks once they are there.

The Multi-Camera Editor

The Main Interface

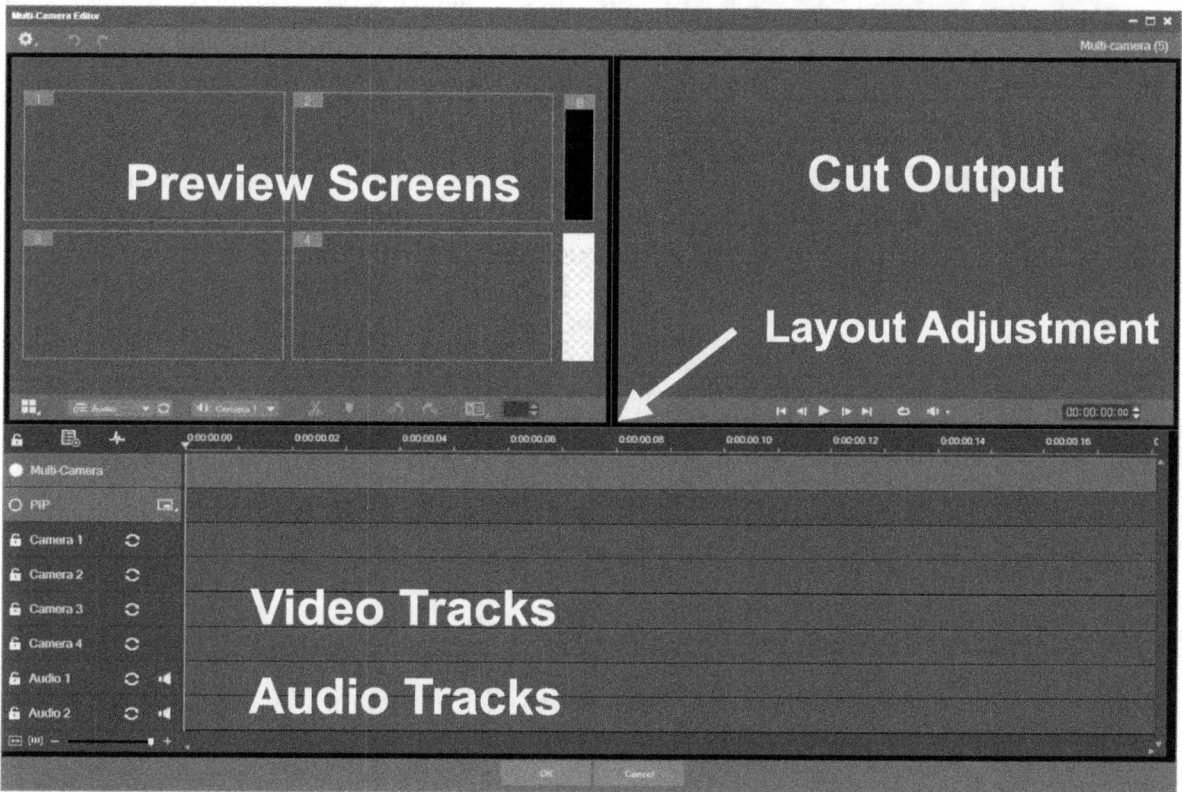

In order to reach this window you need to go via the source selection stage. Let's do that now:

• In the Edit mode of Studio, make sure nothing is selected in the Compact Library.

• Click on the MultiCam tool.

• In the Source selection window there should be nothing on the tracks. Delete any items that are there.

• Click on the OK tab.

The Multi-Camera Editor (or MCE for short) can be displayed as a smaller window over Studio or Full screen, using the standard Windows Maximise/Restore Down tool top right of the window. The layout of the windows is adjustable. Hover over the boundaries of the three areas and you can adjust them in a similar manner to the main edit interface, although you don't get the four-way arrow icon.

The Save as function in the menu

Below the title bar there are three tools on the left. The cog wheel opens a menu that includes Saving and Settings. Using the *Save as* option changes the project name from the default to something more helpful. Audio scrubbing can be turned off, and *Reset Layout* will adjust the screen layout to the default. The most important option is the *Smart Proxy Manager*, and I'll discuss proxies later in this chapter. Beside the menu are Undo and Redo icons. To the right on the other side of the screen is the current MCE project name.

The top half of the editor holds the preview areas. On the left are the Camera sources you have added to the tracks, on the right there will be a larger main preview of the output or selected source. There are also two other potential sources displayed between the Cameras and the Output Preview. B is Black Level and inserts black video. 0 is Transparent, which will be of more use when using the PiP track.

The MCE toolbar

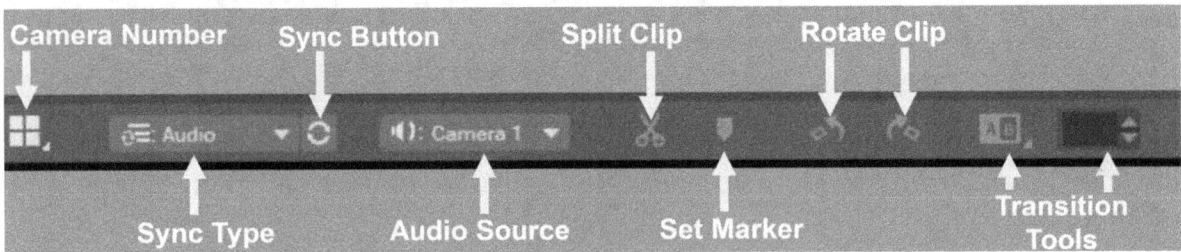

The toolbar immediately below the sources contains 10 items. If you can't see that many, the source preview may be too small to display them all and you will need to adjust the layout. Furthest left a Multi-Camera icon allows you to switch between four or six cameras. You will only have this choice with the Ultimate version. Switching to six sources reduces the size of the Camera previews, so I suggest you only use the six camera mode if you are using more than four cameras. The MCE will automatically open in 4 camera mode unless you have added video to tracks 5 or 6.

Syncing up the tracks

The next tool offers four strategies for syncing up the camera sources. The drop down box offers the choices and the Sync button to the right moves the sources on the tracks below so that they are lined up correctly.

Sync Selection choices

Audio syncing is the most powerful. The audio waveforms of the sources are analysed and Studio attempts to find a match between them. Assuming that there is half decent quality sound on all the cameras you should find this process works well.

Selected Areas is a more sophisticated version of Audio syncing. It allows you to define the areas of each clip that are searched for matching audio. If you experience problems with the program latching onto the wrong piece of audio, you can use this feature to exclude the section that is causing the issue.

Marker syncing is the next best alternative. The user manually places a marker on each track, and when the the sync button is clicked the markers are lined up. If you have shot something with a clapper board or some other type of syncing device this method is reliable. If not you will need to use some sort of visual clue to provide you with a sync point.

Shooting Date/Time will normally only get you in the ball park unless you use professional equipment. Using the file properties relies on the cameras to all be set to the same time of day and stopped at the same time, and even if they are spot on the result isn't going to be frame accurate unless the cameras are all locked together.

You can use a combination of methods to sync up your sources. Two sources might line up correctly using the audio, so then you can lock those tracks with the track locks. You might be able to use a visual clue to line up another track, then lock that. A track that you line up using the Date/Time might be close enough for you to then manually drag and drop along the timeline. You can do this with frame accuracy if you zoom the view in sufficiently using the slider at the bottom left of the window.

You can use a combination of methods to sync up your sources. Two sources might line up correctly using the audio, so then you can lock those tracks with the track locks. You might be able to use a visual clue to line up another track, then lock that. A track that you line up using the Date/Time might be close enough for you to then manually drag and drop along the timeline. You can do this with frame accuracy if you zoom the view in sufficiently using the slider at the bottom left of the window.

Audio Selection

MCE Audio selection

The next tool to the right allows you to choose your audio source. When you are cutting your video, you might also want to cut between the audio sources as well. For this you would select the Auto option. In most circumstances this is going to sound very odd, but you might want to use this feature to provide a "cut feed" of the audio choices to work on outside of the MCE. If you don't want any audio selected as you make the cuts, you can select None.

The most likely scenario is that the audio on one of the cameras will be the best choice, and you can select which camera you want from the drop-down menu.

When I shoot with more than one camera I like to use a Digital Audio Recorder, either using its internal microphone, a better external one plugged into it, or if I'm recording a staged event, getting a feed from the house PA system. If you do something similar, you will want to place the recording on one of the audio tracks and use that as the source.

The final option is to use the audio from all of the cameras. This isn't quite as odd as it initially sounds because the audio from each camera will be placed on a separate track for further editing in the main program.

The Audio selection controls both the audio of the final movie, but also the audio you hear as you are making your choices.

Editing tools

The Scissors icon is used for re-editing operations. The Marker tool is to help with syncing up the tracks, and only becomes available when Marker is selected for syncing operations.

When a source track is selected, the Quick Rotate buttons become highlighted and therefore available. You can't use Corrections, Pre-trimming or Effects on the sources, but the ability to rotate the video is available with these tools.

Finally there is a transition tool with associated duration box. We will look at this in detail when we make the demo project.

The Main Preview screen

To the right of the source previews another display shows either the camera sources or the movie as you edit it. Clicking on a clip on a source track puts an orange border around the source window for that clip and also displays it in the larger preview at the current scrubber position. Clicking on either of the two upper tracks labelled Multi-Camera or PiP displays what is on those tracks.

The controls under the main preview will be familiar to you from all the other preview screens. There is a limited amount of keyboard control of playback, but the most important do work – Space to start/stop and the arrow keys for single frame jogging

The Timeline area

The lower half of the editing screen is filled with timeline tracks, which have headers on the left. Above the headers are three controls, and there is a timescale above the tracks.

The tools above the track headers

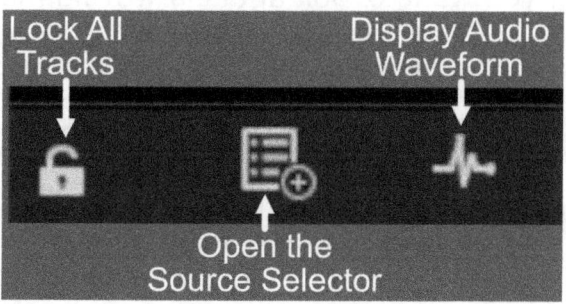

Lock All Tracks sets all the track padlocks. As a general rule, once you have synced up your tracks, its a good idea to lock them to prevent accidents. Clicking on this tool again releases all the locks.

Secondary Source manager

The next tool opens up yet another new window offering a way of modifying the contents of the source tracks once you have entered the MCE. This is a simpler interface, as it doesn't have access to the Compact Library.

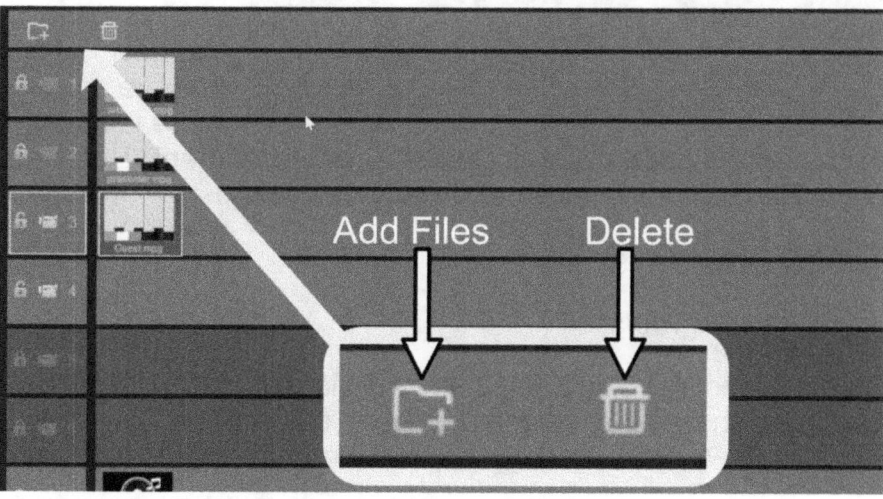

The Folder icon allows you to import new material, the Trash can to remove it, and to change the order of the clips you just drag and drop.

The source manager is very protective of items that are locked, and the track locks are inherited from the main editor, so in order to do anything with a clip you may need to unlock the track it is on, using the padlock icon.

Selection of a track is achieved by clicking on the header. An orange box will appear around the currently selected track. This is now the track that will receive any source material that you import with the Add Files folder icon, which opens a Windows type import dialog programmed to show only compatible source files.

Waveform Display

Normally the tracks of the MCE editor show a thumbnail at the start of each clip, but if you want to look at audio waveforms instead you can use the Audio Waveform tool. This is very useful when trying to sync up clips manually or finding the right spot to place markers when using that form of syncing.

The Timescale and Timeline views

Above the tracks is the familiar timescale, but again this is of a slightly simple form, with no ruler zooming you can click on the timescale or the target tracks to re-position the scrubber, or click and hold on the scrubbers cursor on the timescale to drag it.

Timeline Scaling Views

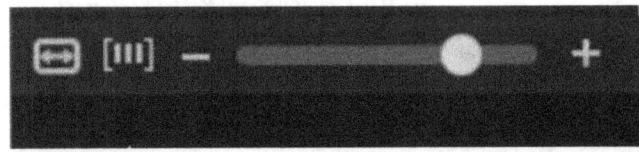

Changing the scale is possible with two controls at the bottom of the Window. The Zoom control works just like any other one in Studio, and there is a handy "Fit to Timeline" tool to the left to enable you to see the whole content. Between the two is a further control button that scales the display to show just what is on the top two tracks.

Track Headers

Track Header Tools

Studio's multi-cam actually has two video outputs. The top track, labelled Multi-Camera, shows the selected source full screen. The track below, labelled PiP (Picture-In-Picture) overlays a shrunken picture over the main source

The only control for the Multi-Camera track is a selection button. When the button is red, that's the track you are editing. The PiP track has the selection button and also

a tool to select one of four positions that the PiP can be placed. It is possible to alter this positioning at a later stage, but for the initial editing you need to stick with one of the present options.

The source tracks have two locks. The padlock on the left performs the usual function of disabling the track so that you can't move or trim the clips on it.

The sync button determines if a particular track is included in a syncing operation. Clicking on the sync lock button puts a line through the icon, indicating that the track will be excluded.

The audio tracks also have a mute button so that can be excluded during the edit process.

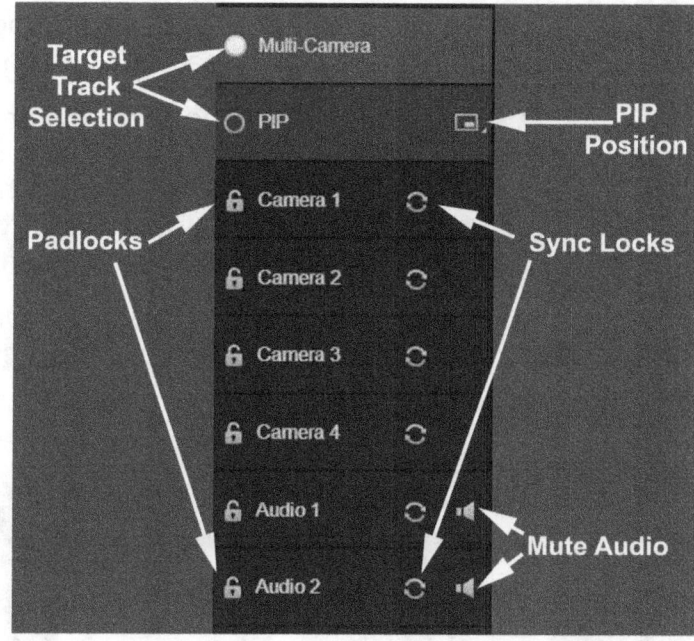

Importing a source using Right-click

It's hard to describe any more of the workflow without any content in the editor, so I'll show you how to quickly add a clip using the track Context Menu.

* Right-click on the empty track space for the Camera 1 source track.

* A Context Menu with just one option appears – Import source.

* Click on it and an Import dialogue opens.

* Navigate to the C:\Users\Public\Public Videos location.

* Highlight **The Sky is the Limit** sample video and click on Open.

* The Import dialogue closes and the sample video appears at the start of the Camera 1 track.

This import method always places the clip at the start of the track unless there is already material on the track, in which case it is placed immediately after the current content.

Source Track operations

The MCE Drag and Drop cursor

There are three operations possible on a source clip. You can drag and drop it, delete it and trim the In and Out points.

The drag and drop cursor is a four way arrow you can use to move the clip on its current track or move it to another. You can't drop it somewhere that there isn't room for it - unlike the main editor there is no Insert, Overwrite or Smart.

There isn't a Delete tool, but you can use the Context Menu or highlight the clip and use the Delete key.

Trimming a clip - the expanded cursor is inset

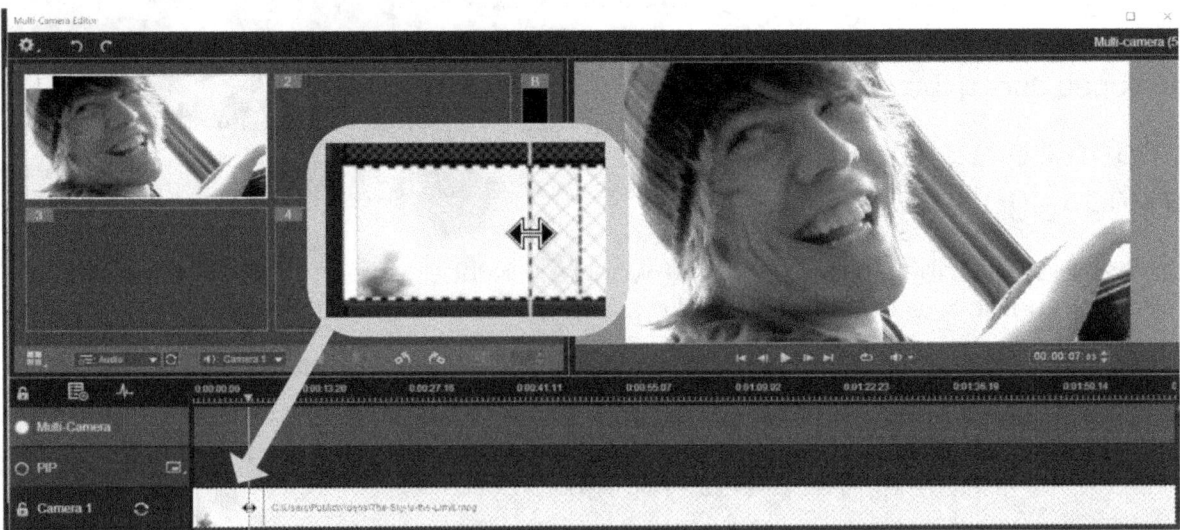

Trimming involves generating a trim cursor. First, click on the clip to highlight it. Yellow bars will appear at either end. When you hover over the yellow bars trim cursors appear. Click and drag and a hatched pattern and two way cursor appears. You can see the trim point in the previews. Drag and release to trim the clip. Unlike the main editor, you can't overtrim a clip.

Selecting output

Moving something up to the output tracks is simplicity itself – you simple click on the source window of your choice.

- Make sure that the Multi-Camera track is active with the red button showing.

- Move the timeline scrubber to the shot of Fred getting out of the van at around 24 seconds.

- Click in the Camera 1 source window.

- That's it. At that point in the movie the shot from Camera 1 appears.

- Make the PiP track active.

- Move the scrubber a bit further down the movie.

- Click on the Camera 1 source window again.

- Camera 1 appears on the PiP track, starting where the scrubber was.

Target track operations

It is not possible to move a clip on the target tracks – after all, you are trying to keep everything in sync. You can delete clips, and trim them to change the point at which they become active. It's therefore possible to adjust to cuts between sources without going to the next stage of the workflow.

The Razor tool also becomes active when you have a clip on one of the target tracks selected, so that you can use Cut and Delete as an alternative to trimming.

The PiP Track Context Menu

It also allows you to split a clip and then replace the split section with another source. You can do this simply by placing the cursor over the clip and clicking on the source preview, or you can use the Context Menu.

Target track context options

The MultiCam track offers you an alternative way of selecting the clip you place on the target track. There is a list of Cameras, Black or Blank (transparent). You can also delete all the content.

Additionally, If you open the Context Menu for a clip on the PiP track you can adjust the PiP position from the PiP tracks Context Menu.

The Main Event - Live Switching

With only one clip on the timeline you can still test the ability to cut live between sources by using camera 1, Black and Blank. Play the project and have a go if you wish. However, I think we need a proper project to show off the MCE at it's best.

The Three Camera Demo

I won't touch on every possibility I've described above because I'm going to keep things fairly simple. To follow the demo you will need four files from the website or data DVD.

* Download or copy the following files: **Guest.mpg**, **Presenter.mpg**, **Wide Shot.mpg** and **MultiCam audio.wav**.

* Create a Project Bin named MultiCam demo and add the files to it.

* Start a new project and then highlight all four files in the MultiCam demo bin using CTRL-A.

* Click on the Multi-Camera tool on the timeline toolbar.

* The first Source Selection window should open.

The Source Selection process

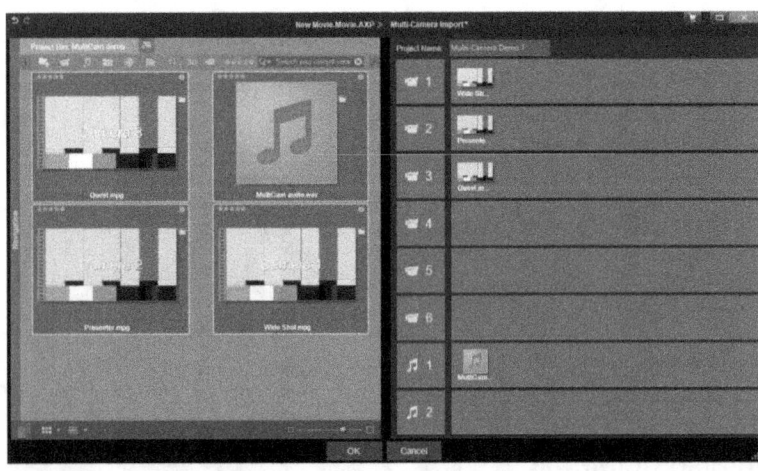

At this point you can see that the video sources have been added in alphabetical order to the three Camera tracks (unless your bin had been sorted in some other way) and the audio source has automatically been added to the first audio track.If you hadn't used CTRL-A but selected the tracks with CTRL-Click then the clips would have appeared on the tracks in the order that you selected them. This is a better way to start your MCE project if you know what order you want the tracks to be in before you even open the Source selection.

In this case I think it would make sense if the three camera sources were on the tracks that tallied with their camera number.

- Drag and drop the Wide Shot clip from the third track to the first

- Drag and drop the Guest clip to the third track

- In the Project Name text box above the tracks, change the project name to Multi-Camera Demo 1

- Click the OK button to move to the next window

- Use the Maximise button for a better view.

Even though the Ultimate version of Studio can handle six cameras, if you specify four or less sources the editing window will open in four camera mode. If you wanted to have the other two tracks available you will need to add more than four in the first place, or use the Camera number tool to switch to six cameras and then use the source manager to re-select your sources. This is

Syncing up the sources

Switch to Waveform view and study the sync between the sources. Nothing lines up.

The 4 sources showing audio waveforms

Camera 3 doesn't even appear to have sound – it looks like they forgot to plug up the audio. The separate audio recording has a much healthier looking waveform. Resist the temptation to start putting things on the target track yet – don't click on the source windows. You might want to try

playing the individual tracks and watching the previews. Cameras 1 and 2 are slightly out, Camera 3 is early and the audio track is even earlier.

- Switch the Source Sync type to Date and time and press the sync button.

- Some of the tracks move, but there are still issues.

- Switch the Source Sync type to Audio and press the sync button.

- Three tracks line up well, despite the difference in levels, but the camera without dialogue has failed to sync and it has also pushed the other sources down the timeline.

- Click on the Source lock button for Camera 3 to exclude it – a line appears across the symbol.

- Sync the project by audio again.

The three tracks with audio synced up

That's a bit better, although we still have to sort out Camera 3. If you zoom the timeline view in a bit you will see that the audio waveforms don't line up perfectly, but they are only up to half a frame out relative to each other. You really won't be able to detect this when the project is put together, and the only solution would be sources that were locked together – not something that generally happens except in the broadcast world.

To sync up Camera 3 I'm going to use the marker method. If we had put a clapper board on the start of the shots, this would have been easy, but in this case I'm going to look for a visual cue.

- Highlight the clip on track 3 so that it appears in the large preview window.

- Jog through the clip to the point where the presenter lifts up the can for the first time. It stops moving at 00:00:10:17.

- With the scrubber at that point, switch the Source Sync Type to Marker.

- The marker tool becomes active. Use it to set a marker on the clip.

- Highlight Camera 2 and repeat the process. The sync point is at 00:00:11:08 so place a marker there.

- We don't want any of the tracks already in sync to move, so switch on the track padlocks for Camera 1, 2 and Audio 1.

- Click on the sync button on the Camera 3 track header to switch it back on.

- Click on the sync button.

All four sources in sync

Now all four tracks should be synced up. Select Audio 1 as the Main Audio, highlight a track and play the clips. The three cameras should all be locked to the high quality audio you can hear.

Sending Sources to the output tracks

While the exciting way to do this is with the video playing, it's possible, and often desirable, to do this while just moving the scrubber.

Let's start by using the Context Menu:

- Make sure that the red selection button is lit in the Multi-Camera header.

- Right click on the body of the Multi-Camera track and select Black.

- The whole of the track is set to black level.

- Set the scrubber to a point where camera 1 is settled, but before the dialogue starts – 00:00:03:07.

- Use the Multi-Camera Context Menu to select Camera 1.

- Ah, that's no good. The whole clip has been replaced. Before you can replace a section of the output track there needs to be some edits defining that section.

- Assuming you haven't moved the scrubber, click on the razor tool to split the target track.

- Now right click on the left hand clip and select Blank.

- Good! We have nothing on the output track until the Wide Shot is usable.

Changing the first clip to Blank

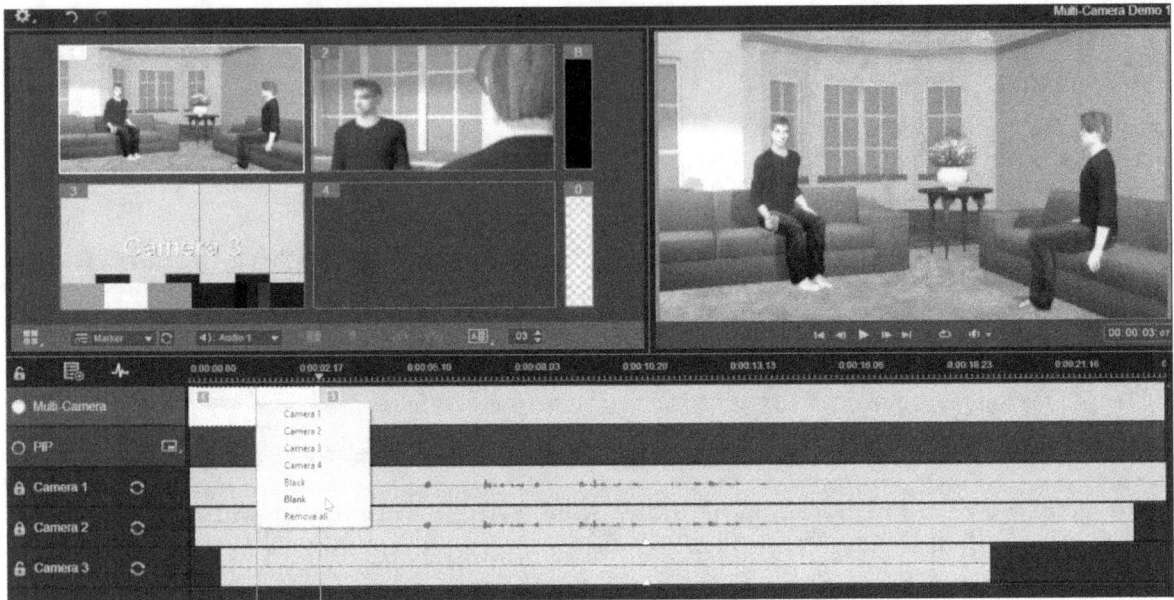

Using the previews to select sources

The Context Menu has limited uses, but as you can see it is a good way to replace a whole shot with another. If you want to switch sources with a new In point and without using the Razor tool, you click on the source preview windows themselves.

- Set the scrubber to 2 seconds

- Click on the Black source to the right of the camera previews

- Black level is added from the position of the scrubber up to the next edit – the start of the wide shot.

That's an important difference between the two methods of adding sources to the output track – the Context Menu method replaces the whole clip, clicking on the source preview replaces the clip from the position of the scrubber, whether the scrubber is playing or not.

You can make edits like this for the whole movie if you wish, but you aren't making the most of the editor.

Live Cutting

You should enjoy the next bit – it's like working on live television. I want you to edit the rest of the movie on the fly.

We start on black level, and then cut to the wide shot once it is stable – we have already done that. The first edit comes after the presenter says "Hi" and is motivated by his head turning to his close up camera.

When he says "and cut out the first phrase" use that as a motivation to cut to the guest, who nods. Wait until the Presenter lifts up the drink, then cut back to his close up for the last phrase.

The next cut needs to be sharp – as soon as the presenter starts to lift the can you need to get back to the wide shot.

Finally, as the guest starts to walk in front of the presenter, cut to Black level.

Play the previews and read the above a few times before trying this live:

• Make sure the Multi-Camera track has the red dot showing it is active.

• Set the scrubber to the start of the movie and press play.

• Hover your mouse cursor over the presenter's close up camera in anticipation.

• You will make 5 cuts by clicking on the chosen incoming source at the correct moment, moving the cursor from source to source after making each cut.

• The result will be 5 camera clips on the Multi-Camera track with Black level at either end.

• Review the cut movie to see how well you did. If you aren't happy, try again!

Adjusting the edits within the Multi-Camera Editor

You may have got the tricky penultimate cut spot on, but if you didn't it's easy to adjust. What's more, you can look at both the outgoing and incoming shot at the same time

• Select the last shot from Camera 2 in the Multi-Camera track.

• Generate a trim handle on the Outgoing and drag the edit point left and right.

• As you do so, look at the preview of camera 3. You can see the last usable frame before the camera starts to adjust is a 00:00:14:18.

• Drop the edit at that point and review the movie.

What's more, if the incoming shot were moving as well you could see that in the preview window as well.

What is even nicer, though, is the split screen that appears in the Output window on the right - the incoming shot on the right, the outgoing on the right.

Adjusting the Edit with Split Screen preview

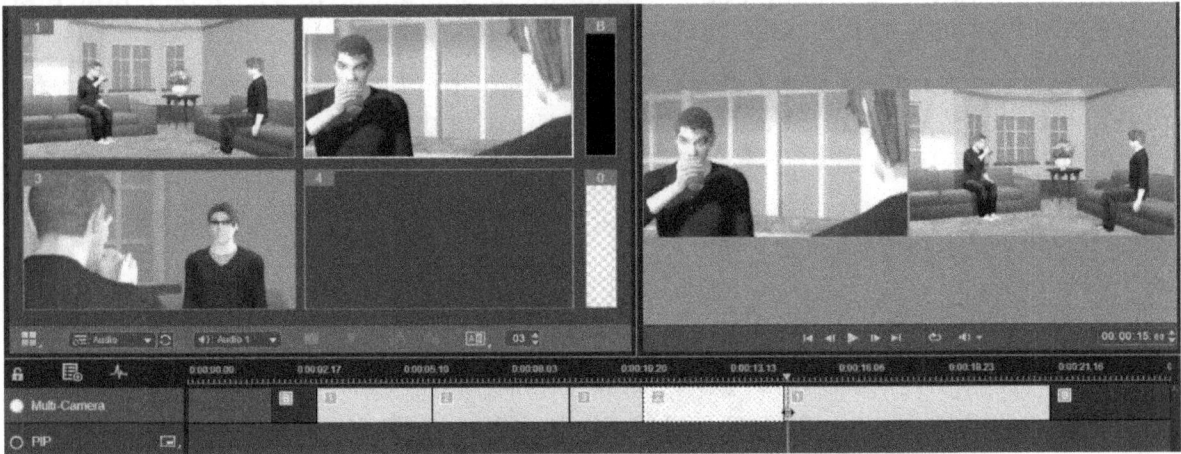

Adding transitions

You can add the default fade at any edit point. With the scrubber within a few frames of the cutting point, the Transition tool highlights to show it is available. Clicking it adds a cross fade of the preset duration determined by the duration box to the right. The transition is normally centred on the cut even if the scrubber was a few frames out:

- Move the scrubber to the last cut between Camera 1 and Black level

- The Transition icon will highlight. It doesn't need to be right on the cut – you have a few frames of latitude

- Click on the icon and a transition A/B icon appears either side of the cut

Playing the movie shows the Wide Shot starts to fade out before the edit point previously set (the Guest walking in front of the Presenter) and end after it. If you examine it in detail the previous edit point is exactly in the middle of the transition.

This behaviour has a bearing on what you might see as the Outgoing shot is faded out as it is unlike the way the main editor works.

- Using the method outlined above add a 3 second default fade between the Black level at the start of the movie and the opening Wide Shot

Catching a Camera moving after adding a transition

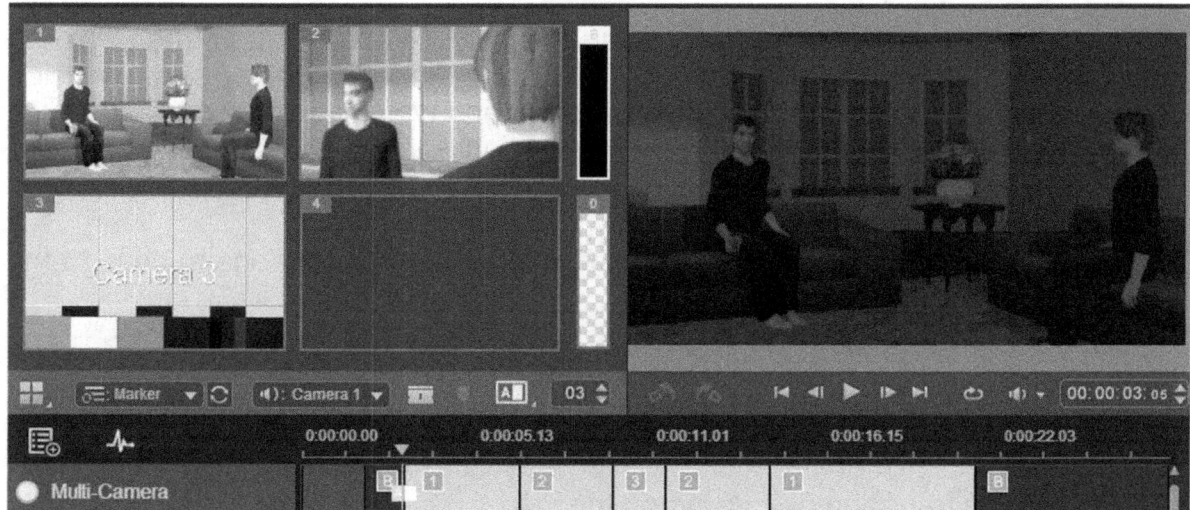

When you play the result you see the camera still settling as the cross fade occurs. There is also another oddity about the transition because there isn't enough of the outgoing Black level for a full 3 second transition.

In these circumstances the Multi-Camera editor shortens the transition more than it needs so as not to overwrite an entire clip, and it may also apply the transition off centre.

When you are using transitions between live video the algorithm used may well give you the best subjective result. If it doesn't you can adjust the duration or move the edit point. You may even decide to add the transitions manually in the main editor.

Removing transitions in the Multi-Camera editor

It's not immediately obvious how you remove a transition from the Multi-Camera editor target tracks, although once you do know, it's easy!

* Move the scrubber into the region of the first transition so that the transition tool icon becomes highlighted.

* Click on the tool.

* The transition disappears.

Transition duration

We could try a shorter transition at the start of the movie to see if it is better. You can adjust the duration using the duration box, either by clicking on the arrows alongside or double clicking on the value so that it flashes and typing in a new one. However, you can also adjust the duration after the transition is in place:

* Recreate the transition that we just deleted (you can probably just use Undo)

* With the scrubber still over the cutting point click on the buttons to change the values in the duration box

* You will see the Output preview change as the transition is adjusted

* Settle on 1 second and play the result – no, we can still see the camera zooming out

* Remove the transition by clicking on the icon

Opening and ending transitions

While we could go through a bit of trial and error adjusting the cut with the trim tool to get the opening transition to work properly, because it is at the beginning of the movie we can take advantage of the fact that adding a transition between transparency and video results in different behaviour

* Right click on the opening Black level clip and change it to Blank.

Fading up from Transparency

Add a transition The default for that cut will still be set to 1 second.

* Change the duration to 2 seconds and test the Movie.

* In the MCE we don't see a proper fade up from Black, but we will when we put the project into a main Movie.

Putting the project into a normal movie

We have finished making the demo within the special editor now. When you close the window with OK it is saved without you being asked and added to the current bin. You can re-edit it by using the Context Menu or double clicking.

To export the Multi-Camera project, to use it in a larger project or to use editing tools not available in the Multi-Camera editor you drag it from the Library to a track in the normal edit window.

- Locate the new project in the MultiCam Demo project Bin.

- Drag and drop it to the start of track 2.

Multi-Camera in the Main Editor

You exit the MultiCam editor with the OK button. A new MultiCam project will appear in the current Bin and the Latest Import collection. You can tell it is a MultiCam project from the icon top right of its thumbnail.

To use the project, just drop it onto the conventional timeline to play or export it.

One important thing to be aware of is that a MultiCam project is trimmed before it is placed on the timeline - it will start when the first item appears on either the Multi Camera track or the PiP track, and end when both those tracks are empty.

A MultiCamera project open as a submovie

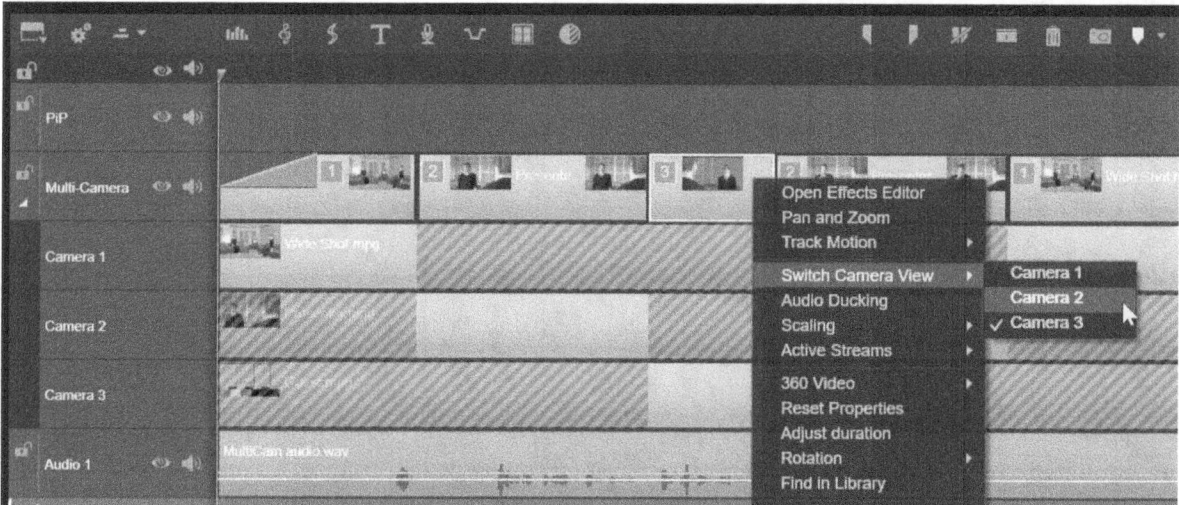

More importantly, if you have left any gaps in the output tracks, these will be removed as well. If you want the gaps to remain, you must put Black or Blank spacing in the timeline.

You can edit the MultiCam project within the main editor. If you right click and select Edit movie (or double-click on the project) it opens as a subproject. However, there are a number of significant differences between a Multicam submovie and a regular one. All the video sources are present, but locked. The Multi-Camera and PiP

tracks, however, are editable so you can add effects and transitions and adjust the cuts as well. One thing you can't do is move the clips, which would destroy the carefully achieved synchronisation!

What you get in the way of audio will depend to some extent as to what your audio selection was. Choosing Auto will have enabled the audio stream for all the camera sources on the MultiCamera track. If you chose a specific camera then its audio will be part of the project as a separate track, and if you selected All Cameras there will be an audio track for each camera. The PiP track never has any audio and the audio tracks will be muted by default, unless you chose one of them as the audio source.

There is a helpful Context Menu option for the two target tracks – Switch Camera view – so that you can replace the choice that you made with a different camera.

But what if you wanted to use Live switching again? You can enter the Multi-Camera editor with the button bottom right if you wish. Any changes you made within the subproject will be lost – and the program warns you about that.

You can also open a MultiCam project in the Multi-Camera Editor from the Library, either using the Context Menu or by double clicking,

Using Proxy Files

The Smart Proxy manager Menu

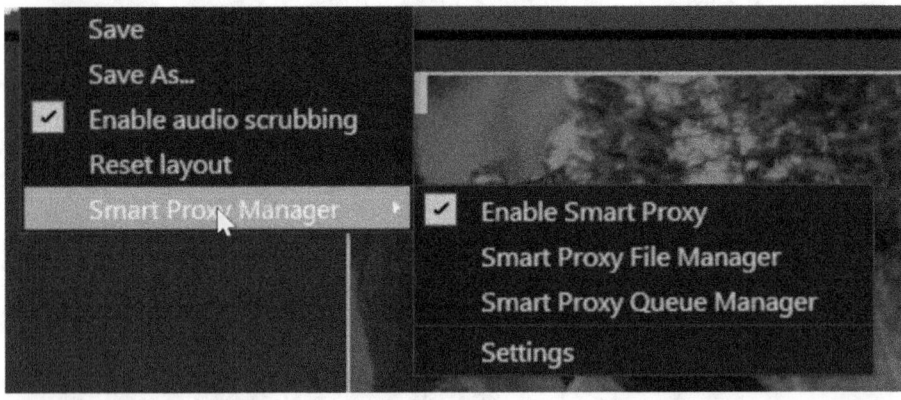

I've deliberately chosen to supply Standard definition MPEG-2 files for the demo above because any computer powerful enough to run Studio properly should be able to handle them within a Multi-Camera project. However, if you want to use HD source material, particularly if it is H.264, then the system may struggle. The preview optimisation tools don't operate within the Multi-Camera editor. Instead, Pinnacle have borrowed the Proxy File feature from Corel's VideoStudio.

I discussed Proxy files in the opening chapter. Briefly, when you add an HD file to a Multi-Camera project a half-resolution, low compression .upx file is created and used for preview within the Multi Camera editor, but when you exit, the Multi-Camera project references the original files which are then used as source material.

The .upx format comes from Ulead, the original creators of VideoStudio, and uses MJPEG compression, similar to DV-AVI. The files have half the resolution of HD but the light compression makes them easy to play back.

The settings for the use of Proxy files are reached from the Settings tool top left of the Multi-Camera editor and clicking on Smart Proxy Manager. If Smart Proxies are enabled then files are created as and when you add them to the Source tracks. If you have already added some content without the feature enabled then you will have to add it again once the feature is turned on.

Settings allow you to specify where you want the files to be saved – I'd recommend you change the setting to a location that is easier to find. If you don't have a lot of free space on your C: drive you might want to use a second hard drive if you have one – proxy files are BIG! I've also seen instances where the Proxy files system has lost track of its files and if you have put them in a unique folder they will be easier to delete.

The Proxy File Setting

The video size parameter seems to behave oddly in the Pinnacle implementation. Sometimes all SD files are ignored, and all HD files are turned into Proxy files, regardless of the setting you choose. I suspect that is the best setting anyway and I suggest you leave well alone.

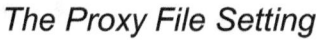

The Smart Proxy File Manager

There are two other components to the Smart Proxy System. The File manager shows you the files that have been created and offers you the chance to delete them.

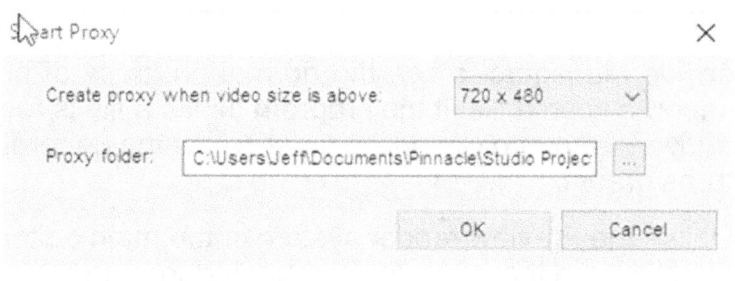

The Queue Manager shows the files that

have still to be created and the progress of the currently running rendering operation.

The Queue Manager

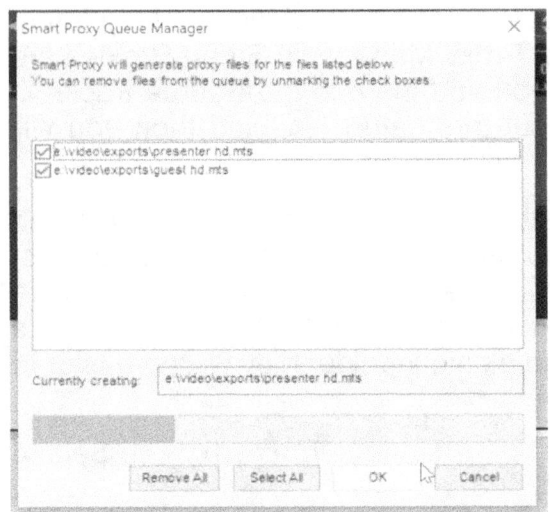

There are currently a few issues with the proxy file system. The File manager seems to lose track of the files that have been generated after a program restart. If this happens then you can sometimes force them to regenerate by opening the Queue manager. However, this means you are building up a lot of unused files, hence my suggestion that you keep tabs on where the program is putting the proxy files. I have also experienced an issue where deleting files in the File Manager makes the program forget about them without them actually being deleted.

You don't actually have to open the Queue or File Managers to see the normal progress of proxy generation. When you first import a source file, if the program thinks a file is required it will place an orange bar above the source clip on the timeline. As the generation of the files progress, the line turns green.

Unlike the Preview render system in the main editor, the green line will remain over the clip once the proxy file has been generated.

Stop Motion

If you have ever fancied making your own animations, then the Stop Motion tool is just the thing you need. If you didn't know that you could make them in Studio, you might be in for a lot of fun!

You may be aware of the principle, but if you aren't the idea is almost as old as film itself. Instead of exposing a series of frames in real time to try to capture live action, you exposed them one at a time, moving the objects you were filming manually between the exposures to give the impression of real time. The objects can be drawings – think Mickey Mouse - or three dimensional objects – think Wallace and Gromit. You can also use real people and real settings for some interesting trick shots.

Of course, film was an expensive medium to use, and you couldn't see the results of your labours until the rushes came back from processing. Video changes all that – not only do you get instant results, you can even correct mistakes while shooting.

What you do need, apart from a lot of patience, is a suitable video source. Studio can handle Standard Definition analogue video capture devices, so if you have a Dazzle or Moviebox and any sort of camera with an SD analogue output, you are good to go, although the quality isn't going to be great. DV and HDV cameras are also a possibility via Firewire.

A good Webcam is another possibility as you will be able to work at much higher resolutions. You may need to set up a decent lighting rig and find ways to override the camera's automatic settings for best results.

The real breakthrough is the ability to capture still frames for a later model Digital Single Lens Reflex camera via USB. With DSLRs quality isn't the issue – most decent cameras shoot at a higher resolution than HD, some are better than UHD. According to Pinnacle "most" Canon DSLRs are supported. I have Panasonic and Olympus cameras, neither of which work, so I've confined my stop motion to SD.

The Stop Motion Editor is part of the Import section of Studio. Open the Importer and connect a suitable source. In the screen shots I've hooked up the AV output of my video camera via a USB 510 capture device and selected it using the Source drop-down. If you are using an Analogue input make sure it is working before clicking on Stop Motion.

The preview on the right should show the output of the camera. In Settings on the left there is a Project Name box where you can name, save or open your projects. Stop Motion has its own Project type with the suffix *axps*.

There is also a checkbox here for Smooth, and a setting slider attached. Smooth is a function that can be added to a project at a later date or used from the outset on

a project to reduce the number of images you need to capture. It is not without drawbacks, however. Before you embark on a major project I suggest you read to the end of this section and then evaluate smooth to see if it meets your needs. For now, leave it unchecked.

The Stop Motion Importer

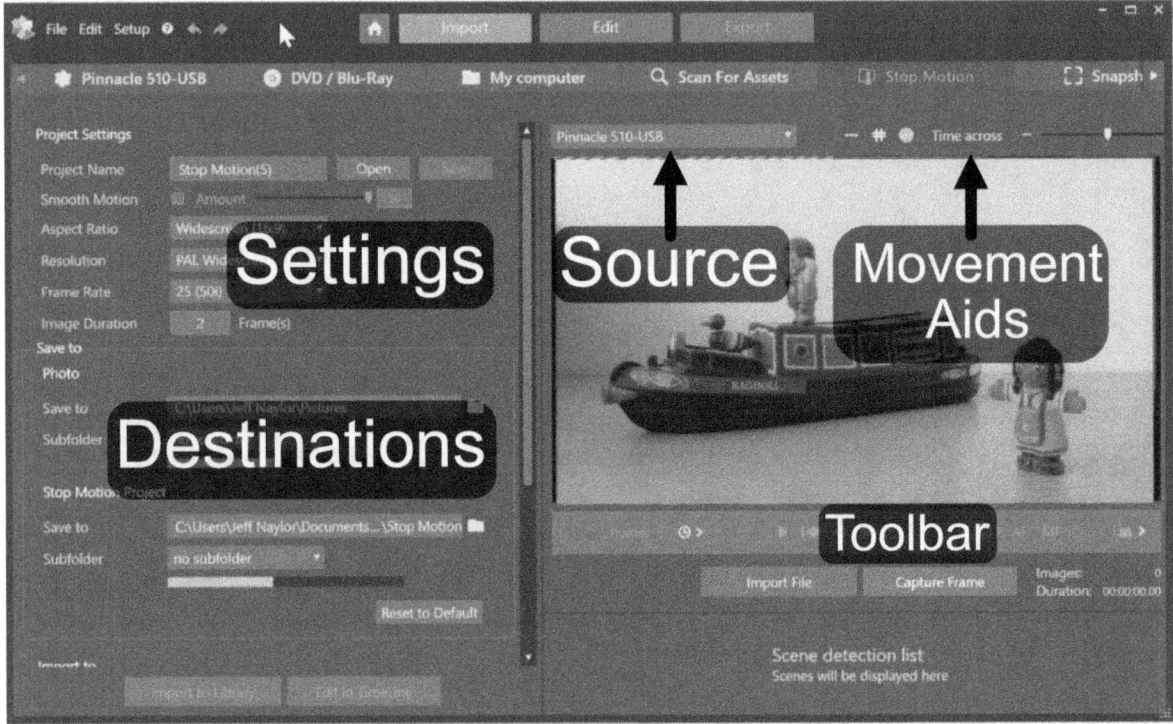

Settings also allows you to define the aspect ratio, resolution and frame rate of the project and additionally to adjust a parameter entitled Image Duration, more of which in a moment.

The Import destinations can be defined in the lower box on the left. When creating stop motion you will be importing a lot of JPEG pictures and you might well want to direct them to a location other than the default. You can also set the default location for the project file, which, like all other project files, is relatively small as it doesn't contain the actual media.

Image Duration

In the Basic Principles chapter we looked at how a series of individual frames, shown at a high enough speed, can fool the human brain into thinking it is watching a moving picture. How many frames per second are required to do this convincingly is a matter of judgement.

Some film cameras shot as slowly as 16 frames per second and still convinced the viewer that they were real "Moving Pictures". Furthermore, if the viewer is watching something they know to be an animation they may forgive an even slower rate. The basic rate of film was standardised at 24 fps, and still is. At that frame rate the viewer can be easily convinced by stop motion. At half that rate, the movement may look a little stylised, but it still works.

Originally video was shot at 25 or 30 frames a second. You might want to look back to the the Basic Principles chapter to see a discussion about interlacing on video, which effectively doubles the frame rate at the expense of the resolution. Nowadays 50 or 60 progressive frames allows fast camera and subject movement and gives very smooth, convincing results.

So, somewhere between 12 and 60 frames per second seems to be the answer!

If you are trying to make a second of stop motion video, 60 fps requires 5 times the number of frames, and with that 5 times the number of adjustments to the objects being animated.

The Image Duration setting allows you to take a single image and then adjust its duration in the movie you are building up. If the movie has a frame rate of 25, then an Image Duration of 2 frames will give an effective rate of 12 – just about passable. At 30fps, a duration of 2 gives a slightly better rate of 15. If you are making your animation at 50 or 60 fps, then you can use a duration of 4 for just about acceptable results.

Why would you want an image duration that is any longer? There are a number of reasons. You may be animating something that doesn't need to have convincing movement, or you might want to process the pictures after shooting. You may also want to take advantage of Studio's attempt at extrapolation, used by the Smooth feature

Image duration is something that can be changed after you have created your movie, either by changing the parameter, which changes all the images in the project, or once you have moved to the main editor.

Creating an animation

There are a number of important things to consider before you start shooting an animation. The camera needs to be stable – ideally on a tripod or other mounting which won't move easily. You also don't want it turning itself off due to a flat battery or power saving mode. Consider how your objects are lit - daylight can be problematic unless you have a fully overcast sky. If you do have control of the lighting then the camera should normally be set to manual, so that the exposure, colour balance and focus don't vary as items are moved.

The toolbar below the preview has two selection buttons on the left. To see your video input you must have Video highlighted.

With an empty project and a working video source, the all-important tab at the bottom of frame is labelled Capture Frame. When you click on that, a snapshot of the video source is taken, and the Stop Motion editor opens a storyboard style display below the tabs, showing the first frame of your movie. Capturing further images adds them to the project and storyboard below, building up the animation. To make an object animate realistically, the amount of movement is critical.

The images being added to the movie

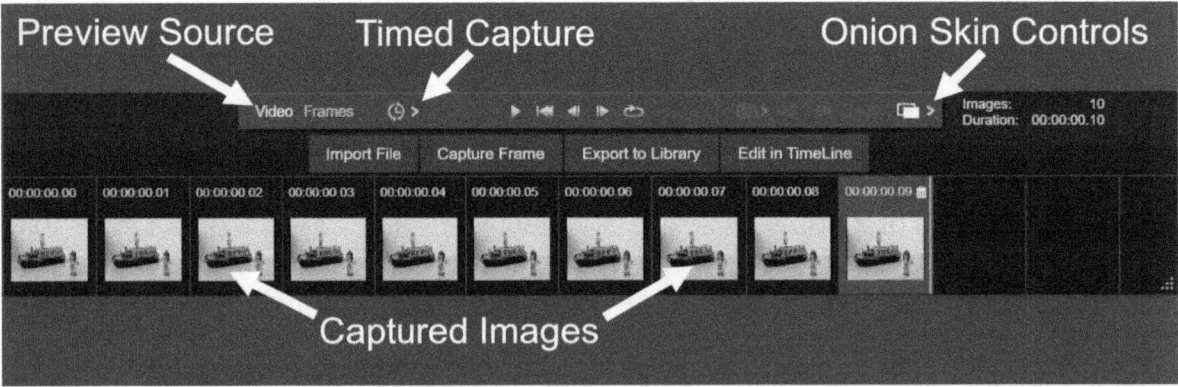

Captured Images

The Onion Skin

When you move your object, you may, or may not, see a blurred image. This will depend on the Onion Skin setting. Far right of the tool bar are an Icon to switch the Onion Skin display on and off, and arrow head to open up the Onion Skin settings. With the icon showing as orange, you should see a mixture of the previous captures and the current video source. If you still can't, then open up the settings. The upper setting controls the amounts the new and old images are mixed together; the lower setting controls how many of the previous images are included.

The Onion Skin feature allows you to position your next capture. If you show multiple previous images you can judge the distance and direction required for smooth movement. It's also useful for lining objects up exactly, perhaps after a mishap!

If you don't want to see the Onion Skin, just the pure camera output, you can toggle off the feature. If you just want to see the previous captures with the camera added, click on the Frames source selection button.

The Onion Skin set to three images

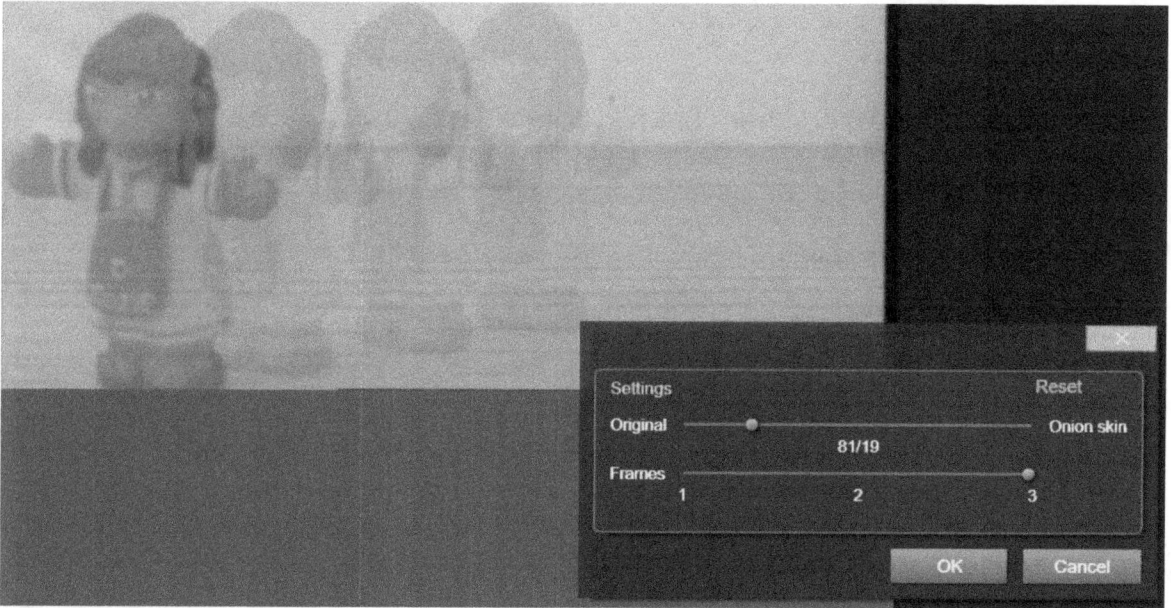

Playback and review

The transport controls in the Stop Motion editor are quite basic. Clicking on any of them switches to Frame mode. If you click the play button or space bar the animation plays from the currently selected image. There is a Back button that takes you to the start of the project, two Jog buttons and a Loop Play tool. You can also jog using the arrow keys or go to a particular frame using a mouse click. Once the storyboard has grown so it doesn't show all the images, a scroll bar appears below the thumbnails.

Editing in the Stop Motion Importer

This is very rudimentary. The current frame is shown in the storyboard with a red dot and border and all the operations are based on this position. You can't drag and drop the images. You can delete a single image with the Delete key, and you can start capturing frames to be inserted at that point. Using the Import File button, it's also possible to insert media. This opens a standard Windows Import dialogue and you can select a single image, or a selection using the standard windows multi-selection tools. You can also add video if you wish – most likely a section of your animation that you have already exported as a video file.

Focusing

If your DSLR is supported, there are two control icons that lets you switch between manual and auto focus. The less you have to touch your camera during the animation process the better, as an accidental knock can take a long time to repair!

Capturing in bursts

A very useful feature is available through the Auto Capture control. This has two main functions.

Once you get into the swing of creating movement, it can become very repetitive, particularly if you have to keep moving between the subject matter and computer to trigger the captures. One approach would be to have an assistant, but if you can't get someone to help then you can set the software up to capture in bursts. What's more, a helpful audio cue track is provided.

To use Auto Capture you highlight the clock tool before you use Capture Frame. To change the setting you use the arrow head to the right of the tool.

The Auto Capture settings

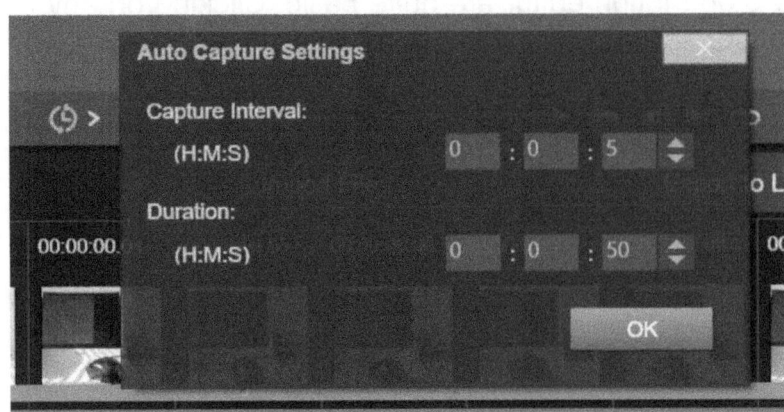

You set the Interval to the amount of time between each capture. An audio "click track" will be played during this time, ticking once a second. When the capture occurs a shutter sound is played. After this you can then move the object the required amount, and wait for the next capture.

The Duration parameter does not set the duration of the animation you are creating, it sets the amount of time the process is programmed to last. So, if you set the Interval to 5 seconds and the duration to 50 seconds, the timer will capture 10 frames.

This helps the other function that you might want to use this feature for – **Timelapse**. This is where you let a natural or staged event happen in front of your camera, capturing frames at fixed intervals to produce a speeded up version of the event. Obvious examples of this are a sun setting or flower bud opening. Most decent cameras have a built-in function capable of doing this, so there isn't normally a need to tie up your computer for the duration of the event.

Movement Aids

There are three types of aid that you can superimpose on the preview window – a line, a grid or concentric circles.

The simplest to use is the **Grid**. The spacing is dictated by the **Time to cross the screen** parameter. This is calculated taking the Project frame rate and image duration into account, and scaled so that a move across the screen needs to have an image captured for each square of the grid. Let's say you want an object to travel from one side of the screen to the other. The project is set to 25fps and the Image duration is 1. If you set Time Across to 1 second, the grid will consist of 25 squares across. As you capture your images you move the object so that a chosen part of it aligns with the next grid square between captures. Want the object to cross slower? Set the Time parameter to higher values – setting it to 5 seconds and 125 grid squares will appear.

The Grid Movement aid

If you want movement in another direction you can do a little maths – on a 16:9 project, vertical distances are roughly half, but you can work them out exactly if you wish. However, two other tools are provided.

Line allows you to click on a point of your choosing and

then drag in the direction you want to move to create a line. When you release the mouse button the software adds a dot to the line for each required image point, calculated in the same manner as the grid. Helpfully, the first dot is coloured magenta. When you capture an image, the next dot in the sequence lights up instead, showing exactly where to move the object next.

The Line in action

Concentric circles can be placed wherever you click on the preview, and use the same principle. They may also be useful if you want to change the size of objects, either by using a zoom on the camera or by moving the objects nearer or further away from the lens.

Export to Library

This is an extension version of saving the project. A new bin using the project name is created and all the images in the storyboard are sent to the bin. The saved project is also added to the bin.

Export to Timeline

You can't actually export your animation as a video file from within the Stop Motion Editor. By using Export to timeline the project is closed in the Stop motion Editor and placed on the timeline of the conventional timeline editor. Now you can export it as

a movie. Here you can also make further changes, add effects, transition and titles and any other things you might want to do before export.

Editing in Stop Motion

If you right click on a *.axps file in the Library, you will see the option to *Edit in Stop Motion*. This re-opens the project in the stop motion editor, so that you can carry on working on it. This route doesn't warn you of something that is flagged up when you use the Open command in the Stop Motion editor itself – that you can only see items on track two. Anything you might have added to other tracks when editing on the timeline won't be accessible. That doesn't say that the items aren't there – in preview you will see any titles you have added, for example – but you won't be able to adjust them.

Smoothing out the animations

One thing that you might consider doing when editing in the timeline with an animation that has used an Image Duration of 2 frames or more is to ripple a crossfade transition through the project. You have to do this in overwrite mode if you don't want to change the overall movie duration. See the transitions chapter as to how to achieve that. This will have the effect of smoothing out the animation at the expense of adding some blur.

The Smooth feature uses a technique that is more sophisticated. Two images are compared and motion detection is applied. New frames are created that attempt to extrapolate what the intermediate frames would look like had they been captured. How well this works depends to some extent on the images and type of movement. Objects tend to get distorted as they go through the movements. Edges of frame can start to show black areas. The Amount setting seems to adjust the sensitivity to movement and the area covers. Set it too high and the distortion may take over, too low and only small areas may be detected.

There is no denying it works, at least partially. However, it's not a substitute for animating at the same frame rate as the movie settings.

Smooth adds its own effect as a transition to the movie. Unfortunately this also shortens the movie by 50% so the Time to Cross frame setting will be wrong. In addition using an Image Duration of 2 frames results in single images having their duration reduce to 1 frame when you check Smooth, so you will never see the effect.

To see Smooth in action I suggest an Image duration of 8 frames and for you to mentally divide the Time to cross value by half and make a short sample animation. If your subject matter is suitable then you may save yourself a lot of time!

Export

At the end of the Whistle-Stop chapter I made the distinction between a video file and a project file, and talked you through a simple export process to turn the project into a file. In this chapter I'm going to talk through all the Export functions, discuss file formats in more detail and look at the problems that might affect you when exporting to disc.

Studio has three export paths. The main exporter works with all types of export. A function called Burn Disc Image deals solely with optical discs, as does MyDVD. We will discuss the main exporter first.

The Export page

You reach this by one of two methods. The furthest right tab on the Menu bar will be available if you have a project on the timeline, and using it in those circumstances will open the page with a project in the Preview window. If you right click on a media asset in the Library and use the context menu command *Export...* then the Export page opens with that asset in the preview.

The Export Tab in File mode using Plus and Ultimate

Note the extra Export Queue features in the above screenshot, available in Plus and Ultimate.

Normally the Export tab will open in File mode, where the output will be a file. If you have the MyDVD Author toolbar open in Edit you may end up in the MyDVD mode of the main exporter. If the Legacy Author tab is present and you switch to Export you will also see the Disc mode tab available.

Export cannot carry on in the background in the same way as some import functions, but the Queue feature in File mode helps you use your time more efficiently.

The Export Window - File Mode

In the Edit tab, place some video on the timeline to enable the Export tab, and then use it to open the window. The left hand panel contains all the settings. A Preview window to the right has a space estimation bar below.

The first setting is **Destination**. By default this will be the My Video location. Use the small folder icon to the right to change the location and that will be remembered until you change it again.

Filename is where you can change the default to one of your own choice. If you use a duplicate filename, this will be sorted out when you start exporting.

The After Export options

To see the **After Export Actions** click on the small arrowhead. As some renders will take a long time, you aren't going to be sitting watching the process at all times, and **Sound audio alarm** can alert you to the fact that the process has finished. Before you ask, no, there doesn't seem to be a way of changing the audio alarm - believe me, I've tried!

Shut down PC will be handy if the export is going to be a long one and you are going to leave the computer unattended. If you have other programs with unsaved data open, this option may not work, which is a good thing, Shut everything else down before you leave your computer. That will also reduce any background tasks so it may speed up the process as well

Open in Windows Explorer will be useful in many situations, but might be a nuisance at times. I tend to leave the first one unchecked and perform that action manually if I wish because you get offered the option when Export completes.

Add exported file to Library does just that, but it doesn't put it in a Bin, nor the Latest Imports collection, so you will need to work with the Library media on view to find this useful.

Same as Timeline

This useful checkbox chooses settings that closely match the resolution and frame rate of the project or the file you have sent to the Export window.

In Studio 23, this became a more intelligent feature than before, and tries to match the format and bitrate of the source. However, once you stray away from the more usual source formats it can make some incorrect choices, and may be fooled by projects that don't start with a video source, but instead a photo or titles. My advice here is to check the settings it suggests before using them.

With regard to the bitrate chosen, if your project is a simple one then the estimate is often correct. However, if you add effects and titles then Studio may increase the bitrate. If you are exporting a file for upload to the Internet then it's a good idea not to trust the bitrate as it may be higher than it needs to be, increasing the upload time.

For example, choosing *Same as Timeline* for a newly created project that just uses the Drone clip_LQ footage (something we are going to use to demonstrate Export with shortly) will result in export settings of 6Mbit/s. However, if you add an effect or title, the chosen bitrate can jump up to 20Mb/s. There appears to be no pattern to this, so it may be a bug.

Format

The Format choices

The label Format can be opened to offer other choices. With Format selected, opening the next drop-down presents you with a very long list of options. They appear to be listed in order of popularity - and the top of the list is H.264/AVC.

I often hear people asking the question "What's the best export format to use?" When I first started writing this series of books the answer was quite complicated, but now the answer is most certainly H.264, also called AVC.

In a few years time the answer is likely to be H.265, also called HEVC. If you refer back to the Basic Principles chapter you can read about the development of the mainstream video formats. It's important to be aware that the file extension doesn't always indicate what codec is being employed, in particular mp4 and AVI

A software encoder is often referred to as a Codec (Compression and Decompression) and various file types - or wrappers - allow a different subset of the codecs available on your computer. If you select MPEG-2 as the file type, for example, you can only have MPEG-2 as the codec, but you can vary the frame size, bitrate and interlacing options. The MP4 file type is far more flexible.

Available Formats

The dropdown list contains the following types:

H.264/AVC The current workhorse of the consumer video industry. There are various levels of quality possible within the specification. Most modern consumer cameras and many professional ones can record in this format, and it is the basis of Blu-ray video as well.

HEVC - This is one option you will only see if you are using Studio Ultimate. HEVC uses a further development of H.264 - H.265. The files are very compact for their resolution and quality. If Studio doesn't see suitable hardware it can use for the encoding it may not offer you the choice to export HEVC, but it has lower hardware requirements for playing and editing than it does for export, so you may be able to import, but not export it.

MPEG-4 Visual - the first iteration of mp4, this codec is far less efficient than H.264, but requires less computing power to encode and decode.

QuickTime Movie – Apple's QuickTime format uses a file extension MOV, which is a wrapper or container that holds video and audio and makes it suitable for playback on Apple hardware and software. The format isn't exclusive to Apple, however, and is used by many NLE's. The type of compression inside the file can be DV, MJPEG, MP4, H.264, H.265 or Cineform. Pinnacle Studio is a bit picky with the audio that can be included. For export, ACC is the only audio option and currently you can't use the H.265 codec.

Sony XAVC S® - This proprietary format is the consumer version of XAVC. It uses the highest level of H.264 encoding, and perhaps its most interesting feature is the ability to create UHD 4K files. The files produced by Studio are in an MP4 wrapper. This format is not available in the Standard version of Studio.

AV1 - not to be confused with AVI! This is a very new format that is comparable to HEVC, but is supposed to have less licensing issues. Currently export to this codec is rather slow.

Transport Stream (MTS) - a range of presets that use either the H.264 or Mpeg-2 codec. MTS is a common file extension used by cameras, while M2TS is used by Blu-ray and AVCHD discs. There are special quality settings for this preset, which I look at when we discuss Blu-ray burning.

AVI - Saying that a file is an AVI means very little. Most video formats can vary, but AVI is one of the most variable of them all. AVI stands for Audio Video Interleave. That's it. The Audio and Video data are interwoven in the same file, but there is no further standards we can guarantee and the data can be encoded in a multitude of ways. So you should never assume that all AVIs are the same.

Studio can read many types of AVI, but only export a few variants. From a consumer video maker's point of view, the most import type of AVI is DV video, which we looked at in the Basic Principles and Import chapters. The file sizes for a given duration are very large, so it's only practical for Standard Definition. *Mjpeg* is an even older format. Both of them use the older type of Intraframe compression. *Uncompressed frames* is the final word in quality, but the files sizes are massive and you will be unlikely to play them back in real time. You may use them in conjunction with animation programs such as iClone.

Cineform Only available for export in Ultimate, this codec allows you to export your timeline with Alpha channel transparency information.

MPEG-2 - historically, this codec is very important. Almost any computer should work smoothly with it and if offers good quality. It's still used in DVD creation and by the preview render system in Studio.

MPEG-1 - The first step in modern Interframe compression, Video CD discs used it, and Studio offers a preset that equates to VHS quality.

Windows Media – This is a proprietary (it is owned by Microsoft) but open (anyone can use it) standard. There are many variations, including codecs designed for slide shows, but Studio makes the most generally accepted type of files. Windows Media has its own settings box layout and you are restricted to presets. The file type is .WMV, and like most modern codecs, it uses Interframe (not Intraframe) compression.

Flash Video – Adobe's format popular for embedding video into web sites. Studio produces FLV files, one of the basic formats of YouTube and other video sharing sites. There is also a Nintendo Wii preset.

3GPP– designed by the Third Generation Partnership, this is a format for mobile phones. It's based on MPEG-4, with variants that use either the Simple version or H.263, a codec designed for low-bitrate video conferencing.

Audio Only – You can make an audio only file of the project as either a .WAV (otherwise called PCM) or an MP3. These are the two most common standards for digital audio. If you delve into the custom settings, you can also make a mp2 file. which is an older form of MP3 and used in making MPEG-2 files.

Image - produces a still image of the frame of video at the In point caliper of the Exporter Player Window. There are plenty of format choices, with even more available in the custom drop-down.

Animation - This option isn't available in the Standard version of Studio. You can use it to export video as a GIF - a format that is over 30 years old but has recently become very popular for including short video animations in social media posts.

Image Sequence - if you need a sequence of frames saved in a photo format, set the In and Out point to the start and end of the area you need and export them in one of a large choice of formats. This may be one way of getting high quality video data into another program to add complex effects or frame-by-frame retouching. Not available in Standard.

Smart - This option will only appear after Studio has determined if it is possible and if you have checked the Smart checkbox in Advanced settings - assuming that it is offered to you. Smart, when enabled, will try to directly copy as much of the timeline to the output file as possible, without re-encoding. This can preserve quality and speed things up enormously. However, Smart can be unreliable, and the time it takes to scan the timeline for it can be problematic. If you want to make a lossless copy of a trimmed file, perhaps with some audio corrections, then it's OK, but otherwise I would recommend you avoid it, despite the potential time saving.

When you are using Smart for export, no export preview is shown.

As Pinnacle Studio develops, more file formats are bound to be added. As hardware gets more powerful, better compression can be achieved and still be coded and decoded in "real time". This means video can be sent via low bandwidth channels such as mobile phone networks. On the other hand, storage space becomes less of an issue, with hard disc sizes getting larger all the time, and high capacity memory cards constantly dropping in price. For high quality video work, there may come a time where even consumers will return to lower compression formats.

Extension

Choosing the .mpg extension

Studio has other options for choosing what type of file you export. Open the Format box and choose Extension, and two boxes will appear. In the first you can choose an extension -

.mp4, for example, and the next box to the right will offer you a list of possible formats. So if someone says "Send me the video as a .mpg" you can select that extension and see that you have a choice of Mpeg-1 or Mpeg-2.

Device

Device options

Some hardware has optimum file types. Choosing *Device* from the Format drop-down shows a list of items that Pinnacle have built specific presets for. If you want to make a video to play on an iPhone, for example, selecting Apple offers you a further choice of hardware devices from which you can select the correct target.

Web

PS24 currently doesn't support direct upload to the web. To be honest, it was often unreliable because the various services keep changing their APIs that allow you to upload automatically. It's far better to upload manually anyway, as long as you know what setting to use. I'll look at exporting files suitable for uploading later in the chapter.

Presets

Opening the preset drop-down offers a comprehensive array of fixed settings for most formats. If you use the *Same as Timeline* checkbox and aren't happy with the suggested settings, you should be able to chose a suitable one here.

Export Limitations

I've already noted that some formats aren't available in PS Standard (HEVC, Gif and AXVC_S), but it's also worth noting that only Ultimate can export UHD/4K, 360 degree video and transparency using the Cineform codec.

Custom settings

Selecting this option enables the Video and Audio setting below for editing. You can also use the Edit icon to enter custom mode.

Edit and save icons

The scope of customisation will vary with the format. Some wrappers will allow you to change the encoding codec, most the resolution, scanning scheme and frame rate, as well as the bitrate and audio settings.

Just to be clear - once you stray away from the preset encoding methods and settings, there is no cast iron guarantee that the file you produce will be universally acceptable. There isn't even a guarantee that Pinnacle Studio will be able to carry out the export.

The bitrate setting can be a bit deceptive. Sometimes you can set it to a higher value than the encoder will be able to achieve.

Audio

As a general rule, the preset audio choices should be compatible with any playing device you use, but there is an exception - Multi-channel surround sound. Pinnacle dropped support for Dolby 5.1 surround in PS23. However, LPCM 5.1 surround is now a choice for mp4, mts and mov file exports using the Custom Channels audio setting. You will also find it in the disc export settings - LPCM audio is a mandatory audio format for Blu-ray players, so it should work, although not all players may adhere to the "mandatory" specifications.

Saving custom presets

The small disc icon alongside the Edit button lets you save the current setting with a customised name, to return to later. You are invited to give the preset a custom name - do so, click on OK and a new preset is added to the list for that format.

An issue at the time of writing is that you can't delete or rename the presets, so unless you tread carefully you might end up with a lot of clutter. You can reset the list in a couple of ways. You will need to make sure Windows Explorer can see hidden files and folders and then:

- Go to your boot drive (normally C:)

- Navigate to Users/Your profile name/App data/Local/ Pinnacle_Studio_24 / Studio /24.0 /Export

- To reset all the presets, delete the entire contents, then restart Studio

To reset the presets for just one format look for an XML file with the format in its name.

You can edit the xml file with a pure text editor such as Notepad (part of Windows). I suggest you take great care when editing, and unless you are feeling adventurous restrict yourself to just renaming the presets.

The customised xml file

Name	Date modified	Type	Size
1321404876000000000.ver	16/10/2019 15:35	VER File	0 KB
XPMDevice.Device_XBOX.xml	13/10/2019 08:59	XML Document	16 KB
XPMDevice.Device_XBOX_One.xml	13/10/2019 08:59	XML Document	22 KB
xpmds.AVI.xml	16/10/2019 15:35	XML Document	28 KB
XPMPROXY.CineForm.xml	16/10/2019 15:37	XML Document	37 KB
XPMWeb.Box.xml	16/10/2019 15:35	XML Document	9 KB
XPMWeb.Vimeo.xml	16/10/2019 15:35	XML Document	9 KB
XPMWeb.Youtube.xml	16/10/2019 15:35	XML Document	9 KB
XPMwmf.Windows Media.xml	16/10/2019 15:35	XML Document	186 KB

Advanced Settings

These offer up to three choices. **Smart** is a checkbox that will appear if Studio determines that the current timeline can be Smart rendered The **Always re-encode entire movie** setting is only relevant if you are making optical discs - it has no bearing on the use of Playback Optimisation files in all the tests I've carried out.

Preprocessing *should* control the use of the the preview optimisation files in the final export. In the current release of Pinnacle Studio, if you have set the preview to *Best Quality* the render files are deemed suitable to use as a source. The preprocessing options should control their use, but as far as I can tell, if the files are there they are used and switching these options has no affect.

The Player Window in File Export

The Preview player has the usual transport controls so you can check out the project or file before you export it.

The In and Out point calipers in the Source Preview window are also present when you are exporting files. You can alter them by dragging, using the buttons or using the I and O keyboard shortcuts to set them to the current scrubber position.

If you have a long project and are only interested in a part of it, or perhaps you are trying to troubleshoot a render issue, setting the calipers to the desired section restricts the export to that part of the project.

Marker navigation works in the Player window as well. If you are working on a project and decide you want to export a number of sections, dropping markers onto the timeline before you switch to export will allow you to find the sections quickly and then set the In and Out points.

Timeline Export calipers

In and Out calipers force a partial export

The Edit timeline toolbar also has three icons that mimic the controls available on the Source preview and Export player windows for setting and clearing In and Out points.

If you wish to choose a section of the movie while still in Edit mode you can use these markers, and then when you go to the Export tab they will be waiting for you in the Export player. I'll explain further uses for markers when we look at Queued Export.

Estimation

Beneath the preview window there is a blue/grey bar indicating the amount of used space on your chosen destination drive, beneath which there is an estimated file size.

Why only "estimated"? Well, in the case of a fixed compression scheme such as DV-AVI, the estimate will be very accurate, but if you are exporting using a codec that uses intraframe compression, it's hard to estimate accurately without scanning the video content - a slideshow with little movement, or a movie with little fine detail will compress far more easily than one with fast action or high levels of detail.

The File Export process

Let's perform a quick export to demonstrate the workflow.

I'm going to work with an h.264 file. Using less popular files will have the same workflow, but I'll be able to show you how Hardware Acceleration, Background Preview Optimisation and Smart Rendering can affect your export results more

clearly using h.246. I'll use the file I've provided for the Whistle-Stop tour project. You can use your own footage if you wish, or download my sample – Drone clip_LQ, or if you want to push your computer harder, the MQ or HQ clips.

Where I don't give a full description of how to carry out a task in the following steps, it is described in detail in the Whistle-Stop chapter.

One further note about the following step-by-step. At the time of writing Studio can misbehave if you change settings while the Export tab is open, so please stick to the order I've given, even if it doesn't seem like the most efficient.

Same As Timeline settings for Drone Clip LQ

- Make sure you are in the Edit Tab.

- Use the *Control Panel/Export and Preview* to set *Playback Optimization* to zero, and *Hardware Acceleration* type to None.

- Switch to *Control Panel/Storage Location*s and delete the Render files, then close the Control Panel.

- Put your chosen test clip into a new Project Bin called *Export Test*. Start a new project, place the test footage of your choice onto the second track of the timeline and save the movie as *Export Test*.

- Now switch to the Export Tab and check the *Same as Timeline* box. If you have used my LQ clip the settings below should now match the screenshot.

We are now ready to Export. You might like to time how long the next stage takes – perhaps using a phone stopwatch app.

Export in Progress

Click on the Export button The controls beneath the player preview are replaced with a progress bar and a status message - the file name and then the information Exporting frame xxx of xxx at hh:mm:ss:ff. The movie plays in the player preview as the export proceeds. In the current case it should play faster than real time unless you have a very slow computer or an issue with your setup.

When the progress bar completes its journey a box will pop up telling you the export has finished. Three icons give you the chance to open the file in Windows Explorer, Windows Media Player or QuickTime Player. If the file isn't compatible with Quicktime or you don't have it installed, you won't be offered that option.

What you see after a successful file render

So what is happening here? Studio works its way through the project, taking the source material – video, music and whatever other assets we may have added to the timeline- and then using any instructions contained in the project file, such as what effects to add, and writes out a new file in the chosen format. This process is often called Rendering.

If you click on the Windows Explorer icon you can examine the size of the completed file. In this case it's almost exactly the size that was estimated.

Render Speed

My main desktop computer is fitted with an Intel i7 4790K CPU (old, but still with a high benchmark of 11165). It took 1 minute 15 seconds to complete the render. My laptop with a i7 6500U (newer, but a slower benchmark at 4424) took 3'13" to perform the same task, which is what the benchmarks would suggest.

Because I got you to switch off all hardware acceleration, the render time is almost entirely governed by the power of the Central Processor (CPU). Reading the data from disc and storing it back to the files will not be the bottleneck unless we are dealing with very lightly or uncompressed video, so a fast SSD will make no discernible difference to render times.

You might wonder why Studio can't inform you of precisely how long it will take to complete an export. The time taken to render each frame depends on the complexity of the operation, thus making a time estimate a little tricky. We haven't included any effects or other assets that would add to that complexity either. You may notice on some projects the rate of rendering varying as the process progresses because Studio is encountering items that take longer to encode.

Using Hardware Acceleration

Studio can use the power of some Graphics Processors (GPUs) to speed up rendering for h.264 and h.265 video. If you are unsure of what GPU you have, hold down the Windows key and press R, then in the Run box that appears enter *dxdiag*.

The Direct X diagnostics tool will open. Click the second tab for *Display* and your GPU will be listed. Studio should support most modern medium to high end AMD, Intel or nVidia GPUs.

Switch back to the edit tab before you carry out the next step. Open the *Control Panel/Export and Preview* and click on the *Hardware Acceleration Auto Detect* button. The Entry should change from *None* to the correct type for your computer. If you have NVidia graphics it should now read *Cuda*.

WARNING – at the time of writing, Studio can sometimes mistake Intel graphics for AMD. If the new setting seems wrong change it!

Top Tip – even if you don't have a supported graphics card, you might want to experiment with these settings anyway, as when hardware acceleration can't find the required hardware it may default to using it's own software routines, which could be quicker than those used when you specify None.

With what should now be the best setting for your computer, let's try exporting the file again. Switch to Export and check the settings haven't changed, then click *Start Export* again. You will be asked if you want to overwrite the previous file – start your stopwatch and then click *Yes*.

So, was that quicker? On my desktop computer, using a Nvidia GTX 1070Ti GPU, the export took 33 seconds – less than half the speed. The laptop, with a Intel 520 HD GPU,showed an even bigger improvement at 52"

Smart Render

The next step in the quest for speed is to use **Direct Stream copying** – where any parts of the project that don't need to be un-encoded and then re-encoded are just copied from the source file to the output file without being processed in any way. The current movie – with just one untouched clip – is ideal for this.

Staying in the Export tab, scroll down to the Advanced options. If there is a Smart checkbox there, check it. If there isn't, Studio has deemed what you have on the timeline is unsuitable for Smart rendering.

The format will change to Smart and the *Same as Timeline* checkbox will become unchecked. The Video section will show the attributes of the clip.Stand by to time the process and start the export again. This time you should not see any video in the preview window as the render goes through.

My desktop computer took 18 seconds to complete the task, the laptop 29". If you open the file using the Windows Media Player option and play it, the video will be of identical quality to the original file. However. Smart comes with a lot of drawbacks. It can mess up cutting points and transitions, omit titles and effects and spoilt audio

sync. If all you want to do is trim a clip, it is great because it is quick and doesn't even cause a quality loss. The Outpoint can be a bit random, so don't trim it too tightly. Anything more than that and you may spend longer checking the file for errors than you save in render time.

It's worth a further demonstration of Smart. In the Export tab, uncheck Smart, and then return to the Edit interface. Split the timeline clip at roughly the halfway point (2'30").

The modified movie

Select the second clip only and use the PiP tool in the timeline preview window to shrink the video into the top right quarter of the screen. Disable PiP and then return to the Export Tab. The Smart checkbox should still be available, so check it and then and export again – no need to time it on this occasion. You will see the export fly along until the halfway mark, and then slow down drastically as Studio has to cease Smart rendering to apply the PiP effect.

Studio carries out a simple check when you switch to export, and once you have checked the Smart box it doesn't automatically get unchecked if you make changes to the timeline, so it can be fooled. However, the result of fooling it is normally a disaster!

Playback Optimization and Export

We have performed all of our test exports on a movie that has Playback Optimisation set to zero. When you generate the files (sometimes called Render Files, even by Pinnacle) they can help you get smooth playback on lower powered computers, complex video formats or effects laden timelines. If you do use Playback Optimisation, would it not be a good idea to use those files to help with export?

Well, yes and no. The first thing to realise is that with the Control Panel/Export and Preview/Quality set anything other than *Best quality*, any preview files will be of a lower quality to that of the project, and are therefore not used.

Let's use the current contents of the timeline to run another demo – The Drone clip is already split into two and an effect has been placed over the second part. Switch off the Smart setting, re-check Same as Timeline and perform yet another export – getting a rough timing on as you do, and also watch the progress bar.

As you might expect, this export takes longer because of the effect – the second part of the render process is visibly slower and on my desktop computer the whole export takes 53" as opposed to 33".

Return to the Edit tab, open the Export and Preview section and then change Preview Quality to Best and set the Optimization level to 80. You should see a brown bar appear over the second half of the movie, and then begin to turn green. When it is all green, the bar disappears, and your Playback Optimization files are ready.

If you want to time how long this takes, use the Control panel to delete the render files and start your stopwatch. On my desktop computer it takes 54 seconds just to produce the files for half the project – as long as it took to export the whole file, which we still have to do.

The reason for the slow production of these files is that there is no hardware acceleration possible – they are a form of mpeg-2. But still, you may have needed these files so that you could preview your movie, so that time was not wasted, and you could still be editing as they were being produced in the background.

What happens to the export performance now? Run another test export. On my desktop computer, it takes 30 seconds, so some time was saved. It is slightly quicker if there had been no effects at all. If the whole of the movie had been optimised for playback the saving would have been a little more still (28").

The conclusion here is that if you have a powerful computer with good hardware acceleration, waiting for the generation of Playback Optimization files that you don't need will only speed up export by a small fraction of the time spent waiting for the files.

If your computer isn't capable of Hardware Acceleration or has limited capability, the tables are somewhat turned. Switching off the Cuda on my desktop computer resulted in an export time of 1'50" for the movie without render files. The render files took the same time to be created. Rendering just the effect and then exporting took the creation time down to 1'22". Creating Playback files for the whole movie made little difference. So you get a lot more of the Preview render time back for parts of the timeline with effects added, but virtually none for parts that are clean of effects.

You may wonder why I'm paying so much attention to the benefits of producing Playback Optimization files. Part of the reason is that some users think it is good practice to let them completely generate before even starting to contemplate exporting. This may be a hangover from Classic Studio, where preview files could be used to generate DVDs, but that's not the case with NGStudio. The other reason is addressed in the next section.

Export Errors

If your file creation halts with an error message if can be extremely frustrating, particularly as the message can be somewhat cryptic. Fortunately, later versions of Studio are a lot less prone to file export errors, apart from one error that can occur right at the end of the export. Other errors can result in a faulty, but complete, export – poor quality, effects that aren't working or other missing components. If you have used Smart rendering, that should always be suspected, and turned off.

Next in the line of suspects should be hardware acceleration. If the export finishes but hasn't come out as you expected, try the export again with acceleration set to *None*. Graphic cards and their drivers vary enormously, and an out of date (or newly released) driver can also cause problems.

Mid-project errors can be caused by an anomaly on the timeline. A tiny gap, invisible until you zoom the timeline right in could be one cause. Using a particular effect or transition with certain parameters might also be the culprit, particularly when using some of the older content. These problems can often be tracked down using the timecodes given in the error message.

Speaking from my own experiences, errors can be associated with Playback Optimization files. If you have added effects to a clip that has already been rendered, things get quite complicated, and an error can often be cleared by deleting the render files. But should you let them be re-rendered before export? Well, that depends on the cause of the error – in the past, I've seen unrendered effects cause errors that are fixed by rendering!

On any computer there is no time advantage in waiting for the render files to be remade. The better your hardware acceleration, the more time is being wasted. So my suggestion is not to wait – go ahead without re-generating the files and try to export again. If the error persists, then wait for the files to be made before the second attempt.

Preparing for Export

This message that can look like an error but normally isn't. You will see a pre-render operation happening under the export preview, and no video will be displayed until the message goes away. The most common occurrence is when the Stabilizer effect has been added, but the analysis phase has not been completed. This process can be very slow, and I'm afraid all you can do is either wait, or quit the export and go back and remove the effect.

Export not complete

Another issue you might encounter is that the render process finishes, but no file seems to exist! When writing a large export file, it may first be sent to a temporary file, with a filename consisting of a long string of numbers and the suffix *.tpm* This has a filename that consists 18 digits which seems to always start with the number 6. The file may also have the extension *.tmp*, or that of the format - *.mp4* perhaps. The final step is to convert the temporary file to the correct name - and sometimes this process stalls. I'm afraid that although Pinnacle have addressed this issue on a number of occasions, and fixed the likelihood of it happening, it does still occur - generally with very large files.

However, if you locate and try renaming the temporary file, you will often succeed in producing the file you were trying to create.

Exporting to the Web

Uploading to the web is not a process that needs to be automated. You can research what format the website requires, export your project to a suitable file, and then manually upload it. Studio used to attempt performing all these tasks for you.

Where this process fell down was two-fold. Often the service would change the way automatic upload worked, at which point web export ceased to work. The other issue is that while Studio is uploading your files, you can't do anything else with Studio. If you upload outside of Studio you can get on doing other things, even if it is just tidying up your Library.

In that case, you might ask - what are suitable settings for manual uploading? Well, h.265 and checking *Same as Timeline* is a pretty good place to start. However, check your bitrates - these only need to be around 4Mb/s for SD, 6Mb/s for 720p, 12Mb/s for HD and 20Mb/s for UHD. If you have a fast internet connection, you can try higher rates for better quality, but these services tend to re-encode everything anyway.

If your computer can encode HEVC, that would be a better format than h.264/AVC and as a rule you could reduce the bitrate by 40% for the same quality and get a much faster upload time.

Queued Export

Want to create a batch of clips from a long video file? Need to export a number of different versions of a project with a variety of opening titles? Want to create different quality versions of the same project?

These are things that can all be done more efficiently if you don't have to wait for each export to complete before you make the changes required before you start the next one, and that's exactly why Pinnacle have added an export queue system to Studio.

Preparing the clips for Queuing

In the example used for the screenshots, I've marked up a few sections of the test clip that I want to export as separate clips, using the Edit tab and markers function. Entering the Export tab I can set the export parameters and filename. Using the marker navigation arrows I can set In and Out points for the first desired clip, and then clicking on Add to Queue switches the right hand pane to Export Queue where the first export is listed.

Switching back to Preview, the In and Out points have been cleared but the markers remain, and the scrubber is still in its previous position. Repeating my actions I can create the next two clips in the Queue.

Note that I didn't change the filename, although I could have done so for further clarity. The duplicate file renumbering will be sufficient. Start Queue then creates all three files – Drone highlights, Drone highlights (1) and Drone highlights (2).

The Export Queue

File Name	Format	Preset	Destination	Status
Drone highlights	H.264/AVC	Custom	C:\Users\Jeff\Videos	Exported
Drone highlights	H.264/AVC	Custom	C:\Users\Jeff\Videos	Exported
Drone highlights	H.264/AVC	Custom	C:\Users\Jeff\Videos	Exporting

Stop Queue

Status test export.movie.mp4: Exporting frame 418 of 1425 at 00:04:12:04

Total : 27 % complete

Queue management

All the tools you need to manage the Queue are accessed by opening the context menu for a list entry. If you highlight an entry you can Update it from the Export Settings panel by using the Update Selected button.

A straightforward, useful, addition to Pinnacle Studio!

Alpha Channel Export

This is another recent feature, only available in Ultimate. You can now create a file that holds the transparency information from the timeline such as the background to a title, or a hole generated by a mask.

Exporting Alpha information

Although it's not immediately obvious from the Export settings how to do this, all you have to do is use the Cineform preset from the Format dropdown and select a preset for either AVI or MOV output at the required resolution.

The exported file can be brought back into Studio (or other editing programs) and placed over other assets, which will show through the transparent areas.

Some of the media playing software on your computer may struggle to play back the file without installing a Cineform codec, but WMP should play back the AVI files and Quicktime the MOV files.

Export to Disc via MyDVD

MyDVD is a standalone program that is supplied with Pinnacle Studio. If you enable the Author toolbar on Studio's Edit page you can add chapter points to a movie. Then when you switch to Export you are given a choice of exporting to File or MyDVD.

I take a look at the Author toolbar, MyDVD Export and using MyDVD itself in the Disc Menus chapter. For now, all you need to know is that exporting to MyDVD creates a suitable file and a chapter list from the movie loaded on the Timeline and then passes it on to MyDVD.

Legacy Mode Export

If you are using the "old" method of making optical discs then you will have a fourth tab available - Author. Later in the book I'll discuss adding menus, but in this chapter we will look at the disc export process only.

What, No Menu?

You don't have to make a disc project that includes a menu in order to burn a Video DVD. Because Menus add a layer of complexity and potential compatibility issues I'm going to give them their own chapter. If you haven't made a DVD before, burning something nice and simple will be a good exercise in proving that you can make a DVD that works. So, if you don't have a suitable disc project yet, or are trying to find out why your DVDs won't play properly, you can work through the following pages with a simple project.

For the example here, I've used the mpeg-2 file that comes with the sample movie If you want to work through the steps, you can also use this file or use one of your own.

The Author tab ready for export

To enable the Author tab, open the Control Panel from the Edit tab and on the first page enable Legacy Author Mode. Click on the newly created Author tab and dismiss the message about creating a disc project from the Edit mode by clicking on No. Switch to the The Sky is the Limit Project Bin and drag the video clip The-Sky-is-the-Limit down the the first track

I'll start by concentrating on Standard Definition DVDs and discuss High Definition optical output options later. Before I show you the steps involved in burning a DVD, let us look at the DVD format.

What exactly is a DVD disc? Like the CD that came before, it is a plastic disc sandwiching a layer of material that has a variable reflectivity. By bouncing a laser light beam off the disc onto a photo-sensitive cell, the playing device can read a series of bits of data - the basis of all digitally stored information. Huge amounts of data can be stored on the disc, but sometimes not all that accurately, so error correction is built into any playback system – something that digital storage achieves quite easily.

The critical difference between DVD and CD is the wavelength of the laser used to read the disc. A shorter wavelength enables a smaller area to represent one bit of data, and therefore more data can be squeezed on a disc. Incidentally, the same

applies to Blu-ray - even more data can fit on a disc because the system uses a shorter wavelength still (a blue laser, not a red laser, hence the name Blu-ray).

Two more facts about DVDs – DVD doesn't stand for Digital Video Disc, but Digital Versatile Disc (they can be used to store other forms of data, including audio only), and the data is written from the inside of the disc outwards, unlike vinyl records.

Optical DVD discs fall into three categories:

Read only discs that are pressed from a glass master. These are used for mass distribution and have a type of "DVD-ROM".

Writable discs that contain an organic dye which can have its reflectivity changed when a high powered laser beam is fired at it. A pattern of 1's and 0's is burned on the disc – hence the name burner. A low powered beam doesn't affect the dye, so the disc can be read using the same laser with adjustable power settings.

Re-writable discs that use an alloy instead of the dye, so that the writing process can be reversed – the disc is therefore capable of being erased and reused.

There are 2 sizes of disc – 12cm and 8cm, although 12cm disc are far more common. Discs can also be double sided – they need to be read from both sides - and Dual layer, where the laser focuses on different layers at different depths in the disc.

Writable and re-writable discs come in a number of formats. There are three basic standards - DVD+R, DVD-R and DVD RAM. DVD RAM is a more flexible format, but only a limited number of stand alone players can read the discs.

This leaves +R and –R. For overall compatibility, -R probably has the edge. I'll discuss compatibility – a thorny subject for many people – at greater length later.

Getting ready to burn

At the risk of stating the obvious, you need a DVD burner fitted to your computer to burn a DVD. Pinnacle Studio 24 can burn a DVD image to a CD disc, but you won't be able to play it on most DVD players.

If you have a DVD burner in your computer that is fairly up to date, then it can probably burn most types of discs, so you will have to make a choice about which type of blank disc to use. If it's an old burner your choices, and the speed at which it can burn, may be limited.

The first few times you make a DVD, I'd recommend using a rewritable DVD as a test. You will eventually want to buy some of the –R or +R discs that are a one-shot

deal. They are much less expensive nowadays, but it's still a shame to waste them on experiments.

NTSC vs PAL

Pinnacle Studio makes either PAL (25fps) or NTSC (29.97fps) DVDs. Not all DVD players are multi standard. Most PAL players can play NTSC discs. Most NTSC DVD players cannot play PAL discs.

The format chosen by Pinnacle Studio normally matches the project format. If the timeline you have opened when you select Export contains a PAL, 25 or 50 frames per second project, Export will produce a PAL disc. If the frame rate is reported as 29.97, 30, 59.98 or 60, then the resultant DVD will be in the NTSC format. Disc authoring in Studio isn't sophisticated enough to produce discs with a mixture of formats.

Because the footage you have loaded onto the timeline has come from your Pinnacle Studio installation, it should match the TV standard of the country you live in - Studio detects from Windows when you install it.

In the vast majority of cases you will end up with the correct format DVD, but it is possible to have the incorrect project format for your type of footage, so before opening export it is a good idea to check the format by opening the Project Settings icon.

This difference in standards isn't to be confused with region encoding. There are nine regional settings to help DVD distributors attempt to stop grey imports. All the DVDs that Studio makes are set to Region 0 – an informal term meaning "Worldwide".

Disc Export Window

Clicking on the Export tab from the Author mode brings up a somewhat different window to file export

Upon opening the Export window, you should have a choice of File or Disc below the Export settings label on the left, with Disc already selected.

The Settings are different, and the Preview area has become a Disc Simulator window. This works in the same way as the simulator in the Author Editor I'll look at in detail later, but for now, think of this as the last chance to check your project before embarking on a lengthy render process.

The Estimation area is now more complex, with a few additional choices and the estimation displayed as a pie chart.

Disc Export

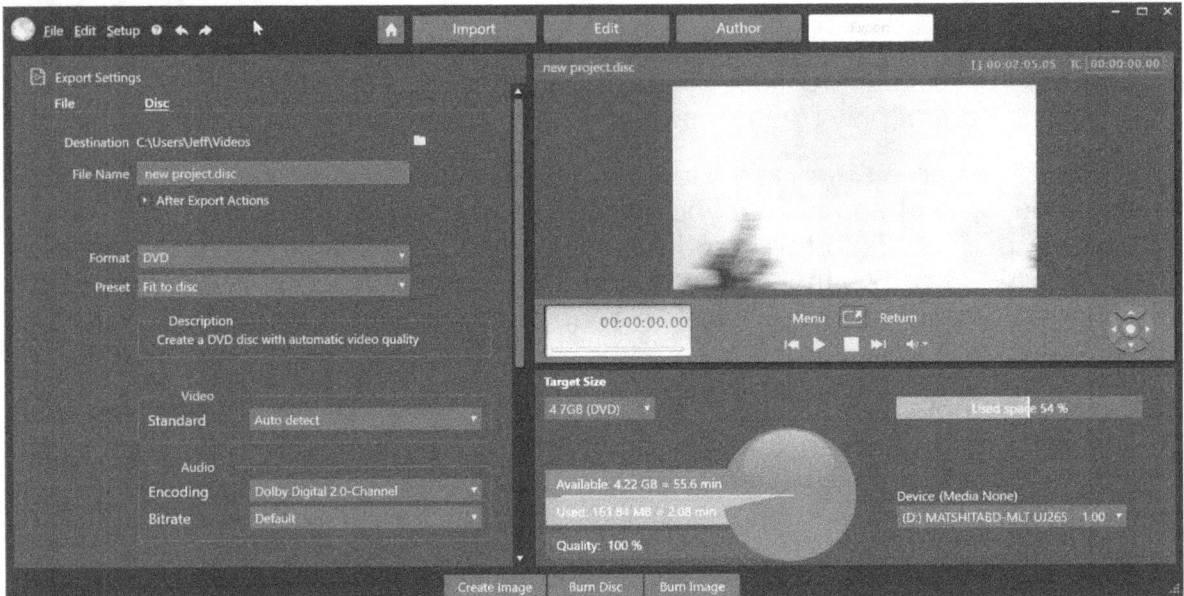

Disc Settings

While Destination and File Name appear to be the same as File Export, they serve a slightly different purpose because you can't burn straight to disc. An image always needs to be created, and you have to put the image somewhere. The folder icon allows you to specify a destination other than the default. If you have specified the image to be an ISO file it will be stored in the destination using the specified filename. If you are creating a Folder (Video_TS) then the Video_TS folder will be placed within a new folder created with the File Name at the specified destination. Note that the disc itself will take it's title from the Disc project, as shown above the preview window, regardless of the File Name.

After Export options are the same as when creating a file.

Format Options

The drop-down box labelled *Format* offers either 3 or 4 choices. If you have paid a small licence fee or inherited the licence from a previous version (using the *Restore Purchase* option in the Control Panel), all versions of Studio 24 offer Blu-ray burning. We are concerned with DVD creation in this section, so I have selected that.

Preset allows you 3 choices. Studio only makes DVDs with full resolution, although the Video DVD standard would allow for lower resolutions.

Disc Preset

The quality settings in Studio only affect the bitrate. Low bitrates affect moving content more than the quality of static pictures.

With only a few minutes on the timeline, we don't need to worry about disc usage. If you put more than an hour of material on a DVD disc, this is accomplished by compressing the MPEG-2 video at a lower bitrate. You achieve this by selecting options in the Preset box. The options are:

Best Quality – gives a nominal bitrate of around 9200Kbps (video and sound combined)

If you keep adding video to the timeline, you will eventually get some red figures in the DVD Discometer. If you try to create a disc once the duration is more than Studio estimates will fit on the target DVD it will throw up an error message with advice as to how to fix the problem.

Options for making a project fit onto a disc

Fit to Disc – this setting estimates what bitrate you need to fit the project onto the target disc.

The estimation can be very conservative. Studio uses a variable compression rate but only does single pass encoding and therefore it can't be sure of the exact size a file will end up.

Custom – You choose the bitrate. When you opt for the Custom option you will find a slider in the Video section that you can use to vary the bitrate between 2 and 8Mbits/sec.

Standards Selection

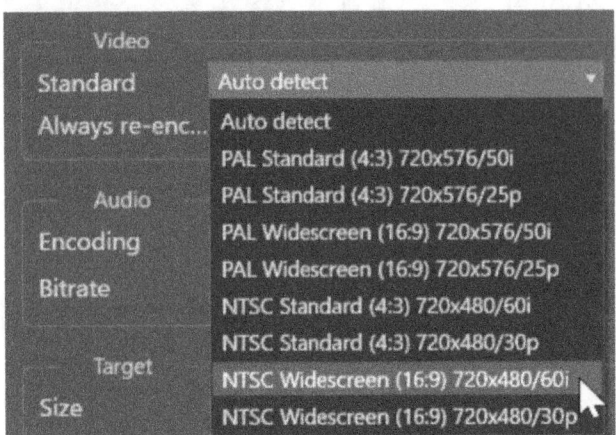

The **Video** section has a Standards drop-down which defaults to *Auto detect*. Because we have put a Widescreen SD clip on the timeline that should match the video settings of your Windows installation, you should automatically get a disc with the correct standard - NTSC or PAL.

One compatibility issue that may occasionally bite you is **Audio** playback. Because you own Pinnacle Studio, your computer will be able to play back all the audio formats that can be used on a DVD. There are 4 possible options available in the Audio settings.

5.1 Dolby surround should play on all DVD players even if they can't output 5.1 sound. If your project doesn't have surround sound, then using 2 channel Dolby will take up less space on the disc and should also play on all DVD players. The problem might be with playing on a computer or laptop not equipped with a Dolby licence. You have one, but does everyone else? Well, most people will have and I've never heard anyone complaining that they can't hear the audio on a Dolby encoded disc, but it could happen.

MP2 audio compression takes up the same space as Dolby, won't sound significantly worse and you don't need a licence, but while any computer should be able to play it, there might be some NTSC DVD players that can't.

PCM is our old friend the Windows Wave (or WAV.) file format. Everything should be able to play it, but the disadvantage is that it takes up significantly more space on the DVD - so much so that the Video compression has to be lowered by 1Mbit/s to make space!

The **Target** box has two options. With DVD selected, Size offers you seven choices. The smallest is a 650Mb CD disc and the largest is Unlimited. If your project is small, you can burn it to a CD disc. The advantage is that blank CDs are a little cheaper than blank DVDs, but the downside can be problems with compatibility. I've not found a DVD or Blu-ray player that recognises a CD as a valid DVD image. It may play on some PCs, but that's not much use.

You can change the Target Size in two places, but they perform the same function. The 4 sizes of DVD are all valid targets. As a generalisation, I have always found Dual layer discs to be more problematic, as well as not such good value for money, but if your project warrants the additional space the option is there.

The choice of *Unlimited* may seem a bit unusual, but it has two possible uses. A DVD image saved on a hard disc can be played using media player software, so you aren't limited by the physical capacity of an optical disc. The other use allows you to optimise disc quality in certain circumstances, more of which later.

Image format controls how the intermediate files for the burn are stored. It is set to *Folder* by default. If you are making a DVD you can create an ISO file. This is a single file that can be seen as a complete disc by using the Mount command in Windows 10, and other special software in earlier operating systems.

Device output controls the burner. You can force it to eject the disc after writing and make multiple copies. The write speed option may be useful for troubleshooting if your burner allows you the option to change it from Auto, as slower burns can be more reliable. If you have more than one burner you can chose the device using the drop-down in the estimation area.

Advanced Settings are the same as for file export, but in the case of discs, *Always re-encode entire movie* actually does something.

Because Studio tries to save time while making discs, it avoids re-encoding video and menus if it can.

Although Classic Studio attempted to Smartrender DVDs, I have never seen any sign of this in NGStudio. If you have already made a disc image so that render files exist, normally the files in the render folder are reused and the *Creating asset* stage is virtually instantaneous. Better still, if you make a change to one separate part of a DVD and leave others untouched, it's possible that some of the render files may be reused. For example, after a long render process you may spot a spelling mistake on a menu. Changing the menu only and creating the image will often result in only the Menu itself having to be recreated.

This time saving technique can on occasions lead to errors. Checking *Always re-encode* should force Studio to ignore any previously created files, but if you want to be absolutely sure that nothing from a previous render operation is making it's way into the final Disc image, I recommend that you also delete the render files using the Control Panel. Note that the disc files will be stored in a subfolder named *DiscExport* within your render files location, if you just want to delete them manually without destroying any other render files.

Disc size estimation

With a Single layer 4.7GB disc as the target and 10 Minutes 28 seconds to be exported, the graphic display shows the space used in orange and the space left in blue. You will note that for some reason Pinnacle have decided to display the durations as minutes to two decimal places, rather than minutes and seconds. The discrepancy between the duration of the project and the time shown that it takes up on disc is because Video DVDs require a number of files and folders to be included to make them valid, and these take up space too.

The Creation choices

Three buttons at the bottom of the Export window show the three possible choices we have at this stage.

Create Image carries out all the steps up to, but not including, the actual process of burning a disc. You can carry out this process without a disc loaded into your burner - in fact, you don't even need a burner attached.

Burn Disc goes through the entire Create Image process. If that completes successfully it takes you to the next step of burning the created image to the media in your selected drive. It can also pick up from Create Image and make a disc from the previously created image.

Burn Image takes an image that you have already made with the Create Image button and carries out the final burning process. There are two situations where this process is particularly useful - troubleshooting and making further copies.

Because I want to walk through the process, I'm going for the troubleshooting route of starting with Create Image.

I've put a re-writable DVD in the drive, but it's not needed at this stage.

Clicking *Create Image* starts the process immediately. With a simple project containing no effects, the first message you will see is *Creating asset: exporting frame xxxx of xxxx* and a time count of progress. Studio is building up a series of files from the source, but it isn't putting them into the image location.

For a simple disc, two files are produced, one video and the other audio, and they are put into a Disc Export folder in the overall Studio Render location defined in the Control Panel.

If errors happen at at this stage, you should use the same troubleshooting steps as for file rendering.

The message then changes to *Creating Disc image*. The folder that you have defined for holding the Disc image is created. The temporary video and audio files are combined into Video Object (VOB) files containing both sound and vision and the remaining files that make up a disc image are added. The creation of the VOB files in particular should not take too long, as the temporary files just need combining, not re-coding. This process is often called Multiplexing, or Muxing for short.

Sometimes a very complex timeline just refuses to render all the way through to image creation.

The idea of pre-rendering to a compatible file is at the root of using MyDVD, the standalone program supplied by Pinnacle as an alternative to using the Author mode. The Export type MyDVD File creates a suitable file for import into MyDVD and there may be circumstances why you can create a MyDVD file and then use that in the Author mode to add Studio menus.

Alternatively, if you split your project into a number of sections and make a file of each section, then remake the project from the newly made files you may well bypass creation issues. For a SD DVD project, I recommend you use the DV-AVI preset. If you are making an HD project for one of the other disc formats, then I would suggest MTS using a preset resolution that matches your project and the bitrate that comes with that preset.

Assuming no error messages have occurred, you now will have a Disc image on your computer. Although I wouldn't always do this, when troubleshooting, the next stage is to examine the image.

Examining the image

OK, hopefully I've given you enough strategies there to get round render error messages, so once you have an image, the next stage is to check it carefully.

Assuming you haven't asked the program to make an Iso file, when you use Windows Explorer to open the hard disc location of the Image you just created, you will find a folder called Video TS.

If you examine a DVD disc in your computer drive in the same way, you will also find a folder called Video_TS. There will probably also be a folder called Audio_TS,

which is there in case the DVD contains Audio_DVD content. This is rare and more than likely the folder will be empty, even if it exist.

The contents of the Video_TS folder are a structure called a Video Title Set - part of the DVD standard. All Video DVDs will have three types of files in the Video_TS folder.

IFO (information) files contain the information pertinent to what the DVD contains including what menus and titles it contains, where the chapters start, and much more.

BUP are backup files. If any of the IFO files become unreadable due to damage or bad quality pressing or burning, the player can try to use the backup information instead.

VOB files files are the Video Object files that contain the MPEG-2 video, the audio in the chosen format (and possibly with multiple streams for different sound tracks) and any subtitles. All DVDs will have at least two VOB files. In the example I have made, the first one - Video_TS.vob - has to be there for the DVD to work properly, even though it contains no video. If there was a "first run" video such as a copyright notice that played before the menu, it would be contained in this VOB file. My example then has one further VOB file, which holds the DVD content. VOB files are limited in size to around a Gigabyte (1,048,574 Kbytes to be precise), so even if your DVD has no menu and only one title or chapter, there may be more than one VOB file.

Playing back Images

Some versions of Windows and WMP can play back mpeg-2 files, but if you can't and don't wish to upgrade, I recommend installing and using the free program VLC. What's more, you can also use it to read DVD and Blu-ray discs or disc images.

Like all "free" programs, take some care. Go to *http://www.videolan.org/* to be sure you aren't getting a hacked version or one that has had adware grafted on. You might even consider making a donation to help keep these genuine open source projects alive.

You can set VLC to be the default program for opening MPEG-2 files. You can do this by right clicking on any Mpeg-2 file in Windows Explorer, selecting *Open with...* and then *Choose default program* and selecting VLC player.

Exploring a DVD Image

In WMP or VLC, clicking on the Video_TS.IFO file will normally open the image as if it were playing the DVD - if we had a menu in place it would operate through the player controls and we could fully test the image before we waste a blank DVD to test it further.

The first stage of troubleshooting DVD playback should be carried out at this stage. See if the disc plays properly and obeys the menu commands correctly. Don't just play the first bit of the video - check through the disc image for smooth playback, video problems or audio sync issues. If you identify an issue at this stage which wasn't there when you previewed the project itself you need to eliminate that problem before proceeding.

Go back a couple of pages to the Advanced Settings section and apply the *Always recode* and *Delete render files* fixes. These are just as relevant to a render process that causes playback issues without stopping the render process with an error.

Has this cured the issue you have with Disc image playback on your computer? If it has, then you can proceed to burning the disc. If it hasn't then your problems are more fundamental.

Menu difficulties are likely to be an issue with the placement of chapter points - these can be very critical to menu operation.

In my experience, playback of video and audio problems at this stage are likely to be caused by using files that appear to be compatible, but aren't properly supported. Some types of MP4 video might fall into this category. Other problem files might have a variable frame rate - video shot by an iPhone, for example. I'd suggest you try making a DVD using a standard video source, and if that succeeds you may need to look at transcoding your source files before using them in Studio.

In troubleshooting terms, if you cannot produce a proper DVD Image, there is no point in proceeding to the Burn stage.

Burn Disc

If you make an image, test it in Windows, then return to Pinnacle Studio and select **Burn Disc** from the buttons at the bottom of the screen, the program will assume that you want to burn a disc from the last created set of files. It won't create the assets again, unless it has to. So for the purposes of troubleshooting, you can use this button.

You can take advantage of the multiple copies setting with this control. If you have come from a successful Create Image session and Always re-encode isn't checked

in the Video section of Settings, you won't even have to wait for rendering to reoccur because the old files will be used.

Once you are confident of your DVD burning process, you may want to use the Burn Disc option anyway, even for a one-off disc creation. If you discover that the disc is faulty, you will be able to go back to the image and test it in the manner I described earlier - but you will have wasted a disc.

OK, I'm going to burn a disc from the Video_TS Image, and the Burn dialogue should be automatically set up for me to do that. Clicking on Start burn will immediately tell me if the burner isn't ready - maybe the tray is open or perhaps there isn't a suitable disc in place. If the disc is re-writable, but not blank, the program will warn me and give me a chance to abort before overwriting the disc.

When I choose to proceed there begins a string of messages as the progress bar crosses the screen. Firstly, the disc will be erased if it needs to be. Next a Lead-in area is burned to the disc - required for the laser of the playback device to find the start of the playable area. Writing disc content occurs next, where the files are burned onto the disc to form the digital patterns of 1's and 0's we discussed earlier.

A lead-out area is burnt next - another part of the disc to help players read the disc. In some cases players don't like very short duration DVDs, so if you think that the time taken to write the Lead-out is taking too long, Studio is writing a long lead out in order to make the burned area of the disc a decent size.

Burn Image

Burning a Video Disc from Disc Image

If you want to burn a disc from an image other than the last one created by *Create Image* or *Burn Disc* you will need to use this tool. It's also available from the File menu and Library context menu where it is named *Burn Disc Image…*

This tool is not just for creating Video format discs as it can also create data discs. In fact, it defaults to making data discs so you must take care to select the right options.

The *From* box allows you to chose which type of disc you want to make. **Files and Folders** will create a data

DVD holding whatever content you want to put on the disc. You can use this option to store items on DVD or Blu-ray discs - perhaps large Project Packages or source footage. **The resultant disc won't play as a Video DVD, however you populate it!**

Disc Image (Folder) is the mode that takes a folder structure and burns a Video-DVD.

Disc Image (ISO) looks for another type of Image - an ISO file. This type can be created in Studio by selecting it in the Advanced options under the Target heading. The advantage of ISO is that it is a self contained format that is portable, so you can use another burning program with ease. The ISO type isn't limited to Video DVD, so whatever ISO file you select, the type of disc format the ISO contains will be burned to disc. The disadvantage of using it is that it can be much more complicated to explore and test the image before burning in operating systems earlier than Windows 8. Pinnacle currently isn't capable of creating an ISO image for HD disc formats.

The small Source folder icon allows us to select a different image, files or folders to burn to DVD, and below is a simple browser that lets us edit the choice - of more use in the Files and Folders mode than either of the Image modes.

We can rename the disc that will be created, choose another burning device if we have one fitted, and force the program to eject the disc and close the dialogue when the burning process is complete.

I have to comment that the Burn files dialogue isn't as comprehensive as other disc burning programs, but it serves the purpose. I would like to see the ability to verify a disc added, as in my experience even using the best quality discs sometimes produce faulty burns. Later I look at another program for burning discs.

Bad Media?

If you have successfully burned a DVD, when you re-insert it into the burner you should be able to use the DVD playing software you have installed on your computer to check playback.

Is all well? Does the disc play smoothly? If it does, then you are on your way to producing DVDs, but sometimes a computer can play a disc that a standalone player struggles with.

If you successfully burned the DVD, then the type of disc must be compatible with your burner. DVD drives in computers are a lot more tolerant of bad media than stand alone DVD players, but the occasional bad burn can happen without triggering an error message. Studio doesn't verify discs it has burned. The easiest

way to check for a bad burn, probably caused by a poor quality or damaged disc, is to try to copy the contents of the disc to a temporary folder on your hard drive. If you get a Cyclic Redundancy Check error message, or your computer has to try re-reading a particular section, then try burning another disc, preferably of a different brand.

If you've come to this section trying to troubleshoot a burning error that has just started affecting you, even though you are using the same batch of DVDs, let me tell you what happened to me once. I had a spindle of 50 blank DVDs which seemed to be fine. I'd burned about 20 discs successfully, and then I started getting skipping problems. This lasted for about ten discs, and then the problem stopped. Somewhere in the middle of the batch were a small group of DVDs that were faulty. I didn't buy that brand again.

I'm sorry to say that brand names are not always a guarantee of quality. Another issue is that there are even some fakes around – very poor discs pretending to be made by one of the top names.

For me the good guys are Taiyo Yuden (hard to find and now using the JVC brand name) and Mitsubishi Verbatim. As DVD usage declines, the cheap brands are leaving the market anyway.

Other burning issues

So, apart from bad media, what else may be the issue?

Don't dismiss the idea that your burner may have developed a fault. Try playing a commercial DVD. If you get jerky playback, the drive may not be able to get data to and from the disc quickly enough. DVD burners seem to age more than other hardware components – lasers can overheat, mechanical alignments can drift. One way of getting accurate burns is to burn at the slowest speed available. Just because the disc says 16x doesn't mean you have to burn at that speed. Imagine a small boy trying to direct a very powerful fire hose.

Does your burner have the latest firmware? How to check that, and how to update it, is something you should be able to do from the manufacturer's web site.

Another potential culprit is clashing software. There are a number of programs that try to take over control of your DVD burner. If you have packet writing software in particular – sometimes marketed as "Drag and Drop" CD/DVD burning software - it may be running in the background.

DVD player issues

OK – let's assume now that the disc plays back OK on your computer. Put it into your stand alone DVD player. Does it play smoothly on the TV? If the answer is yes, a small smile should creep over your face. If you've got more than one player, a DVD recorder or a games console that plays DVDs, try them. If they all work, allow yourself a proper smile. Try the neighbours? How about the Electronics showroom? I'm sure if you search for long enough, you may find a player that either ignores your disc, or plays back in a jerky manner. Let's look at the problem of recognition first.

Why don't all burned DVDs play on all DVD players? A good question without a simple answer, I'm afraid. We can partly blame the DVD player manufacturers. Some of the oldest players just don't play burned DVDs – they aren't designed to. Others only play some types, +R or –R, rewritable or not. So there are a small group of players that are always going be a problem.

I've got an old DVD player that is very picky. Even though it can play some DVD-RW discs, it can't play every brand. It also doesn't like discs that have a duration of only a few minutes, although most burning programs including Pinnacle Studio now burn a longer lead-out sector to overcome this.

A flat refusal of a DVD player to play a disc – either with a "wrong disc" type of error message or by it just going into a sulk - has a few potential solutions:

- Double check you aren't trying to play a PAL DVD on an NTSC DVD player.

- Try a different disc type – rewritable discs are less likely to work, and more DVD players will play –R discs than +R

- Burn at the lowest speed possible if Studio gives you that option

- Try a different brand.

- Use a different burning program

If your reaction to the last suggestion is "I've paid for Studio – why can't it do the job?" then bear in mind that Studio is an editing program that can burn discs. Burning programs will concentrate on burning, and may be better at it. Having said that, there isn't one burning program I've tried that can make my old DVD player accept DVD-RW discs made by one particular manufacturer. I've tried quite a few NLE programs that burn DVDs, and they have all failed as well.

There is one trick that can help you broaden the compatibility of your discs, and that is to disguise them as DVD-ROMs. To do that, you will need a 3rd party program anyway.

ImgBurn

For potentially better burning and the possibility of creating "fake" DVD ROMs I suggest you download ImgBurn. It's free, and even Microsoft have been known to recommend it. It is pretty user friendly, if a bit chatty at times. One reason I often use other programs to burn discs is the ability to verify the disc straight after burning, and the better error messages these programs provide. ImgBurn fulfils both these criteria.

Acquire a copy of ImgBurn from the official website. To do this, go to *www.imgburn.com*. Ignore anything that looks like an advert embedded in the site. Download the latest version of the software - which is over 6 years old at the time of writing!

ImgBurn is bundled with adware, so it is important that you **don't** use the "Express (recommended)" option to install the program (unless you want the adware!)

Even then, watch out as you will be asked if you want to install additional programs. These may vary from user to user. None of these are required but you have to deliberately uncheck the boxes to stop it happening. **Take care!**

You may read some very negative things about Imgburn installing unwanted programs even if you are careful. It's never happened to me, but if you are very cautious, it is possible to get a clean version of the program that doesn't have the installer responsible. Check out the DTVPro website support page for more details.

ImgBurn isn't a complex program and there are plenty of guides and tutorials about it, so I won't waste space here describing how to use it. The first important point is that you need to check a box to set it to verify its burns, and the other is it is capable of Bitsetting, which involves altering the Book Type.

The first few sections of a DVD can't be written to. This is where commercial DVDs hold the encryption information that is supposed to protect them from being pirated. Just after that comes data that tells the DVD player what specification the DVD is – its Book Type. On DVD +R discs, with **some** DVD burners installed with **some** firmware and using **some** burning programs, you can set this book type to DVD-ROM!

There are far too many "somes" in that last sentence for me to go into greater detail, but all you need to know is out there on the Internet. I bought a DVD burner that could do Bitsetting when I used ImgBurn a player belonging to a family member that couldn't play **anything** I burnt then played **everything** I burnt.

Compatibility and lower bitrates

The final suggestion to avoid skipping discs involves lowering the bitrate of the burned DVD. If a particular player is having issues, you might find that not using 100% quality, but knocking 1000Kbits/sec off the compression bitrate, solves the problem. A small reduction in quality, but it means the player has a little less data to retrieve and error correct in real time. Studio can compress MPEG-2 at bitrates up to 8500Kbits/sec - although it rarely does. You will be unlikely to find these rates on commercial DVDs. The maximum the DVD-Video specification allows is 9800Kbits/sec. You will need to use the custom settings to lower the bitrate of a DVD..

Burning multiple copies

Once you have been successful in making a DVD, there are a number of ways of making a batch of copies. In Advanced options there is a selection for the number of copies you want but it only works in Burn Disc mode. Another option if you are going to do a long production run is to use ImgBurn. It's a good idea to create an ISO file for subsequent burns, and you can even use ImgBurn to create an ISO file from a Blu-ray disc - not something possible in Studio.

Labels - a warning

Don't ever stick labels to your DVDs. They might work for a little while, but as the glue ages and the labels peel, you might lose the disc, and even damage the player. Use a CD/DVD marker pen (or Sharpie) to mark up your discs. If you want a better look, buy an inkjet printer that can print directly to printable DVDs.

Blu-ray Discs

To make Blu-ray discs, you will need to buy a Blu-ray licence from Pinnacle. It's an option in the Help Menu. Once you buy the licence, make sure you make a note of the email address you used. If you reinstall the program and lose the option, you can use the Restore Purchase option in the Control Panel so that you don't have to pay again! You can use the licence should you upgrade to a later version.

I mentioned earlier that the Blu-ray disc format uses a higher frequency laser to read and write discs than the DVD format. This allows smaller "pits" to be used, so the disc can store more information. Significantly more, in fact, because a single layer Blu-ray can hold 25Gb of data - over five times as much as single layer DVD.

Much of the disc creation process is very similar to creating a DVD. Instead of a Video_TS folder, A Blu-ray image disc holds two folders with all the important information being held in a BDMV folder. The video is held in a subfolder named

STREAM and consists of m2ts files which can be encoded either as h.264 or mpeg-2.

Blu-ray bitrates and frame rates.

Some DSLR cameras produce video at high level bitrates of 40Mbit/s, and, the maximum theoretical video bitrate of Blu-ray is 40Mbit/s, so you will get just over 80 minutes on a single layer disc. However, the technical limit to the AVCHD standard used by most consumer HD cameras is 24Mbits/s. Often these cameras shoot at an even lower bitrate. You may have a camera that shoots at 50 or 60p with a bitrate of 28Mbit/s, but some Blu-ray players cannot handle 50 or 60p even though Studio can burn discs to these standards.

For the *Fit to disc* setting, Studio uses a maximum of 24Mbit/s, giving a little under 2 hours duration. While this shows a quality of 60%, don't think that your video is being hugely downgraded (unless you are sure it has a bitrate higher than the AVCHD standard). *Best quality* will attempt to use the maximum of 40Mbit/s and if there isn't enough space it will offer you the same options you see when making DVDs.

M2TS/MTS Image Quality

In the case of Blu-ray Disc export, the H.264 files are created as MTS/M2TS files. Studio has a special set of parameters for creating these files: Fastest, Balanced or Best Quality. Unlike Playback optimisation, these settings don't affect the resolution. They also don't affect the bitrate of the final file. They alter the amount of processing that is carried out during the render process, and in my judgement affect fine detail more than movement rendition. There is a speed trade-off, and normally Studio appears to use the Fastest mode as its default setting. The speed trade off is very dependant on your hardware and on my current machine Best Quality adds about a 40% overhead.

The quality improvement is much harder to quantify. A lot will depend on the original quality. I carried out some tests with 40Mbit/s DSLR video re-rendering to the same bitrate, where I could see very little difference between the original and the new file created with the Best Setting or the Fast setting. Downgrading the files to 24 Mbit/s showed a greater difference but I have to say the results were quite marginal.

My recommendation is that if you take a little time setting up a test. If you can see a difference worth the extra time, then do so – after all, you can always leave the render to run and go to bed!

The MTS setting also provides another settings box that gives you the possibility to work with hardware acceleration *On*, *Off* or *Default*. These settings seem to interact

with the Control Panel, but much will depend on your hardware. If you are having render issues you might wish to try with this box set to Off.

Mpeg-2 Blu-ray Discs

The Blu-ray standard allows discs to also contain MPEG-2 video as well as or instead of H.264. You will get lower quality for a given bitrate, but the MPEG-2 render might be of interest if you are experiencing pixelation or playback issues with your discs. You can select MPEG-2 using the Advanced settings/ Settings/ Video/ Encoding.

When you use MPEG-2 and Fit to disc, the bitrate chosen starts at 40mbit/s.

AVCHD Discs

AVCHD Discs discs are a halfway house between DVD and Blu-ray. You can use normal DVD discs and DVD burners to make the discs, but you can only play them back on a Blu-ray player – and because AVCHD discs aren't part of the official Blu-ray specification, not all Blu-ray players will play them. The AVCHD format is promoted by Sony and Panasonic, so if you own a Blu-ray player by either of those manufacturers it's very likely to work with these discs. Look for the "AVCHD" logo if you are thinking of buying a Blu-ray player.

There are a number of limitations in comparison to Blu-ray. The maximum bitrate is 18Mbit/s so some of the better AVCHD cameras will have to have their pictures downgraded slightly. Duration is relatively limited – for example, about 35 minutes at best quality on a single layer DVD - and although you can use menus, I've read that the AVCHD Disc format only supports "simple" menus. What that means, I'm not sure, but Studio struggles to create complex menus that are reliable on this format, so I wouldn't recommend you do anything too elaborate.

For me, the medium offered a great low cost way of viewing home-made HD material on my main TV. You may prefer to go the extra step to Blu-ray if you want the last bit of quality or you make long projects. Only recently, since I've bought a camera that shoots at a higher bitrate than 17Mbits/s and the cost of burners has come down have I joined the Blu-ray camp.

The structure of files on an AVCHD disc is the same as Blu-ray.

All of the leading Blu-ray playing software packages can handle AVCHD discs, and VLC can also play them if you ask it to look for Blu-ray. If you just want to check the quality of the rendered video, you can play the .MTS files themselves with most media players, including WMP. Testing the menus without burning a disc can be

tricky, but I've converted the Folder Image created by Studio into an ISO file using ImgBurn, then mounted that as a drive in Windows 8/10

The process of creating a AVCHD disc is almost identical to creating a DVD. I've not detected any attempt by the software to Smart Render video – so that takes away one source of potential problems although at the expense of speed. The "Always re-encode" checkbox still controls the re-use of the asset files though. Troubleshooting AVCHD discs should follow the same pattern as DVDs, but bear in mind that your discs are not guaranteed to work on players that don't have an AVCHD logo.

If you remember back a few pages, I talked about the AVCHD rendering options. With the likelihood the Disc projects are going to be of a longer duration than files, there is more chance that the preset options will be best for you as they use the Fastest Speed H.264 render setting, but if ultimate quality is your aim, then you can access the Balanced or Best settings from the Advanced Settings button.

AVCHD2 Cards

While this option shows up in the Export Disc Settings options, it's not actually for writing to a disc, but to a memory card. The card can then be played on any device that supports playback. AVCHD 2 lifts some of the limits of the older format – you can now use it for 50p and 60p video, and with bitrates up to 28Mpbs. It opens the way for full HD in 3D as well because it uses an extension to the AVC standard - MVC, or Multi-View Coding.

When Studio prepares an image for this format, it uses full resolution HD and a bitrate of 22Mbit/s. Partly because of the increased specification, you can't put this format onto a disc and the Device selection actually looks for a suitable card to write to. If you have a memory card reader or suitable camera connected to your computer, you can select that as the destination, and the command Burn disc will copy the final files to the memory card. Instead of setting the Target disc size, you choose the capacity of the card you intend to write to.

Disc Creation and Menus

One of the major ways of archiving and distributing movies is still via optical discs, although their days are numbered. TV sets are becoming increasingly able to play back files from memory cards or via a network connection, but the DVD is still a convenient way to be sure that people will be able to watch the movie you send them, and it will stay safe on a shelf for many years.

DVDs can only handle standard definition video.Blu-ray is the optical disc format for high definition video. The intermediate HD standard is AVCHD discs, which can be created with DVD burners and discs but only played back on Blu-ray players, offering lower costs at the expense of reduced duration and slightly lower quality. A later arrival was AVCHD 2, which actually uses memory devices rather than optical media. It can handle 3D video.

Menus

You can make a disc without menus, and I showed you how to do that and troubleshoot the whole burning process in the Export chapter. Menus, however, are a useful feature of DVD, AVCHD or Blu-ray discs. A DVD Disc can have up to four *Titles*. Each title can have up to 99 *Chapters*.

I should make it clear that when talking about a title in a DVD menu structure, it's got nothing to do with text. DVD discs can have separate movies on them. Perhaps one could be the Main Movie, another an "Out takes reel" or "The Making of" or they could be completely different movies entirely. These individual movies are called titles in DVD jargon.

A Chapter is a point in the movie that you can skip to, or select from a chapter menu.

Studio 24 has two methods of making discs. By default, you are encouraged to use the **Export to MyDVD** route. This is fairly simple to use. When it was introduced it had more limitations than it does now, so many users ignored it. However, if you have no experience with either workflow, I would recommend you give MyDVD a chance.

The **Legacy Author** workflow is relatively complex, offers more flexibility but has a few quirks. If you have made discs in past versions of Next Gen Studio, you will need to use the legacy route to edit your old disc projects. If you are starting from scratch you might see less anomalies if you choose MyDVD. Studio's Legacy disc authoring system can only make discs with a single title, but MyDVD can include four.

In this chapter we will produce a simple DVD with MyDVD and then I'll take a close look at the Legacy Author method.

MyDVD

This program has been included with Pinnacle Studio for a number of years. The workflow consists of using a new toolbar to add chapter points to a project, then exporting the movie contents as a single video file along with an additional file holding the chapter point data. Studio then automatically loads MyDVD with the video and data files pre-loaded.

MyDVD creates a navigation structure and adds default menus. If you wish you can proceed straight to disc creation, or you might want to choose new menus and customise your disc before you burn it.

The Author Toolbar in Edit mode

Before you pass over your movie to MyDVD, therefore, it's best to set the chapter links you want, and for this you use the Author toolbar.

It opens with a click on the *Open Author Toolbar* icon on the left side of the Timeline tool bar. This adds two tools – a chapter navigator and a create/delete chapter tool. The Author toolbar itself is a strip below the timeline toolbar on which the chapter markers will be placed. Above the track headers an orange button labelled *Export to MyDVD* allows you to do just that.

I'm going to use the longest demonstration file we have for this chapter. We used it in the Scenes tutorial, but if you haven't worked through that don't worry, you don't have to because we can just use the raw file. If you have a file or even a project that you would rather use, feel free - it just needs to be a couple of minutes long, ideally with a variety of shots so the thumbnails look different.

Load *Flight Over Snowdon Compact.mp4* and click on the *Open Author Toolbar* button. Regardless of where the scrubber was, it is moved to the start of the timeline and a chapter point created there. A new set of Toolbar Tools appear in the centre of the toolbar.

We already have our first chapter point - at the beginning, where it needs to be for the program. You can't move it, by the way.

Scrub to the first shot from inside the plane at 00:01:39:17 on the burnt-in timecode top right of the footage and set a chapter marker using the Set tool, then find the final approach shot (00:09:01:09) and set another chapter marker. We have three markers now, C1, C2 and C3. You will see that the navigation box holds the chapter point names, and if you wish you can edit the text, but this doesn't affect the markers on the strip.

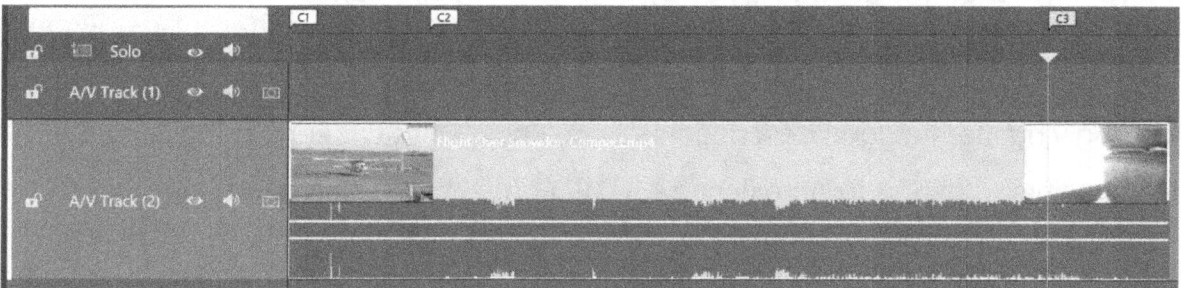

You can jump from marker to marker using the navigation control and the chapter points can be dragged along the timeline if you wish to change your mind. Alternatively, chapter markers can be deleted when the scrubber is in line with them as the *Set* tool becomes a *Delete* tool.

A little warning – If you don't set your chapter markers chronologically you can confuse MyDVD – it may even refuse to open. It's not something you would normally want to do, so it's more likely to be a mistake on your part.

When you have set your chapter points, save your movie (I've called mine **Flight Over Snowdon DVD project**.) You can now move on to the next stage by using the new *Export to MyDVD* button or switching to the Export tab. If you take the latter route you will be questioned if you want to make a file or a disc.

The MyDVD export page has the same layout as File Export,

but some new selections that you have to pay attention to. As we are making a new project we need to select the top radio button *New MyDVD project* - this may not be the default so check carefully. Select the type of disc you want to make using the icons to the right – in this case *DVD*.

The *Destination* is where Studio is going to put the mpeg-2 files for use by MyDVD, so it's a good idea to keep them away from your mainstream video locations. If you want to be able to reuse MyDVD projects you need to keep these files. *Project Name* appears to have no purpose when creating a new MyDVD project. *File Name* lets you specify what the video and data files that are to be sent are called and it's worth giving them a good description so you know what to keep for future use..

It's possible to export to an existing MyDVD project, and this can be very useful if you have created your own custom disc set-up, with menus of your choice. Choosing the *Last Edited* project will load the last MyDVD project you saved (or was saved automatically) while *Existing* will let you browse for MyDVD projects. However, the content you have already added to an existing disc won't be overwritten – the export you are about to perform will be added to the disc.

It is also important that you check the project settings – currently they are not taken from the timeline so may not match which sort of disc you want to make. In this case make sure they are PAL Widescreen (16:9) 720x576 50i if you are in a PAL country. If you want to make a disc that will play on a NTSC player, choose NTSC.

With everything set to your satisfaction, it's time to create the files to pass on to MyDVD, which is just a case of clicking *Start Export*. You will see the creation happen in the preview window. By the way, if you are used to exporting mp4 or other h.264 or h.265 files, you might be surprised at how slow DVD compatible mpeg-2 files are to generate, given that they are only standard definition. This is because hardware acceleration from your graphics card isn't used for making mpeg-2 files.

When the process ends you should see the MyDVD program open automatically even before you dismissed the *Export completed* message that opens over Studio itself.

There may be a short pause before it does, and it can get hidden behind other programs, particularly on a multi-monitor setup, so check the Windows taskbar if you can't see it and click there to open it.

MyDVD open on the right of the Windows taskbar

MyDVD opened with Studio

The view you see when Studio opens MyDVD isn't the same one you would first see if you use it as a standalone program. It will be open in the **Chapter mode**.

The first thing I suggest you do when arriving here is to save the project, otherwise it will be automatically saved with the current date as it's filename. *Save as* is in the **File menu**, along with the usual file operations. One of the File menu entries is **Project Setting** which opens a box where you can check that the video standard we chose has been passed on to MyDVD.

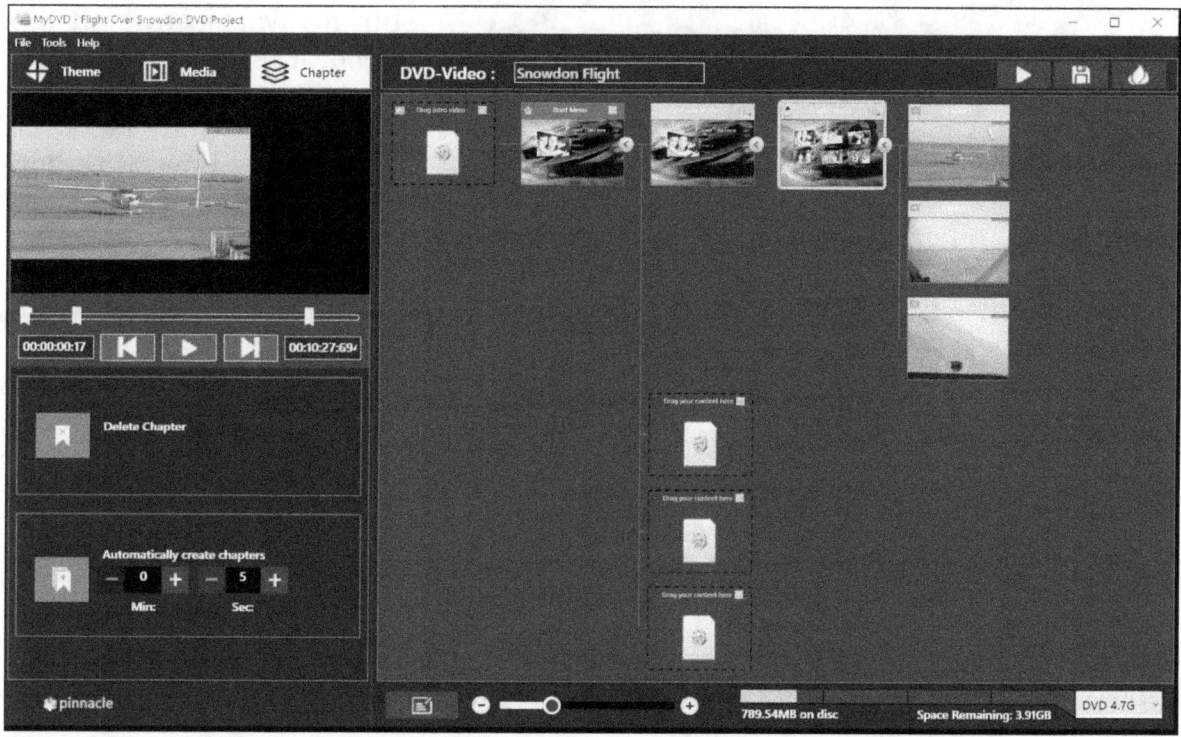

The MyDVD interface has a panel on the left that offers you three tabs. **Theme** is where the selection of pre-made menus can be made while **Media** would be used if we wanted to change or add video content. **Chapter mode** is where you add or edit chapter markers.

The right window displays the DVD disc's structure as a tree view, and running along the top is a box in which to enter the DVD-Video **Title**. This isn't the File name or the Project name, it's going to be the name of the disc you produce.

This text is limited to 15 characters because that's the rule for DVD discs. I've entered *Snowdon Flight*.

The default MyDVD menu structure

If you are struggling to see the whole menu structure there is a size slider below the Tree View window. Given that we simply added three chapter points, there is quite a lot to see! MyDVD has used the Premier Theme to create a root/chapter structure with one title.

You can think of the **Root menu** as the holding page or Home menu – it's what you will normally see when you are waiting to start the movie. If there is more than one title, you choose which one to play from here. I'll show you how to add another title later. The Root Menu can be renamed – just double click on the text – and it will be displayed on the menu, so you might wish to change it to something more interesting. There is also an icon top left indicating that this is the Home menu and a menu icon top left which opens to reveal *Add Title*, *Add Menu* and *Rename* commands.

There is a random thumbnail on the Root menu of three people on the Root menu, However, it's just a placeholder for the title thumbnail and will be replaced.

To the right of the Root menu is the **Title menu** itself, which has been named automatically with the file name we used in Studio – *Flight Over Snowdon*. Again, this text can be edited as it will appear on the root menu. You can also open the small menu to *Remove* this menu from the structure.

Further right still is the **Chapter menu** with more editable text, pictures of unknown people and the option to *Edit Chapters* - and on the far right are the three chapters themselves - again with editable text.

Previewing your Disc

Disc Tools

Three tools are present top right of the Structure window. You don't need to burn a disc to test your disc structure. The **Preview** button opens a DVD simulator window with a remote control panel on the left and a player window on the right. The

first thing you will realise when you open it is that the text we have chosen is running off the screen, so we will need to edit it.

Try the simulator and you will see that the menus have moving backgrounds and the thumbnail on the Root menu page is actually a moving video clip complied from the disc contents. Music plays. You can also see how the thumbnails are really arranged – the Chapter menu in tree view shows six thumbnails, but as we only have three chapters, we only see three thumbnails.

Disc Preview

Additional navigation buttons on the Chapter menu let you go up a menu level or return to the Home menu – in our case the same thing.

Exporting

Making a disc can also be simulated by saving the project as an ISO image using the **Create Iso** tool second from the right on the toolbar. If you use Windows 10 you can *mount* the image and it will appear as a new disc drive, ready to be tested in VLC or another media player. Using Iso images was discussed in the Export chapter.

Burn Disc is the final tool. It requires you to insert a disc, select the size using the drop-down selection and check that there is room using the meter along the bottom of the window. After that it's just a case of clicking the button on the far right of the toolbar.

The speed of creation will be pretty quick, Remember that Studio has already converted the video into the correct format for you so

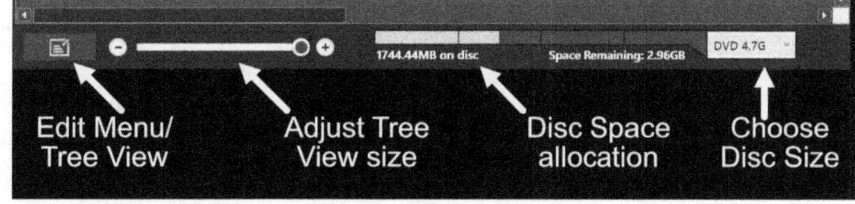

there isn't any heavy conversion to do. If you were using MyDVD as a standalone program with files other than mpeg-2 that would not be the case.

I've covered the basics of troubleshooting discs in the export chapter. If you have issues with MyDVD's burning routines I suggest you create ISO images and switch to ImgBurn.

The Tools Menu

There are just two settings here. **Erase disc** will wipe a re-recordable disc for you so that you can use it again, although the burning routine will also offer to do that for you should the disc in the drive have content.

Settings lets you disable hardware rendering if you are having issues with creating Iso files or discs.

Selecting Different Menus

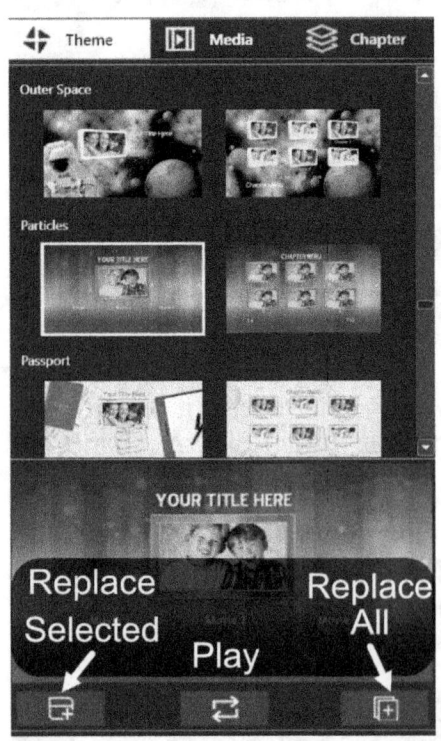

There is a large array of pre-made themes in the left-hand **Themes** panel. You select the Menus just by clicking . Changing themes is a case of clicking on the right hand tool at the bottom of the panel - it replaces all your menus with Main or Chapter menus as requires. The left-hand tool will replace the menu selected in the Tree view with the menu selected in the Themes panel. If the chosen menu is animated, the middle tool plays it for you.

Further customisation

Before we look at customising a MyDVD project further, I should warn you that in many situations Undo doesn't work. I suggest you turn off auto-saving and make incrementally numbered saves as you progress. It's otherwise possible to accidentally delete a whole tree branch with one mouse click and not get it back.

MyDVD as a standalone

I initially believed that as Studio exported movies as Mpeg-2, MyDVD could only work with those types of files when creating DVDs. However, it quickly became apparent that was not the case. MyDVD can also add chapter points, so it might make more sense to create your movies as high quality mp4 files and then move to MyDVD and design your discs from scratch.

You will probably find MyDVD on your desktop, and it will definitely be in the Pinnacle Studio 24 folder of *All programs*. Adding multiple titles and using intro Videos will be quicker if you use the Media tab on the left to find your disc content and then drag it to the destinations in the tree view on the right. When you come to save your disc as an Iso image or burn it to disc,

MyDVD will do the conversion of file formats just as Studio would do it in the Studio Export tab.

Editing Menus

Switching from Tree View to Edit Menu is achieved with the tool next to the Size slider. You change the layout of the menu with nodes and drag and drop. Thumbnails and graphic button elements can be resized, text element cannot.

There are three editing options on the lower toolbar. You can turn on and off Menu music, choose a different audio file for the music, and select a new background - it has to be a picture, it can't be a video file. You can preview your changes with the Play tool

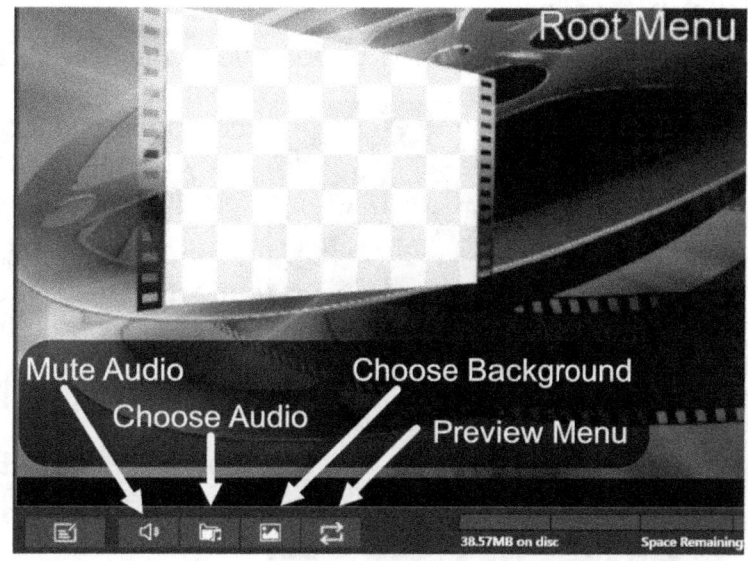

Editing Chapter markers

Once you have started working in MyDVD, if you change your mind about your chapter allocation and delete or create chapter points in the **Chapter Mode**. There is an option to automatically add chapter points based on a time interval. Once you exceed the limit to the number of chapters that can be accommodated by a single chapter menu, Sub-menus are created that lead to the next set of chapters. There is a limit of 99 chapters to each title, so don't set the time interval too short.

Adding a further Title

If you want to add a second title to your DVD project, then you can do so by returning to Studio, preparing the second movie with chapter points and then using the Export option to open an existing MyDVD project. When you export the file your new title will be merged into the menu structure of the old project. However, if you want to start using MyDVD at this level of complexity it might be worth starting to use it independently of Studio.

Adding an Intro Video

At the beginning of most commercial DVDs there is a short message, logo or video clip – either an anti-piracy message or the distributing companies logo. You can't skip it on hardware players. If you want to use this feature the small thumbnail menu for the Intro Video box lets you Add Title. However, you can also drag and drop using the media tab.

Media

The middle tab of the left panel gives you access to the folder structure of your computer. When you select a folder, the compatible video files are shown below, with a Play button at the bottom of the panel allowing you to preview the selected file.

From here you can drag and drop your movies into the tree structure on the right, either as titles or as an Intro video.

Blu-ray and My DVD

You will need a Blu-ray licence to use MyDVD to make AVCHD or Blu-ray discs, but it's not particularly expensive, is valid for both authoring programs, and does not need to be repurchased if you move to a newer version of Studio.

If you open MyDVD via Studio you will be launched into the correct mode. If you are using it as a standalone, you need to decide at the splash screen what type of disc you wish to author.

MyDVD Pros and Cons

Having a choice of two programs for creating discs with menus is to some extent a luxury. I haven't used MyDVD extensively enough to say if it is more reliable than Legacy authoring but I suspect it is. As a standalone program MyDVD is very user friendly, but missing a few features - although those features in Legacy authoring can be a bit flaky anyway.

On the Pro side, MyDVD implements Titles, which in turn increases the total number if chapters that can be set. It can also create Iso files from Blu-ray discs. The text on menus created in MyDVD looks sharper than the legacy versions.

On the Con side, the inability to undo certain actions can be very frustrating if you aren't accustomed to it, and the integration with Studio is very superficial.

If you have never used either program before, try making a disc in MyDVD first and see how you get on. It may well be all you ever need.

Legacy Authoring

So when should you use Legacy Authoring? If you have made disc projects in older versions of Studio, certainly. If you feel you want maximum control of your menus - perhaps create some very simple ones or you can't find a theme in MyDVD that suits your needs, then you can start *almost* from scratch in Author mode. Or you may have tried MyDVD and have found something about it you didn't like.

Movie v. Disc projects

Studio now has three types of projects:

1. **Movie** projects with no disc information whatsoever

2. **Movie** projects with chapter points suitable for use by MyDVD.

3. **Disc** projects with chapter points and menu information suitable for use in the Author tab

The first two types of project have the file name *project name.movie.axp*. The third type has the file name *project name.disc.axp*.

If you want to use the old method of creating discs, you have to enable the Author tab by using the Control Panel/Legacy Options and clicking in the button at the bottom of the page. Author mode will also open automatically if you open a *.disc.axp file.

Some people are confused as to why there is a separate Author tab - why can't Pinnacle have put the author tools in Edit mode? I suspect those people will always want to make a disc from their movies. If you are going to create a project that you are sure will have a menu you can just start in the Author tab, but that is still no reason to start there straight away. You might at some stage decide that your project could be used as a subproject in another project. If it is a Disc project, you won't be able to do that easily.

My suggested workflow for all projects is to start them in the Movie Editor (using the Edit tab), and complete them to the best of your ability. When you transfer a project to the Disc Editor it becomes a separate project, and any further work you carry out on the project will not be transferred back to the Movie project that was the source. This is an important point, similar to the one I made regarding subprojects – the changes don't get passed back to the source automatically. If you do make a few changes to a Disc project you can still export it to formats other than disc, and it is also very quick to create a new Movie project from the whole or parts of a disc project. Just always keep in mind that once you open the Disc tab you have started a new project.

It is perfectly possible to have two entirely unlinked projects in the Movie and Disc tabs. You can compile a new disc project by successively opening different movie projects, copying sections, switching tab and pasting those sections into a growing Disc project. I have used this as a workaround in order to save me the trouble of closing and opening projects, although if you aren't making discs, the new Subproject workflow is probably a better option now.

Opening the Author/Disc Editor

Now that the Movie editor can also export to disc via MyDVD, the current file menu options can be confusing if you want to create a disc project in the Legacy Author tab. Using *File/New/Disc* or *Create New Disc Project from Movie* while in the Edit tab just enables the new Authoring Toolbar in the Edit mode. To get to the Legacy Authoring mode you have to click in the Author tab at the top of the program window or load an existing Disc project.

Normally, just click on the Author tab. If the Author timeline is empty, Studio will ask if you want to copy the current Movie project onto the Author timeline.

Let's create a disc project from a movie, then we can have a look at Author mode.

Open the Drone Clips bin we used in the Whistle-Stop tour chapter and put the LQ clip, or the MQ clip if you downloaded it, on the the timeline of a new project. Now click on the author tab and respond to the message *Do you want to create a Disc Project* from your open movie with *Yes*. The first thing to note in the Author window is the new project name top left of the Timeline preview window. It won't be the same

as the movie we have created the Disc project from, and more importantly it will have the suffix Disc.axp. Movie projects have the suffix Movie.axp. If you try to open a Studio project from Windows, Studio will know which tab to open the project in.

The main addition is the Menu List. This feature can't exist in the Movie Editor. Where the Navigator or Storyboard is normally displayed there should be a Menu List, occupying the full width of the Edit window. If it isn't showing, you need to switch it on now. The toolbar icon for choosing the display mode, third from the left, should have three choices in its drop-down list – Navigator, Storyboard or DVD Menu. Choose the bottom one and click on the Display icon if it isn't already orange.

The Menu List has a header on the left that displays three discs. This is just a cosmetic item. The purpose of the List is clearly stated with a message that displays when the list is empty "Drop Menus from Library here", so I guess we can work out how to get started!

Clicking on the List area – even if it is empty – shows up one further difference from the Movie Editor. There are three preview tabs, Source, Timeline and now additionally Menu where the menu will be displayed when we want to preview it. If you switch to the Dual mode preview, Timeline and Menu still have to share a preview window.

Even with the Menu List switched off, the toolbar has 7 new buttons in addition to those that exist in the Movie Editor. They are subject to customisation, so if they aren't showing, check the Toolbar customisation at the far left of the toolbar.

If you open the Disc Editor with a new project, there will only be one timeline track, named Media. This may be all you need if you create disc projects using sub projects created from movies or have already exported your edited movie to a file.

Creating a Menu

Actually, you can't create a menu from scratch. Studio wants you to drag a pre-made one from the Library and there is no direct path to the Menu Editor. What Studio does provide are a couple of very basic templates under the category *Disc Menus* -

Special which you are expected to use if you don't want one of the many pre-made menus.

There is no point in re-inventing the wheel. If one of the pre-made menus nearly suits your purposes, then you can modify it. You can be confident that even with a bit of mild modification the pre-made menus should work as designed, at least when used in DVDs. I'm not entirely sure that the more advanced menu features always work with AVCHD and Blu-ray discs, at least on some Blu-ray players. Because I like to keep my menus clear and the navigation simple I rarely have issues, but I read of ambitious Blu-ray projects that lead to tears. That's not a cop out – I'm going to describe all the functions – but if you are more interested in the menus than the rest of the disc content then you might find yourself spending some time troubleshooting the end product.

Adding a Menu to a Disc project

Because we can't create a menu from scratch, open the *–Special* menus categories in the Library. This is where Studio provides two simple templates for you to create new menus.

The right-click context options for Menus in the Library are rather sparse. You can *Preview*, which shows and plays the menu in the Source preview window, add the menu to your *Favourites*, add metadata, *Copy* or *Display information*, which is also pretty sparse. There isn't a Send to Menu List option. So let's drag the *Blank_Main 16x9* menu to the Menu List.

A number of things happen when you drag a menu to the list, most of them because the Wizard is automatically invoked. Chapter points, Links and Intro Video can appear, depending on the Wizard settings and the content of the menu used. I want to start from the very beginning; I'll talk through the Wizard options when I've explained the basics by building up a menu completely from scratch. I've only come this way because there is no other path to the Menu Editor.

The Menu Editor

With a Menu selected, the menu tab of the Preview window becomes active, displaying that menu. Beneath the Menu Preview window at the far left is a small Edit button. Click on it and what opens up will be very familiar if you have ever edited a title. If you haven't, I'd suggest you read the Titles chapter before proceeding any further, because I'm going to assume some knowledge of how to use the title editing tools.

The Menu Editor has some additions. A new tab at the top

Menu Preview and controls

adds **Buttons** to Looks and Motions. Here you can browse a vast array of *General*, *Navigation* and *Thumbnail* buttons using the sub tabs and select them to use in your menus.

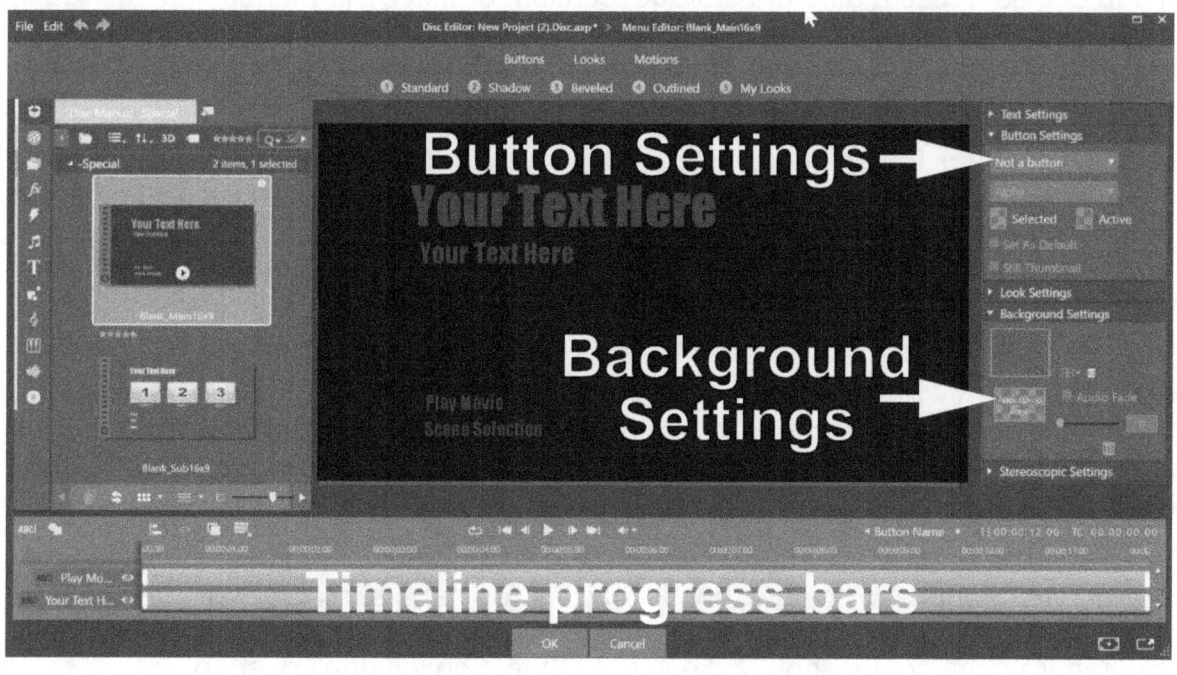

The parameter boxes top right have an addition *Button Settings* box, and there is an extra *Button Name* selection control on the toolbar. From this, it is easy to see that a Menu is a Title – but with Buttons.

Actually, it can also have audio. Look at the Background Settings parameter – open it up if required – and you will see an Audio Drop Zone. We will use that sparingly later on.

A **Button** is a navigation control. When previewing or using the menu on a computer, you will be able to use your mouse to click on a button and the disc will respond to the navigation instruction associated with that button. On a DVD or Blu-ray player you will have to use the up/down/left/right controls on the player or its remote control to highlight a button to make it active, then press an OK/Select/Enter key to activate it. In the Menu Editor, if you select one of the Your Text Here boxes with your mouse, you will see the button Settings type is *Not a Button*. Click on the Play Movie text, and the type changes to *Normal Button*. But I'm getting ahead of myself.

Clear everything out of the menu by using CTRL-A and then hitting Delete. Use the File menu top left of the edit window and Save Menu As... *Completely Blank*. The new menu we have just created will be saved in My Menus as well as the default storage location as specified in the Control Panel.

If you decide to use a different storage location, or move the menus at a later date, new menus can be added to the Library using the Quick Import option. You do need to select *Project Files* as the file type in the Windows style Import Media Files dialogue, however. Menus have the file type *.axp

Close the Menu Editor, remove the –Special menu from the menu list, find the *Completely Blank* Menu in My Menus, then load it into the Menu List. You can also double-click on the Menu in the List to open it in the Menu Editor, so try that now. I know, it's a bit of a palaver. It's almost as if Pinnacle isn't that keen on you making your own menus - and to some extent this may be to prevent the introduction of bugged settings caused by overlapping text boxes or thumbnails.

I would like you to set the background of the menu to a dark colour using the Background settings box and clicking on the *Background Fill* box. I've chosen R=100, G=0 and B=0, you may prefer something else, but as long as white text will show up over it, that's fine.

I'm not going to hold your hand through the next creation stage. You may want to use different fonts and colours, but as long as you get a similar general layout, your menus should behave in the same manner as mine. You can see what I have created from the screenshot. Make sure your text boxes don't overlap.

The font in the screenshots is *Architect's Daughter*. I've since found out that it isn't a standard Windows font. It should make no difference if you use something different, or if when you load my projects the font is substituted. Should you like the look of the one I have used it is available free from Google fonts.

Save this menu as *Main Menu before Buttons* because we will use it later. If you want to cheat, the menus are saved at various stages for you to download or import from the Data DVD.

Let's briefly return to the Disc Editor to save the whole project, giving it the name **Legacy Disc Project_1** and clicking on OK. (Real cheats can pick up the story here by loading the project :-))

The three text boxes in the lower part of the menu are going to be our buttons – navigation links to play movies, initially, although I will enhance the navigation later on. Open the Menu Editor again and highlight the *Grand Union Canal* text box, then

open up the Button Settings parameters at top right of the editor. The first drop-down box defines what sort of navigation behaviour is assigned to the currently highlighted object.

Not a Button is quite obvious. The highlighted object has no navigation properties.

Normal defines the regular navigation – activating the button causes the player to jump to the position in the movie programmed by you. This can be a Chapter Marker or a Menu.

Make the current button a Normal button.

Previous and Next are special navigation commands used with Multi-page Menus and I will describe those in a few pages time.

Root is another special navigation command. It sends the DVD player back to the first Menu, however many nested menus you have.

The next box down defines how a button is highlighted to show if it is Selected or Active.

Alpha means that only the non-transparent parts of a button are highlighted. This works well with text buttons in particular. Most Thumbnail buttons will look best with this style as well, as only a border around the thumbnail will show the highlighting rather than the thumbnail itself.

Box highlights a square area around a button. This may give better or worse clarity, depending on the type and size of the button and the choice of highlighting colour. This isn't a good option for thumbnail buttons.

Underline is the simplest style of all, just drawing a line underneath the button regardless of its shape. This works best with strong highlight colours.

Beneath the choice of style are two colour selection boxes for the highlighting that occurs. When a button is **Selected** it means that it is the current button, and pressing OK will make the player perform the navigation programmed into the button. When a button is **Active** it means you have selected it, and the DVD player is searching for a place on the disc you have sent it to. On a software emulator or a computer playing a disc image from the hard disc you are unlikely ever to see the Active colour for any length of time, but it is needed when a disc is in a set top player to let the user know the keypress has been registered.

These colours are set with the usual Colour Selection controls. Notice that the preset colours are semi transparent and although solid colours can work quite well for Alpha and Underline styles, they make the previewing of buttons quite difficult

when you set the links because Studio uses the Box style by default. For now, I'm going to leave the colours as they are. An important point is that a menu can only have one Selected and Active colour. If you change the colour, it will be applied to all the buttons. Another important point is that the colours tend to look a bit different between the preview and when displayed on DVD players (and even seem to vary between players), so don't get too radical with your choice of colour.

Two checkboxes allow us to set properties for the Buttons. *Set as Default* makes the current button the one that is selected by the player when it first reaches the menu. Normally this will be the first item on the list, but you might want to make it the central button or some other choice. Only one button can have this checkbox set for obvious reasons. The Still Thumbnail makes no difference to a text button, but determines if a thumbnail using video plays the video or just displays a frozen frame.

You can only set one button at a time and the order in which you set the buttons is important, so set *Grand Union Canal* as a Normal button, with Alpha highlighting, and Set as Default. Now set *Flight over Snowdon* and *Special Features* as a Normal Alpha Buttons. When you have done that, you may notice that extra tracks have been added to the timeline display at the bottom of the editor. More of that later.

Save the title as *Main Menu with buttons*, close the Menu Editor by clicking on the OK box at the bottom.

Setting Links

While it is very tempting to use the Chapter Wizard for setting Links, on this occasion I'm going to add the links manually. Before I do, we need to put more content on the timeline. I'm going to do this by using single clips, but you could use subprojects if you have made the relevant projects. Either add *Flight Over Snowdon Compact.mp4* and the cycling clip *PAL_007.mp4* after the drone clip, or replace the drone clip with *Drone Project Stage 6* and add *Audio Edit 4* after the Snowdon clip.

Switch the preview window to Menu. You should see three small red squares with question marks on the left top edge of our three text buttons. If they don't show up, there is a checkbox to the right of the Edit button underneath the preview window and a label with the symbol **C1**. Check this box to Show the Chapter numbers. The question marks are saying "These buttons don't have any links". Hover your mouse

over the Grand Union Canal text button – a tool tip will tell you the name of the button. In the current example, this has been generated automatically. To change a

button name for a non-text button, you edit the name in the track headers of the Menu Editor.

The Cycle Tool

We can select the buttons in one of two ways - directly clicking on them in the Menu preview window, or using the toolbar Button Cycle tool. To the left of our new bunch of menu tools is a box containing the button names, with left and right arrow controls that lets you cycle through the buttons.

The tool has another use, though. You can use it to edit the button name. Click on the name and it becomes a text editing and entry box. What if we change the name? Try changing *Special Features* to *Bonus Features*, then clicking back on the menu. Ah – that's useful! A simple way of editing a text button without having to dive into the Menu Editor. You might not be able to use it all the time – an edit might affect spacing or alignment – but it can be a helpful shortcut.

Dragging from the Menu preview...

Highlight the Grand Union Canal text button. Hover over it, click drag the button and once you begin to move the mouse, a semi-transparent box will appear with the button name inside it.

Drag the box down to the Disc project timeline. Once there, the scrubber becomes active, the Chapter marker strip appears and you find you are dragging about a "C1" chapter flag. Take it all the way to the start of the timeline and release the mouse.

...to the start of the timeline.

There we are, we have created the first link. You will see that the text button now has a "C1" label in place of the question mark and the Chapter strip has appeared with the C1 marker. If you cast you gaze to the end of the timeline a M1 marker has appeared at the end of the timeline. This is a **Return to Menu** marker of which every menu must have at least one of. At its most basic level, it is there

so that when the DVD player gets to the end of the video, it knows what menu to return to.

The first Return to Menu marker

Create a link for the second button to the start of the Flight movie. You should notice that with the magnet turned on, the C2 marker will click into position at edit points and markers. This time you only get a chapter marker, because there is already a return marker.

Of course, there are other ways to create chapter links. Click on the last subproject on the timeline – the scrubber will jump to the beginning of the BMX subproject. Use the Button Cycle tool to select the Bonus Features button, and then click on the Create Link tool – fourth from the left of the DVD tools. There are other methods, too, mentioned later on. If you are adding Chapters manually, though, you have all the tools you need.

Creating the third link with Create Link

If you want to adjust the positioning of the chapters and their links, you can drag them around on the Chapter strip in the same manner as keyframes.

There is also a simple Context Menu where you can delete chapters, or the links to the chapters. Multi-selection of the chapter markers is possible, so you can delete a whole bunch of them at the same time.

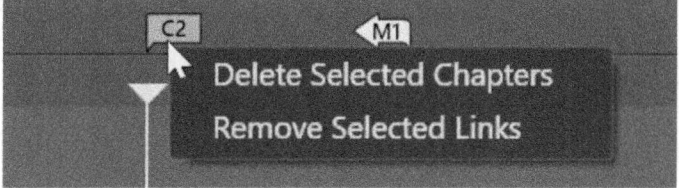

Unlinked Chapters

Deleting a link from a Chapter marker turns it into an unlinked chapter. You may wonder what the use of that is, but chapters without links have a couple of important uses. All DVD players have jump forward and back controls that skip from chapter to chapter. Unlinked chapters are included in this type of navigation, so you can add them to help the viewer move through a long movie.

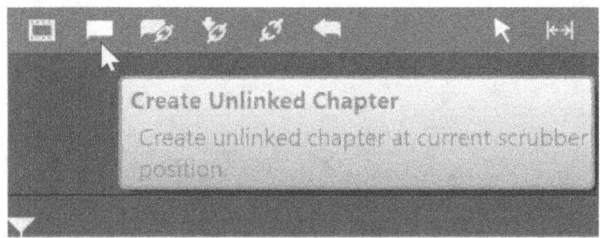

You don't have to add a linked chapter marker and then unlink it. In fact, it's likely that you might want to decide where the chapters should go, and then decide which ones need a link to a button, so there is a toolbar icon just to create unlinked chapters. When the scrubber is over an unlinked chapter this tool allows you to remove it. Double clicking on the Chapter strip also adds an Unlinked chapter point.

For demonstration purposes I want you to add a single unlinked chapter in the middle of the Flight movie. Find the cut to the Interior shot at 00:06:38:10 on the movie timecode (00:01:30:17 on the clip's,burnt-in timecode) and place an unlinked chapter marker there. We will see the effect when we use the next feature of Studio.

The Disc Simulator

We now have three chapters and a complete menu. Time you checked out the Disc Simulator, I think. You enter it by using the play icon beneath the Menu preview window. The new viewer opens over the top of the Editor. You can click on the buttons to activate them, but first of all, try the control on the bottom right.

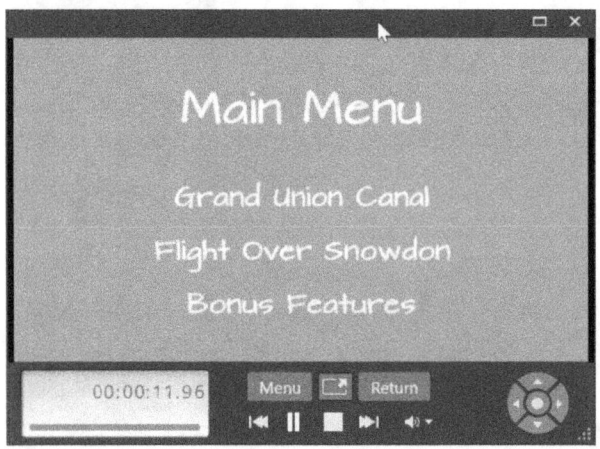

It emulates a DVD player remote control, and you should always use this to check that the buttons get selected correctly. If the positioning or box sizes are slightly out, moving around a menu using these controls might not give you the result you expect – you may even be unable to get to one of the buttons. This may even happen with the current project if you use the Up/Down keys. What you can explore, though, is what happens if you use the left/right keys.

The selected button changes according to the horizontal positioning. Because of the menu layout, most users will try to use the UP/Down Keys anyway, but if you wanted to cater for everyone, then you will need to modify the design. I will sort this out shortly, but let's finish setting up the navigation first.

Once you have established the button order and selection is correct, test all the links to check that they go to exactly the correct places. Use the DVD controls for this. You don't have to sit through every chapter – in fact, you also need to test the Return and Menu buttons on the simulator. The Menu button should take you to the root menu and the Return button to the menu from where you came. In the simple example we have here they will both do the same thing, but when things get complicated later on these navigation controls need to be checked to see if they are doing what you expect.

Between the two buttons is a Full Screen tool, and below a simple set of transport controls including buttons that skip between chapters, unlinked or otherwise. To the left a counter tells you the timecode of the disc.

The disc simulator stage is an important step. You can check that all the navigation works as you expect it to before what could be a long render process. To this end, it also is accessible from the Export screen when you have Disc selected as the Export type. There really is no excuse for not checking the links before you render and burn.

By the way, the disc simulator isn't a final judge of what will work on all players. Some differences in the firmware of players might mean you find issues that do not show up when you play the disc on a PC. Differences in DVD and Blu-ray firmware can be one cause of this (along with potential bugs in Studio). Many Blu-ray players can have their firmware updated quite easily, particularly if they can connect to the Internet. It's much harder or impossible on most DVD players.

If you experience issues with a particular player, you may have to modify your projects to suit. One issue can be that some players start a chapter in a slightly different place – the workaround would be to start your chapters with a few seconds of black video, for example. You might need to space menu returns a little apart from Chapter points for some players.

All the menu examples I have created in this chapter have been tested on a Sony BVP S370 Blu-ray player.

Return to Menu markers

You will notice that the Disc Simulator plays all three chapters back to back unless you stop it. This simple menu contains 3 separate movies, so we probably don't want the disc to play on to the next movie. To change this behaviour we need to add some more Return Markers on the timeline.

The basic principle is that when a DVD player encounters a return marker, it goes to the menu number indicated by the marker. However, to allow you greater flexibility, the player will ignore return markers that try to send it to a different menu than the one that was last displayed. If you have reached the current position of the movie from Menu 1, only a Menu 1 return marker will be obeyed. (If you have graduated from Classic Studio, this is a different behaviour than before – all return markers were obeyed).

The tool for adding Return markers is on the timeline, the furthest right of the menu group of tools. Clicking it places a Return marker for the current menu at the current scrubber position. When the scrubber is over a Return marker, the tool changes

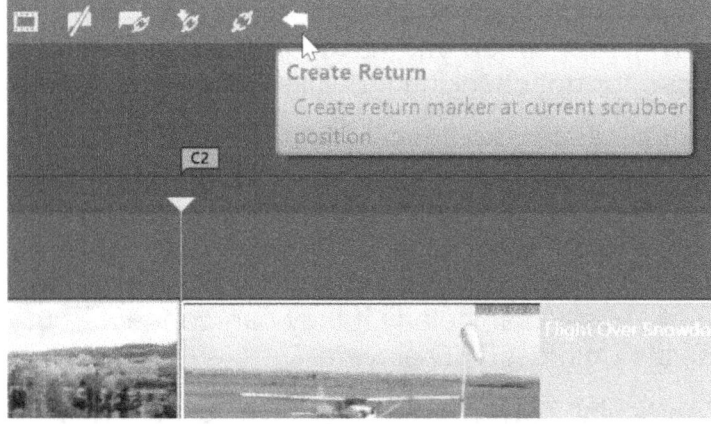

appearance and can be used to remove the Return flag.

Move the scrubber to the start of the Flight clip by selecting the Snowdon menu button and then add a return marker. Do the same with the start of the last clip - the cycling shot. You should now have three blue flags with M1 labels. We'll test the effect in a moment, but I want to add a further enhancement first.

Intro Video

An Intro Video is the (normally short) copyright and other messages you see at the start of a commercial DVD. It's possible for you to do this with your own Disc projects. The video only plays when you first load the disc, then you get taken to the first menu. You may have seen evidence of the Intro Video mechanism when the Chapter Wizard has been at work.

Any clips, audio, titles or subprojects before the first chapter point are treated as an Intro Video by Studio. We have already made a suitable project - I've exported a file from the Template section and called it *Intro Video*; it's on the website and disc. You

could use any other short clip as long as you trim it to 14:24 to make the markers work later in the chapter. Quick Import it into a bin and then drag it to the start of the timeline.

The Chapter timeline will show the Chapter markers have been pushed right to stay in line with the movies they were associated with. Before that an olive green area with the label *Intro Video* makes it pretty clear what the movie below is! This doesn't need to be a video, by the way – you could just have a simple title.

Intro video placed before the first chapter

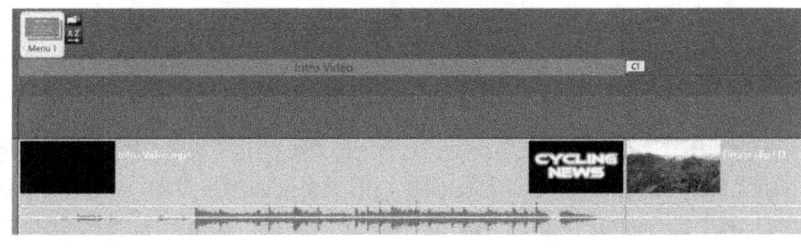

OK, test the modified project and the Disc simulator should play the DVD Intro movie before settling on the Main Menu. If you select Grand Union Canal, the first movie should play and then you will be returned to the Main menu. The other two buttons should also just play the named movie.

If you have a blank DVD disc to hand, particularly a re-writable one, you might fancy making a disc of the current project just to test it in your disc player. It would flag up any issues with DVD menu compatibility you may have. This disc project can be saved as **Legacy Disc Project 2**.

More Menu creation rules

In this section I'm going to improve the main menu we have just created so that the DVD player buttons behave completely correctly. I hope to demonstrate some of the pitfalls of Menu creation. If you work methodically menus will work OK, but if you start to make retrospective changes you can end up chasing your tail.

The **positioning** of buttons on the screen can be very critical for consistent selection. The only sure way I have found to make menus that obey the DVD remote control correctly is to make all the buttons the same size, and to ensure that they line up using the Group Align tool. Even then the left/right DVD remote keys can be an issue, so I end up adding very small offsets. If you want to use text as buttons, then I'd suggest the way to avoid frustration is either not to use centre justification or to group the text with a geometric shape, making sure the shapes are the same size.

The **order** of the buttons determines which chapter number they will be associated with, and the order is determined by which layer the button is on. So, when you add your first button, it will be associated with Chapter 1. The next button will be on a higher layer and associated with Chapter 2, and so on.

You might not be aware of which chapter a button is associated when you set the first chapter because Studio will associate the first link with Chapter 1. Only when you set a second link will the natural button order become clear – if the next link is to a button on a lower layer than the first, it will take the Chapter number 1, and renumber the chapter you set earlier as Chapter number 2.

Here is where things get even more complicated. When you change the Order of a button that has already been set, either by using the Order tool, or dragging the Menu Editor tracks to change the order, the underlying button chapter numbering will change.

Confusing, isn't it? You might be beginning to see why Pinnacle don't encourage you to make menus from scratch. If you set the button order too early, it will change if you ever rearrange the layers to help visibility. If you don't have equal sized buttons aligned correctly, the DVD selection becomes unpredictable.

For the next exercise, it will help if you have read the Titles chapter so you know about Shapes and the Group Align tools. Throughout, important action is happening on the progress bars headers below the preview window of the Menu Editor, so keep your eyes on that. What's more, during the making of this project I sometimes encountered issues where changes I made to old projects didn't always get properly reflected in the new project. Menu behaviour wasn't always what should have been expected. For a completely sane experience you need to stick to the order I use and not try to reuse menus that have had buttons added.

Start a new Disc project, locate the *Main Menu before Buttons* menu I asked you to save earlier in the Menu Editor and put it in the Menu List. If you didn't save it, **don't** use the current menu and remove all the button attributes - remake it or load my version from the data DVD or website.

Open the menu in the Menu Editor. The first thing to address is that we built this menu up by eye. It looks OK, but we can't be sure that the three text elements we are going to use for creating buttons are centred on each other.

Lining up the text elements

Select all the layers and then use *Group Align Horizontal* to achieve that - there may be a little bit of movement even if you thought you were spot on. While all the text is still selected, open Group Align again and use the *Center* Alignment tool to correctly centre them.

I'm going to add some shapes *behind* the text and use those as buttons, rather than the unequal length text labels. Start by clicking on Add Shape tool and c h o o s i n g *Rectangle*.and then opening its Face parameter and

change the Fill to make it a darker red (I've used a value of 50).

Look at the track header and you can see that the new Shape has been put on a new Shape Layer track – and it is at the top of the timeline list. This means it has been brought to the front of everything else, even the Main Menu text I want to put it behind. We could use the **Order** tools, but for clarity I'm going to drag the Shape Layer header down the list so that it sits at the bottom. You can now line up the shape accurately. Re-adjust the size so that it fits neatly behind Main Menu.

To be doubly accurate, select the Main Menu text, then the rectangle and use Group Align to line up the Horizontal and Vertical centres.

Make a copy of the rectangle and then paste and drag it lower down the screen - we will use it in a moment. Now select the Main Menu and the Shape layer behind it, right-click and select *Grouping/Group* or use the group tool on the toolbar.

Now, despite us simply working on two items at the bottom of the tracks, when we made the change the new GroupLayer jumped to the top of the tracks. This action is a good indicator of how you can get into a muddle with the Menu Editor. If we group a button with another shape we (inadvertently) apply the Bring to Front tool, thus affecting the button order. That's the last group we will create, as doing so destroys layer order.

For clarity, rename the new GroupLayer to *Main Menu Layer*.

Now adjust the copied rectangle so that that is slightly wider and taller than the longest text line - Flight Over Snowdon. Copy the shape and paste it twice so we have three identically sized rectangles. Move them apart for clarity.

Select the *Grand Union Cana*l text first, then the rectangle nearest it and use the Group Align Vertical and Horizontal tools. Send the rectangle to the back, and then rename it as *GU Shape*.

Repeat for the other two text buttons - creating *GUC Shape* and *SF Shape*.

Now we need to cheat if we are going to make the left/right DVD remote controls work properly - there needs to be a slight offset on the shapes. Highlight the top rectangle and hit the left arrow twice. This will jog it two pixels to the left. Select the bottom rectangle and jog it two pixels right.

Take a look at your work - would anyone really know that those boxes aren't in line? If it really worries you, then change them to the same colour as the background - I haven't bothered.

Save the menu with a new name at this stage - **Main Menu with Rectangles** – in case you want to backtrack. As I said before, there is sometimes a residue behaviour left over if you modify projects with buttons. We can also use it as a template for other menus.

Now, **in the order you want the buttons to be numbered**, change the three rectangles into *Normal* buttons with a *Box* highlight style, setting the top one as the *Default*. You will now see the continuing issue of order change - the rectangles have been placed into new groups and promoted to the foreground, obscuring the text that we have so carefully placed them underneath. *GroupLayer.73* contains the button at the top of the preview screen. It is the lowest button in the layer list, and therefore will be numbered as Button 1

The three text labels Special, Flight and Grand have now dropped to the bottom of the layer list. This means they are obscured by the shapes. We need to drag them to the top of the layer order so that they become visible. Remember that these text label are not buttons, so moving them will not change the button order. Select them as a group and drag them to the top so the final layer order is as shown in the screenshot. It can be a bit confusing here - the layer order for visibility is top to

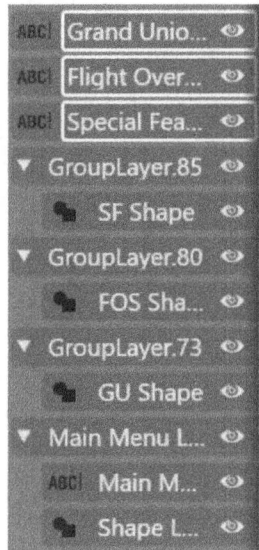

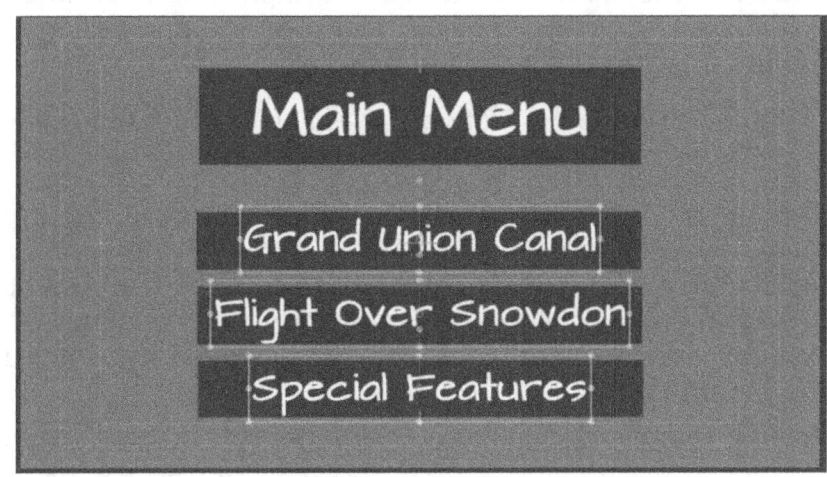

bottom, but for button order it is bottom to top. Neither of these orders are related to the order the buttons or text labels are placed on the screen!

Save the menu again, this time as **Main Menu Final,** and click OK to leave the Menu Editor.

Load the **Legacy Disc Project 2** again. Right click on the old menu and use the option *Delete Selected menu pages* and all the chapter marker should disappear as well, apart from the unlinked chapter marker we added for a test. Now add the new Main Menu Final from My Menus.

The Chapter 1 marker will have been placed at the start of the movie, but we don't want it there. Drag it back and then forward again so that it clicks into place at the start of the Grand Union clip.The Return to Menu marker is at the end of the movie, so that's OK. You are going to have to add the other Chapter and Return markers again, I'm afraid - C2 at the start of the Flight Over Snowdon clip and C3 at the start of the PAL 007 Cycling clip. Add two returns at the end of the Grand Union and Snowdon clips.

Finally, you can test the project using the DVD Simulator. It's short enough to burn quickly to a re-writable disc if you want to check out the results on your DVD player.

Save the project as **Legacy Disc Project 3**. The timeline layout will be the same as version 2, just the menu will have changed.

More than one menu

Some DVDs will only need one menu, but on longer projects you may wish to add additional menus and create quite complex menu structures. Before you do so, it's a good idea to sketch out the structure you are aiming for, thinking through each menu and what options it should offer.

I'm going to leave the first option – to play the Grand Union Canal movie and return to the main menu – as it is.

The second option will lead to a sub-menu. For the purposes of this exercise I'm going to pretend that the *Flight Over Snowdon* project is much longer, and we need an option to start playing from a particular scene. The sub menu will give us the choice of playing the whole movie and then returning to the sub menu, or going to a scene selection menu. The sub menu should also offer us the chance to return to the Main Menu.

The scene selection sub menu will have to be able to offer a large number of scenes so will use the Multi-page menu feature. It will also offer the viewer the option of navigating to other sub-menus or returning to the Main Menu.

The third option on the main menu – Extra Features - will let us see the PAL 007 clip, the DVD Intro movie or let us return to the Main Menu. I'll use this last menu to show off Studio's Motion Thumbnail and Backgrounds and the audio options.

Having planned the menu structure, I'm less likely to have to add something as an afterthought. It's a lot less work, and less likely to cause problems, if the links are all placed at the same time.

Let's make the first sub menu by using the Main Menu as a starting point. Right click on Menu 1 in the list and select *Add menu page*. A copy appears as *Menu 2*. You will notice it uses a different border colour, light yellow. The navigation links for M2 will be this colour. Open the Menu Editor and change the text with care as we don't want to disturb the rectangles. I suggest you use the text entry box in Text Setting for your editing, rather than type into the preview window itself.

Change *Main Menu* to *Flight Over Snowdon* and reduce the font size to 36 so it fits. Replace *Grand Union Canal* with *Play Movie*, *Flight over Snowdon* with *Scene Selection*, and *Extra Features* with *Main Menu*. The track headers should change as well, but if they don't the menu will still work. Click OK to return to the Disc Editor.

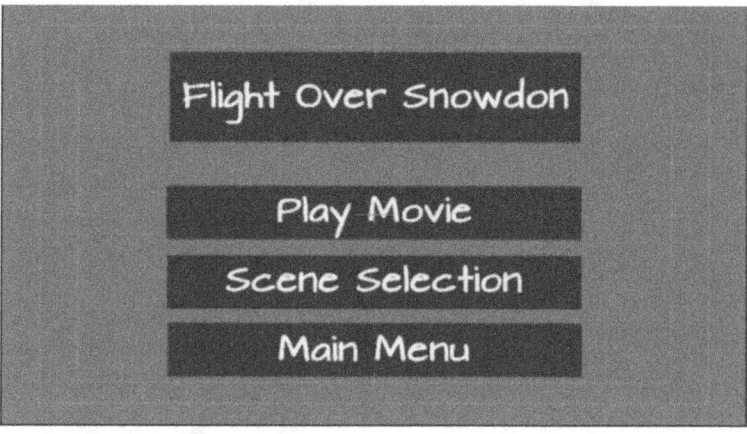

Resist the temptation to add links yet. It will save you a lot of work and potential confusion later on.

We now need a menu with thumbnails to use for scene selection. Locate the – S*pecial Blank_Sub16x9* menu in the Library and drag it to the Menu list as Menu 3 – which will be colour coded green. Don't be alarmed at it's initial appearance in the preview window if it looks wrong. Open it in the Editor and select the Your Text Here

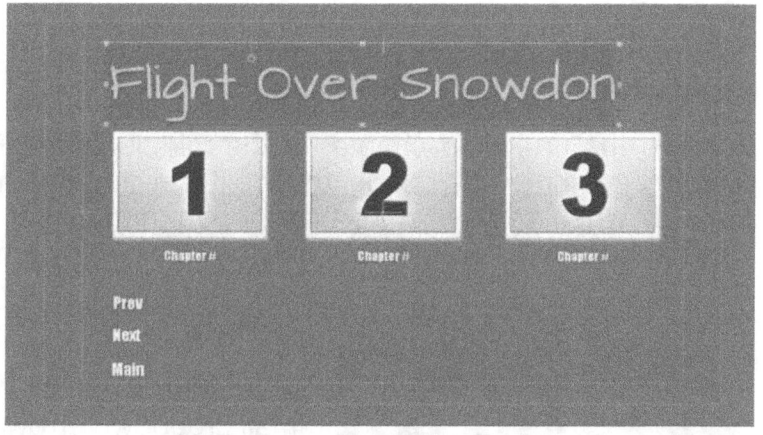

text layer and change it to *Flight Over Snowdon*. Change its font and the menu background to match the other menus. Take a look a the button types allocated to the buttons – they use the Previous, Next and Root buttons described earlier.

Thumbnail buttons

Have a look around the rest of the menu. The buttons have small text labels that say *Chapter #*, where the # sign is a special code that will be replaced by the number of the chapter the button is allocated to. If we decided to edit this text at a later date we could alter it to give the scenes a full description, but once we use the menu in multi-page mode, we will be creating a good deal of work for ourselves. I'm also not going to suggest changing the button fonts – to make it more readable we will have to make it quite big, which will probably upset the shape of the thumbnail buttons with

make it quite big, which will probably upset the shape of the thumbnail buttons with the attendant issues that may cause to button selection.

There is also a checkbox for *Still Thumbnails*, which should be checked for the Thumbnail buttons. Motion thumbnails can be quite neat, but I'll save them for the final menu.

As an aside, if you were wondering how you create a thumbnail button from scratch, the answer is you can't (or at least, I haven't discovered a way yet!) There are, however, plenty available for you to use under the Buttons tab, and we will use one later in the chapter.

Setting Inter-menu Links

Return to the Disc Editor. Even though I still have one menu to make, I'm going to set the links to Menus 2 and 3 now.

Remove the un-linked chapter in the middle of the Flight subproject if you have placed one there. If, during the next section the menus don't always preview correctly when you switch to them, open them in the editor to refresh the display. This happens occasionally, but only on one of my computers.

Linking to Menu 2

Select Menu 1 in the preview window and open the small dropdown arrow alongside the C2 label for the Snowdon button. You will now see a choice of Menu 2 or Menu 3. Choose Menu 2. The red warning flag on Menu 2 disappears, meaning the Menu is no longer unreachable. The Chapter and Return links associated with the Flight Over Snowdon clip have gone. The Extra Features button now points to the same flag, but it has been renumbered as C2.

We now need to set links for Menu 2. Click on it to bring it into the preview window. Set the Play Movie button to the start of the Flight movie. Notice the M2 flag that has appeared at the end of the entire project, and it is sitting over the M1 flag. It has no idea where it should go, so it has

taken a guess. Drag it to the end of the Flight movie, so that is to the left of the C2 marker.

Using the drop-downs, set the Scene Selection button to point to Menu 3 and the Main Menu button to point to Menu 1

Now click on Menu 3 and look at the buttons in the preview window. (This is where I get the issue of the wrong menu background being displayed. If you do as well, open the menu in the Menu editor and then close it again.)

We don't need to set the *Next* and *Main* buttons as this is done automatically. Set the first thumbnail to the start of the blank title that precedes the Flight movie, A green C1 marker will now be sitting over the Yellow C1 marker already set. A thumbnail of the opening of the movie has appeared in the first thumbnail window of Menu 3. Again, the return marker for M3 has been placed at the end on the movie, but we want it to happen before the cycling shot, so drag it left to sit over the C2 marker.

Adding Scene Selections

Although you can drag chapter markers and set them on the fly, for accuracy I'm going to set 4 markers on the Flight clip where we want to set some manual chapter points. They are at the first cut to the interior, the start of the take-off run, the cut from the high view of the airfield to the Ridge and the final approach to the airfield. You can see the timecodes in the screenshot of the markers.

Marker Panel		✕
Position		00:00:00.00
Marker Color		
▪ Marker_1		00:06:53.09
▪ Marker_2		00:09:07.00
▪ Marker_3		00:10:30.22
▪ Marker_4		00:14:56.20
🗑 Delete all markers		

Returning to Menu 3, make sure Snapping is on and then drag a link from the middle thumbnail button to the first marker on the timeline. The Chapter marker should conveniently snap to the marker. Use the same technique to set the third thumbnail to marker 2.

Right, we have run out of thumbnails to add more scene selections to. It's time to use the Multi-menu system to create another copy of Menu 3. Right click on Menu 3 and select *Add Menu Page*. A new Menu 4 appears, but it is linked to Menu 3 and this is indicated with a connector graphic and also by sharing the same colour – in this case green. This action only happens with menus that have Previous and Next buttons. If they don't, Studio just places a copy of the menu but of a different colour and without the linking indication you can see in the screenshot.

Select Menu 4 and link from Menu 4 thumbnail 1 to marker 3 and Menu 4 thumbnail 2 to marker 4. Ignore the final thumbnail for now as I want to use it for a later demonstration.

Notice that Menu 4 hasn't generated its own M4 markers. Multi-page menus all obey the first marker in the series, so it will respond to the M3 marker.

After all that work, you deserve a break and a chance to test the Disc project so far.

Menu 3 should have 3 thumbnail links and a Next button but no Previous button. Menu 4 should have only 2 thumbnails and no Next button. If we had added enough chapters to require three multi-page menus, the middle one would have contained both Next and Previous buttons – like buttons, if they don't have something to link to, they don't get displayed.

If everything looks good, save it as **Legacy Disc Project 4**.

Setting Thumbnails

Even if everything has worked as I planned, there is an improvement that could be made to the second thumbnail of Menu 4. I made a (deliberately) bad choice of still

frame because the runway is bleached out, even though it's a good place to start watching the landing. You can correct this issue with the Set Thumbnail tool.

Return to Menu 4 and select the second thumbnail with the faulty picture. Chapter 5 should show in the Button Cycle tool. Now scrub the timeline to find a better nearby frame - I've chosen 00:15:03:00 on the timeline timecode, 00:09:49:08 on the burnt-in timecode. Click on the Set Thumbnail tool to the right of Button Cycle.

The Chapter flag hasn't moved, but the thumbnail shows a better video frame. The Set Thumbnail button can be used to set to display a still or a moving picture from anywhere on the timeline – even from parts that aren't part of any of the chapters. For example, you can create special little video files, placed at the very end of the project past the last return to menu flag, and set them as the motion thumbnails for any menu.

Using the Insert Link tool

I have also deliberately left out a sixth chapter to demonstrate a menu tool that causes some confusion. In many circumstances the **Insert Link** tool seems to do exactly the same thing as the **Create Link** tool. I've set up a situation here where you can see the difference between the two functions.

Let's imagine that we decide we need another chapter link. The Scene Selection point I'm going to add is between Chapters 4 and 5 – the cut to the view of Caenafon and the Menai Strait. It's at timeline timecode 00:13:43:16, burnt-in 00:08:29:24. Add a marker there. We don't want this link at the end because we want the scenes to remain in story order – we don't expect to see the plane land and then view the castle from the air, do we?

If I were to use Create Link on the Chapter 5 thumbnail button it would destroy the link I've already set up for the final approach. What we want is a tool that will insert a new link but ripple down any subsequent links. Chapter 5 will become Chapter 6, and if there were more links, Chapter 6 would become Chapter 7 and so on. With Chapter 5 in the Button Cycle tool display, set the scrubber to our new marker 5 and use the Insert Link Tool. You should see exactly what I described happen and we end up with a new link for Chapter 5 and the old link renumbered as chapter 6.

At this point you might be wondering what happens if you decide to add even more scenes. Insert Link is a great tool for creating new scenes, but it can also add new multi-page menus - once you run out of thumbnails on the current menu, a new one is created.

Incidentally, if you use the Play Movie menu option to watch the Flight movie, the chapters we have set for the Scene Selection menus will become unlinked chapters – using the DVD player's skip buttons will take you to the next or previous scene. This version is saved as **Legacy Disc Project 5.**

Motion Menus

Right-click on Menu 2 and select Add Menu Page. A copy of Menu 2 appears as Menu 3 and all the other menus are rippled down the list. Drag it to the far right of the list and it becomes Menu 6 – a nice salmon colour - and the other menus return to where they were. Open Menu 6 in the Menu Editor and delete both the Play Movie and Scene Selection layers. Change the *Flight Over Snowdon* text to *Special Features*, and resize it to 36pt.

I want to add two thumbnail buttons. Use the *Buttons* tab at the top of the Menu Editor and open up the *Thumbnails* sub tab.The first one in the list should be 50's

Modern, and it will suit our purposes just fine. Click on it to add it to the menu. Make a second copy and arrange them equally inside the title safe area between the Special Features text and the Main Menu button. Check that they don't have the *Still Thumbnail* checkbox set and make the left hand one the default. To make sure that the left hand one is also numbered as Chapter 1, using Order to bring the right hand thumbnail to the front. I've saved my version as **Two Thumbnails**.

The Special Features Menu

We are going to add moving video clips to this menu, so we need to think about the duration. A lot of the menus supplied with Studio have motion backgrounds which appear to loop seamlessly, but all the menus have a fixed duration that matches the video – designed so that the last and first frame of the motion background video appear not to jump when the menu loops. This effect is spoilt on a lot of DVD players because they take a differing amount of time to loop the video.

In my opinion any looping menu that is too busy gets irritating after a while, but increasing the duration from the 12 second default will help. You alter the duration

by typing numbers into the duration box above the timeline – it is indicated with the two square brackets - [] – alongside.

Enter 15 seconds. If we had longer clips, I would suggest even longer.

Before we set the thumbnails, I also want to add a motion background. Unfortunately you cannot use a subproject for this task, so we will use the unedited *The-Sky-is-the-Limit* video. Locate it in the Library - it should be in the bin of the same name - and then drag it across to the background box. The slider that appears underneath the box can be used to set the In point, so adjust it so that the video starts on the close shot of the red bike frame - you can use the keyboard arrows for accurate placement.

I don't want the video to be too bright, so I'm going to use a layer in front of the motion background. Create a rectangle that fills the screen, send it to the back layer, and, using the Look settings change its colour to black, but at 50% opacity.

We can now exit the Menu Editor. Previewing the menu at this point will confuse Studio – we should set some links first. In Menu 1, set the Special Features button to link to Menu 5. In Menu 5, link the Main Menu button to link to Menu 1. Now you should be able to preview the menu to check out what the motion background does. You may have to wait for the preview optimisation to finish to preview smoothly. The same will be the case when you add motion thumbnails.

Hmm, what about some audio? It will be a bit annoying, but here goes....

Return to the Menu Editor and find the BMX music in the Sky bin of the Library, then drag it to the Audio dropbox underneath the background box. Fortunately we can set

a fade out on the music by checking the Fade box and setting the parameter box underneath. Set it to 2 seconds. If you happen to choose music that is too loud, you can adjust the volume by adding an audio Correction to the level with the aid of the Channel Mixer before adding it to the menu. (In PS24 this fade feature didn't seem to work, by the way. I've definitely used it in the past, so further investigation is needed - or a specially made audio clip!)

Return to the timeline and put another copy of the *Intro Video* at the end of the project. Now return to Menu 5 and set the first thumbnail button to the beginning of the *007 cycling clip* and the second one to the start of the second copy of the *Intro Video*. Change the Thumbnail of the Intro Clip from the black frame to one where you can read the text. Put a M6 return marker at the end of the Cycling clip by using the Add Return tool.

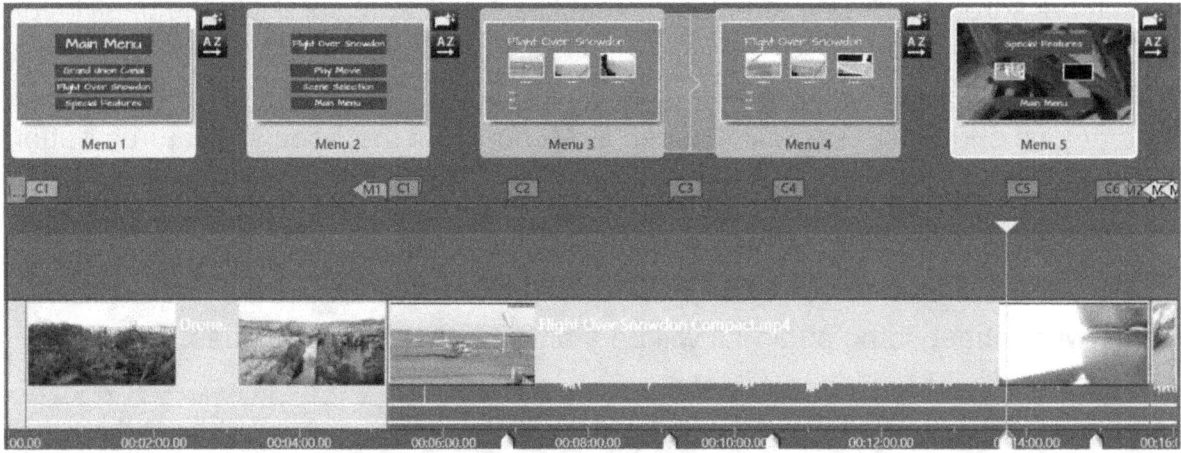

Try the menu in the disc simulator. With luck, and bugs permitting, the disc should work as planned and then subsequently modified. This is **Legacy Disc Project 6**.

I suggest you make a DVD by way of celebration. I successfully rendered this project first time, using the DVD best quality setting.

However, because of the complexity, I suggest you check the Always re-encode entire movie box in advanced settings. In my first rendered disc I encountered a few flash frames. These may have shown up if I had followed my own advice and previewed the Disc Image before going straight to the burning stage.

Timing Issues

One issue rears it's head when I play the disc on an actual player, rather than on a computer - is that the timing appears to be a little different to that programmed into the disc. It is worse on my Blu-ray player - even when playing a DVD - than on my

older player that can only play DVDs. For example, return markers aren't obeyed instantly and the Intro Video overruns into Chapter 1 by a second or so.

You can take this into account when designing your disc structure, but any adjustments you make might not work in the same way with a different player.

One solution that has worked for me is a three second blank title of the same colour as the menus at the beginning and ends of the different component parts of the disc. There is potential here for further embellishment. If we are sure which menus would appear before or after the title, we can add text such as Main Menu to match the menus being linked to and from. This won't work with chapters in a movie which has a Main Movie Play All option, obviously, but it can certainly help with overrunning Intro Videos.

Automatic Chapters and Links

The Chapter wizard can help you with simple tasks. For me, if I push it to try anything too complex it sometimes makes errors that are not only difficult to track down, but also seems to corrupt a project in such a way that even removing all the changes made by the Wizard still seems to leave some corruption behind. So I suggest you save your project before using it.

You access it via the top tab to the right of each menu, and it will only create chapter and links for the menu you select it from.

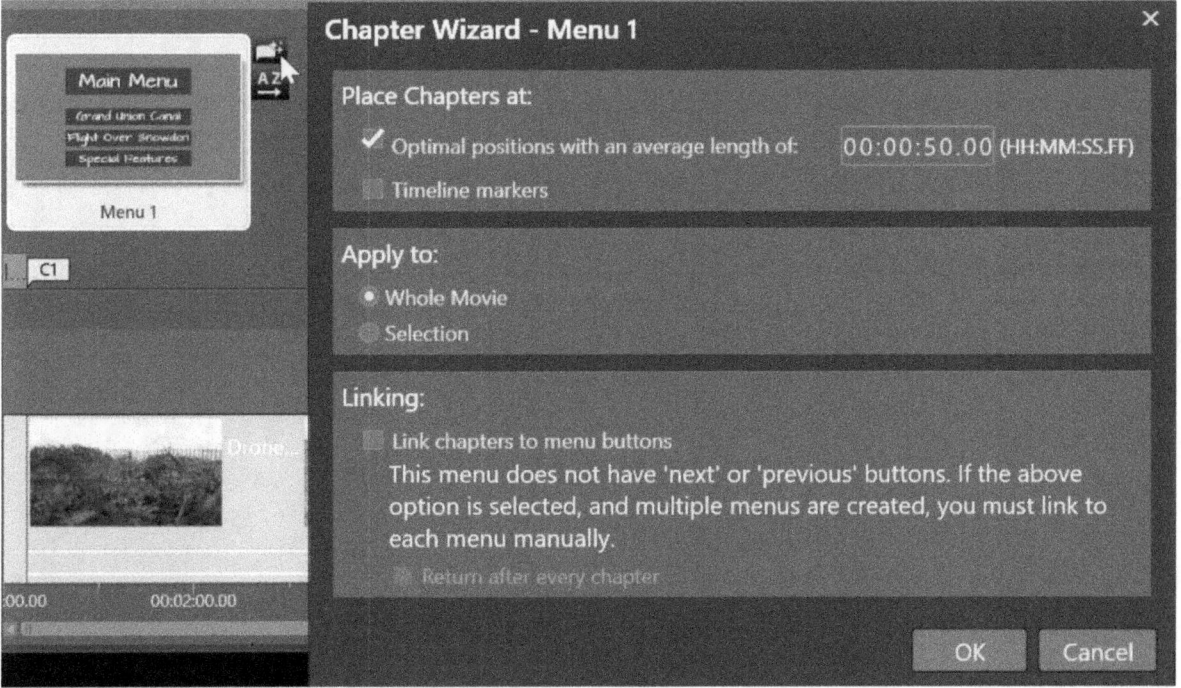

Place Chapters at: gives a choice of Optimal positions where you can set the approximate length. Studio tries if possible to place chapter markers on edit points. This still produces quite random results, but if you just want to pepper some unlinked chapters on a movie so you can use the skip function, it is useful. Timeline Markers means you have to place the markers. If you have been placing them as you have built up the project this too can be useful, particularly if you want a *Return to Menu* after each chapter, but if you are going to have to place the markers manually, you may as well place the linked chapters manually and be sure of the correct result.

Apply to: will create chapters over the whole of the timeline, or just the sections you have highlighted.

Linking: will not only create the chapters, but also add links to the menus. If the menu doesn't have Previous and Next buttons and you try to make too many chapters, although multiple menus will be created you will have to do the linking yourself. At the bottom of the Wizard you can chose if menu returns are added for each chapter.

The other tab below the Wizard allows you to **Sort** chapters. If you have been editing the timeline, adding and altering links, and perhaps even changing the button order while editing, this command will put the Chapter buttons back into timeline order. It's the alternative to you working through methodically and using the Insert Link command when adding more scene selections.

AVCHD and Blu-ray discs

You can make the above Disc project as an AVCHD or Blu-ray disc (if you have enabled Blu-ray) and all the features will work – or at least, all the features work on my Blu-ray player! There doesn't seem to be the compatibility issues that occurred in the past, certainly with the major brands.

I have made a lot of Blu-ray discs with simple menu structures but lots of content and the process seems light years ahead of the early days when I struggled to create a skip-free, compatible disc with menus that did what I expected.

Understanding Studio

The main purpose of this chapter is to answer the frequently asked questions I've seen over the years on forums, and more recently, social media. I'll also use it to place all the odd bits of information that don't fit anywhere obvious in the book. So, if you want to know stuff like how you can move a project to another computer, why you spend ages waiting for the render bars to finish, and what to do to solve crashes, you should look here. I may not know the answer, but may be able to point you in the right direction.

Hardware Requirement

Is my computer good enough to run Studio?

The latest requirements should be included in the pre-sales information. If your computer doesn't meet the minimum requirements, Pinnacle support staff won't be able to offer any help if you can't get Studio running correctly. That's not to say I haven't been able to run the program on lower spec computers, but you may need to be very patient. Even if you have a computer that meets the minimum requirements, you will have a smoother ride if you can exceed them.

CPU Processor: Intel Core i3 or AMD A4 3.0 GHz or higher, Intel Core i5 or i7 1.06 GHz or higher required for AVCHD & Intel Quick Sync Video support, Intel Core i7 4th generation or later or AMD Athlon A10 or higher for UHD, Multi-Camera or 360 video.

The CPU is not only the main workhorse, Studio has to use it to generate Playback Optimisation files as they are MPEG-2 and hardware acceleration isn't possible when creating them. Some parts of Studio aren't optimised for more than two cores.When working on H.264 and similar video, four or more cores can be brought fully into play. If you look at the Performance tab in the Task manager, you will see that on MPEG-2 rendering, for example, quad core CPUs don't use the full capacity, but load share. Adding more cores will just spread the load even more, so clock speed is important.

Graphics card: Minimum resolution 1024 x 768, minimum 256MB VGA VRAM, 512MB or higher recommended for hardware decoding acceleration. DirectX graphics device recommended:

NVIDIA GeForce 700 series / Quadro 600 (Fermi-based) or newer (CUDA-enabled required for CUDA support)

ATI Radeon HD 5XXX series or higher.

Intel HD Graphics from Ivy Bridge or higher.

There is much talk of needing a separate card with a minimum amount of dedicated memory. However, Pinnacle Studio performs pretty well with the built-in HD Graphics that comes with most mid to upper range Intel CPUs these days. The better the CPU, the better the GPU that comes with it.

While being able to handle H.264 video is vital these days, HEVC/H.265 is fast becoming important. But it's the age of GPUs rather than the power that is important - my laptop with a 6500U CPU and Intel HD 520 graphics can encode H.265, even though it's pretty slow in general, because it has the necessary hardware in its graphics chip.

If you are an AMD devotee, their systems are certainly compatible with Studio, and although you don't get access to hardware QuickSync, Pinnacle have finally added AMD GPU support to Studio.

RAM: 4 GB or higher, 8+GB highly recommended for UHD, Multi-Camera, or 360 video.

Don't expect that increasing the amount of the main memory (RAM) is going to give a noticeable gain in performance. Studio is a 64-bit program, so theoretically it could use as much memory as you have free - but it never does. Remember that editing programs don't actually hold large chunks of video data in memory. The publishing program I'm using to compose this book is currently using over 5Gb of memory, but I've never seen Studio use even half of that, unless it is heading for a crash.

Operating system: Windows 10 64-bit is the only "official" operating system on the list for PS24. However, Windows 7 64-bit has been reported to work with PS24. Pinnacle no longer test Studio on anything earlier than W10, and Support will certainly use it as an excuse for any bugs you encounter! Windows 7's days are numbered, and although I read some people claiming that it is faster, the inconvenience of trying to hang on to it is too much for me.

Hard drive space: 8 GB HDD space for full installation.

While you can't have enough disc space when you edit lots of video (I currently have 8Tb without a lot of free space), the transfer speeds of all modern HDDs is above that required to play back consumer video smoothly. This wasn't the case in the past.

There are two main issues with HDDs. I've talked about dropping frames and jerky playback in the Import chapter. Heavy fragmentation (not really possible on W10), other programs using the disc, or a hardware clash between an external drive and capture device can cause this, but not the true underlying speed of the HDD.

The other issue is render bottlenecks. There are only two sets of circumstances where I've seen a benefit from using elaborate multi-disc setups and faster HDDs –

when Studio is able to use direct stream copy (Smart Render), or when working with vast uncompressed AVI files (from iClone), when the CPU might have to wait for the HDD. In every other case it is the other way round.

Don't take any of the above to mean that a Solid State Drive won't improve the overall system performance when used as a system drive. It has a remarkable effect on the speed at which Pinnacle Studio loads and swaps windows. It won't, however, improve the render times of non-Smart render tasks or the preview smoothness of AVCHD video.

Internet connection required for installation, registration and updates. Registration required for product use. You can run Studio without an internet connection, but you need one for setting it up.

Installing Studio

Should I buy a disc or a download?

I doubt if anyone reading this hasn't already gone ahead and installed Studio, but you may well want to re-install it after a hard disc crash or the move to a new computer. The latest install methods are pretty foolproof as long as you use the default settings. I would not recommend installing to a drive other than the computer boot drive, even though it should be possible.

There are two ways to acquire Pinnacle Studio. If you buy the physical product – a disc in a box – then as long as you don't lose the disc or damage it, a slow internet connection is all you need. The latest patch will have to be downloaded from Pinnacle's website but it's normally a lot smaller than a full download.. The disc isn't copy protected, by the way, so I'd recommend you burn a safety copy or store a disc image somewhere safe. Pinnacle tend to get the disc manufactured well in advance of the program release, so it's almost certain that you will need to install a patch even on day one of the release. Obviously, you will need a DVD drive to install the disc, and no, it doesn't come with a printed manual.

Downloading Studio has now become the norm. When you buy an electronic copy, the first step is to download a small program called Pinnacle-installer.exe from the supplier. This will be saved in your Downloads location for you to run, which will then start the process of downloading the rest of the files.

However, Pinnacle have now made it very easy to download Studio at any time - even if you haven't yet bought it! Go to **www.pinnaclesys.com/download** and click on the link for your version. You always get the latest release. If you download it again, the version you get may be newer than the one you have already downloaded, avoiding the need to patch the program.

Despite making it easy to retrieve the Studio install files, it's always good practice to make a backup copy of your files, particularly if you have a slow or intermittent internet connection.

Your serial number

Have I typed it in correctly? Should I write it down somewhere?

This is the one piece of data that is proof that you have paid for Studio – the files are nothing without it. It consists of 25 letters (there are no numbers). If you bought a disc it will be printed on the back of the paper sleeve, if you bought a download it will be included on the Thank you page when the purchase is complete and in the Order confirmation email you will be sent. Keep it safe! You can get Pinnacle to send you a list of all your serial numbers by logging into your support account, but you have to register first to get an account, and also remember the account details.

The serial number dictates which version of Studio you own, not the files you download. The installer can also automatically download the service pack needed.

The files will be saved to a location that you specify, and you can choose to download them, or to install the program as well. If you don't choose to install at the time of download, you can trigger that process by opening the folder that was downloaded and running the Welcome.exe program. This would be how you could re-install Studio from a backup of your downloaded files.

Upgrades

I've paid to step up to Ultimate, but I can't see the extra features!

If Studio has been installed before on the computer and the folder containing this information - the Pixie folder – is intact the last serial number you used is stored there.

A common mistake when upgrading from Standard or Plus to Ultimate is not entering your new serial number but accepting your old one and ending up with the same version as you had before.

Can I leave my old version installed when I upgrade?

If you are upgrading to the latest version number - 23 to 24 for example - you don't need any proof of prior purchase installed on your computer, so you can uninstall the old version beforehand. I highly recommend you leave it in place, however. Your Library will be transferred, and you should get any compatible legacy add-ons you had in the past added as well. Then, when you are happy with the new version, you can uninstall the old one without any worries. I would only do that if you really need

the disc space it would free up, though. On my desktop computer I have every version of Studio back to 16 installed, just in case an older project turns out to be incompatible.

PS24 Ultimate doesn't have the New Blue or Red Giant plug-ins from earlier versions – why not?

To save money, basically. Pinnacle need to pay a licence fee to include these plug-ins and while they are useful, they aren't particularly cutting edge. However, if you have an earlier version of Studio that does include them it might be possible to add them to PS24. The easiest way to ensure that this happens is if to have the earlier version already installed and working before you add the new version to your computer, and to make sure that you use the same email address to register it as as you did the old one. I have a fully featured version of PS23 installed with all the NewBlue effects and transitions and when I install PS24 they are all inherited and not watermarked. At the time of writing the process appears to be less smooth from earlier versions, but check out the Online support as the situation is fluid.

If you want to save space you should be then able to uninstall your earlier versions, as long as you don't also remove the content.

However, although the New Blue effects and transitions do work properly with PS24, the Red Giant plug-ins are somewhat flaky – they are 32-bit and some of them don't work at all.

Registering

Registering Studio is essential. The first time you do so, be sure to use an email address you aren't likely to lose in the future. When re-registering you should use the same email address; if you don't you may compromise your serial number. Fortunately you get a clue as to the address you used. This is a further step in protecting Pinnacle from the effects of piracy.

When you register the software a small royalty needs to be paid by Pinnacle for using some of the codecs, Blu-ray authoring requires you to pay for a licence as a separate transaction, but this licence can be passed on to new versions or installations using the Restore Purchase option in the Help menu.

Passport

Your Passport is as important as your serial number, and it differs from computer to computer. If you decide to move your copy of Studio to a new computer, you can install it with the same serial number, use the same name and email address, but your Passport will change. Your licence is only for one computer, but as there is no

way to deactivate an installation (at present) you can leave the old computer active until you are sure the transfer has been successful. If there are numerous attempts to register a product with the same email and serial number but different passports, you serial number may be compromised.

The passport is displayed when you use the Serial Number option in the Help Menu.

Re-installing Studio

Studio doesn't seem to be running correctly and I've been advised to reinstall the program - but will I lose my projects and settings?

If you run the Pinnacle-Studio_Installer.exe program when you already have the program installed, you get the opportunity to *Modify*, *Repair* or *Remove* the program. You can also use Windows Programs and Features

With all of these options, **there is no danger of losing any work**.

Modify offers you the chance to install the Standard or Bonus content if they aren't in place.

Repair refreshes your installation files. In my experience it takes almost as long as an uninstall/re-install and on one occasion my computer rebooted during the process, so I can't recommend it as the next option has never let me down

Uninstall asks you if you want to remove the content as well. Once removed, run the Installer program again to re-install.

When the process is complete you will find your Library and settings intact, because they aren't stored as part of the program, but in the User area of your operating system – one Library and setting file for each user.

Troubleshooting installations

I've re-installed, but still have the problem - what next?

If a conventional re-install doesn't solve your problems, there could be issues with the Settings file, the project that the program is automatically trying to load, or the Library. I also mentioned problems that could be caused by Watchfolders and incompatible files in the Import chapter.

One possible trick for troubleshooting a corrupt installation after a conventional re-install is to log into Windows as another user and running Studio from there.

If Studio seems to be functioning correctly when logged on as someone else you know the problem lies with the elements mentioned above. If the problem still exists, then you most likely have a hardware or software compatibly issue.

The Refresh and Reset functions

Oooh. what does this button do?

The less radical option, **Refresh** can be found as a tool bottom left of the Library. It will affect the Library, including My Favourites, but won't clear out your Bins, Collections, saved FX compositions or Metadata. While writing this book I needed to use this on a couple of occasions to reset the Replace Transitions menu.

Reset is in the Control Panel as the penultimate entry on the left. When you click on it, the *settings.xml* file will be deleted along with the effects database. You then need to restart Studio, when the settings file will be recreated with default settings, and the computer re-scanned for content. The Library behaves as if it were refreshed and you will lose any changes you made in the Control Panel.

Complete Manual Reset

That's not worked. What's next?

If you think there might be something in the Library causing issues you will need to resort to manually tampering with the contents of Studio's Windows folders. That way you can delete the Studio setting for the current user and trigger the program to start up in its "freshly installed" state. You will force it to display the opening splash screen as well. You will lose your Library, so you might want to back it up as shown in the Library chapter.

Here's how to reset Studio completely:

- Shut down Studio

- Open Windows Explorer and navigate to your boot drive, almost certainly C:

- Navigate to *Users/Your profile name/*

- If you cannot see an AppData folder, you need to force Windows to show hidden items using the checkbox in the View tab of Explorer

- Continue to navigate to *Appdata/Local/*

- Rename the folder *Pinnacle_Studio_24* to *Pinnacle_Studio_24_OLD*

Now when you restart Studio, it will start up as if it were the first time, creating a new data folder. If you don't solve the problem and want to revert to your old user data

delete the Pinnacle_Studio_24 folder Studio has created and rename *Pinnacle_Studio_24_OLD* to *Pinnacle_Studio_24*.

If you are having trouble with thumbnails, refer to the Import chapter where I show you how to reset them.

After any sort of reset it takes a while for Studio to recreate it's settings, particularly if you have deleted the thumbnails. Be patient, and if the program appears to be sluggish check the CPU usage in the Task Manager. If you see high usage from tasks such as Com Surrogate, BGRender or NGStudio, then the rebuild may still be in progress.

Graphics Issues

I've re-installed and reset everything and Studio is still playing up - arggg!

If you have any problems with displaying video or effects, or rendering effects during export, the first thing to check are the drivers for your graphics card. Go to the graphics card manufacturer or the graphic chip manufacturer's websites for the latest drivers. If there is a newer version, update. If you do and the problem gets worse, roll them back, because just occasionally new drivers haven't been fully tested.

Don't assume that any inbuilt update software will automatically keep your machine completely up to date, and don't assume that because you have just unpacked a brand new computer or installed a brand new card it will have the latest drivers.

If you have a computer with an Intel i3/5/7/9 CPU it will probably have HD graphics built in. Studio may try to use this system for decoding H.264 video. Even if your computer has a separate, more powerful, graphics card, you should check the drivers for the Intel graphics as well.

Some laptops allow you to choose which graphics processor to use to run the program when you right click on the Desktop icon. If you have this feature you may be able to use it for troubleshooting.

One other fix that may help is turning off complex Windows themes such as Aero, but this is a historic fix - I don't know how relevant it is today.

Export Errors

Everything is fine until I try to export and then it goes all wrong.

The Export chapter has lots of useful information about troubleshooting your various options for both file and disc export. The most common issues now seem to stem

from the use of **hardware acceleration** for export. Note that this doesn't (currently) make any difference when generating preview files, just the final output.

In earlier versions of Studio, hardware acceleration was just a check box - On or Off. Now you can use the Control Panel/Export and Preview page to choose between *None* (off), *Intel*, *Cuda* or *AMD*. If you have an Intel CPU with HD graphics, then Intel would be the best choice, although the Intel software emulation is pretty good also. If you have a powerful, Cuda enabled Graphics card, then Cuda will probably give you the best results. AMD is the new kid on the block - it may not yet be fully debugged.

If you are experiencing issues, try None. If you have Cuda or AMD graphics but an Intel processor, it might also be worth trying Intel. Using the "wrong" hardware setting shouldn't stop you export from working - in fact it might help. The problem is that it will slow it down.

Playback Optimisation

Do I have to wait for those brown bars to turn green?

Some of this information is discussed in the Whistle-Stop Tour and Export chapters, but it's such an important subject I have fleshed out the details here.

In Classic Studio this feature was called *Background Rendering*. In NextGen Studio it is called Playback Optimisation but can be referred to as *Preview Optimisation*. People often just refer to rendering, when that can also be used as a term to exporting the final movie to a file. Using the phrase "when I render it" should not be used on a forum or social media without expecting to cause some confusion :-)

Pinnacle Studio can work with compatible video files in their raw state. It doesn't insist on converting them to a format that suits its purposes before you can put them on the timeline - the Proxy files we discussed in the Basic Principles and Multi-Cam chapters. The advantages of not using proxies include the ability to edit a file as soon as you have imported it, and a reduction in the amount of conforming required to make the final product.

However, even with a simple Standard Definition DV-AVI file, if you add enough effects, overlaid video, transitions and titles to a Studio project, there will come a time where the most powerful computer will be unable to play back the movie smoothly.

The point at which real-time playback becomes unusable varies with the complexity of the timeline, the video format and the computing power available. Some editing programs, when faced with a certain level of complexity, will just stop and tell you

that you need to render the section of the timeline that it has decided it can't cope with. Studio doesn't normally do that. Stabilisation and Scorefitter are exceptions.

In Studio you can set the level at which Playback Optimisation begins to take effect. When a section of the timeline has reached a certain level of complexity, that area is re-encoded into a single video file that uses a relatively simple codec – MPEG-2. Once that section has been rendered, Studio should encounter no difficulty in achieving smooth playback.

The level at which optimisation starts is determined by the slider named *Optimisation Threshold* in the Control Panel/Export and Preview page. At one end – 100% - it is indeed aggressive – I've not found any circumstances where rendering doesn't begin. At the other end - 0% setting it is normally completely off but sometimes rendering occurs if sub-projects, stabilisation or Scorefitter are involved.

Although Studio defaults to the 100% setting, I don't think that this is a particularly good choice for anyone with a decent computer, particularly if you are making SD projects for DVD. If you can lower the setting and still get smooth playback, then you won't be distracted by the rendering, even though it should not interfere with your editing. Apart from the distraction, after a while you start to build up a huge number of render files, taking up space and opening up the potential for errors.

This is a scale, and not just an on/off checkbox, so I would encourage you to experiment to find a setting that doesn't cause the rendering to kick in at the slightest change. Personally, I start working with it at the 50% mark.

Rendering normally takes place in the background – you don't have to halt work on the project while it occurs. If allowed to work unchecked, it will slow your computer down, another reason not to generate unnecessary render files. Its draw on computer resources may interfere with smooth playback, so Studio allows you control over when it is active. The *Render while play* setting has three options, *On*, *Off* and *Automatic*, which halts playback when it deems your system can't cope. I tend to work with it switched off.

Render progress can be monitored by looking at the bars at the top of the timeline. When a section of the movie requires optimisation (as determined by the level of optimisation set) it will be coloured in what I can only describe as a light brown. While rendering of that section is in progress, it will turn green, from left to right. If no rendering is required, the area will be grey.

The files that are rendered from the timeline are stored in a location that you can define – the Render files location (specified in a section of the Storage Locations settings in the Control Panel). If you take a look in the Render files folder once an

area has been rendered, a file with the type EVMS will exist for the rendered area, along with a number of smaller files.

You may never have heard of an EVMS file and it would be a good bet to assume that it is a proprietary video format especially created for render files by Corel. However, if you rename the file suffix to M2V then you can play the file - it appears to be an MPEG-2 file without audio. Avid Studio, the first build of Studio 16 and Classic Studio used exactly those types of files, and as far as I can tell nothing has changed except the file suffix.

The filename will be a meaningless jumble to you and me, but each file has a unique name. The number of files will soon build up. In order to prevent duplicated renders, old files are not deleted automatically. This is really useful, because if you make a change to the program and then decide to undo that change, Studio reverts to the previous set of render files rather than having to make them all over again. A good example might be if you decide to hide a video track with the eye icon, just to check what is happening underneath an overlay track. Yes, a new preview optimisation file is generated, but if you un-hide the overlay track, Studio doesn't need to regenerate the old file.

Another feature of Studio is that it not only renders selectively along the timeline, it can choose to render only certain tracks. It may then go on to render further layers, but that will depend on the threshold you have set. This explains why on a multi-layered project you may sometimes see a section of the movie's render bars change colour a number of times before finally becoming clear.

Now, if you have preview optimisation working for you, it seems a shame that the process has to be repeated when you finally export your project. There are certain circumstances where Studio can actually re-use the files that it made for preview optimisation in the final Export. However, they aren't as frequent as you might at first think, and also using the files might not be that desirable.

Firstly, if you have the Preview Quality set to Fastest Playback, (or it's set to Balanced and Studio is deciding to lower the resolution) then the files in the Auxiliary location are of no use – they have a quarter of the number of pixels than are needed to match the project resolution.

Next, if the project settings don't match the output format, the files are unlikely to be of use either. You might be making a DVD from HD material, in which case the render files will have too high a resolution to be used. If you make a file with a higher resolution or a different scanning scheme - a progressive file from an interlaced material, for example - then again, the preview render files aren't used.

Studio does use preview files when none of the above applies, but it will only use files that were generated for effects, transitions, titles or any other process that triggers preview rendering at less than 100% optimisation.

Even then, the time saving may be counter-productive. I suspect that many rendering errors at the disc or file stage can be attributed to the use of incorrect render files, and the cure is to delete them and get Studio to rebuild them from scratch or not use them at all.

Why are the Render bars red?

If, instead of brown or green bars appearing over timeline items that need rendering you see dark red bars, the program has failed to render the area. The most obvious cause of this will be that the media is missing, and if that is the case the clips will be yellow and have exclamation marks.

Another possibility is a simple render malfunction. Deleting the auxiliary files normally works in these situations. However, the area may have failed to render because the source video isn't completely compatible with Studio - you may need to convert the video to something else. If Studio cannot generate preview Optimisation files, it's also unlikely to be able to export the video either.

If the clips you are trying to render have a Stabilise effect on them and the .stb data has gone missing, then you may see red render bars. You may need to reapply the Stabilise effect to fix this problem.

I have seen Legacy effects also fail in this way. If you have applied an old Red Giant effect, or are using something obscure from the depths of the Effects folder, you might have to replace it with something more up to date.

Storage Locations

People keep telling me to delete the render files. How?

Studio has a whole page of the Control panel devoted to *Storage Locations*.

The final entry is the most important one. The files in the **Render Files Location** can grow to an appreciable size.

To delete them you just use the *Delete render files* button. It's almost an automatic first step if you encounter preview or export problems in Studio. Some people quite sensibly always delete the render files before performing an export operation. If you aren't in a hurry, it's a sensible route to take, and if you skipped the section on Preview Optimisation, I urge you to read it.

It's important to realise that the Render folder doesn't hold all the temporary files that Studio generates. It's also known that sometimes junk accumulates in other folders so there will be times that you may want to manually clean out your system. In particular, you may be harbouring many disc images which you have forgotten about. These can take up huge amounts of disc space.

If you have more than one hard drive, or even have a single drive divided up into partitions, it helps housekeeping if you keep your video assets in a different place to your operating system boot drive. The storage locations defined in this part of the control panel deal with other assets.

The first six items on the list will never take up a great deal of disc space, but for organisational reasons you might prefer to keep them somewhere else other than the default locations buried inside the users libraries. One reason might be that you work on an external or removable drive that you move between computers – working on a laptop when away, or a desktop when at home, for example. Another reason would be that you want more than one user on the same computer to share projects, titles and menus. Or you might be obsessively tidy!

If you do decide to change any of these locations, you will be warned that you need to reboot Studio to enable the changes to take place. It is also important to remember that any items you have saved in the old locations will not be moved to the new one.

The **Restore Project** location is where the project files and the assets required are placed when you extract a package. You may need a lot of space available in whatever location you decide to restore a project, which may make the default location inside the user area an unattractive choice.

The Event Log

A message flashed up, but I didn't have time to read it properly.

Sometimes things happen in Studio that haven't caused a crash but are important enough for you to want further information about. During a complex operation there may have been messages that you didn't register fully. You will find a record of these events in the Control Panel, where you can use them for troubleshooting, to refresh your memory as to what didn't go quite right or to send to Pinnacle Support.

Third party Codecs

I've imported a file from my Hokey Cokey 2000 and Studio won't play it!

Studio can't play a file if it doesn't have the codec for it. It also will have trouble working with a file that doesn't describe itself correctly in its header. You may see a Padlock symbol on a Library thumbnail that means Studio can't cope.

Studio uses its own codecs, but there is an entry in the Control Panel/Export and Preview page to allegedly allow it to use 3rd party codecs. A device that uses unusual codecs might make them available for installation in Windows, and there are free codec packs on the Internet. In theory, checking this box will make them work in Studio.

I have to be brutally honest here. In all the troubleshooting attempts I've made or heard of others making, checking this box has never made a difference. That doesn't mean to say it doesn't do anything, but I await proof.

Transcoding

So if Studio won't play the file, what can I do?

Video files that aren't completely compatible will require a 3rd party program for conversion. I normally use a free utility called **Mediacoder** for this. If the problem is incompatible audio then in some circumstances you can direct stream copy the video portion of the file so there is no quality loss. Using the program requires a bit of understanding and it is outside the scope of this book, but I do cover its use on the support section of the *Pinnacle Studio Info* website.

Handbrake is another program with a good reputation that is free. It doesn't do direct stream copy but it is easy to use. **VLC** is a comprehensive media player that can be used to transcode. It is open source and trustworthy. I avoid "free" programs that jump out at me on the first page of a Google search - they are often based on open source routines anyway, and there often is a catch.

Running out of memory

After getting slower and slower, now Studio has crashed!

If you get error messages saying that Studio is running out of memory and requesting a restart, then don't rush out and add some more memory to your system. This is almost certainly a memory leak and will occur regardless of the amount of memory you have or allocate to it – more memory just delays the inevitable. I don't want you to waste money. The cause could be one of many, but it's almost certainly a bug.

Studio staying resident

OK, it crashed again and now I can't get it to run (sigh...)

This is an irritating problem that can occur after a crash. What happens is that the Studio process isn't unloaded from memory, but instead of getting a message saying that a another instance is still running, you just encounter dumb insolence in response to your mouse clicks. You can just reboot the computer, but there is also another fix.

You can open the Windows Task Manager (CTRL-Shift-Esc) at the processes tab, and look for **NGStudio**.

Right click on it and select *End task*. Studio should now run when you ask it to.

Belongs to NGStudio

Much further down the list!

If you can't find NGStudio, I have also occasionally seen issues with preview rending that have been linked either to the **BGRenderer** or another other process called **Render Manager**.

Stability

Studio seems flaky and I just don't trust it not to lose my work.

I have used Pinnacle Studio a great deal, and can only recollect a handful of occasions where a full scale "blue screen of death" crash has occurred (always when working on unreleased beta versions) and the automatic recovery has failed. If you are seeing BSOD errors I would suspect your hardware - overheating, bad memory or power supply problems - Studio can push it to limits it won't experience with other programs.

Studio makes a backup save after every single operation, so there is no need for "timed saves" as implemented by other programs. When the program recovers from a crash it will prompt you if you want to load the movie that you were working on at the time of the crash. Read the options carefully, select the right one, and your movie should be restored with all your work intact, except perhaps the very last operation, depending on the type of crash.

Having said that, if you are unlucky enough to be experiencing frequent crashes then you might just want to hit CTRL-S every once in a while.

It's also good practice to make incremental saves with different project names as you work – something I do throughout the projects in this book. If for some reason a project becomes corrupt - something that can happen if you have a hard disc that's misbehaving - then you won't need to start all over again.

Check for Updates

Where's this patch people keep talking about?

If you haven't changed the default Update settings, you should find out about patches when you open Studio within a day of them being released, assuming you are connected to the Internet. You can also check manually.

You can tell which build you have from the splash screen as the program loads or the *About* Help option. This book was written using

24.0.1 I'd expect there to be a 24.1 patch at least. If there is a 24.5 patch it will probably include improvements as well as fixes.

There are occasional releases of hotfixes - something just to fix a specific issue that not all users are seeing or complaining about. Go to the Help page and click on Technical Support, then select Knowledgeable - this will open in an internet browser. Select *Pinnacle* and if there isn't a fix listed on the front page, use the search option.

If you are wondering why *everyone* isn't encouraged to apply *all* the hotfixes, it's normally because they haven't undergone a complete test cycle – they fix the current problem but if you don't have the issue they may cause unpredictable results.

Remember that Pinnacle can only fix issues that they know about and can reproduce. Reporting your problems, using an accurate description of the circumstances in which it occurs can result in a bug fix on a relatively new product.

Where can I get support for Pinnacle Studio?

While the obvious answer is to use the Corel website, accessible from the Help page of Studio, but there are a number of other places that may be able to help.

I suggest visiting the Studio forums that you can also reach via the Help Menu. Try searching the public forums and if you are still stuck, ask a question there. Pinnacle support staff rarely visit the forum but there is an active user base, and the moderators have access to Pinnacle for things like activation issues.

Pinnacle also have a Facebook page but it's mostly a marketing tool. There are a couple of third party Facebook pages as well where you might get a quicker response, but quite possibly from people who also frequent the official forum.

Project Compatibility with older versions

What's all this about Project Conversion?

For the first time since NGStudio was launched, there is a change to the project format between earlier versions and PS24.

You sometimes you won't be aware of this issue because only certain projects trigger the need for conversion. If, when you try to open a project from an older version, Studio 24 decides the project needs adjusting, it will display a message warning you of the issue and asking your consent to continue. If you agree, the conversion is carried out and the new project is saved in the same location as the old one, with the same filename but with _PS24 appended to the end, so *TestProject.axp* becomes *TestProject_PS24.axp*.

If you don't ever intend opening the new project in an older version of Studio again that's all you really need to know, but if PS24 was having trouble exporting and you wanted to try PS23 you may encounter some issues. The first has nothing to do with the conversions – some new features such as keyframed title animation will either not work or not be editable. The second is that the PS24 corrected file may do something different when loaded into an earlier build

So what's the difference?

PS24 changes the direction of the Tilt rotation parameter – the logic is that a positive tilt value should tilt the top of an object forward, and somehow there are crossed wires between the versions so if the older project was not converted, the tilt would happen in the other direction.

This affects Properties and the 3D CPU Effects. There are also a lot of effects that appear to have their rotation direction reversed, as well as some of the Masking settings, Finally, I suspect that the Z axis setting for the Rotation Node may also have been reversed.

I've not used Tilt, Rotate or the Z axis but PS24 still wants to convert my project.

Not only is my list of things that might be causing the conversion not exhaustive, but it seems that you don't need to change the value of Tilt or other affected parameters to trigger the conversion. All that is needed is to set a keyframe for one of them even if you don't alter the value from zero. Enabling all the keyframes for Properties, for example, causes the conversion, even if you haven't touched Tilt. Therefore you might find that converted projects still work as expected back in their original version of Studio, but do check any effects carefully.

Project management and Project packages

I want to work on my project on another computer but I keep getting linking errors.

The Library structure means that it's very easy to work on projects and add assets scattered all over your hard drive. If you import your video and picture files in folders

labelled by shooting time and date as I have suggested that will certainly be a possible outcome.

While you can still use folder structures to collect together assets for each project, its far better to use Bins or Collections, and the final liberation from hard disc folder tyranny is the feature that creates and restores project packages - archiving projects as a package.

These packages will contain every asset used in the project – no more missing media nightmares.

Studio has had a specific File menu command for saving a package - *File/Save Movie as Package* if you are in the Edit tab, or *File/Save Disc as Package* if you are in the Author tab. Project packages have a file type of .axx

Where you save the package is up to you – if you are making an archive or intending to move it to another computer then it makes sense to save it to the cloud, an external drive or other form of removable media. Be warned that the packages can be very large. If you have only used 5 seconds of a 10 minute video file, the whole of the video file will be bundled into the package. This allows you to carry on editing the project and perhaps increase the amount of content from that particular file, but it does mean that a project only a couple of minutes long might require gigabytes of storage space when saved as a package.

When you do create a package, it will be automatically added to the Library, and you will find it in the Navigator tree display under Projects/Studio Project Packages. Obviously, if you put the package on removable media and then remove it, the package is going to disappear and become Missing Media, but assuming that when you connect the media back up it takes the same drive letter Studio will discover the package again when you click on it's icon in the Library.

Restoring the package requires the unpacking of the assets as well as the project files. If you try to open a restored project via the File menu, you need to select the project type again from the drop-down menu before .axx files show up on the Open

project dialogue. When you open a package this way, it is automatically unpacked. If you import a project package via the importer you will need to use the Context Menu option to unpack the project and assets.

After unpacking you will find a new project file, of type .axp, placed in the Restored projects

default location as defined in the control panel. But what about the assets and in particular the large video files?

Studio is clever in these circumstances, recognising if the asset already exists in the correct location. If you have the same file in the same place, the new project is automatically linked to that file. No duplicate copying takes place.

If the asset isn't present on the system where you are unpacking the project then the asset is unpacked into a folder location within the restored projects location – and what is more, a complete folder structure within the parent folder is created to house the asset. There will be a folder with the name of the project and the date and time it was saved, then a folder representing the hard disc the asset was originally stored on, containing all the folders and sub-folders required to form a path to the asset. The new project will be linked to that location.

What's more, if Studio finds some of the files it requires are present and others aren't, it will only restore the files and folder paths that it needs to.

The final action is to create a new bin, with the name of the restored package, containing all the assets used in the project. The new bin will only contain assets which are part of the project itself. If you were hoping to see the bins you were using with the project, I'm afraid that they won't be recreated on the computer you unpack the project to.

The project package feature isn't perfect in other ways either. It doesn't import the assets metadata, so Library clips, collections, tags and ratings will need to be reproduced. However, its considerably easier that any manual methods of moving a project.

I must also warn you that in some rare circumstances when testing project packages I have encountered unpacking errors. Admittedly I've been trying to restore projects in deliberately complex circumstances, but still my advice is to check you are definitely able to unpack an archived project before deleting the original project and source files from the computer on which it was created. I don't want to be the cause of your wrath!

Keyboard Customisation

I've come from another editing program and I don't like the N key being used to split clips - is there anything I can do?

One very nice feature of Studio is the ability to customise the keyboard shortcuts. If you are used to another editor or have a particular operation you use so often you would like to assign it a keyboard shortcut, then you can do it here.

The main window lists all the actions that Studio performs that can have a shortcut assigned to it. Shortcuts can vary between sections of the program – for example the M key adds or removes a marker on the timeline, but when the Trim Mode is activated, it trims the current trim point(s) 10 frames left.

Let's see how we might modify a control. Switching the Dual View on and off may be something you do frequently, and want to assign it to a keyboard shortcut. Enter Dual into the Search box and you can see that CTRL-D is already allocated. That might be all you need to know, and you can use it from now on. Let's say you use it so often that you want it to be assigned to a single key press. Highlight the *Press shortcut keys*: box and press the D key. In the box below you will see

(with the aid of the drop-down arrow) that D is assigned to not just one, but two, functions already, both of which I have never mentioned because I always use the arrow keys. You can assign the D key, but you better remove the other assignment - Go to Previous Edit - because you don't want the scrubber to be moving around just because you have turned on Dual preview. Go to that shortcut and use the Remove button. You will still have Page Up and CTRL-Left available.

When you use OK, the keyboard shortcut should become active. The settings panel allows you to reset either an individual or every shortcut to the default defined by the program and listed in the manual.

There is currently no way within the program of saving and loading just the customised keyboard set ups, so if more than one person uses the program they will

either have to use different Windows user accounts or backup and restore the Settings Folder. If you do use a custom keyboard it's probably a good idea to use the settings Backup feature anyway, which I'm just about to describe!

Saving Settings

If you have made a lot of customisations to your settings, you can back them up and restore them. PS24 introduced a new feature available in the Control Panel under Reset and Backup. Here you can Backup Control Panel Settings. When you use it, you are asked to provide a name for the backup, which are saved in the default location C:/Users/Your User Name/Documents/Pinnacle/Backups.

WARNING: The Legacy Options are NOT saved. If you use Watchfolders and have an extensive list you will need to fall back on the old manual method, details of which in a moment.

Also be aware then if you change a Control Panel setting but don't click on Apply before saving the settings, the change will not be stored in the Settings file.

Restoring Settings

When you use the Restore button, you are given a choice of backups that includes the last three AutoBackup files, so if you have made an accidental change or something has been corrupted you can roll back, or load one of your own saves.

Manual Settings Backup

If you want to include the Legacy settings, including watchfolders, you still need to do a manual backup.

To backup just the current settings using Windows Explorer:

- Go to your boot drive (normally C:)

- Navigate to *Users/Your profile name/App data/ Local/ Pinnacle_Studio_24/ Studio/ 24.0*

- Copy the whole of the Settings folder

- Navigate to a safe backup location of your choice and paste the folder there.

Manual Settings Restore

To restore the saved Library and settings

- Close Pinnacle Studio

- Go to the safe backup location you used to save the data and copy the Settings folder.

- Go to your boot drive

- Navigate to *Users/Your profile name/App data/ Local/ Pinnacle_Studio_24/ Studio/24.0* and delete the whole of the current Settings folder

- Paste the saved Settings folder from the clipboard to the current location.

Downloading files for this book

The main download available from **WWW.DTVPro.co.uk** website contains everything you need in one zip file. If you have a slow internet connection you can download the files on a chapter by chapter basis. If you want the projects to link automatically to the content, follow the install instructions on the website

The website also has details of how to order a data DVD, which is sold on a cost price basis.

There are also contact details available on the website should you wish to email the author.

Index